What's Inside

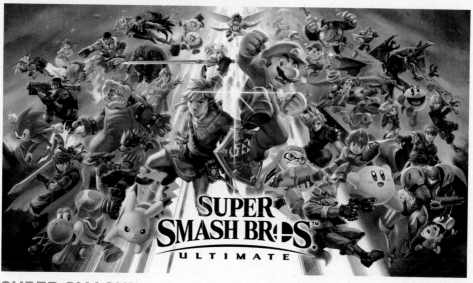

SUPER SMASH!

FIGHTERS

Super Smash!

Super Smash Bros. Ultimate crashes into the Nintendo Switch with the biggest cast of fighters, suite of stages, and bushel of items not just in the history of Nintendo's crossover platform fighter, but also of any major fighting game release of any kind. The endlessly flexible matchups, stage configurations, and battle modes are joined by Spirits Mode, a sprawling adventure that starts with lonely Kirby in a desolate land, all odds stacked against him. If that's not enough, enjoy in excess of 900 music tracks inspired by decades of videogaming's standard-bearers. This game is a celebration, like *Super Mario Odyssey* before it, a piece of media that could only exist from a creator like Nintendo.

Ultimate Glossary of Terms and Mechanics

ACTIVE

Active describes the period where attacks can hit. The hit area of the fist or foot or sword you see on-screen is handled behind the scenes as a dangerous red shape swinging around: the **hitbox**. For most moves, this active hitbox period persists for just a few **frames**, as few as two (a thirtieth of a second) for a quick jab. Most moves hover between three and seven active frames. Longer than that starts to become noticeable even to the naked eye, especially for air moves. Attacks that put an active threat out there for 10 or 20 frames (a tenth of a second to a third of a second) are almost always great staple attacks, good for many situations and easy to connect with.

AIR DODGE (NEUTRAL/NORMAL)

With the control stick neutral, tap the Shield button in midair to air-dodge. Renders fighter briefly **intangible** as they drift along their normal airborne arc. There's vulnerable lag after an air dodge's intangible frames and before the fighter can act again in midair. Air-dodging just before landing adds a little extra landing lag, but not much. See also **directional air dodge** and **defense**.

AIR ATTACK

An attack performed with the Attack button (or C-stick) while airborne, whether from jumping, hopping, stepping off a platform, or reorienting while tumbling after a launch. Air attacks are almost always referred to as "aerials" or "airs." From longtime *Smash* players, you'll hear a shorthand around airs, allowing instant identification of most air pokes: Zair = air grab, Nair = neutral air attack, Fair = forward air, Bair = back air, Dair = down air. See **offense**.

ANTI-AIR

An attack or tactic designed to thwart challengers who attack from the sky. Between up tilt and up smash, a fighter usually has a quicker and slower obvious anti-air option (though certainly this isn't global, and plenty of up tilts and up smashes have distinguishing quirks). Sometimes a fighter's up special fits the bill too, though usually this is pretty risky since most of them have lots of lag afterward. Quicker up air attacks also fit the role. Often the best anti-air strategy is to take to the sky first, **walling** off the airspace by pre-emptively jumping or hopping using good air moves with long **active** periods.

BLAST ZONE

The out-of-bounds zone where fighters are knocked out. There's one in every direction. Using front throw and back throw on high-damage victims is an attempt to hurl them into side blast zones, while going for up throw combos into up air attack (and so forth) is an attempt to catapult them high enough for the blast zone above. Punting someone off the stage, then successfully **edge-guarding** against their **recovery** leads to them plummeting to the blast zone below.

BREAK FALL

Refers to a tumbling fighter springing up just as they smack against a floor or wall. Skips the usual **wake-up** period and avoids the risk of off-the-ground hits while laid out. Accomplished by tapping the Shield button just before impact. See **tech**.

BUFFER

Inputting or holding a command before it can occur. Buffering techniques make consistent gameplay a little easier by essentially making inputs more lenient. Two kinds of buffering are possible in *Super Smash Bros. Ultimate*.

The first is typical buffering, where certain early inputs are carried forward and executed at the earliest possible moment. The most important global example of this is the buffer period when dash-canceling. Flick the control stick left or right to start your fighter's ground dash, then quickly return the control stick to neutral and input any other attack. (The simplest example is to flick the stick, then try a standing neutral attack, just to see how it works.) Correctly done, you'll be able to feel that you input the command early, but you'll see the fighter interrupt the dash at the halfway point with the new command. Any desired action buffers forward and cancels the dash except shielding. This helps ensure your execution is fluid and consistent during aggressive ground movement. This kind of buffer isn't universal to movement actions; it just works for canceling dashes. Some fighters have special follow-up actions or mechanics that can also be buffered (most fighters do their full neutral attack combo if you simply hold down the Attack button, for instance), but this is the biggest example of buffering involving early inputs carried forward.

The second is hold-buffering. This is possible anytime your fighter is in a locked state, busy performing some other action (attacking, shielding, dodging or rolling, anything that prevents them from immediately accepting your input). All you have to do is hold down the next desired action. That's it. Performed correctly, your fighter will carry out the input you're holding as soon as they can. Naturally, implementing this intelligently can go a long way toward improving your results.

The easiest way to implement this is after blocking opponents' moves. Either release Shield and hold down Attack (to come out of blocking ASAP with a quick combo), or keep holding Shield and start holding Attack (to cancel the shield animation with a shield grab). Many fighters have a powerful up special that can work as a kind of reversal, or a launching tilt or up smash attack; you can block, then hold down the command for one of those to counterattack out-of-shield as fast as possible!

CANCEL

Refers to skipping over portions of actions or attacks. This might involve canned canceling actions, like tapping Attack twice quickly to cancel neutral attack 1 into neutral attack 2. It can also refer to canceling different kinds of actions into each other, like dashing into a non-dash attack (dash-canceling) or tapping down just after a neutral attack to briefly crouch, allowing another starting neutral attack or a grab attempt (jab-canceling). It may refer to canceling periods of time. An air move might have lots of ending lag in midair, while not adding much landing lag if used near the ground; intentionally using such a move at low altitude in effect cancels its usual lengthy midair lag.

CATCH

Hitting the Attack button with good timing just before an item arrives can catch it, turning a potential incoming threat into a tool for you. In modes with all the items enabled and lots of opponents at once, there are plenty of opportunities to try out catching tossed items. (Also remember to use any unique moves your fighter might have to absorb or reflect items and shots.) Just keep in mind that catching also whiffs an attack while snatching the incoming item. An adversary who's thinking ahead and knows you'll go for a catch might chuck something your way, then rush in, waiting to whiff-punish when you swing for the catch.

Even outside item-heavy modes, certain fighters can produce their own items at will with special moves. So catching is useful beyond chaotic free-for-alls, even if items are disabled.

CHARGE

All smash attacks can be charged, and lots of specials too. Usually you can expect charging to increase damage and knockback, at the cost of the time required to charge up. (A handful of moves charge for some other purpose, like Snake's up smash.) A few fighters—like Donkey Kong, Samus, and Wii Fit Trainer—have neutral specials that take time to charge up one powerful attack. Usually this special charge period can be interrupted, breaking up the charging into chunks.

CHARGE CANCEL

Interrupting a charging period with an evasive action. A fighter may be able to **dodge-roll** or **on-the-spot-dodge** or jump, or all three—it depends on the fighter. Charging up bit by bit with charge cancels is usually required for safety unless you've hurled someone offstage and have plenty of time.

COMBO

A combo is a bit more flexible in *Smash* than in many fighting games, because encounters are so situational, and defense is never disengaged. Broadly, a combo is a sequence of moves that hit a foe in a row for good damage, maybe even as a KO setup. But so many variables—widely varying fighter weights and matchups, different stage sizes, position onstage, increased knockback as damage percentages pile up, the ability of defenders to shuffle or use directional influence to steer—make it hard to speak generally about combos.

Often, players will specify they're talking about a "true" or "guaranteed" combo when they mean an inescapable sequence, one that would increase the combo meter on the Training Stage.

Much of the anti-air/combo/juggle game blurs together, especially midstage. Many moves pop enemies into jugglable positions, but not for guaranteed combos: technically, as you rise to meet them with your up air attack (for example), perhaps they emerge from the controllable portion of their tumble with an air move that beats yours, or perhaps they air-dodge through the juggle attempt and gain advantage, maybe even a guaranteed punish against you. So then it becomes more of a mind game: launching moves are still great, but instead of going for the obvious combo follow-up hit that's not quite guaranteed, it's a good idea to pretend to do that, then fast-fall and block, or air-dodge with downward momentum. With this fake aggression, tumbling defenders can be coerced into pre-emptive attacks or air dodges, which you can then punish, perhaps putting them right back into a similar situation.

COUNTERATTACK

As a concept, this involves anything that's retaliating against an aggressor. A common example: blocking their poke attempts and immediately striking back (with shield grabs if they're close, with neutral attacks or your farthest-reaching pokes if they're not). Another frequent scenario: you're sparring with someone, exchanging feints and pokes, and they whiff something really laggy like an up special or smash attack, giving you a clear opening to rush in and hit them before they can act again.

CROUCH

A ducking stance accomplished by holding down on the control stick. Fighters are smaller targets while crouching, and some attacks and shots might miss just overhead, especially for smaller fighters crouching.

DAMAGE

Instead of having a health bar that's depleted when attacks are received, like most fighting games, Super Smash Bros. fighters have a damage percentage, which increases with hits taken. (There's also an HP bar mode, which plays more like a conventional fighter with life bars and FS Gauges building up Final Smash energy, though that's not how you'll see the game played competitively.) The more damage accumulates, the more knockback will be received on future hits. Harder knockback hurls victims closer and closer to the deadly blast zones on the far edges of the stage.

Although exceptionally powerful moves can start causing knockouts at medium percentages, the real danger zone opens up at 80%+ damage accumulated. Many hard-hitting attacks become KO risks here. Once damage builds to about 120-130%+, dangerously high, any potential exchange could lead to a knockout.

GENERAL DAMAGE GUIDELINES	
Low damage	0-39%
Medium damage	40-79%
High damage	80%+

Fighters with high damage built up begin exhibiting **rage**, a subtle increase in their own knockback power, which can help them pull back from the brink with their own knockout hits.

DASH

Quick movement accomplished by flicking the control stick all the way left or right, like performing a smash attack but without the button press. Tapping the stick makes your fighter dash, then stop. Tapping and holding the stick makes the fighter go from dashing to running. See **movement**. Tap the Attack button during a dash or run to produce a dash attack. Usually this is the farthest forward-moving move a fighter has, unless they have a side/up special that travels far laterally. See **offense**.

DEFENSE

The first line of defense is to take advantage of the crisp mobility available, skirting the playing field around enemies to stay out of their attack reach. Teasing out attacks that don't touch you at all grants opportunities to move closer without risk, perhaps even to whiff-punish for free damage. Eventually, though, whether against quick opposition or groups of enemies in free-for-all fights, you'll be forced into a passive defending state. Understand the ins and outs and options so you can stymie opposing offense and get back to your game plan.

Shielding

Holding the Shield button causes the fighter to put up a bubble shield around them, color-coded to always match up with 1P, 2P, 3P, and 4P positions. Shields rise instantly—you can block attacks the very next frame after holding the Shield button.

Tapping the Shield button—putting the shield up for the minimum amount of time—takes up no fewer than eight **frames**; blocking persists for a few frames after button release. This means you have to wait a bit to **buffer** any post-blocking attack. **Shield grabs** skip this block-lowering period, which is why they're usually the fastest **out-of-shield** option (except for heavyweights or **tether**-grabbing fighters). If an incoming attack hits during that delayed blocking period, after having released the Shield button, a perfect shield occurs, basically a universal parry! For more details, see **perfect shield**.

Shields block damage from almost all attacks (though not grabs). Shields have a limited amount of durability, represented by their sizes, and simply holding up a shield depletes its area. If shield size is allowed to dwindle completely (either from holding it up too long or from blocking powerful attacks), the defender's shield is shattered, dazing them and leaving them totally open. While dizzy, they're unable to act or defend themselves; this period of true helplessness allows an opponent to punish with a heavy attack or combo.

Rolling

Tapping left or right while holding the Shield button results in a dodge roll, a lateral evasive movement. It's like a laggier dash with an instant and lengthy **intangible** period, allowing it to totally pass through any attack, but with some punishable lag at the end when intangibility wears off.

The outcome of a roll depends on which direction your fighter faces. Roll backward to stay facing the same direction. This makes backward rolls great as baiting feints. You can dash in, roll back, then perhaps capitalize if your foe whiffs something big into the space you vacated.

Roll forward, and your fighter ends up turning around. This is perfect for rolling right through opponents. You end up on the other side, still facing them. If you read their attack intentions correctly and roll through an attack of theirs, you should be poised to strike into their exposed backs!

Sidestepping

Hold the Shield button and tap down on the control stick for a sidestep, also called a spot dodge. Sidesteps are the most challenging of the dodging defensive options, since they're immobile. Rolls and directional air dodges are mobile, and even a neutral air dodge keeps the momentum of the jump up to that point. Spot-dodging, in comparison, leads to cleaner potential opportunities right after but is harder to get away with.

Spot-dodging makes your fighter **intangible** for a brief period without going anywhere. It doesn't last as long as a roll, and it has less end lag. Since it's over faster and less vulnerable at the end, a sidestep allows quicker retaliation than a roll. However, a sidestep is also harder to time, since you don't pass through attacks in progress and you don't move out of the way of long-lasting multi-hit moves.

But with good timing, sidestepping is powerful. It lets you severely punish foes when you have a good read on their laggy single-hit swings. But like rolling, sidestepping can be risky, like badly whiffing a smash attack.

Air-Dodging (Neutral)

Tap the Shield button in midair without directional control stick input to air-dodge. The air-dodging fighter is briefly **intangible**, then has a bit of midair lag afterward. Depending on the fighter, it's not too bad. If used near the ground just before landing, air-dodging doesn't add too much extra landing lag. If you're not attacking just before landing, it can potentially let you avoid incoming attacks and shots to air-dodge instead, making the period right before landing intangible.

When you're recovering from offstage, if you have enough altitude to work with on a fighter with decent movement options, you can use an air dodge as a change-up at some point on your return trip. Aggressive **edge-guarding** foes will jump out after you, chasing you offstage; you can turn the tables on them using a well-timed air dodge to, for example, make their attempt at a KO-shot back air totally whiff, giving you a clear path back to the stage (or maybe to take a bold midair shot at them after dodge lag, depending on how far you've fallen).

Directional Air-Dodging

To get more oomph from an air dodge, point the control stick in a desired direction while tapping the Shield button in midair. There's total control over the direction, any angle possible. Your fighter lunges in that direction, briefly becoming **intangible**. The combination of a kind of midair dashing motion and the intangibility means that directed air dodges can be used to evade clean through all kinds of incoming attacks. Like with sidesteps compared to rolls, directional air dodges are far more potent than neutral air dodges for passing through attacks unharmed, but much laggier afterward.

Landing lag after an angled air dodge near the ground is far more noticeable (and punishable). The air lag afterward means angled air dodges offstage typically lose much more altitude, making them riskier during recovery unless a directional air dodge toward a ledge is your last offstage action.

Aside from their intended use of dodging through things in midair, the flexibility of directional air dodges lets them be used as an aerial feint, an alternative to short-hopping and fast-falling repeatedly. Short-hop sort of close to enemies, then angle an air dodge back down to the ground. Don't do this right up close; you don't want to expose yourself during the landing lag. But done just beyond attack ranges, it's another twitchy way to bait challengers into committing to their game plan first.

DISJOINTED

Term used to describe why some attacks seem to have such high priority. An attack whose **hitbox** extends greatly away from the fighter's **hurtboxes** is said to be disjointed. A lot of things influence which attacks seem to overpower others. Attack hitboxes might have **hurtboxes** underneath that are **intangible** or **invincible**, helping them win clashes. But even better is when active hitboxes don't have anything underneath them at all, which is the case for disjointed pokes. This is common on fighters who use weapons—Cloud's sword, Ness's baseball bat, and Simon's whip are basically invincible in effect, because they extend so far away from their wielders as threats, with nothing vulnerable underneath.

Aside from it being nice that disjointed attacks generally can't be beaten, there are a few attacks in the game that look like they're projectiles, but they're actually disjointed pokes. Examples include Bayonetta's follow-up gunshots and Mr. Game & Watch's fully filled bucket splash. They might look like attacks that can be negated by shot-absorbing moves, but they're more like far-reaching, disjointed portions of their body.

DODGE

Broadly, refers to different evasive actions possible using the Shield button. On the ground, fighters can dodge-roll to either side, or **sidestep** in place (also called an **on-the-spot dodge**, or **spot dodge** for short). In either case they're briefly **intangible**, then have a little vulnerable **lag** at the end before fighters can act again.

Dodging backward keeps grounded fighters facing the same way. You can dash in aggressively, then dodge backward to potentially bait whiffed counterattacks; you still face forward after the dodge's lag.

Dodging forward turns grounded fighters around. When close to a target, this is great. The dodging fighter passes through the defender and ends up at their backs, facing them. But far from targets, keep in mind that dodging forward ends with you backturned. There's not much reason to roll forward from far away anyway (unless you're rolling through a single incoming projectile or something).

In midair, tapping the Shield button results in an **air dodge** without changing air momentum. Tapping a direction on the control stick plus the Shield button causes a **directional air dodge**, which is like an intangible angled air dash. Angled air dodges have more lag afterward than regular air dodges.

DRAG

Property of certain moves (usually multi-hit attacks) that keeps victims suspended close, guaranteeing that follow-up hits connect. Hits that drag can be steered to set up advantageous situations. For instance, with a five-hit air attack that drags, you can catch an opponent with the first hit, then fast-fall, dragging them downward with the rest of the hits. This usually ends with the opponent forced to tech or wake up, scoring you a situation to read and punish their sudden defensive reactions.

EDGE

The end point of a stage, where land gives way to a sheer drop leading to the lower **blast zone**. The ends of "**soft**" **platforms** don't count as edges. For something to count as an edge, fighters must be able to **ledge-hang** off it. "**Ledge**" is a frequent edge synonym.

Much of the most interesting combat in Smash occurs at the edge. There's a tug-of-war between fighters who've been hurled off the side and want to **recover** past the edge to safe ground, and temporary "kings of the hill" who've knocked opponents off and are **edge-guarding**, trying to prevent them from returning. See any entries starting with **edge**, **ledge**, and **recovery**.

EDGE-GUARDING

In a nutshell, edge-guarding means preventing someone offstage from **recovering** safely. Many knockouts come from building damage on an opponent to a high level, like 80%+, then smacking them with a heavy move with high KO potential, like a good air move, smash, or your strongest throw. The rest comes from edge-guarding: tossing someone over an edge, then stopping them from making it back. Ideal edge-guarding essentially involves giving recovering fighters more chances to mess up.

Being Annoying

One basic edge-guarding tactic is to toss items and projectiles into the likely return path of offstage fighters. Most fighters have a pretty telegraphed way to return to solid ground: they drift a bit; employ a tactic to move laterally, like a side special or directional air dodge; then use up special to lunge for an edge. So every object put in the way of this path forces them to modify their approach, even if just a little, and every time they have to do that is a chance for them to miscalculate over a sheer drop.

Chasing Them Over the Abyss

A higher-risk, higher-reward tactic is to chase enemies out over thin air. Aggressors put themselves at risk this way but are naturally still safer than whoever is trying to recover; someone who jumps off a stage or drops from a ledge on purpose is more in control of their situation than someone trying to drift back to safety after getting launched off the side. You can step off the stage, take a strong swing at someone with your best air move, and still have a double jump and midair specials available to move back to the edge. Fighters with high air mobility, great air moves, and more midair jumps than the usual have an edge when getting proactive about interfering with recovery.

Canceling Out Hanging Intangibility

Experienced fighters won't recover simply by drifting out over a stage to fall to their death. The vast majority of up specials leave their users helpless until landing, so recovering by drifting alone makes you an easy target for being launched and juggled with moves like up tilt and up air attack. Savvy players usually try to drift in position to target an edge with their side or up specials. Well-aimed, this lets them go from surging toward the edge to hanging from it, intangible. Edge-guarding against these players involves either stuffing their up special in progress, stopping them from making it to the ledge at all, or slapping at the ledge just when they arrive.

Ledge-Snapping

Besides slapping foes' fingers during the two-frame window when they're just starting to grab an edge but haven't yet become intangible, there's another way to knock ledge-hangers off, ending their intangibility. Only one fighter can hang from a given edge at a time. Anyone who gets close enough in midair to grasp the same ledge knocks the first hanging person off! It takes too long to hop off an edge, fall, and grasp it to knock someone off, but there's a trick makes you appear to "snap" directly from running off the edge of a stage, to hanging off the side:

On the ground, a few steps from the edge, flick and hold the control stick to run toward it. Run clean off the side, and right when you do, rotate the control stick in a rapid half-circle from forward, to down, to back toward the edge. You have to register you've left the stage, but without drifting away from it at all. Properly executed, this "ledge snap" maneuver makes it look like a fighter is running toward the edge, then is suddenly hanging off the side. If you see them pivot at the edge, you've rotated the stick backward too fast; if you see them plunge off the side, you've done it too slow. Don't fret if it's hard to see how this works for a while—it is hard! Practice in Training Mode first, with the speed reduced (Training Mode allows you to try stuff out at 2/3, 1/2, and 1/4 speed, which is really useful for understanding concepts and mechanics).

Leveraging the Position

Holding off and blocking may work better when it seems like the enemy will probably make it back to the stage edge or a ledge-hanging position (whether you're not in position to interdict with good timing, or other skirmishes are developing close by, or you're playing a fighter who lacks great edge-guarding tools). The key to passively edge-guarding like this is to make sure you still end up facing the edge, most of the stage at your back, with the enemy hanging from the ledge or touching down on the short slice of stage in front of you. Even if you don't chase them offstage or toss annoyances at them, you control the situation if you control the space. If they fall to the stage after most up specials, you can definitely hit them. If they fall with an air move, you can block it and attempt to punish. If they hang from the ledge, any option they pick can be thwarted if you react correctly: you can shield and punish against a rising ledge attack or hopping move, and you can grab them right after their attempt to roll past you or climb up in place. If they drop from the edge voluntarily, they've just given up the biggest ace a recovering brawler can play, exploiting hanging intangibility; their next ledge grasp in the same airborne interval won't have any!

The TL;DR version of this extremely important article is that edge-guarding involves finding a balance between bold moves—tossing stuff in the enemy's way, chasing them offstage proactively to go for a spike, sprinting off an edge and ledge-snapping to nudge them back off right after they start hanging—and not overcommitting recklessly, overplaying your positional advantage.

EMPTY JUMP

An aggressive, posturing jump (or hop) with no attack performed. This is most useful to score **grabs**, since grounded targets who raise shields anticipating jump-in air moves are vulnerable to attackers who **fast-fall** and grab.

Empty-jumping/hopping can also be used as bait against reactive challengers. If someone is twitchy against jump-ins—always ready with an up special, up tilt, up smash, just generally up—you can hop aggressively without attacking, **air-dodging** just before you get to them (neutral, for lower landing lag). If you've **read** them correctly, their reactive **anti-air** will whiff through the air dodge's **intangible** period, and you'll land in time to grab or strike them!

FAST FALL

Once a fighter arrives at the apex of an airborne period, tapping down on the control stick makes them **fast-fall**, returning to earth much faster and allowing long-lasting air moves to be pulled down along a tall vertical swath. This doesn't just work during jumps; you can also fast-fall after being launched! The only time you can't fast-fall in midair is during special-move execution, or air grabs.

This is an extremely important and subtle movement skill to develop. It's almost easier to talk about when you wouldn't want to fast-fall than when you would. When leaping aggressively at foes and sticking out air pokes, you're pretty much always best served by fast-falling to cut short the second half of the jump, and to maximize the amount of airspace that your air poke hits. Hopping forward with air pokes, then fast-falling is so common and important in Smash that there's an acronym you might see used: SHFF, for "short hop fast fall."

Defensively, when jumping and sticking out air pokes to wall off aggressors, you might forgo fast-falling so you have time to squeeze out an extra air attack or two. When you're tumbling after being launched or thrown, sometimes your attacker will count on you to fast-fall, eager to get back to land faster, and aim their juggle attempts accordingly. Drifting wide away from them and skipping the fast fall can mess up their combo attempt. And offstage, when you're trying to **recover**, it's obviously not the time for fast-falling.

Use the C-Stick to Improve Fast Fall Control

When using the control stick plus the Attack button for air moves, you always trigger a fast fall while attempting down air attacks. To down air without fast-falling built in, flick the C-stick downward instead. Getting used to using the C-stick for air moves in general helps solve some aerial execution challenges like this. For instance, when trying to "SHFF" aggressively with forward air attack, you'd need to tap the Jump button (or up on the control stick, if you leave "tap up to jump" enabled in extra control options), tap forward+Attack, then tap down. It's hard to always be totally crisp with control stick motions under duress, so it's easy to mess up part of this; you get a neutral air attack instead of forward air attack, or you tap down too early or too unassertively, failing to trigger fast fall. Instead, try hopping, flicking the C-stick forward to trigger forward air attack, then tapping down on the control stick for the fast fall. You might find this is more consistent and easier to do rapidly.

FINAL SMASH

Each fighter's most powerful attack, fully unleashing their abilities. To use a Final Smash, you either have to crack open a Smash Ball, or fill up the FS Gauge (with that option enabled under a custom rule set). When your fighter glows with Final Smash energy, a neutral special input activates the ultimate move. Depending on the rule set, mode, and environment, Final Smashes may not be enabled.

FOOTSTOOL JUMP

A special type of jump any fighter can execute when flush against an opponent in midair. It works on grounded or airborne enemies, acting like a wall jump—just off an enemy's face! If used against grounded opponents, a footstool jump provides some loft while momentarily making them flinch. Their penalty for getting footstooled isn't significant while standing. In midair, though, a footstool victim is sent falling straight down quickly.

FRAME

The smallest unit of time measurement. The game runs at 60 frames per second. Both Training Mode and Photo Mode allow you to advance the game one frame at a time, to see how thinly sliced the game action is. This doesn't just help you get the best Photo Mode capture; it can also illuminate how combat works.

FRAME DATA

Frame data is sometimes used to describe move speeds and properties, and is neither required information for game enjoyment, nor as intimidating as it might seem before you get acquainted.

Testing Frame Data in Training Mode

When looking into frame data, the most important piece of information for a move is its active frames. When is the move a threat on-screen? After that, it can be helpful to know how long a move preoccupies a fighter—not when its attack or animation ends, but when it accepts different inputs.

Luckily, the Training Stage in *Super Smash Bros. Ultimate* offers a built-in frame counter, so you can accurately check anything you want! Check out the Speed setting in Training Mode options and put it on "1 frame." Now, tapping ZL advances a single frame at a time. (You can play at normal speed by holding down ZL.) While the game's frozen, holding any desired input and tapping ZL advances one frame while inputting that command. This is how you can test things accurately. For example, stand next to a CPU dummy, hold any attack command, and skip a single frame to start, then count single frames until the attack hits. That's the start-up right there; a neutral attack that strikes three ZL taps after the initial input hits in four frames.

Pick "Control" under CPU Behavior and have another controller ready to test out interactions between two fighters using frame skip! For instance, you can check if certain things are safe in a given matchup by starting the attack with one fighter, then blocking with the other and holding down Attack or Grab to buffer, executing either as soon as possible out of shield-stun. Then, that command held (you might have to get creative with both hands or feet or friends), you might try to shield up or dodge or jump away with the original aggressor before the retaliation comes. In this way, you can minutely test out any interaction in the game, finding weaknesses or opportunities.

Attack Speed Generalizations

The very fastest attacks hit in a single frame after input, but that just covers neutral attack jabs from Little Mac and Zero Suit Samus.

Usually, a very fast neutral attack hits in two or three frames. A neutral attack hitting in four or five frames is usually heavyweight territory; slower than that is rare, typically on an unusual fighter. (Look for a faster reliable tilt or smash attack. There will be one or two.)

Most decent tilt attacks hit around seven frames, give or take a frame or two. For a burlier fighter this might be closer to 10 or 12, like they're miniature smash attacks. The very fastest, like Snake's side tilt, hit in four frames.

Smashes vary, with some as fast as five to eight frames uncharged (many up smashes especially have a brief hit directly in front or on both sides that's relatively quick, before transitioning to a slower anti-air hit), but the majority clock in around 14-ish frames. Heavier fighters have smash attacks that edge into 20-to-30-frame territory, taking as long as a third of a second to half a second to hit.

Air attacks vary a lot. Some are as fast as good neutral attacks, active in two or three frames. Some are like flying smash attacks, taking 18 or more frames to hit (this is usually a down air attack with a spiking meteor smash effect on hit). It's almost more important to be aware of how much lag an air attack has than how fast it hits to start. Moves with lots of aerial lag make it hard to recover if you use them in offstage airspace; air moves with extra landing lag when used low to the ground leave you vulnerable on touchdown while messing up potential combos or shield pressure.

A grab that pulls in defenders within five or six frames is very fast. There are nimble fighters who yet have seven-frame grabs, too. Eight-frame grabs are the beginning of heavyweight territory, considered slow. Slower than that usually involves a tether throw, which has extra range at the cost of added start-up.

Specials are all over the place and can't be broadly generalized.

When this guide refers to various attacks as being fast, typical, or slow for their classes, it's with these figures in mind.

GRAB

A close-range grappling move that can't be blocked, initiated with either the Grab button (if assigned) or the Attack+Shield buttons together. Leads to grab attacks and throws when successful. Always one of the fastest (if shortest-reaching) moves in a fighter's arsenal, not to mention a terrific counterattack thanks to shield grabs. See **offense** and **shield grab**.

GRAB ATTACK

A quick, weak attack that can be repeated against a grab victim several times before throwing them. This helps up the overall damage of the throw sequence. Get in two or three quickly before your throw of choice, but don't push for more or your foe starts shaking free.

GRAB PARRY

When two fighters attempt to grab each other simultaneously, a grab parry occurs. This is like a "tech throw" in other fighting games, with both fighters returned to a **neutral** state and neither taking damage.

GUARANTEED

"Guaranteed" is often used in reference to punishes and combos. For example, on a basic level, it's important to pay attention to whether you can block each fighter's frequent attacks and strike back with "guaranteed" shield grabs and neutral attacks (usually, but not always, the fastest retorts in a given move set). It's also key to learn scenarios where your favorite fighters are "guaranteed" follow-up damage and combos. For example, at low to mid damage percentages, you might know that you can always count on down tilt and up throw to start short guaranteed combos, while at high-damage percentages you have to switch to down throw.

HITBOX

The dangerous, damage-dealing area of a move. When you talk about the **active** period, it concerns how fast-hitting and long-lasting a move is; when you talk about the hitbox, it's how much area it covers.

HITSTOP

Hitstop occurs during frames where attacks actually touch targets, whether shielded or on a clean hit. It's called hitstop because it's a subtle effect where the game is briefly slowed down, helping almost subliminally reinforce for players that contact has occurred. It's during this period that **hitstun shuffling** and **shieldstun shuffling** are possible, allowing the recipient of the attack to influence the direction of their recoil.

HITSTUN

The period after a fighter has received a hit when they're **flinching**, unable to perform any actions. No inputs are possible for a certain period of time except giving control stick input for **hitstun shuffling** (while being hit) and **directional influence** (during a launch). Any other hits that connect during this period result in a guaranteed combo, racking up lots of damage.

HITSTUN SHUFFLE

By tapping directions on the control stick while being struck by the opponent's attack, you can subtly nudge the way your fighter **flinches**. This defensive mechanic is relevant only while attacks are connecting, not when they've launched victims away; at the point of launching, that's when **directional influence** comes into play.

Hitstun shuffling is most useful against multistage attacks that hold defenders in place for several seconds. This gives the most time to react and the most time to register lots of inputs, causing more shuffling. Examples of attacks that provide a good opportunity to try shuffling are the multi-hit neutral attack combos of Bowser Jr. and Inkling, among others. These types of attacks finish with a flurry of small hits, a dozen or more at a time, which provide a good chance to try shuffling out by rapidly tapping backward. Basically, any multi-hit attack or combo is a candidate for shuffling.

Shuffling occurs in the direction you tap, and more taps are better. Like **shield-shifting** and directional influence, this is an extremely situational defensive technique, and not something to worry about much at a novice or intermediate level. But when you start looking for every trick you can find in every kind of situation, it can make a difference.

HIT-CONFIRM

A sequence of attacks you perform only up to a point, verifying that hits are successful before completing the sequence. Some hit-confirm starters include repeated down tilts from fighters like Ken, Ryu, Luigi, and Ness, and the side tilt follow-through options of Bayonetta and Snake. The neutral attack combo of almost every fighter works this way too. Generally, in any lengthy sequence of attacks, you want to cut the whole thing short as soon as possible if you realize the opponent is blocking or dodging successfully. This allows you to start up a secondary attack or bait out and punish a counterattack attempt.

HURTBOX

Guidelines behind the scenes, invisible to the player, that determine the space a fighter occupies, and the places where they're vulnerable. Hurtboxes for both taking damage and physically pushing against opponents pretty much conform to what you see the fighters doing, with one quirk: the really big, tall fighters (mainly Charizard, Ganondorf, Incineroar, and Ridley) have big vertical hitboxes for absorbing incoming attacks, but other fighters who hop against their towering upper bodies simply pass through. As a concession to smooth gameplay, the huge dudes aren't physical impediments to smaller fighters leaping through short-hopping airspace.

INTANGIBLE

Intangibility means the **hurtboxes** on a fighter or limb don't interact with the **hitboxes** of other fighters. If something slashes past, it's like an intangible fighter isn't there. Fighters are fully intangible head-to-toe during **dodges**, whether **on the spot** or **rolling**. Fighters are also fully intangible the first time they **ledge-hang** during an airborne period. Often, a fighter with long-reaching **pokes** has an intangible fist or forearm, reducing the likelihood that this attack will lose head-on encounters. Headbutting fighters are often blessed with an intangible noggin. This is one of several properties and mechanics that lead people to say a move has good priority.

INVINCIBLE

Invincible fighters and limbs interact with other objects and fighters—it isn't like passing through a ghost, like **intangibility**—but the invincible fighter doesn't **flinch** or take any **damage**. Unless aim is off, this means invincible moves usually win out, if contesting moves clash during invincible **frames**. Everyone is invincible while executing throw moves on opponents. Invincible attacks are rare, but include several shell-related Bowser moves, and the armored belly portion of King K. Rool's move set, among others.

ITEM

Items can be picked up, wielded as weapons, tossed... There are all kinds of items! Weapons, single-use projectiles, crates, Poké Balls that explode into a Pokémon helper, and Assist Trophies that summon a classic helper from all over the gaming universe. The ultimate item is the Smash Ball, which fills whoever shatters it with **Final Smash** energy! Watch out for the Fake Smash Ball, which likely KOs whoever's foolish enough to break it. (Tell them apart by which strip is thicker. A real Smash Ball has a thick vertical strip. If it's a thick horizontal strip, stay back.)

Weapons can be swung with the Attack button and thrown as projectiles with the Grab button (or Grab command, the Attack+Shield buttons together).

Items that aren't weapons can be thrown with either the Attack or Grab buttons. Unless an item is very heavy, you can usually jump and midair-jump while carrying it. Some items, like heavy crates or Wario's ditched bike, are too heavy to jump while hefting them.

Whenever throwing an item, the speed and power of the throw can be increased by flicking the stick in a smash-style input as you press the button. This is called a **smash throw**, and you'll know it works because the fighter flashes just like during a smash attack.

You can catch items the enemy has thrown at you, though this is risky, and you can even catch items you've thrown to yourself, whether tossing them straight up and then catching them, or jumping, dropping them in midair, then catching them on the way down before they hit the ground.

JAB-CANCELING

Almost every fighter's neutral attack combo is performed by pressing the Attack button repeatedly. During neutral attack 1, another press initiates neutral attack 2, then another press initiates neutral attack 3. For many fighters, merely holding down the Attack button executes the combo. This isn't always desirable; most neutral attack combos are punishable if the whole thing is blocked, and the finishing attacks usually don't have great KO or follow-up potential.

But there's so much leniency on tapping/holding the Attack button to continue through the neutral attack combo that it can be hard not to speed through a full neutral combo. Try doing it based on timing: perform your favorite fighter's "jab," neutral attack 1, then wait long enough to tap Attack and get another jab, without going to the next stage in the combo. You'll be surprised how long you can wait and still cause neutral attack 2.

The way around this is to interrupt the first neutral attack as soon as possible with something else that "breaks" the potential neutral attack combo. The best examples are crouching and shielding. You don't have to crouch or shield long enough to see them happen as more than a flicker at best; you just need the game to register them. (As with many techniques, it can help to practice at 1/4 or 1/2 speed in Training Mode first, so it's easier to see what's happening at full speed.)

By cutting short the end lag of the first jab with a "flickered" shield or crouch—merely tapping down or Shield—if you then go for another neutral Attack input, you produce another starting jab. This allows you to perform earlier stages of neutral attack combos repeatedly, avoiding the unsafe finishing hits, and also sets up "tick-throw" grab attempts and mix-ups. You can also jab-cancel by turning around: nudge the control stick to your fighter's back during end lag of your initial neutral attacks.

JUGGLE

Juggle is hitting a midair foe who's tumbling **helplessly**. This isn't necessarily a part of a **combo**, but often is. Lots of throws and hard-hitting moves end up putting victims in ripe position for juggling, especially at higher-damage percentages. Fighters trying to fall back to the stage have some options to ward off or avoid juggles (even while tumbling fighters can make themselves drift left or right, or **fast-fall**, and once locked **hitstun** ends, tumbling fighters can reorient themselves with an air move or **air dodge**). But advantage still rests with the aggressive fighter on the ground, aiming at juggle candidates with upward-aimed attacks of every type (up air attack is always appropriate, and up tilt/up smash usually are too, except for a few fighters with quirky moves), plus fighter-specific juggle tricks.

JUMP

A full leaping maneuver accomplished by holding down the Jump button until after takeoff. A shorter press produces a **hop**, essentially a short jump. See **movement**.

KNOCKBACK

Knockback is the strength of the launching power of attacks. Every attack has its own degree of base knockback. Just like damage, if there's a sweet spot, it improves the knockback, maybe adding a special hit effect, like a **meteor smash**.

Generally, high-damage attacks dish out more knockback. It's high-knockback power that makes moves credible knockout threats, once enemy damage builds up to medium and beyond. Yet you'll find the occasional low-damage attack with respectable knockback, or a move with reliable damage that nevertheless lacks KO potential.

Aside from varying attack to attack, knockback also gradually increases as foes take damage. Thanks to the **rage** buff when badly hurt, knockback for a high-damage fighter is increased both for and against them.

LAND

Solid ground, midstage, not immediately under threat of being pushed down or sideways into a lethal **blast zone**, thus losing a stock. At low damage near the beginnings of matches, combat takes place mostly over land. As damage piles up and skirmishes stray to one side or another, that changes. Brawlers punted off the land to either side have to try and **recover** back to safety, with limited tools to do so.

If they use up whatever midair jumps, movement-oriented special moves, and air dodges that might be useful to them and they haven't made it back, they drop. But if they can make it back to the stage somehow, either touching down with feet firmly or hanging from a ledge, they restock all those options, useful for dropping off on purpose, or if you get immediately launched back out (it happens).

While midair movement options are restocked by either putting boots on the ground or hanging from a ledge, full ledge-intangibility properties aren't restocked until you touch down with both feet, standing. Ledge-hanging and repeatedly tethering rapidly diminish in evasiveness, and trying to ledge-hang more than six times (or tether more than three) simply fails until standing again.

LAG

Lag refers to any period of time where a fighter is occupied with a current action without an actual **active** threat of some kind extended. Lag can refer to a move being sluggish in general, or it can specifically call out slow starting or ending lag, highlighting where the windup or follow-through of a move is extra vulnerable. Lots of starting lag on an action means you're much more likely to get interrupted before it ever comes out. Lots of end lag means you're much more likely to get punished after the active period on whiff or block.

LAUNCH

Refers to any attack or throw that pops victims up off the ground. They're stuck briefly tumbling in hitstun, unable to do anything except try to hold perpendicular to the direction of the launch for directional influence. Then they start tumbling helplessly back to the ground.

LEDGE

Synonym for **edge**. See also **edge-guarding** and **ledge-hanging**.

LEDGE-HANGING

Whenever a fighter falling offstage passes a viable handhold, they grasp it, arresting their fall and hanging from the ledge.

Don't think of ledge-hanging as an imperiled, panicky position. Instead, think of it as another base of operations, with its own set of follow-ups, opportunities, and weaknesses, just like standing or jumping or dashing.

The first time a fighter hangs from a ledge per airborne period, the move has significant evasive properties that make ledge options hard to deal with for edge-guarding adversaries. There are long **intangible** periods on any rising action from the ledge.

Repeated ledge-hanging instances in the same airborne period (like grasping a ledge, dropping, then double-jumping back up to the handhold) drastically diminish any intangibility bonuses conferred to options out of a ledge hang. Persistent **edge-guarders** count on this, finding each time they knock hangers off a handhold easier than the previous time, until there's nowhere for hangers to go but down and out. From a hanging position, there are many actions one can undertake, whether aggressive or defensive. Ledge-hanging doesn't have to be a defensive posture or exclusively a part of **recovery**.

Ledge Attack

Attack performed, naturally, with the Attack button, causing the ledge-hanging fighter to rise with a strong forward strike.

Ledge Rise

Performed by tapping forward toward the ledge. Makes the fighter rise in place at the edge, like getting straight up after a knockdown.

Ledge Roll

Aggressive rising movement, performing by tapping the Shield button while ledge-hanging. The fighter rises and rolls forward, regaining control about a dash's distance from the edge.

Ledge Jump

Tapping upward on the control stick (even with up to jump disabled) or the Jump button makes ledge-hangers throw themselves up into a jump. Now that's shoulder strength!

Ledge Drop

There are two ways to simply release the ledge, intentionally falling. Tap down to fast-fall from the ledge like a stone. Or tap back to drop more gently and slightly away.

Ledge-dropping is a somewhat high-level tactic, going the extra mile along with ledge-jumping toward making a ledge-hanging posture less defensive and more empowered.

Ledge Snap

An advanced movement technique that involves sprinting right off the side of a stage, immediately cutting lateral inertia, then hanging from the ledge. If properly done, fighters seem to go straight from running at the side to hanging from it, with not much in between.

METEOR SMASH

A downward-aimed move that sends victims hurtling downward quickly. Many down air attacks can meteor smash with a clean hit from above. But some other moves can meteor smash too, like Mario's forward air attack. This goes case by case, but almost every fighter has at least one move that can meteor smash. On a successful spiking hit, there's a telltale sound, letting you know the smash has worked. It should also be obvious when the attack recipient bounces hard off the stage, or plummets down toward the lower blast zone.

MOVEMENT

Understanding and mastering movement in *Super Smash Bros. Ultimate* is perhaps the most important aspect to feeling comfortable in combat.

LEDGE-HANGING INTANGIBILITY*					
Consecutive Ledge Hangs	Hanging	Ledge Attack	Rising	Rolling	Jumping
1	1.5 seconds	Through active frames (attack is basically unbeatable)	Tiny vulnerable end lag (one frame)	20 frames of vulnerable end lag	12 frames
2	0	Ends just before active frames (start-up unbeatable, active frames vulnerable)	Tenth of a second of vulnerable end lag	24 frames of vulnerable end lag	10 frames
3	0	Only briefly as fighter starts rising	Quarter-second of vulnerable end lag	32 frames of vulnerable end lag	6 frames
4	0	0	0	0	0

*These values serve as guidelines, but can vary depending on how long you dangle during each ledge hang.

Walking

Walking is accomplished by gently nudging the control stick left or right. The speed is variable depending on how much you press the stick. The key is not to flick the stick at first, which produces a dash instead.

Walking forward is slower than other forms of movement, but allows a measured approach and instant access to tilt attacks (since you've already nudged the stick off-center, you can easily tap the Attack button for a side tilt or rotate the stick to up or down first for an up or down tilt).

Dashing

Flick the stick quickly in either direction for a dash. This is a quick lunging movement that covers a little bit of ground. Dash in one direction repeatedly for jerky, fast forward movement, or dash back and forth in place to seem erratic and unpredictable (see **dash dance**).

Dashing fighters cover ground much more quickly and suddenly than by walking. Across a short distance it's also faster than running. Lots of ground combat is about making the opponent guess whether you'll dash in and out, dash in and attack, dash in and grab, or dash in and try to bait them somehow (like by rolling backward or through them, or by simply stopping and shielding).

Running

After starting a dash, keep holding the control stick to run. The fighter sprints across the stage as long as this is held. Pressing the Attack button while running produces a dash attack. Like with dashing, letting the control stick go back to neutral first allows you to cancel the run with anything but immediate blocking. Tapping the opposite direction while running results in a sliding **pivot**, a sudden change of direction and inertia. See **reverse rush**.

Jumping

Jumping is accomplished by holding down the Jump button until takeoff ends, four frames after input starts. Releasing the Jump button earlier than that causes a short hop.

Moving around on the ground, walking/dashing/running/rolling left or right, is inherently more predictable than being in midair. But while jumping, you might use all sorts of air moves and specials along all kinds of trajectories, especially with everyone being able to jump in midair at least once. Shielding isn't possible, but air-dodging is (both neutral and directional).

Keeping track of the direction a fighter faces as they jump is crucial. For most fighters, they're locked in to the direction they face on takeoff until they touch down again (with exceptions for techniques like **special-reversing**, and floaty fighters like King Dedede and Kirby, and those with an extra wing flap like Charizard and Ridley). This can be something inconvenient to deal with, like when launched backturned and forced to ward while descending with a down air attack that's hard to aim. Or it's something to employ on purpose, like backturning (see **reverse rush**) to jump at people with a terrific, far-reaching back air.

By default, upward presses on the control stick are set to trigger jumps as well. Unless you're really fond of it, **it's recommended to disable control stick jumping**, since it makes it harder to do up tilt and up air moves on command, and to move around in midair without inadvertently wasting midair jumps. It might seem intuitive at first for upward motions to cause jumps, but it results in sloppier play and is best unlearned unless you use some quirky personal control scheme or controller.

Midair Jumping

Everyone is capable of a single midair jump, basically a double jump. This is great for keeping air movement unpredictable midstage, reorienting when launched into a tumble, and as an extra movement tool when recovering from offstage. Double-jumping can facilitate some juggle combos, especially if your fighter has up air attacks that pop foes up without much end lag.

Midair jumps, after use, are unavailable again until either landing or hanging off a ledge. A few fighters have more midair jumps available to them per airborne period than usual. Naturally, this improves their midair mobility and recovery, and becomes one of their main strengths.

Hopping

Short-hopping, or just hopping, is an invaluable and challenging maneuver to master. Hop by tapping the Jump button for under four **frames**. Basically, you have to release the Jump button before a fighter's "squatting" pre-jump frames end. You perform a regular jump, not a hop, if you're still holding Jump on the fourth frame after input, as you're taking off.

A new shortcut allows easier short hops, with an instant rising air attack attached. Input the Attack+Jump buttons together for a **short hop attack**.

A hop gives the same air time as a jump, but with much lower altitude. Short-hopping air moves are a staple of both offense and defense. On defense you can short-hop repeatedly in place with your best quick air moves, **walling** opposition to discourage them from advancing. A hopping fighter is less predictable and less susceptible to **combos** and **grabs** than a standing one.

Short-hopping forward drives lots of offense. Air moves with long **active** periods are fantastic for hopping forward, sticking them out, then **fast-falling** back to the ground, for a rapid ascent and descent covered by an attack the whole time. This covers both anyone ahead in short-hopping airspace and anyone below standing on the ground, and is particularly effective with attacks that have high shield-stun and low landing lag (fighter-specific; for details, see the fighter chapters). Short-hopping sequences are superb for edge-guarding, too. With your back facing a ledge, you can threaten short-hopping back airs against recovering foes, a highly effective, low-commitment option. Short-hopping down air attack is often perfect for slapping at foes grasping at ledges, attempting a **two-frame punish**.

Defensively, short hops are a great out-of-shield option. For instance, if an opponent performs a cross-over jumping attack and ends up behind you, on the wrong side for typical pokes, you can short-hop right after blocking and strike them with back air.

When enemies catch on and start shielding against hops, you can "empty"-hop without using an air move, fast-falling to grab the moment you land.

Wall-Jumping

Wall jumps are special jumps that many fighters have access to, allowing them to bounce off a surface without using up their midair jump. Wall jumps are performed near a wall by pressing the control stick in the opposite direction of the wall—no Jump button press is necessary. Consecutive wall jumps can be performed in the same airborne period as long as two vertical surfaces are close enough together, like the space between tall buildings in certain stages. While there are no limitations in terms of the amount of wall jumps one can perform in a single airborne interval, each successive wall jump incurs a jump-height penalty, diminishing returns until the fighter stops gaining altitude altogether.

Wall-Clinging

Wall-clinging is the ability to stick to walls. It's usually used during a player's **recovery** to stall, messing with an **edge-guarding** opponent's timing. Wall clings are performed by holding the stick toward a nearby wall, making the fighter rest against it for a while. Anyone who can wall-cling can also wall-jump.

Rolling & Directional Air-Dodging

While these are not explicitly movement options, they relocate a fighter and should be thought of as dashes that are much better at the beginning, but much riskier at the end.

Falling

Falling is important and inevitable. Whether jumping or tumbling, you'll end up airborne eventually. Different fighters drift down at different speeds, depending on weight and buoyancy.

Faster falling can be easier for enemies to juggle in close-range combos, but harder for them to catch you off launches farther away. Slower falling can make it easier to drift back to the stage during **recovery**, but harder to land without being harassed by quicker airborne enemies swinging with up air attacks.

NEUTRAL

Neutral has several different meanings in fighting games at large and Smash specifically.

A **neutral input** means the control stick is centered, with no directional press registering. This is important all over the place. Neutral specials, neutral attacks on the ground, and neutral air attacks when jumping all require the control stick be centered during the Attack/Special button input. Returning the control stick to neutral during a dash or run allows for non-dash attacks out of the aggressive forward movement (which is a huge change for Super Smash Bros. combat compared to past editions).

The **neutral game** is the state where all combatants are relatively evenly matched, with no one having a gross frame or position advantage. This is where feinting and poking takes place, attempting to fish for clean hits or bait out overcommitments that can be punished. When opponents joust and spar, but neither is actively being forced to deal with the consequences of a previous exchange, that's the neutral game.

The neutral game favors quick, low-commitment fishing attacks, like shooting projectiles, tossing items, poking with the tips of neutral attacks and quicker tilt attacks, attempting grabs and dashing grabs and dash attacks that cross up against shielding enemies, and jumping/short-hopping airs with long active periods (fast-falling to return to earth quickly and cover more airspace, naturally).

Laggy, high-commitment moves are risky in the neutral game. This includes more ambitious special moves, most smash attacks, and dash attacks that can't push through defenders on block. Unless you're making a **hard read** based on opponents' habits, save these attacks for situations where you have a heavy advantage over someone, so it's less likely they can see it coming and jump, block, or dodge. Examples of situations with a heavy advantage, where you can leverage higher-risk, higher-reward attacks (like charged smashes or laggy specials), include when you've just thrown or launched someone, so they have to tumble and perhaps tech on the ground, or when you punt someone clear off the stage, forcing them to focus on recovery instead of combat.

OFFENSE

There are several layers of offensive moves, which all fill different roles at times.

Neutral Attack

Neutral attacks are like jabs, usually the quickest, lowest-commitment options available to a fighter (though not always—some oddballs have ponderously slow neutral attacks and should look elsewhere for short-notice pokes). Almost all fighters have several stages of a neutral attack combo, which you can speed through either by tapping the Attack button repeatedly, or simply holding it down (fighter-dependent).

Up close, neutral attack combos are quick out-of-shield retaliations and whiff punishers, good when you're not sure whether you can score something juicier (like an up tilt launcher). Performing just one or two neutral attacks (stopping short of the final neutral attack in a sequence, always the most punishable) can be good for setting up an immediate grab attempt or mix-up. See **jab-canceling** for execution tips on using interrupted neutral attack combos.

Dash Attacks

Dash attacks are done by pressing the Attack button while holding the control stick to dash or run. Execution-wise, remember that you have to keep holding left or right during the dash/run as you press Attack for a dash attack. Also, producing dash attacks on short notice without room to run is possible using normal inputs, but difficult. You have to register that you've snapped the control stick to the side and held it, but you can't press the Attack button so soon that you trigger a smash attack first.

There's a trick for an alternate method: if you snap the control stick sideways and hold it, then immediately flick the C-stick sideways too, you get an "instant" dash attack every time. Keep this in mind for situations where a quick dash attack would be great but can be hard to execute normally. This includes situations like throwing someone forward or down, then chasing their bodies with an immediate dash attack, or jumping in on grounded foes with a successful air attack that pops them off their feet, then dash-attacking right away on landing to launch them.

Facing off against attentive foes on their feet, dashing in with a dash attack is usually fairly unsafe, since they might block or dodge and punish you. (Some dash attacks can at least push beyond someone who shields, making them a little safer.) It's usually better to play more measured and close in with forward movement, lower-commitment ground moves, and short-hopping pokes.

However, when foes are inattentive or off-balance, like if they're fighting someone else or tumbling from being launched or thrown, about to hit the ground, it's a great time to rush in and pressure with dash attacks. Tumbling foes who tech poorly can get relaunched by the dash attack, and opportunistic hits against distracted brawlers is kind of the name of the game in free-for-all modes.

Tilt Attacks

If neutral attacks are like light moves, and smash attacks are heavy, tilt attacks can be thought of as medium. Each fighter has a side, up, and down tilt attack. Tilts can be performed either by gently nudging the control stick and pressing the Attack button, or by holding a direction for longer than the smash attack flick window, then pressing the Attack button.

Most up tilt attacks are used as anti-airs and for juggling. Some fighters can use up tilt repeatedly in combos, carrying enemies upward bit by bit, eventually in position for you to jump and chase them with air hits. This is especially true of sweeping up tilts with a broad arc overhead. Side tilt attacks usually consist of midrange pokes, effective for stopping aggressive grounded opponents. Side tilts can often themselves be tilted a bit, by angling the sideways input slightly up or down to alter the side tilt's trajectory. This is most useful for aiming some side tilts slightly downward while **edge-guarding**, knocking off ledge-hanging foes. Down tilt attacks are commonly quick pokes, which can sometimes trip, knock down, or pop victims up for a close juggle.

Tilt attacks can be difficult to execute on demand in high-pressure situations due to the hectic and fast-paced nature of the game. Inadvertent smash attacks can result from trying to register tilts on the analog control stick. To alleviate this, you can alter your smash attack flick sensitivity in controller settings. Alternatively, the C-stick can be set to tilt attacks, allowing you to perform them without worrying about fine control stick operations. For example, to dash into a down tilt, you can simply dash and release the control stick, then flick down on the C-stick. If you do this manually, it's easy to accidentally perform a dash into down smash attack because of the quick control stick movements involved.

Smash Attacks

Smash attacks are ground-based powerhouse moves used to finish off opponents. Smash attacks are performed by flicking the control stick all the way to the side and hitting the Attack button at the same time. All smash attacks can be charged by holding the Attack button upon execution. Charging a smash attack almost always increases the attack's damage and launching power.

Most smash attacks are punishable when shielded (and even more so when whiffed), making them high-risk, high-reward attacks. However, they can be essential tools in your arsenal, allowing you to threaten KOs at early damage percentages. Notable up smash attacks include those that have broad hitbox coverage and/or low start-up times, making them effective for launching aggressive foes into the upper **blast zone**.

Side smash attacks are generally solid **edge-guarding** attacks. If you can create enough time and room to charge up a smash attack while your opponent is offstage, you can time your release for a potential KO. In the neutral game, they can be heavily punished if you whiff them.

Down smash attacks are usually double-sided clear-out attacks. They're great for getting rid of enemies surrounding you in hectic situations, but can leave you extremely vulnerable if you miss or have them shielded. Some down smash attacks are good for edge-guarding, either for **two-frame punishes** against **ledge-hanging**, or for punishing ledge-recovery rolls.

Grabs

An unshieldable attack initiated by pressing the Attack+Shield buttons together. There's also a Grab button assigned by default, which you can relocate if you like.

After grabbing someone, a grappler can opt to pound them with **grab attacks**, before hurling them with a **throw**. Victims can struggle with inputs while stuck in a grab, shaking out if the aggressor doesn't throw quickly enough.

A fighter's grab is usually one of the fastest moves they have (though never the fastest), key in scaring opponents away from shielding all incoming offense. When dropping shield, grabbing is always the fastest possible retort a defender can muster. When you're shielding an incoming move and want to hit back, you have to release the Shield button and buffer/tap the input for your out-of-shield attack of choice. But to shield-grab while blocking, since you're already holding the Shield button, all you have to do is hold down the Attack button too. If foes are close enough to grab after blocking, a shield grab is always your surest option. This is why it's smart to poke from the max range of good attacks, or to aim jump-in air moves to cross over and land at defenders' backs, negating the threat of retaliatory shield grabs.

Grab range is usually pretty short, equivalent to a fighter's neutral attack or slightly worse. Naturally, grabbing during a dash adds some extra reach by virtue of the dash's forward inertia. But a fighter's dashing grab **hitbox** is often larger than when merely standing still. This is especially true when grabbing right after starting a **pivot**; most fighters have extra-large grabbing hitboxes when pivoting, the better to pull in someone running overeagerly at their heels. However, note that grabbing out of a dash or pivot universally adds three extra **frames** to a grab's normal **start-up lag**.

Throws

After grabbing an enemy, you can opt to throw them with one of four throws: front, back, up, or down. Each fighter's four throws have distinct uses and properties. Some throws deal more damage than others, while some are designed to set up juggling opportunities, **tech** traps, or guaranteed follow-up attacks. Choosing which throw to use is generally intuitive. If close to a ledge, you want to throw your ensnared opponents off the stage. To rack up more damage, you can go for an up or down throw, setting up a combo or mix-up opportunity (this is fighter-dependent).

Since grabs are a core component of your arsenal, learning which throws lead to more potential damage is vital for optimizing a fighter's damage output.

Air Attacks

Air attacks are executed while airborne, whether popped up tumbling by enemies or jumping and hopping under your own agency. Since the best movement in Smash usually occurs while airborne, air moves are extremely important.

Neutral air attack is usually the quickest air move, just like neutral attack on the ground. It often has a decent active period, even hitting on both sides like an aerial clear-out option. Forward air attack is usually a more directed poke, aimed at a specific forward angle. Back air is usually a variation on forward air attack, with some twists—like higher damage, but more starting and ending lag, or a shorter active period. It's not uncommon for back airs to be a fighter's best general air-to-air and air-to-ground poke, forcing the use of conscious **reverse rush** movement to keep your back to foes. Depending on the fighter, this logic for neutral, front, and back air might be all scrambled, so it's ultimately case by case.

Up air attack and down air attack are a little more universal. Up air is virtually always an upward swiping move, great for chasing tumbling enemies and jumpers above. Down air attack is usually a precise, downward-aimed spike, capable of **meteor smashing** victims if it hits squarely from above.

Whether you set the C-stick to produce smash attacks or tilts, it can produce air moves when jumping around. Performing air attacks with the C-stick makes it easier to use the control stick for fast-falling when desired.

OUT-OF-SHIELD

This adjective describes an attack or sequence performed immediately after a player drops their shield.

Not to be confused with a **shield grab**, which is a built-in defense mechanic. An out-of-shield attack is performed by releasing the Shield button first, whereas shield grabs are performed by tapping Attack while continuing to hold the Shield button. After releasing the Shield button, there's an eight-frame interval that must pass before other actions are possible. **Buffer** the desired attack input immediately during this window, for it to execute as soon as possible.

Out-of-shield neutral attacks are usually the fastest and most obvious retaliatory options. Out-of-shield short-hopping air attacks are also common, especially for fighters with fast back air attacks, since it's much more practical to buffer a hop out-of-shield than to turn around in order to perform a frontal attack.

PERFECT SHIELD

Perfect-shielding is a defense mechanic that rewards precise shield-release timing. The moment you release the Shield button, there's a five-**frame** window where your shield is still active. If your fighter blocks an attack during this window, they block the attack while negating all **shield-stun**. This lets them act again after dropping shield much faster than normal, usually early enough to allow guaranteed punishment.

To register a perfect shield parry, a raised shield must be up for at least three frames. This means perfect shield isn't possible after a shield flickers on for only two frames. The fastest possible perfect shield block occurs in four frames, tapping and releasing the Shield button as though for a short hop. If you quickly tap and release the Shield button, the earliest perfect shield block is four frames later (three frames of a normal raised shield, then five frames with a chance to perfect shield).

PIVOT

Run in one direction, then tap and hold backward to turn sharply, sliding with inertia briefly before reversing course.

Pivoting isn't just cosmetic. During a pivot, a fighter turns around and scampers against their own momentum. This is still moving forward relative to the original running direction, so jumping or attacking backturned from this state can be powerful on purpose. Many fighters have different ground pokes that are useful to aim backward, including many up tilts and down smashes, and this trick allows their aggressive use from a backward slide. Similarly, the reverse air rush technique enables aggressive backturned aerial movement, starting out running at an intended target, pivoting, then hopping at foes with back air.

POKE

A poke is a quick, safe, and spaced attack carefully deployed in the **neutral game**, intended either to keep an enemy at bay or to pressure them and put them on the defensive.

Poking is a crucial tactic in both offense and defense. It allows you to keep initiative if you're the one attacking, or to deter aggressors from the edge of your attack range.

POKÉ BALL

Poké Balls in *Super Smash Bros. Ultimate* are special items that, when thrown, release a randomly selected Pokémon. The released Pokémon activates a unique power that affects the battlefield and its combatants. Some Pokémon unleash an area-of-effect attack, some perform attacks against the summoner's opponents, and some Pokémon can produce effects that harm everyone, including its summoner (the player who picks up and uses the Poké Ball).

PRE-JUMP FRAMES

Sometimes also called takeoff or jumpsquat frames. The tiny period of time in between inputting a jump command and the fighter leaving the ground. See **movement**.

PRIORITY

While an attack is **active**, its priority is determined by a number of things. The positions of an attacker's **hitboxes** and **hurtboxes** are first and foremost. Often, these areas overlap, so a fighter's extended limb is both a weapon and a vulnerable area. If the limb's hurtbox is **intangible** or **invincible**, the fighter's vulnerable area is reduced. This second hypothetical move wins out if it encounters a typical first move, with intangible/invincible limbs overpowering those whose hitboxes and hurtboxes overlap without special properties.

Often, though, a fighter doesn't have any intangible or invincible portions, but has something better: a hitbox that extends well beyond the vulnerable hurtbox. This is sometimes referred to as an attack having a "**disjointed**" hitbox, since the hitbox and hurtbox for the fighter don't match.

This is usually found with fighters and moves that use items and weapons. But there are plenty of instances of weaponless fighters who have exceptional hitboxes on an attack here or there, enabling them to safely swing beyond their vulnerable reach.

PROJECTILE

A projectile is a ranged attack, usually fired from a fighter like a shot. Projectiles are generally used to threaten opponents with long-range damage.

Projectiles vary wildly in properties, such as damage, velocity, acceleration, trajectory, and on-screen duration. For instance, some projectiles can stick to enemies, some can track and pursue foes, and some can detonate into an area-of-effect explosion that damages both friend and foe. Most projectiles have damage drop-off as they fly—the farther they travel, the less damage they deal.

In broad terms, slower projectiles that stay active for a long time are effective for distracting foes, providing the projectile user an opportunity to rush in with an attack. In contrast, shots that launch and fly quickly are effective for dealing damage to enemies since they're more difficult to react to, but they don't create follow-up openings. Tossed **items**, which are in effect projectiles, also work this way. A slower toss can be followed in, allowing you to pressure the foe's attempt to shield or dodge the thrown item. Meanwhile, a **smash throw** deals increased damage and is faster to hit, giving them less time to defend, and you less time to capitalize on the brief on-screen threat.

Projectile hitboxes are treated as a different type of attack in terms of collision interactions. Most projectiles collide and nullify each other, while bigger projectiles such as Samus's fully charged Charge Shot can plow through minor shots unscathed, still decimating opponents in the way.

Most projectiles can be reflected by deflection attacks like Falco's Reflector and Ness's side smash. Reflected projectiles deal higher damage, according to the reflector's properties. Reflected projectiles can be reflected right back; if a shot bounces between reflectors several times in a row, watch out! It's almost become a mini **Final Smash**!

PUNISH

In general terms, a punish is any reaction that penalizes an opponent. However, this term is mostly used to describe a specific transaction: whenever a player extends an attack that leaves them vulnerable, going through end lag, and their opponent responds with a punishing attack, causing unavoidable damage. For instance, when a player's laggy down smash whiffs or gets shielded, they can be punished by most reprisals as they're stuck in the attack's retraction animation.

Punishing is a core concept in fighting games. Almost all attacks are punishable in some form, although some are less practically punishable than others. (Since you can **perfect-shield** and remove all shield lag, you can theoretically punish all jabs with a quick one of your own, though in practice this is really unlikely unless you're a DARPA AI project playing *Super Smash Bros. Ultimate* competitively.)

In this guide, "punish" usually refers to attacking an enemy who's either whiffed an attack, or whose laggy attack you've just shielded. Whether an attack is punishable is determined by how much **shield-stun** it inflicts and how much end lag it has before the attacker can raise their own shield or dodge. Range is also super important: the farther away an attack is used, the less likely opponents can close the gap in time. If the only things they can punish you with quickly enough are a short-range neutral attack and shield grab, and you poke from outside that range, then you're safe even if the **frame** situation technically says otherwise.

In *Super Smash Bros. Ultimate*, most blocked close-range melee attacks are vulnerable to quicker shield grabs (think Mario speed, not heavyweight speed) if the attacker is within range. Against an immediate shield grab, attackers can't jump away or dodge in time even if they **buffer** those actions. However, retaliating after blocking isn't so simple since there are many variables to consider, including whether the enemy will end up too far away, or even behind you, after the attack. High-level players will seek to end up at max range or at your back on purpose, negating the counterattack speed of shield grabs.

Some attacks are good for punishing foes in these positioning scenarios. For instance, Cloud's up tilt can hit enemies behind him quickly, so it makes for a powerful anti-cross-up punish attack. Many fighters' side tilts and down tilts are also effective retorts against foes just outside of jab. Many side and down tilts start relatively fast, usually with good horizontal reach. Of course, this becomes matchup-specific, so learning the ins and outs of your fighter's moves (and the major places where common opposing fighters are vulnerable) is vital to your punish game.

RAGE

Rage is an informal term used to describe the passive power-up gained by fighters with very high damage built up. When a fighter with a dangerous damage total (edging into red) starts smoking (especially noteworthy on their portrait), their attacks dish out extra damage and knockback! This gives fighters at extreme risk of knockout a bit of a comeback mechanic.

High rage makes a wounded fighter that much deadlier, and should give their pursuers a pause, since being overzealous chasing a knockout can easily backfire. In the Rule Settings, Rage is known as Underdog Boost and can be toggled On or Off (the default).

Learning how to play around your opponent's rage, as well as using your own when you're beat up, is crucial. Some players may flirt with hovering in high damage on purpose, counting on brinkmanship as a winning strategy. With good avoidance, **directional influence** if you get launched, and well-aimed high-damage hits on foes chasing you, exploiting rage on purpose can get surprising mileage.

RANGE/REACH

Range and reach are used interchangeably to describe the distance covered by an attack. It's frequently preceded by an attack-as-adjective, such as "jab range" (a fighter's reach with their neutral attack).

Fighters who wield weapons (like swords) usually have terrific reach on their tilt and smash attacks. Long-reaching attacks are doubly good because they're usually disjointed—they don't extend vulnerable hurtboxes alongside—making them basically invincible if well-spaced.

RECOVERY

In this guide (and in almost all Smash community discussions) this term is used to refer to a particular phase of a match: when a player is thrown offstage and is trying to drift back to either grab on to a ledge or land on solid ground (either of which restores aerial-mobility options, while grabbing a ledge the first time also grants temporarily **intangibility**). In the recovery phase, the player protecting the ledge, trying to prevent recovery, is **edge-guarding**. While defending a ledge, this aggressor has a big position advantage. The recovering player is at risk of being knocked out, since they're closer to a side **blast zone** and hovering above a sheer drop, all but forced to use predictable moves (usually midair jumps, side specials, up specials, and directional air dodges) to return to solid ground.

Recovery is an essential concept since most knockouts scored revolve around the game of recovery versus edge-guarding. All fighters have at least one special that helps them reach for a ledge—often there are two—and some fighters have more midair jumps available than usual, or special moves that can pass as extra midair jumps. Some fighters are more effective at recovering, and some fighters can be very predictable. Some fighters are kind of bad at fighting but are so good at recovering that they still make worthwhile fighters. But whether a fighter has above-average recovery tools or not, everyone is forced to play the recovery game, so it's important to approach every time you're forced to recover as a learning opportunity, and a chance for tiny victories (snagging the ledge and going intangible with well-aimed up special or directional air dodge, for example; or beating out your attacker air-to-air when they chase you over the drop, then making it back to the stage to boot).

REFLECT

Certain special moves, like Pit's Guardian Orbitars and Mario's Cape, can reflect projectiles, sending them back to the original shooter. Usually, reflecting a shot also buffs its damage. Reflect moves used well go a long way toward negating zoning and camping tactics, since challengers who think they can win by sitting back and firing projectiles can find their own hailstorms turned against them. See fighter chapters for specific details.

REVERSE RUSH

An execution technique that allows sliding backturned attacks, given a little starting runway. Start by tapping the control stick and holding it to dash and then run. Anytime after the run begins, tap the control stick in the other direction to pivot and slide. Immediately during the slide, input the ground move of choice, or tap the Jump button to hop. Either way, you're using initial forward momentum of the starting run to create an aggressive backturned attack.

This is much more important in older *Smash* games, where actions while running are very restrictive. Basically, you could only dash-attack. To do anything else, you had to pivot, starting a slide and turning around. From here, a few extra actions were possible; the primary use was to run, pivot, hop backturned, then poke with low-altitude back air aimed in the original running direction.

One of the biggest mechanical updates in *Super Smash Bros. Ultimate* is that you can now cancel a dash/run with just about anything (except raising your shield). So this isn't as important as it once was. But it's still useful, especially if your favorite fighters have great back airs for aggressive rushdown use, and ground pokes with exceptional backward-aimed hitboxes. It's not that unusual for a fighter's back air to seem like a better quick poke than other air options when facing forward, and for moves like a double-sided down smash or arcing up tilt to have safe lag when aimed backward.

ROLL

Defensive maneuver accomplished by tapping the control stick left or right while holding the Shield button. Rolling fighters are **intangible**, with some vulnerable lag at the end after the motion ends. This is the grounded equivalent to **directional air dodges**, with more end lag than **sidestepping** but a better ability to dodge stuff. See **defense**.

RUN

An extended sprint that begins after dashing and holding the control stick direction. Attacking while holding the stick during a dash or run causes a dash attack. Canceling a dash with other actions leads to the other actions happening, but canceling a run adds much more sliding momentum (as explained in **pivot** and **reverse rush**). See **dash** and **movement**.

SHIELD

The most basic and important defensive maneuver accomplished by holding down the Shield button. Incoming attacks are blocked, except grabs and (extremely rare) unblockable or shield-shattering moves. Releasing the Shield button just before an attack impacts results in a **perfect shield**, basically a universal parry allowing the defender to counterattack much faster than normal after blocking. See **defense**.

SHIELD BREAK

A shield break happens to a fighter when their shields are completely depleted and shrunken, either from blocking too long or from shielding too many attacks (or a shield-decimating one, like Ken's Nata Otoshi Geri + Inazuma Kick follow-up).

SHIELD GRAB

A raised shield can be immediately canceled into grab at any time. While holding the Shield button, simply press the Attack button too. Shield grabs are primarily used to punish shielded attacks. For many fighters (generally those with close-range grabs), this is their fastest punish. However, most fast close-range grabs suffer from short reach, and there are no grabs in the game that cover behind the grappler, so spacing and position awareness are vital to using shield-grab punishes well.

SHIELD SHIFT

Shield-shifting is performed by holding the Shield button while gently tilting the control stick in any direction. This nudges the shield's curve accordingly. Pressing too far results in a dodge or roll, which can be avoided by shield-shifting while holding two Shield buttons (ZL+ZR together). This disabled dodge moves and allows maximum shield-shifting.

Shields only cover all of a fighter when they're fresh and haven't been held up too long recently or chipped at. If shield size is depleted at all, your fighter has vulnerable portions sticking out somewhere. Attentive shield-shifting in these scenarios can save you from glancing hits.

SHIELD-STUN

Shield-stun is the amount of time a shielding fighter is forced to stay in a blocking animation. This forced state cannot be avoided, even if the defender releases the Shield button.

Attacks inflict varying amounts of shield-stun. Generally, stronger attacks inflict more, although this isn't a universal rule. Certain rapid-fire attacks (like Sheik's neutral attack 3 loop) can keep foes locked in shield-stun until the shield pushback pushes them out of range, since the strikes occur so quickly.

Chainable attack sequences, like Cloud's Cross Slash series, have very low shield-stun, so it's possible for the defender to drop their shield in between hits. Either player can use this to their advantage in these types of situations, depending on timing and **reads**. For instance, if a Cloud player guesses that the opponent will drop their shield immediately and try to counterattack, chaining into the second hit of Cross Slash will pre-empt the enemy.

On the other hand, an opponent who correctly reads when Cloud will cease his attack sequence can attack with up tilt out-of-shield, launching Cloud during his end lag if correct.

A fighter's shield-stun can be completely nullified with perfect shield or by shield-grabbing. Shield-grabbing can be a risk, though, especially with fighters who have limited grab range. Whiffed grabs are usually punishable.

SHIELD-STUN SHUFFLE

Shield-stun shuffling is an advanced technique used to manipulate your fighter's body positioning while blocking. As the attack strikes the shield, the precise moment the game's action is minutely frozen in hitstop, flick the control stick in the direction you want to scoot. Your fighter ever so slightly repositions.

This technique is difficult to implement, but can be useful in specific situations, allowing you to shuffle out of a multi-hit attack and freeing yourself from shield-stun in order to punish the enemy. Comparable to **hitstun shuffling** while eating hits.

SHORT HOP

A short hop is what it sounds like: a jump with less altitude. Short hops are performed by quickly tapping the Jump button (releasing it before the takeoff frames end) and are a crucial gameplay element. Short-hopping allows you to throw out aerial attacks without fully committing to jumping airspace. Short hops take just as long as jumps to leave the ground, and hang in the air the same amount of time. They just don't travel as high vertically, so they allow more aggressive use against opponents on the ground, and other foes in short-hopping airspace. See **movement**.

SHORT HOP ATTACK

This refers to a built-in shortcut for a short-hopping air move, performed from a standing position by pressing the Attack+Jump buttons together. Hold a direction on the control stick if desired to pick specific airs (for example, hold down while tapping Attack+Jump for a short-hopping down air attack).

It used to be that short-hopping attacks had to be performed with a brief tap of the Jump button, then an Attack button press later, which is a lot harder. You might get a jump instead, pressing Jump too long; or get the wrong air move, juggling the control stick between steering your airborne fighter and choosing the air poke. With this command you always get a short-hopping air move. Short hop attacks do 85% of the damage done by an aerial attack during a full jump.

The only shortcoming is that the timing is immediate, so there will probably be midair end lag and no late coverage. It's frequently better to manually short-hop and delay air moves to hit with the best timings, usually while descending, but this trick is great to remember when an instant short-hopping poke suffices, attacking while rising.

SHOT

Synonym for **projectile**.

SIDE

"Side" can reference areas in relation to the direction a fighter is facing (front, behind), or the fighter's position relative to an opponent's (left side or right side of an opponent). It can also refer to moves requiring left and right inputs, like side tilts, side smashes, side specials, and rolls. **Side rolls** are basically just rolls, so see **rolls** and **defense** for those.

SIDESTEP

A sidestep is commonly called a spot dodge or on-the-spot dodge, with the former being more commonplace. It's an evasive move without movement, accomplished by tapping down+Shield button.

SLIDE

Sliding can refer to low-profile forward-moving attacks. Slides are powerful because of their gap-closing potential and lengthy **active** windows. Not only do they advance a fighter forward, but they also prevent enemies from approaching at the same time.

Long, far-moving active periods on slides have interesting applications in terms of frame advantage and potential combos. Advantage is dependent on when the slide hits; hitting with the tail end of a slide results in way more advantage than hitting earlier. Some fighters can take advantage of this with a guaranteed follow-up combo, particularly if the slide has a launching effect.

Sliding also refers to momentum that carries a fighter across a stage briefly, perhaps in a state where they shouldn't usually be moving. The biggest example is **reverse-rushing**—running, then pivoting to slide backturned. In older Smash titles, sliding right after air-dodging into the ground enables some movement tricks, but the potential for post-air dodge sliding is greatly diminished here.

SMASH ATTACK

The strongest and slowest class of grounded attacks, after neutral attacks and tilt attacks. See **offense**.

SPECIAL MOVE

Special moves refer to the unique abilities each fighter possesses, performed with different control stick inputs and the Special button. A special-move toolkit usually has some mix of a projectile or two, a couple of recovery tools (mobility specials that boost horizontal and vertical movement), a defensive ability (projectile reflection or parrying attack), and/or a mega-powerful (sometimes chargeable) attack.

Special moves can all be performed midair, with some special moves having an alternate aerial version with different properties. Specials are vital to both offense and defense, usually define a fighter's playstyle in large part, and are explored in depth in fighter chapters.

SPECIAL REVERSE

This is commonly referred to as a "b-reverse" in *Super Smash Bros.* discussions. This is a technique that allows special-move direction to be reversed right after input, but before action begins. This is especially relevant when it comes to neutral specials. You might not be able to turn around at all in midair, and turning around on the ground might involve turning or pivoting time you don't have. It's invaluable being able to start a neutral special facing the wrong way, then snap it to the other direction. Almost all special moves can be special-reversed, but there are some exceptions (important to note to avoid disaster, if you try special-reversing something that can't).

To perform a special reverse, input the special move and immediately follow with a control stick input toward your fighter's back. The reversed-direction input must be extremely fast, like releasing Jump before takeoff to trigger a hop instead of a jump. Special-reversing is especially important in midair, where you might need to reorient a neutral special as mentioned, but where you also might have to start an up special aimed the wrong way, immediately correcting direction after input.

SPIKE

An attack effect that sends the victim falling straight down quickly. See **meteor smash**.

SPOT DODGE

A grounded evasive move in place, done by pressing down on the control stick along with the Shield button. Also called a **sidestep** or on-the-spot dodge.

STAGE

Stage refers to the battlefield (or map, level, etc.) that combatants fight on (e.g., Battlefield, Corneria, Final Destination). Stages vary vastly in properties, including size, hazards, transitions, and platform placements. Check out the Stages chapter for a full list of battlegrounds!

STALL-THEN-FALL ATTACK

Air attacks that pause briefly, hovering in place, before plunging down to the ground. May descend at either a diagonal or straight-downward trajectory. Also often referred to as dive kicks. The persistent falling hitbox until landing is great, but most of these attacks have considerable landing lag.

STOCK

A stock is one player's "life" in certain game modes. In tournament settings, stock settings can vary between two and four, with the game ending once a player loses all of their stocks. Stocks are lost by being launched beyond a **blast zone**. Fighters respawning after losing a stock are briefly **invincible**. Losing a stock resets damage to 0%.

SUPER ARMOR

A rare but powerful property of certain moves, usually confined to a specific period of the move. When a fighter has super armor, they don't **flinch** when struck, allowing them to blow through incoming attacks. Super armor absorption power varies. Some special moves, like Little Mac's Straight Lunge, have super armor throughout. Others are specific, like Captain Falcon's Raptor Boost, which has a brief super armor window that only stops relatively weak attacks.

SWEET SPOT

Certain attacks can deal significantly more damage when hit at specific frames of the move's **active** period, and/or specific areas of the **hitbox**. This is usually easy to specify: the move's peak damage is early during active or late; the best place to hit is either at the tip of the range or up close. Most examples are like this. Moves with sweet spots are occasionally called "tipper" attacks, particularly when referring to sword-wielding fighters. But sweet-spot locations vary, sometimes located within the inner portion of an attack as opposed to the tip. Move damage listed in fighter chapters is based on sweet-spot hits, if applicable, and sweet-spot location or timing is listed in notes.

TAKEOFF

Sometimes used to refer to the brief period while a fighter is prepping to jump or hop but hasn't yet left the ground. Also called jumpsquat or pre-jump frames. See **movement**.

TAUNT

Taunts are rude or celebratory gestures each fighter can perform: dances, provocations, or good old showboating. Most fighters have three distinct taunts, executed with the side, up, and down input directions on the D-pad. A few fighters have four taunts, with different ones for front and back directions. Most taunts don't affect combat, but a few have small hitboxes or other quirks worth checking out.

TECH

A tech, or break fall, is a defensive maneuver that prevents fighters from being knocked down or bounced off walls. Techs are performed by accurately hitting the Shield button right before your tumbling fighter hits a surface of the stage. You can opt to tech in place, or with a side roll. If successful, you're granted a slight **intangibility** period, followed by a brief window of vulnerable lag.

Techs are used to prevent aggressors from scoring free off-the-ground hits after knockdowns, and to avoid being bounced off the side of a stage from wall-splatting attacks. While teching is important, it has its drawbacks. After the brief intangibility window, your fighter becomes vulnerable temporarily as they get up from the ground, similar to a sidestep or roll.

TETHER

A tether is a far-reaching grab that can be performed both in the air and on the ground. Air tether attacks are versatile, extending a far-reaching, **disjointed**, persistent **hitbox**. They're commonly used to zone out foes past neutral attack range, usually extended during a short hop's descent to prevent enemies from closing in.

Fighters with tethers have an extra recovery tool, too. They can use their tether moves to latch on to nearby ledges. Fighters like Ivysaur and the vampire-hunting Belmonts have other means to tether ledges. If the tether succeeds, the fighter can reel themselves into the ledge and grab it, starting the typical ledge-hanging intangibility period.

During one airborne period without standing firmly on a floor, there are limitations to how many times a tether can latch on to a ledge. This prevents infinite ledge-stalling tactics. After you tether a ledge three times without your feet touching solid ground, your fourth tether attempt simply bounces off the ledge, usually resulting in a loss of a stock as you plummet to the bottom blast zone!

THROW (FOE)

A follow-up action after grabbing an opponent. Hurls them in the chosen direction. Squeeze in a few grab attacks for extra damage before the throw, and be sure to follow up for possible **combos** or **tech** pressure after. See **offense**.

THROW (ITEM)

You can throw items after picking them up by pressing the Attack button (or the Grab button or Grab command). Items can be thrown forward, back, up, or down. Extra power can be added to the throw by flicking the stick like a smash attack, resulting in a faster, harder-hitting smash throw. You can also throw items forward while dashing, allowing you to set up a follow-up attack as the enemy is forced to shield your thrown item. See **item** and **catch**.

TILT ATTACK

A class of grounded attack in between neutral attacks and smash attacks in terms of strength and speed. Executed by either gently nudging the control stick before Attack button input, or holding it all the way to the gate beforehand (which is kind of like pre-loading tilts). In terms of control stick input, going for a tilt instead of a smash is like walking instead of dashing. The C-stick can also be assigned to perform tilt attacks, which can greatly help consistency. See **offense**.

TUMBLING

Tumbling usually occurs right after the hitstun of a launching attack. Tumbling fighters are noted by their rotating animation. Hence, tumbling. Tumbling is notable in that while it looks like you're in a combo-ready hitstun state, it's more like a kind of limited defensive drifting posture.

While tumbling, you can adjust your fighter's aerial trajectory, perform any aerial action to cancel the tumble, tech (if close to a surface), and grab nearby ledges. If you hit the floor while tumbling, you transition into a knockdown state, allowing the enemy an opportunity to hit you with an off-the-ground attack.

TWO-FRAME PUNISH

This refers to the ever-so-slight vulnerability window the first time a player grabs a ledge during a given airborne period. Although the first ledge hang of a jump is **intangible**, the first two **frames** of hanging are vulnerable to punishment.

This tiny window is there to give **edge-guarders** a chance against savvy recovering fighters who zero in on a ledge handhold, seeking out the intangibility (and the restocking of their midair options after touching the ledge).

The best kinds of attacks to aim at the ledge right when recovering fighters surge toward it: projectiles dropped/fired around the ledge, melee swings with long active periods and hitboxes that stretch under the floor, and low-altitude downward-aimed aerial attacks. Two-frame punishing requires a lot of experience and is prediction-heavy, since it's hard not only to react to an opponent going for a ledge hang, but also to recognize which move they're using, altering their timing.

Strong two-frame punish-attack examples include lengthy active attacks like Bowser's Fire Breath, Pac-Man's Fire Hydrant, Rosalina's down air attack, and "z-dropped" items.
Fighters without these types of attacks can use low-hitting smash attacks, such as Samus's down smash and Mario's down-angled side smash.

This mechanic is occasionally referred to with a verb. For example, "two-framing" someone means hitting their ledge-recovery window. See **recovery** and **edge-guarding**.

WAKE-UP

After being knocked down, fighters have several options available to prevent further damage. Pressing up on the control stick causes you to rise normally. This also occurs if the knocked-down fighter lies for a certain amount of time. The getup animation includes a brief **intangibility** period, followed by a vulnerability window. Getting up in this manner is effective against an attacker waiting to punish your clear-out **wake-up attack**.

Wake-Up Attack

While knocked down, all fighters have some form of unique double-sided wake-up attack, performed by pressing Attack while laid out. The knocked-down fighter becomes intangible while getting up, then delivers a clear-out attack, hitting both sides. Some wake-up attacks hit both sides at once, but most of them swing first to one side, then turn and swing at the other, knocking away nearby enemies. Some fighters have different wake-up attacks depending on whether they're lying prone faceup or facedown.

Like with ledge attacks, the game here is straightforward. If opponents try to do anything while you're getting up with a wake-up attack, you'll win and bat them away. But if they bait you into using a wake-up attack, then they block it or sidestep, they can score guaranteed punishment afterward.

WALL CLING

Fighters who can wall-cling can stick to vertical surfaces for a bit before wall-jumping away. This adds an extra stalling, anti-**edge-guarding** option. See **movement**.

WALL JUMP

Springing off a vertical surface, an extra form of midair jump some fighters can perform. See **movement**.

WALLING

This is a colloquial term for using defensive attack sequences to ward off and hit enemies attempting to advance into range. For example, the neutral air attacks of Mario, Dr. Mario, and Luigi are excellent walling attacks if you jump, stick them out, then fast-fall down. The lengthy **active** period of the kicks covers the whole fast fall duration. Another example of this kind of tactic involves jumping and double-jumping while sticking out a quick high-priority air move over and over, like Mario jumping with his back to foes and repeatedly poking with back air.

WEIGHT

Fighter sizes and weights are all over the place, ranging from hulking ultra-heavyweight Bowser to featherweights like Jigglypuff and Pichu, who might as well be couch cushions. Weight determines how far they'll be launched and thrown. Lightweights move a lot more while flinching, basically, while sturdier heavyweights are harder to knock around. Heavier fighters are also slower in general than more pixie-like fighters (though there are exceptions for certain traits here and there, like Charizard's excellent ground speed and Wario's top-notch air mobility; see **movement** for relative comparisons).

But while it's easier to hurl featherweights toward blast zones, their faster, farther travel speed makes them less susceptible to damage-racking combos. Meanwhile, heavier fighters are usually have faster fall speeds too, making them extra-susceptible to juggle hits. The most basic example is that tons of fighters can simply up tilt over and over against heavy, fast-falling fighters.

It tends to be easier to launch lighter fighters long distances, but combo opportunities shrink; heftier fighters won't fly as far, but it's easier to dance around them, and to rack up damage quickly on big openings.

WHIFF

What it sounds like—a missed attack. This might not be a big deal, like whiffing most initial neutral attacks, or whiffing your best air move while short hopping then fast falling, or a dash-in grab attempt. But whiffing telegraphed, laggy moves is a bad habit. It might be tempting to go for the strongest smash moves all the time, but it'll quickly get chewed up by evasive opponents.

Bayonetta

Bayonetta Vitals	
Movement Options	
Jumps	1
Crouch Walk	No
Tether	No
Wall Jump	Yes
Wall Cling	Yes
Movement Ranks	
Ground Speed	C- (31-34)
Air Speed	C (49-51)
Falling Speed	B (17-18)
Weight	D- (64)

OVERVIEW

Bayonetta is unique among *Super Smash Bros.* brawlers. Her air-to-air pressure, combos, and flexibility with aerial movement are second to none. Per jumping period, no one is armed to the teeth quite like Bayonetta: two Witch Twist up specials, a double jump, and up to two uses of After Burner Kick. And that's without mentioning her normal air moves, which are all great. She can wall-jump and wall-cling too.

Her combo and movement abilities are so good that they're controversial in some competitive circles. But the witch pays for this unique toolkit quite a bit: she may be lithe, but Bayonetta's moves are quite slow. Most heavyweights have a faster neutral attack jab than she does, but the ground isn't really where she wants to be, anyway.

Grounded Attacks

Neutral Attacks	
Move	**Damage**
Neutral attack 1	1.4
Neutral attack 2	1.4
Neutral attack 3	2.2
Neutral attack 4	0.2x4+, 0.5, 5

Dash Attack	
Move	**Damage**
Dash attack	10

Defensive Attacks	
Move	**Damage**
Ledge attack	9
Wake-up attack	7

Neutral Attacks: With the first three attacks of her neutral attack combo, Bayonetta attacks with pistol-whip punching. She starts with a forward jab, follows with a backhand punch, then ends with an uppercut. This initial three-hit combo doesn't have much knockback, and any of the moves is extremely unsafe from punishment if shielded.

Dash Attack: Bayonetta emerges from a dash with a forward-rushing gun punch, knocking back anyone in the way. Damage is highest striking as the attack starts, and she slides forward a bit during the attack. It's just a bit slow to start up, hitting out of dash about the same speed as your typical side smash. Bayonetta's end lag on the move is sizable, so foes who shield the dash attack may retaliate.

Move	Damage
Side tilt 1	3
Side tilt 2	3
Side tilt 3	7
Up tilt	1.5, 6
Down tilt	6

Side Tilt: Side tilt leads into combo follow-ups like with neutral attacks. Bayonetta begins with a side kick forward. While that's in progress, another input leads to a follow-up high kick. Another attack input during the high kick leads to the final kick, a powerful launcher that ejects victims upward into perfect juggle position. Most simply, you can usually jump forward and catch the tumbling target with a forward air combo. Hold the button during any side tilt move for a stream of weak shots afterward. Side tilt kick gunshots aim upward at an increasingly steep angle.

Up Tilt: Bayonetta whips a pistol upward, passing through the space directly in front of her before aiming upward. The strong, upward-aimed hit is at the very end of the attack's active period; the attack's early period is a low-damage hit rising in front of Bayonetta, which carries close-range victims into the anti-air part, serving as a potential juggle-starter. When using up tilt against someone who's already airborne, keep this in mind, as you'll need to allow for extra lead time.

Down Tilt: Bayonetta lies low and lashes out with a sweep kick just ahead. The range is decent and it's faster to hit than any other grounded Bayonetta move, so this is more reliable when you're afraid of using moves with more starting lag. It's still unsafe from counterattacks if foes attack immediately after blocking, but the frame disadvantage isn't quite as bad as during blocked portions of neutral attack or side tilt combos. Damage is highest at the tip of Bayonetta's leg, but juggle follow-ups work best if down tilt hits closer in, with slightly less damage.

Move	Damage
Side smash	16-19.2
Up smash	17-20.4
Down smash	5, 16-6, 19.2

Side Smash: With the windup signaled by the purple glyph that appears around her, the Umbra Witch swings one hell of a haymaker punch. Like other smash attacks, this gigantic fist is made of Bayonetta's Wicked Weave, stripping away some of her "costume" as she attacks. For hitting speed, side smash is a bit below average for an attack of its kind, but it makes up for this with size. The fist's hitbox isn't a part of Bayonetta and can't be hit, basically a huge intangible limb. The fist extends far forward of Bayonetta while the ghostly forearm covers directly above her for slightly less damage.

Up Smash: Bayonetta sends Wicked Weave underground to erupt in front of her as a raised fist. In action and hitting area, this is like an enhanced (or perhaps tousled) version of Isabelle's up smash. The hit area is just around the fist, rising in a column from the ground. There's no coverage right above Bayonetta, or to her back; up smash is strictly a frontal attack. Like side smash, the biggest weaknesses are starting and ending lag. It's slow to hit on the ground, and even slower to rise to cover heights above Bayonetta's head. Lots of notice is necessary to use this against jumping or tumbling enemies.

Down Smash: Bayonetta struts and spikes one foot down, summoning Wicked Weave to duplicate this with a colossal stiletto stomp. Like other smashes, this enormous limb of tightly woven hair is impervious to enemy attacks. This is even slower than other smash moves, taking a third of a second to hit uncharged. It starts with Bayonetta's human foot stomping, and quickly follows with the Wicked Weave's mega-sized version stomping from the sky. Even between Bayonetta's foot and the gigantic one made of hair, this attack is active briefly, so it requires precision with the hit timing. On impact at medium percentages and higher, victims are bounced off the ground, vulnerable to more attacks.

Grabs

Move	Damage
Grab attack	0.6, 0.7
Front throw	10
Back throw	3, 6
Up throw	3, 4.5
Down throw	3, 5

Bayonetta's grab is slightly below average in speed, snagging anyone close in front with the same speed as a down tilt sweep. Her range on the grab is short, so dash in first to make sure she's close enough. With enemies so worried about Bayonetta's far-reaching Witch Weave attacks and gunshots and her multistage neutral and side tilt combos, there should be lots of chances to rush in and snatch them up. During forward throw, Bayonetta pops the victim forward with a body check that hits anyone else nearby in front. Back throw kicks them to Bayonetta's backside, pushing them toward a desired edge. Up throw kicks them up into juggle position in forward airspace, while down throw bounces them right off the ground in front of Bayonetta. In either case, you can pursue immediate juggle combos using forward air, Witch Twist, and After Burner Kick.

Aerial Attacks

Aerials

Move	Damage
Neutral air attack	8
Forward air attack 1	4
Forward air attack 2	3.3
Forward air attack 3	7
Back air attack	13
Up air attack	7.5
Down air attack	9 (5 on ground hit)

Neutral Air Attack: This is a dominating and variable air move that almost seems like a version of Ryu's and Ken's Tatsumaki Senpukyaku. Tap the input to trigger a spin kick that hits in front, then behind, then in front again as Bayonetta flies through the air. This initial period deals the most damage on the initial spin, and a bit less for follow-up spins. The active period is generous, lasting a little over a fourth of a second. Whether jumping or short-hopping, if you neutral air at the apex, then fast-fall, Bayonetta is covered all the way back to the ground.

Forward Air Attack: Forward air is a multistage attack like neutral attacks and side tilt. The first part is a short-range jab right in front of Bayonetta in midair. This has decent speed, faster than neutral air, but it's not in the same class as some lightning-quick aerial attacks like those of Zero Suit Samus or Captain Falcon. While forward air is in progress, tap the Attack button up to two more times for a three-swing combo in midair. The second attack is another punch, and the final hit is a downward-slashing axe kick.

Back Air Attack: Bayonetta strikes behind her in midair with a stout jump kick. It's a little slower to hit than neutral air or forward air, but deals its damage in one quick hit, with decent knockback. Especially as damage percentages build up, the payoff for nailing someone with back air grows larger. Hold the button down for a flurry of gunshots afterward, aimed up-back.

Up Air Attack: Bayonetta twists in midair to attack with a flipping wheel kick, mostly aimed upward. The kick starts out hitting up-back, behind Bayonetta, before rotating to hit upward and then in front. Most of her moves are kind of aimed linearly, so this is useful as a slashing attack that covers all upward angles. It's good for aiming at people above, and for continuing juggle combos. Her lag afterward is brief too, allowing quick follow-up actions or double jumps while still in midair.

Down Air Attack: The Umbra Witch plunges straight down with a guillotine kick, dealing the most damage at the foot. During down air, Bayonetta falls downward far enough to cover the distance of jumping and double-jumping, so you can leap up from the ground and smash back down at grounded foes like the move has fast fall built in. Used at double jump height or lower, Bayonetta smashes into the ground with another hitbox on impact. The falling hit and impact tremor can combo together if foes are in the right place. If shielded, though, Bayonetta is in trouble, since down air has by far the most landing lag of any of her air moves.

Special Moves

Neutral Special: Bullet Climax: For this ranged special attack, Bayonetta alternates between two versions. On first use, she takes four quick standing gunshots, aiming slightly up-forward. Next time, she fires along the same path but from a handstand, using the guns attached to her feet! Regardless of whether she's firing with hands or feet, tapping the Special button repeatedly results in more gunshots, up to 16 at a time total.

The first four shots can be charged up by holding the Special button down. This doesn't take long; the charged shots are ready slightly *before* the purple flash that indicates a complete charge. Tap forward or backward to dodge-roll out of a charge without firing Bullet Climax at all. This doesn't "store" the charge like with some charged special projectiles, but it gives you an option for cutting the attack short if you recognize a threat incoming from a new angle.

Special Moves

Move	Damage
Neutral special	1.4x4-16
Side special (ground)	8, 0.5x3, 5
Side special (air)	7
Side special (diving)	6.5, 5
Up special	3, 0.2x5, 3
Down special	—

Side Special: Heel Slide / After Burner Kick: Side special is essentially three different special moves, depending on how and when it's used. On the ground it's Heel Slide, a long-reaching slide kick that launches enemies if it hits early or in the middle (toward the end of the slide, knockback is reduced significantly). Functionally, this is like a dash attack that covers much more ground.

As Heel Slide slides, hold down the Special input for a special finisher. Bayonetta still slides with a hit that diminishes in damage a bit as it travels, but she adds up to three low-damage foot gunshots toward the end.

As the slide and gunshots come to a stop, she performs a launching backflip kick. In midair, side special is After Burner Kick. This is a blazing air-to-air move with slight upward travel, about like the path of Bullet Climax shots. Bayonetta has almost no lag afterward, so she can act again right away in midair.

Up Special: Witch Twist: After an initial, quick launching hit up close next to Bayonetta (slightly faster even than down tilt; Witch Twist point-blank is Bayonetta's fastest attack, during the first active frame), the Umbra Witch rockets a short distance upward, carrying victims with her. She hits several times before blasting them a short distance sideways, in perfect position for an immediate After Burner Kick to combo. Witch Twist doesn't have good KO potential, with the small knockback, but it makes an unreal air-mobility, recovery, and combo tool.

Down Special: Witch Time: Bayonetta backflips and poses flirtatiously, countering any attacks against her with a powerful curse aimed at nearby challengers. The counter period doesn't start immediately, but after about the same "start-up" as down tilt. At that point Bayonetta is intangible, and incoming attacks trigger the Witch Time counter. If something hits her, enemies nearby are slowed for a couple of seconds. They don't have to be the fighters who attacked her; they just have to be close enough. Everything they do is like being trapped in molasses—moving, attacking, and flinching in slow motion. This provides a huge opening to cut loose with a combo.

Final Smash: Infernal Climax

With Final Smash energy ready to go, neutral special triggers a special Witch Time state, slowing down everyone except Bayonetta. A clock timer shows up in the center of the screen, indicating how much slo-mo time Bayonetta has to work with. During this time, scoring hits on enemies fills up a secondary gauge within the timer. If you fill this gauge before the timer runs out, Bayonetta triggers the real Final Smash: the onslaught of Gomorrah, an Infernal Demon who's sometimes Bayonetta's ally, sometimes her foe! Mash inputs during the demon's reign on-screen, adding to the damage output on your enemies.

Bowser

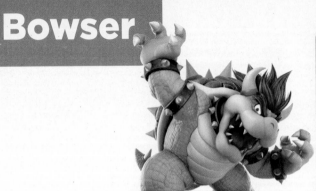

Bowser Vitals	
Movement Options	
Jumps	1
Crouch Walk	Yes
Tether	No
Wall Jump	No
Wall Cling	No
Movement Ranks	
Ground Speed	C+ (20)
Air Speed	B (19-24)
Falling Speed	B (17-18)
Weight	A+ (1)

OVERVIEW

Bowser is a dense, hulking menace, the heaviest fighter in the game. His heavy weight reinforces his attack power and makes him harder to punt huge distances offstage, so he's harder to outright KO. On the other hand, his weight also means he's easier to juggle repeatedly in combos, since he won't be knocked as far away with launchers, keeping him in a hittable position. His weight influences his attacks, which are mostly slow but extremely powerful. Side smash, down air, and down special in particular are devastating to enemies even if blocked, likely shattering shields, but they're very sluggish to land. Conditioning challengers to be more susceptible to Bowser's plodding, brutal attacks requires leaning heavily on his neutral attack one-two punch combo, down tilt, up tilt, forward air, and his up special at close range, Whirling Fortress.

Grounded Attacks

Neutral Attacks

Move	Damage
Neutral attack 1	4
Neutral attack 2	6

Dash Attack

Move	Damage
Dash attack	12

Defensive Attacks

Move	Damage
Ledge attack	10
Wake-up attack	7

Neutral Attacks: The Koopa king swings with two hefty palm strikes. The first one is slow for a neutral attack, hitting at about the speed of most tilt attacks. Be wary of speedy fighters overwhelming Bowser in close when trying to use neutral attack combos. Two of Bowser's specials are actually faster than his neutral attack: side special and up special. Hitting from neutral attack's max range helps a lot, especially since Bowser's hands are intangible during these strikes. After the one-two strike combo, victims are knocked away. Short, sweet, and strong.

Dash Attack: Bowser lunges sideways with one leg extended in a heavy kick. Hitting with a dash attack launches targets up into the air, where you can try for another attack.

Side Tilt: The king leans forward while swinging with a fierce backhand, hitting a bit slower than neutral attack (and most tilt attacks), with about the range of the second neutral attack punch. Bowser's backhanding hand is intangible. Angle the side input (or C-stick, if it's set to tilt) a bit diagonally to aim Bowser's backhand slightly up or down. Keep in mind that down tilt hits as fast as side tilt while hurting more, and up tilt covers air angles way better than a slightly angled side tilt. This move isn't bad, but gets squeezed out in usefulness by neutral attacks and up/down tilts.

Tilts

Move	Damage
Side tilt	12
Up tilt	11
Down tilt	7, 8

Up Tilt: Fingers splayed on one clawed hand, Bowser slashes with arm outstretched from front to back over most of his body. Up tilt hits to the front only slightly slower than side tilt, while also covering above and behind. Bowser's arm is intangible from the forearm to the hand, too. Anyone swatted by Bowser is knocked off their feet, vulnerable to more hits. This is one of Bowser's best attacks.

Down Tilt: A crouching Bowser pounds anyone in front with two shin-level hook punches. This hits with the same speed as side tilt, with a lower profile and bigger reward. The punches have good reach forward, with intangible hands like most of Bowser's moves. The two hits also give it a chance to catch someone who rolled or sidestepped through the first swing.

Smashes

Move	Damage
Side smash	23-32.2
Up smash	22-30.8
Down smash	16 front, 15 back-22.4 front, 21 back

Side Smash: Bowser squats briefly, then takes a tiny hop forward while sticking out a withering two-legged dropkick. This takes almost a half-second to hit, even uncharged. At least Bowser's feet are invincible just before they hit, and briefly during hitting frames. The payoff is *frightening* damage and KO potential, and heavy shield damage on block. Lag after the dropkick is long, as Bowser flops on his side and rises.

Up Smash: After crouching on all fours and readying himself, Bowser springs up, spinning his spikes to the sky. His shell is invincible during the attack, giving it absolute priority against anyone coming straight down onto it. Afterward, Bowser crunches to the ground before he can act again. While his shell is the star of the show here, there's also a less-damaging hitbox around his head and feet, which hits grounded foes in front of him on the way up. This doesn't make it worth aiming up smash at standing people on purpose—up tilt is better for that—but it's a side benefit.

Down Smash: Bowser swings to the front, then behind himself with tearing claw swipes. The frontal hit is Bowser's fastest smash attack hit, only slightly slower than up tilt for attacks with coverage on both sides. The hit to the back ends up being slow, though. It's just for contingency in party battles, when opponents might be closing in from both sides. The back swipe's lagginess also leaves Bowser vulnerable if someone blocks the frontal hit.

Grabs

Move	Damage
Grab attack	1.6
Front throw	12
Back throw	12
Up throw	11x0.5, 6
Down throw	10, 4

The king's grab is slow compared to most other grabs, but barely slower than his neutral attack. So it's not too bad relative to the rest of Bowser's arsenal. Anyone threatened by Bowser's slower attacks will naturally clam up sometimes, granting opportunities for him to grab them.

Back throw has the most raw KO potential and knockback when damage is high. Front throw is fine for pushing enemies toward the ledge Bowser faces. Bowser spins them on his spiked back during up throw, racking up lots of hits before launching them into a typical up throw juggle position. For down throw, Bowser plants them on the floor, then flops forward on top of them, potentially nailing anyone else standing nearby too.

When thinking of his throw game, always remember his Flying Slam side special, a big part of what makes Bowser Bowser. It's faster than his regular grab, faster even than his neutral attack, while being usable in midair too, and dealing more initial damage than any of his throws (though not more damage than if you do something like grab, add a couple grab attacks, up throw them, then juggle them).

Aerial Attacks

Aerials	
Move	Damage
Neutral air attack	6
Forward air attack	13
Back air attack	19
Up air attack	15
Down air attack	16 (2 on landing)

Neutral Air Attack: Bowser splays all limbs out and pinwheels, each hand and foot a rotating hitbox. The first outstretched claw here is aimed up-forward, and new hitboxes rotate proliferating backward around Bowser as he spreads his limbs. This makes down-forward the last quadrant around Bowser that gets hit, so this attack is ill-suited to aggressively jumping at enemies below, like during short hops on the ground. It's best moving up-forward at a target, in which case it's technically Bowser's fastest air move.

Forward Air Attack: When you're aiming straight ahead or at someone ahead and below, like when jumping in at defenders, this is better than neutral air. Bowser slashes in an arc from up-forward to down-forward, covering all forward angles. Damage is highest at his hand, and lower if this hits farther up his arm. Used as a jump-in, this air move has the lowest landing lag of Bowser's airs, further cementing it as the best to use when hopping and jumping in for pressure.

Back Air Attack: This backward-aimed two-foot dropkick is Bowser's fastest air attack, for practical purposes. (Neutral air is faster but only at the very start and only up-forward; midair up/side specials are also faster.)

It deals heavy damage and knockback, and is great if you have good aim kicking backward at targets. It requires more precision than other Bowser air hits, which have longer active periods. Beware the extra landing lag when using it just before touching down.

Up Air Attack: Bowser headbutts from the front to the back, hitting up-forward a hair slower than neutral air. The payoff for hitting with up air is much better than neutral air. Bowser's head is also intangible, helping up air win out when encountering downward-aimed enemy attacks. This is great in combos and when chasing helpless tumblers trying to land.

Down Air Attack: Bowser's air momentum is temporarily halted as he flips upside down and retracts into his shell. He then plunges down, spikes extending a brutal hitbox ahead of an invincible turtle shell. While plummeting, the king can be steered slightly to either side. When he hits the ground, there's a secondary impact hitbox.

Special Moves

Special Moves	
Move	Damage
Neutral special	1.8x1-12
Side special	18
Up special	1x6, 6 ground, 7, 1x10, 2 air
Down special	4, 20, 11

Neutral Special: Fire Breath: Bowser spits out continuous gusts of flame. Anyone caught in the firestorm is hit repeatedly, potentially taking lots of damage. Holding the input keeps the flames coming, and the spout can be angled up or down a little. After a few seconds of continuous use, the flames die out. You need to let Fire Breath cool off for about 10 seconds before it can be used at full power again. This move is great for edge-guarding, and when aimed into distracted groups midstage.

Side Special: Flying Slam: This notorious slam can snag enemies air or ground. During Flying Slam he grabs, quickly pulling in anyone close, leaps high into the air, then dives down and bounces the victim off the ground. Not only does the thrown victim take heavy damage, but anyone they land on is blasted away by the impact, taking almost as much damage.

Bowser can move left or right in midair before slamming down. This move can even be steered offstage, in which case both fighters are KO'd. Bowser's KO comes first, so you can't use this to win unless you're up on spare stocks.

Up Special: Whirling Fortress: This special is slightly different on the ground versus in midair. Grounded, Bowser spins suddenly in place inside his shell, hitting multiple times. This is technically his fastest physical attack (tied with Flying Slam for fastest overall), and the hitbox covers his whole shell, but the horizontal range is short.

This is fast enough to be used defensively after blocking laggy attacks, which is its best grounded use. In the air, it is an upward-surging combo and recovery tool. It hits just as fast as on the ground (making it technically his fastest air attack too, besides Flying Slam), with an even better hitbox. The damage is highest early in aerial Whirling Fortress, with the rest of the hits dealing less damage.

After air Whirling Fortress, Bowser falls inside his shell, helplessly drifting. His exposed limbs are intangible, making him small during descent. Use this to leap and catch tumbling enemies for big damage, and to recover back to safe ledges from offstage.

Down Special: Bowser Bomb: Bowser Bomb is an interesting multi-stage attack that's also slightly different air versus ground. On the ground, Bowser starts with a horned headbutt hitting directly before him. This launching headbutt strikes with the speed of one of his tilt attacks. From here, Bowser leaps upward for a cannonball dive, putting all his weight into the plunge. The main hit comes from Bowser's form itself, but there's another hit on touchdown.

If the launcher flicks someone off their feet, the dive-bomb portion combos but the impact doesn't. If the launcher part doesn't hit but the dive-bomb catches someone under it on the ground or at low altitude, it may carry them down for the heavy hit *and* the impact follow-up.

When used in midair, Bowser skips the launcher part and performs the high-damage dive-bomb-into-impact-shudder. Both hits can combo if this hits squarely on someone low to the surface underneath.

However Bowser Bomb is used, it's hugely damaging on contact. If blocked, it will very likely shatter the defender's shield! Be ready to capitalize with something devastating like side smash...or point-blank Bowser Bomb.

Up close on the ground, it can be treated as a high-risk/reward close-range move that follows itself up, or even a powerful defensive reversal against the opponent's laggiest moves and misses. In midair, it's top-of-the-line for plunging straight down with seriously scary damage. When either edge-guarding or recovering, it can even be used with precise aim to dive-bomb toward a ledge. Well-aimed, as though you meant to plunge right past the drop-off, Bowser will actually grasp the handhold!

Final Smash: Giga Bowser Punch

Fully charged up, the king of the Koopas reveals his idealized form, a gigantic Bowser! Upon activation, Giga Bowser looms over the fight while a cursor appears. Move the cursor around and center it above your peskiest challenger to smash them with a terrifying punch! It's easily possible to wallop multiple enemies if they're close together.

Bowser Jr.

OVERVIEW

Bowser Jr. and other relatives of the Koopa king return, fighting with the Junior Clown Car. Bowser Jr. is the default costume for this fighter, but you can play as any of the Koopalings. Koopalings are small, but clown cars are heavy, so the combo of Koopa kid plus Junior Clown Car equals a heavyweight fighter. Koopalings all look different, but they share Bowser Jr.'s moves. Koopa kids have few attacks of their own; almost all weapons and moves are courtesy of the car. The car's ability to attack with unhittable limbs, taking reduced damage if attacks strike the car chassis itself, is one of the biggest strengths of Bowser Jr.

Bowser Jr. Vitals	
Movement Options	
Jumps	1
Crouch Walk	No
Tether	No
Wall Jump	No
Wall Cling	No
Movement Ranks	
Ground Speed	B- (28-33)
Air Speed	D (58)
Falling Speed	B (26-28)
Weight	B+ (8-10)

Grounded Attacks

Neutral Attacks: The Junior Clown Car swings with a flurry of boxing jabs. The first punch is one of the car's fastest attacks. It's slightly slow for a neutral attack in general, though, but not as sluggish as other heavyweights. The punches have good range, and since they're a part of the car and not the pilot, there's no vulnerable hurtbox on them. Use the decent range and invincibility of the punching robot arms to overcome the speed shortfall.

Neutral Attacks

Move	Damage
Neutral attack 1	2
Neutral attack 2	2
Neutral attack 3	0.5x11, 3

Dash Attack

Move	Damage
Dash attack	1.8x5, 4

Defensive Attacks

Move	Damage
Ledge attack	10
Wake-up attack (faceup)	6
Wake-up attack (facedown)	7

Dash Attack: While speeding forward, the Junior Clown Car opens its maw and extends a circular sawblade forward. The spinning blade swipes once with a multi-hit attack, then again with a knockback blow.

Tilts

Move	Damage
Side tilt	8
Up tilt	6
Down tilt	2x2, 6

Side Tilt: The car stabs forward with a novelty-sized fork. The extended tines provide good range in front. Angle the side tilt input slightly off-center up or down to tilt the fork a bit diagonally. The downward version can be good for impaling a recovering foe's fingers just as they grab a ledge for safety, while the up-forward version can nail short hoppers falling a bit short instead of jumping right on top of the car.

Up Tilt: The clown car stabs with the fork ruthlessly upward, hitting directly in front first. Along the way, the fork lifts anyone it hits into a potential juggle position. Unlike many up tilts, this one doesn't provide a hitbox to the back. If a crowd approaches from behind, use up smash to cover upward angles while hitting to both sides too.

Down Tilt: For this strange attack, the pilot Koopaling crouches low inside the Junior Clown Car while the car forgoes using a weapon in favor of a multi-hit tongue-lashing. The car's flicking tongue has slightly less range than side tilt, while keeping the Koopa kid much more protected.

Smashes

Move	Damage
Side smash	1x5, 10-1.4x5, 15.4
Up smash	1, 1.3x4, 6
Down smash	18-25.2

Side Smash: After a considerable windup period, the Junior Clown Car brings two spinning drill bits together directly in front. Anyone caught in between takes multiple hits before they're knocked away.

Up Smash: The clown car flips upside down, balancing on the pilot's head for an attack aimed straight up. While the Koopa kid does a handstand, thrusting the car upward, the propeller underside spins for rapid hits.

Down Smash: Starting with a small hop to put torque into the hit, the Junior Clown Car swings a wrecking ball to either side, covering front and back at the same time. This delivers a powerful single hit that clears out anyone rushing in.

Grabs

Move	Damage
Grab attack	1.3
Front throw	3, 7
Back throw	11
Up throw	7
Down throw	1.2x4, 4

The car extends a pincer arm forward to tow in defenders. The car's grabbing reach is decent, but it's very slow, even slower than most heavyweight fighters. It's in the territory of tether/gimmick grabs, without quite having the full reach of most of those. You have to put to good use the unconventional movement, arsenal, and defense of the Koopa kid and Junior Clown Car combo in order to make enemies susceptible to an abnormally slow grab animation.

Once a challenger is safely in the car's clutches, a front throw hurls them forward, also damaging anyone in the way of the throw. A back throw hurls them backward with the most pushback and KO potential. Up throw tosses them quickly upward, above the car and Koopaling and slightly to the back, ready for a juggle. Down throw follows a multi-hit drill combo on the floor with a low, forward-launching hit.

Aerial Attacks

Aerials

Move	Damage
Neutral air attack	8
Forward air attack	11
Back air attack	14
Up air attack	10
Down air attack	1.5x8, 2.5

Neutral Air Attack: An extended boxing glove springs from each side of the car in flight as it begins to spin horizontally. This neutral attack isn't super-fast, but it's not sluggish either. It's active for a decent amount of time as the car spins, giving it good use as an air "meaty" attack, extending the glove first and then dragging it into foes with lateral or fast-falling movement. Damage is highest right at the beginning with the fully extended fists and diminishes with duration (or proximity to the car).

Forward Air Attack: Moving forward in midair, the car extends a heavy wrecking ball forward, waggling it back and forth once before retraction. It's slightly slow to start up, but stays out a long time. There's time to jump or short-hop near someone, extend forward air, then fast-fall to bring the ball down on them. The damage is highest at the wrecking ball at the beginning of the attack, and lowers closer in and later in the swing.

Back Air Attack: The backward-hitting wrecking ball counterpart to forward air. To account for pivot time, back air is slightly slower to nail foes than forward air, but deals more damage in a more powerful hit.

Up Air Attack: One of the few attacks where Bowser Jr. attacks instead of relying on the gadgets of the Junior Clown Car. The Koopaling swings directly overhead, swiping from up-back to up-forward and back again with a scepter. Anyone above takes a small amount of damage and gets launched up slightly. This is the best option for swinging at airborne opponents above.

Down Air Attack: The clown car directs a spinning drill bit straight down during the longest-lasting attack in its arsenal. The attack is slow to start hitting, but it deals great damage with many hits and has good launching potential off the last hit. The last hit does more damge if it lands in the middle of the opponent's hitbox.

Special Moves

Neutral Special: Clown Cannon: The Junior Clown Car sprouts a cannon similar to those of Bowser's airships, eventually launching a spiraling cannonball far horizontally. Cannonballs can be charged before firing, greatly increasing damage, speed, and distance traveled. When fully charged, cannonballs automatically fire. Having a projectile attack is never bad, but having such a slow one means you need a lot of clearance to put it to use. It's great to put into sheer airspace off the side of a stage when edge-guarding, or to fire at unsuspecting groups facing off against each other at the edge of your range.

Special Moves

Move	Damage
Neutral special	10-20
Side special	7.4-4 ground, 2.6-2 air, 16.4-10 ground spin, 12.3-8 air spin, 11.3-8 bounce spin
Up special	5/13 car, 15 mallet
Down special	2, 7

Side Special: Clown Kart Dash: Along with Abandon Ship, this is a complex special. The car speeds in the direction of the Special input, whether on the ground or airborne. The car plows aside anyone it hits. While driving, the car is capable of jumping for movement, or spinning to attack. Either action ends the drag-racing sprint and returns the Junior Clown Car to normal operations. Being able to Clown Kart Dash in midair, then jump essentially gives Bowser Jr. and the Koopalings a triple jump, since you can double-jump, then side special jump. You can only use Clown Kart Dash once per airborne period.

If you opt to kart-spin rather than kart-jump, the spinning car attack is performed either by pressing the control stick in the opposite direction of travel, or by pressing the Attack or Special buttons.

If neither a jump nor spin is used to end the driving period, the car automatically spins after driving for a while...if it doesn't just drive off a stage edge first! If you do drive clear off the level, quickly use the car's jump in midair to end the attack while giving you a little extra loft, then recover back to solid ground.

Up Special: Abandon Ship: The driver ejects, rocketing upward while the car tumbles away. The car acts as a downward-drifting explosive, bumping anyone in the way with a physical hit, before violently exploding after falling as far as a jump's height. (As the car falls and goes kaboom, the Koopaling hurtles upward and then falls, unprotected by the car. Tap Attack or Special on the way down for a two-sided scepter swing

There are two ways to skip the landing lag after using Abandon Ship. One is to fall and grasp a ledge; the car reappears while rising from the ledge. The second is to get hit while falling. After the hardened hitstun is over, you can spring from a midair tumble with the usual attack/dodge options. The damage on this attack is potentially huge, if every part connects.

Down Special: Mechakoopa: Junior Clown Car deploys a mechanical Koopa explosive, which walks quickly back and forth on whichever platform it sets foot upon. Only one Mechakoopa can be on-screen at a time. It traverses back and forth for about five seconds before detonating automatically. If it's deployed in midair, this timer doesn't start until Mechakoopa hits a valid walking surface. If it gets close enough to a valid target, it latches on to them before exploding, launching the victim a good distance.

Final Smash: Shadow Mario Paint

With a Final Smash ready to go, a neutral special input slathers a gigantic shimmering X on-screen, courtesy of Shadow Mario. As this happens, the Koopaling and Junior Clown Car are ejected out the top of the screen, falling back down as Shadow Mario departs, having painted a huge part of the playing field. Enemies overlapped by the painted X take continuous damage. Since you're free to act on the way down, you can return to the fray and tack on extra hits while the Final Smash is still in progress.

Captain Falcon

OVERVIEW

Captain Falcon is an incredibly strong fighter with unconventional movement for someone of his size and weight. He has one of the fastest running speeds in the game, allowing him to weave in and out of combat, as well as a quick jump and fast fall trajectory that bolster his up air juggle game.

He has high-damage combos, particularly in his neutral air and up air "loops" (using the same attack back-to-back, racking up the combo and damage counter). Not only does Falcon have an effective ground game, but his up air is one of the best, especially on platform levels like Battlefield where he can manipulate his landing time to overwhelm airborne foes with up air offense and loop combos.

Captain Falcon Vitals	
Movement Options	
Jumps	1
Crouch Walk	No
Tether	No
Wall Jump	Yes
Wall Cling	No
Movement Ranks	
Ground Speed	A+ (2)
Air Speed	B+ (11)
Falling Speed	A (6)
Weight	B (18-21)

Grounded Attacks

Neutral Attacks: Captain Falcon checks the opponent with a swift jab, follows up with a right straight, then transitions into

either a rapid-fire flurry combo or a driving knee launcher attack. The rapid-fire feature of Falcon's jab is effective for edge-guarding call-outs, and for deterring ledge-climbs and ledge-jumps. It's also on the faster end of the jab-speed spectrum, so you can punish most point-blank attacks coming out of your shield.

Dash Attack: From his speedy dash, Captain Falcon shoulder-charges the enemy and launches them up and away. Since most of Falcon's ground game is centered around his dashing grab, dash attack is your mix-up attack. For example, when your opponent is landing from the air and you're dashing at them, they may go into a reactionary offensive posture and try to hit what they think will be a dashing grab. If you time and space it correctly, you can beat out their air attack with your dashing attack, thanks to Falcon's extended horizontal hitbox.

Neutral Attacks

Move	Damage
Neutral attack 1	1.5
Neutral attack 2	1.5
Neutral attack 3 (lightning fists)	0.6xN, 3
Neutral attack 3 (knee)	5

Dash Attack

Move	Damage
Dash attack	10

Defensive Attacks

Move	Damage
Ledge attack	10
Wake-up attack (faceup)	6
Wake-up attack (facedown)	7

Tilts

Move	Damage
Side tilt	9
Up tilt	11
Down tilt	10

Side Tilt: Captain Falcon performs a spinning side kick to the opponent's midsection, knocking them back. Falcon's tilt attacks are decent, but most of his ground game revolves around his grab. Side tilt can be used to stop and check enemy aggression, but your time and space are best left for dashing around and baiting out enemy attacks.

Up Tilt: Captain Falcon raises his heel toward the sky, then drives it downward heavily into a nearby opponent's skull, slamming them into the ground and bouncing them into the air. Up tilt can meteor smash if Captain Falcon's heel connects with an airborne enemy. It has some uses as an edge-guarding spike attack against ledge jumps, and limited uses as an anti-air (your up air is much better).

Down Tilt: Captain Falcon slinks down low and delivers a powerful leg sweep that sends foes flying back. Down tilt lacks in overall speed relative to its damage and knockback effect. It doesn't generally lead into more damage, it's unsafe when shielded, and is a bit on the slower side.

Smashes

Move	Damage
Side smash	20
Up smash	12, 14
Down smash	14

Side Smash: Captain Falcon musters power, then drives forward with an explosive backfist that launches enemies up and away with extreme force. This powerful fist attack is essentially a mini Falcon Punch. It starts faster, deals 6 less damage, but it's still unsafe to throw out randomly. You can use it to surprise foes dashing at you for a surprise KO at higher percentages.

Up Smash: Captain Falcon launches a foe sky-high with two spinning heel kicks, one after the other. The first heel kick extends a horizontal hit effect in front of you, making it a good retaliation option right after shielding laggy attacks. Alternatively, you can use up smash as an air dodge punish or a finishing move anti-air. While it's not safe when shielded, it's a little safer than side smash.

Down Smash: Captain Falcon punts the area in front of him with a heavy toe kick, then turns around with a rear back kick. If spaced to connect at max range, down smash can be relatively safe, but it's best used to clear out multiple foes around you or as a punish attack against a roll if you make the right read on your opponent's evasive movements.

Captain Falcon reaches out and quickly scoops an enemy into a grapple. Captain Falcon's forward throw is a fierce gut punch that launches away while his back throw is a high-powered rear kick that blasts his foe behind him into the sky.

His up throw is a vertical-launching palm strike that sets up for juggle mix-ups with his incredibly effective up air anti-air. Most of your throw damage (and potentially most of your overall damage) comes from your down throw. Against low- and medium-percentage foes, down throw usually guarantees a follow-up neutral air combo, and potentially an additional dashing hop up air after that.

Grabs

Move	Damage
Grab attack	1.3
Front throw	7.5
Back throw	7.5
Up throw	9
Down throw	6

Aerial Attacks

Aerials

Move	Damage
Neutral air attack	4, 6
Forward air attack	22
Back air attack	13
Up air attack	10
Down air attack	14

Neutral Air Attack: In midair, Captain Falcon performs a double spin kick combo, hitting foes in front of him. Neutral air is one of your staple air attacks, both as a poke and for combos and juggles. Its speed and comboability are remarkable in almost every way. It has relatively low air lag (so you can perform multiple neutral airs in a single jump), its landing lag isn't too punishing, and you can chain multiple neutral airs against low-percentage foes.

Forward Air Attack: While flying through the air, Captain Falcon extends a persistent knee attack, knocking away foes he encounters. During it's first active frame, the knee is a powerful sweetspot. Captain Falcon leaves his knee out for a considerable amount of time as he jumps through the air. While it doesn't have great range, it's a solid attack for descending on foes, thanks to its persistent effect. You can use it from the peak of a jump, then cancel into a fast fall for a strong air-to-ground attack. Against lower-damage foes, you can combo into a jab.

Forward air has more landing lag than neutral air, so it can leave you slightly vulnerable if you whiff with it. It's relatively safe when shielded (especially if you pass through your opponent).

Back Air Attack: Captain Falcon turns around and backfists an enemy behind him while in midair, knocking them back. This is a conventional edge-guarding finisher that can be used as an air-to-ground jump-in attack. Its air lag is short, so you can use it multiple times in one jump. While it's not as versatile as up air, it's better for attacking foes who are level with you in the air.

Up Air Attack: While airborne, Captain Falcon does a somersault flip kick above him, popping foes overhead higher into the air.

Captain Falcon's up air is an outstandingly fast up air attack. It starts up quickly, ends quickly, and allows you to chain multiple up airs together. In some cases, you can land three up airs as a guaranteed combo. As an air-to-ground attack, it whiffs against many fighters, potentially hitting medium-sized ones (although that can be difficult). While your opponent is airborne and anywhere near you, always be thinking about going for up air loops.

Down Air Attack: Captain Falcon drives both feet downward with incredible might, dunking them down into the ground or into a blast zone. Down air is specifically used to finish off opponents offstage. Its start-up and short active window can make it challenging to hit, though.

Special Moves

Neutral Special: Falcon Punch: Captain Falcon's renowned Falcon Punch starts with a lengthy windup charge. After a full second of gathering power, he thrusts forward and delivers a fistful of Falcon energy, obliterating a nearby foe. Falcon Punch is solely used for hard-read punishes. In other words, you can only use it if you predict that your foe will end up in front of you whiffing an attack or performing some kind of sluggish recovery move (such as a ledge climb). It takes a full second to activate, and missing with Falcon Punch can get you punished by a smash or dash attack. It deals significant shield damage, but it's also punishable when shielded.

Special Moves	
Move	**Damage**
Neutral special	25 (28 when changing direction)
Side special	10
Up special	5, 13
Down special	15

Side Special: Raptor Boost: On the ground, Captain Falcon charges forward and delivers an armored uppercut attack that launches foes into the air, primed for a potential follow-up attack. While airborne, Captain Falcon's Raptor Boost is a punch attack that spikes enemies downward. Like Falcon Punch, Raptor Boost leaves you vulnerable if it's whiffed or shielded. Against good players, it's best left as a versatile offstage recovery tool. Be careful, because if you miss with it in the air, you're left in a helpless falling state until you touch ground.

Up Special: Falcon Dive: Captain Falcon propels himself into the air with an explosive jump. As he rises into the sky, he grabs the first foe he contacts, then springboards off them, launching them away. You can alter your trajectory during your ascent, albeit slightly. Hold the control stick toward the Captain's back during his brief crouching window to change your flight direction. Falcon Dive is considered a grab, so it can't be shielded by foes above you. Enemies standing in a shielded defensive posture on a platform (or ledge) above you are prime targets for Falcon Dive. Smart opponents know this, so keep an eye out for potential baits. If they dodge the attack, they can punish you heavily.

Down Special: Falcon Kick: Engulfed in flames, Captain Falcon soars forward with a flying kick that not only sets foes ablaze, but sends them hurtling through the air. When performed in the air, Captain Falcon descends with a stall-then-fall-type dive kick attack at a down-forward angle. This is one of Captain Falcon's most unsafe attacks when shielded. Shielding opponents recover well before your ending lag even begins, so they can run up to punish you with a dash attack, a grab, or even a ranged smash attack. This goes for both the ground and aerial versions. Use Falcon Kick sparingly, if at all, when fishing for a hit.

Final Smash: Blue Falcon

The Blue Falcon races directly in front of the Captain, striking opponents and launching them to a racetrack where an *F-Zero* machine is waiting to run them down.

Cloud

OVERVIEW

Cloud is a heavyweight fighter with powerful aerials and a unique set of special moves, many of which are based on his iconic attacks from the *Final Fantasy VII* series. His Buster Sword naturally grants him astonishing range and priority, as most of his attacks extend massive hitboxes while minimizing his vulnerability. True to form, he can unlock a powered-up mode by filling his Limit Gauge. When this gauge is full, Cloud's overall movement speed increases, but more importantly, he unlocks additional special attacks that inflict massive amounts of damage, all with high launching power. Cloud's strengths center around his damage output, overwhelming aerial neutral game, and threatening Limit Break attacks.

One of your sub-objectives with Cloud is to create space to charge up your Limit Break (down special), especially if it's close to max. Anytime you earn a launch, an offstage throw, or if your opponent is playing timidly, you can charge a bit of your Limit Break until your opponent reacts to it. The threat of your powered-up special attacks generally forces the enemy to go aggressive, so you can think of your down special as a sort of stage-control "attack" (although stay sharp and be quick to cancel out of it if you're in a tight spot). You can cancel Limit Charge in a number of ways: inputting down special (allows you to almost immediately attack), rolling, shielding, and jumping.

Cloud Vitals

Movement Options	
Jumps	1
Crouch Walk	No
Tether	No
Wall Jump	Yes
Wall Cling	No
Movement Ranks	
Ground Speed	B (12)
Air Speed	B (19-24)
Falling Speed	B- (25-26)
Weight	B- (25-26)

CLOUD'S LIMIT BREAK DETAILS

Charging Limit Break from empty to full requires around seven seconds of Limit Charge, assuming no interruptions. Cloud receiving damage from an enemy increases his Limit Gauge. A full gauge equates to roughly 100% damage taken. Taking damage while charging it reduces his gauge (unless it's fully maxed). Dealing damage fills the gauge. Requires dealing 150% to enemies to fill it entirely.

While the Limit Gauge is maxed out and flashing, Cloud's mobility is enhanced: his dash speed increases by 20%, air velocity increases by 20%, fall speed increases by 10%, and walk speed increases by 15%.

Limit Break power-up lasts for 15 seconds, so you can't keep the buff forever. If Cloud is KO'd, the gauge is reset to zero.

Grounded Attacks

Neutral Attacks: Cloud delivers a thrusting side kick with his left leg, then another with his right, finishing the three-hit sequence with a horizontal outward slash that sends foes flying away. Cloud's jab combo can be jab-canceled quite early. Hold the down direction on the left control stick during the second attack, and as soon as the animation ends, release Crouch to perform another neutral attack 1. You can use this outside your opponent's reach to bait them into dashing at you, punishing them with your quick kick attack combo.

Dash Attack: Cloud uses the momentum of his speedy dash and holds out the Buster Sword as if it were a shield. Enemies hit by it are launched high into the air. While Cloud's dash attack is unsafe when shielded, its active window persists for a long time (a sixth of a second!). This makes it an excellent punish attack against spot dodges, air dodges, ledge jumps, and tech get-ups. You can use it to follow up some of your throws as a mix-up option.

Neutral Attacks

Move	Damage
Neutral attack 1	2.5
Neutral attack 2	2
Neutral attack 3	3.5

Dash Attack

Move	Damage
Dash attack	11

Defensive Attacks

Move	Damage
Ledge attack	10
Wake-up attack	7

Tilts

Move	Damage
Side tilt	11
Up tilt	8
Down tilt	7

Side Tilt: Cloud takes a big swing at the area in front of him with his Buster Sword. The hit effect covers a massive area height-wise, from Cloud's knees to just above his head. Side tilt boasts a massive frontal hitbox and increased range over Cloud's jab, but has a short active window. You can use it to deter advancing foes and punish whiffed attacks from outside your neutral attack range. It deals good damage, and at around 40%, it can knock down, forcing a tech get-up situation you can take advantage of.

Up Tilt: Cloud brings the Buster Sword behind him, then performs an upward slash that arcs above and ends in front. On hit, it knocks foes up into the air, allowing for a potential follow-up attack. Up tilt is a staple ground attack; it has a pronounced upward hit effect with some horizontal reach, hitting grounded foes nearby (just within your jab range). At low percentages, it usually knocks up enough to guarantee a follow-up up tilt.

Down Tilt: Cloud slides forward quickly with a sweeping kick attack that launches foes directly into the air above. If Cloud hits with the tail end of the attack, you can follow up with an up tilt for a guaranteed combo (at lower-percentage ranges). Down tilt can be used as a gap-closing whiff-punishing attack, thanks to its remarkable start-up speed and high forward travel velocity. On hit (early or late), it propels the enemy straight into the air for a prime juggle-trap opportunity with Cloud's powerful aerial attacks.

Smashes

Move	Damage
Side smash	3, 4, 13
Up smash	13
Down smash	3, 11

Side Smash: With the Buster Sword in his right hand, Cloud winds up and delivers a potent horizontal slash attack combo. The first hit staggers grounded foes, setting them up for two more strikes, each strike increasing in range. The last hit launches the enemy away. This is Cloud's most damaging smash attack, so naturally, it starts up slowly and it's unsafe when shielded or whiffed.

Up Smash: Wielding the Buster Sword with both hands, Cloud performs a heavy slash aimed up above him. It starts by covering the area in front of Cloud, then swings and arcs behind. Up smash is Cloud's most versatile smash attack due to its hit coverage and decent speed. While it doesn't deal as much damage as his other smash attacks and has some end lag, its high-priority hit effect makes it a strong finisher attack against very high-percentage foes, especially if you use it as a reactionary attack to fend off aggressors coming in from a dash or the air.

Down Smash: Cloud leans low to the ground with a low-profile attack, striking the enemy's feet with the hilt of his Buster Sword. The first attack pulls the enemy in while the second attack knocks them away behind Cloud. Although down smash is relatively quick to start, it leaves you at a severe disadvantage when shielded. It can be used to extend specific low-altitude juggle combos, but it should be left out of your neutral-game arsenal.

Grabs

Move	Damage
Grab attack	1.3
Front throw	7
Back throw	6
Up throw	8.5
Down throw	7

Cloud's grab speed is below average, and its range is relatively lackluster (about half the range of his max jab range). He also doesn't get any guaranteed damage off his throw follow-ups. His front and back throws don't have much launching power and leave the enemy relatively close. Off of down throw, you can potentially punish with a down-back buffered down tilt sliding attack if your opponent tries to go for an "auto-cancel" landing recovery. Up throw launches the enemy up and slightly away at an angle, but Cloud isn't actionable early enough to capitalize with a guaranteed combo, especially if your opponent shuffles away.

Aerial Attacks

Aerials	
Move	Damage
Neutral air attack	8
Forward air attack	14
Back air attack	13
Up air attack	11
Down air attack	15

Neutral Air Attack: While jumping, Cloud swings the Buster Sword in a circular motion all around him. The attack begins behind him, arcs above, and swings back around, ending where it began. This 360-degree attack is relatively fast, has moderate end lag, and a low amount of landing lag. These features make it Cloud's best non-Limit Break attack. It's a superb anti-air thanks to its superior hitbox coverage.

Forward Air Attack: Cloud descends on the enemy with a mighty down-forward swing of his Buster Sword. It has a small sweet-spot meteor hitbox out in front, slightly below the middle of the slash effect. On hit, forward air knocks enemies up and away, and if you hit it deep enough during your hop, you can potentially follow up with a down tilt for a guaranteed combo. Forward air can be used as a powerful air-to-ground attack by fast fall-canceling it from a jump. If timed accurately, it's safe when shielded, even against some shield grabs!

Back Air Attack: Cloud performs a rear Buster Sword swing behind him while he's midair, potentially staggering grounded foes (if their damage is low). If it hits an airborne foe, they're knocked away. Cloud's back air has the least amount of landing lag, so it's an excellent air-to-ground attack when your back is facing the enemy. But for the most part, back air is used as an edge-guarding tool to knock out offstage foes against a side blast zone.

Up Air Attack: While airborne, Cloud holds the Buster Sword over his head perpendicular to the ground and thrusts it upward for a wide horizontal attack that knocks foes directly over him. Against taller foes, you can hit with up air if timed and spaced so that Cloud begins raising the sword while at a low altitude. On hit against low-percentage foes (around 30%), you can combo into up tilt and potentially into an up air after that. Or to keep it simple, perform your Cross Slash combo immediately after hitting with up air.

Down Air Attack: Cloud drives the Buster Sword straight down beneath him while he's midflight. The initial thrusting motion meteor smashes foes, while the remainder of the attack's persistent downthrust effect launches them up and away, allowing for a potential follow-up attack. Down air is incredibly unsafe when shielded unless you connect with it at a low altitude, and only if you cross over the enemy. It's primarily used as a KO attack for its meteor smash effect in order to finish off recovering foes near the ledge. It has considerable air-lag time and landing lag.

Special Moves

Neutral Special: Blade Beam: Cloud drives the Buster Sword along the ground, generating a massive energy wave that travels horizontally a long distance. If it hits an enemy, it knocks them back. Blade Beam is a one-hit projectile that provides horizontal stage control. While it can easily be eaten by stronger projectiles, it's an important tool in Cloud's arsenal, as it gives him a way to force reactions from timid foes. Its relatively slow travel speed is a double-edge sword; while it's easy to react to with projectile-reflecting specials, its on-screen presence allows you to use it as cover for a follow-up assault.

Special Moves	
Move	Damage
Neutral special	Grounded: 8, Airborne: 6.4
Neutral special 2 (Limit)	Grounded: 6, 2x5, 3, Airborne: 4.8, 1.6x5, 2.4
Side special	4, 3, 3x2, 6
Side special 2 (Limit)	5x2, 3x2, 10
Up special	3, 4, 4.5, 3.5
Up special 2 (Limit)	6, 7, 4.5, 3.5
Down special	—
Down special 2 (Limit)	1

Against fighters who can't deal with projectiles easily, you can throw out a max-range Blade Beam and follow it up with a dash-in mix-up (alternatively, you can start charging your Limit Gauge).

Blade Beam's Limit Break version has a brief intangibility window before it's released. It deals much more damage, neutralizes most incoming projectiles, and causes much more knockback, potentially KO'ing foes at higher percentages. It's particularly effective against enemies recovering offstage since it's a huge projectile attack that's difficult to avoid. You can hit someone off into a side blast zone or slam them into a wall with an in-facing offstage Blade Beam attack, ping-ponging them off the stage.

Side Special: Cross Slash: Cloud performs his signature Cross Slash combo attack, a five-hit sequence that inflicts immense damage and launches the opponent up and away. Cross Slash is a three-input attack, but unlike most neutral attack combos, you can only transition into the second and third attacks if you connect with the first one (hit or shielded). The first and second hits pop the enemy up a bit. It's important to note that you can be punished if the first or second hits without following up into the rest of the combo, since the opponent can act almost immediately while they're falling from the attack and you're still in your swinging animation. Essentially, if you hit with it, go ahead and execute the whole combo since there's no reason not to.

The Limit Break version of Cross Slash requires only one input. If you hit with it in any form, Cloud transitions into the rest of the combo. It's unsafe when shielded, but it deals much more damage and has a bit of intangibility before it hits.

Up Special: Climhazzard: Cloud drives his Buster Sword forward into the enemy, then launches himself sky-high, taking the enemy with him into the air. He finishes the sequence with a helm-breaking dive attack, smashing the opponent into the ground with his Buster Sword.

Climhazzard doubles as a combo extension and an offstage recovery tool for gaining height to grab on to ledges. The optional follow-up dive attack allows you to descend to the ground quickly, but once you commit to it, you can't alter your horizontal trajectory in any way.

Unlike most other vertical-launching special recovery attacks, Cloud can't immediately latch on to a ledge during the attack's upswing animation. You have to wait until after the attack ends, leaving you potentially vulnerable as you peek your head out over the ledge. This is one of Cloud's biggest weaknesses since it can make recovering against skilled opponents incredibly difficult.

The best way to recover is to time your Climhazzard as low as possible so that when you launch up to the ledge, you don't peek your head over it. This can be risky since astute foes will chase you below the stage and take advantage of your situation. Alternatively, if you notice your opponent camping too close to the ledge, you can try to hit them with your Buster Sword from the bottom of the ledge.

Limit Break Climhazzard is an essential tool and, in many cases, is worth saving your gauge for. It deals more damage and launches 50% higher than regular Climhazzard. More importantly, it allows for early ledge grabs, whereas the regular one does not.

Down Special: Limit Charge / Finishing Touch: Cloud remains in a stationary stance gathering power, filling his Limit Gauge. It requires roughly 6.5 seconds to max out the gauge.

While your Limit Gauge is maxed out and flashing, your next down special input executes Finishing Touch. Cloud performs an ultra-powerful uppercut slash arcing in front of him and ending behind. The slash offers massive area coverage. On hit, it registers a cinematic effect: Cloud blasts the enemy into the sky with extreme launch power. It deals only 1% damage, but can KO foes as low as 70% damage. It's very unsafe when shielded up close.

The end of the move has a pushback effect (or a "windbox") that deals no damage, but can push foes off ledges. If you can time the attack against an offstage recovering enemy, you can potentially blast them with a gust of wind to force them offstage for a KO. This can be used while in midair, so you can chase after someone you've launched offstage; then, when you're close to them, execute Finishing Touch to have the windbox push them away so that they can't recover.

Final Smash: Omnislash

Cloud dashes forward and hits opponents. He then dashes upward and unleashes a flurry of swift slashes, finishing with a powerful blow that launches opponents straight down. Use it when the battle gets heated, and try to hit several enemies.

Corrin

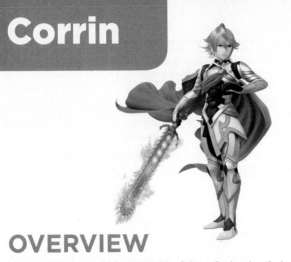

Corrin Vitals	
Movement Options	
Jumps	1
Crouch Walk	No
Tether	No
Wall Jump	No
Wall Cling	No
Movement Ranks	
Ground Speed	D (50)
Air Speed	C (49-51)
Falling Speed	B- (28-33)
Weight	B- (27-29)

OVERVIEW

Like most of the sword-wielding *Fire Emblem* fighters, Corrin enjoys the benefits of having hitboxes that stretch away from his body with huge range. Corrin's unique dragon form allows him to transform his limbs into various dragon attacks, such as a Dragon Fang—a spear-like weapon with incredible range. Though most fighters who benefit from far-reaching normal attacks are encumbered with slow start-up speeds, many of Corrin's attacks start quickly, particularly his neutral attack and tilt attacks. Many of his attacks afford him combo opportunities, even at low percentages.

Grounded Attacks

Neutral Attacks

Move	Damage
Neutral attack 1	2.5
Neutral attack 2	2
Neutral attack 3 (rapid)	0.5xN, 3
Neutral attack 3 (single)	4

Dash Attack

Move	Damage
Dash attack	2x5, 3

Defensive Attacks

Move	Damage
Ledge attack	9
Wake-up attack	7

Neutral Attacks: Corrin transforms his left arm into its Dragon Fang spike form and thrusts forward, followed by a small upward sword slash, then completes the sequence in one of two ways: with a rapid-fire dragon-bite attack that sends enemies flying directly away from him, or with a heavy horizontal midlevel sword slash that pops foes up into the air. Reserve this as a quick close-range deterrent, rarely used as part of your spacing and offensive sequences.

Dash Attack: While dashing, Corrin dives into the enemy with a horizontal sword-drill attack, striking multiple times before launching the foe diagonally upward. Like most dash attacks, it can be heavily punished if you miss with it, but has its uses for chasing down retreating enemies. Its hit effect pops the enemy up and away with low knock-up power, but it's difficult to follow up with an attack for a combo.

Tilts

Move	Damage
Side tilt	10.5
Up tilt	9
Down tilt	7.5

Side Tilt: Corrin delivers a conventional downward slash in front that sends foes spinning up into the air. Corrin's side tilt is decent for knocking out and finishing foes at high percentages, but it can be moderately risky to throw out without proper spacing.

Up Tilt: With her sword raised above, Corrin performs a pirouette, clearing out the air directly around her head and knocking up enemies struck by her blade. Up tilt can start combos from around 15%. From a grounded hit, you can combo into another up tilt, then follow up with juggle and mix-up opportunities in most situations. At higher percentages (around 70%), you can combo into up air from a grounded up air hit.

Down Tilt: Down tilt is an excellent spacing poke. Corrin crouches down and performs a low-altitude slicing attack. On hit, it pops up foes directly into the air, providing a combo opportunity. Down tilt starts combos in most grounded scenarios. From around 15%, down tilt can combo into up tilt. At higher percentages, you can start following with up air and up smash instead, as the enemy is launched higher into the air.

Smashes

Move	Damage
Side smash	15.2
Up smash	15
Down smash	14

Side Smash: Corrin sends out a long-range Dragon Fang spike, piercing foes directly in front of him and blasting them far away. The angle of attack on side smash can be angled upward for a slight anti-air effect, or downward, in order to hit crouching and ledge-hanging foes. During charge, Corrin extends a vertically angled hitbox that hits rapidly and for as long as the charge is being held.

Up Smash: Corrin leans down with her arms transformed, and launches two Dragon Fang spikes directly above, impaling enemies struck by its points and spiking them into the air. This has a small horizontal hitbox covering Corrin's front and back that can hit nearby crouching foes. The overall active window is short, so be accurate in its timing.

Down Smash: Corrin simultaneously thrusts the point of his sword in front and his right dragon-formed leg behind, for a double-sided clear-out attack. Use this to punish rolls that end up past you, or to hit enemies jumping behind you. Its ending lag can make it risky to throw out as a poke.

Corrin's grab is slightly below average in speed, not as slow as heavyweights, but not quick either. The range is limited. Corrin's grab and throw game isn't her strong suit, considering it generally doesn't lead into guaranteed damage and her grab animation speed is mediocre. Her up throw leads into the most potential damage, but still not guaranteed. Down throw launches enemies up as well, but like up throw, Corrin's throw animation persists for a lengthy time, making it difficult to follow up with combo attacks.

Grabs

Move	Damage
Grab attack	1.3
Front throw	7
Back throw	8.5
Up throw	6.5
Down throw	9.5

Aerial Attacks

Neutral Air Attack: While airborne, Corrin executes a two-pronged spinning attack. With his sword in his left hand and his dragon-transformed arm, he covers an incredibly large arc while swinging both weapons through the air. Thanks to its effective area coverage, neutral air is an all-around strong attack that can be used in many situations. Its amazing double-sided hit effect has its cost, as its landing lag is longer than the landing lag of his forward air attack.

Aerials

Move	Damage
Neutral air attack	7
Forward air attack	7.5
Back air attack	11
Up air attack	9
Down air attack	2x4, 3

Forward Air Attack: Corrin delivers a midair slash in front. The arc begins near his head and ends at his feet, covering a sizable area before him. Forward air is a potential combo initiator at low percentages. Off of a deep forward air attack, you can follow up with your neutral attack auto-combo since it pops up enemies low enough and long enough for you to link the two attacks.

Back Air Attack: Corrin extends a pair of massive weaponized dragon wings behind him that knock foes away, while at the same time boosting Corrin in the opposite direction. While this is one of Corrin's slowest-starting air attacks, it gives him a boost in aerial mobility, useful for recovery purposes.

Up Air Attack: Corrin leaps into the air and delivers a wide-arc upward swipe with her sword, launching her victims above her. Corrin's up air isn't very effective as an air-to-ground attack, although it works when timed and angled correctly (especially with the ending rear arc).

Down Air Attack: Corrin's legs transform into a single giant Dragon Fang before he plummets in a high-velocity descent, potentially meteor smashing foes. Upon landing, it causes a minor impact that knocks away nearby foes. This dive kick (or "stall-then-fall") attack is a high-risk maneuver in many cases, particularly if you're predictable with it. It should be mainly used as a deliberate finishing attack against recovering foes.

Special Moves

Neutral Special: Dragon Fang Shot: Corrin charges up a projectile with her dragon arm. Upon release of the projectile, she follows up with a close-range bite with her arm. Charging Dragon Fang Shot increases its range and damage. Charging up the dragon-bite follow-up increase its damage and horizontal hitbox. It's essentially two special moves in one and can be executed in a variety of ways. You can opt to charge the projectile to max before charging up a separate dragon-bite attack, or you can instantly release an uncharged projectile and begin charging a separate

Special Moves	
Move	Damage
Neutral special	Projectile: 4 (max charge 11), Dragon Bite: 10 (max charge 20)
Side special	15, Follow-up: 12
Up special	4.5, 1.2x5, 3
Down special	10 (minimum damage)

dragon-bite attack. At any point during the initial projectile charge, release Special and immediately begin holding it again to initiate dragon-bite charge. This is one of the more important special-reversible attacks, particularly because it can alter your trajectory midair.

Side Special: Dragon Lunge: Corrin leaps forward and extends a Dragon Fang angled toward the ground (down-forward). If the Dragon Fang connects with ground or a wall, Corrin transitions into a stance from which he can execute one of four follow-ups: a rear flying kick, a forward flying kick, release (drop down), or a vertical jump.

You can hit with an instant Dragon Lunge immediately canceled into the Dragon Fang follow-up extremely fast, about like a quick side tilt, quite fast for its range and functionality. Input side special and immediately hit Attack (this can be done either by using two separate fingers or by sliding your thumb across the two buttons, depending on your button layout). Use this technique to punish ground and ledge rolls.

Air Dragon Lunge can also be used in a variety of situations. It's an angled and ranged aerial attack at a down-forward angle you can use to pester ledge-recovering enemies, meeting them in the air and forcing them to deal with your fang. You can also use it to punish specific ledge-hanging recoveries by spiking into the ledge the enemy is hanging on to with your Dragon Fang and then going for a specific follow-up according to how the enemy recovers, although this takes practice and experience to time correctly for each possible option. For instance, if you spike onto the ledge while your opponent ledge-hangs and then rolls back onto the platform, you can go for a chasing forward flying kick to punish their roll.

Up Special: Dragon Ascent: Corrin flies into the air with impenetrable resolve, launching nearby foes and drilling them with multiple aerial attacks. You can alter the trajectory slightly with the control stick. For instance, you can hold the control stick forward upon liftoff to increase your forward momentum a bit. Alternatively, if you hold the control stick in the opposite direction, you gain additional altitude on Dragon Ascent.

Down Special: Counter Surge: Corrin transitions into a dragon form countering stance. During its brief intangible window, if Corrin absorbs an incoming attack, she retaliates by completing her dragon transformation, smashing into the ground with a massive area-of-effect splash attack that devastates nearby foes. While most parry-type attacks are severely risky, Counter Surge has potential use in free-for-all brawls against multiple opponents due to its ability to counter attacks from both sides. With practice, you can also use Corrin's Counter Surge as an edge-guarding tool if you can make a hard read on your opponent's recovery attack.

Final Smash: Torrential Roar

Corrin sends two columns of light, one on each side. If the columns hit an enemy, Corrin transforms into a dragon and unleashes a maelstrom that launches anyone caught in the attack. This move is especially effective at hitting enemies overhead.

Diddy Kong

OVERVIEW

Diddy Kong is an agile middleweight fighter with a versatile move set. Although you can play Diddy Kong in a variety of styles, Diddy Kong specializes in stage control, trapping, and grapple setups. While most speedy ground-based fighters have bait-and-punish- and hit-and-run-focused playstyles, Diddy Kong is most effective when he's controlling his opponent's mobility and using his agility and quick attacks to capitalize on the enemy's positioning.

Your primary objective with Diddy Kong is to create and earn space to set up Banana Peel traps. You want to maneuver around your enemy and try to score any kind of launch, knockback, or grapple. Diddy Kong has all the tools to do so effectively, thanks to his outstanding overall attributes on most of his moves (they're all quick, relatively safe, and have solid hit coverage). In conjunction with his versatile aerial attacks, Diddy Kong's impressive mobility makes him one of the kings of the neutral game. He has a fast dashing speed, a fast falling speed, above-average jump height, and the ability to wall-cling.

Diddy Kong Vitals	
Movement Options	
Jumps	1
Crouch Walk	Yes
Tether	No
Wall Jump	Yes
Wall Cling	Yes
Movement Ranks	
Ground Speed	C+ (19)
Air Speed	D (67-69)
Falling Speed	B (20-21)
Weight	D+ (50-52)

Grounded Attacks

Neutral Attacks: Diddy Kong reaches out and slaps a nearby enemy twice, then delivers a spinning roundhouse that knocks them away. Neutral attacks 1 and 2 are both quick to start and safe when shielded (against everything but instant shield-grab reprisals). You should almost always transition from the first jab slap to the second, since the second is slightly safer.

Neutral Attacks	
Move	Damage
Neutral attack 1	2
Neutral attack 2	1.5
Neutral attack 3	4

Dash Attack: While dashing, Diddy Kong uses his momentum to tumble forward with a three-hit cartwheel attack that launches foes into the sky, allowing him to follow up with an aerial attack. Against low-percentage middleweight foes (around 30%), dash attack launches the enemy into a high launch state, allowing you to combo with a guaranteed forward air or up air.

Dash Attack	
Move	Damage
Dash attack	2, 2, 3

Defensive Attacks	
Move	Damage
Ledge attack	9
Wake-up attack	7

Tilts	
Move	Damage
Side tilt	10
Up tilt	6
Down tilt	5.5

Side Tilt: Diddy Kong puts all his weight onto one leg while delivering a high-powered double-fist thrust straight in front of him. Side tilt extends a strong hitbox-to-hurtbox ratio, considering Diddy Kong uses his own fists for the attack. It's a great approach-deterring move, allowing you to surprise-attack your pursuers. It has relatively high end lag, so it can be punished in most cases, especially if it's not spaced.

Up Tilt: Diddy Kong performs an upward slap attack with an effective arc covering the entire area above him. The attack hits front first, then ends up behind, knocking up foes for a potential follow-up attack. Diddy Kong's up tilt inflicts a surprising amount of shield stun. It's punishable by most fighters' neutral attacks if they block, but can be safe against slower attacks, especially if spaced out.

Down Tilt: Diddy Kong delivers a prone low attack, targeting the enemy's feet with his hands. Not only does down tilt start exceptionally quickly, but it leaves you at a positive actionable advantage when it's shielded, enough so that you can jump out of slower shield grabs (like Greninja's).

Side Smash: Diddy Kong performs a mighty upward leaping slap, followed by a powerful airborne backfist. The two-hit sequence launches enemies up and away. After the initial slap, Diddy Kong goes slightly airborne, avoiding low attacks. When both attacks are shielded, side smash is punishable by most defensive retorts.

Up Smash: Diddy Kong shows off his acrobatic skills with a three-hit sequence. He begins with an upward palm strike, transitions into an anti-air cartwheel kick, then finishes with a vertical uppercut punch, launching foes directly above him. This is your fastest smash attack, and it is bananas. Its start-up is faster than most fighters' tilt attacks; hits front, behind, and above; and it launches. It's extremely unsafe when shielded, leaving you as vulnerable as if you had simply whiffed the attack in front of your opponent. Nevertheless, it's an incredibly powerful attack that acts as an anti-air, a high-damage get-off-me option, and a dash-punisher attack.

Down Smash: Diddy Kong performs a break-dancing kick called a nickel, sweeping foes in front of him before striking enemies behind. Foes hit by the stylish dance move are launched away. Diddy Kong's vulnerability is minimized while he performs this attack, as he slinks low to the ground. However, it has an extremely high amount of end lag as he recovers with a small bounce. Down smash is best saved for hectic free-for-all and team battles (i.e., when you need to defend yourself against multiple foes).

Smashes

Move	Damage
Side smash	5, 11
Up smash	2.5, 2.5, 6
Down smash	12

Diddy Kong's grab speed and grab range make the move a serviceable one if you consider his above-average ground speed. The throws he can follow up with make his grab game incredibly strong. His back throw is standard, used when your back is facing a blast zone to throw an enemy offstage. His front throw, while conventional in most ways, has a remarkably early actionable time. Up throw has high launching power, so even low-percentage foes are thrown high into the air. Down throw allows for follow-up attacks as well.

Grabs

Move	Damage
Grab attack	1
Front throw	9
Back throw	12
Up throw	5
Down throw	7

Aerial Attacks

Neutral Air Attack: While soaring through the air, Diddy Kong performs an aerial cartwheel, with each one of his four limbs striking foes as he spins. If you hit a grounded opponent with neutral air, they're popped up into the air enough for a potential follow-up combo. Diddy Kong's cartwheeling neutral air remains active for a good amount of time. Its landing lag isn't too bad either, although if you land in front of a shielding enemy, they can shield-grab you.

Aerials

Move	Damage
Neutral air attack	6
Forward air attack	10
Back air attack	9
Up air attack	6
Down air attack	13

The main drawback is vulnerability midflight. As Diddy Kong exposes his limbs, they can be beat out with anti-airs and other high-priority attacks.

Forward Air Attack: In midair, Diddy Kong extends a high-powered dropkick that knocks away enemies it connects with. Forward air is one of your staple aerial attacks. While it's a linear attack, it's highly versatile thanks to its extended hitbox range, as well as its persistence. You can use it as a high-priority air-to-air for offstage knockouts and edge-guarding, or as an air-to-ground maneuver to "wall out" advancing foes. It has much higher landing lag than neutral air, so space it out if you're using it at low altitudes.

Back Air Attack: Diddy Kong thrusts his foot out behind him with a fast aerial donkey kick. Back air has extremely low air lag and moderately low landing lag and makes Diddy Kong's edge-guarding game amazingly effective. While its active window isn't as pronounced as forward air's, its speed and low lag make up for it, allowing you to become actionable after your air-to-air attempts against airborne foes.

Up Air Attack: Diddy Kong performs a vertical kick while midair, covering a wide arc above him and knocking up airborne opponents for a potential follow-up. The tail end of the attack can hit foes behind Diddy Kong and has a hitbox low enough to hit most grounded fighters. This is your primary juggling tool.

The tip of the attack (Diddy Kong's foot) doesn't extend a hurtbox, so it can beat out weak down air attacks. It has decently low air lag, so you can go for multiple up airs in a single hop.

Down Air Attack: Diddy Kong comes down on the enemy with a heavy double-fisted hammerblow, potentially dunking airborne foes and causing them to plummet offstage. While down air doesn't have many practical uses, it's your main meteor smash attack for spiking foes recovering near the ledge. If you happen to smash a grounded foe with it, you can usually follow up with an up air combo. Its air lag is low enough for you to jump offstage and attempt a dunk, then double-jump back onstage.

Special Moves

Neutral Special: Peanut Popgun: Diddy Kong draws his wooden firearm, the Peanut Popgun, firing a giant peanut at the enemy. Charging increases velocity (peanut damage is heavily influenced by velocity), and the gun's launching power dramatically extends travel distance. You can cancel the charge by Shielding, but only during the early part of the move. However, you're committed in the later part, which can leave you vulnerable. Also, charging up your Peanut Popgun to its maximum overheats it, causing a close-range high-damage explosion (only damaging the opponent, even though it looks like it damages Diddy).

Special Moves

Move	Damage
Neutral special	Peanut: 2 + (1.4 to 13), Backfire: 23
Side special	Kick: 10 to 14, Grab attack: 1xN, Grab leap: 8, Grab slash: 10
Up special	Midflight: 10, Explosion: 18
Down special	Airborne: 4-5

Side Special: Monkey Flip: Diddy Kong leaps forward with a gap-closing jump, mounting the first enemy he makes contact with. He begins clawing at his ensnared victim as soon as he mounts them. From here, he can follow up with a springboarding stomp attack or a slash attack that sends the enemy flying away. Monkey Flip can be canceled with a flying kick attack immediately upon leading into the air. During the ascent of Monkey Flip's jump, Diddy grabs standing and jumping foes, but also grabs foes low to the ground as he descends. Its weakness is in its end lag. Opponents expecting it can jump over your lunge and punish you if you're too predictable with it.

Up Special: Rocketbarrel Boost: Diddy dons a jetpack consisting of two fuel-filled barrels that launch him soaring through the air, wildly. Diddy Kong's trajectory is heavily influenced by control input. If Diddy launches headfirst onto a stage or platform, the barrels explode upon impact, blasting away nearby foes. This can potentially be used to attack edge-guarding foes if they don't react properly. If it's shielded, it can be heavily punished since Diddy is left flopping around from the impact. Rocketbarrel Boost leaves you in a helpless falling state if it ends while you're airborne, and if Diddy is hit midflight, the barrels are knocked off him and fly off on their own while Diddy falls.

Down Special: Banana Peel: Diddy Kong cavalierly throws out a Banana Peel behind him. Enemies struck by it or stepping on it slip and fall, leaving them exposed to attacks. Tripped-up foes eventually recover into a tech get-up state if they aren't attacked (while standing, they're briefly intangible, but can be hit afterward). Note that Banana Peels are interactable items anyone can pick up. Once an enemy grabs the peel, it becomes dangerous to Diddy.

Mastering the art of the Banana Peel is crucial to playing Diddy Kong optimally, which means you also have to learn how to generate space to pull out Banana Peels (the move has a considerable start-up time). Generally, you want to toss out peels after launch-away effects, such as off of front throw, back throw, and forward air attacks. Banana Peel is also an incredible edge-guarding tool. If you throw an enemy off a ledge, your best follow-up is usually to set up a Banana Peel near the ledge.

Final Smash: Hyper Rocketbarrel

Diddy Kong multiplies himself and flies around the stage. He sometimes targets an opponent and charges at them. At the end of the attack, Diddy Kong charges at the opponent he's damaged most to launch them.

Donkey Kong

Donkey Kong Vitals	
Movement Options	
Jumps	1
Crouch Walk	No
Tether	No
Wall Jump	No
Wall Cling	No
Movement Ranks	
Ground Speed	C (25)
Air Speed	B+ (12-16)
Falling Speed	C (34)
Weight	A (3-4)

OVERVIEW

Mario's old nemesis turned ally packs the power of 10 plumbers in his swollen frame. He's a heavyweight for sure, but more agile than the other bruisers. Donkey Kong's fighting style is straightforward and honest brutality. He's strong, and most of his strikes have intangibility of some kind, whether to protect his arms during swipes or his topcurl during headbutts. Well-spaced, his priority is top-notch. His attacks do what they look like they'll do, and he's brimming with ways to grab, juggle, and spike challengers into submission.

Donkey Kong's effortless strength allows him to scoop up his sparring buddies after grabs, relocating before tossing them. After tossing someone off a platform, DK has four different ways to try smashing them downward, with forward air (late hit), down air, air side special (hit with bottom edge), and air down special (second hit) all spiking. On top of all that, charging up his Giant Punch gives instant and obvious KO-punch potential. If Donkey Kong has weaknesses, they're simply that many fighters are faster, and his recovery is on the predictable side.

Grounded Attacks

Neutral Attacks

Move	Damage
Neutral attack 1	4
Neutral attack 2	6

Dash Attack

Move	Damage
Dash attack	12

Defensive Attacks

Move	Damage
Ledge attack	10
Wake-up attack (faceup)	7
Wake-up attack (facedown)	7

Neutral Attacks: The original Nintendo bruiser attacks directly in front of him with a hook punch, followed by an uppercut. Most of Donkey Kong's other attacks are fairly slow to hit compared to quicker fighters. Donkey Kong's punch combo is no Zero Suit Samus jab, but it's not bad, dealing solid damage with two hits. The first hit can be used as a poke to tick close-range foes and hold them in place, where you can follow up with a grab attempt. The first hit shielded isn't disastrous for Donkey Kong, but both hits being shielded leaves him very open.

Dash Attack: While running or dashing forward, Donkey Kong can start rolling, turning his body into an impromptu boulder! Anyone in the way is rudely displaced. Hitting with the early part of DK's boulder roll launches foes up into the air, but hitting with the later part deals less damage and knocks them out of the way just a little.

Side Tilt: Donkey Kong's farthest-reaching ground attack. He can't be hit on his punching arm, which helps him overwhelm other pokes. Aiming slightly up or down when performing side tilt angles it a bit, helpful for being sure when the target is slightly off-center.

Up Tilt: Starting at his front shoulder, the gorilla takes a mighty swat front-to-back, covering all upward angles. Though up tilt is tailored mainly for anti-air and juggling, the very beginning of the attack hits close enemies on the ground.

Down Tilt: The king of the jungle hunches low and swings with a far-reaching slap attack. Donkey Kong's arm is intangible for the attack, helping him out-prioritize enemy attacks within range. This punch turns foes around if their backs are to Donkey Kong, forcing them to face him.

This poke is great for setting up grab attempts. Messing with enemy movement is always a bonus, and scoring a trip guarantees the follow-up grab succeeds. Down tilt does less damage than Donkey Kong's other ground pokes, but leads more directly to good stuff right after.

Tilts

Move	Damage
Side tilt	7
Up tilt	10
Down tilt	6

Side Smash: Donkey Kong reaches far forward with a mighty two-handed clap. Charging can increase the damage to absurd proportions for a single hit, if the opposition gives you the time to try it.

Up Smash: DK brings both hands together above his head for another powerful clap. The hitboxes cover Donkey Kong's arms only while they're straight up, palms together. His arms don't hit foes to the sides on the way up, unlike up tilt. This is for clapping back at foes directly above, like on shallow platforms or ramps, or descending from a jump or launch.

Down Smash: Donkey Kong brings both fists down with arms out, slamming both sides. He also has surprisingly good coverage above his shoulders. This is his most reliable clear-out move when surrounded on the ground. With this move's generous hitbox across the ground between his fists, down smash can work shooting for enemy fingers as they grasp for a ledge.

Smashes

Move	Damage
Side smash	22-30.8
Up smash	19-26.6
Down smash	17.2-25.2

Grabs

Move	Damage
Grab attack	1.6
Front throw	0
Back throw	11
Up throw	9
Down throw	7

Donkey Kong's grab animation is quick for a heavyweight, but slow compared to most fighters. Once he pulls in a defender, he has options. You can take the standard route and pummel them a couple of times before hurling them with a throw. But Donkey Kong can also throw the defender over one shoulder with the Kong Karry, started by grabbing someone, then tapping forward on the stick. Donkey Kong can move around and jump with the foe

Kong Karry Throws

Move	Damage
Front throw	12
Back throw	13
Up throw	12
Down throw	11

helplessly perched. Press direction+Attack/Grab to end the Karry by tossing them in the chosen direction. Don't wait too long before throwing, as the victim recovers and shakes out of Donkey Kong's grasp after a few seconds.

Aerial Attacks

Neutral Air Attack: Putting his immense upper-body strength to work, DK spins himself like a top in midair. He hits to his front and back, with good attack duration for an air move. This is his best attack when trying to escape air scrambles. It's not multi-hit, though. It can easily plow through multiple opponents, but it hits them each only once.

Forward Air Attack: Donkey Kong swings forward with his fingers interlocked, hitting anything in the way with a hammer-blow punch. The gorilla's wingspan gives the move incredible coverage. Starting almost straight back, swinging over the top, and ending at straight down, forward air covers almost 75% of the space around the ape at some point in its hit arc.

Back Air Attack: In a rare kicking maneuver, DK hits backward with one leg. Back air has surprising reach, and stays active for a long time for a move of its type. When going air-to-air with floaters, back air hits quicker than forward air and farther than neutral air, while requiring a little more precision than either.

Aerials

Move	Damage
Neutral air attack	11
Forward air attack	16
Back air attack	13
Up air attack	13
Down air attack	16

Up Air Attack: Up air hits hard straight up, launching victims high and outright knocking out targets with high damage built up. Donkey Kong sweeps his head quickly upward, covering a little bit above his shoulders. The hitbox is just around DK's head and it's not active for long, so it requires precision when looking to headbutt someone into the sky.

Down Air Attack: Donkey Kong stomps hard with one foot, spiking victims. Down air hits briefly and only around his foot, so it's harder to aim than some attacks. The rewards are worth it if you catch someone offstage or ledge-grasping. Off short hops it can help work the shield of overly defensive opponents, along with side special and air down special.

Special Moves

Neutral Special: Giant Punch: Donkey Kong's signature megaton punch must be charged before it can be used. Start the charge with an initial neutral special input. Donkey Kong spins one arm, building up power. When fully charged, DK stops spinning his arm; you can tell he's got a max-power Giant Punch stored because of his enraged facial expression! Charging takes a while, and leaves Donkey Kong open to punishment. Luckily, the charge-up period can be cut short by tapping down (triggering an on-the-spot dodge), or left or right (triggering a side roll). You retain charge already built up, so it's fine to build up a maxed Giant Punch in bits and pieces.

Special Moves

Move	Damage
Neutral special	10-28
Side special	10
Up special (ground)	5, 1.4x5, 4
Up special (air)	5, 1x11, 2
Down special (ground)	14
Down special (air)	5, 6

With a max-power Giant Punch stored, Donkey Kong becomes much more threatening. Such a forceful blow is a KO threat even at medium percentages, and can seriously surprise enemies in midair or edge-guarding trying to keep DK off the stage. You can double-tap the Special button on activation for an immediate, weak-powered punch, but the lag on Giant Punch is so significant that this is not recommended. It's better to fully build up Giant Punch's charge, even if the charging is in bits and pieces. This assures the punch will be worth the lag when you decide to use it.

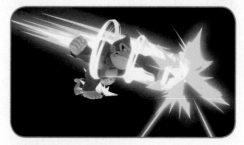

Side Special: Headbutt: Donkey Kong rears back for a moment before swiping forward with a mighty forehead headbutt. This move doesn't have much range, but it has a lot of uses because of some special traits. First, during the start-up, Donkey Kong has super armor. This means he can plow through incoming attacks and hit them back, if they strike him before he lunges with the headbutt. Second, on standing or crouching targets, eating a Donkey Kong headbutt briefly plants them in the ground like one of Peach's turnips.

They're totally vulnerable to more hits while they try to shake out of the dirt. Third, when using a headbutt to joust with other jumpers air-to-air, hitting squarely with the bottom of the hitbox can spike them straight down with a meteor smash effect, scoring fast KOs offstage and leading to bounce combos midscreen. Finally, the headbutt deals tremendous damage to an opponent's shield. If it doesn't outright break their shield, it'll put them in serious danger of it should they block any more attacks.

The only caveat for such a strong, multipurpose attack is that it's slow to hit, a deficiency mostly covered up by the initial super armor phase.

Up Special: Spinning Kong: On the ground or in the air, Donkey Kong spins furiously with a powerful multi-hit attack. He whirls with intangible arms, striking both sides, fast enough to slightly lift himself in midair. The first and last hits are the most powerful whether on the ground or in the air, and in between are lots of lower-damage hits that pile up quickly on anyone close. On the ground, Donkey Kong advances if you hold forward on the stick.

During aerial Spinning Kong, Donkey Kong can be piloted in either direction. Aerial Spinning Kong is DK's main (or only, really) recovery move when punted offstage. It doesn't gain much height, and its trajectory is extremely predictable. It's lucky, then, for Donkey Kong that his brute force keeps it effective.

Down Special: Hand Slap: The gorilla slaps ferociously one hand after the other, with different results depending on whether it's used on solid ground or flying through the air. In midair, down special is basically a powerful two-hit frontal jump-in, covering only diagonal down-forward angles. Used near the ground, it has minimal lag when landing, and deals huge amounts of shield damage against defenders. On the ground, each slap causes a minor local tremor, launching anyone caught in a wide swath.

Final Smash: Jungle Rush

If you thought charged Giant Punch was scary, wait until you see Jungle Rush. Load up by breaking a Smash Ball (or filling FS Gauge, if enabled) then get into punching range. Neutral special unleashes a terrifying hook punch, which traps anyone struck by it in a hugely damaging rapid-fire combo. For a Final Smash this has unusually small range, so make sure the target would be viable to swing at with Giant Punch. Groups are even better; Donkey Kong can make multiple defenders into punching bags together.

Dr. Mario

OVERVIEW

Weighed down by his smock and stethoscope (not to mention the weight of duty conferred by taking the Hippocratic oath), Dr. Mario is a bit denser and slower than off-duty Mario. His jumps and hops are more compact and quicker to return to the ground, and his attacks hit harder. If you want a little less finesse and a little more oomph behind the famous plumber's stomping kicks, you might find Dr. Mario to your liking. Dr. Mario improves on Mario's spinning down air with the much more powerful Dr. Tornado down special (mashable for extra height). The doctor replaces down air with a double-boot stomp aimed straight down, great both for fast-falling on defenders with solid ground below, and for trying to spike fighters into pits where the ground drops out. Dr. Mario's dash attack slide kick looks like Mario's, but instead of punting victims away, it pops them straight up, creating a juggle combo opening. Dr. Mario's challenger-spinning Super Sheet covers more area than Mario's equivalent cape (though it doesn't float like the cape).

Dr. Mario Vitals

Movement Options	
Jumps	1
Crouch Walk	No
Tether	No
Wall Jump	Yes
Wall Cling	No
Movement Ranks	
Ground Speed	F (70)
Air Speed	D (67-69)
Falling Speed	C- (49-51)
Weight	B- (27-29)

Grounded Attacks

Neutral Attacks: Dr. Mario's most basic attack is a three-hit punches-into-kick combo. Tap or hold the Attack button to perform the combo; from afar, holding it down produces a flurry of whiffed jabs, while tapping repeatedly whiffs the whole three-hit sequence. Up close, with a defender in attack range, holding and tapping both suffice to produce the combo.

The first hit of Dr. Mario's neutral attack combo is terrifically fast, striking up close almost instantly. This means it's a great assured punish tool when someone leaves themselves open, whether by whiffing an attack, dodge-rolling poorly, or giving you something laggy to shield against before counterattacking.

Dash Attack: Dr. Mario's sliding dash kick resembles Mario's, but does a tiny bit more damage, like most of the doctor's attacks. On a solid hit, it also pops the victim straight up above Dr. Mario, leading to better immediate juggle combos.

Neutral Attacks

Move	Damage
Neutral attack 1	2.9
Neutral attack 2	1.8
Neutral attack 3	4.7

Dash Attack

Move	Damage
Dash attack	11.5

Defensive Attacks

Move	Damage
Ledge attack	10
Wake-up attack (faceup)	7
Wake-up attack (facedown)	7

Side Tilt: Dr. Mario quickly sticks out a spinning front kick. This basic kick can be angled slightly up or down with a subtle diagonal input. This attack has the farthest forward reach of Dr. Mario's grounded strikes, slightly outranging down tilt, side smash, and down smash. A dashing attack has more range on the ground, but that's a much more committed action.

Up Tilt: The good doctor swings upward with a punchy uppercut, spinning himself around with the follow-through. This attack has very little horizontal range and might even whiff completely against a fighter standing next to Dr. Mario, depending on the size of their profile (like if they're crouching). Still, this is a terrific move because of its usefulness aiming straight up, swinging at airborne foes and juggling floating targets, and in enabling combos.

Down Tilt: Dr. Mario sweeps enemies in front of him with a quick kick, popping them off their feet on contact if they fail to shield. Like side smash, down tilt deals more damage at point-blank range, close to Dr. Mario. Hit with just his foot, and he deals out slightly less damage. Down tilt can lead straight to guaranteed combos at low to medium percentages; on an opponent between 10% and 30% damage, down tilt can be followed immediately by Super Jump Punch for big damage out of only two hits (the whole thing can be preceded by a last-second neutral air or down air just before landing next to the victim). At higher-damage percentages, down tilt can be followed by up tilt to pop the foe higher, before you chase after them with a high-jumping up air.

Tilts

Move	Damage
Side tilt	8.2
Up tilt	7.4
Down tilt	8.2

Side Smash: Dr. Mario rears back for a second, charging the attack up if desired, before unleashing a close-range electrical punch. Like Mario's fiery version of side smash, this attack has range that extends beyond Dr. Mario's palm strike. Dr. Mario's side smash deals max damage at close range, with the palm hit. Keep this in mind when poking with this attack. While charging, hold up or down to aim the punch slightly in that direction—useful when edge-guarding.

Up Smash: Dr. Mario stretches way back, then whips his head forward in a ferocious headbutt. Like with similar headbutt attacks from Mario and Luigi, this up smash has more range behind Dr. Mario than in front of him. It also covers the sky directly above him, since his head is intangible during the attack.

Immediately after input, this move hits behind Dr. Mario; halfway through its travel, it's a great anti-air or juggling move; only during the final moments does it hit before

Smashes

Move	Damage
Side smash	20.9-29.3
Up smash	16.5-23
Down smash	11.8-16.5/14.1-19.8

him. Keep this in mind when deploying this attack. Rather than a frontal poke, it's better suited to clearing out all around Dr. Mario, juggling after down throws or up tilts, or covering short hop space above him. It also has some use aggressively if you first run, slide by tapping the other direction, then immediately up smash. Done quickly enough, it'll look like Dr. Mario transitions seamlessly from running to headbutting backward. (Tricks like this can be easier if the C-stick is assigned to smash attacks, so an upward C-stick flick always reliably smashes, rather than sometimes getting an up tilt instead of up smash when trying this entirely on the control stick.)

Down Smash: Many of Dr. Mario's actions are different and slower than normal Mario's, but this breakdancing kick is just as fast and useful. Dr. Mario kicks to his front side first, then whirls and kicks behind too. In front of the doctor, uncharged down smash hits as quickly as side or down tilt, making that his fastest hard-hitting ground poke. The hit behind is great for covering both sides in party battle modes. When using smash attacks to ward off enemies closing in from both sides, remember that up smash hits behind Dr. Mario first, then the front, while down smash is the opposite, covering him in front first, then behind.

Grabs

Move	Damage
Grab attack	1.5
Front throw	9.4
Back throw	12.9
Up throw	8.2
Down throw	5.8

Dr. Mario's really quick grab motion covers a short range in front of him. Always be ready to dash in close and throw when engaging enemies on the ground. To condition opponents to be vulnerable to dash-in/empty jump grab attempts, feed them a steady diet of short-hopping neutral air (performed early in the jump, before fast-falling) and down air kicks (performed later in the jump, to hit squarely with the sweet spot), not to mention dashing attacks, down tilts, and down smashes.

Back throw has the highest base damage, distance thrown, and high-damage KO potential. Up and down throw both lead to potential juggle follow-ups, though they're rarely guaranteed if the victim takes evasive action. At lower percentages you can always at least juggle with up air or Super Jump Punch, but at higher percentages with a bigger launch, you should switch gears from going for true combos and instead look to keep up offensive pressure against tumbling foes who take evasive action in midair with dodging or air attacks.

Aerial Attacks

Neutral Air Attack: Dr. Mario's basic air attack is distinctive because it's stronger *later* in the attack's active period. You dole out the most damage and knockback by sticking out neutral air early and letting the kick travel into the target (or the target into the kick). Coupled with Dr. Mario's brief jump, this is an ideal air attack to use when jumping or hopping directly above intended targets before fast-falling with neutral air extended.

Aerials

Move	Damage
Neutral air attack	9.4
Forward air attack	17.6
Back air attack	14.1
Up air attack	10.2
Down air attack	14.1

At low-damage percentages it doesn't knock standing victims away, which allows you to potentially tack on grounded attacks for a combo. For example, hopping/jumping neutral air, down tilt, then neutral attack x3 works even on 0% damage opponents. Neutral attacks, tilts, or Super Jump Punch all work after late neutral air immediately before landing. The hitbox is generous, scoring hits on targets below even if Dr. Mario crosses over to their backs and lands facing away. In this case, to combo from falling neutral air, you have to perform immediate up smash upon landing.

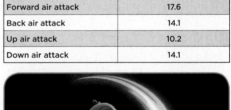

Forward Air Attack: Dr. Mario swings with a mighty hook punch in midair. The timing to hit just right with the fist forward for full damage is tight, but extremely satisfying when it hits. Dr. Mario relies on down air for bounce combos and spike KOs. But since Dr. Mario's short hop is even shallower than Mario's, it's easier to use short-hopping forward airs against standing/hopping enemies. With Mario, there's some timing involved to not whiff forward air just over a standing foe's forehead, or to start it too late and land without punching; but with Dr. Mario you can short-hop forward with instant forward air punches and threaten most fighters.

Back Air Attack: Dr. Mario juts both legs out in a stout, hard backward kick. You won't ever go wrong relying on this attack in midair, unless the up air angle is required. Back air dishes out good damage and knockback, and is much easier to aim and hit with than front, up, or down air. The only issue is, unless it's a purely reactionary back air used against someone sneaking up from behind, you must have your back to the intended target.

Up Air Attack: Dr. Mario flips backward, kicking along the way. Despite appearances, the hitbox to his back is deceptively small. It'll likely whiff against fighters behind him. It's intended for chasing down challengers floating above. Sometimes a quick up air juggle is assured, like at low percentages, short-hopping with up air after popping a victim up with up tilt/smash or up/down throw. At medium-damage percentages, a full jump is needed to rush higher after the target beforehand. At high damage, when they're launched too high for guaranteed follow-ups, it becomes a game of predicting where they'll drift while tumbling, and whether they'll choose to dodge/counterattack if you go after them.

Down Air Attack: A double serving of stomping boots is what the doctor ordered. This is Dr. Mario's meteor smash attack, capable of spiking recipients straight down into pits before they can recover. Midstage, it can bounce victims high off the ground, working as a juggle combo starter. The spike/bounce effects show up just short of medium damage, starting above 30%. Depending on how high the victim is bounced, you can juggle immediately with up tilts/smashes, or at least jumping up air, for starters.

Special Moves

Neutral Special: Megavitamins: The doctor tosses multicolored Multivitamins in big bouncing paths in the direction he's facing. The vitamins are heftier than Mario's fireballs and bounce a bit higher. Tossed on level ground, the bounce height isn't so high that they won't hit most opponents, but thrown from jump height, the vitamins can easily bounce clean over foes. Multivitamins can be swatted away or reflected, but it's more like dealing with items than energy shots for opponents. Like most projectiles, Megavitamins are great for edge-guarding, defensive stalling, and moments when you're separated from the main battle and want to safely toss some hazards into the way.

Special Moves	
Move	Damage
Neutral special	5.9 close, 4.7 far
Side special	8.2
Up special	14.1
Down special	1.9x6, 3.5
Down special (ground)	—
Down special (air)	—

Side Special: Super Sheet: The conscientious physician lays out a hygienic sheet for his patients. The sheet covers the air in front of Dr. Mario before whipping upward, briefly covering the airspace above too. Anyone contacted by the sheet gets turned around! They also take a little damage, but that's not the important part. This is a variation on Mario's cape, but Mario's version doesn't hit upward at all. On the other hand, Dr. Mario's Super Sheet lacks the momentum-killing effect of Mario's cape, so it can't be used to alter airborne arcs.

Up Special: Super Jump Punch: Dr. Mario leaps upward with a powerful uppercut. For full damage, hit up close with the beginning of the move. If Dr. Mario hits someone later, after he takes off, the damage is halved. Once the uppercut's upward momentum is used up, Dr. Mario lags until landing, drifting downward helplessly except for being able to steer slightly left or right.

Dr. Mario's move set provides ample opportunities to combo Super Jump Punch. At low percentages, down and up tilt, along with down throw, can all lead into immediate Super Jump Punch. With juggle combos at higher percentages, you might have to jump and attempt to Super Jump Punch flush against your target in midair for max damage.

Down Special: Dr. Tornado: This whirling special move is quite flexible, allowing for a lot of variance depending on inputs. The initial input is enough for Dr. Mario to start up his tornado motion. Left or right inputs steer him, as he inflicts multiple hits on anyone caught in the vortex. A final heavy hit at the end of his travel launches them away.

While he's swirling, repeated Special button inputs cause Dr. Mario to ascend. Dr. Tornado can give Dr. Mario another jump's worth of height with spirited (if not quite furious) Special button mashing. If you want the full-height Dr. Tornado, think of the input as being down+Special, then three or four more quick Special button presses during the spins. Used while moving left or right, an ascending Dr. Tornado can help Dr. Mario recover, putting him back in ledge-grasping reach. Dr. Tornado can only be used for upward loft once per airborne period.

Final Smash: Doctor Finale

Crack open a Smash Ball for access to Dr. Mario's strongest prescription. Draw a bead laterally on as many combatants as possible, then input neutral special to send two enormous vitamins spiraling across the battlefield. Fighters caught by either gigantic vitamin will likely be carried along in a combo by both of them, blended up by their motion around each other.

Duck Hunt

OVERVIEW

This tandem works together to put each of their distinct advantages to good use. The dog gives Duck Hunt decent mobility and the ability to wall-jump, while the duck grants far-reaching, sharp beak attacks, not to mention saving the dog's bacon over pits with the Duck Jump up special. Many of Duck Hunt's attacks work like unique projectiles. All smashes are barrages from an NES Zapper light gun, striking around duck and dog and making them cower while dealing damage to their opponents. Trick Shot, Clay Shooting, and Wild Gunman specials all offer ways to put variable projectile threats on-screen, almost like moving land mines you can detonate at will.

The quirkiness of Duck Hunt's attacks is both strength and weakness. There's nothing quite like Trick Shot, which is both a grenade-type move and a bomb you can shift around the screen with secondary shots, even while performing other actions. But the specials require some premeditation and hard reads to use well, and the unique zapping smash attacks don't always hit like you'd expect them to.

Duck Hunt Vitals	
Movement Options	
Jumps	1
Crouch Walk	Yes
Tether	No
Wall Jump	Yes
Wall Cling	No
Movement Ranks	
Ground Speed	C- (30)
Air Speed	B (19-24)
Falling Speed	B- (28-33)
Weight	D (59-60)

Grounded Attacks

Neutral Attacks

Move	Damage
Neutral attack 1	1.5
Neutral attack 2	1.5
Neutral attack 3a	5
Neutral attack 3b	0.4x8, 3

Dash Attack

Move	Damage
Dash attack	10

Defensive Attacks

Move	Damage
Ledge attack	9
Wake-up attack	7

Neutral Attacks: There are two ways to perform Duck Hunt's neutral attack combo. The first is to hold down the Attack button. This speeds through Duck Hunt's basic three-hit combo: a quick paw swipe, a puppy headbutt, then a two-hind-legged kick with front paws planted. This is an easy punish out-of-shield when you block an opponent's attack. Alternately, manually tap the button repeatedly for a different ender: the dog ducks while the duck thrusts forward repeatedly in a beak flurry. At the end, the dog launches the target.

Dash Attack: From a forward four-legged run, the dog leans out of the way so the duck can thrust way forward, issuing a high-damage hit that launches away. Early beak hits knock foes up and far forward, but late beak hits (just before the attack's active period ends) launch them up and over Duck Hunt, offering immediate juggle chances behind.

Side Tilt: The dog flattens and allows the duck to stretch ahead, striking far forward. Holding slightly up or down during execution aims the bird a little bit. The downward-angled side tilt can snipe recovering foes the instant they grab a ledge, dislodging them. Side tilt is slower to hit than down tilt or neutral attack, but has more reach.

Up Tilt: The duo aims a bird swing upward. This move is mostly intended for use against foes above. It can hit enemies pressed flush against Duck Hunt, but it might miss small or thin fighters even up close. Focus on using it for low-altitude juggles and knocking short hoppers away. When it hits, it pops the opponent into a vulnerable arc right above.

Tilts

Move	Damage
Side tilt	8
Up tilt	7
Down tilt	8

Down Tilt: While the dog crouches low, the duck stretches around to poke with its beak. This has a low profile and hits with decent reach, pushing enemies away. It's the fastest move Duck Hunt has for neutral game dancing on the ground, besides a plain neutral attack or grab. When shielded, down tilt is much safer from retaliation than most other Duck Hunt pokes, as long as you aim from max range.

Side Smash: It's time to break out the trusty old NES Zapper! For each smash, a series of light gun reticles appears and explodes, automatically juggling anyone in the way before launching them away. The last shot is always the strongest. For side smash there are three light gun shots in front of Duck Hunt, starting right next to the duo and proceeding outward, each comboing to the next on a clean hit. The speed is nothing to write home about, hitting slightly below average for a side smash.

Up Smash: Three quick shots above the uneasy alliance of dog and duck. The first shot zaps a bit above and in front of Duck Hunt, with the same speed as down smash, decent for a smash attack. The second shot is slightly above and behind, and the final shot is centered directly above the pair, hitting much harder than the preceding shots and launching quarry straight up into juggle position. Any of the hits connecting carry prey forward into the rest.

Smashes

Move	Damage
Side smash	4x2, 9-5.6x2, 12.6
Up smash	2.5x2, 10-3.5x2, 14
Down smash	5x2, 6

Down Smash: The duo ducks together while NES Zapper shots go off on both sides. The first shot hits in front with decent smash speed, the second shot is behind (getting kind of slow, if someone's standing behind Duck Hunt), and the final shot is in front almost a half-second after input. Any of these shots, if they connect, pull the victim over Duck Hunt, ready to eat the next shot. Someone standing in front and not shielding during the first hit is launched behind Duck Hunt, then relaunched forward.

Duck Hunt's grab speed is very good, just shy of the fastest grabs. The dog leans forward, adding decent reach. It works well with neutral attack paw pokes and down tilts, not to mention short-hopping air moves. Front and back throws let you pick a side to chuck foes. Up throw has the dog launching them upward with a hind-leg kick, allowing for follow-ups straight above, like with hopping up air. Down throw smacks them off the ground for follow-up chances lower to the ground and in front.

Grabs

Move	Damage
Grab attack	1.2
Front throw	8
Back throw	9
Up throw	6
Down throw	5

Aerial Attacks

Neutral Air Attack: The dog spins in midair, all limbs active. The whole dog is basically a hitbox, and the attack is active with good speed. It then lasts just short of half a second, making it an extremely useful jumping move. It's a sure thing ramming into other fighters air-to-air at any angle, and it's easy to deploy and then pull down into foes from above via fast fall.

Against opponents standing on the ground, it doesn't start knocking them back very far until high damage is built up, which means you can go right into ground combos or grab tries.

Aerials

Move	Damage
Neutral air attack	11
Forward air attack	10
Back air attack	12.5
Up air attack	3x2, 6
Down air attack	5, 10

Forward Air Attack: The very first active part of this attack is the dog checking with a shoulder, but the duck then jabs ahead with the strongest part of the attack. The attack is stronger aimed with the beak. It's active starting just a tiny bit slower than neutral air but with more forward reach. The lag on landing is slightly less too, allowing even tighter combos and grab pressure.

Back Air Attack: The dog leans aside so the duck can spear sharply behind the duo. The damage is good, and the knockback is great starting at mid percentages and higher. The only downside is the long landing lag is used near the ground.

Up Air Attack: The duck snaps upward quickly three times, with the final hit being the strongest. With three snapping attacks, this has a decent active period, but only the final hit launches enemies back up, so it can be hard to get all three hits. If foes get bitten by the first or second beak hit but then glance off, they fall alongside Duck Hunt.

Down Air Attack: Unlikely animal friends work together, with the dog and duck flipping one after the other with downward-aimed headbutts. The speed is like an average smash attack. Like up air, the separate hits can make it hard to aim and get both hits. The second hit, from the duck, is a powerful meteor smash on a clean hit. Landing lag used near the ground is bad, with the poor dog flopping hard.

Special Moves

Neutral Special: Trick Shot: The duo tosses out a *Hogan's Alley* can, ripe for target practice. This is an explosive, and detonates for solid damage on contact with enemies (higher downward velocity on the can leads to a little more damage). This means the simplest way to use it is as a grenade. If a can hits the ground without detonating, it comes to rest. If nothing happens to it, the can disappears after 11 seconds.

Both Duck Hunt and foes can swat at the can, knocking it around; it's possible to physically assault it enough to detonate it. While a Trick Shot is on-screen, further inputs of neutral special result in NES Zapper shots aimed at the can. This works no matter what Duck Hunt is doing. Up to eight shots can be pumped into a can before it explodes.

Side Special: Clay Shooting: The dog spins to hurl a clay pigeon forward like a Frisbee. It travels either a medium or long-range distance, depending on whether you use a tilt-style side special input (holding direction in advance, or gently angling control stick) or a smash-style input (flicking the stick plus the button).

Special Moves	
Move	Damage
Neutral special	10-14 (shots 1.7)
Side special	2 pigeon
Up special	0
Down special	Varies

Wild Gunmen	
Move	Damage
Red bandanna, black vest	8
White shirt, no vest/duster	8
Black duster	9
Red duster	10
Sombrero	11, fire rounds

The smash-style input tosses the disk farther and faster. The disk itself is a projectile attack, with a weak hit on its own. While the pigeon is on-screen, inputting neutral special takes NES Zapper shots at the disk. This works whether it's in motion or lying still but not yet vanished. These individual gunshots are weak, like when pinging shots off a Trick Shot can. But if a shot strikes the clay pigeon, it shatters, dealing extra damage to anything nearby.

Up Special: Duck Jump: The duck briefly, nobly resists gravity, lugging the dog upward as long as it can (which is just a second). As the duck flaps, holding the control stick up-forward gains the most distance traveled in a desired direction. A flapping duck can also easily change directions, like Villager and Isabelle during Balloon Trips, but turning while flapping reduces how much distance and height the duck achieves.

There's no innate attack portion of Duck Jump. On its own, this is a movement-only special. However, Duck Jump is a unique up special in that you can interrupt it partway up with *any other air move*. The catch is, you still enter the usual helpless drifting state that most fighters end up in after up specials. Ultimately, physics wins, and duck and dog drift back down to the ground.

Down Special: Wild Gunman: Duck Hunt deploys a pixelated helper, plucked straight from 1984's NES light gun title *Hogan's Alley*. If used in midair, Duck Hunt's air momentum is briefly slowed. The gunner drifts downward for a moment (or just stands there, if they're already on the ground) before firing straight ahead. This is basically a drop-and-forget projectile. Different gunmen have different armaments, so they deal slightly varying amounts of damage.

Final Smash: NES Zapper Posse

With Final Smash stocked and viable targets relatively close in front of Duck Hunt (they don't have to be point-blank, but they can't be too far), cut loose to summon a sudden flock of ducks. If the ducks nail anyone in the way, those opponents find themselves in a recreation of *Hogan's Alley*, at the whim of all the Wild Gunmen. (Their whim is to shoot things.)

Falco

OVERVIEW

Falco is one of three *Star Fox* fighters in *Super Smash Bros. Ultimate*, sharing a similar special moves list with both Fox and Wolf. Whereas Fox is a hyper-fighter and Wolf is a heavy-hitting brawler, Falco is a graceful combo-centric combatant with the highest jump in the game. While Falco is faster than Wolf, he isn't as speedy as Fox, nor does he have huge hitboxes on his attacks, so his playstyle is much less offense-based and is more centered around waiting, baiting, and punishing with high-damage combos. Falco's individual strikes don't cause absurd amounts of damage on their own. Instead, he has a plethora of combo-starting attacks that lead into damage-racking opportunities. Furthermore, most of Falco's attacks have amazingly fast start-up times, making it much easier for him to punish whiffed and shielded attacks. Falco's jump height, ability to wall jump, and his myriad special recovery tools can potentially make him difficult to finish off.

Falco Vitals

Movement Options	
Jumps	1
Crouch Walk	No
Tether	No
Wall Jump	Yes
Wall Cling	No

Movement Ranks	
Ground Speed	D (47)
Air Speed	D+ (58)
Falling Speed	B+ (10-15)
Weight	D (62-63)

Grounded Attacks

Neutral Attacks	
Move	Damage
Neutral Attack 1	1.5
Neutral Attack 2	1.5
Neutral Attack 3	0.3xN, 3

Dash Attack	
Move	Damage
Dash attack	9

Defensive Attacks	
Move	Damage
Ledge attack	9
Wake-up attack	7

Neutral Attacks: Falco performs an incredibly swift two-hit slap combo before transitioning into a wind-based flurry attack that ends with a final overhead axe kick. The first jab is limited in range, but starts up extremely fast. Falco extends the second jab farther than the first, coming out quickly, but he becomes punishable by most out-of-shield jab reprisals.

Dash Attack: Falco dashes at the enemy and then delivers a flying side kick, driving them diagonally into the air. This is your primary midrange whiff-punish attack while dashing on the ground. The initial hitbox launches foes up into the air, but this doesn't lead into a guaranteed combo follow-up. However, it does allow you to transition into a strong juggle-trap game. Hitting with the tail end of the kick causes small knockback.

Tilts	
Move	Damage
Side tilt	6
Up tilt	3.5, 4
Down tilt	13

Side Tilt: Falco unleashes a quick side kick to the enemy's midsection, staggering them briefly. Falco aims the downward angled side tilt at the opponent's feet. When angled upward, Falco targets the foe's head. Side tilt is a solid aggression-deterring attack and a good poke that extends beyond his neutral attack range. However, it doesn't lead into extra damage, so it's best used sparingly.

Up Tilt: Falco performs two consecutive slashes above him in a wide arc. The first hit pops the opponent into the second hit, which launches them directly above him into the air, setting up a potential juggle combo. It's a remarkably versatile attack and can be used as an out-of-shield option, an anti-air, a combo-starter, and to extend combos.

Down Tilt: Falco crouches low and sweeps the ground in front of him with a powerful tail attack that launches foes vertically into the sky for a potential follow-up combo. Down tilt has a relatively slow start speed when compared to Falco's other attacks, but has strong KO potential. It's also safe when shielded, especially if you space it. Against high-damage foes, you can fish for knockouts against grounded enemies by sticking out down tilt as your opponents approach you with an attack.

Side Smash: Falco bends backwards and puts his might into a heavy overhead wing-slash attack, devastating foes in its path. Compared to the rest of Falco's attacks, side smash is super slow, but it can obliterate high-damage foes near an edge.

Up Smash: Falco performs a quick double-rising kick that arcs in front of him and above his head. The first kick knocks the enemy up into the second launching kick. Falco's up smash is one of the better up smashes in the game. Its active window starts very early for a smash. It has outstanding area coverage and strong combo potential as it launches foes above you.

Down Smash: Falco hops up and lands on the ground, extending a leg in front of him and the other behind him simultaneously, clearing out nearby enemies. Down smash's active window starts quickly, just slightly slower than up smash, so it's a relatively fast double-sided clear-out tool.

Smashes

Move	Damage
Side smash	16
Up smash	4, 13
Down smash	15

Grabs

Move	Damage
Grab attack	1.3
Front throw	7
Back throw	9
Up throw	8
Down throw	5

Falco reaches out and holds the enemy by the collar, preparing with a follow-up attack. Falco can almost instantly begin grab-attacking enemies as soon as he grabs them, so you can usually sneak a few hits in before you go for your throw.

Up throw leads to the most potential damage since it propels foes directly above you after the Blaster shot follow-up. However, at very high percentages (above 100%), the opponent can shuffle out of the follow-up Blaster shot. At lower percentages, you can combo up air after the Blaster shot.

At lower percentages, down throw sets up a guaranteed combo into dash-in short hop forward air. However, up throw is generally better to use since it deals more damage up front and sets up vertical juggle-combo potential.

Aerial Attacks

Neutral Air Attack: Falco performs a midair spinning attack that strikes foes up to four times. Neutral air is an incredibly versatile attack, effective in both the neutral game and in combos. It starts up quickly, hits several times, and has relatively low landing lag. Many of your offensive sequences should revolve around using neutral air optimally. Off of a short hop, you can use neutral air as a rising attack (short-hop into immediate neutral air while next to an opponent), or as a falling attack (from midrange, short-hop toward an enemy and then neutral air at the peak of your jump, then fast-fall).

Aerials

Move	Damage
Neutral air attack	3, 2, 2, 4
Forward air attack	1x5, 4
Back air attack	13
Up air attack	9
Down air attack	13

Forward Air Attack: In midair, Falco becomes a bullet-like bird, spiraling forward, drilling his beak into the opponent several times, and knocking them back. Upon landing during the forward air animation (e.g., hitting forward air right before touching the stage), Falco extends a launching attack that knocks enemies up and away. This is essentially an instant launcher move that can punish foes attempting to meet you with an attack while you descend.

Back Air Attack: While airborne, Falco thrusts his leg back behind him for a powerful aerial kick attack. Back air is a solid attack for air-to-air and air-to-ground situations when your back is to the opponent. It has a short animation with low lag, so you can stick it out multiple times in a jump. From a short hop, it's best used early on while rising since its mid-animation landing lag can leave you exposed.

Up Air Attack: Falco performs a forward-somersault axe kick, hitting enemies behind, above, and in front of him. Up air has a short animation with low lag, allowing you to aggressively attack with it, swinging multiple times in a single jump. It also boasts wide-angle coverage, swiping from behind, above, then in front of you, so it makes for an excellent air-to-air juggle-trap attack.

Down Air Attack: Falco descends on the opponent with a spiraling drill foot stomp that spikes foes down, causing them to plummet into the ground. The initial active frames can meteor smash, spiking enemies off the stage if timed correctly. The smash effect can be used to launch grounded enemies into the air for a potential combo, but its landing lag when used this way can get you punished if it's shielded.

Special Moves

Neutral Special: Blaster: Falco quickly draws his gun and fires a Blaster shot that stops enemies in their tracks. Blaster lasers don't interact with most projectiles, and they simply bypass each other instead of dissipating. If you end up trading blows, it's usually (but not always!) a bad trade for you since your beams don't do that much damage compared to most other projectiles. Falco's shots inflict hitstun (flinching), although minor. Falco's draw and holster animations are quite long, leaving you vulnerable even if your shots connect. At point-blank range, most fighters can punish you with their neutral attack. Blaster is best saved for harassing enemies at long range, dealing some shield damage, and forcing them to attack you, or at least reposition.

Special Moves	
Move	Damage
Neutral special	3
Side special	7
Up special	2x7, 3, 2x8
Down special	Reflector object: 5
Reflected projectile	1.2x

Side Special: Falco Phantasm: After a brief windup period, Falco lunges forward at supersonic speed while leaving behind trailing phantasms. Enemies hit by the phantasms are launched into the air. If performed low to the ground, Falco suffers much less landing lag. If you perform a short hop into immediate side special, you can bypass several frames of landing lag when you land. The gap between inputting short hop and side special can be extremely small, so much so that you're barely off the ground. This applies to offstage Falco Phantasms as well. If you can accurately time and space your side special to fly back on the stage, but close to the floor, you can make it incredibly difficult for enemies to punish.

Falco Phantasm on hit usually combos into a buffered hop into back air. You can adjust your hop height depending on enemy damage. At low damage, use short hop, while at higher-damage percentages, use a jump. If you hit with phantasm and end up close to the enemy (i.e., with the tail end of your special) while they're spinning into the air, you can follow up with hop neutral air.

Up Special: Fire Bird: Falco becomes engulfed in fire, charging up a multi-hit flaming super-dash that burns foes. Fire Bird can be aimed in any direction with precision. Hold the control stick toward the desired direction while Falco charges up the attack. Like most special recovery tools, Fire Bird leaves you in a helpless airborne state after it ends, free-falling and unable to act.

Although it has an extremely long start-up time before it's active, hitting an opponent with the initial immolation along with the follow-up dash deals a massive amount of damage.

Down Special: Reflector: Falco flings his activated Reflector device out in front of him like a boomerang. The Reflector device hits foes in close range before it returns to Falco. The activated Reflector shield reflects projectiles back to the shooter, with the projectile dealing an extra 20% damage.

Reflector is an incredibly versatile attack. Not only does Falco's Reflector reflect enemy projectiles, but it also extends a boomeranging persistent hitbox out in front of him, making it a strong defensive attack against approaching foes. If you find yourself cornered at a ledge, you can protect yourself by throwing out Reflector at a rushing opponent.

Final Smash: Team Star Fox

Falco uses a targeting reticle to lock on to any opponents directly in front of him. If he acquires a target, a team of Arwings shows up and fires at will.

Fox

OVERVIEW

Fox is an extremely agile brawler with an aggressive hit-and-run playstyle, centered around snowballing combo momentum. With his incredibly fast fall speed and ground speed, he can create damage opportunities by baiting and punishing enemy attacks even while he's hopping around in the air sticking out safe aerials. As a speedy fighter, Fox's tilt and aerial attacks are especially safe and fast, allowing you to rack up damage on foes while mitigating your own exposure to attacks.

Fox Vitals	
Movement Options	
Jumps	1
Crouch Walk	No
Tether	No
Wall Jump	Yes
Wall Cling	No
Movement Ranks	
Ground Speed	A+ (5)
Air Speed	B- (32)
Falling Speed	A+ (1)
Weight	F (71-72)

Fox has two main recovery specials in Fox Illusion (side special) and Fire Fox (up special), plus a wall jump, giving him several ways to recover back onstage without sacrificing the use of his crucial double jump. His Reflector (down special) can also be used to modify his fall speed. While his fast-falling attribute is generally a positive in the neutral game, it makes Fox more susceptible to certain juggle combos. Fox can be considered a "glass cannon": he can dish out a massive amount of damage, but he can also be punished heavily if the enemy scores a combo-starting launch.

Grounded Attacks

Neutral Attacks: Fox performs an incredibly quick one-two punch combination followed by a flurry of lightning legs, finishing with a spinning heel kick that knocks enemies away. Fox's jab starts up ludicrously fast, able to essentially punish any attack within range after it's shielded.

Neutral Attacks

Move	Damage
Neutral attack 1	1.8
Neutral attack 2	1
Neutral attack 3	0.6xN, 2

Dash Attack: While dashing, Fox delivers a swift leaping kick that launches foes directly above him into the air. Dash attack is your primary whiff-punishing attack against your enemy's missed attacks. It's quick and relatively difficult to punish and leads into combos depending on how you connect with it. Thanks to Fox's incredible ground movement speed, you can play an amazingly effective bait-and-punish style, dashing around the stage luring out misplaced attacks, then punishing them with your flying kick.

Dash Attack

Move	Damage
Dash attack	6

Defensive Attacks

Move	Damage
Ledge attack	9
Wake-up attack (faceup)	7
Wake-up attack (facedown)	7

Side Tilt: Fox does a swift far-reaching side kick in front of him. It can be angled upward or downward by tilting the control stick diagonally up or down for a little more damage. Fox's side tilt is a conventional one. It starts up quickly, provides a bit of knockback on hit, and boasts solid horizontal range. It doesn't start combos, but it's good for whiff-punishing attacks from midrange.

Tilts

Move	Damage
Side tilt	6
Up tilt	6, 8
Down tilt	8

Up Tilt: Fox performs a half-cartwheel kick attack, striking foes at his rear and those in the air above him. This is one of your staple attacks and should be used often as a ground-based punish and ground-to-air anti-air, thanks to its speed and generous hitbox. Several up tilt attacks can be consecutively chained together, depending on enemy weight and percentage. Up tilt's versatility allows you to use it against grounded enemies while they're both in front of and behind you.

Down Tilt: Fox crouches down and sweeps the ground in front of him with his tail, which launches foes vertically into the air. Down tilt is an incredibly safe low attack with some combo-starting potential. When shielded, it's only punishable by the fastest moves (like neutral attacks from Zero Suit Samus and Little Mac). Down tilt is good for chipping away at enemy shields and deterring your opponent's approach. If the enemy shields your down tilt, you can likely interrupt their retaliation with another down tilt or a jab.

Side Smash: Fox pounces forward with a heavy axe kick that sends foes flying across the battlefield. Fox's side smash is one of the better smash attacks in *Super Smash Bros. Ultimate* and can be used effectively in the neutral game, thanks to its relatively quick start-up speed and solid damage. It's unsafe when shielded, so it's not an attack you want to poke with, but it's a solid whiff-punish attack against enemies within range.

Smashes

Move	Damage
Side smash	14
Up smash	16
Down smash	14

Up Smash: Fox performs a reverse-somersault kick attack with both legs extended, which launches enemies high into the air.

Fox's up smash can be used as a finisher against high-percentage enemies. It deals a lot of damage and packs a lot of knockback, especially if you hit with the frontal hitbox (the first half of the somersault deals higher damage). While trapping the enemy in the air, you can bait out an air dodge and go for an up smash finisher, or you can use up smash if you make a good read on their descending attack, since it's a solid anti-air move. Against agile foes and experienced players, Fox's smash attacks may be difficult to incorporate into your game, as they leave you exposed if you miss.

Down Smash: Fox does the splits, kicking both legs out to his sides simultaneously. Down smash hits on both sides, but isn't a particularly amazing attack in the neutral game. It's best used right after blocking an enemy's laggy attack into your back, or as a follow-up to one of your cross-up aerial attacks. Otherwise, it can be punished in most cases.

Grabs

Move	Damage
Grab attack	1
Front throw	7
Back throw	8
Up throw	8
Down throw	7

Fox reaches out and grabs a nearby foe in front of him. Fox's down throw leads into combo opportunities against low-percentage enemies. Follow down throw into dashing short or jump forward air for a combo. For an advanced combo, you can fast fall the forward air before its final kick connects, leaving the opponent in a knockdown state where they're forced to tech get-up or lie on the ground. If they miss their tech get-up, you can combo into side smash. If they tech get-up, you can punish them with a charged side smash. At higher percentages, you can go for a mix-up with a dashing reverse-rush back air. If they air-dodge the back air, you can fast-fall and punish their air dodge with a fast fall into up tilt attack.

Aerial Attacks

Neutral Air Attack: While airborne, Fox lets out a remarkably fast kick attack and leaves his legs extended for a short duration. Against grounded enemies around 10%, fast fall neutral air is a remarkable combo-starter. Follow up with your jab combo for a solid amount of damage on hit. Neutral air doesn't start knocking enemies back until much higher percentages than attacks of the same class. It's important to note that neutral air can leave you at a disadvantage on hit against enemies with very low damage percentages, so in some cases, if you connect

Aerials

Move	Damage
Neutral air attack	9
Forward air attack	1.8, 1.3, 1.8, 2.8, 4.8
Back air attack	13
Up air attack	5, 10
Down air attack	1.4x6, 3

with neutral air against a 0% opponent with a fast jab, it's likely they can beat out your follow-up jab with their own, even if you connect with your falling neutral air kick.

Forward Air Attack: Fox executes a sequence of five spinning kicks, with the final spin kick launching enemies directly above him higher into the air. Forward air suffers severe landing lag if you land while the kick sequence is still active. You can mitigate this by executing the move early on in your jump. Using fast fall forward air isn't recommended in the neutral game since it's highly punishable on shield. It deals good damage, so it makes for a good combo extension or for meeting enemies in air-to-air combat. The first four kicks in forward air cause a forced knockdown state.

Back Air Attack: Fox delivers a mighty aerial donkey kick, knocking away opponents behind him. Like most back air attacks, Fox's back air is a superb edge-guarding tool. It deals a high amount of damage and knockback and has almost zero landing lag when performed at the start of a short hop.

Up Air Attack: Fox performs a double-kick attack directly above him that knocks enemies up. This attack should strictly be used as anti-air. Its active window is short, considering it's a two-hit attack, and its hitbox is narrow. It deals solid damage and has very little air and landing lag, allowing you to go for jump up air without leaving yourself too vulnerable upon landing.

Down Air Attack: While airborne, Fox descends with a multi-hit drill kick attack. The last hit of the drill kick pops foes airborne. Down air has a highly punishing landing lag if you land before the final attack animation completes, so it's recommended that you begin this attack early on in your hops. If you can time your down air to connect with its final hit against a grounded foe, it pops up the enemy into the air with a considerable amount of hitstun. While down air has a persistently active hitbox and is effective for air-to-ground assaults, its hitbox is narrow, making you vulnerable to attacks.

Special Moves

Neutral Special: Blaster: Fox shoots rapid-fire laser beams that deal damage but don't knock opponents back (i.e., projectiles don't cause hitstun). Fox's Blaster shot is a unique projectile attack. The beams fire at high velocity but deal minor damage (the farther they travel, the less damage they do) and don't cause foes hit by them to flinch. That is, enemies can run straight through them, and while they take some damage, they aren't hindered in any way. You can rack up some damage with Blaster shots, but they basically can't set anything up. It's best used to pester offstage enemies, scoring some damage on them as they recover to a ledge.

Special Moves

Move	Damage
Neutral special	Up close: 3, Midrange : 2, Tail end: 1.4
Side special	8
Up special	1.8x7, 16
Down special	Activation: 2, Reflected projectile: 1.4x

Side Special: Fox Illusion: Fox dashes forward at supersonic speeds, damaging foes in the way, but leaving him incredibly vulnerable if they avoid or shield the attack. Hitting with the tail end of Fox Illusion can set up combo opportunities, but if your foe sniffs this out and shields it, you're going to be punished heavily. Fox Illusion is best used as an airborne recovery tool since you have much better options in the neutral game for advancing on enemies. If used toward a ledge, Fox stops at the ledge instead of flying off.

Up Special: Fire Fox: Fox engulfs himself in an inferno and then rockets into the sky. The rocket path can be altered by holding any direction on the control stick during Fox's immolation period. Like Fox Illusion, Fire Fox is difficult to use as an offensive measure and is best left as a recovery tool in most cases. It starts up slowly and leaves you in a helpless falling state. If you direct the Fire Fox rocket from the air into the ground, you bounce off, exposing yourself to a potential punish.

Down Special: Reflector: Fox activates a barrier that reflects incoming projectiles back at his attacker. Reflected projectiles deal 40% more damage. Naturally, Reflector shines against projectile-heavy fighters like Link and Samus and can totally negate certain fighters' game plans if your reactions are sharp enough, forcing your opponents into changing their approach.

One of Reflector's most important properties is its fall speed reduction; you can use Reflector midair to slow down your fall speed dramatically. Also note that Reflector damages nearby foes upon activation. The hitbox starts quickly, and is then active only briefly.

Final Smash: Team Star Fox

Fox uses a targeting reticle to lock on to any opponents right in front of him. If he acquires a target, the Star Fox team shows up and unleashes a formation attack.

Star Fox—fire at will!

Ganondorf

Ganodor Vitals	
Movement Options	
Jumps	1
Crouch Walk	No
Tether	No
Wall Jump	No
Wall Cling	No
Movement Ranks	
Ground Speed	F (73)
Air Speed	F (73-74)
Falling Speed	B- (28-33)
Weight	A- (5)

OVERVIEW

Ganondorf is a methodical bruiser, a slow heavyweight who mostly dishes out strong single hits. He's brought along a greatsword to boost his arsenal since the last time you saw him in *Super Smash Bros.* As slow as most of his attacks are, this makes them bad bets to use frequently in the neutral game. But thankfully he has a handful of somewhat quick (or at least not painfully slow) moves to rely on as a foundation. These attacks can be used to safely poke and punish foes while you wait for them to make a mistake before unleashing one of Ganondorf's many stronger moves.

His quickest moves are neutral attack, grab, neutral air, side tilt, down tilt, and dash attack. Use these for minimal risk when fishing for hits. Short-hopping neutral air in particular can help Ganondorf threaten aggressively, making him seem faster than he is. This can help bait out overcommitted reactions from enemies, which is when you can safely strike with his special grabs (Flame Choke and Dark Dive), the fast-moving down special slide kick (Wizard's Foot), or Ganondorf's fastest reliable move not already listed, down smash.

Grounded Attacks

Neutral Attacks

Move	Damage
Neutral attack	11

Dash Attack

Move	Damage
Dash attack	15

Defensive Attacks

Move	Damage
Ledge attack	10
Wake-up attack (faceup)	7
Wake-up attack (facedown)	7

Neutral Attacks: Ganondorf strikes with a tremendously powerful, electrified palm punch. He doesn't have follow-up attacks for a combo with his neutral attack; it's just the one beefy hit. It's his fastest physical attack, and out-damages most fighters' neutral attack combos with one strike, so it's a staple for him by default. It has good reach, and if shielded, it's safe from guaranteed strike counterattacks! If foes are close enough, they can snag Ganondorf by canceling shield with grab, so it's not totally safe unless well-spaced.

This move has one glaring weakness: Ganondorf is so big that neutral attack totally misses over very small or crouching fighters who are under Ganondorf's arm. Opt to grab the tiniest brawlers up close, or poke with short-hopping neutral air, fast-falling halfway through.

Dash Attack: Hunching to shift his weight, Ganondorf plows forward out of a run with a bruising shoulder check. This lasts a fair bit of time, with max launch acceleration and damage early. A hit late in active frames deals less damage and flips foes over Ganondorf's shoulder. It's not fast in general for a dash attack in *Super Smash Bros. Ultimate,* but it's almost as fast as Ganondorf's neutral attack and grab. It's technically unsafe shielded, but after an early hit, right as he juts his shoulder, Ganondorf's momentum can carry him clean through. If the opponent shields facing the shoulder, Ganondorf ends up to their back, safe from shield grabs and front-hitting pokes.

Side Tilt: Ganondorf kicks straight ahead with a heavy boot kick, dealing the most damage at his foot. As damage piles up on opponents, this kick starts to knock them back low and far. It leaves Ganondorf punishably disadvantaged when shielded, but if you aim to hit with his boot, the sweet spot, the pushback is probably enough to keep him safe. Plus, it dishes out superb shield damage for a side tilt. It's a tiny bit slower than neutral attack, but doesn't whiff over smaller fighters.

Tilts

Move	Damage
Side tilt	14
Up tilt	24
Down tilt	14

Up Tilt: This unique tilt attack is one of the most unconventional moves in the game. Ganondorf begins by holding a leg aloft for a full second, gathering strength. During this time, where wind is kicked up ahead of him, opponents are sucked in toward him, pulled from a distance of about two dashes. At the end of the second of gathering power, his foot crashes down in a powerful burning axe kick.

On hit, this deals incredibly high damage for a tilt attack, and if blocked, it shatters their shield in one blow!

Down Tilt: Ganondorf lies low and sticks one leg way out in front. This hits at the same speed as side tilt but with a lower profile for both Ganondorf and the hitbox. At medium-damage percentages and higher it launches on hit, allowing for immediate air hits or follow-up mix-ups. It's at a small disadvantage on block, like neutral attack, but only the fastest attacks can hit him back. As usual, with such long limbs, making sure you aim with the extended foot goes a long way toward preventing successful clapbacks.

Side Smash: Ganondorf comes a little more heavily armed this time, using a massive greatsword for his smash moves. For side smash, Ganondorf brings his greatsword crashing down in front of him, slashing in an arc from up-back to down-forward. Even for a heavyweight side smash, this is slow, not hitting until a half-second after initiation. On hit, the damage and KO potential are amazing, especially charged. If shielded, it does enormous shield damage. It's punishable on block, but the move's pushback might save Ganondorf.

Smashes

Move	Damage
Side smash	24-33.6
Up smash	24-33.6
Down smash	5, 15-7, 21

Up Smash: Ganondorf attacks in a rainbow arc covering first in front, then slashing above and behind. Its angle makes it appropriate for anti-air swings and low-altitude juggles, but not on short notice. It's not quite as slow as side smash, but it's below average even for a heavyweight up smash, hitting in a third of a second. Once it gets going, it has the same advantages as side smash: Ganondorf covers a huge area with the sword's hitbox, which beats out anything in the way. Again, quick defenders can block and strike back and hit Ganondorf before he can shield up, but pushback might gain enough space to protect his end lag.

Down Smash: Crouching down, Ganondorf strikes first in front with a weak hit from the pommel at the base of his greatsword, then drives the blade backward for a strong finish. Victims struck by the pommel are driven back over Ganondorf's shoulder, so the follow-up stab strikes for a two-hit combo.

This can be a good close-range punisher against laggy, missed moves and shielded attacks. It's around the same speed as Dark Dive, Flame Choke, and Wizard's Foot, but with higher damage potential (and shorter range).

As a two-sided attack it's also decent as a clear-out in free-for-alls. Getting it blocked in front of Ganondorf basically guarantees he eats something strong. Having it blocked behind him is better, but still unsafe.

Grabs

Move	Damage
Grab attack	1.6
Front throw	5, 8
Back throw	5x2
Up throw	10, 3
Down throw	7

Ganondorf's grab has decent range and pulls in with typical heavyweight speed. It's a good complement to his neutral attack, dash attack, and hopping neutral air. His throw game should include mention of Dark Dive and Flame Choke, special grabs that both lunge toward potential victims, either upward or sideways. Front and back throws can slam into other combatants near Ganondorf and his throw victim. Up throw punches them up high for potential pressure or hits as they fall. Down throw bounces them off the turf for a juggle chance at lower altitude.

Aerial Attacks

Neutral Air Attack: Ganondorf lashes out in midair with two surprisingly nimble kicks back-to-back. Each kick does max damage and knockback early, but persists a few more frames, making aim easy. The second kick hits harder and lasts longer. Together, they make the move perfect for use in both aggressive and defensive hops.

Forward Air Attack: This crescent punch in front feels like a jumping smash attack. Ganondorf swings across most forward angles with about a typical side smash's speed, hitting up-forward first before slashing his hand forward, then down-forward. Depending on timing and angle jumping into enemies, this can hit targets above early, or below late, as long as Ganondorf faces them.

Back Air Attack: This midair backhand swats directly behind Ganondorf, faster and harder-hitting than forward air, but with a shorter, less-generous active period and hitbox. This just hits around his hand, and only momentarily. Still, it's quicker, more powerful, and takes up less of his aerial time, making it better for use during repeated short hops.

Aerials

Move	Damage
Neutral air attack	7, 12
Forward air attack	18
Back air attack	18.5
Up air attack	13
Down air attack	19

Up Air Attack: A spinning aerial kick strikes 180 degrees, from forward to up to back. The forward-hitting portion is the second-fastest aerial move Ganondorf has, hitting slightly slower than neutral air's first kick. When poking at targets higher in the air, up air is the move to use.

Down Air Attack: Ganondorf's downward double stomp hits hard, spiking enemies on clean hits. It asks a lot for precision, kicking downward even slower than forward air swings, and active for only a couple frames. A clean hit is worth it, though, especially against an offstage foe underneath.

Special Moves

Neutral Special: Warlock Punch: Ganondorf crouches low, gathering dark energy for a long time before unleashing a scathing magical punch. The start lag for this special punch is even longer than for up tilt, over a full second. Ganondorf has super armor while charging the punch, though, allowing him to absorb attacks without flinching, which helps with connecting with this move.

Warlock Punch has an easier version of the common special-reversing trick. Start up Warlock Punch, then tap toward Ganondorf's back. This must be done early, but nowhere near as instantly fast as a typical special-reversal. Doing this turns the dark lord around while powering up the punch even more, delaying the eventual hit by another sixth of a second but amping up damage and knockback.

Special Moves

Move	Damage
Neutral special	30 (37 if turned)
Side special	12 ground, 15 air
Up special	1.9x4, 9
Down special	16 ground, 15 air (8 air landing)

Side Special: Flame Choke: The evil king rushes forward, covering about two dashes' worth of territory, grabbing anyone in the way to follow up with a flaming body slam. It's slow compared to the average grab but generous when you consider Ganondorf rushes forward for a fourth of a second. Damage on the slam is a bit higher air-to-air than ground-to-ground. Like with Bowser's special grab, grabbing someone and slamming them offstage isn't a winning idea. Ganondorf will be KO'd first, and (in party battles) whoever touched the throw victim before Ganondorf gets KO credit. Keep Flame Choke aimed onstage.

Up Special: Dark Dive: upward, fist glowing with dark power. If someone's in the way, he grabs them and bounces off with high damage and knockback. Think of this as the XXL version of Captain Falcon's similar up special! This is also a bit like Flame Choke aimed upward, gaining about as much altitude as Flame Choke travels laterally. In his grab game, this works together with Flame Choke and normal grabs to make him scary to be around up close. Up special is also Ganondorf's main recovery tool.

Down Special: Wizard's Foot: This heel slide burns with dark power. On the ground this is like a sliding dash attack, while in the air it's like a dive kick. Like dash attack, it can push through someone blocking the beginning, sliding Ganondorf well past them and probably messing with their attempt to punish. On the other hand, sliding to hit late in the attack is disadvantaged, but surprisingly safe, unless they're close enough to shield-grab out of blocking. Unlike dashes or many other sliding special moves, there's nothing stopping grounded Wizard's Foot from skating right off a stage edge.

Final Smash: Ganon, the Demon King

Revealing the full scope of his power, Ganondorf swells to huge size and smashes two enormous swords down before him. He then rushes forward with a super-sized tackle move. Anyone in front of Ganondorf is in serious trouble when this Final Smash is set off.

Greninja

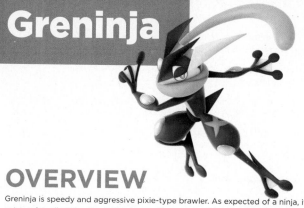

Greninja Vitals	
Movement Options	
Jumps	1
Crouch Walk	Yes
Tether	No
Wall Jump	Yes
Wall Cling	Yes
Movement Ranks	
Ground Speed	A (7)
Air Speed	A- (10)
Falling Speed	B+ (7-9)
Weight	D (55-57)

OVERVIEW

Greninja is speedy and aggressive pixie-type brawler. As expected of a ninja, it's extremely agile. It has incredibly fast walk speed, a quick dash, a high-reaching jump and double jump, and the ability to both cling to walls and jump off of them. And its standing animation is shorter than most fighters of its height as it slinks down ninja-style.

Greninja's attacks and overall toolkit reflect its ninja combat style—lightning-fast, designed for assassin-like hit-and-run tactics. With its fast ground mobility and Water Shuriken neutral special, Greninja can dominate the horizontal platform space against slower foes, dancing around them.

Greninja's fast-falling ability is astounding, making its vertical game just as fearsome as its horizontal game. By quickly traversing and attacking with high jumps, fast-falling air attacks, and fake-out fast falls into grabs, Greninja can keep its enemies on their toes. While Greninja's air attack hitboxes are lacking compared to many other fighters', Greninja makes up for it with remarkable air mobility.

Grounded Attacks

Neutral Attacks

Move	Damage
Neutral attack 1	2
Neutral attack 2	2
Neutral attack 3 (rapid)	0.5xN, 2
Neutral attack 3 (splash)	3

Dash Attack

Move	Damage
Dash attack	8

Defensive Attacks

Move	Damage
Ledge attack	9
Wake-up attack (faceup)	7
Wake-up attack (facedown)	7

Neutral Attacks: Greninja performs a swift one-two palm-attack combo, followed by either a multi-strike looping water attack or a double-palmed water burst. Neutral attack is your main counterattack option right after blocking. It starts up quickly, and the rapid-fire follow-up finisher is a combo, netting you at least 10% damage. On a hit-confirm, you generally want to finish with the rapid water-attack finisher. In the neutral game, for spacing purposes and consistency, the normal double-palmed splash attack is better.

Dash Attack: While dashing, Greninja utilizes its incredible forward movement with a sliding kick attack that launches enemies up into the air and away at a slight angle. On hit, you can follow up with a dashing short hop into up air to score a combo.

Side Tilt: Greninja performs a spinning heel kick to the enemy's midsection, blasting them away. This attack can be angled by tilting the control stick up or down during execution. The up-angled version is particularly effective for combos off hits that pop the enemy up into the air (such as neutral air). Side tilt is a strong horizontal attack with a slight range advantage to down tilt.

Tilts

Move	Damage
Side tilt	7.3
Up tilt	4.5
Down tilt	4

However, it can leave you vulnerable to aerial attacks. It's punishable on shield, but at max range you're a bit safer, although not that safe. However, its start-up is relatively fast compared to most ranged side tilts of its class.

Up Tilt: Greninja crouches low to the ground and lashes its tongue above, launching licked foes into the sky. This is your ground-to-air anti-air attack and one of your grounded combo-starters.

Its rear hitbox starts extremely early, but there's a bit of travel time as Greninja's tongue arcs upward. While the total duration of the attack is a bit lengthy compared to Greninja's neutral attack, its low-profile stance means you're less likely to be hit with descending aerial attacks, and more likely to successfully anti-air the opponent.

Down Tilt: Greninja leans down and swiftly swipes at its opponent's feet, popping them up in front. This low attack is your best ground-based poke. It boasts excellent speed, faster than some fighters' neutral attacks. On hit, it pops up enemies into a potential juggle state (although it may be difficult to combo off of it). If you can condition your opponents into a defensive grounded posture, you can harass them with down tilts and Water Shurikens, along with the occasional side tilt to pressure their shields.

Side Smash: Greninja delivers a heavy far-reaching front swing with one of its water kunai, sending foes flying away. This smash attack features respectable speed and range for how much damage it deals, making it an excellent whiff punisher. However, you need to be deliberate with its use—throwing it out haphazardly can get you in trouble, as it leaves you vulnerable from a grounded state.

Up Smash: Greninja thrusts its dual-wielded kunai above itself, proceeding into a double-sided slash and striking enemies around it. Up smash is a strong finisher, especially if you can land the initial vertical thrust that naturally chains into the rest of the strike. The outer slashes of this attack are much easier to connect with when used as an anti-air, as they cover a lot of area.

Down Smash: Slashing its sides with a kunai in each hand, Greninja clears out nearby enemies behind and in front. Down smash hits on both sides sending figthers away at a shallow, horizontal angle. You can use this to punish mistimed air dodges or as a call-out attack against ledge rolls going past you.

Smashes

Move	Damage
Side smash	14
Up smash	5, 14
Down smash	13

Greninja clasps its foe with webbed hands, trapping them in a whirlpool. Greninja's grab is very slow, worse than many heavyweight grabs. However, it has incredible reach, slightly farther than its neutral attack. Its grab attack is a water squeeze, dealing minor damage. For its up variant, Greninja tosses its victim into the sky. Greninja's forward throw is a heavy palm thrust that flings the enemy away, and its back throw is a rear spinning toss. Off of down throw, Greninja slams its victim into the ground with a fierce chop, bouncing them up into the air.

Grabs

Move	Damage
Grab attack	1
Front throw	8
Back throw	9
Up throw	5
Down throw	5

At low percentages, up throw can be naturally followed by up smash for a potential combo if the opponent fails to air-dodge. Down throw is useful at mid percentages, as it launches the opponent up enough for you to follow up. Down throw at low percentages can put you at a disadvantage, as there's hardly any hitstun, with the enemy free to act early.

Since Greninja is such an incredibly quick fighter on the ground, grabbing is one of your best tools. While you aren't rewarded with extraordinary damage off your grabs, you potentially have more chances at them because of your speed and extraordinary range.

Aerial Attacks

Neutral Air Attack: Greninja uses its ninjutsu to expel a gushing water attack all around. While you emit a hitbox all around you, neutral air can be cumbersome to use because of its high amount of lag and start-up. This attack is best used from short hops and in combination with intelligent fast-falling. It can be difficult to use effectively since its active window is quite short.

Aerials

Move	Damage
Neutral air attack	11
Forward air attack	14
Back air attack	3.0, 2.5, 6
Up air attack	1.3x5, 3
Down air attack	8

Forward Air Attack: With a reverse grip on one of its water kunai, Greninja performs a midair slash in front of it that launches foes. Forward air is similar to forward smash. It's a good KO tool with considerable range, although its start-up and active window are lacking compared to other fighters. It requires accurate timing, spacing, and technique to use optimally.

Back Air Attack: Greninja turns around and sends out three lightning-fast back kicks. Back air is an incredibly fast-starting aerial attack, effective for edge-guarding situations and in combos with great KO potential. Although it requires accurate timing to pull off (as well as having the enemy at least at medium-damage percentage), the first hit of back air against grounded enemies causes a pop-up effect from which you can combo into up air, finishing with up air.

Up Air Attack: Greninja flips upside down in the air and becomes a living corkscrew, delivering a multi-hit kick attack and ensnaring foes briefly before launching them skyward. This is your primary air-to-air anti-air and juggle-combo tool. Its multi-hit property allows you to use it to drag low-altitude foes to the ground for unique combos and setups.

Down Air Attack: Down air is a "stall-then-fall" attack. After a brief pause while airborne, Greninja transitions into an aerodynamic ninja stance and quickly descends, damaging and bouncing off the first foe it lands on. Otherwise, regardless of altitude, Greninja continues descending until landing on a platform. On a direct hit, it meteor smashes, kicking its victim to their doom if they're over a ledge. However, this attack is risky since it has a high amount of landing lag.

Special Moves

Neutral Special: Water Shuriken: Greninja cups its webbed palms together and conjures a Water Shuriken before releasing this incredibly potent projectile straight ahead. Charging increases its power, and at max charge it passes through foes, potentially hitting multiple enemies. It has a fast travel speed, which can be a positive and a negative attribute. It's difficult to react to, but unfortunately, you can't use it as a persistent on-screen threat that covers your offense.

Special Moves	
Move	**Damage**
Neutral special	3 (13 max)
Side special	10
Up special	—
Down special	11

Side Special: Shadow Sneak: Greninja disappears behind a mini tornado and reappears behind a cloud to deliver a rising kick attack. If Greninja reappears behind an enemy, it delivers a rear thrusting kick instead. With sharp reactions or accurate predictions, you can use Shadow Sneak as a strong finisher attack, essentially to warp through your opponent's strikes and kick them offstage. Shadow Sneak doubles as a recovery tool since it doesn't force you into a helpless free-fall state.

Up Special: Hydro Pump: Greninja propels itself with a powerful jet stream emanating from its hands. This recovery special has two notable properties: it can be aimed in any direction after its initial execution, and in a gravity-defying fashion, it can be abruptly redirected around its halfway point. During flight, Greninja cannot pass through enemies and instead pushes them around. With practice, you can use this effect in your edge-guarding arsenal to interfere with the opponent's air mobility, potentially scoring a KO.

Down Special: Substitute: Greninja transitions into a parry stance. Upon absorbing an attack, it disappears into the shadows, quickly reappearing with a flying kick attack directed toward the enemy.

Once you absorb an enemy attack, you can direct Greninja's flying kick in various ways by using the control stick. Angle the attack of your flying kick into the air by using up-left, up, and up-right. Appear a few meters in front and perform a rear flying kick by holding back. Holding forward (or no input), you simply reappear and perform a forward flying kick. Holding down-left, you reappear from above and to the right with a flying kick directed down-left. Holding down-right, you reappear from above and to the left with a flying kick directed down-right.

Final Smash: Secret Ninja Attack

In Greninja's Final Smash, it uses Mat Block to flip opponents into the air. It then slices them repeatedly before smacking them back down to the ground. The initial Mat Black doesn't have much range, so make use of Greninja's speed to get in close to opponents.

Ice Climbers

OVERVIEW

Ice Climbers are a unique pair of fighters. While Popo and Nana are both controlled by a single player simultaneously, they're counted as two separate fighters. Each one has its own attacks and hurtboxes, so just because one is being hit doesn't mean both are. Your Ice Climbers don't always combo with each other, especially since Popo leads in front of Nana in terms of spacing. Nevertheless, their attacks usually do combo with each other, so they dish out a hefty amount of pain with their doubled-up hammerblows.

Ice Climbers excel in ground combat. Most of their ground-to-ground attacks are safe to throw out, allowing you to chain several together to pressure shielding foes. Side tilt and down tilt are incredible pokes, especially when spaced out, as the Ice Climbers' hammer strikes extend hitboxes without exposing their limbs to enemy attacks. They also have reliable and versatile aerial attacks in neutral air and forward air. While having two separate fighters is amazingly strong, Popo is weak on his own. If your climbers become separated, your specials become much weaker and you lose access to your recovery special, Belay. If Nana is knocked off the stage into a blast zone, she doesn't return until Popo is also eliminated. If your opponent successfully knocks out Nana, a solo Popo is one of the weakest fighters in the game, if not *the* weakest!

Ice Climbers Vitals

Movement Options	
Jumps	1
Crouch Walk	No
Tether	No
Wall Jump	No
Wall Cling	No

Movement Ranks	
Ground Speed	D- (61)
Air Speed	F (73-74)
Falling Speed	D (67-69)
Weight	C (44-47)

Grounded Attacks

Neutral Attacks: Popo and Nana swing their hammers in front of them, knocking away nearby foes. Neutral attack is the Ice Climbers' fastest ground-based attack. Both swings (neutral attacks 1 and 2) are relatively safe when shielded, only punishable by fast out-of-shield jabs, making the Ice Climbers' jab one of the best neutral attacks in the game. If both Popo and Nana hit both of their attacks (four hits), they deal great damage and knock the opponent up and into the air. The main drawback is the lengthy overall animation time (almost as long as some tilt attacks), so it can leave you vulnerable to whiff-punish attacks if you're not careful.

Dash Attack: While running, Popo and Nana perform mighty hammer swings as they lunge toward the enemy, launching their foe vertically into the sky. Although the Ice Climbers can be punished if their dash attacks are shielded, it's not particularly easy for the enemy to do so, as your duo passes through the enemy's body, forcing your foe to turn around before attacking. On hit, dash attack launches the enemy straight up into the air, giving you ample time to mount a juggle-trap offense.

Side Tilt: The Ice Climbers both unleash a powerful horizontal hammer swing that knocks away enemies. Side tilt is an excellent ground-based attack that's safe when shielded (even without Nana) and fast enough to deter enemy aggression. It inflicts considerable damage and knockback, giving you enough space to set up an Ice Shot follow-up.

Neutral Attacks

Move	Damage (Popo / Nana)
Neutral attack 1	2/1.5
Neutral attack 2	3.5/2.6

Dash Attack

Move	Damage (Popo / Nana)
Dash attack	6/4.5

Defensive Attacks

Move	Damage (Popo / Nana)
Ledge attack	8/6
Wake-up attack	7/5.2

Tilts

Move	Damage (Popo / Nana)
Side tilt	9/6.8
Up tilt	0.8x6/0.6x6, 4/3
Down tilt	6/4.5

Up Tilt: Popo and Nana twirl their hammers above them, striking foes several times before popping the enemy vertically into the air. Up tilt should strictly be used as a persistent anti-air attack against descending foes. If you miss with it, you're left exposed to punish attacks. While the Ice Climbers extend a large hit effect above them with their hammers, they also have small hitboxes surrounding their bodies, so opponents who dash into you can potentially be hit (although they have to dash all the way in). Overall, up tilt is incredibly unreliable as a ground-to-ground attack, since it's easily punishable when shielded.

Down Tilt: Popo and Nana crouch down and sweep at the enemy's legs, knocking away their foe. Like side tilt, down tilt is remarkably safe when shielded. Down tilt extends a sizable hitbox while at the same time limiting your vulnerability as both of your Ice Climbers crouch low to the ground. You can throw out down tilt as a ground-to-ground poke to check the opponent's ground aggression.

Side Smash: The Ice Climbers raise their hammers into the air and deliver a heavy smashing attack that blasts foes far away. While visually, the Ice Climbers swing their hammers down from above and downward, the hit effect only covers a small horizontal range in front of them (so it's not a viable anti-air). Side smash can punish recovering opponents just as they rush to grab a stage ledge, if timed and spaced properly (such as after knocking them off the stage with down tilt). It's also a powerful finishing move against foes near the left and right blast zones thanks to its high knockback power.

Smashes

Move	Damage (Popo / Nana)
Side smash	12/9
Up smash	11/8.2
Down smash	13/9.8

Up Smash: Popo and Nana perform an upward hammer swing, starting at their front and arcing above and behind, launching foes they hit into the sky. Up smash is a powerful anti-air with a wide arc that hits in front and behind the Ice Climbers. You can use it against short-hopping foes or as a surprise reactionary attack against aggressive opponents dashing into you. Naturally, it's largely punishable when shielded.

Down Smash: Popo sweeps the front with his hammer while Nana immediately follows his lead with a rear sweep. Foes hit by the attack are knocked up and away. Unlike most clear-out attacks that sweep forward, then backward sequentially, the Ice Climbers' down smash attack covers the front and the rear almost instantly as Nana quickly follows Popo's lead with her rear sweep.

Popo reaches out and grabs a nearby opponent. Popo's grab has moderate range, but is slow to start. Popo's front throw is a simple hammer swing that knocks the enemy away, while his back throw is an over-the-shoulder backward throw into the air. Up throw is an upward hammer swing that launches the enemy vertically into the air.

Down throw leads into a potential guaranteed combo with up air or neutral air against low-percentage foes.

While Popo performs a grab attack or throw, control of Nana is deactivated, disallowing any kind of desynchronization tricks.

Grabs

Move	Damage
Grab attack	1
Front throw	8
Back throw	6
Up throw	8
Down throw	6

Aerial Attacks

Neutral Air Attack: While midair, both Popo and Nana perform aerial spin attacks that hit in front of and behind them. Neutral air is a remarkably versatile attack that can be used in combos, the neutral game, and during your advantage state. It has low landing lag, so you can throw it out as a safe jumping attack to set up a dash attack combo.

Aerials

Move	Damage (Popo / Nana)
Neutral air attack	7/5.2
Forward air attack	12/9
Back air attack	10/7.5
Up air attack	9/6.8
Down air attack	8/6

Forward Air Attack: The Ice Climbers deliver a forward-somersault hammer attack in front of them. Before Nana's downward swing, she extends a meteor smashing effect in front of her. Forward air has much more landing lag than neutral air, but deals much more damage, making it better for finishing off enemies, especially while they're offstage near the side blast zones.

Back Air Attack: Popo and Nana turn around in midair with a rear-swinging hammer attack. Back air is similar to neutral air in its landing lag while boasting lower air lag and higher damage. You can use low-altitude air-to-ground back air (off of short hop, for instance) in your offense. Back air starts up relatively quickly, and thanks to its low air lag, you can swing multiple times in a single hop. This makes it one of your best edge-guarding attacks against midair opponents offstage.

Up Air Attack: Popo and Nana perform an upward wide-angle hammer swing that launches foes up higher into the air. The beginning and tail end of this attack (behind the Ice Climber) can hit taller fighters standing on the ground, with the tail end having a slightly higher chance of doing so.

Down Air Attack: While soaring through the air, the Ice Climbers almost instantaneously plummet to the ground with their hammerheads extended below them. Enemies crushed by the weight of their hammers are launched into the air. Down air has a unique landing-lag animation. Instead of being grounded for a set amount of time, Popo and Nana bounce off the ground and slightly into the air. During this bounce, they're vulnerable to attacks, although they're considered airborne. It's unsafe to most shield-jab reprisals.

Special Moves

Neutral Special: Ice Shot: Popo and Nana summon ice chunks in front of them before whacking them forward with their hammers, damaging foes they slide into. Ice chunks have special properties: they can bounce off walls and damage the Ice Climbers themselves. Ice chunks can be hit and "reflected" by normal enemy attacks, potentially hitting Popo and Nana during the ice's return path. While Ice Shot can be reflected by enemies, it's a useful tool in your arsenal since it forces a reaction from the opponent.

Special Moves	
Move	Damage (Popo / Nana)
Neutral special	3.5/3.5
Side special	2.2x4/2.2x4, 8
Up special	0/16
Down special	1.8(1.0)x9/1.8(1.0)x9

Side Special: Squall Hammer: The Ice Climbers become a single unit and deliver a high-speed spinning hammer attack, striking both in front and behind several times before launching nearby enemies up into the air. While spinning, the duo can move left and right with control stick input. Adding Special inputs boosts the Ice Climbers up into the air slightly, making Squall Hammer useful as a recovery option.

If Squall Hammer is executed while Nana is defeated, or if the climbers are "desynced" (that is, if they're apart or if one of the other climbers is currently performing a certain move), Popo and Nana perform a solo Squall Hammer. The final hit of their solo Squall Hammer packs much less punch, and the attack deals less damage overall.

Up Special: Belay: With the duo connected by a safety rope, Popo picks up Nana and throws her high into the air. When Nana reaches the apex of the launch, she pulls Popo up with her. During Nana's speedy ascent, she launches foes who collide with her. Belay is unique in that it's only effective if Nana is near Popo. If she's been knocked off the stage, or if the two have been desynced, Popo goes into his throw animation with no effect. As a recovery special, Belay can be used to grab on to a ledge from very low altitudes.

Down Special: Blizzard: Both Ice Climbers fire a flurry of ice from their palms. Enemies in close range become frozen in a large ice formation, unable to act. Blizzard's freeze effect activates once a sufficient amount of damage is inflicted with it at close range. Once frozen, further Blizzard hits extend its freeze duration. Blizzard is one of Ice Climbers' best attacks when they're synced. It's relatively safe when shielded, and if all of their projectiles hit, the enemy is frozen helplessly. The main downside is that it has quite a bit of start-up time.

Final Smash: Iceberg

This Final Smash causes a huge Iceberg to emerge in the center of the stage. Opponents who touch it take damage upon each contact. You can control the Iceberg with the left and right inputs. You also move as normal, so be wary of self-destructing.

Ike

Ike Vitals

Movement Options	
Jumps	1
Crouch Walk	No
Tether	No
Wall Jump	No
Wall Cling	No

Movement Ranks	
Ground Speed	D- (64)
Air Speed	B (26-28)
Falling Speed	B- (28-33)
Weight	B+ (11-15)

OVERVIEW

Ike is a no-nonsense heavyweight brawler, boasting impressive reach with his powerful Ragnell Sword. Like most sword-wielding fighters, his extended sword cannot be struck by opposing attacks, giving him priority over fighters using vulnerable limbs to attack. Ike's sword hitboxes are even better than average for a swordfighter, though slower. Ike's combat style favors simplicity over complexity, so committing to deliberate attacks is the name of the game. Ike makes for an excellent fighter to learn if your goal is to improve on the basics of play, and Ike's playstyle doesn't demand complex techniques to fight effectively.

Grounded Attacks

Neutral Attacks: Ike sticks out a jab to the midsection, followed by a straight leg kick. He finishes this three-hit sequence with a heavy overhead sword swing, knocking away foes. Neutral attack is mainly used as your quick out-of-shield option for punishing your opponent's mistakes. However, as a poke, you can set up traps if you can read your foe's retaliation habits. For instance, a common response after shielding an attack is to shield-grab. You can go for neutral attack, then a slightly delayed neutral attack 2, beating out the opponent's grab attempt and rewarding yourself with a knockdown combo you can capitalize on.

Dash Attack: Ike performs a running uppercut swing with an incredible amount of weight and might behind it, launching foes up and away into the air. Ike's dash attack is a high-impact, high-risk maneuver. It inflicts a considerable amount of shield-stun when shielded, so it's usually only punishable by neutral attacks and extremely quick tilt attacks. However, whiffing it leaves you exposed to reprisal.

Side Tilt: Ike delivers a horizontal slash directly in front of him, knocking back foes. This ground attack is a good middle-of-the-road option for punishing certain recoveries and laggy attacks. You can also use it to punish maneuvers like on-the-spot dodges and ledge rolls without having to commit to your slower smash attacks.

Up Tilt: Ike raises Ragnell over his head and performs a short hop into the air with blade extended, defending himself from aerial aggression. Ike's up tilt is a remarkably powerful anti-air attack, thanks to its persistent hitbox as he raises Ragnell. While a true combo follow-up after hitting with up tilt is rare, up tilt puts the enemy into a prime juggle-trap situation, giving you a strong advantage state, as you can begin mixing up your follow-up anti-air attacks and forcing your opponent to double-jump or air-dodge.

Neutral Attacks

Move	Damage
Neutral attack 1	2.5
Neutral attack 2	2.5
Neutral attack 3	5

Dash Attack

Move	Damage
Dash attack	14

Defensive Attacks

Move	Damage
Ledge attack	10
Wake-up attack	7

Tilts

Move	Damage	Note
Side tilt	13.5	Launches foe away.
Up tilt	12	Launches foe directly above. Deals more damage during first half.
Down tilt	8	Launches foe up and away.

Down Tilt: Ike crouches low and performs a swift sweeping attack with his sword. Down tilt is a low-profile attack with excellent combo-starting potential, as it pops up foes on hit. It has very little lag and is best used to condition and test your opponent's reactions. If you connect with down tilt, keep an eye on how your foe responds while in their disadvantage state, and adjust your game plan accordingly.

If your attack is shielded from range, you can follow up with more aggression or another down tilt poke, since it's largely safe on shield.

Side Smash: With a two-handed grip and considerable windup, Ike smashes Ragnell down over his head, obliterating foes in front of him. You're not likely to hit with this attack without setting it up. The most likely scenario where you can KO an enemy with Ike's side smash is if you can make a hard read on an opponent's defensive reaction, such as off of an air dodge after a down tilt pop-up. You can also go for a predictive side smash attempt on an opponent's ledge roll or ledge climb.

Smashes

Move	Damage
Side smash	22
Up smash	17
Down smash	16

Up Smash: Ike launches an incredibly powerful upward slash over his head, blasting away nearby foes. While it's a considerably slow-starting attack, the arc of this smash covers Ike's front, head, and rear. However, it leaves him highly vulnerable if shielded or avoided.

Down Smash: Ike crouches down and performs two heavy sweeping attacks with Ragnell: one in front, followed by one behind. The rear hit deals more damage and launches farther than the frontal hitbox. Down smash is mainly used to clear out multiple foes (in free-for-all and team play, for instance). Otherwise, it's extremely unsafe to use in a standard neutral game.

Ike grabs his foe with his left hand. Ike grabs with okay speed, not the quickest but not heavyweight speed either, with moderate reach. Forward and back throws are mainly used for tech setups, as they force the opponent to respond with a tech get-up option, from which you have a strong advantage state. For enemies at roughly medium-damage percentages, up throw into forward air is a true combo.

At higher percentages, it's no longer guaranteed, but turns into mix-up and juggle-combo opportunities instead.

Grabs

Move	Damage
Grab attack	1.6
Front throw	7.5
Back throw	7
Up throw	7.5
Down throw	7.5

While up throw can lead into a true combo follow-up, down throw is your best option for dishing out damage in most situations. The timing for linking a follow-up up air or forward air is a bit more lenient. However, the direct vertical launching effect of up air makes it better for finishing off enemies near the top blast zone.

Aerial Attacks

Neutral Air Attack: Ike leaps into the air and performs a spinning sword attack, covering almost every angle around him with Ragnell's impressive reach. This is your main aerial poking and spacing attack for both air-to-ground and air-to-air neutral game. While forward air fulfills a similar role due to its similar hitbox coverage, neutral air has an advantage when it comes to starting combos, as it pops up enemies for potential combo follow-ups off of most grounded hits.

Aerials

Move	Damage
Neutral air attack	7.5
Forward air attack	11.5
Back air attack	14
Up air attack	11
Down air attack	15

Like most attacks, the height and time at which you connect with the attack largely determine your advantage, and this is particularly true of Ike's aerial attacks, as they have considerable landing lag.

Forward Air Attack: While wielding Ragnell with both hands, Ike delivers a heavy downward swing as he plummets down from the air. Like neutral air, forward air covers an incredibly large area. Ike begins the swing above him and covers his entire front before ending the swing near his feet. Unlike neutral air, forward air doesn't extend a rear hitbox, but can be easier to use as a fast fall attack directly onto an enemy's head. Because its knockback effect is a pronounced horizontal one, it's not a great combo-starter.

However, it's much better than neutral air for KO'ing high-percentage opponents, especially near ledges.

Back Air Attack: While airborne, Ike quickly turns and lashes out with his sword, striking enemies behind him and knocking them down. This is Ike's fastest-starting aerial attack by a mile. What it lacks in range, it makes up for in speed.

Back air is one of your main edge-guarding attacks, both as an air-to-air to deal with airborne recovering opponents and as an anti-ledge-hanging tool, for punishing ledge-rolling and ledge-climbing.

Up Air Attack: While airborne, Ike slashes up into the air in a wide-angle crescent arc, clearing out enemies above him. Up air is a quintessential anti-air attack with a superb hitbox-to-hurtbox ratio. Up air's attack window isn't as wide as neutral air's, but boasts remarkable vertical and horizontal reach. Naturally, up air and up tilt are your primary anti-airs for combo-juggling purposes.

Down Air Attack: Ike descends upon his foe with a weighty downward thrust, smashing them down. Down air is a relatively slow downthrust-type attack, with a meteor smash effect when connecting with the tip. It's mainly used for finishing off foes over a pit or as a follow-up to knocking down an enemy.

Special Moves

Neutral Special: Eruption: Ike plunges his sword into the ground, triggering a fiery burst. The longer you charge this special, the more pillars you unleash (up to a maximum of three). At maximum charge, Ike deals 10% damage to himself. At around halfway charge, Eruption causes a vertical launching effect, while at max charge, it causes a horizontal knockback effect. The vertical launching effect generally has a higher chance of knocking out enemies, depending on the situation. Eruption is an effective edge-guarding attack since its reach extends above and below, as well as in front and behind, making it great for punishing recovering challengers with expert timing, just as they grasp the ledge.

Special Moves	
Move	Damage
Neutral special	10 (35 max charge)
Side special	6 (13 max charge)
Up special	6, 1, 1, 3, 6
Down special	1.2x damage

Side Special: Quick Draw: Ike lunges forward and slashes at foes in his path. Quick Draw is an attack that doubles as a recovery option. It has a unique mechanic: if you successfully hit an enemy with it while airborne, you don't suffer from a helpless free-fall. Otherwise, if you whiff Quick Draw, your trajectory and descent are locked and you have to land on a platform to survive.

Up Special: Aether: Ike throws his sword high, launching the enemy into the air, then leaps to catch his blade and completes the sequence by crashing down on his victim. Ike is briefly invulnerable (has super armor) to flinching before the active attack portion. The first few frames of its descending hitbox cause meteor smash.

It's important to note that Aether allows for only a slight horizontal trajectory drift, so you have to train your spacing with this recovery attack, particularly when it comes to aggressive edge-guarding. It's also punishable in most cases, so use it sparingly.

Down Special: Counter: Ike blocks an enemy's attack and then returns the favor with a powerful reprisal blow. The stronger the blocked attack, the more vicious his reprisal.

As with most parry and reprisal attacks, Counter is a high-risk maneuver, and its use is advised against in most situations. But if you have a good read on your opponent's attack patterns, you can totally demoralize them with repeated Counters.

Final Smash: Great Aether

Ike knocks his foes into the air and then strikes them repeatedly. Finally, he slams them down to the ground with a single powerful blow. The first strike lacks reach, but it can hit multiple opponents.

Incineroar

OVERVIEW

This Fire- and Dark-type Pokémon is the final evolution of Litten (after Torracat), and a newcomer in the *Super Smash Bros. Ultimate* brawl. Incineroar's fighting style is wrestling, so it favors high-commitment, high-reward attacks. All of its specials basically take a full second, and it poses after successful smash attacks and neutral attack combos, adding a little extra lag. On the ground, the most reliable and least risky moves are neutral attack and down tilt, with dash attacks joining the list if aimed to hit early at defenders' front sides.

But at least it's a high-flying wrestler. Incineroar is a relatively quick heavyweight, always ready to spring the surprise of the Alolan Whip special grab, and with surprisingly fast air attacks to back it up. This gives the feline an agile reactionary air game to bolster devastating but risky ground moves. Every air move is useful and multipurpose, but look to neutral air for its long hitting period and fast fall synergy, back air for its use as a dominating short-hopping poke, and up air for its combo potential.

Incineroar Vitals

Movement Options	
Jumps	1
Crouch Walk	No
Tether	No
Wall Jump	No
Wall Cling	No
Movement Ranks	
Ground Speed	F- (76)
Air Speed	D (70)
Falling Speed	B (19)
Weight	A- (6-7)

Grounded Attacks

Neutral Attacks

Move	Damage
Neutral attack 1	2.5
Neutral attack 2	2.8
Neutral attack 3	4.7

Dash Attack

Move	Damage
Dash attack	13

Defensive Attacks

Move	Damage
Ledge attack	10
Wake-up attack	7

Neutral Attacks: Incineroar attacks with a backhand chop to start, then follows with a forward-jutting knee, before finishing off the combo with an elbow uppercut. The initial chop has decent speed, nothing like the quickest fighters but not unusually slow. It's quick enough to use defensively after blocking moderately laggy attacks, hitting them right back. It's not the best proactive offensive option, though, since every part of the combo is punishable if blocked. It's best to save for whiff-punishing, catching people just after rolls or rising from the ledge, or doing your own out-of-shield retorts.

If the full combo is completed, the enemy is knocked away and Incineroar takes a moment to pose, psyched out. This gives it a little extra lag at the end, so watch out in free-for-alls.

Dash Attack: From a run, Incineroar leaps off the ground to cover about a dash's distance of territory with a rising knee strike. This blasts victims away, with more knockback if you strike early in the attack. Although being blocked here puts Incineroar at a disadvantage, hitting early with the attack may make Incineroar push through to the defender's other side with later frames. Incineroar's technically punishable after a blocked dash attack, but it's much harder for most foes to punish if they're facing away (exceptions of course for something like Fox using up tilt).

Side Tilt: Incineroar reaches forward with a midsection stab using the claws on its open hand. This hits about half as fast as neutral attack's chop, but with a bit more reach. It also does more damage in one hit than the entire neutral attack combo. It can be angled slightly, most useful for flicking foes away at stage edges just as they lunge for a handhold. Side tilt technically leaves Incineroar at a slight disadvantage when shielded, but better off than most other attacks, and perhaps totally safe from the edge of its reach, thanks to pushback.

Up Tilt: Taking a small upward hop for momentum, Incineroar swings its burly head in an arc from up-back to straight forward, covering upward directions along the way. The initial rearing-back frame hits quick, one of the fastest moves in the toolkit, as long as you're aiming backward. This is important to Incineroar, thanks to backward-facing up tilt's speed and combo potential.

Tilts

Move	Damage
Side tilt	13
Up tilt	9
Down tilt	9

Down Tilt: Planting a hand for balance, Incineroar lies flat and swings its whole body into a sweeping forward kick. Priority is increased with the kicking foot turning intangible during hitting frames. On contact, victims are popped off their feet in front of the Pokémon. At low percentages, you can combo right away by turning and using backward-aimed up tilt, before jumping to pursue for more.

Side Smash: Incineroar squats, then throws itself into a bruising rising kick, lagging afterward as it falls back to the turf. This is a swinging-for-the-fences kind of moves, hitting hard with lots of knockback and KO potential, but with lots of end lag. Incineroar flops on its back afterward, incredibly open. It's not advised to used this on a whim in the neutral game, but may be worth keeping in mind when you've used Revenge to deflect a move or three, when the risk/reward starts to really favor Incineroar...

Up Smash: Clasping its hands together, Incineroar swings a double-hammer-fisted attack in an incomplete circle, striking first directly in front, then rotating to hit up and up-back on the follow-through. Up tilt covers the same angles with less risk (and less range). But uncharged up smash hits in front of Incineroar just slightly slower than front-facing up tilt does, while dishing out more damage. If up smash is shielded, Incineroar is in danger no matter which side, but at least has high shield-shattering potential.

Smashes

Move	Damage
Side smash	20-28
Up smash	17-23.8
Down smash	16-22.4

Down Smash: Springing almost instantly into a canned short hop, Incineroar crashes down with all limbs splayed, dealing a flopping hit that covers both sides at once. The wrestler arrives at short hop height right away, then hangs, flopping down almost a third of a second later. Because of Incineroar's movement, it's possible for this attack's start-up period to dodge low-aimed hits, like sliding attacks or up air swings from underneath platforms.

When Incineroar reaches out to pull in a shielding or inattentive foe, it does so with standard heavyweight grab speed. The reach is maybe a little smaller than you'd expect standing still or during a forward run, but grab range increases a lot during a pivot. Throws make good candidates for Revenge damage conversion.

Front and back throws can hit other foes nearby (front throw on all sides, back throw only to the back) while Incineroar tosses the target. Back throw is the highest raw damage, best for KO attempts or easy Revenge conversion. Up throw bounces foes straight up off the ground, where you can harass them on their way down. Down throw bounces them lower in front, in juggle position.

Grabs

Move	Damage
Grab attack	1.6
Front throw	10
Back throw	12
Up throw	10
Down throw	9

Aerial Attacks

Neutral Air Attack: Almost like a weaker version of down smash, Incineroar stretches itself out and lets gravity do the rest with this body flop. This is the fastest air move available, with decent speed used out of a short hop too. An early hit deals the most damage and knockback, but the flop lasts a long time as an active hit, a third of a second. This makes it great both for jumping right into targets, and for starting neutral attack above them, then fast-falling down. The landing-lag penalty for this air attack is surprisingly low, like all Incineroar's airs.

Forward Air Attack: Incineroar kicks both legs out in front for a powerful dropkick, with surprisingly little ending air and landing lag for a move of its kind. It's almost like a heftier version of Mario's back air, a decent jump kick for warding, walling, and going air-to-air. You can stall with two per jumping period as long as you double-jump to full height first.

Back Air Attack: Incineroar strikes with a quick, spinning back kick aimed directly behind. This hits faster, with a longer-lasting hitbox, than forward air, while always knocking victims away. It's a fantastic aerial poking move during manual backward hops (tapping the Jump button ever so briefly, then doing back air later in the hop), for reverse-air-rushing tactics (running, pivoting, and backward-hopping), and for walling with repeated air attacks to see if anyone is willing to just run into them for you (many people will be!).

Up Air Attack: Flipping backward, Incineroar slashes across all upward directions with a one-legged wheel kick. For a heavyweight this is very quick, allowing Incineroar to combo up air, double jump, up air on airborne targets. The speed is decent and the end lag is low, even landing on the wrestler's head. It's primarily aimed upward, but if you can hit low or grounded foes just before landing, they're left in position for you to juggle them right away.

Down Air Attack: Incineroar stomps downward in midair with both legs, potentially meteor smashing victims on a clean hit. The initial leg thrust deals the most damage, but the attack persists as a hit a bit longer, making this easier to aim than many similar short-lived spiking attacks. This also increases its potential for overlapping with enemy hands just when they grip a ledge, usually after using an up special to lunge upward.

Aerials

Move	Damage
Neutral air attack	13
Forward air attack	13
Back air attack	13
Up air attack	8
Down air attack	15

Special Moves

Neutral Special: Darkest Lariat: Whether in the air or on the ground, Incineroar whirls into a long-lasting claw spin that strikes both sides. This is one of the fastest attacks in the toolkit here, matching neutral attack for speed. During the spins, Incineroar can be steered left or right with the control stick, whether to move toward targets or press repeatedly against someone shielding, which forces them to react or have their shield chipped away. As for the hitting period, this is one of the longest-lasting moves possessed by anyone, a threat for almost a full second. For the ground version only, after the brief windup period, during the first few hitting frames as arms begin spinning, Incineroar is fully invincible, head to toe!

Special Moves	
Move	Damage
Neutral special	16 front, 12 back
Side special	20/12/4
Up special	3, 3.5, 9
Down special	2.4

Side Special: Alolan Whip: Incineroar rushes forward with a special grab, covering more than two dashes' worth of ground. The grab speed isn't fast, slower than the most sluggish tether grabs, but the long grabbing window and distance traveled more than make up for this. If it connects with an opponent, they're sent stumbling toward temporary ropes and turnbuckles, summoned from thin air to honor Incineroar's wrestling spirit. The opponent bounces off the ropes and helplessly stumbles back to the wrestling feline.

The timing of your next input determines which attack Incineroar nails them with. An early input leads to a high-launching throw catapulting the victim well past double jump height while inflicting 12% base damage. With no input, or with a late input, Incineroar doesn't act in time and the target bounces off, dealing minor damage (4%) to both fighters. For the most brutal finish, input either the Special or Attack buttons *right before* the foe returns to Incineroar, after bouncing off the ropes. Done correctly, Incineroar nails them with a ferocious clothesline, which sends them flying far backward, 20% damage added to their total!

Up Special: Cross Chop: The fiery feline rockets straight upward, almost to the height of a full double jump, before plunging diagonally down-forward. Both portions are attacks, the way up and the way down, and opponents caught by the rising portion are also hit by the diving finish. Like Darkest Lariat, Cross Chop commits Incineroar for an unusual amount of time, almost a full second (though slightly shorter than Darkest Lariat).

Down Special: Revenge: Input down special, and Incineroar flashes with light while jutting out its muscular chest, going for an almost instant defensive countermeasure. Incineroar can be interrupted during the first couple frames of this move, before the counter period begins. Once the counter is active, any incoming hit triggers Revenge, a counterattack roar that powers up Incineroar while knocking attackers away. Once the counter is active, after the brief start-up, it lasts for a third of a second, so it's fairly lenient for parrying incoming threats.

Incineroar still takes damage from the hit, though it's reduced to 37.5% of normal. Enemies are knocked clear, though they only take a little damage: 2.4%, barely anything. So what's the point? The point is that a successful Revenge counterattack grants a damage bonus to Incineroar's next connected attack. The damage buff remains on Incineroar until one of four conditions is fulfilled:

- 60 seconds elapse from the successful Revenge activation.
- Incineroar is KO'd.
- Incineroar hits an enemy, dealing bonus damage.
- Incineroar is knocked out of control by an enemy (not simply made to flinch, the Pokémon must be sent tumbling by a powerful attack or throw).

Final Smash: Max Malicious Moonsault

Imbued with Final Smash power, the strongest of the Pokémon fighters (sorry, Charizard) rushes horizontally to grab the first opponent in the way. The unlucky victim is temporarily whisked to Incineroar's home ring, to be subjected to the meanest wrestling moves Incineroar can muster. Other foes nearby might take damage from the ending slam, but this is primarily focused on one target, so aim carefully.

Inkling

OVERVIEW

The squid kids swim into the *Super Smash Bros. Ultimate* scene, outfitted with unique mechanics and weapons interesting both for party play and one-on-one matches. Inklings have access to many of their ink-filled soaker weapons from the *Splatoon* shooter series. These tools require ink, shown as a gauge by Inkling's portrait. Many attacks deplete ink with use, but ink can be quickly refilled anytime by holding down the Shield+Special buttons together. Inkling sinks low into a puddle and greedily sops up enough ink for more full-powered moves. Not only that, but ink-soaked moves get ink on foes too, which reduces their defense! The most important ink-based moves include side smash, front throw, Splat Roller, and Splat Bomb.

This doesn't mean Inkling is helpless without ink moves, far from it. Neutral attack, down tilt, dash attack, and neutral air are all quick and reliable, and smash attacks fulfill their purpose even if they're weaker without ink. Most importantly, Super Jump (up special) works with or without ink, making it hard to KO Inkling without a launch clear to a blast zone.

Inkling Vitals	
Movement Options	
Jumps	1
Crouch Walk	Yes
Tether	No
Wall Jump	Yes
Wall Cling	No
Movement Ranks	
Ground Speed	B+ (12-16)
Air Speed	C (40-43)
Falling Speed	C (23)
Weight	C (40-43)

SQUID KID INK

Some attacks apply certain amounts of ink to targets, while depleting Inkling's ink reserve. The tables here show how much ink each attack requires, and how much ink each applies to attack recipients.

The Ink Gauge is visible by Inkling's portrait. The gauge has 150 units (graphically represented by the gauge). While Inkling's gauge goes to 150, the (hidden) gauge tracking how much ink is weighing down an Inkling enemy goes to 300.

The gauge amounts aren't related; an attack might spend 30 Inkling ink while applying 150 ink to the target.

An Inkling's ink is opportunity. You can use ink-powered moves until you're running low, and then you have to find time to refill, or else a bunch of attacks are just useless or weakened. An enemy's ink is a debuff that increases how much damage they take! The ink amount tells you both how long the debuff lasts, and how much of a damage multiplier attacks inflict on the inked fighter.

The damage-multiplier aspect increases little by little up to 180 enemy ink. It's a x1.2 multiplier at 75 enemy ink, x1.25 at 100 enemy ink, and x1.5 at 180+ enemy ink. Beyond 180 enemy ink, you're just adding duration. A debuff of 180 enemy ink takes 12 seconds to fully wear off. Inking foes to the max of 300 adds another eight seconds, for a 20-second-maximum ink duration (assuming no further ink applications). They can wash it off faster if there are any water features on a stage to splash through, or water attacks to get rinsed off by.

Now's as good a place as any to mention Inkling hates water, and takes minor damage just from getting soaked!

Grounded Attacks

Neutral Attacks: Inkling has a standard neutral attack combo, done by holding the Attack button down for all three hits. Squid kid starts with a jab, then follows with two kick attacks, the final one knocking foes a bit away. This neutral attack has decent speed, not among the best but not bad. It's a totally respectable out-of-shield option on defense, especially since Inkling's grab has below-average speed.

There's an alternate neutral attack combo when you want to cash in some ink. Hold or tap the Attack button for the first two hits—it doesn't matter which—then make sure you tap for the third attack. Inkling whips out the shooter and unloads at least eight quick shots up close, finishing with a launcher move that kicks the foe away. If out of ink, this alternate neutral attack just spasms uselessly.

Neutral Attacks		
Move	Damage	Ink
Neutral attack 1	2	—
Neutral attack 2	2	—
Neutral attack 3a	3.5	—
Neutral attack 3b	0.4x8+, 2.5	Inkling ink -2/150 per shot. Foe ink +10/300 per shot.

Dash Attack

Move	Damage
Dash attack	8

Defensive Attacks

Move	Damage
Ledge attack	9
Wake-up attack	7

Dash Attack: A running Inkling is a beautiful thing, not so much "running" as "swimming through a trail of its own ink in squid form." Dashing/running Inklings have a very short profile as a result, and can avoid the same kinds of threats that Wii Fit Trainer or Solid Snake do by crouch-walking, and Pichu does simply by existing. During dash attack, Inkling rises from squid-dashing with a short-range elbow. Hit when the elbow extends for max damage and launch potential, setting up mix-ups or air hits against an opponent's tumbling. An early hit is also usually safe when shielded, because Inkling slides through the defender.

Side Tilt: The squid kid swipes in front with the shooter, using the gun as a club. The shooter isn't a part of Inkling, so it overpowers incoming enemy pokes unless they stretch all the way through the gun. This hits with shocking knockback power, blasting enemies backward even at low-damage percentages. It's punishably laggy if shielded, but if you aim from max range, many shield grabs and neutral attacks out-of-shield will whiff. This is sort of like a slower neutral attack combo packed into one swing, in terms of results.

Tilts

Move	Damage
Side tilt	9
Up tilt	6
Down tilt	3, 6

Up Tilt: Inkling whirls heels-over-head with a launching bicycle kick. This move hits fast, quicker than side tilt, and has little lag after, so it can combo into itself two to three times in a row in most situations. After enough up tilts to push foes too high for another one, jump up and pursue the victim. This is a terrific attack, with one major catch. Because the kick is aimed relatively high, even though Inkling isn't a huge fighter, it's common for this move to miss against smaller fighters on the ground (or crouching ones).

Down Tilt: Squid kid hits the deck and breakdances briefly, kicking quickly twice. The first kick is Inkling's second-fastest attack (after neutral attack). The second kick combos after the first and knocks foes a little way away. If shielded, it's unfortunately unsafe from reprisal. However, if enemies drop shield prematurely after the first kick, anything they do loses to the second kick.

Side Smash: Ink during smash attacks is spent instantly upon smash start-up, and is expended even if Inkling is interrupted before hitting. If not enough ink is present, the smash attack loses power and fails to ink victims. Wielding a huge inkbrush, the squid kid swings fiercely in front. Side smash swings uncharged with pretty typical side smash speed, neither quick nor sluggish for this kind of move. Damage, knockback, and ink applied to foes are all max at the brush head, which has extremely good reach. Inkling is unsafe if shielded, technically, but when tapping them with the brush's tip, the frame disadvantage is negated by the space.

Up Smash: The blaster emerges, briefly hitting in front as a weak launcher while Inkling raises

Smashes

Move	Damage	Ink
Side smash	16-22.4	Inkling ink -10/150. Foe ink +120/300 (+100/300 with handle hit).
Inkless side smash	12-16.8	
Up smash	4, 15-5.6, 21	Inkling ink -30/150. Foe ink +120/300.
Inkless up smash	4, 10-5.6, 14	
Down smash	12.5 front, 11 back-17.5 front, 15.4 back	Inkling ink -20/150. Foe ink +120-150/300 front, +100-130/500 back (more up close).
Inkless down smash	10 front, 9 back-14 front, 12.6 back	—

the powerful soaker. Once it's aimed straight up, the blaster detonates, splashing damaging ink in a wide radius centered comfortably above Inkling. This is definitely unsafe against a defender shielding both hits up close, but it's possible they could drop shield too early after the forward hit and try to retaliate. The blaster blast will get them, just like if they drop shield too quick against down tilt. You need a third of a second's lead time to nail an airborne target with up smash's explosion. On the bright side, the damage, launch potential, and ink applied are all great.

Down Smash: Crouching low, the squid kid dumps out a slosher soaker to both sides, starting in front. The splashed ink deals decent damage (more in front) and applies plenty of ink, filling the foe's invisible Ink Gauge by as much as half all at once if down smash hits up close in front. The delayed second hit to the back gives this attack clear-out use, and might hit foes who dodge-roll through to Inkling's back.

Inkling's grab speed is heavyweight-grade with short range, which is a weakness on a fighter who's agile in other areas. You get significant bonus range (at the cost of a little extra start lag) when grabbing out of a dash or pivot. Once a victim's in the squid kid's clutches, front throw is noteworthy as a move that uses ink. It pastes the victim, along with anyone else directly in front, so it's efficient in free-for-all battles. It deals low damage with comically low knockback, though, if you try to front throw without spare ink. Back throw offers the most raw distance and damage, not counting follow-ups. Up throw hurls foes straight up for possible air pursuit, and down throw bounces them before Inkling, barely in hitstun at all.

Grabs

Move	Damage	Ink
Grab attack	1.3	—
Front throw	5, 3 (inkless: 3)	Inkling ink -10/150. Foe ink +80/300.
Back throw	9	—
Up throw	3x2	—
Down throw	7	—

Aerial Attacks

Neutral Air Attack: Inkling strikes quickly to both sides with an upside-down spin kick. It's a great multipurpose aerial move, fulfilling any role except for "meaty attack pulled down with fast fall." Unlike most neutral air moves, it's active very briefly, but at least it covers both sides simultaneously.

Forward Air Attack: Inkling strikes with a two-legged dropkick thrusting forward. This is Inkling's longest-lasting air move, so it's the best for fast-falling tactics. Other air moves hit too briefly to stick out above, then pull down into people. The damage is highest early at the sweet spot on the feet, though.

Back Air Attack: Inkling swings the shooter behind in a gun-whipping backhand. The hitbox is generous since enemies can't interrupt this attack by hitting the shooter. It strikes backward quicker than forward air hits forward, but lasts for a shorter period of time. It's better for precise walling attacks or pokes during short jumps than other air attacks, but less lenient.

Up Air Attack: Inkling flips upward, kicking with each leg, one after the other. This double wheeling kick is slower than most up airs to hit, but persists much longer than most as an upward-aimed threat. This makes it easy to hit someone above with *some* part of this attack, but difficult to aim and score max damage on both hits. If you score a solid hit, it launches foes upward.

Down Air Attack: Inkling swings the shooter straight down in a spiking swing. The start lag is long for an air move and the active hitbox is brief, making it challenging to aim. The payoff is high, though, with good damage and a meteor smash effect on a clean hit.

Aerials

Move	Damage
Neutral air attack	7
Forward air attack	12
Back air attack	10
Up air attack	4.5, 6.5
Down air attack	12

Special Moves

Move	Damage	Ink
Neutral special	0.3 per shot	Inkling ink: -1.5/150 per shot. Foe ink: +12/300 per shot.
Side special	4-15.9	Inkling ink -45/150 per second. Foe ink +60-120/300 depending on speed of impact.
Up special	8 direct, 6 splash	Direct hit: foe ink +50/400. Splash hit: foe ink +40/300
Down special	8-14	Inkling ink -30/150. Foe ink +80-140/300 depending on speed.

Neutral Special: Splattershot: The shooter's full potential is deployed with this rapid-fire burst of small ink shots. The stream of fire can be aimed up or down, and can be maintained until Inkling's ink reservoir is empty. As ink gets low, the shots' range slowly peters out, like when Charizard or Bowser runs out of firepower for fiery breath. With any ink in reserve, shooter shoots until it's empty. With no spare ink, a neutral input sends Inkling into the Shield+Special refilling pose.

Side Special: Splat Roller: Upon activation, Inkling produces a huge splat roller and speeds forward. This works a bit like Wario's Wario Bike or Bowser Jr.'s Clown Car. After the initial burst of speed to get Splat Roller going, the forward-rushing Inkling is always decelerating. Push the control stick forward to accelerate, building up speed (and impact damage, and ink applied), or tap toward Inkling's back to flip around and roll in the other direction. While turning, or once speed drops enough, Splat Roller deals no damage or pushback, though Inkling keeps pushing a harmless roller. To speed back up, simply press toward.

Splat Roller can be canceled by tapping Special or Attack, but jump-canceling tends to be better. Jumping to cancel Splat Roller doesn't count against your normal jump total. Ink diminishes rapidly while rolling, at a rate of about -45 ink per second. From full ink, you can get about three solid seconds of grounded rolling time before needing a refill. Interestingly, you can still pull out the Splat Roller with no ink in reserve. It doesn't have a hitbox at all, but it allows for the pseudo-triple jump in midair.

Up Special: Super Jump: One of the squid kids' most exceptional physical abilities involves being able to dive into their own puddles before rocketing out to huge heights, covering lots of space suddenly. This is illustrated in *Super Smash Bros. Ultimate* style with this recovery special. Up special doesn't require ink, and inks anyone it hits even with no ink in reserve. By default Inkling launches straight up, but hold left or right after input but before takeoff to launch Inkling at a 60-degree diagonal angle—both to aim in a preferred direction and to make it more likely that you connect against anyone in the way with a stronger direct hit rather than a weaker splash. There's no attack hitbox while flying.

High-flying and avoidant, with hits both launching and landing, this is a great survival-oriented up special. If anything's wrong with it, it's that it takes a long time, with Inkling traveling for about a second and a half between flying up and coming all the way down.

Down Special: Splat Bomb: Inkling's Splat Bomb is basically an ink grenade, whose travel arc you can alter a lot like Snake's Hand Grenades. Tap the down special input as briefly as possible for a quick upward-arcing toss, with a bomb that falls directly in front of Inkling before exploding. For a faster, longer-range, stronger Splat Bomb, charge the input. It doesn't take long to produce a toss like a smash throw, flying straightaway and detonating on contact with fighter-shaped obstacles in the way.

Without enough ink left for a Splat Bomb, Inkling is just confused if you input down special. With no ink left at all, down special duplicates Inkling's unique Shield+Special refilling pose.

Final Smash: Killer Wail

Wherever you activate Inkling's Final Smash, the kid deploys a Killer Wail special weapon. It emits a high-powered laser cutting through to long distance straight ahead, but you can tilt it up or down with the control stick. While this is happening, Inkling can move around freely. Even if Inkling is KO'd while Killer Wail is active, you can direct its laser stream.

Isabelle

OVERVIEW

This civic-minded Shih Tzu assistant joins the *Super Smash Bros. Ultimate* action with a tool set similar to Villager's, but distinct in important ways. Isabelle brings along a similar slingshot, giving unparalleled air control in a small line to either side. She can also catch items and shots with Pocket. These two abilities let her harass enemy zoners, thwarting their ranged game plans while implementing Isabelle's own.

Isabelle's Fishing Rod and Lloid Trap are where she's most distinguished. Fishing Rod works as a combo hit-throw and tethering move, good for pulling in enemies from surprisingly far away, and for snagging the edges of stages before falling. Combined with Lloid Traps, like vertical fireworks designed to go off when an enemy triggers them, Isabelle has the moves to institute her own zoning, ranged attack. With slingshot rounds, the ability to catch anything thrown at her, a friendly rocket trap that works like a land mine, and a unique Fishing Rod grapple, she can lay claim to her own patch of the stage and dare adversaries to push her off.

Isabelle Vitals	
Movement Options	
Jumps	1
Crouch Walk	No
Tether	Yes
Wall Jump	No
Wall Cling	No
Movement Ranks	
Ground Speed	D- (67)
Air Speed	C (48)
Falling Speed	D (67-69)
Weight	D (55-57)

Grounded Attacks

Neutral Attacks	
Move	Damage
Neutral attack 1	2

Dash Attack	
Move	Damage
Dash attack	10

Defensive Attacks	
Move	Damage
Ledge attack	9
Wake-up attack (faceup)	7
Wake-up attack (facedown)	7

Neutral Attacks: Isabelle swings quickly with a colorful mallet, hitting directly in front. It might look like this move swings over her head, but the hitbox only strikes in a line ahead of her. Holding Attack or tapping it repeatedly makes Isabelle swing over and over.

Dash Attack: While running, Isabelle trips and drops a breakable vase. Oh no! Until it smashes into the ground, the vase has a small circular hitbox. She can usually juggle right afterward, depending on how far away the opponent is launched.

Side Tilt: Isabelle swings a cute plaid parasol. This hits in front of her with good range and height, with the parasol on its side against anything in front. The opened umbrella is the main hitbox, but the handle hits as well if it's used closer up. This is a good poke from several steps away, and can often combo right after popping an enemy up with down tilt or a dash attack. Solid parasol hits knock the recipient away a good distance, scoring Isabelle breathing room.

Up Tilt: Isabelle sweeps upward, literally, with a broom. She swings the cleaning implement from up-back to up-forward, hitting fairly fast to the back but pretty slow if you're expecting this to hit someone standing on the ground in front. It's intended mainly as a tool for swinging at jumping or helpless tumbling challengers. Since up smash hits only in front of her in a vertical line, up tilt has more significance than usual for Isabelle.

Tilts	
Move	Damage
Side tilt	9
Up tilt	8
Down tilt	13

Down Tilt: Isabelle notices an unsightly weed and crouches to pluck it up by the root. As she rises with the agricultural intruder, anyone in the way is launched upward. This does the most damage up close to Isabelle, right where she's weeding, but the hitbox extends a surprising distance in front with the vigor of Isabelle's effort.

Side Smash: With a combination confetti-and-firework-party-favor, Isabelle sets off a close-range blast. This attack has terrific knockback and good KO potential at higher percentages.

Up Smash: Isabelle blasts on a whistle as a stop sign springs from the ground at her feet. There's a weak launching hit at ground level, followed by a stronger hit as the sign pops up to full height. This is a strong attack in front, good for nailing prone foes who haven't gotten up yet and tumbling enemies you're sure will drift in front of Isabelle. But it lacks the wide horizontal coverage of many up smash attacks, since the only hitbox is along the sign in front.

Down Smash: Isabelle spins while emptying out a bucket of water, sloshing away challengers nearby. This hits pretty quickly in front, before Isabelle empties out the second half of the water behind her. The back hit isn't painfully slow, and can knock away enemies approaching from behind. Since up smash doesn't cover both sides, down smash is your go-to when you need a clear-out option.

Smashes

Move	Damage
Side smash	17-23.8
Up smash	2, 12-2.8, 16.8
Down smash	10 front, 8 back-14 front, 11.2 back

Swinging a big butterfly net over her head, Isabelle looks to wrap up defenders before a helping of grab attacks transitioning into a throw. Using a net gives her long reach on the grab attempt, but it's very slow to compensate. It takes almost three times as long as the fastest grabs to reach opponents. Practice canceling a dash with a grab attempt for the max possible reach against ground enemies. Keeping Lloid Traps set up and harassing foes with lots of short-hopping slingshots paves the way for this slow grab to succeed.

Upon netting someone, front throw is the best options for raw knockback. Interestingly, back throw barely hurts the enemy at all, keeping them close to Isabelle's back. Almost all other back throws are actually the *farthest* options, so use this to your advantage by immediately going for a mix-up where foes don't expect it. Up throw hurls them straight up, perhaps triggering a Lloid Trap combo if he was set up beforehand (like if you set up a trap and camp on top of it, daring people to attack you). Down throw bounces them off the ground directly in front, in position for you to threaten with a dash attack or short-hopping slingshot.

Grabs

Move	Damage
Grab attack	1.3
Front throw	9
Back throw	11
Up throw	10
Down throw	6

Aerial Attacks

Neutral Air Attack: A demonstration of civic spirit is in order, and Isabelle sets about it by spinning in the air with pom-poms. Coverage is decent on this attack, with hitboxes surrounding both arms as she twirls in circles with the pom-poms out to both sides. This is her fastest air attack to start up, and the hitboxes persist for a surprisingly long time, a third of a second, as she spins.

This makes neutral air great for using above enemies before fast-falling down into them, and during short hops. Short-hop with neutral air, then fast-fall as soon as possible, and you'll have a small jump with a spinning attack that covers almost the entire airborne period on the way up and down.

Aerials

Move	Damage
Neutral air attack	10
Forward air attack	7
Back air attack	9
Up air attack	10
Down air attack	10

Forward Air Attack: Isabelle's front and back air attacks are tiny projectiles launched from a slingshot. The slugs travel fast with incredible distance for air pokes, dealing decent damage right up close but quickly dwindling to low damage along the travel path. Release these lateral to desired targets. They're great at any range along the path, allowing Isabelle to harass and zone, and covering her during forward jumping movement. Despite their reach and travel speed, shots require decent aim.

Back Air Attack: Isabelle's backward-facing slingshot attack. Back air is slower to shoot than forward air, but dishes out a little more damage. Err toward forward air when moving at enemies for the speed edge, and back air when zoning/running away from foes, when you have no intention of moving forward. Shot damage diminishes with distance traveled.

Up Air Attack: Isabelle swings straight up very quickly with a small harvest of turnips, which she holds out for almost half a second. This does the most damage on the initial thrust, but stays active as a weaker hit for a *long* time for an air move. Unfortunately, the hitbox doesn't hit low enough on Isabelle's body to make the attack useful as a long-lasting jump-in. But it does make it a great all-purpose move when juggling or jousting with airborne targets above.

Down Air Attack: The downward-aiming counterpart to up air. Isabelle swings turnips straight down. This is much slower to hit than up air, and is in fact Isabelle's slowest air move. Use it for spiking foes offstage and bouncing them midscreen at medium-damage percentages and higher.

Special Moves

Neutral Special: Pocket: Isabelle reaches out, grabs any nearby projectile or item, and quickly stores it. Pocket works against projectiles and items whether they're in motion or resting on the ground. An icon above Isabelle's portrait indicates when she has something stored. When something is Pocketed, the results upon inputting neutral special depend on the object in question. For items that can be held and swung/thrown, Isabelle pulls the item out and holds it in her hands. For projectile items that exist only as shots and not as objects that a fighter can grab and heft, Isabelle ejects the projectile as if it were hers all along. In some cases, Pocketing an enemy's item might deprive them of one of their special moves, which is naturally a huge hindrance to their plans.

Side Special: Fishing Rod: Casting a line with a reach that's a bit less than that of a forward/back air slingshot round, Isabelle takes a relaxing fishing break. After casting, she leaves the line out for about five seconds before automatically reeling it in. The hook at the end of the line is a hit-throw, reeling enemies in if it hits them and they don't dodge or block. With no further input, Isabelle throws them forward. Hold the control stick during the reel-in period to choose a different throw direction. Fishing Rod throws deal a lot more damage than grab throws, and fulfill the same general roles.

There's nothing else quite like this attack, which is like a tether-throw hit and a sort of shield that can be active for a huge amount of time. Since it can be used in midair and left out for full airborne periods all the way to the ground, it gives Isabelle the means to ward away people in front. Offstage, attempting to thwart recovery, Fishing Rod is devious and hard to deal with. Leap out toward enemies offstage and cast the line into airspace they have to traverse. Don't leave the line out too long, since you have to recover too! If the hook hits the enemy in midair, immediately hold the stick down to thwart their recovery attempt; if there are no bites, retract manually before falling too far. Either way, use Balloon Trip to return to firm ground.

And Fishing Rod has uses beyond attacking. It can reel in items, and it works for tether-style ledge recovery! When in midair facing a ledge and within range, side special casts the line to catch the handhold. From here, a dangling Isabelle can reel herself into the ledge, grabbing it, or release, falling down.

Special Moves

Move	Damage
Neutral special	Varies
Side special	~16 front, ~11 back, ~14 up, ~12 down
Up special	0
Down special	1.6x2, 0.9x3, 12

Up Special: Balloon Trip: This skill is strictly for movement and recovery, and has no attack portion. Isabelle sits on a swing buoyed in the air by one or two balloons. Two full balloons allow Isabelle to gracefully float through the air for a huge amount of time, giving almost unsurpassed mobility and recovery ability. Use the stick to direct her left/right travel, and tap or hold the Special button for Isabelle to take little swings for momentum, traveling upward quicker. When the balloons' loft is exhausted, they automatically release, leaving Isabelle to fall to the ground, helpless except for being able to steer and fast-fall. To cut the balloons early, tap Attack.

Down Special: Lloid Trap: Isabelle plants her friend Lloid the gyroid. Lloid bides his time underground, sticking around for up to 10 seconds before disappearing. During that time, if any enemy steps on him, he automatically launches vertically, dragging them upward for several hits before a powerful finishing explosion high off the ground. In addition to Lloid going off automatically, Isabelle can manually launch him with another down special input.

Lloid Trap combines with forward/back air slingshots and Fishing Rod to form the foundation of Isabelle's harassing zoning game plan. Lloid Trap can be used to lay claim to a particular bit of land, since anyone encroaching on Isabelle's territory will inevitably have a rocket launch to deal with.

Final Smash: Dream Town Hall

Activate Isabelle's Final Smash to call upon Tom Nook for a grand new contracting project: the construction of a new town hall! Unfortunately for whoever is caught in the build, such rapid work falls a bit short of safety standards, causing heavy damage. The range on this Final Smash is short, so make sure you're right next to the target and facing them before unleashing the industriousness.

Jigglypuff

OVERVIEW

Jigglypuff is a straightforward fighter.
That's not to say it's easy to play effectively,
though. Jigglypuff's goal is a simple one: score
hits with Rest, Jigglypuff's down special, while
overcoming Jigglypuff's extreme weaknesses.
Jigglypuff isn't a middle-of-the-road or flexible fighter
by any stretch of the imagination. It has weak range on its attacks,
a slow dash speed, a short grab, a and remarkably low hop height.
And if Jigglypuff is shield-broken, it's launched off the screen,
worsening its weaknesses even more.

Jigglypuff Vitals

Movement Options	
Jumps	5
Crouch Walk	No
Tether	No
Wall Jump	No
Wall Cling	No
Movement Ranks	
Ground Speed	F- (74)
Air Speed	A (2)
Falling Speed	F- (76)
Weight	F- (75)

While Jigglypuff struggles in several aspects, its main strength—aside from its ability to KO at low percentages—is a
solid aerial arsenal. Jigglypuff's limbs are relatively small, but its extended hitboxes stretch well beyond its vulnerable
hurtboxes (you may hear hitboxes like these described as "disjointed") on most of its attacks, with its aerials being the
most important.

Spacing your aerial attacks is vital to defending and attacking with Jigglypuff. Fortunately, it can midair-jump five
times, allowing you to change your facing direction and alter jump trajectory. These qualities give Jigglypuff a solid
edge-guarding game for harassing offstage foes, with neutral air extending a long active window and both front and
back air covering decent horizontal range.

Grounded Attacks

Neutral Attacks: Jigglypuff pokes its little arms out for
a one-two punch combo, knocking back enemies in
range. Jigglypuff's jabs are unremarkable. They aren't
particularly fast, and the second hit doesn't set up
anything meaningful when it hits. The main selling point
for Jigglypuff's neutral attack combo is that it's safe when
shielded, so you can use it to beat out overaggressive
enemies within range.

Dash Attack: While dashing, Jigglypuff transfers its
running momentum with a devastating headbutt that
sends foes flying far away or slightly knocked back. The
sweet-spot early timing of dash attack causes dramatically
more launching power than hitting with its non-sweet-spot
portion. Jigglypuff's dash attack also has a pronounced
"lingering" effect. That is, it has a modest active window,
so with its dashing momentum, it has a better chance of
ramming into aggressive foes. If you hit with the tail end
of this attack, it causes much less knockback.

Neutral Attacks

Move	Damage
Neutral attack 1	3
Neutral attack 2	3

Dash Attack

Move	Damage
Dash attack	12

Defensive Attacks

Move	Damage
Ledge attack	8
Wake-up attack	7

Tilts

Move	Damage
Side tilt	10
Up tilt	9
Down tilt	10

Side Tilt: Jigglypuff performs a mighty roundhouse kick to the opponent's midsection, knocking them back. Side tilt can
be angled upward or downward using the control stick. The up-angled roundhouse version targets the opponent's head,
while the down-angled version hits even the smallest of crouchers. Jigglypuff's side tilt has a decent active window,
making it effective for stopping aggressive foes on the ground. Its start-up is slightly longer than Jigglypuff's neutral
attack, but has slightly longer range.

Up Tilt: Jigglypuff delivers a rear high heel kick, attacking foes behind and above. On hit, it launches enemies up into the air, allowing for a follow-up thanks to low end lag. Like most of Jigglypuff's attacks, up tilt is deceptively powerful, with an excellent hitbox-to-hurtbox ratio making it difficult to challenge with an aerial.

Down Tilt: Jigglypuff halves its size, transitioning into its squishy form, and unleashes an elongated kick attack, obliterating the enemy's shins and knocking them back. Jigglypuff's low-profiling hurtbox is smaller than most fighters' crouches, allowing it to sneak under and poke foes more effectively. Down tilt has a bit more start-up and end lag than side tilt, but boasts more range while making Jigglypuff more evasive. It's a solid attack when spaced out, especially since it leaves you with advantage.

Side Smash: Jigglypuff winds up briefly, then lunges forward with a beastly leap kick, sending foes flying away. Although side smash is punishable when shielded, Jigglypuff extends a persistent hitbox while it's leaping forward. At lower percentages, it doesn't pack much of a punch, but above 100%, Jigglypuff's smash attack can absolutely destroy a fighter, sending them off into a side blast zone if they're caught off-guard.

Smashes

Move	Damage
Side smash	16
Up smash	15
Down smash	11

Up Smash: Jigglypuff leans back, then headbutts, covering a wide arc that reaches in front of it. Foes struck by the headbutt attack are launched directly up above, allowing you to transition into Jigglypuff's juggle-trap game. This is Jigglypuff's most versatile smash attack. It's a high-powered anti-air that sets up for further damage thanks to its vertical launch trajectory.

It can hit foes behind Jigglypuff and in front, so it can be used to clear out aggressive enemies if you make a good read. But it's slow to start and punishable when shielded (not nearly as punishable as side smash, though).

Down Smash: Jigglypuff squishes low to the ground with a heavy double-sided leg attack that demolishes enemies behind and in front of it. Jigglypuff's legs are intangible during the at tack, and its launching power is multiplied significantly against foes at higher-damage percentages. Jigglypuff's hitboxes during this attack cover and overlap its ears, so you can potentially swoop under aerial attacks and other mid-hitting moves while punishing the enemy's attack.

Jigglypuff's grab is almost as fast and reaches almost as far as its neutral attack. Its front and back throws are effective for setting up its edge-guarding game, while front throw has slightly less end lag, allowing you to follow up earlier. Up throw has high launching power, even at low percentages, making it one of the best tools for setting up a high-altitude juggle-trap game, although you usually don't get a guaranteed follow-up attack off of it. Jigglypuff's down throw launches the enemy high into the air at a slight angle. It's Jigglypuff's most damaging throw, but has much more end lag than up throw and launches the opponent away at an angle (whereas up throw launches them directly above).

Grabs

Move	Damage
Grab attack	1.3
Front throw	10
Back throw	10
Up throw	8
Down throw	12

Jigglypuff's grab game has a glaring weakness due to its range. Jigglypuff has difficulty getting into point-blank range, so its low grab range exacerbates this weakness. Still, up throw, front throw, and back throw are powerful since they all set up Jigglypuff's effective edge-guarding and juggle-trap game.

Aerial Attacks

Neutral Air Attack: While floating through the air, Jigglypuff drives its foot forward, leaving it extended briefly. While the attack is extending, it deals much more damage and inflicts much more knockback power. This is one of Jigglypuff's staple attacks since its persistent hitbox can be used to "wall out" foes with fast fall techniques (similar to Mario's neutral air). It has low landing lag, so it's relatively safe, usually only punishable by quick shield grabs.

Aerials

Move	Damage
Neutral air attack	11
Forward air attack	9
Back air attack	13
Up air attack	9
Down air attack	1.5x8, 2

Neutral air is incredibly versatile. It's good for blocking foes from recovering to ledges and punishing aggressive grounded foes, and it's one of your best aerial attacks to defend yourself with in air-to-air situations, thanks to its pronounced hitbox that covers Jigglypuff's vulnerable limb.

Forward Air Attack: Jigglypuff delivers a midair dropkick that knocks foes away. Forward air starts slightly slower than neutral air, but extends a much bigger hit effect. Its landing lag is identical to neutral air, so it can be quite safe to use as a deep jumping attack against grounded foes.

Back Air Attack: Jigglypuff spins around with a heavy rear roundhouse kick, knocking away foes behind it. It has high launching power when hit within point-blank range. Back air doesn't have a high active-window hit effect, but has solid range and high KO potential against offstage foes. As an air-to-ground attack, it can be made relatively safe with good spacing and timing.

Up Air Attack: Jigglypuff waves its hand above, arcing from slightly behind to out in front. Enemies hit by it are popped up, giving you ample time to follow up with a guaranteed attack. Up air is an essential part of Jigglypuff's toolkit. It has low air lag and, in conjunction with Jigglypuff's midair jumps, allows Jigglypuff to extend juggling combos since its pop-up effect is perfect for following up with additional aerial attacks.

Down Air Attack: Jigglypuff performs a Fox-like drill kick attack aimed directly beneath it. The first eight hits of the attack can be used to drag foes around to set up potential grab mix-ups. For instance, if you catch a short-hopping foe out of the air with down air that's canceled into fast fall, you can pull the enemy down with you to the ground where they're forced into a standing state, giving you a chance to throw or hit them with an up tilt. Down air can be risky to throw out haphazardly since it has considerable air and landing lag.

Special Moves

Neutral Special: Rollout: Jigglypuff charges up a rolling attack that can reach incredible speeds, similar to Sonic's Spin Charge special. The longer Rollout is charged, the more damage it deals and the longer Jigglypuff rolls. Unlike Sonic's Spin Charge, though, Jigglypuff bounces off the enemy when Rollout hits. Jigglypuff passes through the enemy if it's shielded. You can reverse Jigglypuff's rolling direction with control input (left/right). While turning, Jigglypuff can't hit enemies, making it vulnerable briefly.

Special Moves	
Move	Damage
Neutral special	12 to 20
Side special	11
Up special	—
Down special	20 + 38 over time

The rolling hitbox reactivates after Jigglypuff gains momentum. If Rollout isn't charged sufficiently (e.g., if you tap the Special button), Jigglypuff just rolls forward slowly and helplessly.

Side Special: Pound: Jigglypuff winds up a forward-lunging punch that knocks foes up into the air. If Jigglypuff connects with the tail end of the attack as it lunges forward, the launch effect provides enough hitstun for you to follow up with a forward air against foes at low percentages. Unlike most aerial special attacks, Pound can be used repeatedly to prolong Jigglypuff's air time. It has relatively low air lag and suspends Jigglypuff's descent each time you use it.

Up Special: Sing: Jigglypuff sings a soothing song that causes nearby opponents to fall asleep, leaving them vulnerable. The attack starts up slowly with a large circular hitbox extending all around Jigglypuff, and the song pulses three times rhythmically (each time Jigglypuff sings a note). The closer the opponent is, the longer they sleep. This is further compounded by how much damage they've taken. Jigglypuff's signature song is primarily used to set up its Rest attack, potentially finishing off slumbering foes.

Down Special: Rest: Jigglypuff takes a nap. But before the nap, Jigglypuff itself becomes a hidden power attack. Rest's hit effect is incredibly small, contained within Jigglypuff's body, so it's extremely difficult to hit with. But hitting with it causes massive damage (and a stylish little cutscene animation!) with an extreme vertical launch effect, all while bleeding out the enemy, causing further pain. Of course, if you miss, you're left napping for three whole seconds... If you have rage (if Jigglypuff is around 100%), Rest can obliterate and knock out heavyweights like Bowser (as low as 75%)!

Final Smash: Puff Up

Jigglypuff puffs itself up until it takes over the majority of the stage, then it rapidly deflates, launching nearby opponents. It's super effective on small stages.

Ken

OVERVIEW

Ken Masters has specialized mechanics that faithfully represent the in-depth combat of *Street Fighter IV*. Like Ryu, Ken is equipped with a vast range of attacks, many of which have varying strengths depending on how the moves are executed. Most of Ken's move arsenal from the *SF* series carries over to *Super Smash Bros. Ultimate* and is applied in his game plan similarly. In terms of weight, Ken lands at the heavier side of the spectrum. While he's susceptible to certain juggle combos, he resists KO launchers better than most. He has an average max run compared to the rest of the cast, so he can readily approach with most of his ground-based light attacks.

Ken Vitals	
Movement Options	
Jumps	1
Crouch Walk	No
Tether	No
Wall Jump	No
Wall Cling	No
Movement Ranks	
Ground Speed	C- (31-34)
Air Speed	B (29-30)
Falling Speed	C (36-39)
Weight	B (22-23)

As a *Street Fighter* character, Ken's move set includes unique *Street Fighter* special moves that can be performed with quarter-circle, half-circle, and "dragon punch" control stick motions. These reward you with higher damage and stronger attack properties.

UNIQUE STREET FIGHTER MECHANICS

When facing a single opponent in a one-on-one match, the Street Fighters behave even more like in their home games. They automatically face their foes, and moving the control stick away from the enemy to move backward doesn't make them turn around. Instead, they walk backward, just like in *Street Fighter*. This makes it much easier to execute manual-input special moves such as Tatsumaki Senpukyaku.

Grounded Attacks

Neutral Attacks

Move	Command	Damage
Standing light punch	Neutral attack tap	1.5
Target combo	Neutral attack tap x3 (4 if up close)	1.5, 1.5, 1.5, 5
Inazuma Kick	Neutral attack hold	6, 6

Neutral Attacks: Ken sticks out a swift jab with his left hand (when facing right). Ken's neutral attack is a quick jab that functions conventionally as a combo-starter, quick punish attack, and close-range poke. While it can be applied in a variety of scenarios, it differs from other fighters' neutral attacks with its relatively strict input requirement.

Like Ryu, Ken has retained much of his normal attack arsenal from the *Street Fighter* series, which means he can use light, medium, and hard versions of his move set. Because medium and hard normal attacks are performed by holding the Attack button while light attacks are executed by quickly tapping and releasing the button, using Ken's jab can prove difficult in certain situations.

Neutral Attack Combo (Target Combo): Ken's *Street Fighter* target combo is a three-hit sequence, beginning with a jab, transitioning into a right-handed body blow, then finishing with a fierce left hook.

Up close, this "auto-combo" requires four Attack inputs, as Ken starts the sequence with two jabs before leading into the body-blow follow-up. From past point-blank range, Ken executes the body blow into hard punch sequence after a single jab. The body-blow attack is cancelable with any special move, so you're not limited to finishing the combo with the final basic Attack input.

While this target combo is relatively simple to execute, it's generally unsafe if shielded, particularly the body blow and hard punch portions. If you finish the entire target combo against a shielding foe, they can almost always score a guaranteed buffered neutral attack punish (or shield grab). Thanks to Ken's special-cancel ability, you can get around this weakness by calling out your opponent's retaliation. By special-canceling the body blow (the third Attack input while up close) with Focus Attack, you can absorb the incoming "punish," punishing the punish with your Focus Attack kick release!

Dash Attack

Move	Damage.
Dash attack	12

Defensive Attacks

Move	Damage
Ledge attack	10
Wake-up attack	7

Neutral Attack Hold: Ken extends a leg skyward, then transitions into an axe kick, chopping down enemies in front of him. Ken's "overhead" medium kick, also known as Inazuma Kick, is performed with a long-press neutral attack command, and doubles as an anti-air and defensive attack. It starts with a vertical hitbox and ends with an axe swing downward. While it doesn't excel as an anti-air or horizontal poke, it's moderately effective against enemies coming down from directly above or in front of you.

Dash Attack: While running, Ken delivers a flying kick attack, similar to his jumping roundhouse kick, that launches foes up and away. Although Ken's dash attack leaves you extremely exposed and vulnerable to retaliation if blocked or dodged, it starts incredibly quickly and, if spaced correctly, rewards you with a huge payoff.

Ken's flying kick can launch in two ways: If you hit the early high-damage window, the foe is launched up and away. If you hit with it later on as the attack lingers, it launches the foe straight up into the air. This vertical launch allows you to follow up with a guaranteed up air combo (canceled into fierce Shoryuken for maximum damage).w

Tilts

Move	Command	Damage
Close light punch	Up tilt tap	2
Close hard punch	Point-blank neutral attack hold OR up tilt hold from any range	12
Standing medium kick	Side tilt tap	6.8
Close medium punch	Point-blank side tilt tap	6
Standing hard punch	Side tilt hold	10
Crouching light kick	Down tilt tap	1.6
Crouching medium kick	Down tilt hold	7

Up Tilt Tap: Ken quickly performs an elbow strike that pops enemies into an airborne state (*Street Fighter* players will recognize it as his neutral jab attack). This attack is similar to his neutral jab attack, but slightly slower with less reach. While its range and speed may seem inferior to standing light punch, the pop-up effect of close light punch makes it a much more versatile attack. It can be used to harass enemies while providing safe hit-confirm opportunities against both grounded and airborne foes. Close light punch should be one of your staple moves, prioritized over other attacks while you're in close proximity.

Up Tilt Hold / Close Neutral Hold: Ken's close standing fierce attack from the *Street Fighter* series is a powerful left-handed uppercut that launches his foe into the sky. This attack is an incredibly effective anti-air thanks to its upper-body intangibility as Ken thrusts his fist above his head. This up tilt long-press attack is generally much safer to use than his Shoryuken special move, particularly against air dodges.

It can be special-canceled as long as you make contact with it, potentially scoring a follow-up Shoryuken juggle. It's unsafe when shielded, but since it's special-cancelable, you can avoid punishment by canceling its ending lag with Tatsumaki Senpukyaku directed away from the enemy.

Side Tilt Tap: Ken delivers a quick leg thrust to the enemy's midsection. This kick is a fast poke with intangibility around Ken's extended attacking leg, making it effective for stuffing and beating out other grounded combatants. It isn't special-cancelable and doesn't naturally provide combo opportunities. While it's effective for its niche use, you generally don't use it often because of the fast-paced, aerial-based nature of combat.

Close Side Tilt Tap: Ken drives his right elbow into the opponent. At point-blank range, inputting a side tilt tap attack results in Ken's close medium punch instead of standing medium kick. This attack is special-cancelable. But combos such as close medium punch canceled into heavy Shoryuken can be tough to pull off in a real match against elusive opponents. In most up-close situations, target combo and standing light punch are much more practical tools.

Side Tilt Hold: Ken's side tilt long-press attack is a direct right-handed fierce punch (also known as a standing hard punch). Connecting with the fist portion (essentially at its maximum range) causes extra damage. Overall, it's an unremarkable attack because it lacks speed, cancelability, and range.

Down Tilt Tap: Ken prods the enemy's foot with his own in this quick low-profiling foot attack. Since high and low blocking (shielding) doesn't exist in *Super Smash Bros. Ultimate* as it does in *Street Fighter*, this attack's utility lies in its chainable property rather than as an avenue of breaking an opponent's defense. Essentially, this lightning-fast "low" attack functions similarly to standing light punch. You can chain multiple crouching light kicks that can then chain into a crouching medium kick, which can be canceled into a special move, resulting in a true *Street Fighter* combo.

Down Tilt Hold: Ken crouches low and attacks the opponent's feet with a far-reaching foot thrust. Veteran *Street Fighter* players will recognize this as "low forward" or "crouching medium kick." This cancelable attack boasts respectable range (relative to Ken's other attacks). On hit, it pops up the enemy, providing moderate combo opportunities.

Side Smash: Ken delivers a heavy spinning roundhouse kick to the enemy's midsection. It sports decent range and damage. Unfortunately, Ken's smash attacks cannot be special-canceled. In certain situations, side smash can be used to punish extraordinarily unsafe whiffs, or as a charged move while edge-guarding a ledge. Take caution with these types of smash attacks, as they leave you vulnerable to reprisal.

Smashes

Move	Command	Damage
Standing hard kick	Side smash	16
Crouching hard punch	Up smash	17
Crouching hard kick	Down smash	16

Up Smash: Ken performs his well-known alternative anti-air—a vertical uppercut from the crouching position, also recognized as a crouching hard punch. This move is a strong anti-air attack with an intangible hitbox around Ken's extended arm. While it's an adequate anti-air, it isn't cancelable.

Down Smash: Ken sweeps the floor in front of him with his dominant leg, knocking foes away. Ken's *Street Fighter* sweep is standard fare for a down smash attack, but doesn't cover his rear. This move is best left unused, especially since it's not cancelable while being easily punished by sharp and ready foes.

Ken quickly grabs a nearby foe and puts them into a mixed martial arts guard position where he can follow up with one of four throw options. Ken's tumbling back throw deals the most direct damage out of a grab, but for optimal damage, down throw followed by holding up tilt (close hard punch) canceled into Shoryuken deals a massive amount of damage against 0% opponents. Ken's up throw is a vertical toss, giving him an opportunity to mix up the descending enemy with anti-air juggle combos, such as with up air.

Grabs	
Move	Damage
Grab attack	1.3
Front throw	9
Back throw	12
Up throw	8
Down throw	6

The other two grab and throw options for Ken are lackluster. Forward throw deals low damage, though it gives you a chance to mount a follow-up offense. It's important to note that since buffering light attacks may be difficult for Ryu and Ken (because of how their medium long-press attacks work), buffering grabs is your next best defensive option in up-close situations.

Aerial Attacks

Neutral Air Attack: Ken extends a moderately quick kick from the air. Ken's neutral air attack is his *SF*-style jumping medium kick (with cross-up trait included!). It's a solid air-to-air and air-to-ground attack with respectable reach. Its active window is relatively short, so unlike Ryu's jumping neutral attack, you need to time it accurately. Its recovery is short enough so that you can do two jumping neutral airs in one normal-height jump—one during your ascent and one during your descent—a safe and effective poking/walling attack pattern.

Aerials		
Move	Command	Damage
Jumping medium kick	Neutral air	8
Jumping hard kick	Forward air	14
Neutral jumping hard kick	Back air	16
Jumping light kick	Up air	6.5
Jumping hard punch	Down air	12

Forward Air Attack: Ken delivers a jumping hard kick attack from the air. Ken's jumping front attack (jumping hard kick) is similar to his jumping neutral attack. It deals more damage and has a high-damage sweet spot around his extended foot. It makes for an excellent descending attack while fast-falling on top of the opponent.

Back Air Attack: Ken jumps into the air and delivers a weighty rear roundhouse kick. While this is his back air attack, most *SF* players will recognize it as his neutral jumping roundhouse kick. This attack deals the most damage out of all of Ken's aerial options, but requires accurate spacing and timing due to its low active-frames window and particular horizontal hitbox. It can be used aggressively as a reverse air rush (run, pivot, back air).

Up Air Attack: Ken quickly performs an aerial "crane" kick, thrusting his right leg into the air. This incredibly fast aerial air-to-air move is a staple attack in your arsenal when it comes to aerial combat. Its vertical hitbox is designed to deal with foes above you, great for taking advantage of "juggling" falling opponents, giving you an excellent air-to-air harassment tool. It also makes for a decent combo follow-up to close light punch (up tilt tap into quick jumping up air).

Down Air Attack: From the air, Ken descends on the opponent with a hefty fist thrust, striking them down, familiar to *Street Fighter* players as jumping fierce punch. While this air attack doesn't feature the range and active window of Ken's jumping kick attacks, it allows for more damage opportunities. Ken's down air is the quintessential meteor smash. Like Ryu's down air, it spikes and plummets airborne foes, making it your optimal attack for knocking out opponents over a pit or ledge.

Special Moves

The strengths of the following attacks depend on how long the Attack button is held upon execution. Hadoken, Tatsumaki Senpukyaku, and Shoryuken each have three levels: weak, medium, and strong. Performing these attacks with the special *Street Fighter* directional inputs rewards you with higher damage and other beneficial properties.

Short hold: Activates quickly and leaves you less vulnerable.
Long hold: Powerful and has a long reach.

Variable Strength Street Fighter Specials

Move	Command (When Facing Right)	Damage Totals (Light/Medium/Heavy)
Hadoken	Neutral special OR ↓↘→ + Attack (hold button to increase power level)	4.5 (5.6) / 5 (6.2) / 5.5 (6.8)
Tatsumaki Senpukyaku	Side special OR ↓↙← + Attack (hold button to increase power level)	6 (6.9) / 12 (13.9)
Shoryuken	Up special OR →↓↘ + Attack (hold button to increase power level) OR ↘↓↘ + Attack	13 (15.6) / 14 (16.8) / 15 (20)

Neutral Special: Hadoken: Ken summons and fires an energy wave ("fireball") across the battlefield. There are three separate strengths and speeds for the two methods of executing the iconic Hadoken projectile. Performing Hadoken "manually" with quarter-circle forward (↓↘→ + Attack) motion rewards you with a bigger fireball (better hitbox), along with higher damage. You should almost always use the full-command version since the motion doesn't interfere with movement (at least not as much as the Shoryuken and Tatsumaki Senpukyaku motions do). The longer the Attack button is pressed when performing Hadoken, the faster and stronger the projectile becomes.

Side Special: Tatsumaki Senpukyaku: Ken becomes a human hurricane, flying forward with a flurry of spinning kicks. Tatsumaki Senpukyaku is a multi-hit, multifunction hurricane kick. It can be used as a gap-closing horizontal-mobility option, a combo-finisher, and an escape. Although it's unwise to throw this out randomly as a fishing attack, it makes for a good method of traversing the field quickly, either to recover onto a ledge or as a retreating tactic. The longer the Attack button is held, the farther you travel and the more damage you deal in total, assuming all of your kicks connect (although this is rare in most practical scenarios).

Up Special: Shoryuken: Ken flies into the air with a jumping uppercut, also known as the Shoryuken (or "Rising Dragon Fist"). Ken's iconic uppercut special doubles as an anti-air and ledge-recovery tool. Shoryuken power level determines the height Ken flies into the air, as well as the total damage of the attack. Like Hadoken and Tatsumaki Senpukyaku, the longer you hold the Attack button upon executing the attack, the higher the resulting power level.

Other Special Street Fighter Moves

Move	Command (When Facing Right)	Damage
Focus Attack	Down special (chargeable)	12 / 17 (max charge)
Nata Otoshi Geri	→↘↓ + Attack (hold to follow up with Inazuma Kick)	10 (15 with Inazuma Kick)
Oosoto Mawashi Geri	←↙↓↘→ + Attack (hold to follow up with Inazuma Kick)	10, 10 (Inazuma Kick)

Down Special: Focus Attack: Ken swings his dominant leg back, posturing and charging up a powerful kick while becoming resilient against an incoming attack. This is recognized as Ken's *Street Fighter IV* Focus Attack. Focus Attack is performed using down+Special and can be charged. While charging the attack, you can absorb up to one hit, so it essentially behaves as a parrying counterattack.

There are three distinct Focus Attack power tiers. The first tier (releasing the attack anytime before Ken flashes white) deals high damage and knocks away foes hit by the kick. Charging just past Ken's flash point powers up the attack to cause a crumple-stun on enemies you hit, leaving them vulnerable to a follow-up attack or combo sequence. The third, and maximum, power level not only inflicts crumple-stun, but also breaks through enemy shields. While charging, Focus Attack can be dash-canceled by tapping forward, forward or back, back quickly on the control stick.

Nata Otoshi Geri: Ken performs a swift two-hit reverse heel kick. This kick can only be performed with a special command (→↘↓ +Attack), with the ability to transition into an Inazuma Kick if the Attack button is held down. This follow-up version of the Inazuma Kick differs from the normal neutral attack hold in that it deals much more block damage, making Mata Otoshi Geri most effective as a block string ender in order to punish your opponent's shielding habit with a potential shield-break stun.

Oosoto Mawashi Geri: Ken delivers a powerful roundhouse kick to the opponent's face, sending them flying away. Like Nata Otoshi Geri, this roundhouse kick can only be done with a special command (←↙↓↘→ + Attack), and functions similarly. The most notable difference is that it knocks enemies farther away on hit. The Attack button can be held upon execution to transition into a shield-breaking Inazuma Kick. Both Nata Otoshi Geri and Oosoto Mawashi Geri are best used as special cancels from Ken's normal attacks (like down tilt hold and neutral auto-combo).

Final Smash: Shippu Jinraikyaku / Shinryuken

Ken twirls around, then rises with Shinryuken, dealing damage to opponents by tossing them into the air. If the opponent is close to Ken, the attack becomes Shippu Jinraikyaku, instead unleashing a flurry of kicks.

King Dedede

OVERVIEW

King Dedede floats into the fray with a powerful hammer and a kit that emulates Kirby without copying him (no pun intended). For starters, King Dedede can float like Kirby, giving him the equivalent of a quintuple jump. After double-jumping, tapping or holding the Jump button gives him up to three more chances to increase his altitude. This also gives Dedede an easy way to change direction in midair. Aside from the recovery staying power afforded by having this air movement, Dedede also has an Inhale move. Just like Kirby, he sucks in hapless nearby victims, able to spit them out to inflict damage and to put them into dangerous positions offstage.

King Dedede Vitals	
Movement Options	
Jumps	4
Crouch Walk	No
Tether	No
Wall Jump	No
Wall Cling	No
Movement Ranks	
Ground Speed	D- (66)
Air Speed	F (76)
Falling Speed	A (2-3)
Weight	A (3-4)

When he's not busy copying his nemesis, King Dedede outfits himself with a toolbox of slow, incredibly hard-hitting moves, mostly using his barrel hammer. Playing Dedede means compensating for the long windup on his strikes, but the benefits are both high damage and virtually unmatched shield-shattering ability. Even an uncharged side smash is likely to shatter the block of a defender.

Grounded Attacks

Neutral Attacks

Move	Damage
Neutral attack 1	2.5
Neutral attack 2	2.2
Neutral attack 3	0.5x7, 3

Dash Attack

Move	Damage
Dash attack	16

Defensive Attacks

Move	Damage
Ledge attack	10
Wake-up attack	7

Neutral Attacks: Tap or hold the neutral attack input for the first two swings, a horizontal hammer swing into a scooping follow-up. After these first two swings, inputting neutral attack again results in a spinning hammer attack that inflicts rapid minor hits before finishing with a launching attack. The hammer's spin can be extended by holding down the button during the third attack, though holding it too long runs the risk of allowing the victim to escape the last hit.

Dash Attack: King Dedede flops from a run or dash into a belly slide, hitting as he skids with his hands and head. This is slow to hit and laggy afterward, but powerful.

Side Tilt: The king juts his barrel-hammer forward and spins it rapidly, with a poking attack that's like a more powerful version of the neutral attack combo's third move. The horizontal reach for this attack is very good, with the hammer's spinning head sticking around for a moment when extended. You can combo this attack after jumping in with a last-second neutral air, or after popping someone up with down tilt.

Tilts

Move	Damage
Side tilt	2x3, 3
Up tilt	10
Down tilt	10

Up Tilt: King Dedede leans back, then delivers a painful arcing headbutt, covering upward angles starting at up-back and rotating to straight forward at the end. The king's head is intangible during the headbutt, increasing the chances it'll win out against whatever the enemy is sticking out. Keep in mind that this hits behind King Dedede first; this gives it some use covering his backside, like hitting at people who've rolled past Dedede, or for use as a last-second backturned attack out of a forward dash or run.

Down Tilt: While crouching, King Dedede luxuriates in a relaxed-looking pose. From here, he can roll forward with one of his quickest attacks, a tumbling bump. At the end, he returns to his reclining posture briefly before being able to do anything else. Hitting faster than King Dedede's neutral attacks or his grab animation, down tilt is important in his arsenal, even though it's very laggy and likely to lead to punishment if it's dodged or shielded.

Side Smash: King Dedede hefts his wooden hammer for an extremely slow but extremely strong overhead smash. The hammer's hitbox begins when it's swinging vertically over Dedede's head, but reaches full power while aimed up-forward. It does full damage from here until slamming into the ground, at which point a secondary impact tremor hitbox springs up around where it hits, giving the attack good reach (if weaker damage) past the hammer's head. This is one of the game's slowest attacks, with even the uncharged version taking over half a second to strike, and the fully charged version striking in a second and a half (if it's released as soon as it's fully charged). It's hard to land this in the heat of combat against quicker fighters (which is almost everyone), but if you do, the damage and knockback are staggering.

Smashes

Move	Damage
Side smash	25-35
Up smash	16-22.4
Down smash	13-18.2

Up Smash: Starting with a scooping motion forward, King Dedede raises the hammer from ground level and swoops it over his head. It hits to the front first, before sweeping up overhead and then behind, eventually covering all angles except downward ones. Whether enemies get hit in front, above, or behind, they're launched off their feet, into a position that allows for follow-ups as damage accumulates.

Down Smash: The king whirls with the hammer held low, smacking both sides with a forceful clear-out spin. He hits in front first before twirling to hit behind. For a forward hit, this is a bit faster than the front-facing portion of up smash—it's also a bit faster to make it to the backswing—though it doesn't cover upward angles as up smash does while Dedede turns around. Down smash is strictly a floor-level swipe.

King Dedede's grab attempts are normal for a heavyweight, but slow compared to most fighters. With his neutral attack being one of the slowest in the game, you have to threaten with down tilts, hopping attacks, and high-bouncing Gordo Throws to coach challengers into being susceptible to throws. When you're seeking to pull in enemies and toss them, remember to think of Inhale as a longer-reaching throw you can also do in midair.

Grabs

Move	Damage
Grab attack	1.6
Front throw	4, 6
Back throw	4, 9
Up throw	4, 5
Down throw	6

Aerial Attacks

Neutral Air Attack: The king extends all his limbs and falls, using his bulk as a weapon. This attack's hitbox is essentially a circle around King Dedede's midsection, effective against grounded foes whether the king lands in front of or behind them. Immediately after he jumps at a grounded opponent with neutral air and lands, a combo is possible by catching them with side tilt or up tilt. It's possible to juggle immediately after a fast-falling neutral air with two up tilt juggles back-to-back, before short-hopping to finish the juggle with something like up air.

Forward Air Attack: In midair, King Dedede brings the hammer down with a chopping attack, first hitting at an up-forward angle, then swinging to down-forward, covering all forward directions. The hammer here has more range than neutral air, making it better for pursuing a target from farther way. It just requires a bit more lead-in time for the hit.

Back Air Attack: King Dedede whirls backward in midair, bring the hammer around for a sideways swing. This doesn't have any upward or downward slashing coverage, and hits laterally to his back. It's slower to hit than forward air, and linear, but the damage is higher, and the knockback is much more useful.

Up Air Attack: Dedede extends the hammer straight up while spinning the handle, rotating the hammer head rapidly. The extended handle has a narrow hitbox on it, but the star of the show is the hammer head above. This doesn't provide any use against ground-level enemies or enemies on the same plane in midair, but it's great to harass and juggle those at higher altitude.

Down Air Attack: Winding up by pulling the hammer back over his shoulder while falling, King Dedede then swings the weapon straight down, slamming anyone underneath and knocking them off balance. This hard-hitting move will certainly pummel anyone in the way, and Dedede's hammer won't lose out to other attacks on clean hits, but the lead-in is quite long, so this can be hard to aim effectively.

Special Moves

Neutral Special: Inhale: King Dedede opens wide for this attack, creating a vortex that pulls in anyone directly in front. With a foe held captive in his gullet, King Dedede can move and jump (although at greatly reduced speed) to seek a desired regurgitation point. Another Attack or Special input makes him spit them back out (he does it automatically should enough time elapse). The captive is spat out as a star projectile, taking damage and seriously hurting anyone they're flung into.

Whether on the ground or in the air, this essentially works like a special-move throw with terrific reach. It can be used for the raw damage whenever available, but it can be made even more potent on purpose by launching enemies into each other, or by spitting them off ledges. Even better, near stage edges with gaps underneath the level, Inhale someone, hop backward off the stage, spit them *under* the stage, then quickly use your double-jump and up special to return to safety!

Side Special: Gordo Throw: King Dedede produces a Gordo—a cute, spiny creature that looks like a spiked ball with eyes. He then swats the Gordo like a baseball, knocking it on a bouncing path forward. The Gordo bounces several times moving forward, then disappears. It also disappears prematurely after bouncing off a target. The Gordo's damage diminishes a bit as it travels. Only one Gordo can be active at a time.

Aerials	
Move	Damage
Neutral air attack	12
Forward air attack	12
Back air attack	16
Up air attack	1x7, 5
Down air attack	15

Special Moves	
Move	Damage
Neutral special	10
Side special	14
Up special	15, 12
Down special	12-40

Immediately after you start a side special, control stick input dictates the kind of bounce Dedede sends the Gordo on. With the regular side special input, the Gordo bounces far and low, traveling the longest distance. For higher bounces and less travel, input side special, then immediately hold down on the control stick. This Gordo bounces forward about two-thirds the distance of a "normal" side special Gordo toss. For the highest-bouncing, shortest-traveling Gordo, input side special, then hold up on the control stick. This spiked ball doesn't travel far from King Dedede at all, with the highest bounces of the three versions.

Remember that Inhale allows Dedede to pull in and eject projectiles. This includes his own Gordos! This can be done before or after a Gordo is reflected back by an opponent. Finally, it's important to note that a Gordo may stick into vertical surfaces, in which case it stops bouncing and becomes a motionless hitbox for a couple of seconds before disappearing.

Up Special: Super Dedede Jump: The king squats, then launches himself high, quickly gaining lots of altitude. The trajectory of this super jump can be altered by holding left or right during ascent. With no further input, Dedede transitions to a powerful diving attack at the apex. He hits hard on the way down, smashing grounded foes with such force that they're planted into the dirt. That doesn't last long, since his ground impact is a secondary hitbox, launching them away if the dive-bomb connects.

As an attack, Super Dedede Jump is highly telegraphed and relatively easy for enemies to see coming, though it's extremely strong if it hits. It's best for literally leaping into the fray when a few other brawlers are tangling midstage, not paying attention to Dedede.

Down Special: Jet Hammer: It turns out the hammer isn't just a hammer. There's a rocket engine inside, the better to power up this special hammer swing. Hold the initial input, and Dedede begins charging Jet Hammer's power. Release for the swing. While charging, King Dedede can still move around, with about the same mobility as when an enemy is sucked in with Inhale but not yet ejected. This means you can start charging Jet Hammer, then jump and release to hit someone in midair, for example. Charging longer increases power and knockback. You know it's fully charged when King Dedede's determined stare at his enemies becomes an exasperated stare at *you*, the player!

Final Smash: Dede-Rush

With a Final Smash loaded and ready to go, the king attacks with his mightiest swing. Get a preferred target in your sights up close, and let the attack loose with a neutral Special input. The initial swing can hit multiple enemies, but it only draws one of them in for the full-damage cinematic, with King Dedede walling them off in a personal ring of pain

King K. Rool

King K. Rool Vitals	
Movement Options	
Jumps	1
Crouch Walk	No
Tether	No
Wall Jump	No
Wall Cling	No
Movement Ranks	
Ground Speed	D- (65)
Air Speed	D (61)
Falling Speed	B (23-24)
Weight	A (2)

OVERVIEW

The lumbering lord of the Kremlings relies on his raw strength, prodigious gut, and skill with self-made gizmos. He has many attacks that deal high damage, and he's not as slow as you might expect, with his neutral attack and up tilt hitting fairly quickly. His belly has super armor during many attacks, which helps him endure attacks and strike back even with slower moves. The belly itself becomes a weapon for moves like neutral air. Even side taunt has belly super armor, offering the most insulting method for dismissing incoming projectiles. Aside from his belly, the king is distinguished by his tools. Blunderbuss and Crownerang give him ranged threats he can overlap, dealing meaningful damage from far away. Both of them supplement his offense up close, with Blunderbuss offering cannonball-ricochet or opponent-launching follow-ups. Meanwhile, the Propellerpack storing all his stuff is ready at a moment's notice to whirl him up away from danger.

Grounded Attacks

Neutral Attacks

Move	Damage
Neutral attack 1	2.5
Neutral attack 2	2.5
Neutral attack 3	7

Dash Attack

Move	Damage
Dash attack	15

Defensive Attacks

Move	Damage
Ledge attack	10
Wake-up attack	7

Neutral Attacks: The Kremling king has decent speed for his neutral attack combo, especially considering its damage. You can't call it a fast opening jab, but it could be worse. He starts with a short-range palm strike, follows with a farther-reaching claw swipe, and finishes with a hefty kick to knock defenders away. Since King K. Rool's up special doesn't work as a quick, strong reversal, you'll likely rely on neutral attacks more than usual when dropping shield to counterattack.

Dash Attack: The king rushes forward with his belly out, dealing anyone in the way a heavy hit. The initial belly jut does more damage, but the flop after can hit as well. His belly has super armor during both parts of the attack. Afterward, K. Rool has quite a bit of lag getting up, so be careful.

Side Tilt: The king reaches way back with both hands, belly out. During this windup, the belly has super armor, absorbing anything it blocks. Then K. Rool slaps his hands together for the attack. Damage is highest where the hands clap; closer in, it's a little lower. The clap can be aimed a bit diagonally up or down with a slightly off-center side tilt input. The speed for a single-sided poke attack is sluggish, but the armored belly at the beginning helps it plow through many things.

Up Tilt: While most of King K. Rool's moves are somewhat slow, up tilt joins his neutral attack as surprisingly quick. It starts out punching directly in front of the king before proceeding into a hopping uppercut straight up. It doesn't cover all upward angles, but the close-range and anti-air coverage in front are great.

Down Tilt: King K. Rool raises a leg and stomps fiercely, slamming a big area in front of him with the impact. This attack has a shockingly big hitbox stretching ahead from his shoulder and foot. It even extends slightly down into the ground, perhaps hitting at the underside of soft platforms as enemies leap up from underneath. The large hit area is the impact tremor from his foot stomp, which does a little less damage than the foot, while launching victims into the air. If they get hit by the king's foot, they'll be planted in the dirt like a rail spike, stuck briefly and totally open to more attacks from K. Rool! It's his slowest tilt attack, but potentially has the biggest payoff.

Tilts

Move	Damage
Side tilt	13
Up tilt	11.5
Down tilt	13

Side Smash: The boxing-glove punch deployed during side smash is an extremely strong punch, and can be slightly aimed up or down. On a solid hit, sparring partners are sent into a brief backward tumble. This attack pretty much just has brute force going for it, since it lacks the belly super armor of many moves.

Up Smash: This quirky alligator flop starts out with a headbutt straight up, very fast for a smash attack; only marginally slower than up tilt, if uncharged. This initial hitbox is aimed upward, but the king's belly is already super armored on the way up. After the initial lunge, King K. Rool flops forward, with belly still armored and a small hitbox around his head that can drag down close-range airborne foes. Upon belly-flop landing, there's another hit from the impact. This means up smash has a serious lateral hitbox, but it's late in the move.

Down Smash: Down smash is almost a built-in smash version of a short hop attack. King K. Rool springs up with a short jump and splays his limbs, preparing to fall with all his weight. His belly is super armored on the way down, though it's not an active attack until he lands. The initial, most damaging hitbox surrounds the king, and is shortly followed by a *huge* (but much weaker) impact area that can clear out an entire soft platform.

Smashes

Move	Damage
Side smash	19-26.6
Up smash	15-21
Down smash	18-25.2

The king's grab isn't noteworthy speed-wise, taking twice as long to grab as his neutral attack takes to hit. But he has good potential once someone is in his clutches. In party battles against several foes, the front throw hits anyone else in front as it bounces the victim off the turf. For raw distance and KO potential at high-damage percentages, back throw is best, as is often the case. Up and down throw are where it gets interesting. Up throw deals exceptional damage, and virtually guarantees you can juggle with something else right after. Down throw deals underwhelming throw damage, but plants foes in the ground like a close-range down tilt, guaranteeing you can tack on something else that's juicy.

Grabs

Move	Damage
Grab attack	1.6
Front throw	10
Back throw	11
Up throw	16
Down throw	5

Aerial Attacks

Neutral Air Attack: With this useful all-purpose air move, the king juts his swollen belly out as much as possible, like a flying battering ram. It deals the most damage right when it starts, and a bit less after it's extended for a few frames. As a long-lasting, partially armored attack, it's good whether going air-to-air or jumping at people on the ground, like while fast-falling. The angle is also decent for attacking out of tumbling states, to out-prioritize enemies trying to (for example) leap up and juggle K. Rool with up airs.

Aerials	
Move	Damage
Neutral air attack	12
Forward air attack	14
Back air attack	19
Up air attack	14
Down air attack	9

Forward Air Attack: King K. Rool kicks forward with both legs all the way out, adding quite a bit of reach. This might look like a Mario-style dropkick, but it's way slower and laggier than that. In general, the king's air attacks take a lot more aerial commitment, so he can't jump and double-jump while jutting out a dropkick-like move three or four times to control space and threaten.

Back Air Attack: The king swings with a mighty hook overhead, dealing heavy damage and knockback on direct fist hits, and can even meteor opponents. The hit area begins aimed 45 degrees up-forward and curves to 45 degrees down-forward. Back air isn't well-suited to reactionary use against nimble aerial attacks coming up from behind. Like with up tilt and up smash, K. Rool lacks coverage to his back in many situations. Part of using him involves being aware of who's sneaking around behind, and avoiding getting forced into jousting with your back to them.

Up Air Attack: One of K. Rool's fastest air attacks (tied with neutral air) features him in another upward dive, headbutting straight up like up smash. Like with up smash, the king's belly is armored, blocking threats in front. Using this attack gives a little upward lift, almost like a triple jump. The lag after this move is lengthy, lasting most or all of the way back to the ground, so it can't be used frivolously.

Down Air Attack: King K. Rool kicks straight down, again with an armored belly protecting his front side. This has the expected use of aiming at adversaries just below, though with a sluggish start and brief kicking period it can be hard to aim. It works well in manual short hops, performing the kick a bit later than with a built-in short hop's timing. As a bonus, the belly is well-aimed to protect the king when short-hopping. Like Back Air, it can meteor opponents.

Special Moves

Neutral Special: Blunderbuss: The Kremling king gets fully into character for this move, slapping on a pirate's hat as he launches a cannonball from an all-purpose, old-school scattergun. With space between you and enemies, you can treat Blunderbuss shots as strong projectiles. Cannonballs hit hard, and after they bounce off a foe, they can hit other targets on the rebound for less damage. Fired cannonballs persist for a second after rebounding and coming to a rest, then disappear. Only one can be on-screen at a time.

Special Moves	
Move	Damage
Neutral special	13
Side special	8, 6
Up special	3x6
Down special	Incoming attack x1.5

When using cannonballs near enemies, the Blunderbuss's secondary function comes into play. When a cannonball is already on-screen, holding neutral special engages the scattergun's amazing suction feature. If the cannonball is close enough after bouncing off a target's noggin, it'll get reloaded and fired from the gun! This bonus shot is aimed up-forward by default, but you can manually aim it up-back or straight up. It's fired faster and more powerfully than the initial shot.

It isn't just cannonballs that the Blunderbuss launches. With a cannonball already on-screen, use neutral special facing a foe. If you're close enough, they'll be sucked in, and you can quickly chose which direction to launch them! Enemies sucked in and launched take a base amount of 12 damage; if an enemy is fired into *another* enemy, the new victim takes 18 base damage.

Side Special: Crownerang: Give the king's head a rest and fling the Kremling crown forward with a side special input. The crown returns after traveling about two-thirds the length of a cannonball's path. It deals more damage on the outgoing trip and a bit less on the way back. When it eturns to the king, he automatically puts it back on. If you're not doing anything, this animation occupies him for a second in a crown-catching lag. Avoid this by doing basically anything just as he's about to catch the crown—for example, a neutral attack or sidestep dodge. If King K. Rool can't make the rendezvous with the flying crown for some reason, it continues on its path until it lands on the ground. To throw it again, he has to go get it.

Up Special: Propellerpack: The king uses his gizmo expertise to zoom upward quickly with a one-reptile helicopter. The vertical travel is incredible, and the king can be steered left and right during ascent and descent. He drifts downward gently afterward unless you tap down to fast-fall. Propellerpack is tailor-made for rapidly climbing a multitiered stage or recovering from getting tossed out over thin air.

Down Special: Gut Check: Input down special to make the king enter a belly-jutting pose. Only the first few frames of this pose are vulnerable, then the king goes briefly fully intangible as his belly flashes and becomes invulnerable. Anything that hits the belly during this invulnerable period is reflected with its damage amped up! Enemy projectiles are sent back both faster and more damaging. If an opponent physically attacks the invulnerable belly during Gut Check, they'll eat about 1.5 times their attack's base damage. After countering an attack, quickly flick the left control stick to the opposite direction the King is facing and he turns around and releases his counter attack in the new direction.

Final Smash: Blast-O-Matic

On activation, K. Rool lunges straight ahead laterally about a cannonball's travel distance, marking anyone struck along that path. They eat some collateral damage from the enmity displaced by K. Rool toward the Kongs in the ensuing cinematic.

Kirby

OVERVIEW

Kirby returns as his usual self, a
lightweight brawler with the unique
ability to absorb attacks from foes and
use their own powers against them.
Kirby retains his excellent aerial mobility
and is one of the few fighters with five
midair jumps that allow him to turn around in the air on demand. He also has
an improved dash speed, allowing him to utilize the superb overall speed of his ground-based attacks, as most of them
are safe (some even leave him at a positive frame advantage). When Kirby crouches, he squashes his body down to
slightly less than half-size, making him remarkably difficult to hit; some attacks and grabs can whiff as he ducks under
them (such as Captain Falcon's Falcon Punch).

Kirby's signature Inhale special has been improved. Not only can he swallow and spit out incoming projectiles, but you
can opt to absorb them to restore Kirby's health.

Your overall goal with Kirby is to exploit his exceptional air mobility and defensive pokes in the neutral game, scoring big
damage with his effective anti-air juggles. Play around your opponent's offense with your fast ground attacks until you
can land a clean launcher or grab. You can rack up damage off most shield grabs if you have a strong follow-up plan.

Kirby Vitals	
Movement Options	
Jumps	5
Crouch Walk	No
Tether	No
Wall Jump	No
Wall Cling	No
Movement Ranks	
Ground Speed	C- (36)
Air Speed	F (72)
Falling Speed	D- (72)
Weight	F+ (67-69)

Grounded Attacks

Neutral Attacks: Kirby lunges forward with a two-punch
left-right sequence, then transitions into his rapid-fire
Vulcan Jab into Smash Punch combo, knocking the enemy
away. While it's limited in range, Kirby's jab starts up
quickly and leaves him at an advantage when shielded,
making it a safe and effective defensive retaliation
option that doesn't require you to commit to a grabbing
animation. Neutral attack 3, the loopable Vulcan Jab,
extends a much more pronounced hit effect, covering
almost twice the range as the first two jabs with a taller
vertical hitbox.

Dash Attack: While dashing, Burning Kirby becomes a
spiraling infernal torpedo and launches himself into the
opponent, setting them ablaze and launching them away
into the air. Although Kirby's torpedo is punishable when
shielded, it has a pass-through effect when executed
close to the enemy, forcing them to turn and close some
distance (or use a midrange attack) before punishing you.
While it's not a great move to throw out haphazardly,
you can use it to escape being cornered. Like most dash
attacks, it starts up fast enough to punish whiffed attacks
from mid to long range.

Neutral Attacks

Move	Damage
Neutral attack 1	1.8
Neutral attack 2	1.6
Neutral attack 3	0.2xN, 3

Dash Attack

Move	Damage
Dash attack	10

Defensive Attacks

Move	Damage
Ledge attack	9
Wake-up attack	7

Side Tilt: Kirby delivers a midrange side kick to the enemy's midsection, knocking them back slightly. Side tilt can be angled upward or downward for a bit of flexibility, with the up-angled version having uses to follow up with awkward-launching combos. The down-angled variant is similar to down tilt, but with slightly more range. Side tilt is slightly slower to start up than down tilt, which is slightly slower than neutral attack. It's relatively safe against shields and even more so when spaced out. But you don't get much in the way of a follow-up for hitting with it, so it's best used as a safe poke against aggressive foes just past your down tilt and up tilt range.

Up Tilt: Kirby performs a scorpion kick, lifting his leg from behind him and arcing it over his head and then slightly in front of him. Kirby's up tilt is of the conventional wide-arcing variety. Its rear hitbox hits extremely early, as fast as some jabs, and launches for a guaranteed follow-up of additional up tilts (against low-damage enemies). At higher percentages, it starts to launch much higher.

Tilts

Move	Damage
Side tilt	8
Up tilt	4
Down tilt	6

Down Tilt: Kirby squashes himself half-sized and prods at the enemy's legs with a low-profiling kick thrust. Kirby's down tilt is a staple ground-based attack. It's an incredibly swift poke that can set up a quick dash-in follow-up grab/up tilt/jab mix-up. It's safe when shielded to everything but the fastest shield grabs, and reaches far enough to deter foes dashing in on you.

Side Smash: Kirby winds up and springs forward with a horizontal flying kick that launches foes up and away. Side smash deals significantly more damage at the beginning of the attack, but has a lower-damage lingering effect as Kirby moves forward. If performed next to an enemy, Kirby can pass through shielding foes, making it more difficult for them to respond with a clean punish. You can angle the attack upward or downward by inputting a side corner while charging (or instantly, while you flick the control stick). The up-angled version can be used as situational anti-air, while the down-angled version hits the smallest of crouching foes (such as a crouching Kirby).

Smashes

Move	Damage
Side smash	15
Up smash	15
Down smash	14

Up Smash: Kirby delivers a somersault kick attack that extends in front of him and arcs behind, launching enemies sky-high. It has sizable horizontal hit coverage and can hit foes in front of and behind Kirby. Although it's unsafe to throw out haphazardly, up smash is your best high-risk, high-reward attack (for staging a comeback, for instance). You can potentially KO an aggressive opponent, or at least set up your strong juggle-trap up air sequence.

Down Smash: Kirby squashes down low and performs a cyclonic sweep attack, clearing out foes in front and behind. Down smash is extremely unsafe when shielded and offers little range. You can use it to punish ledge rolls, but if you guess wrong, you're likely to be punished. The attack persists for a relatively long time.

While Kirby's grab is limited in its range, it starts up quickly, making it one of his primary damage sources (usually off of a punishing shield grab). Kirby's back throw is his Big Suplex. After pulverizing the enemy, Kirby becomes actionable in the air. Off of down throw, Kirby launches the enemy up and away. Up throw is your most effective KO throw against foes in the middle of the stage or on a higher platform level, and made even stronger if you can sneak in a couple of Kirby's lightning-fast pummels.

Grabs

Move	Damage
Grab attack	1
Front throw	5
Back throw	8
Up throw	10
Down throw	10.2

Aerial Attacks

Neutral Air Attack: While airborne, Kirby spins around with his outstretched limbs, knocking away nearby foes. Neutral air has a relatively long start-up time, but boasts a remarkably long active window and low landing lag. Thanks to its persistent hit effect and low landing lag, this versatile attack can be used to wall out foes (short hop forward into neutral air, then immediately retreat).

Forward Air Attack: While soaring through the air, Kirby performs his Aerial Spin Kick attack, a three-hit horizontal kick combo. The first two kicks can drag foes, while the last hit launches them away. Forward air is a decent air-to-ground attack with moderately low landing lag.

Back Air Attack: In midair, Kirby delivers a mighty double-leg dropkick, driving his legs behind him and knocking away foes in range. It has moderate air and landing lag, but when combined with Kirby's midair jumps, you can throw out multiple back airs.

This is particularly effective as an edge-guarding tactic. Kirby's back air starts up quickly, so use it to defend yourself as an out-of-shield short hop attack against foes behind you.

Aerials	
Move	**Damage**
Neutral air attack	10
Forward air attack	4, 3, 5
Back air attack	13
Up air attack	9
Down air attack	1.3x5, 2; Land hit: 2

Up Air Attack: Kirby does a backflip somersault, kicking out in front of him, then arcing the swing above and then behind. Like Meta Knight, Kirby can continually midair jump while buffering up air to extend combos and juggle traps. With five midair jumps, you can dish out a lot of damage from your launcher setups, or at least force a midair mix-up.

Down Air Attack: Kirby performs a multi-hit corkscrew drilling attack that hits up to six times. The first five hits can drag foes, with the final hit having a slight meteor smash effect. If he lands on the ground during the attack, he delivers a unique grounded double-sided attack that knocks foes away. Down air has a relatively long start-up time and almost double the landing lag of his neutral air, so it can be punished if you're too predictable.

Special Moves

Neutral Special: Inhale: Kirby opens his maw and sucks in nearby foes and projectiles. Foes within range of the vortex are pulled in, then swallowed by the "grab" and left struggling inside Kirby's belly. If you successfully Inhale an enemy, press Special or the down direction to absorb their powers, replacing your neutral special with your victim's (with Kirby donning a costume of his copied foe). Remove this extra ability by taunting, which sets your neutral special back to Inhale. To spit out the enemy instead of absorbing their power, use the Attack button. Kirby spits the ensnared foe as a projectile that deals damage to other fighters in its path. Inhale also works against projectiles. If you swallow a projectile, you automatically absorb it to replenish your health. Explosive items confer damage if inhaled, while items that have attributes confer the effect on Kirby, and also heal a bit of damage. There are over 70 neutral specials you can copy. For the most part, Kirby's copied special behaves identically to its owner's.

Special Moves	
Move	**Damage**
Neutral special	Swallow: 10, Star Spit: 6
Side special	Ground: 19-35, Air: 16-28
Up special	5, 2, 5
Down special	14

Side Special: Hammer Flip: Kirby pulls out a giant mallet, mustering up the strength to ignite it before unleashing a devastating swing that launches foes away. While Kirby's charging, you can move slowly and jump. If fully charged, Kirby takes self-inflicting damage. Charged-up hammer grants armor as he swings, ignoring hitstun and plowing through enemy attacks. Hammer Flip is essentially an ultimate smash attack. If you can force an opponent to shield the attack, especially at max charge, it can decimate their shield health.

Up Special: Final Cutter: Kirby whips out a sword and leaps high into the air with a rising slash before descending with a follow-up dive attack that causes a small shockwave as he touches down, launching foes hit by it up and away. With left/right control inputs, Kirby's trajectory can be slightly altered on the way up and down. Final Cutter is Kirby's main recovery special. Its high velocity and large hitbox as he's launched upward make it a strong offstage recovery tool. Kirby can't attempt a ledge grab until he begins descending.

Down Special: Stone: While grounded, Kirby performs the Stone Change. As he transforms into a Stone, he launches nearby foes up and away. When he transforms while airborne, Kirby performs his Stone Smash, slamming into the ground below him and potentially spiking foes. While Kirby's in his Stone form, he becomes resistant to attacks, ignoring weaker ones completely while taking half damage from powerful ones. Stone deals a heavy amount of shield damage (aerial Stone is particularly effective for this).

Final Smash: Ultra Sword

Kirby swings a sword that's waaaaay bigger than he is. Make sure the first swing connects with an opponent, or nothing else happens!

Link

OVERVIEW

While Link doesn't boast moves that are noticeably exceptional when it comes to speed, lag time, and mobility, he has an absurd amount of options, particularly when it comes to his projectile game. He can control and limit his opponent's safe zones, setting traps and restricting parts of the stage, giving him a strong battlefield-presence advantage. Link shines most when he's up against slow fighters with few air-mobility options, as he's most dangerous when he's given plenty of space to set up. He may struggle against fighters with fast and accessible aerial options (such as Zero Suit Samus) who can get around his trap-based projectile game.

Link's Hylian Shield (the physical shield he's holding up on his left arm) isn't there for decoration—he can block all projectiles, including bigger ones like Cloud's Blade Beam. As long as he's facing the incoming projectile with his shield up (while walking, crouching, or standing still), he blocks and totally nullifies the shot!

HYLIAN SHIELD BLOCKING MECHANICS

While pivoting (turning from one direction to the opposite direction), there's a transition period where the Hylian Shield doesn't block. While transitioning from crouching to standing, and vice versa. After dropping normal shield, there's a transition period where Link cannot block projectiles with his Hylian Shield.

Link Vitals	
Movement Options	
Jumps	1
Crouch Walk	No
Tether	No
Wall Jump	No
Wall Cling	No
Movement Ranks	
Ground Speed	D- (60)
Air Speed	D (67-69)
Falling Speed	C (36-39)
Weight	B (18-21)

Grounded Attacks

Neutral Attacks: Link's jab attack is a quick blade extension, followed by another horizontal swipe (with an increased attack size), finishing with an uppercut slash that knocks enemies down and away. As with most neutral attacks, Link's quick slashes are used to defend himself from advancing opponents. If you can read your enemy's movements and attack patterns, stick out your neutral attack to intercept them for moderate damage.

Dash Attack: While dashing, Link leaps into the air with a mighty overhead attack, smashing his sword into the ground (recognizable as his Jump Slash). Although it packs a powerful punch, Link's dash attack is one of the slowest-starting in the game. It has all the expected upsides and downsides: it has high KO potential, but leaves you incredibly vulnerable if whiffed. Using this move haphazardly can get you in trouble.

Side Tilt: Link performs a heavy wide-arc overhead attack with his sword, slamming it down into the ground, slicing foes in a large area before him. Like most side tilt attacks, Link's is one of his most effective ground attacks to use as a poke. It's decent for knocking out enemies, has reasonably low end lag, and sports excellent reach, making it a superb attack for sticking out to deter aggression (colloquially known as "walling").

Neutral Attacks

Move	Damage
Neutral attack 1	3
Neutral attack 2	3
Neutral attack 3	4

Dash Attack

Move	Damage
Dash attack	14

Defensive Attacks

Move	Damage
Ledge attack	9
Wake-up attack	7

Tilts

Move	Damage
Side tilt	13
Up tilt	11
Down tilt	9

Up Tilt: Link delivers a back-to-front slash above him with his sword, controlling a significant portion of airspace around his head. Up tilt is your non-committal, quick anti-air. Up tilt features a different attack arc in *Super Smash Bros. Ultimate*. Link now swings from the back to the front, making it a little bit safer when shielded. Hitting with the later portion (when Link swings the sword downward) can combo with an up air attack (mid to high percentages).

Down Tilt: Link crouches and swiftly performs a sweeping sword attack at his opponent's feet, knocking them into the air. This is your safest ground attack because of its low lag and great low-profiling attribute. It's also an excellent way to start combos. On hit, it pops up enemies high into the air right in front of you, allowing you to go for a forward air attack or up air follow-up. Fishing for a ledge combo-starter with down tilt is a great way to set up knockouts when the enemy is at mid to high damage percentages.

Side Smash: With a double-handed grip, Link begins this combination sequence by swinging the Master Sword over his head and toward his foe. He then delivers an upward heavy slash, knocking foes away. If Link is at 0% damage, side smash also unleashes a sword beam projectile.

Up Smash: Link launches a three-hit combo, starting with two head-level swipes above him and finishing with a mighty jump attack that sends his foe sky-high. Since there's a high commitment and vulnerability cost for going for up smash, it should be used for specific and deliberate purposes. Against descending opponents, you can often score a knockout with up smash if you either bait out an air dodge or catch them coming down without a double jump. And because Link's Master Sword has amplified hitboxes, you'll generally beat out incoming attacks.

Down Smash: Link crouches down and sweeps the floor in front of him, then swings around to sweep the ground behind. Thanks to its rear hit effect, this attack is primarily used to clear out multiple enemies and to punish ground rolls and air dodges. It's not safe on shield, making it less optimal as a poking move.

Smashes

Move	Damage
Side smash	14 + 5
Side smash 2	13
Up smash	4, 3, 11
Down smash	17

Link's grab attack is a swift pommel strike. For his up throw, Link tosses the enemy into the air before connecting a hopping up-slash, leaving them vulnerable to additional follow-up attacks. His forward and back throws are conventional knockback attacks as he kicks them away.

For his down throw, Link performs a surprisingly agile wrestling maneuver, slamming his victim into the ground before dropping a precision elbow strike into their chest that pops them up for a combo opportunity.

Grabs

Move	Damage
Grab attack	1.3
Front throw	5.5
Back throw	5.5
Up throw	7
Down throw	6

Aerial Attacks

Neutral Air Attack: Link extends a lightning-fast flying kick for a short time, striking down foes. This *Street Fighter*-like jump kick is one of Link's most versatile physical attacks. Its hitbox persists for a lengthy duration, making it an excellent air-to-air poke and fast-falling attack. Its start-up is exceptional, so you can use it as a decent jump attack just after dropping shield. You can use it offensively as well, thanks to its little end and landing lag.

Aerials

Move	Damage
Neutral air attack	6
Forward air attack	8, 10
Back air attack	5, 7
Up air attack	15
Down air attack	18

Forward Air Attack: Link jumps into the air and performs a one-handed spinning attack with the Master Sword, slashing the area in front of him twice. In *Super Smash Bros. Ultimate*, the first hit of forward air attack auto-links to the second hit when it connects with an enemy, with the second hit having most of the knockback. It has sizable horizontal range and high damage and makes for an excellent air-to-air, great for punishing ledge jumps and jump-in air dodges (thanks to its double attack animation).

Back Air Attack: Link spins around midair and delivers two rear spin kicks, one after the other, potentially connecting with both. This is one of Link's fastest air moves, excellent right after shielding an enemy's attack from behind. From a short hop, the second hit occasionally misses, especially against smaller fighters, so it's crucial that you fast-fall during the attack.

Up Air Attack: Link performs his Jump Thrust attack, a recognizable attack from *Zelda II: The Adventure of Link*. While the attack remains active for a significant duration, connecting with the first few active frames rewards you with extra damage. Link's up air attack has slightly less lag than it used to, making it less punishing to use if you whiff it, and opening up more possibilities for up air confirms.

Down Air Attack: Link commits to a powerful downward thrust (also known as the learnable skill Down Thrust, from *Zelda II: The Adventure of Link*). Primarily used as a meteor smash finisher while edge-guarding, such as off of an edge-slip combo.

Special Moves

Special Moves

Move	Damage
Neutral special	Single Arrow: 4 (12 max charge), Double Arrow: 3 (9 max charge)
Side special	Normal: 8, Flicked: 9.6
Up special (ground)	Ground: 14
Up special (airborne)	4, 2x3, 4
Down special	Bomb throw: 1, Bomb detonation: 7

Neutral Special: Bow and Arrows: Link fires an Arrow from his Bow. The longer he draws and holds his Arrow, the faster and more powerful the projectile becomes. If Link picks up a fallen Arrow from a prior shot, he can fire an extra projectile (up to two at once) the next time he shoots his Bow.

Side Special: Boomerang: Link chucks his trusty Boomerang either straight ahead, angled upward, or angled downward. The Boomerang can strike multiple enemies during its return path. There are essentially two strength versions of this attack. One is performed normally, by tilting or holding a side direction and pressing Special; and one executed like a side smash attack: by flicking the control stick to a side direction and pressing Special.The flicked version travels farther and deals more damage, while the shorter distance of the normal version means less time for the Boomerang to make its return trip.

ITEM MANIPULATION

Like Peach, Link can generate usable items for pickup (which anyone can interact with, including opponents).

Link's Bow and Arrow (neutral special) generates interactable Arrows when the Arrows are shot into the ground or a wall. While Link is holding an extra Arrow, his next Bow and Arrow shot releases an additional Arrow. Remote Bomb also generates an interactable item—one that can be detonated manually. As long as the bomb isn't being held by a player, Link can detonate the bomb to deal damage to anyone in the vicinity (including himself!).

Link's Arrows and bombs can be manipulated through the game's built-in item-interaction mechanics. You can throw and smash-throw items in various directions, from a grounded or airborne state. A key skill to learn is how to quickly pick up and release items. Details to keep in mind:

While airborne, you can instantly retrieve items without committing to an animation with the Grab command.

While grounded, you can instantly retrieve items without committing to an animation with the neutral attack command.

Up Special: Spin Attack: Link performs a pirouette with the Master Sword extended, clearing out foes around him. While airborne, Spin Attack is essentially a separate move. Air Spin Attack is a multi-hit combo that launches Link higher into the air. Note that using air Spin Attack puts you into a free-fall state, so you can't drop off a platform or ledge and use up special, then jump.

Down Special: Remote Bomb: Link creates a bomb with the Sheikah Slate. Link can carry the bomb with him, then throw and detonate it on command. The bomb's blast radius is incredibly large. Once the bomb is created, there are several ways to manipulate it. You can throw it a short distance with the Attack button or a farther distance with down+Special. You can also throw the bomb straight up into the air with up attack, or straight down while airborne with down attack. While the bomb is in an airborne throw state, it can be detonated with a down special input. Bombs also detonate after receiving a set amount of damage from attacks, and can be instantly ignited by a fire-based attack!

Final Smash: Ancient Bow and Arrow

Link shoots an Ancient Arrow that flies straight ahead. If the Arrow hits an opponent or the terrain, it explodes. While the Arrow itself can only hit one target, the resulting detonation can launch nearby opponents.

Little Mac

OVERVIEW

Little Mac has the third-fastest dash speed in *Super Smash Bros. Ultimate* and is one of two fighters with a one-frame jab (i.e., the first active hit starts on the first frame after neutral attack is pressed). As you'd expect from a boxer, Little Mac is all about the ground game. His incredible foot speed and absurdly quick ground attacks make him unrivaled in ground-based melee combat. Unfortunately for boxers, most combat in *Super Smash Bros. Ultimate* is fought in the air, so Little Mac has to work quite hard to outsmart his foes.

Little Mac Vitals	
Movement Options	
Jumps	1
Crouch Walk	No
Tether	No
Wall Jump	Yes
Wall Cling	No
Movement Ranks	
Ground Speed	A+ (3)
Air Speed	B+ (12-16)
Falling Speed	A (2-3)
Weight	D (58)

While Little Mac has a straightforward, no-nonsense fighting style, earning wins with him can be challenging. His aerial attacks are lackluster; although a few have incredibly fast start-up times, none of them are flexible in their hit coverage, so each one must be used accurately (in both your timing and spacing). He also has nearly unbreakable super armor during his smash attacks, only broken by final smashes or an opposing Little Mac's KO Punch.

LITTLE MAC: THE KO POWER METER

The Power Meter (represented by arrows) above Little Mac's fighter portrait fills up as he deals and receives damage. Once the gauge is fully charged, it becomes a flashing "KO" sign, signifying Little Mac's access to a new neutral special. While Little Mac is powered up with this KO buff, his neutral special is replaced by the KO Uppercut, a high-damage, unshieldable attack with some invulnerability.

The KO Power Meter is reset to empty if Little Mac is KO'd, even if the KO Uppercut is fully charged and ready to go. If, while the KO Uppercut is ready, Little Mac is launched into the air (by a smash attack or if he's at a high-damage percentage and gets knocked up by a strong enough attack), the KO Power Meter is completely reset. So while the KO Uppercut is an extremely powerful tool, you take a risk if you sit on it for too long. Use it or lose it!

Grounded Attacks

Neutral Attacks

Move	Damage
Neutral attack 1	1.5
Neutral attack 2	1.5
Neutral attack 3 (rapid)	0.5xN, 3
Neutral attack 3 (uppercut)	5

Dash Attack

Move	Damage
Dash attack	10

Defensive Attacks

Move	Damage
Ledge attack	9
Wake-up attack	7

Neutral Attacks: Little Mac bends the laws of physics with a lightning-fast one-frame jab, followed by a one-frame right hook. After the one-two combo, he transitions into either a rapid-fire left-right flurry attack that ends in a launching right-handed uppercut, or he completes the one-two combo with a left-handed uppercut. While these attacks are hyper-quick, they're both punishable when shielded, making them a bit risky to throw out against sharp opponents waiting to shield-grab you.

Dash Attack: Little Mac speedily runs toward his foe and delivers a heavy overhead punch to the enemy's head, sending them into the air. Dash attack packs a lot of punch for its speed, but is risky to throw out since it's easily punishable on whiff. Little Mac cannot pass through foes with it either, even at point-blank range, so you're almost always going to be shield-grabbed if the opponent is expecting some kind of ground attack and they're standing opposite from you.

Side Tilt: Little Mac lunges forward with a left straight, then follows up with a stronger right straight that launches foes away. Little Mac's side tilt is faster than some fighters' jabs while dealing side tilt damage. Its range is exceptional too, considering its incredible speed. Side tilt is one of your main attacks for checking opponents approaching you on the ground. It's one reason why Little Mac dominates the ground game. If your foes are challenging you in hand-to-hand ground combat, use side tilt to remind them why they shouldn't.

Move	Damage
Side tilt	4, 8
Up tilt	6.5
Down tilt	8

Up Tilt: Little Mac flails his right arm up above his head in a wide arc, knocking up enemies in front, behind, and above. Up tilt is one of few ways Little Mac can initiate an air combo and one of his most versatile attacks. Its hit coverage is exceptional, starting with an early hitbox in front of him and ending behind him. It's punishable when shielded, although you can mitigate this by spacing it out.

Down Tilt: Little Mac leans down and extends an extremely quick low attack, ducking under body shots while sweeping the opponent off their feet and launching them into the air. Little Mac has one of the fastest down tilts in *Super Smash Bros. Ultimate*, with a hit faster than many fighters' neutral attacks. On hit, it causes a pop-up effect. Down tilt is relatively safe and usually unpunishable when shielded.

Side Smash: Little Mac winds up as if he's about to throw a record-breaking baseball pitch, then drives a haymaker through his opponent, blasting them across the field. Side smash can be angled upward or downward. Up-angled side smash produces a powerful uppercut attach with high launch power, while down-angled side smash is a downward knee punch that deals massive damage.

Smashes

Move	Damage
Side smash	20
Up smash	21
Down smash	13

While quick side smash (no charge) is heavily punishable when shielded, if you charge it slightly, it inflicts much heavier shield-stun, making it much safer. This is effective as a ledge-guarding tool since you usually have enough time to charge it while your opponent is hanging off the ledge (or offstage trying to jump back onto it).

Up Smash: Little Mac leans back and puts all his might into his iconic uppercut punch from *Punch-Out!!*, sending foes sky-high directly above him. Up smash is the ultimate anti-air, but also incredibly risky. It's ideally used as a finisher attack, anti-air, or as an anti-ledge-jump punish. Naturally, it's incredibly unsafe to throw out haphazardly.

Down Smash: Little Mac clears out enemies from both sides with a high-powered sweeping punch. Like most of these double-sided attacks, down smash isn't safe when shielded and has a considerable amount of end lag. Although it can be used to attack ledge-grabbing vulnerability windows, this takes incredibly sharp timing.

Move	Damage
Grab attack	1
Front throw	8
Back throw	9
Up throw	7
Down throw	7

Little Mac's grab boasts impressive range (about the length of his jab), but its start time is considerably slow. His dashing grab is even slower. Front throw and back throw are used to force an air recovery and ground-game mix-up, or to finish off an enemy near a side blast zone. Up throw launches the enemy up and not too far away, but Little Mac's actionable time starts a bit too late for him to follow up with guaranteed damage. Down throw leads into the most potential damage, but overall, Little Mac's grab game is lacking.

Aerial Attacks

Neutral Air Attack: While airborne, Little Mac delivers a quick punch at a down-forward angle, causing minor damage and knockback. Little Mac's neutral air attack starts up faster than most other fighters' jabs and inflicts very little air and landing lag. It provides little functionality other than interrupting enemy moves since you can't combo off its minor knockback power. It offers a sizable hitbox, though, so it's likely to beat most moves that challenge it.

Forward Air Attack: In midair, Little Mac swings forward with a heavy hook that knocks away its target. Forward air attack has moderate air lag and landing lag, but a relatively short active window and strict area coverage. It's a lackluster aerial attack, but a necessary one in your arsenal. Your timing and accuracy need to be precise to use it effectively against airborne opponents.

Back Air Attack: Little Mac turns around midflight and backfists an enemy behind him, knocking them away. Back air is similar to forward air attack in its properties.

It has a narrow hitbox with a small active window, and a sweet-spot hitbox at the tip of the attack. While not the ideal air attack by any stretch of the imagination, it's one of few tools Little Mac has to knock out offstage foes while airborne.

Up Air Attack: Little Mac reaches above him with a skyward punch that pops enemies up. Against lower-percentage foes, up air inflicts very little launch power, leaving little room for air-juggle potential. It suffers from high air lag and moderate landing lag and, like his other air attacks, has rather limited hit coverage aimed above him.

Down Air Attack: While descending from the air, Little Mac delivers a downthrusting punch, smacking his opponent's head and causing them to flinch. Down air behaves akin to

Move	Damage
Neutral air attack	2
Forward air attack	5
Back air attack	6
Up air attack	5
Down air attack	5

neutral air attack. It's quick, but inflicts extremely minor knockback, so it's difficult to start combos with. It also has a narrow hitbox, so you have to be accurate with its spacing, ensuring that your opponent is directly beneath you when you go for it.

Special Moves

Neutral Special: Straight Lunge: While shrugging off incoming blows, Little Mac charges up for an ultra-powerful attack. When released, Little Mac drives toward his foe with an immense straight punch, blasting them away. Press neutral special to begin charging, and press it again to release. Straight Lunge direction can be altered by holding the opposite direction on the control stick while pressing Special to release the punch. The entire duration of Straight Lunge is bolstered by super armor. At max charge, Little Mac passes through foes, perhaps making him safe if they're facing the wrong way, though he's still very punishable.

Neutral Special 2: KO Uppercut: When KO Uppercut is available (after you deal and receive enough damage without being KO'd yourself), your next neutral special becomes a unique uppercut with remarkable properties. KO Uppercut is a high-damage launch attack with some invulnerability. Its unshieldable property changes the match dynamic dramatically and makes Little Mac a much more viable fighter when he has access to it. He essentially threatens a knockout anytime he's in range to connect with it. Note that once you achieve the blinking KO status buff, you can lose your KO Uppercut if you're KO'd, or the enemy successfully launches you.

Side Special: Jolt Haymaker: With his lower body invulnerable to attacks, Little Mac leaps forward and delivers an overhead flying punch that launches opponents away. Although the follow-up attack leaves you incredibly exposed and vulnerable to reprisals (on whiff and when shielded), Jolt Haymaker offers lower-body intangibility, allowing you to blow out most enemy ground attacks. But for the most part, Jolt Haymaker is best used as an offstage recovery tool and to attack enemies launched off the side of a stage.

Up Special: Rising Uppercut: Little Mac propels himself into the air with a spinning uppercut attack that sends foes high into the air. Little Mac is immediately invincible upon executing Rising Uppercut, allowing you to blow through enemy aggression. It also starts up quickly, just as fast as down tilt, making it a strong combo-extender. While Little Mac doesn't have the strongest air-combo game, you can often follow pop-up and launching effects with Rising Uppercut. Rising Uppercut offers much more jump height when performed while grounded.

Special Moves

Move	Damage
Neutral special	10 to 30
Neutral special 2	35
Side special	14
Up special	3, 1x4, 3
Down special	10

Down Special: Slip Counter: Little Mac puts his gloves up in a defensive position for about half a second. If he's attacked within this window, he becomes intangible before responding with a powerful lunging uppercut. Like most parry-into-counterattack moves, Slip Counter is a high-risk, high-reward maneuver. It's good in hectic battles like free-for-alls and team fights.

Final Smash: Giga Mac Rush

Little Mac transforms into Giga Mac and charges forward. If he strikes an opponent, he unleashes a flurry of punches, finishing with a powerful uppercut. If the initial blow misses, he simply transforms back into Little Mac.

Lucario

OVERVIEW

Lucario is a Fighting- and Steel-type Pokémon with a special Aura mechanic that boosts its combat effectiveness the more damage it receives. In terms of *Super Smash Bros. Ultimate*, Lucario's weight and movement attributes are all relatively middle-of-the-road, but with some distinctions. Lucario can crouch-crawl, cling to walls, and wall-jump. Because of the variable-heavy nature of Lucario's Aura mechanic, performing its combos and setups requires a vast amount of experience. You have to adapt to situations on the fly, considering enemy fighter weight and current damage percentage in addition to Lucario's current Aura state.

Lucario's Aura power is a persistent effect that modifies Lucario's damage output, depending on its own damage percentage. It affects every single move and makes Lucario an incredibly dynamic fighter. Simply put, the more damage Lucario takes, the stronger it becomes. Lucario's Aura multiplier maxes out at 2.5x damage when it's at 190% damage. Additionally, this multiplier is further modified by Lucario's stock differential. If Lucario is ahead in stocks, Aura's multiplier is slightly lowered. If Lucario is behind in stocks, it's raised even further.

Lucario Vitals

Movement Options	
Jumps	1
Crouch Walk	Yes
Tether	No
Wall Jump	Yes
Wall Cling	Yes
Movement Ranks	
Ground Speed	D+ (38)
Air Speed	A (6-7)
Falling Speed	B- (25-26)
Weight	C (44-47)

Grounded Attacks

Neutral Attacks: Lucario delivers a quick downward smashing punch followed by a lunging thrust punch, and finishes the three-part Shaolin combo sequence with a front snap kick. If you're outside grab range, your next-best option after blocking a laggy move is neutral attack (although prioritize grab when you can). Connecting with all three hits of the neutral attack combo doesn't net a particularly strong follow-up, but at least deals some damage and deflects aggression.

Dash Attack: While dashing, Lucario delivers a flying kick that knocks foes up and away at a slight angle. Lucario's dash is average for a fighter of its weight class and speed. The first part of the hit deals considerably more damage, but generally doesn't allow for a follow-up hit. If you hit with the tail end of the move, you can go for a combo with forward hop forward air attack if you're quick enough.

Side Tilt: Lucario delivers a thrusting palm attack with considerable force, knocking back its target. Side tilt can be slightly angled up or down with the control stick during input. Although not Lucario's fastest attack, it can be effective as an aggression check to put space between you and your aggressor. With down-angled side tilt, it's possible to catch a recovering enemy's attempt to grab a ledge, punishing them with decent damage depending on your Aura. At specific angles, you can use the up-angled version as an anti-air.

Neutral Attacks

Move	Damage (At 0% Aura)
Neutral attack 1	1.7
Neutral attack 2	1.3
Neutral attack 3	2

Dash Attack

Move	Damage (At 0% Aura)
Dash attack	6.6

Defensive Attacks

Move	Damage (At 0% Aura)
Ledge attack	5.9
Wake-up attack (faceup)	4.6
Wake-up attack (facedown)	4.6

Tilts

Move	Damage (At 0% Aura)
Side tilt	2.6, 4
Up tilt	4
Down tilt	3.3

Up Tilt: Lucario performs an anti-air leaping wheel kick that pops foes up into the air. The wheel kick begins arcing from behind Lucario and ends in front. The initial active window hits behind you. With quick start-up, it's incredibly effective for punishing shielded attacks while you're facing away from an enemy, which commonly occurs when they go for a hop attack, leaving them to your rear. Like most up tilts, it starts and extends combos. The entire active window of up tilt launches foes directly above you and, at low percentages (and low Aura), allows for at least one additional up tilt combo follow-up. In many cases, you can hit with up tilt three times before the opponent can act.

Down Tilt: Lucario crouches low to the ground and extends a ranged foot attack to its enemy's legs that knocks them away. Down tilt has the lowest amount of end lag and moderately fast start-up, making it great for poking and spacing. Unfortunately, it doesn't start combos very well, like some other fighters' down tilts. With a higher amount of Aura, it provides a decent opportunity for you to mount an offense, such as dash-in grab, short hop into deep forward air attack, and Aura Sphere.

Side Smash: Lucario leans back briefly, then lunges forward with a thrust attack, driving its palms through enemies. Side smash can be a surprisingly powerful move, especially in comeback scenarios where you're behind in stocks and damage. With high Aura, you can knock foes out of the arena earlier than you normally would be able to.

Up Smash: Lucario slinks down before launching a leaping fist attack straight up above that sends airborne foes sky-high. This attack offers an initial hit that's deceptively low to the ground.

If this hit makes contact, it pushes the foe into its second upward thrusting attack for a potential knockout. With low Aura and against low-damage foes, up smash doesn't provide adequate lift by the time you can swing again, so it's difficult to mount a meaningful follow-up attack sequence.

Down Smash: Lucario thrusts its palms outward from its sides, simultaneously knocking back enemies behind and in front. While it leaves you vulnerable, down smash hits on both sides, useful for free-for-all situations or to punish an enemy rolling past you (a ledge-rolling recovery attempt, for example).

Smashes

Move	Damage (At 0% Aura)
Side smash	10.6
Up smash	2.6, 9.2
Down smash	9.2

Lucario's grab speed is average, with above-average range. Lucario's Aura slightly influences the knockback range of its throws. Since Lucario can begin grapple-attacking its grabbed victim earlier than most other brawlers, much of your game plan should involve earning a grab. Up throw generally leads to the most damage, as it directly deals more initially while providing juggle-combo mix-up opportunities as the opponent descends from the air. Consider your Aura, enemy weight and damage percentage, and adjust your up throw follow-ups accordingly. Up throw to neutral air attack against heavier enemies at low percentages works, while up throw to up air works on most other fighters.

Grabs

Move	Damage (At 0% Aura)
Grab attack	0.9
Front throw	5.2
Back throw	6.6
Up throw	7.2
Down throw	4.6

Aerial Attacks

Neutral Air Attack: While airborne, Lucario performs a two-hit spinning attack with its Aura-infused palms, taking down other airborne opponents front and back. This two-hit attack is one of your best poking tools, but can be difficult to use effectively because of its short active windows. With accurate timing, you can mount exceptionally powerful offensive sequences if you can get the opponent to shield a deep short hop neutral air into a grab or attack mix-up.

Forward Air Attack: Lucario delivers a swift aerial front kick that pops up foes in front. Lucario is free to act incredibly early after performing forward air attack, making it one of your most flexible attacks, usable in combos, as anti-air, and in your offensive sequences. You can combo multiple forward air attacks in a row. Of course, most of your Lucario combos are highly dependent on your current Aura modifiers, but if you can adapt and adjust accordingly, you can almost always find a way to link into forward air attack off of your launchers. At the very least, you can set up juggle opportunities.

Aerials

Move	Damage (At 0% Aura)
Neutral air attack	5.3, 4
Forward air attack	4
Back air attack	14
Up air attack	7.3
Down air attack	3.3, 4

Back Air Attack: While airborne, Lucario turns around and unleashes a mighty rear backfist that blasts foes away. Back air attack is a heavy-hitting strike, and at high Aura, it becomes one of your best attacks. It threatens high shield damage and can easily knock out high-percentage enemies. It's one of your slowest aerial attacks, and its short active window can make it difficult to connect with, so it requires some premeditation and good timing.

Up Air Attack: Lucario performs an aerial half-somersault kick attack that extends directly above its head, knocking up enemies. Up air attack is primarily used as a follow-up to your skyward launching attacks like up tilt and up throw. Like Samus's up air, it's effective for damaging shields when the enemy is in a defensive posture on a platform above you.

Down Air Attack: In a gravity-defying move, Lucario halts all of its leaping momentum and executes two incredibly fast foot stomps imbued with Aura. Down air attack hits extremely quickly, making it excellent for checking and interrupting an enemy's offensive sequence. It's a strong edge-guarding tool as well, allowing you to smack down foes quickly as you meet them air-to-air while they're attempting to recover back onto a ledge.

Special Moves

Neutral Special: Aura Sphere: Lucario charges a releasable ball of energy that can damage foes while it's being conjured. It becomes absurdly powerful when Lucario's Aura is high—not only does its damage increase, but its size potentially doubles (including the size of the active charging hitbox), making it extremely difficult to avoid! Charged Aura Sphere is amazing for punishing double jumps and ledge climbs, and can potentially snipe someone's fingers lunging for a ledge in a recovery attempt. As with most charge-attack strategies, you want to play around this special as much as you can.

Special Moves	
Move	**Damage (At 0% Aura)**
Neutral special	4.6 (11.4 max charge)
Side special	Grab: 8.5, Projectile: 7.8
Up special	4
Down special	8.2

Mechanical skill plays a significant part of using Aura Sphere optimally. At higher Aura values, you can use the charging hitbox effect of Aura Sphere offensively. By jumping at an opponent and performing neutral air attack to begin charging, you use your forward hop momentum to carry your charging attack into the enemy. With proper technique, you can cancel out of your charging animation after it pops the enemy into the air, potentially scoring a combo.

Side Special: Force Palm: Lucario either fires a force of energy from its palms or grabs a nearby enemy and blasts them away with a palm attack. Force Palm's range and damage directly scale with its Aura. When used from a distance, Force Palm is a projectile-type attack (which means it can be reflected). At max Aura, its beam range is essentially doubled!

At point-blank range, Force Palm is an unshieldable throw with great launching power when the Aura meter is high, potentially knocking out foes with a single throw. Unlike Robin's Nosferatu, it can't grab airborne foes. It's best used when you've conditioned the enemy into shielding your more powerful attacks, such as your back air attack. At max Aura, Force Palm's grab attack becomes a brief cinematic as Lucario drives massive energy through its victim's chest.

Up Special: Extreme Speed: Lucario dashes through the air before crashing into foes and knocking them away. The tail end of this special recovery move can launch nearby enemies. If spaced and timed correctly, you can potentially knock out enemies. The distance Lucario flies correlates with how high its Aura is, which is a blessing and a curse. At higher Aura values, Extreme Speed can leave you incredibly vulnerable if you're not acutely aware of your Aura.

Down Special: Double Team: Lucario transitions into a countering stance, absorbing enemy attacks. Upon successfully parrying an attack, Lucario seemingly splits into several images of itself before reappearing behind the aggressor with a sliding kick that blasts them into the air. Lucario is entirely intangible during its reprisal attack. If the control stick is held in the forward position after countering an attack, Lucario reappears a set distance behind its original position, then flies forward with a flying kick attack (instead of appearing behind or in front of its original position). Basically, Lucario's flying-kick path is reversed from its default state.

Final Smash: Aura Storm

In Lucario's Final Smash, it Mega Evolves into Mega Lucario and jumps straight up, then fires Aura straight down. The angle of the Aura can be adjusted left or right. Aim for opponents to deal the most damage.

Lucas

OVERVIEW

Lucas, star of *Mother 3*, the legendary Japan-only *EarthBound* sequel, fights like Ness in certain ways but blazes his own trail in others. He also puts his brain waves to good use with PK powers, controlling fire and ice and thunder. Instead of Ness's PK Flash, Lucas controls PK Freeze, which is similar but temporarily immobilizes victims. Lucas's PK Fire travels horizontally in midair and flames out more quickly, making it more a direct shot and less a potential holding tool than Ness's downward-angled, simmering version. Lucas's PK Thunder is crucially different in that it doesn't disappear when it hits foes. No, it cuts right through them, hitting rapidly with different segments of the tail. On the ground, Lucas is more competent than Ness, with faster moves: his neutral attack, down tilt, and up tilt are some of the fastest attacks in *Super Smash Bros. Ultimate*. He does his best to imitate Ness's projectile-returning bat swing, though using a stick means it's not quite as devastating.

Lucas Vitals

Movement Options	
Jumps	1
Crouch Walk	No
Tether	Yes
Wall Jump	No
Wall Cling	No

Movement Ranks	
Ground Speed	D (44-45)
Air Speed	B (19-24)
Falling Speed	D (57)
Weight	C (40-48)

Grounded Attacks

Neutral Attacks: Lucas swings with one of the fastest moves in the game to kick off his neutral attack combo. The first poke is a quick kick that is just as fast as the quick pokes of pixies like Mario and Luigi. Tap or hold the input for a similar follow-up kick, then a stronger finishing kick that punts victims away. When blocked, the first and second kicks of Lucas's neutral attack combo leave him safe from most guaranteed retaliation. Neutral attacks as fast as Zero Suit Samus's and Mario's (and Lucas's own neutral attack kick) can hit him immediately after blocking, but anything slower allows Lucas to shield or dodge in time. So Lucas is the rare fighter that can tick with one or two neutral attacks freely, whether to set up grab attempts or to interfere with the opponent's movement and poking. Especially since Lucas's own neutral attack opener is so speedy, this means he can overpower lots of fighters in close with this kickboxing sequence.

Dash Attack: While running, Lucas swings forward with a hook palm strike that projects PK energy ahead of the hand. Max damage and knockback are achieved by hitting with the tip of this attack, aiming with the PK burst. Hitting deeper in with Lucas's arm is fine too, but deals less damage and pops the foe into a different aerial position, closer in.

Neutral Attacks

Move	Damage
Neutral attack 1	2.5
Neutral attack 2	1.5
Neutral attack 3	3.5

Dash Attack

Move	Damage
Dash attack	13

Defensive Attacks

Move	Damage
Ledge attack	9
Wake-up attack	7

Side Tilt: Lucas swings quickly with a backhand slap that produces a short-lived PK blast. Damage and knockback are highest within the PK blast, with Lucas's arm dishing out a lot less. In particular, max-range side tilt flings enemies away almost like a mini smash attack at medium percentages, while a point-blank hit leaves them right by Lucas.

Tilts

Move	Damage
Side tilt	11
Up tilt	1.5, 8
Down tilt	5

Up Tilt: Lucas flips heels-over-head for an upward-striking kick. As he inverts, Lucas strikes out to both sides with his fists, giving him extremely rapid lateral coverage. If you're close to someone on the ground, up tilt always hits. If they don't shield or dodge, they'll be carried into the upward-aimed kick to find themselves launched. Against viable targets in low-altitude airspace, the upward-kicking finish is great on its own, hitting as anti-air as fast as any other up tilt, even though this one has an earlier side-hitting portion.

Down Tilt: Lucas pokes with an extremely fast, low kick. Lucas's profile isn't too small for a crouching attack thanks to his big head, but with a move this fast, it's no big deal. If shielded, down tilt is totally safe from guaranteed retaliation. At upper-low to medium percentages, around 20-50%, down tilt will combo into itself on grounded enemies, and also into neutral attacks. In fact, in that damage range, down tilt x2, neutral attack x3 is a real combo that ends with enemies kicked away!

Side Smash: Taking after Ness, Lucas goes for a serious home-run swing with his side smash. The only catch here is that Lucas doesn't have Ness's home-run bat! Lucas uses a humble stick instead. This reduces the power compared to Ness's, but still has an invincible, projectile-redirecting hitbox, and tremendous knockback on a successful hit. It's also faster to hit than Ness's bat swing.

Up Smash: This unusual up smash is almost more like a special move. After a *long* windup period, during which he hunches and gathers tremendous psychic energy, Lucas rises and spreads his arms upward, sending a big PK vortex straight up. When Lucas spreads his arms, there's a momentary hitbox on either side of his body on the ground, which pops anyone in the way off their feet.

This carries them into the main event, the upward-aimed PK blast. It starts out strongest right when Lucas releases it, and diminishes in power bit by bit as it floats up.

Smashes

Move	Damage
Side smash	15-21
Up smash	2, 21-2.8, 29.4
Down smash	17-23.8

The PK blast eventually dissipates once it reaches jump altitude—that's right, it keeps going past short hop height.

Down Smash: Down smash starts with Lucas leaning back, before reaching forward to aim finger guns at the ground directly in front of his feet. Where he points, a PK blast emerges. Ultimately, Lucas pantomimes shooting at the ground three times, creating three consecutive PK blasts. The initial attack of down smash doesn't hit for a third of a second, even uncharged. The follow-up blasts hit quickly thereafter, keeping an active hitbox in front of Lucas for about another third of a second. Like up smash, this is a very laggy attack.

Lucas's grab is a special tether grab that puts Rope Snake to good use. It means his grab speed is below average, like most fighters with grappling tools, but that's a small price to pay if you use the attack from max range. His ultra-fast attacks like neutral attack, down tilt, and point-blank up tilt give him plenty of tools to pressure people quickly, making them more susceptible to a "slow" grab attack.

Both his front and back throws are noteworthy for their powerful pushback. They're great for pushing foes toward a desired stage edge, or for going for outright KOs when their damage is built up to dangerous levels. Up throw flings them straight up with PK power, putting them in position for immediate follow-up attacks. Down throw plants them in the ground briefly, before they're ejected forward into a lower juggle position.

Grabs

Move	Damage
Grab attack	1.3
Front throw	10
Back throw	10
Up throw	10
Down throw	11

Aerial Attacks

Neutral Air Attack: Lucas seems to almost intentionally lose control of himself while jumping, tumbling vertically while PK blasts shimmer around him. He cuts loose with three weak pulses while flipping before finishing with a stronger blast that knocks victims away. Whether the target is flipped forward or backward depends on whether Lucas is flush pushing against them or farther away, grazing them with the edge. If you can either predict or react to the direction they'll get tossed, you can pursue foes after a successful neutral air attack.

Aerials

Move	Damage
Neutral air attack	2x3, 4
Forward air attack	12.5
Back air attack	12
Up air attack	11
Down air attack	3.5x3, 5

Forward Air Attack: Flying through the air, Lucas sticks out a frontal one-legged jump kick. This air move isn't particularly fast for an air poke, so make sure you have time to stick it out. There's another reason for making sure you have good clearance before poking with forward air attack. His leg itself can hit, but the sweet spot on the move is actually beyond the foot, where the PK blast appears. Aim with that blast when using this attack, since the damage and knockback are much higher. If you hit with Lucas's leg closer in, there's barely any pushback, and foes might fight back immediately, air or ground.

Back Air Attack: Lucas spins backward with a downward-slashing kick. The hit starts out aimed up-back, then swings lower, ending aimed almost straight down on the final hitting frames. Like most other Lucas pokes, this extends an invulnerable PK blast ahead of Lucas's vulnerable limbs. Unlike other Lucas pokes, the damage and knockback here are highest if you hit squarely around his knee, not with the PK blast (and not closer in, with his hips).

Up Air Attack: Lucas swings his head upward for a launching anti-air headbutt. The initial hitbox gives a little bit of coverage in the up-back direction, but is mostly aimed straight up. As he sweeps his head forward, the attack shifts forward slightly, but is still mostly aimed up. This move is primarily for attacking airborne enemies above, or foes standing on higher-level platforms. It's also a great option when juggling helpless enemies from underneath. Though the side hitboxes don't cover laterally like some headbutting up air attacks, Lucas is small, so this can be used as a last-moment jump-in falling at foes on the ground.

Down Air Attack: Stomping downward, Lucas kicks four times, with three weaker kicks preceding a heavy meteor smash hit. This move's active period, with four attacks, stretches over a third of a second. This makes it easy to score hits with any part of down air attack, but hard to score *all* the hits. Even using it just off the ground with short hops right next to a foe, the last hit will usually fail to hit before Lucas lands again. And the last hit is the one you want; the rest are just prelude. Get used to the timing so you can aim for hitting the last kick, and consider any earlier kick hits a nice bonus. If you can allow for the lag before the important final kick, this is another powerful spiking move, good used alongside back air when chasing recovering foes before they return to safety.

Special Moves

Neutral Special: PK Freeze: Lucas guides an orb of icy energy like a slow mortar, detonating it on command. Holding the input and steering with left or right guides PK Freeze. On button release, the icy energy crystallizes, dealing heavy damage to anyone close enough while freezing them, if they fail to shield it. The longer PK Freeze travels before the freezing hit, the higher the damage. PK Freeze makes a great part of Lucas's projectile-harassing game plan, especially since it gives him an avenue to rush in and transition to close-range offense if foes are frozen solid for a moment.

Special Moves	
Move	Damage
Neutral special	10-23
Side special	3, 7
Up special 1	2.5, 0.8xN
Up special 2	5, 2x5, 1.5x5, 10
Down special	8

Side Special: PK Fire: Whether in the air or on the ground, Lucas throws a small bolt of fire energy straight ahead. This initial shot is low-damage, but blossoms into a powerful flame attack on a clean hit. If the enemy shields it, it simply fizzles out, with no big explosive payoff. This is lower-commitment than Lucas's other big projectile attacks, which can occupy much more of his time if you charge and guide them. PK Fire is simply fire-and-forget. With a manual short hop and immediate PK Fire after leaving the ground, you can throw a horizontal fire projectile that catches all but the smallest fighters' heads (watch out for fighters like Pikachu and Luigi craftily crawling under ground-level shots), while providing more mobility than throwing PK Fire on foot.

Up Special: PK Thunder: Using PK power, Lucas summons and directs a snake of lightning. PK Thunder can be steered with the control stick. It disappears if it hits a solid surface or object. While Ness's version is a single-hit projectile that ceases to be once it hits something, Lucas's is a multi-hit version that can cut through multiple foes without vanishing. The head of the lightning snake hits hardest, with lighter hits making up the tail. This gives Lucas's PK Thunder a slightly different flavor as a ranged harassment tool, since you can drag it back and forth across several enemies, scoring lots of hits, instead of threatening with Ness's single-target all-or-nothing hit.

If you steer PK Thunder into Lucas, he's launched at high speed as a super-powerful projectile. He doesn't take any damage, but anyone in the way is in trouble. Electrified, Lucas dishes out rapid hits on a long path, dragging anyone he catches along for the ride. If you score a direct hit and carry the victim through the full duration, they take 32.5% damage, while being launched a long distance!

Down Special: PSI Magnet: Like Ness, Lucas can absorb incoming energy shots, converting them into health. Lucas's PSI Magnet is centered on his hand, as opposed to Ness's being centered on his body, so Lucas's absorption move has a little more reach to the front. Lucas keeps the field going as long as you hold the input. The move ends upon button release.

Aside from absorbing enemy energy shots, PSI Magnet also has use as a momentum stopper. When Lucas activates it, he briefly slows his falling speed in midair. This can aid his offstage game, adding unpredictability. Instead of doing the obvious thing everyone knows you're going to do, which is to use PK Thunder at some point to rocket back toward a handhold, you can "flicker" PSI Magnet one or twice, delaying the timing of your thunderous return to the stage.

Final Smash: PK Starstorm

With old friends Kumatora and Boney by his side, Lucas joins their psychokinetic forces together for a stunning meteor shower. The impactors fall randomly from above, but you can urge them to drift this way or that by holding left or right on the control stick.

Luigi

OVERVIEW

Mario's brother brings his own spin on their brawling style. The taller Luigi has longer range on attacks and more hang time during jumps than Mario. He's also a slippery customer on defense, with extra pushback when shielding attacks, and the ability the crouch-walk backward or forward, which is capable of dodging underneath threats with the low profile. His down taunt is a woeful-looking little kick that's actually capable of launching anyone it hits into prime juggle position. Luigi has many other moves that distinguish him from his bro. Green Missile is a strong lateral torpedo attack with its own small chance to explode with unexpected momentum. His grab puts his Poltergust pack to good use, giving the grab exceptional reach, at the cost of speed. Fireball, Green Missile, and dashing grab attempts allow Luigi to attack comfortably from midrange, and his fireball is better at covering short hop airspace and interfering with offstage recovery than Mario's.

Luigi Vitals

Movement Options	
Jumps	1
Crouch Walk	Yes
Tether	No
Wall Jump	No
Wall Cling	No
Movement Ranks	
Ground Speed	D (46)
Air Speed	F (75)
Falling Speed	D (64-65)
Weight	B- (30-31)

Grounded Attacks

Neutral Attacks: Luigi jabs with a one-two punch combo before following up with a playful flying backside bump. Up close, simply holding down the Attack button produces the full three-hit combo. From afar, holding down Attack results in a flurry of whiffs jabs. Luigi's first punch is shockingly fast, just as quick as his brother's jab, one of the very fastest attacks in *Super Smash Bros. Ultimate*. Its primary purpose is to quickly punish foes up close. When you've blocked someone's point-blank attack, release the Shield button and hold down neutral attack to fight back instantly with this combo. (Be sure to drop the shield first, or Luigi leaves shield-stun with a grab attempt instead, produced by the Shield and Attack buttons together.)

Dash Attack: Luigi lashes out with one of the fastest-hitting dash attacks, a series of five goofy slaps as Luigi lurches to a halt. This is a great sudden lateral attack, and can even combo right after Luigi's down tilt pokes (though the execution is tough).

Neutral Attacks

Move	Damage
Neutral attack 1	2
Neutral attack 2	2
Neutral attack 3	4

Dash Attack

Move	Damage
Dash attack	2x4, 4

Defensive Attacks

Move	Damage
Ledge attack	9
Wake-up attack	7

Side Tilt: Luigi swings a leg out front for a stout side kick. Like with Mario's side tilt, this kick can be angled slightly up or down, but don't use a 45-degree diagonal input or you'll produce an up/down tilt instead. Side tilt reaches about as far as side smash. It's not as fast to hit as Luigi's neutral attack, but it's much faster than side smash when ground-sparring. Use it from the edge of its range, since having it shielded up close leaves Luigi open to guaranteed punishment.

Up Tilt: Luigi swipes upward with a vertical punch. It's aimed just above his head, so it's great for low-altitude juggles and anti-air. It also has a bit more reach directly in front of him than Mario's up tilt, so it won't miss against close fighters who are small or crouching. At medium-damage percentages (between 30% and mid-60%s), up tilt pops grounded challengers up perfectly for you to immediately combo several more up tilt uppercuts in a row!

Tilts

Move	Damage
Side tilt	9
Up tilt	6
Down tilt	5

Down Tilt: Luigi turns slightly to poke at the opponent with his back leg at floor level. It hits with the same speed as side/up tilt, a bit slower than his blazing-fast neutral attacks, but still faster than smashes and specials. Like most moves that don't launch or floor targets, at low to medium-damage percentages (under 60%) this foot kick has a small chance to trip opponents, knocking them onto their seats for a second. At higher percentages, it simply knocks them a short distance away.

Amazingly, Luigi retains advantage when down tilt is shielded, so not only is he safe from punishment, but he can also take initiative to keep up his attack. This makes dash-in down tilt a safer (if marginally slower-to-hit) rushing tactic than dash attacks or dash-in neutral attacks.

Side Smash: Luigi builds up tension with one hand out, palm upturned. Whenever the smash attack is released, he strikes with his arm extended straight ahead. Hold Up or Down before release, and Luigi directs his hand diagonally up or down, which can make a difference depending on the angle of targets. Side smash is most effective when edge-guarding against a predictable opponent trying to recover from offstage. It's also great when following up down tilt hits, which combo into uncharged side smash at low percentages.

Smashes

Move	Damage
Side smash	15-21
Up smash	14-19.6
Down smash	15-21

Up Smash: Luigi rears back for up smash before delivering a fierce headbutt that covers back, above, and front angles. Like Mario's up smash, this hits earliest (and with the most reach) directly behind Luigi, and slowest in front of him. His head has intangibility during the attack, making the upward-pointed part of the headbutt an excellent anti-air. Since up smash covers three directions, it's a decent clear-out move when you're surrounded or unsure where threats will emerge from. It can be used to catch floating foes too, to keep juggles going.

Down Smash: Luigi falls to the ground and spins with one hand planted, swinging his leg first in front and then behind him. It's sort of like Mario's down smash—a kick that covers both sides—but not exactly. Luigi lacks the graceful breakdancing posture of his brother, and the first part of the kick is a tiny bit slower to hit. However, Luigi's kick has the same power on both sides, and he can link the forward-facing kick immediately after down tilt pokes.

Luigi uses one of his Poltergust's attachments to augment his grab attempts. Instead of reaching for foes with his hands, he launches a suction cup to reel them in. This suction cup travels about as far as a dash. Where most brawlers have to dash and grab from a few steps away, Luigi can just start up his grab. Luigi's special grab can also be started out of a dash for even more reach. The only catch is that the suction cup is much slower to snag targets than most grab moves. From the edge of the suction cup's reach, it's even worse, taking just short of *four times* as long as Mario's point-blank grab. Of course, when you account for the fact that Mario must dash or run before grabbing to cover the distance, the disparity isn't quite so big. Still, the point is that Luigi's grab speed is far below average, so keep that in mind when fishing for throws.

Luigi can't grab in midair, but he can use his suction cup Poltergust attachment as an aerial poke. Produce it with a grab input in midair (whether a button assigned to Grab, or Shield+Attack) for a base damage of 5.

Aerial Attacks

Neutral Air Attack: Luigi's neutral air kick is fast, short-range, and deals max damage with the immediate thrust, but it stays out for a long time after activation. This makes it a great kick for controlling airspace, since you can kick out above foes, then fast-fall into them with the latter part of the move. The initial thrusting hit is by far Luigi's fastest air attack; neutral air is so fast that it'll link after forward air against airborne victims. Above medium-damage percentages, neutral air starts launching victims straight up on contact, meaning any connected neutral air can start or perpetuate a juggle combo. This is great for midstage juggles and aggressive air-kicking. Out over the edges of the stages, though, popping enemies higher isn't what you want, so use back air attack and down air attack when chasing enemies offstage.

Aerials	
Move	Damage
Neutral air attack	12
Forward air attack	8
Back air attack	14
Up air attack	11
Down air attack	10 Meteor smash on sweet spot hit.

Forward Air Attack: Luigi swats forward with a surprisingly quick slap. He finishes this move faster than any other air attacks, allowing for quick follow-up actions and even aerial combos. For example, you can usually link neutral air attack after you hit an airborne opponent with forward air attack (producing neutral air's upward launch effect if damage percentage is high enough, leading to even more potential air hits). At certain angles, you can go straight from forward air attack to up air attack for a juggle combo, too.

Back Air Attack: Luigi sticks out both legs behind him in a dropkick just like Mario's. It has similar applications, for quick and reliable poking at targets behind him. Reverse-rush techniques allow for aggressive use of this move, rather than just reactionary use when approached from behind while airborne. Luigi spends more time in the air along an arc that springs up with faster acceleration but descends more leisurely than Mario. His ability to stick back air out toward the enemy repeatedly as a deterrent or rushing tool is slightly less snappy than his brother's.

Up Air Attack: Luigi whirls backward, kicking upward, covering angles in front of and above him. Surrounding coverage is less thorough than you might expect. Up air attack has the usual use, swinging for challengers directly above, and going for juggle follow-ups after up/down throws.

Down Air Attack: Luigi sticks his feet out at a sharp downward angle while twirling. Despite the spin, down air attack is a single-hit attack. Luigi's feet are aimed almost straight down; although they can hit a target slightly off-center, the most damage is dealt by hitting squarely from above.

Special Moves

Neutral Special: Fireball: Luigi throws a glowing green projectile that tumbles in small loops straight ahead. If it hits a horizontal surface, like a wall or tilted platform, it ricochets backward (though don't worry, it won't hurt Luigi on the backbounce). Luigi's green fireball doesn't last quite as long as Mario's, but it does a little more damage and is a bit more potent for edge-guarding, or for defending low-altitude airspace. Hop and toss a low-altitude fireball, and you've temporarily covered the short hop/fast fall airspace for advancing aggressors.

Side Special: Green Missile: Luigi builds up tension before launching himself forward as the projectile. Uncharged, there's mild variance in how much this move does, either 6.1 or 9.5 damage. This move can be charged quite a bit, with a wide variance in damage dealt and distance traveled. Like with Super Jump Punch, there's a brief intangibility period around the initial active hitting period. The rest of the rocketing attack lacks special defensive properties, but Luigi's noggin remains a projectile threat during forward momentum.

With variable attack timing (depending on how long you charge) and far horizontal travel, Green Missile is perfect for launching Luigi into preoccupied groups and for recovering when knocked offstage. Obviously it won't help if you've already descended too far, but if you're out over a pit with some altitude and a double jump left, double-jumping before Green Missile (or, if height permits, air-dodging up-forward, then launching sideways with Green Missile) can cover a lot of lateral ground.

Special Moves	
Move	**Damage**
Fireball	6 close, 5 far
Green Missile	6.2-9.5-21 (or 25)
Super Jump Punch	25 (sweet spot) or 1 (otherwise)
Luigi Cyclone	2x4, 4

Because it's Luigi, Green Missile has a few catches. Charge too long and he'll shrug, exhausted and vulnerable. It's easy to tell how long is too long, thankfully; once the gathering energy waves disappear, he's fully charged, with a split-second left before exhaustion. If a horizontal surface is in –rocketing Luigi's path, there's a chance he'll become stuck, embedded like his upper body is a nail in a block of wood. Again, vulnerable.

Up Special: Super Jump Punch: Luigi erupts almost straight upward with a walloping punch. While it hits all the way up, the only good spot to aim is right in front of Luigi, flush against him. Any kind of glancing hit besides point-blank results in pathetic damage and knockback. Since Luigi ends his version of Super Jump Punch by floating helplessly down into significant landing lag, he's almost certainly going to get punished for missing a square hit.

On the other hand, if the target *is* right up close, Super Jump Punch deals very heavy damage and knockback, with a stylish zoom-in effect on impact. This can even work in juggle combos, if you jump and position perfectly flush against the floating target before catching them with up special.

As for recovery, Super Jump Punch only saves Luigi if he's directly below a desired ledge. He'll grab a ledge at the end of his travel, but if he misses a handhold, he really doesn't have much lateral drift to save him.

Down Special: Luigi Cyclone: This is a higher-octane version of Mario's down air. "Green Thunder" whips himself up into a little vortex, during which he can be steered a bit left or right. Luigi Cyclone has a short-range suction effect, subtly pulling in opponents who get too near the brief current. Especially when steering the tornado their way, this helps bear down on targets nearby. Luigi is also briefly invincible just before he starts actively spinning, giving the initial hit some extra brute-force power. Anyone pulled in is hit multiple times in the blender before being launched skyward by the final spin. There will be plenty of chances to steer Luigi Cyclone aggressively into groups of enemies on the ground, or to start it up under tumbling airborne targets.

Final Smash: Poltergust 5000

Collect a Smash Ball for a chance to unleash the full capability of the Poltergust pack, pulling in items and opponents within a wide circumference. Anyone sucked in is ejected shortly thereafter, naturally the worse for wear and potentially hurtling into a dangerous position. The more enemies nearby, the better, when activating this move.

Mario

Mario Vitals	
Movement Options	
Jumps	1
Crouch Walk	No
Tether	No
Wall Jump	Yes
Wall Cling	No
Movement Ranks	
Ground Speed	C- (31-34)
Air Speed	B+ (12-16)
Falling Speed	C- (49-51)
Weight	B- (27-29)

OVERVIEW

This is Mario, humble star of a famous video game or two. He's back from his globe-trotting sojourn in *Super Mario Odyssey*, ready to take on all challengers. His diminutive size and seemingly short reach compared to many fighters shouldn't make you worry about his combat effectiveness. Mario careens around the battlefield like a little cannonball, moving safely with terrific aerial attacks and sparring in close with some of the quickest attacks of any brawler.

Grounded Attacks

Neutral Attacks

Move	Damage
Neutral attack 1	2.2
Neutral attack 2	1.7
Neutral attack 3	4.0

Dash Attack

Move	Damage
Dash attack	8

Defensive Attacks

Move	Damage
Ledge attack	9
Wake-up attack (faceup)	7
Wake-up attack (facedown)	7

Neutral Attacks: Mario's neutral attack is a lightning-fast short-range jab, one of the fastest attacks in the whole game. Hold the Attack button (or press it repeatedly) for a three-hit combo, a one-two punch followed by a rising boot kick that knocks victims back. Anytime you shield a laggy attack that leaves Mario close to his aggressor, hold down the Attack button for an easy and quick combo.

Dash Attack: Mario crouches from a forward run or dash into a sliding kick. The kick's slide distance and hitbox aren't huge, but on contact the kick launches foes into potential juggle position.

Side Tilt: Mario wheels around with a mighty side kick. Angle the stick slightly up or down when pressing Attack to aim higher or lower. The damage is the same for any angle, but a straight side tilt has the most range by a tiny margin.

Tilts

Move	Damage
Side tilt	7
Up tilt	5.5
Down tilt	7

Up close, opponents who block side tilt, then retaliate immediately with a fast attack or grab punish Mario before he can shield or dodge. Poke with side tilt from the edge of its range, where the kick's pushback leaves Mario safe from punishment.

Up Tilt: Mario swings upward with a punchy uppercut, spinning himself around in the process. Mario's shortest-range punch isn't very effective against opponents on the ground, and may even whiff at point-blank range against short or crouching opponents. A defender who blocks isn't pushed back at all, and can grab Mario or hit him. That said, up tilt is great for poking ground-to-air at jumping targets. It's also a good move for juggles. At medium-damage percentages, simply hitting an enemy up close with up tilt may allow you to juggle with several more right after (or to transition into juggling with Super Jump Punch, or short-hop down air attack).

Down Tilt: Mario crouches with a sweeping front kick. With the low profile, this move can avoid attacks aimed higher. In terms of reach, this low kick outranges neutral attacks, but doesn't reach as far as side smash or side tilt.

Side Smash: Mario rears back a little bit, then punches forward with a fiery close-range blast. This is his farthest-reaching smash, dealing full damage. If this move strikes closer in, with Mario's actual limb, it deals less damage and knockback (and is much less safe from a quick counterattack). Tap for a quick flaming punch, or hold it to begin charging. While charging, aim up or down with the stick.

Smashes

Move	Damage
Side smash	17.8-24.9
Up smash	14-19.6
Down smash	10-14/12-16.8

Up Smash: Mario leans way back, then whips his head forward in a chopping half-circle. Up smash couples with down smash to provide clear-out options, covering multiple angles. Up smash covers three vectors for Mario, striking first behind him, then above, and finally right in front.

It can fulfill any role along that path, poking behind Mario, juggling or anti-airing airborne adversaries, and swatting in front.

Down Smash: A more powerful variant to Mario's down tilt kick, and a two-sided complement to the arching punch of up smash. Mario lies low and kicks hard first to the front, then behind. The first kick hits as fast as Mario's tilt attacks, so it's easily his fastest and most reliable smash attack. The backward-striking kick is slower and does slightly more damage.

Grabs

Move	Damage
Grab attack	1.3x1-5
Up throw	7
Front throw	8
Back throw	11
Down throw	5

Mario's grab snags the opponent quickly. Defensively, his grab is up there with holding neutral attack for an immediate counter. Offensively, dashing grabs make great counterpoints to side tilts and dash-in pokes.

Of Mario's throws, back throw deals the most direct damage, while throwing the victim the farthest. It can even hurt other combatants, if they're nearby! It's up throw at low-damage percentages that has the most potential, since you can catch the floating foe with several up tilt juggles in a row as a follow-up.

Aerial Attacks

Aerials	
Move	Damage
Neutral air attack	8
Forward air attack	14
Back air attack	10.5
Up air attack	7
Down air attack	1.4x5, 5.5

Neutral Air Attack: Mario juts one leg forward with a flying kick that stays active for days. It's ideal for hopping or jumping forward, kicking with neutral air at the apex, then fast-falling. This covers a long swath just before and below Mario, and he recovers quickly upon landing.

Forward Air Attack: While moving forward in midair, Mario whirls forward with a walloping overhand punch. Strike with the right spot of the attack to spike the victim down in a meteor smash effect, launching them sharply downward.

Up Air Attack: Mario spins backward with an airborne wheel kick that covers upward angles. Other fighters scampering on platforms or leaping above are prime targets. Popping someone up with up throw, a smash attack, or a forward air attack spike can give chances to juggle with up air. If enemy damage is high enough, it starts being a KO threat on hit.

Back Air Attack: Mario puts his whole body into a flying sideways dual-boot kick. Back air is more powerful than neutral air, though it doesn't stay active as long. It's much easier to aim with than forward air attack, though it doesn't hit as hard.

Down Air Attack: Mario whirls in a spinning lariat before popping into a clothesline swat to both sides. This can hit up to five times, before the finishing punch launches the victim away. A signature move for Mario, down air adds to his multi-hit potential along with Super Jump Punch. It hits a little higher than his lower-angled kicks, but is still fantastic air-to-air or air-to-ground if well-aimed.

Special Moves

Special Moves	
Move	Damage
Neutral special	5 close, 4 far
Side special	7
Up special	5.0, 0.6x5, 3
Down special	0

Neutral Special: Fireball: This classic fireball toss projectile travels forward for just over one second before dissipating. Released in midair, it travels diagonally down-forward until it hits a platform, then starts bouncing. Thrown on solid ground, a fireball bounces three times before vanishing. Mario can throw another fireball while one is already out, putting two on-screen at a time.

Side Special: Cape: Mario whips out a cape and swings it before him. Incoming projectiles and items can be reflected with a deft swipe. Any opponents hit by the cape take a little damage while getting turned around and having their controls momentarily reversed! If a cape swing is performed in midair, Mario's falling momentum is halted briefly during the swing (with diminishing returns during the same airborne period).

Up Special: Super Jump Punch: Mario springs upward with the jumping punch he's honed since time immemorial, ideal for busting brick blocks or knocking upstart challengers out of the way.

Catch someone with the beginning of Super Jump Punch's rise, and Mario carries them upward, scoring several hits as coins spew noisily out of the victim.

Like most up special moves, one of Super Jump Punch's vital functions is a kind of triple jump, giving Mario another option to save himself when ejected off the side of a stage. Super Jump Punch hits quickly up close, faster than any of Mario's tilt attacks and only a tiny bit slower than his neutral attack. It also has a period of intangibility starting for a few frames right after it hits but before Mario springs upward.

Down Special: F.L.U.D.D.: Mario's water cannon must be charged before use to refill the water tank. If bogeys are inbound while Mario is charging F.L.U.D.D., tap left or right to dodge-roll out of the charging stance, potentially avoiding harm. The next time you input down special after that, Mario sprays the water at high velocity. Input up or down to direct the spray. F.L.U.D.D.'s water jet deals no damage but has a powerful pushback effect!

Final Smash: Mario Finale

Imbued with the power of the Smash Ball, Mario is ready to unleash his most powerful attack with a neutral special move input. Upon activation, Mario fries almost one half of the screen (whichever direction he's facing) with an enormous gout of swirling flames. Mario finale is capable of striking multiple targets over a dozen times each, possibly scoring several KOs at once.

Marth / Lucina

Marth / Lucina Vitals	
Movement Options	
Jumps	1
Crouch Walk	No
Tether	No
Wall Jump	No
Wall Cling	No
Movement Ranks	
Ground Speed	C+ (21-22)
Air Speed	C+ (39-39)
Falling Speed	C (40-43)
Weight	D+ (50-52)

OVERVIEW

Marth's general game plan is to create danger zones around him with his wide array of far-reaching sword attacks. His effective attack range protects most of his angles, but while he excels at deterring enemies from approaching him, his effective hitboxes can and should be applied aggressively. With well-timed full and short hop jump attacks, Marth can be a deadly force of nature on both offense and defense. Once you condition your foes into constantly shielding your overwhelming airborne sword attacks, your game plan should alter into a much more aggressive style, baiting the enemy into dropping their shield, or straight-up breaking it and going for high-damage Dancing Blade combos. Marth and Lucina have identical attacks and moves, but differ in their damage output. Marth's attacks have sweet and sour spots, while Lucina's attacks are balanced across her sword. Marth hypothetically deals more overall damage, including higher shield-breaking potential since you're rewarded for your improved sweet-spot accuracy. However, you can apply the same strategies to both fighters.

SWEET AND SOUR DIFFERENCES

Marth and Lucina have identical attacks and moves, but differ in their damage output. Marth's attacks have sweet and sour spots, while Lucina's attacks are balanced across her sword. Marth hypothetically deals more overall damage, including higher shield-breaking potential since you're rewarded for your improved sweet-spot accuracy. However, you can apply the same strategies to both fighters.

#1 WALKERS

Marth and Lucina are tied for having the fastest walk speed in the game, allowing them to use their tilt attacks more consistently.

Grounded Attacks

Neutral Attacks: Marth	
Move	Damage
Neutral attack 1	5
Neutral attack 2	6

Neutral Attacks: Lucina	
Move	Damage
Neutral attack 1	3.3
Neutral attack 2	4.8

Neutral Attacks: Marth quickly lashes out with a backhanded slash, then follows with an inward swipe, knocking away enemies to midrange. Neutral attack, or "jab," is Marth's fastest strike and is primarily used to interrupt enemy aggression. Its effective attack area (its hitbox) is relatively large for such a fast attack, and although you don't get any kind of guaranteed follow-up (jab 1 doesn't pop up standing foes), it's one of your best defensive punishers, against whiffs or right after dropping shield.

Dash Attack: Marth

Move	Damage
Dash attack	12

Dash Attack: Lucina

Move	Damage
Dash attack	10.9

Defensive Attacks

Move	Damage
Ledge attack	9
Wake-up attack	7

Dash Attack: While dashing, Marth uses his momentum to deliver an outward horizontal swipe attack that launches foes, dealing more damage if he hits with the tip of his blade. If spaced properly, Marth's dash attack is incredibly dangerous. It deals high damage with high launching power if you can hit with the outer edge of the attack. You're doubly incentivized to space it out to hit at max range since it's a bit safer when shielded.

Side Tilt: Marth delivers a defensive midrange upward cut, slashing away enemies. This ground attack is one of your staple universal attacks, suitable for a variety of situations. You can use side tilt to zone out both grounded and airborne enemies, punish laggy attacks, and to knock out high-percentage enemies.

Up Tilt: Marth swings his sword high above him, creating a no-fly zone and cutting down airborne foes within reach. Up tilt is one of your fastest ground attacks. It features an amazing effective attack area, with incredible vertical reach. While it's designed to clear out the space above you, it's versatile enough to be used in certain defensive attack scenarios. Up tilt even has a rear hit effect in case you need to immediately hit an enemy behind you.

Tilts: Marth

Move	Damage
Side tilt	12
Up tilt	9
Down tilt	10

Tilts: Lucina

Move	Damage
Side tilt	11
Up tilt	8.1
Down tilt	8.5

Down Tilt: Marth crouches low to the ground and quickly thrusts at the enemy's feet. This low-profile attack is Marth's safest ground poke. He becomes difficult to hit because of his crouching animation, and when shielded, the attack is relatively unpunishable. It makes for a superb edge-guarding attack against hanging opponents, as you can quickly poke at the ledge from a distance, forcing out mistakes.

Side Smash: Marth smashes his sword down with a powerful overhead swing in front of him. The tip of the blade has astounding launching power, but can be difficult to connect with. Side smash is an absurdly powerful punish attack—not only does it deal a ridiculous amount of sweet-spot damage, but it's also one of the fastest forward smashes in the game (along with Pit's and Samus's)!

Up Smash: Marth forcefully thrusts his sword straight into the air above him, causing a small upward force around his lower body that propels foes into the air. This high-risk, high-reward kill move has a unique lower hitbox around Marth's feet that, on hit, deals minor damage but throws enemies hit by it into Marth's extended sword.

Down Smash: Marth sweeps the floor and clears out nearby foes with front and rear blade attacks. While it's unsafe and easily punishable, down smash has a relatively fast start-up time and can occasionally be used right after blocking for retaliation. But for the most part Marth's down smash should be left out of your neutral-game arsenal. Down tilt is simply much safer, faster, and more effective.

Smashes: Marth

Move	Damage
Side smash	18
Up smash	17
Down smash	12

Smashes: Lucina

Move	Damage
Side smash	15
Up smash	14.3
Down smash	9.5

Marth's grab is conventional, with a quick start-up and solid range. It's about the same speed as his neutral attack, so they can be used in similar situations (they're both great options immediately after you block). Marth's grab attack is a knee strike. His forward and back throws are conventional, used to force tech get-up situations (at certain damage percentages), and for knocking out high-damage foes into a blast zone.

Off of down throw, you can usually score a guaranteed combo with back air or up air (depending on how your victim shuffles). For the most part, Marth's grab game isn't his strong suit, and can be highly risky to go for unless you make good reads on defending opponents.

Grabs

Move	Damage
Grab attack	1.3
Front throw	4
Back throw	4
Up throw	5
Down throw	4

Aerial Attacks

Neutral Air Attack: Marth performs two consecutive slices into the air in front of him. The first swing targets enemies directly in front, while the second swing can potentially take down foes behind him. Neutral air attack is primarily a spacing tool. It also makes for an excellent defensive maneuver right after blocking.

Forward Air Attack: Marth delivers a downward slash starting from above him and ending the swing around knee level. This air attack is a superb aggressive poke. Use this attack to force your opponents into a defensive posture and to damage their shields. Forward air attack is your main edge-guarding knockout attack, thanks to its wide-arc hitbox and relatively quick speed. It's also an amazing combo-starter in the neutral game because of its pop-up effect.

Back Air Attack: Marth turns around midair for a quick upward slash. This is a unique move in that after the beginning part of the move, he changes direction in midair. The power and versatility of being able to switch the direction you're facing midair can't be overstated. Marth's back air gives him access to several on-demand options, particularly when it comes to edge-guarding.

Up Air Attack: While airborne, Marth performs a somersault while swiping with his sword above him in a wide-ranging arc. Up air attack is almost as versatile and powerful as front and neutral air attack, making Marth's air game absurdly strong. It's as good as it gets when it comes to conventional up air anti-air attacks. Plus, its pop-up effect is similar to forward air attack, giving you another way to combo into up tilt and other naturally quick launcher strike.

Down Air Attack: Marth delivers a 180-degree downward swipe, potentially spiking foes plummeting to their deaths. Marth's down air attack is an excellent attack for descending upon enemies. Its arc almost ensures that you connect with an enemy beneath you, forcing them to respond with a high-priority anti-air or to eat a significant amount of shield damage. Down air has a meteor smash spiking effect at a specific point and angle in its swing. If you can score a hit during the halfway point in the animation (as Marth's sword is pointing straight down), you can land a sweet-spot meteor smash that allows you to either knock down enemies into a pit, or cause them to bounce off a platform for a potential follow-up.

Aerials: Marth

Move	Damage
Neutral air attack	5, 9.5
Forward air attack	11.5
Back air attack	12.5
Up air attack	13
Down air attack	14

Aerials: Lucina

Move	Damage
Neutral air attack	4.3, 8.6
Forward air attack	10.5
Back air attack	11.9
Up air attack	11.4
Down air attack	12.4

Special Moves

Neutral Special: Shield Breaker: Marth charges up his sword and unleashes a shield-penetrating thrust, breaking the enemy's guard. Shield Breaker, as its name implies, deals bonus shield damage, especially when connecting with its sweet spot, the tip of Marth's blade. Without charging the attack, connecting with Shield Breaker's sweet spot deals 80% of a fighter's shields, essentially leaving them with one more block before they're forced into shield-break dizzy, giving you freedom to go into full offense mode.

Side Special: Dancing Blade: Marth performs a multitude of slashes, ending the sword dance with either a skyward launch attack or a lightning-fast flurry of thrusts. Hold toward the enemy on the fourth swing for a powerful high knockback attack. Hold up on the fourth swing for a good KO attack. This special combo is where a majority of your damaging punishes come from. The up plus special series is generally used for setting up potential juggle combos, while the neutral (forward) series is for knocking out enemies offstage, and the down plus special series is for dealing the most damage or forcing a tech roll (followed by even more offense).

Special Moves: Marth	
Move	Damage
Neutral special	10.3 (27.6 max charge)
Side special	3, 3, 4, 6; Up special (second, third, fourth attack): 3, 4, 7; Down special (third, fourth attack): 4, 2x4, 5
Up special	11 (early), 7 (later)
Down special	26.4 (max)

Special Moves: Lucina	
Move	Damage
Neutral special	8.5
Side special	2.8, 2.8, 3.3, 4.8; Up special (second, third, fourth attack): 2.8, 3.3, 5.7; Down special (third, fourth attack): 3.3, 2x4, 4.3
Up special	11 (early), 7 (later)
Down special	26.4 (max)

Up Special: Dolphin Slash: Marth launches himself into the air with his sword extended, striking down his foes from the sky. Dolphin Slash can be used as a quick and invincible buffered out-of-shield attack, even faster than shield-grabbing. It's extremely unsafe if whiffed, so don't be too predictable with your actions right after shielding attacks.

Down Special: Counter: Marth quickly transitions into a defensive posture, absorbing enemy attacks and responding in kind with a counterattack. This is a no-nonsense parry attack with few frills. As most of these types of special moves are high-risk, high-reward, it's generally best saved for free-for-all play modes when you're surrounded by foes. Otherwise, it can be used as a ledge-recovery option to Counter an incoming attack from an enemy guarding an edge.

Final Smash: Critical Hit

Marth dashes forward to deal an incredibly powerful blow. If the attack connects, it has the potential to be a one-hit KO. Marth dashes forward a long distance, so there's a risk that you can self-destruct, but you can quickly press the button to stop in place.

Mega Man

OVERVIEW

Mega Man, true to character, is a projectile-centric fighter with an outstanding midrange zoning game. He has a remarkable toolkit, with several normal moves replaced with his Mega Buster pellet shots. His main strength is clear: Mega Buster shots (neutral attack, neutral air attack, and side tilt). Enemies in range of these shots are forced to reposition or weather the storm.

Naturally, this can make playing a conventional style of neutral game difficult since he doesn't have a "real" jab or melee-based neutral air.

While Mega Man's attacks are primarily zoning tools, this doesn't necessarily mean he's a heavily defensive brawler. He's much more mix-up- and setup-heavy than it seems at first glance. Instead of focusing on successfully dealing damage with every single Mega Buster pellet, Mega Man players should think two steps ahead of the opponent and focus on how their opponents react, and use that information to determine their approach. The persistent threat of your projectiles can be a much more effective tool than the projectiles themselves.

Mega Man Vitals	
Movement Options	
Jumps	1
Crouch Walk	No
Tether	No
Wall Jump	Yes
Wall Cling	No
Movement Ranks	
Ground Speed	D (51)
Air Speed	B (19-24)
Falling Speed	B+ (10-15)
Weight	B (24)

Grounded Attacks

Neutral Attack: Mega Man punches the enemy with his iconic Mega Buster, then fires it several times, dealing minor damage. While it's a remarkable zoning tool, Mega Buster shots inflict less hitstun the farther they travel, so while you may be hitting your foe with it from far away, they recover quickly. Both the Mega Buster melee punch and buster shot cause standing hitstun against grounded foes.

Dash Attack: Mega Man emulates Top Man and becomes a human tornado, delivering a multi-hit spin attack before transitioning into a final area-of-effect hit that knocks foes into the air. On hit, Mega Man's dash attack knocks away, so it doesn't lead into damage-racking combos well. It does allow you to set up a projectile game. Follow up with either a Metal Blade item-pull or Crash Bomber. For the most part, keep Mega Man's dash attack out of your neutral game. His projectiles are safer and cover the ground space well.

Side Tilt: Mega Man's side tilt is identical to his neutral attack Mega Buster shots, except he can walk forward and away while shooting, and doesn't extend a melee attack before he begins firing.

Up Tilt: Mega Man performs his X2 Shoryuken attack, blasting a nearby foe into the air. Up tilt deals significantly more damage up close (just like Ryu's and Ken's Shoryuken attacks). While foes struck by up tilt are sent high into the air, it doesn't lead into any meaningful damage since Mega Man isn't free to act early enough to follow up. It makes for a strong finisher attack when the foe is close to the upper blast zone. Up tilt is extremely unsafe on whiff and shield, so it should be used rarely as a poke.

Neutral Attacks

Move	Damage
Neutral attack 1	1 (melee), 2 (projectile)

Dash Attack

Move	Damage
Dash attack	1.2x7, 4

Defensive Attacks

Move	Damage
Ledge attack	9
Wake-up attack	7

Tilts

Move	Damage
Side tilt	2
Up tilt	17
Down tilt	8

Down Tilt: Mega Man propels forward, sliding on the ground with a kick attack. Enemies in his way are launched into the air. Down tilt's active window begins almost immediately. The closer you are to an enemy, the earlier the attack hits. Of course, the earlier the slide hits, the easier it is for your opponent to punish if it's shielded. The initial portion of the slide deals more damage and causes a more vertical launch, while the lingering portion of the attack knocks away.

Side Smash: Mega Man charges his Mega Buster for up to a full second, then unleashes it toward an enemy, blasting them away. This attack is based on his Mega Man 4 Charge Shot. Charging up Mega Man's Mega Buster leaves you incredibly exposed, so it's best left as an edge-guarding tool. You can use it to harass offstage foes as they try to jump to a ledge. Vary your timing to keep them guessing, potentially messing up their recovery moves and scoring a knockout.

Smashes

Move	Damage
Side smash	11.5 to 13.8
Up smash	2, 1.5x5, 6
Down smash	17

Up Smash: Embracing Spark Man's powers, Mega Man raises two lightning rods above him, surging with a powerful electrical current. Foes above Mega Man are shocked several times before they're launched directly into the air above. Mega Man's up smash can be used to KO higher-damage foes if you can sniff out and counter an enemy's aerial attack. It has a brief hit effect horizontally, but it's largely unsafe when shielded.

Down Smash: Mega Man becomes an effigy of Flame Man and thrusts two flamethrowers down at his sides, then unleashes two magnificent bursts of flames that set nearby enemies ablaze while they soar through the air. Flame Blast is an extremely risky attack to throw out haphazardly, but if you're successful in hitting with it, it rewards you with a huge payoff in damage and knockout potential. It covers both your sides, so it can be used to fend off multiple assailants. If it's shielded or if you whiff with it, you're left helpless and exposed for a long time.

Mega Man uses Guts Man's Super Arm to grab a nearby foe. Mega Man's grab has outstanding range and speed, considering his projectile-heavy toolkit. Since his projectile game forces out shields often, you're given more grab opportunities. His forward and back throws are used for throwing foes offstage or to finish them off at higher percentages near a blast zone. Up throw tosses them high into the air, setting up a potential up air or air-dodge-bait 50/50. Down throw leads into the most damage.

Grabs

Move	Damage
Grab attack	1.3
Front throw	8
Back throw	11
Up throw	7
Down throw	4.5

Mega Man's run speed is on the slow end of the spectrum, so his offensive grab game isn't particularly impressive. But grabbing is one of his only solid out-of-shield options (with up tilt and down tilt being the only viable alternatives).

Aerial Attacks

Neutral Air Attack: In midair, Mega Man whips out his Mega Buster and punches a nearby foe, then starts firing buster shots, up to three times. Neutral air attack is your most important attack. While every form of the Mega Buster pellet shot is crucial, you use the neutral air version the most. It gives you freedom in mobility and allows you to throw out several harassment projectiles. Jockeying for ground-stage control and positioning usually means short-and jumping around while firing pellets at the opponent. Neutral air doesn't have any landing lag, regardless of when you land during your buster shots.

Aerials

Move	Damage
Neutral air attack	2 (melee), 2 (projectile)
Forward air attack	8.5
Back air attack	3, 4, 5
Up air attack	3x3, 2, 2, 1x5, 2
Down air attack	14

Forward Air Attack: Mega Man equips Sword Man's Flame Sword and swipes it forward while he approaches his foe in the air. Forward air attack is one of few of Mega Man's melee attacks. It has two distinct hit effects. If you hit with the tail end of its active hit window, it deals much less damage and applies no knockback against grounded foes. If you hit with the early active window as Mega Man swings, it sets enemies on fire and blasts them up and away.

Back Air Attack: Mega Man uses Slash Man's claws to unleash a flurry of slashes behind him that knocks enemies away. Back air attack is your fastest aerial move and is best used as an edge-guarding tool and as a quick air-to-air defensive attack. It suffers from high landing lag, so if you use it as an air-to-ground attack, you can be easily punished if the opponent shields it. Back air should be used sparingly. If you use it, complete the total animation airborne to keep yourself safe.

Up Air Attack: Mega Man launches Wind Man's Air Shooter attack above him. The cyclone travels into the sky, damaging and dragging foes high into the air. Up air attack allows Mega Man to control a large portion of linear vertical space, and Air Shooter can rack up a massive amount of damage.

If all hits connect, it deals almost 21%! Against taller fighters, you can use it as an air-to-ground attack if you time it so Mega Man releases it low to the ground. It can be surprisingly difficult to shield-grab, especially if it's spaced.

Down Air Attack: While soaring through the air, Mega Man transforms his Mega Buster into Hard Man's Hard Knuckle, then fires the Hard Knuckle directly below him. Hard Knuckle deals slightly more damage upon launching, but causes a spiking meteor smash effect after it's a bit farther away from Mega Man's body. It's decent on its own, thanks to its range and verticality from the air, allowing you to go for relatively safe meteor smash dunks against offstage foes.

Special Moves

Neutral Special: Metal Blade: Mega Man throws Metal Man's spinning saw in one of eight directions, cutting through and potentially damaging multiple enemies. While Mega Man is pulling out the Metal Blade, you can input any of eight cardinal and intercardinal directions to change the projectile's launch direction, making it an incredibly versatile attack. If the blade connects with stage ground or a wall, it becomes a generated interactable item, giving you (or the enemy) the opportunity to pick it up to throw again.

Special Moves

Move	Damage
Neutral special	5
Side special	1x4, 4
Up special	—
Down special	1.5xN(3 to 8), 3.8

Metal Blade deals less damage when thrown as an item. You can only have one Metal Blade on-screen at any given time.

Side Special: Crash Bomber: Mega Man shoots out Crash Man's Crash Bomber, planting a timed explosive device that detonates after two seconds, knocking up nearby foes (and potentially Mega Man himself) with its explosive blast. Crash Bomber's bomb can stick to walls and floors. It can also be passed from fighter to fighter. If you plant a bomb on a nearby foe, they can plant it back on you if they're quick enough.

Up Special: Rush Coil: Mega Man deploys and springs off of his robot dog, Rush. As Mega Man is propelled into the air, Rush remains active for two seconds. If Mega Man lands on Rush, he's relaunched into the air. Mega Man's up special makes him evasive in the air and difficult to chase. If you land on Rush, you can even deploy him again, as you're able to perform your special moves after springing back up. Hilariously, other players can jump on Rush to go after you, so keep that in mind and prepare to defend yourself with neutral air attack or forward air attack while you're airborne with the spring-jumping foe.

Down Special: Leaf Shield: Mega Man activates Wood Man's Leaf Shield: four rotating leaf projectiles that deal damage to nearby enemies. Mega Man then throws the quartet of leaves forward, knocking up enemies in its path. Leaf Shield is an exceptional ground-control attack, particularly against foes without their own projectiles. Against close-range "pixie"-type fighters, Leaf Shield allows you to approach safely so that you can mount your offense and damage-racking setups. If you hit with Leaf Shield, it has high damage potential because of its extendibility. On hit (after Leaf Shield throw), you can go in for a mix-up by throwing the landing foe, or you can continue throwing Crash Bomber or Metal Blades at them.

Final Smash: Mega Legends

For Mega Man's Final Smash, the Black Hole Bomb is fired forward and draws in opponents. Anyone pulled in faces several generations of Mega Man, as well as Proto Man and Bass, who all fire their Busters in unison.

Meta Knight

OVERVIEW

Meta Knight is a small sword-wielding fighter with remarkable aerial mobility. Like Kirby, Meta Knight has multiple double jumps. Thanks to his bat-like wings, Meta Knight is able to propel himself higher up to five times while airborne. While each air jump boosts his altitude by a small amount, simply having the ability to alter air trajectory five times affords Meta Knight incredible flexibility in his air-recovery and air-to-air games.

Meta Knight Vitals	
Movement Options	
Jumps	5
Crouch Walk	No
Tether	No
Wall Jump	No
Wall Cling	No
Movement Ranks	
Ground Speed	B (15)
Air Speed	C (44)
Falling Speed	B- (27)
Weight	D- (65-66)

Much of Meta Knight's game plan centers around his ability to seamlessly flow between a ground game and an aerial one thanks to his low short hop, midair jumps, and quick fast fall. Meta Knight's main damage sources are down tilt and dash attack. One of his strongest assets is his edge-guarding game, with persistent hitboxes on his neutral air attack and early knockout potential on his back air (particularly as an offstage attack).

Meta Knight can be difficult to master. While his game plan is straightforward, many of his optimal combos can be difficult to perform for novices, but they heavily reward practice and experience.

Grounded Attacks

Neutral Attack: Meta Knight unleashes a flurry of sword strikes before finishing with a powerful blow that knocks his victim away. This doesn't function as a conventional jab and shouldn't be used as one since it starts up significantly slower than most lightweight fighter jabs. It deals reliable damage on hit and can be used to punish rolls and air dodges, thanks to its persistent hit effect.

Dash Attack: While dashing, Meta Knight delivers a leaping side kick, knocking up his target into the air above him. This is one of your core attacks, and much of your damage originates from connecting with dash attacks, either from tripping the enemy with down tilt or catching retreating foes. The tip of Meta Knight's dash attack launches the enemy directly above him, while hitting with the inner hitbox launches them up and away. Both provide an opportunity for follow-up damage.

Neutral Attacks	
Move	Damage
Neutral attack	0.8xN, 2

Dash Attack	
Move	Damage
Dash attack	7

Defensive Attacks	
Move	Damage
Ledge attack	9
Wake-up attack (faceup)	7
Wake-up attack (facedown)	7

Side Tilt: Meta Knight performs a swift three-hit combo sequence, beginning with two quick short-range slashes and ending with an upward slash that sends foes directly away from him. Meta Knight's side tilt combo is unique in that it behaves like a conventional neutral attack sequence (i.e., as a jab combo). It deals reliable damage and is relatively safe on shield. Its main weakness is in its third attack, as there's significant end lag, leaving you open for reprisal.

Tilts	
Move	Damage
Side tilt 1	2
Side tilt 2	2
Side tilt 3	4
Up tilt	7
Down tilt	5

Up Tilt: Meta Knight performs a small twirling hop into the air as he drills his sword into enemies above him, launching them skyward. Up tilt is a ground-to-air anti-air with a specific and narrow hitbox aimed directly above him. It has niche uses as a poke, mainly to harass foes on platforms above you, or as a point-blank, out-of-shield retaliation punish attack that sets up your up air attack loop combos. It can leave you vulnerable on the ground if you whiff with it.

Down Tilt: Meta Knight crouches low and jabs out his blade at the opponent's legs. Down tilt is a staple in your arsenal. It's incredibly safe and fast, potentially sets up combo opportunities, and at higher percentages (around 115%), it can knock down foes, putting them in a tech situation.

Side Smash: Meta Knight winds up for a brief period before unleashing an ultra-hefty front slash that blasts enemies diagonally upward. While this is your slowest-starting attack, it's safe when shielded (you're at an advantage), and deals a considerable amount of shield damage. In some cases, you can bait out-of-shield retaliation attempts with your side smash and immediately "frame-trap" (baiting and pre-empting at once) your opponent with a punishing follow-up attack like down tilt.

Smashes

Move	Damage
Side smash	16
Up smash	4, 3, 5
Down smash	Front: 10, Rear: 13

Up Smash: Meta Knight swings his sword up above him three times in rapid succession. The first two swings lock his foes in place, while the third and final strike launches them into the air directly above him. Up smash has great knockout potential, but leaves you extremely vulnerable if whiffed, so you should mainly reserve this attack as an anti-air (against descending foes who've used up their double jump, for example). It can also be used to harass foes standing on platforms above you or as a follow-up to a pop-up attack, such as point-blank up tilt.

Down Smash: Meta Knight performs an incredibly fast spinning sword slash at an upward angle in front of him, then transitions by swinging around and slashing behind. Meta Knight's down smash is one of the fastest smash attacks in the game, and is particularly effective as an out-of-shield attack or as a quick checking attack against aggressive opponents. It has some end lag that may leave you exposed to attacks, but it's a decent option for punishing ledge rolls and other moves that leave the opponent behind you, thanks to down smash's rear hitbox.

Meta Knight's grab severely lacks in range, but generally leads into a considerable amount of damage. Meta Knight's grapple attack impales his grappled foe with his spiky wing thumbs. He uses front throw to pick up his grappled enemy, then drives a mighty roundhouse kick into them, popping them up into the air. For back throw, he hurls his foe down behind him and plunges his sword into them, knocking them away. For up throw, Meta Knight flies into the sky and off the stage, dragging his victim with him, before plummeting back into the ground and

Grabs

Move	Damage
Grab attack	1
Front throw	9
Back throw	10
Up throw	10
Down throw	7.5

slamming the enemy with incredible force. His down throw uses his opponent as a trampoline; he stomps on their back several times before ending the sequence with a much heavier double-legged stomp that bounces the enemy up and away. Down throw leads into the most potential damage.

Aerial Attacks

Neutral Air Attack: Meta Knight takes a page from Samus's book and performs a less-spectacular version of her Screw Attack, spinning in the air and striking foes with his sword extended. Neutral air attack is a strong attack when used from a jump. Jump into fast fall cancel allows you to stick out a persistent spinning attack as you descend on enemies. It's also fairly effective for edge-guarding, but doesn't knock out as easily the longer the attack is active (i.e., it deals more damage and has more knockback at the beginning).

Aerials

Move	Damage
Neutral air attack	10
Forward air attack	1.5, 1.5, 3
Back air attack	1.5, 1.5, 4
Up air attack	4
Down air attack	6

Forward Air Attack: In midair, Meta Knight delivers three consecutive slashes in front of him. The first two slashes lock his foe in place, while the final slash sends them flying away. Forward air attack is one of your slower aerial attacks, but it's an excellent air-poking and spacing tool if positioned and timed correctly.

Back Air Attack: While airborne, Meta Knight performs a three-hit spinning back-slash combo directly behind him. Back air attack is one of your main air-to-air knockout moves, used for offstage edge-guarding setups, such as from a ledge trump (knocking off a ledge-hanging opponent with your own ledge grab).

Up Air Attack: Meta Knight quickly swipes the area above him with his sword, causing a slight pop-up hit on foes. Naturally, this is your primary juggling attack. Its active window is incredibly short, so it asks a certain degree of accuracy and timing to use effectively. Its start-up and end lag are quite low, giving you much more aerial flexibility with a bit more control.

Down Air Attack: Meta Knight delivers a fast slashing attack in a horizontal arc below him. Like up air, down air has very little end lag and is active only briefly. Nevertheless, it's a great attack when paired with your ability to quintuple-jump. If you can put your opponent into a defensive shielding posture, you can go for short hop down air into buffered double jump down air attack to apply a strong air-to-ground pressure game. There's noticeable landing lag, so use your batwing jumps to reposition yourself away from landing next to your opponent if possible.

Special Moves

Neutral Special: Mach Tornado: Meta Knight becomes a whirling tornado that launches enemies into the air as he collides with them. Mach Tornado is mainly used as a recovery tool and is rarely effective as an offensive one because it leaves you in a helpless falling state, followed by massive landing lag. However, in niche situations, you can use Mach Tornado to punish high-altitude air dodges as your opponent attempts to get through your juggling advantage state. Follow your airborne opponent, and if you read an air dodge, activate Mach Tornado and mash on the Special button to nail them as they come out of their dodge.

Special Moves	
Move	**Damage**
Neutral special	12
Side special	1.1x11, 3
Up special	9, 6
Down special	16

Side Special: Drill Rush: Meta Knight propels himself forward through the air like a torpedo, drilling into foes with a multi-strike attack before bouncing off them. Meta Knight's side special is another recovery option in his arsenal, doubling as a horizontal air attack. While in flight, you can heavily influence your trajectory by inputting up or down on the control stick.

Like Mach Tornado, Drill Rush can leave you extremely vulnerable. It has a considerably lengthy start time, and if you end the drill in the air, it leaves you in a helpless falling state. If you drill and hit the ground at certain angles, it bounces you off the stage, adding even more end lag. Learning how to manipulate your drill trajectory so that you land on the stage without bouncing is crucial in order to mitigate your end-lag.

Up Special: Shuttle Loop: Meta Knight launches into the air with a rising sword strike, performs a loop in the air, then completes the two-hit combo with another upward sword stab. Shuttle Loop is another one of Meta Knight's recovery options that doubles as an attack. Shuttle Loop is used in many of Meta Knight's juggle combos, primarily as a finishing attack after an up air.

Down Special: Dimensional Cape: Meta Knight vanishes and then reappears a short distance away, potentially following up with a massive area-of-effect sword attack. Dimensional Cape is a recovery move that teleports you a set distance (or in place without a control stick input) after a brief disappearing intangibility period. If the Special button is held down or pressed again, Meta Knight comes out of his teleport with a huge sword swing, dealing a high amount of damage. After inputting down special, you can aim Meta Knight's teleport direction with the control stick. Not only can you control which direction he launches in, but you can manipulate his trajectory as he's moving.

Final Smash: Darkness Illusion

Meta Knight throws his blade upward and fires an electric projectile. If he hits an opponent, he tosses them up in the air before multiplying himself to attack and launch them. If the electric projectile doesn't hit anyone, the move doesn't activate.

Mewtwo

OVERVIEW

Mewtwo is a quintessential glass cannon, with one of the best chargeable projectiles in the game with its neutral special, and incredible aerial mobility with up special and a wall jump. To top off its comprehensive kit, Mewtwo has powerful high-damage combos. It also has one of the best air dodges in the game, in which it's intangible almost immediately as it Teleports around its enemy's attacks. While its Teleports are punishable, they require the opponent to predict where Mewtwo will be in order to punish.

Mewtwo's remarkable power is balanced by weaknesses in its defense and vulnerability. In addition to being a relatively large target, Mewtwo is a light and floaty fighter with a slow double jump and slow fall speed, so it's highly susceptible to certain setups and mix-ups. Mewtwo's wake-up and roll options are also lackluster, with its roll and get-up attacks being quite laggy, but thanks to its vast variety of aerial options, Mewtwo has a strong kit for recovering onto a ledge. It can mix up its recovery to keep the opponent guessing between its various techniques involving ledge jumps, ledge releases, double jumps, Teleporting air dodges, and its up special Teleport. Mewtwo is a skill-intensive fighter to play as and master, particularly when it comes to execution and survivability.

Mewtwo Vitals

Movement Options	
Jumps	1
Crouch Walk	No
Tether	No
Wall Jump	Yes
Wall Cling	No

Movement Ranks	
Ground Speed	B+ (8)
Air Speed	A (3)
Falling Speed	C (44-47)
Weight	F (71-72)

Grounded Attacks

Neutral Attacks: Mewtwo extends its palm and sends out a pulsatile attack, then follows it up with an emission of several energy strikes before finishing the combo with an upward moon-shaped claw slash, knocking enemies away. Neutral attack is one of your possible out-of-shield options for punishing aggressive enemies. However, it's on the slower side, with a lackluster start speed and relatively mediocre range. Like most rapid-attack jabs, you can use it to guard ledges against ledge-hanging foes.

Dash Attack: While dashing, Mewtwo uses its flight momentum to extend a mass of dark energy before itself, launching foes up and away. When shielded, it's punishable by most neutral and tilt attacks. Mewtwo's dash attack is best used for chasing down foes and whiff-punishing your opponent's missed grabs and high-lag maneuvers. On hit, it launches foes up and away, so it doesn't set up juggle combos well.

Neutral Attacks

Move	Damage
Neutral attack 1	3
Neutral attack 2	0.8xN, 2.5

Dash Attack

Move	Damage
Dash attack	12

Defensive Attacks

Move	Damage
Ledge attack	9
Wake-up attack (faceup)	7
Wake-up attack (facedown)	7

Side Tilt: With a hip pivot, Mewtwo lashes out with its tail, swinging at foes and knocking them away. This attack can be angled up or down slightly with the control stick. Unlike most side tilt attacks in the game, Mewtwo's isn't a particularly attractive option in the neutral game or in combos. It has better tools in its down tilt and air attacks.

Tilts

Move	Damage
Side tilt	10
Up tilt	6
Down tilt	5

Up Tilt: Mewtwo delivers a telekinetic somersault attack with its tail over a large area, arcing from the front and over its body and ending behind it. Up tilt is your typical anti-air, but with extra combo potential. The initial hitbox has a particular knock-up effect that allows you to combo into another up air (against low-damage foes), which you can then combo into up air attack.

Down Tilt: Mewtwo crouches in a low-profile stance and sweeps the enemy off their feet with its tail. This is your primary aggression-stopping tool, deterring approaching enemies and knocking them up into combos, followed by more Shadow Ball charging and zoning. This attack is so fast that you can almost mash it repeatedly to prevent your attacker from even getting in (although most good players won't fall for this if it's all you're doing).

Side Smash: As if mimicking Ryu, Mewtwo clasps its hands at its side, then thrusts them forward and unleashes a powerful energy blast. While this move looks awesome, it's incredibly difficult to use as a poke. You'll only want to use this when you can make a good read on your opponent's ledge-grabbing habits, and rarely anything else. It leaves you way too vulnerable for you to just throw it out, especially since your air attacks are so much better and safer.

Up Smash: Mewtwo quickly thrusts its arm into the air, conjuring a swirl of dark energy that devastates and pounds on its victim for several hits before knocking them away. This is a particularly unsafe attack reserved for high-damage combos or as a defensive counterattack. Grab is usually a better option, if your opponent is within range.

Down Smash: Mewtwo conjures a massive radial blast directed at the ground in front of it, sending nearby foes flying away. Down smash starts slower than forward smash, but is much safer with less end lag, especially at max range. You can use it to punish recovering opponents trying to grab a ledge thanks to its large hitbox, if you can time it accurately.

Smashes	
Move	Damage
Side smash	20
Up smash	2x3, 10.1
Down smash	16

Mewtwo uses its telekinesis to subdue its enemy. Mewtwo's grab attack is a telekinetic squeeze that starts somewhat slow and offers moderate reach. Its forward throw is a high-damage, multi-hit attack, with Mewtwo levitating the enemy and hurling several Shadow Balls at them, which can potentially hit other foes. Mewtwo's back throw is a simple toss that deals high damage, potentially knocking out high-damage foes.

For its down throw, Mewtwo slams and pins its victim into the ground, then whips its tail down, launching the enemy up into the air for a potential air mix-up follow-up.

Grabs	
Move	Damage
Grab attack	1.3
Front throw	13
Back throw	10
Up throw	12
Down throw	9

Mewtwo's up throw is one of its best options for knocking out enemies at high percentages, especially if you've conditioned your opponent into shielding your oppressive Shadow Ball and down tilt pressure. However, it's not as effective for racking up damage since the knock-up and launcher-type throws don't provide enough tumbling hitstun in most cases.

Aerial Attacks

Neutral Air Attack: Mewtwo's body surges and emits a pulsating electrical current, shocking nearby enemy several times before launching them away with a final shock blast. There are three ways to use neutral air attack optimally: short hop neutral air, short hop neutral air into fast fall, and jump neutral air. Controlling your trajectory during a move is particularly important, since where your fighter is in relation to your opponent determines how they're knocked away.

Short hop neutral air attack (shortcut: dash, Jump+Attack, with optional fast fall on hit) can combo into up air attack and other attacks with good spacing and drift control.

Aerials	
Move	Damage
Neutral air attack	1.6x5, 4
Forward air attack	13
Back air attack	13
Up air attack	11
Down air attack	15

You want to drift your neutral air attack so that the opponent is in front of you, but still close to your body, allowing you to up air attack or immediate forward air attack as soon as your neutral air end lag is over.

Forward Air Attack: Mewtwo hops into the air and swiftly delivers a dark-energy-enhanced slap in front of it, blasting foes away. This is one of your staple attacks during the neutral game, dealing impressive damage and shield damage. When you're on offense, go for deep (low-altitude) forward air attack attacks to keep yourself safe and at an advantage. For a short hop forward air attack sequence into retreat sequence, use the C-stick to immediately input forward air attack while you jump forward (then hold back) with the control stick. For an aggressive triangle-jump-type sequence, short-hop above an enemy, then as early as possible fast-fall, then immediately input forward air attack with the C-stick.

This low jump fast-fall forward air attack is incredibly strong, allowing you to follow up with most attacks on hit. Like most forward air attacks, Mewtwo's forward air attack swipe is its best edge-guarding tool.

Back Air Attack: Mewtwo looks over its shoulder and then whips its tail behind it and into an upward arc, slapping away foes. Back air is much slower than forward air attack, and isn't nearly as safe, but its hit area is larger and opens up juggle opportunities. It's primarily used as an edge-guarding tool, thanks to its wider arc and decent knockout potential.

Up Air Attack: While airborne, Mewtwo performs a backflip somersault with its tail extended, knocking up foes and leaving them vulnerable to a potential follow-up assault.

As with most up air attacks, Mewtwo's up air is used to extend and keep enemies stuck in the air and guessing. Knock away descending opponents with up air and then charge your Shadow Ball to keep up zoning pressure. Against grounded foes, you can do: short hop, fast-fall, cross-up up air as a combo-starter, followed by another up air or forward air attack, then into your juggle game.

Down Air Attack: From the sky, Mewtwo fires a bolt of dark energy directly below, causing a meteor smash effect on foes hit by its force. Mewtwo's down air attack can be used as a combo-starter, but it's punishable and less safe than its other air attacks. It's best used as a meteor smashing attack to knock down foes over ledges.

Special Moves

Neutral Special: Shadow Ball: Mewtwo cups its hands and begins summoning a mass of dark energy. Upon release, the projectile speeds along the ground, dealing damage to the first foe it hits. Shadow Ball is one of the best projectiles in the game. As with most charge-up mechanics, a good portion of your game plan should revolve around earning space and breathing room in order to squeeze in any bit of charge-up time you can. Combos and knockbacks should almost always be followed by Mewtwo mustering up its dark energy, which you can store by shielding, jumping, or rolling out of.

Special Moves

Move	Damage
Neutral special	2.5 (25 max charge)
Side special	9, reflected projectile: 1.4x damage
Up special (ground)	—
Down special	1

Because Shadow Ball deals so much shield damage (around 70% of max shields), the threat of Shadow Ball is omnipresent. If your opponent doesn't deal with you and your charge, you'll eventually be able to shield-break them, from which you can land a free combo.

Side Special: Confusion: Mewtwo uses its psychic powers to suspend its victim helplessly, for a brief duration. This psychic energy field can reflect enemy projectiles. Confusion doubles as a command throw (an unshieldable grab) and a projectile reflector.

Additionally, using Confusion in the air gives you some extra mobility, as the first air Confusion boosts you up a tiny bit. Successfully grabbing with Confusion suspends the enemy into the air for a brief duration, but you can't combo from it. The opponent can always act once they're free, so expect them to double-jump or air-dodge, and be ready for it with a follow-up option.

Up Special: Teleport: Mewtwo instantly warps to another location. You can Teleport up-left, up, up-right, left, right, down-left, and down-right. Teleport is a straightforward recovery tool. Not only does this give Mewtwo an incredibly versatile evasive maneuver, but it's also difficult to punish for less-experienced opponents since doing so requires some guesswork. As with most recovery specials, you're left vulnerable once you use your double jump and Teleport, so be careful not to be too predictable near ledges or while trying to touch the ground after being launched.

Down Special: Disable: Mewtwo attempts to make eye contact with its target with a Medusa-like gaze attack. If successful, its victim becomes dazed and unable to act. Disable is a unique attack with heavy drawbacks, but offers an incredible payoff on hit. It's limited in range and only connects if the opponent is facing you, and it can be shielded. If the opponent is facing away from you, the projectile is completely ignored. Furthermore, it doesn't stun airborne enemies. On hit, Disable temporarily stuns the target, with its stun duration directly correlated with the target's damage count. At 50%, stun lasts for around three seconds; at 100%, ~4.5 seconds; and at 200%, around seven seconds.

Final Smash: Psystrike

Mewtwo's Final Smash begins with a Mewtwo Mega Evolving into Mega Mewtwo Y. It then fires a projectile that freezes and launches every foe it hits. This move travels through landscapes and opponents, making it easy to hit multiple foes.

Mii Fighters

BUILD A FIGHTER

Mii Fighters return, both more standardized to make them fair game in matches, and more customizable to make gathering outfits more fun. You'll find Mii Fighter customization under Games & More from the Main Menu. Here you can build many different Mii Fighters, based either on plain sample Miis, or using Miis you've created on your Switch console.

When building a Mii Fighter, you can select their nickname, outfit and headgear, favorite color, and even the tone and pitch of their voice. You'll also need to select their special move loadout. For each special slot (neutral, side, up, down), each Mii Fighter type has three specials to choose from. The breakdown of available specials in this chapter will help you construct your ideal custom fighters.

BRAWLER OVERVIEW

Of the Mii Fighters, Mii Brawler has the best speed and close-range attacks. Ground and air neutral attack and grab speed, along with scary, fast special moves—like Suplex, Thrust Uppercut, Head-On Assault, and Counter Throw—make Mii Fighter the best for simply rushing in after foes. The ability to wall-jump bolsters Mii Brawler's dominant movement. The only projectile option is the Shot Put special, but it offers high knockback and great edge-guarding power. Feint Jump offers novel movement and extra attack and recovery options. Apart from that, building a Mii Brawler is about choosing the aggressive close-range moves you like the best.

Mii Brawler Vitals	
Movement Options	
Jumps	1
Crouch Walk	No
Tether	No
Wall Jump	Yes
Wall Cling	No
Movement Ranks	
Ground Speed	D- (68)
Air Speed	B (25)
Falling Speed	A (4)
Weight	C (40-43)

Grounded Attacks

Neutral Attacks

Move	Damage
Neutral attack 1	1.8
Neutral attack 2	1
Neutral attack 3	0.5x10+, 2

Dash Attack

Move	Damage
Dash attack	11

Defensive Attacks

Move	Damage
Ledge attack	9
Wake-up attack	7

Neutral Attacks: The Brawler is a martial arts specialist, so you can expect a good neutral attack combo. The first hit is lightning fast, and the rest happens automatically if you repeatedly press the Attack button. The third neutral attack in a combo unleashes a rapid-fire blur of punches, which you can prolong by holding down an Attack input. The enemy eventually drops out of the combo if you let this go more than twice as long as the normal amount of hits. The third attack finishes with a launching kick if the enemy doesn't fall out of the punch flurry.

Dash Attack: The Brawler takes a short leap forward and performs a jump kick just off the ground. The kick comes out quickly and does good damage, though a little less if you hit late in the attack's active period.

Side Tilt: This typical side kick can be aimed slightly up or down. The upward-aimed side tilt does the most damage, followed by the downward-aimed side tilt; the standard side tilt kick does the least of the three.

Up Tilt: Mii Brawler fires with a close-range uppercut, capable of warding off airborne foes and popping victims into a juggle position. The hitbox in front at the start is good, so there's no need to worry about whiffing against point-blank enemies like with some up tilts.

Down Tilt: Mii Brawler's down tilt is a sweep with great range that pops up foes into juggle position even at 0% damage. Follow up with upward-aimed side tilt, or an up special juggle.

Tilts

Move	Damage
Side tilt	8.5
Up tilt	6
Down tilt	8

Side Smash: Mii Brawler attacks with a straight-armed punch. Hold up or down before the attack to angle it up or down slightly.

Up Smash: A quick wheel kick upward hits first in front before rotating to cover upward and then backward angles. Wider coverage than up tilt when aiming for jumpers, short hoppers, and foes standing on ramps and low platforms.

Smashes

Move	Damage
Side smash	18-25.2
Up smash	14-19.6
Down smash	13-18.2

Down Smash: Mii Brawler punches in front and kicks out behind, striking both front and back. This clear-out move is about as quick to hit as Soaring Axe Kick and Head-On Assault, not in Thrust Uppercut territory but serviceable.

Grabs

Move	Damage
Grab attack	1.3
Front throw	9
Back throw	4, 5
Up throw	11
Down throw	2, 4

Mii Brawler's grab is fairly quick, just short of matching the fastest grab animations. Options from the grab are standard: front or back throws to get foes nearer to stage edges and to outright KO high-damage victims, and up/down throws to set up juggle combos. Mii Brawler's throw game can be made more robust by equipping the Suplex and Counter Throw specials, which grant dashing and parrying throw options.

Aerial Attacks

Aerials

Move	Damage
Neutral air attack	10
Forward air attack	5, 6
Back air attack	12
Up air attack	8
Down air attack	13

Neutral Air Attack: Mii Brawler sticks one leg out for a fair bit of time while floating in midair. This is a lot like Mario's neutral air, and goes well with fast-falling tactics.

Forward Air Attack: The Brawler lashes out in midair with two quick kicks, kind of like some air attacks from Zero Suit Samus, Captain Falcon, and Fox. You can aim to hit at hopping height by short-hopping with forward air attack, then use fast fall to drag the second hit down on standing opponents.

Back Air Attack: The Brawler kicks quickly backward with one leg, like Donkey Kong. Great for reacting to fighters coming up from behind when you've already jumped and committed to a direction in midair, or when used paired with movement tricks like reverse air rushes.

Up Air Attack: Mii Brawler spins backward with a typical upward-aimed wheel kick. This can go toe-to-toe with airborne targets above, and juggle tumbling targets.

Down Air Attack: The Brawler strikes straight down with a double-fisted hammer blow. This requires precision to aim with the brief active period, but the reward can be extremely worth it. On a successful hit, this will meteor smash opponents straight down.

Special Moves

Aerials

Move	Damage
Neutral special 1: Shot Put	15 air, 11.2 ground
Neutral special 2: Flashing Mach Punch	0.3x21, 9.5
Neutral special 3: Exploding Side Kick	25
Side special 1: Onslaught	2, 1.5x6, 5
Side special 2: Burning Dropkick	13
Side special 3: Suplex	3, 15
Up special 1: Soaring Axe Kick	4, 3, 6
Up special 2: Helicopter Kick	3, 1.5x4, 6.
Up special 3: Thrust Uppercut	0.8x5, 9
Down special 1: Head-On Assault	6, 16
Down special 2: Feint Jump	7 flip hit, 10 dive kick hit
Down special 3: Counter Throw	14

Neutral Special 1: Shot Put: Mii Brawler hefts a Shot Put they've somehow kept pocketed, then hurls it forward. It doesn't arc upward very high or far—it's basically a bowling ball, after all—and quickly descends. The heavy projectile has extra-high knockback and is especially good tossed off of stage edges toward foes trying to float back up. If you find yourself in midair and wanting to hurl a Shot Put backward, tap neutral special, then *immediately* tap the control stick in the opposite direction.

Neutral Special 2: Flashing Mach Punch: The Brawler takes some exploratory punches at the space right in front of them, punching rapidly five times. If any of those hit, Mii Brawler tacks on 16 more light punches before finishing with a launching uppercut. If the first five punches whiff, or if they're shielded, the attack simply ends.

Neutral Special 3: Exploding Side Kick: This heavy-hitting side kick takes just short of a full second to charge up. When it's ready, the fighter kicks automatically, and you can't cancel or store the charge. If you have time to get it out, it's tremendous, but it's easy for the enemy to see coming if they're not stunned or otherwise preoccupied. As a neutral special, the input starts the charging kick in whichever direction Mii Brawler is facing. Tap the other direction on the control stick to turn the kick around before it hits. This slightly increases damage.

Side Special 1: Onslaught: The fighter rushes laterally about the length of two dashes. On hit, the charge becomes a brief auto-combo. The power of the final hit is higher when you've got lots of damage built up! As a sideways-rushing move, this has use both as a sudden attack, and as an extra recovery tool when trying to make it back to safe ground.

Side Special 2: Burning Dropkick: Mii Brawler hops a bit laterally, about as far as during Onslaught, striking with a fiery two-legged kick. On hit or shield, the Brawler bounces off with a backflip. This is a quick single-hit alternative to Onslaught. Since it's a flaming move, it can detonate bombs and destroy flammable objects.

Side Special 3: Suplex: The Brawler dashes forward with a weak rushing attack. If that attack hits, Mii Brawler lifts the victim and crashes down with a powerful slam. This is great to catch people by surprise, and to add extra oomph in sideways juggle combos. Beware using this out over pits or near stage edges; if you Suplex someone and carry them straight down off an edge, both players lose a stock, but Mii Brawler's KO is considered the first one. Suplexing someone into a pit during a last-stock situation will mean you lose.

Up Special 1: Soaring Axe Kick: Upon activation, the Brawler soars upward with a launching kick. This is good for low-altitude juggles, and offstage when lunging back toward a safe ledge. It's not useful as a reversal. Initially, this kick just hits directly next to the Brawler as they kick and rise. To transition into a plunging axe kick, press the Special button again at the top of the kick's ascent. If the first portion picks someone up, the second portion will carry them down. The second kick does the most damage on a direct plunging hit, but also hurts anyone caught too close to the impact zone.

Up Special 2: Helicopter Kick: Mii Brawler springs upward with a series of rising spin kicks. Both legs are intangible during this attack, adding to the move's priority. It's a tiny bit faster to hit than Soaring Axe Kick or Head-On Assault, so slightly better for reversing enemies up close, but it's still not one of the faster up specials (for that, you want Thrust Uppercut).

Up Special 3: Thrust Uppercut: The Brawler does their best impression of Street Fighter's Ken Masters, rocketing off the ground with a flaming uppercut. If you're looking for a close-range defensive/anti-air special, this hits faster than any other Mii Brawler option. It's just a bit slower than a standing neutral attack, and even faster than tilt attack pokes. Hold back immediately after activation for an uppercut straight up; hold forward for a far-reaching one, like Ken's fierce Shoryuken!

Down Special 1: Head-On Assault: This flipping launch kick into diving head attack starts a bit like the Soaring Axe Kick up special and is slightly faster if you're looking for a reversal. The overall damage if the whole thing hits is quite high. When using Head-On Assault from the air, the Brawler simply plunges down with the dive-bomb portion.

This is a great special, with the only downsides being the heavy lag after slamming into the ground, and the danger of misusing it near a stage ledge and plummeting straight down.

Down Special 2: Feint Jump: Upon the initial down special input, the Brawler flips forward in the direction they're facing. They land with their back to the original direction, like during a forward dodge roll. If they fall on an opponent from the forward flip without an air input, they bounce off their head like a footstool jump, dealing some damage. Input Attack or Special during the forward flip, and the Brawler suddenly dive kicks from wherever they are. A neutral attack or special input results in a dive kick back in the direction the flip started. To dive kick forward out of the front flip, hold forward during the neutral or special input.

Down Special 3: Counter Throw: The Brawler raises an arm into a defensive "catch" stance, briefly intangible during this. If foes up close touch Mii Brawler during the parry animation, they get swept up into the follow-up throw. Very few combatants have special move throws, let alone rushing special-move throws, so this can be hard for enemies to deal with.

Final Smash: Omega Blitz

With Final Smash energy built up, Mii Brawler is ready to execute an overwhelmingly powerful close-range combo. Just make sure targets are at point-blank range before going for it. If two or more enemies are close together, even better. They can all get swept up into Mii Brawler's ultimate attack at once.

SWORDFIGHTER OVERVIEW

The Swordfighter is a varied warrior who uses a far-reaching sword for attacks. The sword is like an intangible limb, overpowering anything it hits if the enemy's attack doesn't extend all the way through the sword. The cost is that sword swipes aren't as quick as Mii Brawler punches and kicks. In exchange you get a good selection of strong single-stab and multi-hitting sword-spin moves.

Mii Swordfighter Vitals

Movement Options	
Jumps	1
Crouch Walk	No
Tether	No
Wall Jump	No
Wall Cling	No
Movement Ranks	
Ground Speed	D (57)
Air Speed	B (18)
Falling Speed	C (44-47)
Weight	B- (25-26)

Grounded Attacks

Neutral Attacks

Move	Damage
Neutral attack 1	3
Neutral attack 2	3
Neutral attack 3	5

Dash Attack

Move	Damage
Dash attack	10

Defensive Attacks

Move	Damage
Ledge attack	9
Wake-up attack	7

Neutral Attacks: Mii Swordfighter's three-swing neutral attack combo has decent reach, since the sword is like an intangible limb. Well-spaced, it overpowers anything in the way. It's a bit slower than most neutral attack combos, though, hitting in about the same time as most fighters' side tilts, so keep that in mind.

Dash Attack: The Swordfighter comes out of a dash or run with a sword swipe that hits directly in front. This dashing attack isn't particularly fast, and Mii Swordfighter comes to a quick halt while using it. It's good for running in to smack foes during their laggy attacks, or when they're knocked down and not being attentive about getting to their feet, but it's not a good surprise dash attack.

Side Tilt: This sideways slash hits heavier and a bit farther away than the first neutral attack but is twice as slow. Unlike many side tilt attacks, it can't be aimed diagonally up or down.

Up Tilt: This relatively quick up tilt attack covers 180 degrees around the Swordfighter, sweeping from slightly down-forward to straight back. It fulfills the expected functions of an up tilt (juggling and anti-air) while also hitting ground-level adversaries on either side.

Down Tilt: During this long-reaching toe-level sword stab, Mii Swordfighter crouches into a low stance, potentially avoiding incoming hits. The victim is popped a bit off the ground, leaving them vulnerable to follow-ups.

Tilts

Move	Damage
Side tilt	12
Up tilt	7
Down tilt	8

Side Smash: It might look like Mii Swordfighter swings over the top for this attack, but the hitbox is only extended straight in front. This is an even stronger version of side tilt, which is an even stronger version of the first neutral attack.

Up Smash: In an enhanced version of up tilt that's like some of Link's upward-striking swings, Mii Swordfighter leaps off the ground for a double-spinning slash.

There's a somewhat quick hit at ground level right as the sword rises, launching anyone in front. It's not as fast as up tilt, but it's pretty good for a smash attack. Foes are dragged into the aerial spins, which score a three-hit launching combo up close.

Down Smash: The Swordfighter slashes first to the front, then to the back. This clear-out attack has terrific range on both sides and is fast for a down smash—not quite as lightning-quick as Mario's down smash, but close. Like with Mario's down smash, the backward hit is stronger than the front-facing one.

The Swordfighter's grab game is low-damage on the throw hits but leads to powerful follow-ups. Front and back throws kick the enemy away at a lower angle than usual, leaving them in line for hits from moves like Airborne Assault, Gale Stab, and Power Thrust. Meanwhile, up and down throws put the foe in position for air juggles with air pokes and up tilts/smashes/specials.

Smashes

Move	Damage
Side smash	16-22.4
Up smash	4, 3, 7-5.6, 4.2, 9.8
Down smash	12-16.8 front, 15-21 back

Grabs

Move	Damage
Grab attack	1.3
Front throw	3, 3
Back throw	3, 3
Up throw	2, 3
Down throw	2, 2

Aerial Attacks

Neutral Air Attack: Mii Swordfighter's neutral air attack is a somewhat slow circular slash that covers every angle. It begins aimed backward and down, rotating over the top all the way around. If you're aiming this at opponents in front of you, like when short-hopping with neutral air toward standing targets, be advised that it's even slower to make it there than most smash attacks. A move that hits in 360 degrees will never be bad, but this is nowhere near as fast as most neutral air staples.

Forward air Attack: After a little windup, the Swordfighter thrusts into the air before him or her, stabbing three times. The first stab is down-forward, the second is straight across, and the final one is slightly more powerful and aimed up-forward. All three combo together if the angle with the victim is lined up. It's perfect for use in short hops toward standing enemies, as the down-forward hit naturally pulls them up into the rest.

Aerials

Move	Damage
Neutral air attack	8
Forward air attack	3, 3, 5
Back air attack	14
Up air attack	16
Down air attack	1.5x5

Back Air Attack: This powerful single slash reaches behind an airborne Mii Swordfighter, knocking away anyone approaching from the back. It's only active for a split second, though, so it requires better aim than many of the Swordfighter's longer-lasting attacks.

Up Air Attack: The customizable sword master strikes straight up with an attack that would be right at home in Link's kit. Unlike many up air attacks, this doesn't hit a front-to-back slashing swath, so it requires good aim. Hit just as Mii Swordfighter extends the attack for max damage.

Down Air Attack: The inverse to up air attack, during down air attack the Swordfighter spins aimed downward, hitting multiple times against anyone in the way. With this falling stab, if an opponent is caught up in the spinning hits and dragged into the ground, they take extra damage.

Special Moves

Neutral Special 1: Gale Strike: Mii Swordfighter spins and hurls a small tornado, which plows through anything in the way across a surprisingly long lateral path. The tornado can drift a bit up or down, but generally moves across from where it's generated. More than one Gale Strike projectile can be on-screen at once, giving the Swordfighter solid long-range power. Vortex hits launch victims straight upward, creating juggle openings. Damage diminishes with distance traveled, until the tornadoes finally dissipate.

Neutral Special 2: Shuriken of Light: For a basic projectile, Mii Swordfighter tosses small bladed stars that travel in a straight line out to about the distance of four dashes. A tossed shuriken is weak up close, dealing only 2% damage right when it's released, with no knockback power. Their strength grows as they travel, so it's best to aim with these from just where they'll dissipate.

Neutral Special 3: Blurring Blade: The Swordfighter slashes rapidly about the distance of side tilt, before finishing with a launching slash upward. Tap the input for the fastest version of the attack, or hold it down to charge for more power and knockback. Once fully charged after about a second, the attack launches at full power automatically; it can't be held extra long at full power while you wait for the perfect moment, like with smash attacks or Gale Stab.

Side Special 1: Airborne Assault: The sword master rolls straight left or right, not quite as far as Gale Strike's tornadoes travel. If anyone gets in the way, the Swordfighter transitions into a strong single-hit attack, bouncing off of the victim. With such a far-reaching straight lateral path, this move isn't just good for sideways assaults. It's also a good option to consider when recovering from offstage.

Side Special 2: Gale Stab: The Swordfighter rushes forward suddenly with a single-hit stab. If used in midair, this can be good for reaching a desired platform or recovering from offstage, but beware that it has infinite lag until landing. On level ground, this works like an even more souped-up side smash. It can be charged just like a smash attack, increasing its damage and range. It reaches full charge after just one second but can be held for up to about five seconds. Apart from its function as the top of the neutral attack > side tilt > side smash > Gale Stab sword-poking hierarchy, it's also great for combos and ground hits after front or back throws, where the opponent usually ends up even with the Swordfighter.

Aerials	
Move	**Damage**
Neutral special 1: Gale Strike	13
Neutral special 2: Shuriken of Light	6.5
Neutral special 3: Blurring Blade	0.8x5, 8-1.9x5, 19.2
Side special 1: Airborne Assault	12
Side special 2: Gale Stab	8-18.5
Side special 3: Chakram	Tilt: 1.1x-4, Snap: 8
Up special 1: Stone Scabbard	4, 3, 4
Up special 2: Skyward Slash Dash	2.2, 3x5, 4
Up special 3: Hero's Spin	Ground: 14, Air: 3, 2x3, 5
Down special 1: Blade Counter	8-29.4
Down special 2: Reversal Slash	6
Down special 3: Power Thrust	Ground: 15, Air: 13, 7

Side Special 3: Chakram: This variable projectile can be used several different ways, depending on how you input the command. Treat it like a tilt move (a half-analog control stick press, or hold the stick fully to the side in advance of the button press) for a slow, low-damage Chakram that displaces anyone in the way. Treat it like a smash move (snapping the control stick fully to the side at the same time as the button press) for an extremely fast, long-range Chakram that cuts through anyone in the way for a single hit of solid damage.

The slow "tilt" Chakram is a short-range space-dominance weapon. It doesn't make enemies flinch much, but it pushes them out of its way as though it were Bowser walking forward. This is especially potent at stage edges, if you time a tilted Chakram to move slowly through the space the enemy needs to cross to make it back onstage. The faster "snap" Chakram is a long-range sniping weapon. With either version of Chakram, input up or down immediately after the command input to choose a diagonally thrown Chakram instead of one thrown straight ahead.

Up Special 1: Stone Scabbard: The blade bearer leaps upward, then plunges down in this two-stage sword attack. Mii Swordfighter is intangible for a few frames right before the hitting portion of the attack, increasing the likelihood that close-range attackers will be out-prioritized. The initial sword uppercut makes a good recovery move when lunging for a ledge from below, but otherwise this is a poor recovery choice, because the sword plunge leads right to the bottom of the screen if there's no solid ground below. If you equip Stone Scabbard for your up special, consider prioritizing specials with good lateral travel elsewhere.

Up Special 2: Skyward Slash Dash: The Swordfighter twirls the sword briefly before taking off with an extremely strong multi-hit spin attack. Simply input up special, and the Swordfighter takes off heading straight up. But input any direction before the attack begins, and Mii Swordfighter heads in that direction. So Skyward Slash Dash isn't just good for surging up into a tumbling enemy for a combo or lunging to grab a ledge before falling into a pit. It can be aimed sideways as a high-power ground attack, or downward from midair to dive-bomb lower-altitude targets.

Up Special 3: Hero's Spin: This up special is basically two different moves, depending on whether it's used on the ground or in the air. During the grounded version, the blade-bearing fighter spins four times, slashing to both sides with the sword. Grounded Hero's Spin occurs in one place without jumping and knocks anyone away with any single hit. Each spin deals diminishing damage: the first blasts close-range enemies away with 14% damage inflicted, the second slash does 9%, and the third and fourth 7%. In the air, Hero's Spin lofts upward with five spins, scoring a combo against anyone caught by the blade. Naturally, it's also a decent option for offstage recovery. Hold left or fight to influence its trajectory.

Down Special 1: Blade Counter: Mii Swordfighter enters a defensive stance almost immediately after this move begins, turning intangible. Attacks that connect during this invulnerable period trigger the Swordfighter's counterattack, a launching sword slash that puts the victim in perfect position for more hits. Damage dealt is based on the strength of the deflected move.

Down Special 2: Reversal Slash: The sword bearer attacks at close range with a quirky slash that deals somewhat low damage while forcing the victim to reverse direction. If they're backturned, it turns them to face you; if they're facing you, they'll find themselves backturned. This is especially potent during air duels around stage edges, when even momentary confusion with controls can result in someone inadvertently falling off and losing a stock. Reversal Slash also reflects projectiles, with good timing.

Down Special 3: Power Thrust: On the ground, Power Thrust features Mii Swordfighter lunging suddenly with a powerful single-hit stab. The attack pierces through multiple foes and does max damage at the sword's tip, right at the start. The damage diminishes a bit with distance traveled, or if enemies are caught by the blade up close instead of at the tip. In the air, Power Thrust is a diving stab attack. Upon landing, the impact causes a secondary hit; with good aim, a diving Power Thrust won't only stab a victim into the ground, but also bounce them off on the impact hit.

Final Smash: Final Edge

In one of the Final Smashes with the most screen coverage in the game, Mii Swordfighter launches a maelstrom of energy projectiles that extends in an expanding cone across the entire stage. With this incredible coverage, it's best to get well off to one side of the stage so you can fire at everyone else on the other side.

GUNNER OVERVIEW

Mii Gunner sports an arm that seems like it's mostly bazooka and uses it for a variety of powerful single-hit explosive blasts, and multi-hitting, lower-caliber flurries. As you might expect, the Gunner's close-range attacks are not exceptional. Oddly, the fastest physical attack the Gunner has access to is down special 1, Echo Reflector, which deals a brief close-range zap against anyone nearby as the shot-reflection field turns on. Otherwise the most reliable physical swipe is up tilt. But boxing isn't why someone would pick a fighter with a gun arm. Mii Gunner comes equipped with a solid selection of mid- and long-range attacks using a variety of delivery systems. There are dumb-fire and homing rockets, timed grenades and mines, and ways to turn back or absorb any shots enemies send your way. And while Mii Gunner is hardly the most agile fighter on the roster, wall-jumping is still possible, adding some offstage variety. Up special 3, Arm Rocket, can also greatly enhance maneuverability and survival power.

Mii Gunner Vitals

Movement Options	
Jumps	1
Crouch Walk	No
Tether	No
Wall Jump	Yes
Wall Cling	No
Movement Ranks	
Ground Speed	F (72)
Air Speed	D (66)
Falling Speed	C- (54)
Weight	B (18-21)

Grounded Attacks

Neutral Attacks

Move	Damage
Neutral attack 1	1.5
Neutral attack 2	1.5
Neutral attack 3	1, 4

Dash Attack

Move	Damage
Dash attack	10

Defensive Attacks

Move	Damage
Ledge attack	9
Wake-up attack	7

Neutral Attacks: This neutral attack begins with a fairly sluggish two-jab combo with the first two inputs. The third input uses Mii Gunner's gun arm for a thrust-into-explosion capper. The initial jabs have pitiful range and are about as fast as most tilt attacks, so this neutral combo is not a central part of the Gunner's game plan. It's a decent defensive retort after dropping shield when blocking laggy moves. Otherwise, your time is better used on other options.

Dash Attack: While moving quickly forward, the Gunner swings with a powerful hook punch from the gun arm, the barrel discharging for extra oomph along the way. This has very good range and distance in front, and sends victims hurtling away, smoking from the heat.

Side Tilt: Mii Gunner takes aim with a short-range laser blast. The projectile extends forward from the gun barrel like a sword stab, covering about the territory of a single dash. The extended laser is like a sword, not a part of Mii Gunner, so it beats out anything it overlaps with. It can't be angled up or down like some side tilts. Damage is highest close to the barrel, but it's safest to aim from max range, hitting with the laser's tip.

Up Tilt: The Gunner's up tilt punch puts the gun arm to use increasing punching power. Mii Gunner performs a flaming uppercut, hitting directly in front at first, before hopping and hitting straight up briefly.

This is a terrific close-range poke, which is good for close-range sparring or anti-air attempts and juggles. Up tilt strikes in front just as fast as a neutral attack, yet with a much better hitbox. And it's meaningfully faster than Mii Gunner's other tilt attacks (though not as far-reaching). The only thing to be wary of is the landing lag from the uppercut's little hop.

Tilts

Move	Damage
Side tilt	13
Up tilt	10
Down tilt	14

Down Tilt: The Gunner blasts into the floor at close range, causing a small detonation that functions as a launching sweep. The range is decent, about the same as side tilt with a lower profile and hitting just a hair slower. If the target is closer in, the gun arm hits them just as well as the blast.

Side Smash: After whirling with a flourish, raising the gun arm, Mii Gunner unloads a fusillade of shots that reach a couple dashes' distance away. Six small shots are followed by a seventh finishing shot. All the shots combo together if early shots connect. Like side tilt, this is aimed horizontally along a fine line and cannot be angled, so beware barely missing against targets slightly off-plane from your fighter. The lengthy shooting period leaves Mii Gunner open to other fighters besides the target. But this also makes it a decent preemptive defensive move. When you're running away from aggressors, a sudden side smash volley back at them is a C-stick flick away (assuming you have it assigned to smash attacks).

Up Smash: The Gunner cuts loose with a series of local blasts from the gun arm, which seem to carry the arm back over the Gunner's head with the recoil. Anyone caught in front with the initial forward-facing blast is carried up and over, ending in a jugglable position in the air behind Mii Gunner.

Smashes

Move	Damage
Side smash	1.5x6, 6.3-2.1x6, 8.8
Up smash	3, 2.5x3, 6-4.2, 3.5x3, 8.4
Down smash	11.5 front, 14 back-16.1 front, 19.6 back

Up smash covers the up tilt directions, but is slightly slower and harder-hitting, and reaches all the way straight back for the hard finishing shot. The final hit being the launcher, and aiming straight back, gives this some unorthodox use as an intentionally slow backward-facing hit, like dashing at a foe, pivoting, and using up smash while sliding backward, or pre-charging a full-up smash and holding it while facing away from enemies.

Down Smash: Mii Gunner crouches for a close-range toe-searing blast in front before turning to repeat another shot behind. This is basically like if down tilt spun around and repeated itself, and is Mii Gunner's main clear-out move (though up smash also works). The backward-facing hit actually does a bit more damage. Hits on either side launch foes away, gaining breathing room for the Gunner.

Grabs

Move	Damage
Grab attack	1.3
Front throw	4, 3
Back throw	7, 3
Up throw	7, 3
Down throw	7

Aside from up tilt, Mii Gunner's best option in close is to go for a grab. Throw in two or three grab attacks before choosing a throw direction based on the situation. Mii Gunner's front throw spikes the victim a decent distance forward and can also hit anyone else in front during party battles. Back throw shoots them backward with more damage and knockback. The up throw also shoots them backward, but in position for quick follow-up attacks. Meanwhile, down throw does less damage than the others, but bounces foes into the best juggle position in front.

Aerial Attacks

Neutral Air Attack: The Gunner trails a hot gun barrel, which starts aimed almost straight back. From here, the active arm spins over the top, eventually ending where it started. This gives neutral air attack total coverage in all directions, though it's not as speedy as many neutral air pokes. If you intend to aim down-forward with it, for example, you'll have to swing extra early to give the arm time to come around.

Forward Air Attack: The Gunner's quickest, weakest projectile attack. A small energy shot is fired forward, traveling a bit farther than a dash. The shot travels straight across from wherever it's fired, and Mii Gunner's air arc isn't affected by forward air attack's windup. It requires precision to jump or fall and aim forward air attack shots where you want them. For example, if you want to shoot just off the ground to interfere with both standing opponents and short hoppers, automatic short hop timing (tapping forward+Attack+Jump all together) places it too high.

Back Air Attack: Mii Gunner aims backward in midair with a single-hit explosive blast, aimed back and slightly down.

Aerials	
Move	Damage
Neutral air attack	10
Forward air attack	8
Back air attack	12
Up air attack	1.8x6, 4
Down air attack	15

It's good when you're forced to use it on reaction to fliers creeping up from behind, and also for going after the enemy intentionally with backturned air attacks (like from a short hop backward). It's faster than the Gunner's other air attacks.

Up Air Attack: This is like an upward-aimed version of side smash, with a volley of projectiles dominating a thin strip of space. It's great in juggles from underneath with good aim, but less lenient going for enemies above than up airs that feature circular slash hitboxes.

Down Air Attack: An airborne Mii Gunner fires straight down, creating a small bomb blast underneath. The main hitbox is on the explosion, but the gun barrel itself also issues a weaker hit. Drop down on standing enemies or those attempting to recover to hit them with the short-range shot, spiking them down on clean contact.

Special Moves

Aerials	
Move	Damage
Neutral special 1: Charge Blast	4-26
Neutral special 2: Laser Blaze	5
Neutral special 3: Grenade Launch	0x1, 1.4x4, 6.6
Side special 1: Flame Pillar	2, 2.2x4, 2.8
Side special 2: Stealth Burst	-12.1-18
Side special 3: Gunner Missile	7.5 homing, 14.5 dumb
Up special 1: Lunar Launch	7
Up special 2: Cannon Jump Kick	9, 8
Up special 3: Arm Rocket	0
Down special 1: Echo Reflector	2
Down special 2: Bomb Drop	2, 9
Down special 3: Absorbing Vortex	4

Neutral Special 1: Charge Blast: This is a variable energy projectile that can be charged and stored. Like many such attacks, the charging period can be interrupted, keeping what you've built up so far. Cancel standing charge with dodging or jumping, and airborne charge with double jump. Once fully stored, you have an extremely powerful long-range attack available at a moment's notice. To fire it before the charge is fully built up, launching a weaker projectile, double-tap the input to begin charging, then fire.

Neutral Special 2: Laser Blaze: As straightforward as shooting attacks get, Laser Blaze is a fast, low-damage, long-range laser shot. You can fire these over and over to keep up a long-range rain of pesky projectiles.

Neutral Special 3: Grenade Launch: A smoking grenade is launched up and away, coming down to explode in about a second. Depending on the terrain, it can bounce around before exploding, or detonate immediately if it contacts a valid target. To switch directions before firing, input neutral special, then immediately snap the control stick in the opposite direction. This is necessary if you realize you need to snap a Grenade Launch backward while airborne.

Side Special 1: Flame Pillar: A low-damage fireball is launched down and away. On contact with a foe or surface, it explodes into a short-term conflagration. Anyone nailed by the initial fireball or caught in the follow-up blaze is juggled for several hits until it gutters out. Flame Pillar gives great forward space control, warding off aggressors from in front if the fireball strikes the ground. Keep in mind it has fairly long lag after the fireball is hurled, limiting follow-up potential.

Side Special 2: Stealth Burst: Once you input and hold the side special command, the Stealth Burst projectile begins flying laterally away from Mii Gunner. Once the input is released, the gossamer projectile explodes. The farther Stealth Burst travels before detonation, the higher the damage. Stealth Burst can be powerful and sneaky against faraway foes, but can be hard to direct accurately.

Side Special 3: Gunner Missile: This homing missile resembles Samus's. Multiple Gunner Missiles can be on-screen at once. The side-switch correction trick possible at the beginning of many specials (input the special, then snap to the other direction on the control stick within three frames, usually) doesn't work with Gunner Missile, so aim correctly the first time. For a homing Gunner Missile, use a tilt-style input (either hold left or right ahead of the button input, or use an analog half-press of left or right plus the button).

Up Special 1: Lunar Launch: Mii Gunner's up specials are all slight variations on a theme, using the arm cannon to blast the Gunner up, up, and farther up! There are important differences between them. Lunar Launch initiates with a somewhat sluggish single-hit blast, which catapults the Gunner upward a huge distance. It's basically a super jump, and lags until landing, though the tumbling Gunner can be steered a bit. With such an absurd altitude gain from Lunar Launch, it's a strong recovery tool, not to mention a rapid way to go from the bottom floor of a multitiered stage to the top.

Up Special 2: Cannon Jump Kick: Here, the gun arm is used to launch the Gunner straight up with a rocket-propelled kick. It hits faster and with more damage than Lunar Launch, and the kick can be steered a bit left or right on the ascent. It's a much better attack than Lunar Launch but doesn't gain as much altitude for recovery.

Up Special 3: Arm Rocket: This curious special features Mii Gunner using the gun arm strictly for propulsion. After activation, aim with the control stick to direct the Mii Gunner suddenly in any direction. There's no hitbox on this move, so its use is for recovery and quick, erratic repositioning only. If not using it to float back from offstage, then use it to run away from enemies to the other sides of platforms, farther away and into better position to fire with ranged attacks.

Down Special 1: Echo Reflector: As the Echo Reflector flickers on, it's briefly a low-damage attack. This Echo Reflector activation spark is actually the fastest physical attack in Mii Gunner's entire arsenal (quicker than neutral attack or up tilt), if weak and unconventional. After the spark, Echo Reflector becomes a reflection hitbox against incoming projectiles. They're returned to sender more powerful than they arrived.

Down Special 2: Bomb Drop: The Gunner ejects a timed explosive from the gun arm along a ponderous arc like a shot put. The bomb bounces a bit and detonates after about three seconds pass, or on contact with a valid target. Launching another Bomb Drop while one bomb is already active prematurely detonates the first one.

Down Special 3: Absorbing Vortex: This is a variation on Echo Reflector. Like that special, Absorbing Vortex has a brief sparking hitbox at the beginning, before the absorption vortex initiates. Absorbing Vortex's physical hit speed isn't noteworthy like Echo Reflector's, though. After the hit, the special becomes a vortex that pulls in any incoming enemy shots. Absorbed projectiles refill a shocking amount of Mii Gunner's health. The return for sucking in a projectile with Gunner's Absorbing Vortex is much better than pulling off something like Wii Fit Trainer's Sun Salutation or Deep Breathing. If enemies insist on using shots from far away and don't adjust their game plans, this special is a restorative boon.

Final Smash: Full Blast

The Gunner's Final Smash is an overpowering projectile attack that cuts a straight swath to almost infinite lateral range. Except across the very biggest stages, anyone level with you and in the gun arm's sights is blown away by this concentrated laser assault. The vertical range isn't much bigger than Mii Gunner's height, though, so be sure you have potential targets even with the Gunner when opening fire.

Mr. Game & Watch

OVERVIEW

Mr. Game & Watch is a quirky fighter built from leftover parts of '80s LCD games, predating even the NES! He's small and light, so he's got to be careful, but he has piles of great attacks to make it hard for foes to take advantage. Mr. Game & Watch's attacks and projectiles are like invincible extensions of himself, unable to be interrupted, deflected, or absorbed. It can be hard for aggressors to even get close to Mr. Game & Watch flinging nonstop pieces of food with Chef, or fending with basically any aerial move. When enemies do hurl him off the stage, Fire makes it easy to return.

Mr. Game & Watch Vitals	
Movement Options	
Jumps	1
Crouch Walk	No
Tether	No
Wall Jump	No
Wall Cling	No
Movement Ranks	
Ground Speed	D+ (39)
Air Speed	B (17)
Falling Speed	D- (71)
Weight	F- (73-74)

Grounded Attacks

Neutral Attacks: Mr. Game & Watch assumes the role of the fumigator, hearkening back to the 1982 release *Green House*. A small cloud of pesticide blows right in front of him with the initial press. This initial puff deals decent damage and hits relatively quickly, not pixie-speed but not as slow as heavyweights either. On hit, double-tap the Attack button to transition to the speedier second stage, in which Mr. Game & Watch fumigates furiously with quicker, lower-damage hits. Hold down the button to perpetuate this flurry. Upon release, he finishes with a knockback move that blows victims away.

Dash Attack: Remembering his construction days dodging tools in 1981's *Helmet*, Mr. Game & Watch slides to a diving stop. This starts up quickly for a move out of a dash or run. Anyone in the way is launched backward. Damage is a bit lower if you hit with the tail end of the active period here. If the enemy shields the dash, Mr. Game & Watch is technically at a punishable disadvantage, but thanks to his prone posture, their swing might miss right over him!

Neutral Attacks

Move	Damage
Neutral attack 1	3
Neutral attack 2	0.8xN, 3

Dash Attack

Move	Damage
Dash attack	10

Defensive Attacks

Move	Damage
Ledge attack	9
Wake-up attack	7

Side Tilt: Mr. Game & Watch goes back to his roots as a lion tamer in 1981's *Lion* with this poke, a warding chair swing directly in front. This has a bit more forward reach than neutral attack. The chair can't be aimed, unlike many side tilts, but the hitbox covers both his arm (where he's vulnerable) and the chair (where he isn't). The initial thrust of the chair deals max damage, with later active frames dealing half as much. The chair stays active for a surprisingly long time for a side tilt, active for a fifth of a second.

Tilts

Move	Damage
Side tilt	12
Up tilt	7, 7
Down tilt	9

Up Tilt: Retrieving his flags from 1980's *Flagman*, Mr. Game & Watch raises numbered flags first in front, then behind. (The numbers on the flags don't matter. Sometimes he attacks first with #2, sometimes with #1, depending on the direction he's facing.) The hitbox around the flag extends safely above Mr. Game & Watch's vulnerable head, and his hands are also safe from harm during this attack, increasing likelihood that he wins exchanges cleanly.

Down Tilt: Mr. Game & Watch leans low to upend a manhole cover (pulled straight from 1981's *Manhole*) before him, knocking away anyone in front. Down tilt hits as fast as Mr. Game & Watch's grab, quicker to hit than side tilt or up tilt but not as fast as neutral attacks.

Side Smash: Inspiration for this fire attack comes from...1982's *Fire Attack*. Mr. Game & Watch swings a fiery torch in front, outranging both neutral attack and side tilt. The speed is average for a side smash, and on hit this has good knockback even at low percentages. At high-damage percentages, it makes a great KO attempt.

Up Smash: Mr. Game & Watch dons his diving helmet from 1981's *Octopus* for this headbutt, which hits back-to-front. During the attack frames, his head is invincible, negating incoming enemy attacks. As he leans back, the initial frame hits behind him, but the rest of the brief attack can hit either side, or enemies above. Successful hits pop enemies up into the air, vulnerable to immediate follow-up hits.

Down Smash: Mr. Game & Watch slams mallets down simultaneously on both sides in this clear-out move, inspired by 1980's *Vermin*. His head is exposed, but a lateral hitbox covers the rest of his body, and the hammers on either side. If this whack-a-mole attack hits, victims are knocked away a fair bit, giving Mr. Game & Watch space. Standing opponents have a chance to be planted into the dirt for a second, leaving them wide open!

Smashes

Move	Damage
Side smash	18-25.2
Up smash	16-22.4
Down smash	15-21

It's pretty typical for smash attack speed, and a much faster defensive option than up smash. If shielded, Mr. Game & Watch is technically punishable if foes react immediately, but they might be pushed too far by the hammer hit to reach him in time. Down smash also inflicts decent shield damage on blocking foes.

Grab speed for Mr. Game & Watch is very quick on his feet, just slightly slower than the game's fastest grapplers. The standing reach is small, though. When used during a dash, his grab is slightly slower, like a heavyweight's, but it gains a lot of extra range (not just from the dashing action—Mr. Game & Watch actually reaches farther during dashing grabs). Once the foe is pulled in with a successful grab attempt, Mr. Game & Watch uses animations borrowed from his very first game, 1980's *Ball*. Tossing them from one hand to the other like a juggler, he flings his opponent with variations of the usual throwing themes.

Grabs

Move	Damage
Grab attack	1.3
Front throw	8
Back throw	8
Up throw	12
Down throw	4

Aerial Attacks

Neutral Air Attack: Mr. Game & Watch gingerly transports a fishbowl (pulled straight from 1985's *Tropical Fish*) during neutral air, but not gingerly enough, since two fish hop out the sides. At first, the leaping fish and fishbowl hit straight up, as though this were an up air attack. The fish can hit enemies on both sides as they fall alongside Mr. Game & Watch. The upward hit is quick, but the side hits are a bit slower. If intending to float sideways in midair into people, covered by the falling fish to the sides, consider this air move about as quick as an average side smash on the ground.

Aerials

Move	Damage
Neutral air attack	3x3, 4
Forward air attack	3, 12
Back air attack	2x3, 3
Up air attack	1.8x5, 3
Down air attack	11

Forward Air Attack: Mr. Game & Watch holds up a bomb left over from 1983's *Mario's Bombs Away*, then drops it. His initial arm-raising action to release the bomb is a weak hit aimed up-forward.

The bomb itself deals no damage until it explodes, which happens either when it collides with a foe or surface, or (if nothing is in the way) about three-quarters of a second after it's dropped. This is a strange air poke, almost more like a special.

Back Air Attack: Mr. Game & Watch strikes toward his back with the most fearsome of weapons, a snapping turtle borrowed from 1982's *Turtle Bridge*. The turtle isn't a part of him, so enemies can't out-prioritize it if their attacks overlap. The turtle bites with three weaker hits before finishing with a knockback snap. Air-to-air, back air attack is Mr. Game & Watch's best jousting weapon, since the turtle head beats out enemy moves. It's a bit slow to hit at first compared to many aerials, so plan to swing slightly ahead of time.

Up Air Attack: Like in 1984's *Spitball Sparky*, Mr. Game & Watch blasts a puff of long-lasting air that wafts straight upward. While he drifts back down after blowing out the puff, the air blast flies a long way straight up, over the height of a double jump. As it travels, the air blast has an enormous active period as a threat, over half a second!

Down Air Attack: Briefly halting his air momentum, Mr. Game & Watch produces a key (a relic from 1982's *Donkey Kong Jr.*) and then plunges down, stabbing with it. He plummets until he lands, but he can be steered a bit left or right on the way. On touchdown, his impact creates a secondary hitbox, knocking anyone close out of the way. If he plunges into someone below with the falling key hit, the impact hit *can* also hit them for a two-hit combo, but the spacing doesn't usually work out that way.

Special Moves

Neutral Special: Chef: Breaking out the frying pan like in 1981's *Chef*, Mr. Game & Watch serves up lobbed food items, up to five at a time. Hold down the input, and Mr. Game & Watch lobs them one after another slowly; tap the input repeatedly to speed up his food-flipping. While he flips pieces of food, hold forward or backward to alter their arcs. Holding toward Mr. Game & Watch's back flips food items upward in a high arc, so they fall closer to him and can act as a kind of defensive shield. Holding forward, toward his front, flips the food low and farther away, more of an offensive option.

Side Special: Judge: While swinging a gavel in front, Mr. Game & Watch holds his verdict aloft, 1980's *Judge*-style. The hammer hit has the same speed regardless, as fast as most uncharged side smashes, but the power varies wildly depending on which number he produces. The number is random; embracing the randomness and learning to react to different results is part of playing Mr. Game & Watch.

Up Special: Fire: Assisted by two firefighters from 1980's *Fire*, Mr. Game & Watch trampolines high upward, even higher than during a full-height double jump. The firefighters appear as hits to both sides of him almost instantly, faster than any other Mr. Game & Watch move, even neutral attack. Mr. Game & Watch then launches high up, intangible for the first third of his ascent, his body a projectile as he hurtles upward. It's possible for the low-damage firefighter hit to pop the opponent into position for the takeoff to combo, but it doesn't usually work out that way. With this attack, you're usually aiming to hit either immediately with the firefighters to the sides, or slightly later with Mr. Game & Watch's flung body.

Down Special: Oil Panic: Mr. Game & Watch produces a harmless bucket, held over from 1982's *Oil Panic*. On its own, this move does nothing. But if an energy-based projectile or shot is nearby, Mr. Game & Watch scoops it up in the bucket, storing it. It takes three absorbed shots to fill the bucket, which has a visual indicator of how full it is, divided into thirds. When he holds out the bucket, his falling momentum is briefly halted, giving this some use for modifying fall timing.

What the bucket does is convert stored shots into hot oil. When it's full, a down special input makes Mr. Game & Watch dump out the oil as a powerful projectile splash in front. This splash's damage can vary widely, since it's based on the power of the projectiles absorbed. But even an "average" Oil Panic made of run-of-the-mill projectiles like Pikachu's or Mario's produces an extremely strong attack. It's just that absorbing three strong energy shots like Ness or Samus can produce results in absurd damage.

Special Moves	
Move	Damage
Neutral special	5x5
Side special	Varies
Up special	3, 6
Down special	Varies

Judge Verdicts	
#	Damage
1	2
2	4
3	6
4	8
5	3x4
6	12
7	14
8	13
9	32

Final Smash: Octopus

In what can be one of the hardest Final Smashes for enemies to dodge, a gigantic Octopus (from 1981's *Octopus*) skates across the screen, taking up a huge bit of airspace as it passes while grasping with sticky tentacles. Anyone caught in its grasp is dragged sideways off the stage, in grave danger of being KO'd outright if they react poorly! As the Octopus travels, hold the control stick up or down to direct its path, making it harder for enemies to escape.

Ness

OVERVIEW

Ness, the hero of *EarthBound* fame, fights with his favorite baseball bat and yo-yo. Oh yeah, and his psychokinetic powers! PK Flash, PK Fire, and PK Thunder are the most distinctive aspects of the boy hero. Using PK Thunder in particular takes some getting used to, both controlling it as a ranged attack and using it to save Ness when knocked offstage. His PK specials form the backbone of a defensive projectile/camping game, chipping away at enemies and coaxing them to react. Ness is no slouch when forced to fight in close, with a good neutral attack and grab, an amazing down tilt, and multiple clear-out options with up smash and down smash. Not to mention his signature attack, the side smash home-run swing, which is a walloping KO move and also a means to bat projectiles back to sender.

Ness Vitals	
Movement Options	
Jumps	1
Crouch Walk	No
Tether	No
Wall Jump	No
Wall Cling	No
Movement Ranks	
Ground Speed	D (49)
Air Speed	C- (53)
Falling Speed	D (66)
Weight	C (40-43)

Grounded Attacks

Neutral Attacks: Ness attacks quickly with a short-range punch-punch-kick combo. The first jab is quick, not as fast as someone like Zero Suit Samus or Mario but barely behind them. It's a great out-of-shield option to retaliate up close. Ness is punishable if enemies block neutral attack hits, but they have to react fast to punish him after just one or two blocked punches (it's much easier for people to react if you do all three attacks, finishing with them blocking the kick).

Neutral Attacks	
Move	Damage
Neutral attack 1	2
Neutral attack 2	1.5
Neutral attack 3	4

Dash Attack: While running, Ness uses brainpower to attack in front, projecting PK energy in three quick blasts. The first strikes right in front of Ness, and each subsequent blast hits slightly farther away. The third and final dashing PK hit has good knockback, launching victims off their feet. This offers a juggle chance even if only the third hit connects.

Dash Attack	
Move	Damage
Dash attack	4, 2, 4

Defensive Attacks	
Move	Damage
Ledge attack	9
Wake-up attack	7

Side Tilt: Ness spins forward to attack with a tough side kick. Ness might be small, but his damage isn't. This dishes out respectable damage with a decently fast hit, and it can be aimed slightly up or down. The downward version's hitbox is perfect for kicking at a recovering enemy's fingers just when they lunge for a safe ledge. Like Ness's neutral attack combo, side tilt doesn't knock foes off their feet until medium-damage percentages.

Tilts	
Move	Damage
Side tilt	10
Up tilt	7
Down tilt	4.5

Up Tilt: Ness makes a little hop up while punching upward with both palms. This is a fast attack for a tilt, hitting even faster than Ness's grab up close. This attack has decent coverage to his sides if enemies are up close on the ground, but the main hit (and max damage) is around his hands, aimed upward.

Nailing someone with up tilt (whether they're airborne or standing next to Ness) launches them into the air. At low to medium percentages, you can usually combo up tilt into itself two or three times quickly before jumping to hit foes in midair after. Enemies might hit or grab back up close when blocking up tilt, but they have to be quick.

Down Tilt: Ness kicks the ground in front with a low kick that's incredibly fast and safe for a tilt. This down tilt hits just as fast as Ness's first neutral attack, almost instantly, and can combo into itself if used repeatedly in close. Five or six rapid down tilts at point-blank range on a foe who fails to block quickly adds up to 20% damage or more!

Side Smash: Swing, batter batter! Ness uncorks one of the strongest knockout moves in the game, a home-run swing that can reflect incoming projectiles. There's an invincible hitbox in front of Ness just before and during the bat's hitting frames, giving the bat overwhelming priority against enemy attacks in that area, while also deflecting ranged attacks and sending them back faster and stronger than they arrived.

Smashes

Move	Damage
Side smash	22-30.8
Up smash	13-15.6
Down smash	1, 10-1.2, 12

Up Smash: During up smash, Ness shows off his yo-yo skill by whipping the stringed weapon in an arc that covers all around him like a rainbow. The yo-yo's active hitting period starts out at Ness's front foot and rotates up over his body, ending up behind him.

The initial hit at his feet is decently fast for a smash, and about twice as fast to hit someone in front as side smash. The yo-yo stays out a long time, hitting upward about a third of a second after start-up, and hitting behind Ness about a half-second after start-up.

Down Smash: Showing off his yo-yo control, Ness starts this double-sided down smash attack by "walking the dog" behind him. Yup, this is the rare clear-out attack that hits to the back *first*. It's also unique in that there's an attack while charging the smash: start down smash and hold the input, and Ness makes the yo-yo spin in place behind him. If someone's standing in this area, it can hit them several times before the attack is even released, like some "flurry" neutral attack finishers.

Grabs

Move	Damage
Grab attack	1.3
Front throw	11
Back throw	11
Up throw	10
Down throw	0.5x3, 1.5, 4

Ness's grab speed is very good, just short of the fastest grabs in the game. He can set up grab attempts easily with his down tilt attack, which serves as a safe, perfect tick move before grabbing. At any damage percentage, front throw has terrific forward knockback, throwing victims a long way and securing KOs at higher percentages. Back throw doesn't hurl them far at low percentages, allowing for immediate close-range pressure. At medium damage and higher, its throw distance is more like front throw's, giving great KO and offstage-toss potential.

For up throw, Ness flings foes upward using the power of his mind, leading to pressure and juggles as they tumble. Down throw inflicts some quick fire damage on the ground before popping them up in front, allowing for closer juggles. If someone is standing nearby while Ness pins his throw target and roasts them, they can take incidental damage from the flames.

Aerial Attacks

Neutral Air Attack: Ness extends his hands to either side and spins. His hands and body all have hitboxes around them, so this attack has good coverage all over. His arms are tilted forward, so it's aimed slightly diagonally downward. It's quick to start hitting, with max damage during the earliest spin. The attack persists for a sixth of a second, with the latter half dealing less damage and knockback. The active period and hitboxes all over Ness's body allow this to be used right above targets before fast-falling to drag the move into them.

Aerials

Move	Damage
Neutral air attack	11
Forward air attack	1.5x3, 5.5
Back air attack	15
Up air attack	2.5x3, 5
Down air attack	12

Forward Air Attack: Ness holds his hand in front, striking with PK energy four times. The first three hits are small, with most of the damage coming from the final hit.

The extended hitting period makes this good for firing at airborne targets ahead of Ness, but it's hard to use against enemies on the ground. When falling with forward air to strike air-to-ground, use it a little early so you whiff the first hit or two above your target before striking with later hits.

Back Air Attack: This backward-aimed dropkick is powered up by Ness's psychic skills. Hitting with good aim early in the attack is very strong, with great knockback strength and damage. Ness's legs persist as hitboxes after the PK power disappears, though with lower damage and knockback.

Up Air Attack: A determined Ness points to the sky above him, sweeping his hand back-to-front for PK coverage across upward angles. This hits above and behind him first, before dragging forward to the front.

The initial hitbox appears quickly, but without coverage straight up or up-forward. The PK blasts get there before too long, hitting up-forward with about the speed of a typical smash move. Enemies struck by up air get launched upward, where you can pursue them for more attacks.

Down Air Attack: Ness aims straight down with a kick that might look slow and unimpressive, but is backed by his PK force. With a clean hit, down air can meteor smash opponents, spiking them straight down to bounce off the stage or plunge down a drop-off.

Special Moves

Neutral Special: PK Flash: Ness focuses his energy, sending forth a pulsing projectile. Hold down the Special button and move the control stick left or right to direct this projectile, which arcs out slowly for up to almost two seconds. The pulsing energy moves until one of three things happens: you release the button, it hits a surface, or its travel time runs out. Whichever happens, the energy explodes, hitting a large area with a high-damage flash. The longer PK Flash exists, the higher the damage whenever it finally goes off.

Special Moves	
Move	**Damage**
Neutral special	11-25
Side special	6, 1x5-16
Up special 1	10
Up special 2	25
Down special	4

Side Special: PK Fire: On the ground, Ness throws a small bolt of fire energy horizontally. In the air, he throws it at a 45-degree angle downward. The range on the firebolt is decent, about the length of two dashes. Thrown from either air or ground, if the firebolt strikes an enemy, it explodes into a brief conflagration, inflicting lots of low-damage hits as it roils. Someone grazed by PK Fire takes at least five burning hits, leading to a special that does 11% damage total. Depending on where it hits them and how much they shuffle while being seared, PK Fire may stack up as many as 16 extra hits, exceeding 20% damage total.

Up Special: PK Thunder: Ness's most infamous move can be used several ways. It's a controllable shot that can hit enemies directly or strike Ness to make him into an even more powerful projectile, and it also powers his recovery plays. On activation, Ness employs his psychokinetic powers to send forth a sparking, snaking bolt of lightning. While this twisting blue projectile is active, Ness stands still (or floats slowly, if started in midair), crackling with mental effort.

PK Thunder can be used as a controllable, far-reaching projectile. Activate it, then steer it straight for foes, looking to hit them head-on. Depending on the stage's layout, Ness may be able to pepper enemies with PK Thunder from a relatively safe position, moving it around impediments and platforms to seek out desired targets. PK Thunder is also Ness's only recovery tool when he finds himself over the edge. Launch PK Thunder and fly it around Ness in a tight circle, hitting him on the opposite side of the way you want him to go.

Down Special: PSI Magnet: Ness conjures a sphere of absorption power. Any energy moves that touch this field are negated, refilling a bit of Ness's health. This is great against fighters like Samus and Wii Fit Trainer, who build their game plans around powerful chargeable projectile specials. It even works wonders against another Ness or Lucas, should they attack with their PK-powered shots.

Final Smash: PK Starstorm

Joined with friends Paula and Poo, Ness unleashes a meteor shower using their combined PSI powers. Holding left or right slightly aims the shower of projectiles from the heavens. There's no safe place under where the energetic bolides fall!

Olimar

Olimar Vitals	
Movement Options	
Jumps	1
Crouch Walk	No
Tether	No
Wall Jump	No
Wall Cling	No
Movement Ranks	
Ground Speed	D (48)
Air Speed	D (71)
Falling Speed	D (58-61)
Weight	F+ (67-69)

OVERVIEW

Olimar is a unique fighter, most of whose attacks are enabled by his squad of loyal Pikmin helpers. A lot of playing Olimar is about arranging and keeping track of your stock of Pikmin. Different Pikmin have different advantages and disadvantages. Specials Pikmin Pluck and Pikmin Order are concerned with restocking and rearranging the little vegetable-like helpers. Pikmin Throw is the Pikmin special attack, and probably Olimar's most important move overall. All smash attacks and grabs, and most air moves also require the presence of Pikmin.

Up to three Pikmin can be active at a time, and Olimar always starts matches and fresh stocks with the same team in the same order: red, yellow, blue. Any Pikmin attack employs the red Pikmin and rotates the line, making the new order yellow, blue, red. If Pikmin are defeated (they're vulnerable to enemy attacks and can fall off stages), openings are created on Olimar's team. Pikmin Pluck produces a new helper, always in this order:

Red > Yellow > Blue > White > Purple

So the first new recruit in a given match is a white Pikmin (since every match starts with red, yellow, and blue), the next purple, the next red, and so on. Take care not to ditch all of your Pikmin at once, or you're left without access to lots of moves. Current Pikmin order may get mixed up out of this default, depending on how quickly different Pikmin make it back to Olimar after being dispatched on Pikmin Throw or side smash missions.

PICKING PIKMIN

Playing Olimar often involves rebuilding the Pikmin lineup to prioritize different things. As the match develops and your Pikmin take losses and force you to patch up the team on the fly, getting back to "ideal" setups might require any combination of ditching and plucking Pikmin. From the consistent start of red/yellow/blue, there are clear beginning pathways to good setups:

For focusing on grabs, an ideal team is red/blue/white, which requires that you toss the yellow Pikmin off a ledge and pluck up a white one next.

For focusing on pokes, you want the strongest options in red/yellow/purple. Blue isn't so bad either; mainly you want not to use white for physical attacks. You have to ditch both a blue and white Pikmin before plucking up a purple one.

For focusing on Pikmin Throw, yellow/blue/white is ideal. (An argument could be made for purple over blue as a heftier change-up). All you have to do here is ditch the red Pikmin and pluck a white one.

Pikmin	HP	Plus (+)	Minus (-)	Best for
Red	6	Fire attack, strike and shield damage	Throw damage	Smash/air moves and shield pressure, up/down throw (for follow-ups), foes weak to fire
Yellow	6	Electric attack, bigger hitboxes, higher Pikmin Throw arc	—	Ease of hits, Pikmin Throw, foes weak to electricity
Blue	8	Throw damage, can be tossed into water without dying	—	Pikmin durability, raw throw damage
White	5	Grab range, Pikmin Throw damage, longer Pikmin Throw arc, causes poison damage	Strike damage, hitstun/shield-stun	Pikmin Throw, grab attempts
Purple	11	Strike and shield damage	Range for Pikmin Throw, side smash, and grabs	Pikmin durability, smash/air moves and shield pressure

159

Grounded Attacks

Neutral Attacks (DON'T INVOLVE PIKMIN): The industrious captain strikes with a one-two punch combo. Neutral attack a staple of his solo offense and defense. It's not the fastest jab combo in the world, but it's serviceable, and both hits are safe from guaranteed striking counterattacks on block! The best foes can do is cancel their blocking with a shield grab up close, but they can't hit back just because they block Olimar's neutral attack punches.

Dash Attack (DOESN'T INVOLVE PIKMIN): Showing off more gymnastic agility than you might expect, Olimar flips heels-over-head toward foes with a cartwheel attack. This move hits twice if you connect with early frames, launching victims up into a jugglable position in midair. Hit late and it still pops them up, but inflicting less damage. If shielded, dash attack leaves Olimar at a disadvantage up close. However, he usually pushes through a blocking enemy's body during the cartwheel.

Side Tilt (DOESN'T INVOLVE PIKMIN): Olimar winds up (taking a long time for a side tilt) before issuing a big slap in front. In terms of use, think of this like an unchargeable side smash. Red, yellow, blue, and purple Pikmin-powered smash attacks are strictly better than this move, hitting faster and harder. This is one of the slowest tilt attacks in the game, so you might be better off relying on "instant" dash attacks or short-hopping neutral air attack when you need a Pikmin-free ground poke. But if you want a KO-capable move without any Pikmin around, side tilt's the only option.

Up Tilt (DOESN'T INVOLVE PIKMIN): Taking a little hop in place, Olimar pirouettes upward, hitting to both sides with a flurry of weaker strikes before popping up anyone in the way with a twirling headbutt. Enemies on either side on the ground are pulled into the blender of hits and launched upward. At low percentages, you can usually combo up tilt into itself at least once. Watch out against smaller targets or crouching enemies, because up tilt can miss over their heads, even point-blank. It's also unsafe from immediate retaliation if shielded.

Down Tilt (DOESN'T INVOLVE PIKMIN): Olimar slides forward, bopping anyone in the way with a helmet headbutt. It hits with the same speed up close as up tilt, but with a much lower profile. Like up tilt, it can be punished if shielded, though it's not quite as unsafe, and doesn't provide the same visual cue that Olimar will be briefly open afterward. On the plus side, it doesn't miss close, small enemies in front like up tilt often does.

Neutral Attacks

Move	Damage
Neutral attack 1	4
Neutral attack 2	4

Dash Attack

Move	Damage
Dash attack	7, 4

Defensive Attacks

Move	Damage
Ledge attack	9
Wake-up attack (faceup)	7
Wake-up attack (facedown)	7

Tilts

Move	Damage
Side tilt	11
Up tilt	0.6x5, 4
Down tilt	6

Smashes

Move	Red	Yellow	Blue	White	Purple
Side smash	20.3-24.3	14.5-17.4	14.5-17.4	11.6-13.9	23.2-27.8
Up smash	18.2-21.8	13-15.6	13-15.6	10.4-12.5	20.8-25
Down smash	15.4-18.5	11-13.2	11-13.2	8.8-10.6	17.6-21.1

Side Smash: Olimar grabs the next Pikmin and hurls it straight ahead. This is a fast and powerful side smash attack, hitting faster (and usually much harder) than Olimar's Pikmin-free side tilt. The tossed Pikmin travel out to about the distance of two dashes, giving this great range (with the exception of the heavy purple Pikmin). Damage is highest right when the Pikmin are released, up close to Olimar, and drops off quickly as a Pikmin flies toward the end of its travel. Amazingly, with any Pikmin type except white, Olimar is safe from guaranteed strike reprisals when this is shielded up close.

Up Smash: Olimar flips the next Pikmin in line straight up in the air directly in front of him. It takes twice as long to hit as up tilt, but doesn't whiff over small fighters in front. At the outset, there's a big hitbox in front of Olimar, as well as one above. Once the Pikmin is clear of Olimar and traveling upward, there's just a hitbox around the little helper. It spins up to cover as high as short hop height. The only risky Pikmin for this strike is, as usual, the white one, which inflicts a lot less shield-stun on defenders.

Down Smash: Since this full attack needs two Pikmin, it rotates two at a time, so you move right to the third in line for the next Pikmin move.

Olimar directs the two Pikmin to spread out, striking at both sides simultaneously. This is Olimar's fastest smash attack (much faster than side tilt, too), affording him breathing room front and back. Down smash is relatively safe from punishment shielded, unless it's the white Pikmin doing the attacking.

If there are only two Pikmin present, they don't change positions! With only two Pikmin, you can use down smash repeatedly to keep hitting with the same desirable Pikmin (red and purple in this case). If only one Pikmin is available, Olimar sends the solo helper forward, getting no backward coverage.

Grabs

Move	Red	Yellow	Blue	White	Purple
Grab attack	1	1	1	1	1
Front throw	6.7	8.4	14.2	7	7
Back throw	8.6	10.8	18.3	9	9
Up throw	1.2, 6.4	1.2, 8.4	1.2, 15	1, 7	1, 7
Down throw	1.2, 6.7	1.2, 8.4	1.2, 14.2	0.8, 7	1.6, 7

To grab, Olimar requires at least one Pikmin alongside him. Instead of grabbing with his own two hands, he sends the little helper(s) forward to do it. This works sort of like a tether grab, in that the Pikmin running forward are slower than typical grabs, but reach much farther ahead. This throw is slow up close, so take advantage of the range to avoid getting jabbed or grabbed up close before the Pikmin even move.

The more Pikmin you have, the longer the grab reach is. With one Pikmin, a grab's range is as far forward as a dash. With three Pikmin, it's about a dash and a half—huge grab reach and one of Olimar's big strengths. The throw selection is pretty typical; the variety is more in which Pikmin you use for the initial grab. For max reach, go for a grab with a white Pikmin up next. If you're purely interested in throw damage, the blue Pikmin is your pick. The red Pikmin's throw damage is lower, but leads to better combos and mix-up pressure.

Aerial Attacks

Aerials

Move	Red	Yellow	Blue	White	Purple
Neutral air attack	1.5x4, 2	1.5x4, 2	1.5x4, 2	1.5x4, 2	1.5x4, 2
Forward air attack	11.9	8.5	8.5	6.8	13.6
Back air attack	15.1	10.8	10.8	8.6	17.3
Up air attack	12.6	9	9	7.2	14.4
Down air attack	12.6	9	9	7.2	14.4

Neutral Air Attack (DOESN'T INVOLVE PIKMIN): Olimar stretches out his arms and spins five times, creating hitboxes everywhere on his body. His head, arms, and legs are all at threat. This attack starts fairly quickly and is active a long time, making it a good all-purpose jumping move. It's also the only air attack Olimar can access if no Pikmin are nearby. It's good falling in on standing enemies, going air-to-air with fliers, and short-hopping right out of shield-stun as a retaliatory change-up.

Forward Air Attack: Olimar swings a Pikmin forward by its stem (ouch!), swatting anyone in front. It hits in an arc from up-forward to down-forward, with the Pikmin's hitbox extended generously in front of Olimar. Don't use this or other directed air moves without Pikmin coming along.

Back Air Attack: Olimar turns in midair and swings a Pikmin behind him, arcing it from down-back to up-back. While forward air attack starts out aimed upward, back air starts out aimed downward. Because of this, although forward air attack technically starts up faster, they both hit a standing or low-altitude target at about the same time if done during an aggressive short hop.

Up Air Attack: Olimar waggles a Pikmin over his head, sweeping it from diagonally above and behind, to above and in front, finally waggling it straight up toward the end of the active period. This is a good warding move to anti-air enemies incoming from the skies, or to juggle tumbling targets. It hits relatively fast, and can even work falling at ground targets, setting up immediate up tilt if it hits them as Olimar lands.

Down Air Attack: Olimar grabs a Pikmin and swings it quickly straight down. The Pikmin hitbox extends linearly a long way, making this great for falling on enemies and spiking tumbling or recovering targets. The hitbox extends so far down that it even works during short hops for slapping opposing foes' fingers just as they try to recover to a ledge for safety!

Special Moves

Neutral Special: Pikmin Pluck: This special is useful only on the ground. It plucks up another Pikmin from the earth, if there's space for a new member on Olimar's field team. Pikmin have small amounts of health, from the weakest (white) at 5, to the sturdiest (purple) at 11. Therefore, a handful of anyone's attacks can defeat any individual Pikmin, but it's easy for you to replace them. To rearrange your team on purpose, you might toss certain colors off yourself!

Special Moves

Move	Damage
Neutral special	–
Side special	Varies.
Up special	–
Down special	–

Side Special: Pikmin Throw: During Olimar's defining move, he tosses the next Pikmin in line far forward, quicker than any of his smash attacks (though not quite as fast as up tilt or down tilt). For a special move that's basically a projectile, this is extremely fast. It can also potentially travel extremely far, since the Pikmin is an active projectile all the way until the ground. Jump, double-jump, and use Pikmin Throw at the apex, and you toss a Pikmin quite a long way. Pikmin Throw has very little start or end lag, so it's easy to toss all three Pikmin during the same jump, filling the airspace in front of Olimar with grasping threats.

Pikmin Throw

Red	Yellow	Blue	White	Purple
2xN	2xN	2xN	4.7xN	6

When any Pikmin except purple gets near a foe who isn't shielding already, they cling to them. If a Pikmin isn't knocked off by attacks that hit them, they swat over and over while clinging, hitting up to 10 times or more! Most Pikmin are capable of dishing out up to 20% damage after a connected Pikmin Throw. Like all Pikmin moves, each Pikmin is different. The heavy purple Pikmin doesn't travel as far as the rest, and doesn't cling; it just thuds into the victim like a big rock! The yellow Pikmin's flight path is different from most of the rest, arcing upward more to fall more sharply downward. Most importantly, the white Pikmin is capable of *much* more damage off Pikmin Throw, over twice as much as any other helper! It also flies out the fastest and farthest, though it's the easiest to squish.

Up Special: Winged Pikmin: A pair of Winged Pikmin arrive to lift Olimar to safety. Like Villager and Isabelle's Balloon Trip, this is a movement-oriented special, with no attack hitbox. The control stick allows nimble movement as long as the Winged Pikmin's energy holds out, but once they're exhausted, Olimar falls helpless to earth. It's possible to use any of Olimar's air moves during Winged Pikmin, but the Winged Pikmin depart immediately and he's helpless until landing after that too.

How long the Winged Pikmin carry Olimar depends on how recently they've been summoned, and how many support Pikmin tag along for the ride. If you're using Winged Pikmin repeatedly, and taking all three current Pikmin with Olimar, Winged Pikmin doesn't last long at all. But if the Winged Pikmin are well-rested and no Pikmin are taken with, this up special lets Olimar travel farther and faster in midair than almost anyone else can.

Down Special: Pikmin Order: With a blow of a whistle, Olimar orders Pikmin to form up and order themselves. Olimar, after the first frame of start-up, gains super armor for a tenth of a second, potentially absorbing attacks in some situations without flinching.

The Pikmin's actions depend on where they are when the whistle blows. Pikmin Order forces dispersed Pikmin to rendezvous at Olimar. If all Pikmin are already following Olimar, Pikmin Order forces them to align themselves in the standard order: red, yellow, blue, white, purple. If all Pikmin are already formed up on Olimar and they're already adhering to the standard order, then they rotate forward: yellow, blue, white, purple, red.

Final Smash: End of Day

Olimar and the Pikmin family board a high-flying rocket ship as Bulborbs clamor in the foreground. The rocket can be aimed a little on the way up and on the way down, and causes heavy damage on impact if anyone is in the way!

PAC-MAN

OVERVIEW

PAC-MAN is a floaty middleweight fighter with an unconventional move set drawn from the *PAC-MAN* games. While PAC-MAN deals relatively low damage and can't extend his combos as efficiently as other fighters can, his eccentric fighting style gives him a distinct advantage when his moves are used properly. His projectiles become items that can be picked up and thrown for added pressure, his trampoline can be used to launch himself higher and higher with repeated uses, and his odd Fire Hydrant waterspout shots can cause unpredictable effects for the enemy.

PAC-MAN Vitals	
Movement Options	
Jumps	1
Crouch Walk	Yes
Tether	No
Wall Jump	Yes
Wall Cling	No
Movement Ranks	
Ground Speed	D+ (40-41)
Air Speed	C+ (36-37)
Falling Speed	D (58-61)
Weight	C+ (36-39)

Your main objective with PAC-MAN is to find ways to set up his odd yet versatile special moves. Most of them require some kind of prohibitive start-up period, whether it's from charging his neutral special or planting his Fire Hydrant. This means you have to defend yourself against aggressive foes with your solid aerial attacks (forward air and back air are particularly effective for deterring offense).

Grounded Attacks

Neutral Attacks

Move	Damage
Neutral attack 1	2
Neutral attack 2	2
Neutral attack 3	4

Dash Attack

Move	Damage
Dash attack	2x3, 4

Defensive Attacks

Move	Damage
Ledge attack	9
Wake-up attack	7

Neutral Attacks: PAC-MAN lunges forward with a close-range one-two punch combo, then completes the sequence with a somersault backflip kick, knocking away foes. PAC-MAN's first jab has moderate start-up speed, but short reach. His follow-up jabs cause him to lunge forward, extending his reach. Neutral attack combo is best used to quickly stuff enemy aggression or extend low-altitude knock-up combos (such as from a deep up air attack).

Dash Attack: PAC-MAN turns into his 2D wedge-shape form and assaults the enemy with several chomp attacks before launching them into the sky for a potential follow-up. PAC-MAN's dash attack is unique in that it's safe when shielded (you're actually at a frame advantage!), thanks to its remarkably low lag. You can potentially score a follow-up air attack, depending on the enemy's shuffle.

Side Tilt: PAC-MAN quickly extends an enlarged boot out in front of him, stopping foes in their tracks. PAC-MAN's big boot kick can be angled up or down using the control stick. Side straight kick variant boasts superb reach, the up-angled version can be used as a situational anti-air, and down-angled side tilt can punish recovering opponents as they grasp a ledge.

Tilts

Move	Damage
Side tilt	8
Up tilt	6.5
Down tilt	6

Up Tilt: PAC-MAN drives his giant-sized fist directly above him and launches foes into the air long enough for him to follow up with an attack. Although the hit coverage is narrow with no horizontal range, it has very little lag, allowing you to throw it out repeatedly against foes above you.

Down Tilt: PAC-MAN turns into a wedge and chomps at the opponent's feet, knocking them away. Unlike most down tilt attacks, PAC-MAN's down tilt isn't a low-profile type, since he's still a big circular wedge. But it's quick, safe from counterattacks when shielded (and safe to most shield grabs if well-spaced). Poke at grounded foes with down tilt to chip away at their shields safely. On hit, it can cause a tech get-up situation.

Side Smash: PAC-MAN summons Blinky, a red ghost, in front of him that launches foes away with a high amount of power. PAC-MAN's ghost attacks have pronounced hit effects, covering large areas wherever they appear. When spaced out, it can be difficult for the enemy to challenge these ghost attacks. Side smash can be used as an edge-guarding attack to finish off opponents recovering onto a stage. Beware that it's highly vulnerable on whiff and when shielded.

Up Smash: PAC-MAN whips his fist into the air and conjures Inky above him. Inky launches enemies sky-high. Up smash begins with a point-blank frontal strike. If this hits an enemy, it knocks them up into Inky.

Down Smash: PAC-MAN extends both hands out to his sides, summoning Pinky behind him and Clyde in front. The ghosts clear out foes nearby, launching them back. Down smash is best saved for free-for-all battles when you're surrounded by multiple enemies. In one-on-one battles, it can leave you vulnerable due to high end lag.

Smashes

Move	Damage
Side smash	16
Up smash	3, 14
Down smash	13

PAC-MAN emits a tractor beam with a range that extends farther than his side tilt attack, ensnaring foes hit by it. PAC-MAN's grab is unique compared to the rest of the cast; it starts up slowly, but has incredible reach. Down throw deals good damage while allowing you to go for a mix-up with your amazingly safe dashing attack. If the opponent shuffles up, try to punish their air move; if they go for a tech get-up, go for your safe dashing attack to punish them. If you think your opponent will go defensive by putting up their shield, you can attempt another tractor beam grab instead.

Grabs

Move	Damage
Grab attack	1.3
Front throw	8
Back throw	11
Up throw	5
Down throw	10.5

Aerial Attacks

Aerials

Move	Damage
Neutral air attack	10
Forward air attack	7.7
Back air attack	11.8
Up air attack	10
Down air attack	2x3, 7

Neutral Air Attack: PAC-MAN transforms into his wedge form and chomps nearby foes in a circular pattern, knocking them up briefly. Neutral air attack starts up quickly and deals the most damage at the beginning of the animation. It's an excellent defensive attack and can be used just after blocking, since PAC-MAN's shield grab isn't a viable option. Neutral air starts up quickly, and because it's a circular hitbox, it hits even the smallest fighters if buffered from a short hop. It has considerable air lag, but a short landing lag, so it's not easily punishable if you throw it out defensively. Its main drawback is that its hitbox is about the size of PAC-MAN's hurtbox (i.e., he's vulnerable to attacks while he's attacking).

Forward Air Attack: In midair, PAC-MAN performs a swift spinning roundhouse kick in front of him, knocking away foes. Forward air attack is as fast as PAC-MAN's jab and has an extraordinarily short animation time with very little air lag. You can throw it out twice in a jump and still double-jump, as you become actionable early.

Back Air Attack: PAC-MAN drives his legs behind him for a rear-hitting dropkick attack. Back air persists for a significantly long time, making it your best air-to-air attack. Back air attack can be used to defend yourself while your back is facing the enemy, stifling the enemy's forward aggression. Its extended hitbox makes it a strong tool for harassing offstage foes.

Up Air Attack: PAC-MAN performs a somersault attack in the air that covers a wide angle. He kicks out in front, then arcs the attack up above and behind him. Up air can knock foes up for a potential follow-up up air combo. It also causes PAC-MAN to float slightly. Up air is a strong anti-air with decent start speed and great angle coverage, hitting in front and behind.

Down Air Attack: While airborne, PAC-MAN dances on an opponent's head with a multi-hit stomp attack. The first three kicks cause a dragging hit effect, while the last hit launches the enemy up and away. Down air attack has a high amount of air and landing lag, but it inflicts great damage if all of the hits connect.

Special Moves

Neutral Special: Bonus Fruit: PAC-MAN cycles through a list of fruits and objects. Once he selects one, he attacks the enemy with it. The first neutral special input begins "charging" Bonus Fruit. During charge, various fruits and projectiles are cycled (like a slot machine). Pressing Attack or Special causes PAC-MAN to grab the item and throw it in front of him. Each item has its own unique effects, varying in damage, trajectory, and range. Bonus Fruit charging can be canceled and stored by inputting a direction (dodge roll), jumping, or shielding. After you store-cancel the move, the next time you tap Special, you release your stored projectile. To continue charging, hold Special instead. For example, if you have an apple stored, you can tap Special to throw the apple, or you can hold Special to continue cycling through projectiles, starting at apple (with melon being next).

A large part of PAC-MAN's game revolves around intelligent use of his Bonus Fruit special, including the item-generation property. Most Bonus Fruit projectiles turn into interactable items whenever they hit an enemy or wall. It's important to note that, like most interactable items, opponents can pick up your projectiles. This can be debilitating since, while one of your items exists in some form, you can't activate Bonus Fruit, causing a whiff animation when you try.

Special Moves	
Move	Damage
Neutral special	Varies (see table)
Side special	4 to 5, 6
Up special	5
Down special	Drop: 9, Launched: 13

Bonus Fruit Damage	
Object	Damage
Cherry	3.3
Strawberry	5
Orange	6.5
Apple	8.5
Melon	11
Galaxian	8x2 (loop hit)
Bell	6.5
Key	15

Cherry: Thrown a short distance, bounces once before dissipating, and deals low damage with a low knockback effect.

Strawberry: Like cherry, except packs a bit more punch.

Orange: Flies horizontally through the air a great distance before dissipating. Good for horizontal stage control.

Apple: Slams into the ground and bounces several times. Deals much more damage than the other fruits, with more launching power.

Melon: Floats through the air slowly. Deals even more damage than apples. Excellent offense-covering projectile.

Boss Galaxian: Flies forward, then loops up and around before flying away. Ship can hit multiple times if spaced out, so that the enemy is struck by the looping trajectory.

Bell: Unique trajectory. Flies up-forward a set distance, then slams straight down. Stuns foes whether hit midair or grounded.

Key: Flung forward at a high velocity. Deals the most damage out of all Bonus Fruit projectiles. Powerful KO tool against offstage foes.

Side Special: Power Pellet: PAC-MAN summons a row of pellets, then transitions into his pellet-chomping wedge form, eating up the pellets and chomping on foes in his path. When the pellets are released, you can heavily influence their pathing using the control stick (thus, controlling where PAC-MAN will attack). Power Pellet is a vital part of PAC-MAN's recovery game. It's flexible, allowing you to launch PAC-MAN in almost any direction. If an opponent hits your Power Pellet as it's being deployed, the attack is canceled and PAC-MAN's chomp attack is interrupted, causing you to fall.

Up Special: Pac-Jump: PAC-MAN jumps higher with repeated use of the trampoline. The trampoline has a set amount of health, so astute foes can attack it to stifle your mobility. With PAC-MAN's grab having an abysmal start-up time, he doesn't have access to strong shield grabs that most fighters use to punish shielded attacks. Happily, Pac-Jump can be used as an alternative out-of-shield option; upon releasing your shield, hold the up direction and the Special button for a quick launcher attack to punish the enemy's shielded attack.

Down Special: Fire Hydrant: PAC-MAN drops a heavy Fire Hydrant under him. If he throws it out midair, it can land on and damage foes beneath him. PAC-MAN's Fire Hydrant can be launched away as a projectile if it's struck with powerful attacks, like side smash and down air. While flying through the air, the hydrant becomes a high-powered projectile with high launching power. The water spouted from the Fire Hydrant affects everyone, including PAC-MAN.

Final Smash: Super PAC-MAN

PAC-MAN transforms into a giant PAC-MAN and moves across the screen at high speed. You can adjust the direction a bit with each crossing. The landscape doesn't affect this giant PAC-MAN, and any opponents he eats are launched.

Palutena

OVERVIEW

Palutena is a unique fighter with unconventional moves and mobility. She's on the taller end, making her slightly more vulnerable to combos than most, but this is balanced by her excellent ground movement, thanks to her faster-than-average walking and dashing speeds.

While most of her attacks have relatively slow start speeds, they deal damage reliably, especially her neutral attack combo. Her grab game is incredibly strong, especially when factoring in her solid ground mobility and superb grab range. But her other ground attacks can be lackluster in most close-range skirmishes. Unlike other tilt attacks, most of Palutena's tilt attacks are cumbersome and relatively easy to punish.

Palutena Vitals	
Movement Options	
Jumps	1
Crouch Walk	No
Tether	No
Wall Jump	No
Wall Cling	No
Movement Ranks	
Ground Speed	B (16)
Air Speed	C- (54)
Falling Speed	C (44-47)
Weight	C- (48-49)

PALUTENA SHIELD ATTACKS

Palutena's dash attack and back air attack attack nullify incoming attacks. Palutena essentially wins in any potential clashing effects when using dash attack and back air.

Grounded Attacks

Neutral Attacks: Palutena extends her staff in front of her, activating bursts of light emanating from its orb. She ends the attack with a launching staff swing. Palutena's neutral attack combo is one of the best in the business for dishing out damage reliably. While the first attack is lackluster in speed and range, the follow-up light-burst attack boasts impressive reach and deals solid damage on anyone hit by it.

Neutral Attacks	
Move	Damage
Neutral attack 1	3
Neutral attack 2	0.6xN, 3.5

Dash Attack: While dashing, Palutena quickly extends her shield in front of her, blowing past most enemy attacks and launching them into the air. Palutena's dash attack is one of her best tools in her move set. It hits very quickly, especially for a dash attack, and it has a unique move-decimating property that makes her uncontestable and uninterruptible to most other attacks. On hit, this attack launches the opponent up into the air for potential mix-ups and combos.

Dash Attack	
Move	Damage
Dash attack	9

Defensive Attacks	
Move	Damage
Ledge attack	9
Wake-up attack	7

Side Tilt: Palutena throws out her staff in front of her, causing two consecutive strikes as it magically rotates in place. Enemies struck by the staff are knocked away. Palutena's side tilt is slow and generally difficult to use in the neutral game, but punishes on-the-spot dodges and certain ledge recoveries thanks to its persistent hitbox.

Tilts	
Move	Damage
Side tilt	6, 7
Up tilt	1.4x5, 2.5
Down tilt	8.5

Up Tilt: Palutena levitates her staff into the air above her, spinning it in place and striking foes multiple times before sending them vertically into the air. Up tilt can be used to punish on-the-spot dodges and makes for a decent ledge-guarding tool that can punish ledge jumps and other low-altitude recovery options.

Down Tilt: Palutena leans down and flings her spinning staff low to the ground before her, hurling away nearby enemies. Palutena's down tilt is considerably slow to start, but has a sizable active window that can be used to punish rolls and dodges. However, like her other tilt attacks, it's not an optimal move to use in the neutral game since it leaves her vulnerable.

Side Smash: Palutena unleashes a horizontal wing attack. Enemies within range of her wings are knocked away, while those just beyond them are blown back by the wind-force generated. While Palutena's side smash attacks aren't great attacks to throw out in the neutral game, they have unique wind effects that shove nearby foes away (without dealing damage). This wind effect's hitboxes are known as "windboxes," since they're separate hitboxes that extend farther than her normal wing hitboxes.

These windboxes are the main reasons to use side smash. With a proper edge-guarding setup and preparation, you can use these highly persistent windboxes to blow recovering enemies out during their ledge-recovery options, forcing them to grab the ledge, or potentially knocking them out if they make a mistake during recovery.

Up Smash: Palutena raises her staff into the air, summoning a massive pillar of light in front of her that extends high into the sky. The beam of light launches foes it contacts.

Smashes	
Move	Damage
Side smash	16
Up smash	16
Down smash	15

This giant column can be used to hit enemies at jump height, but is also effective for punishing air dodges. Thanks to its long active window, up smash is great for edge-guarding, as it covers most of the possible ledge-recovery options, including hitting enemy fingers just when they try to grab a ledge.

Down Smash: Palutena slams her angel wings downward by her sides, clearing out the area in front and behind. Like her side smash, foes just past her wing attack range are blown back by the gales she produces. The wind effect of this attack is a bit weaker, pushing opponents back with less force than side smash. The attack on down smash covers both sides, so it can be used to punish rolls or hit enemies landing behind you.

Palutena's grab reaches farther than most grabs in *Super Smash Bros. Ultimate*, and isn't too bad for speed either. It's not among the fastest, but it's faster than heavyweight and tether grabs. Its reach extends considerably far in front of her, well beyond the average fighter's grab range. This makes her grab an excellent complementary attack to her dash attack. Essentially, you can force 50/50 decisions onto your opponent by mixing up your dash attack with your dash grab. Palutena's up and down throws lead into the most potential damage.

Grabs	
Move	Damage
Grab attack	1.3
Front throw	9
Back throw	10
Up throw	8
Down throw	5

Aerial Attacks

Aerials	
Move	Damage
Neutral air attack	1.4x6, 5.1
Forward air attack	10
Back air attack	14
Up air attack	1x5, 5
Down air attack	11

Neutral Air Attack: Palutena twirls her staff around her in midair, striking enemies up to six times, with the final hit launching up foes at an angle. Neutral air attack has several applications. In combos, you can start with neutral air and follow up with another neutral air (or any of her other aerial attacks). However, it has considerable landing lag from a short hop, so it's not a move that should be thrown out too often in the neutral game.

Forward Air Attack: Palutena performs a jumping side kick infused with a light aura, popping up foes hit by its radiance. Forward air attack is an excellent combo-initiator. Off deep forward air, you can follow up with several options. Forward air into dash attack or another forward air are possibilities. With well-timed low-altitude forward air attacks, you can pressure a strong offense as long as you time the attack accurately (its active window is relatively short). Short hop fast fall forward air is one of your best attack sequences.

Back Air Attack: In midair, Palutena uses her shield to bash foes behind her. Like dash attack, Palutena's back air is uninterruptible when colliding with opposing attacks. This is your primary edge-guarding attack, so you should be deliberately standing with your back facing the ledge whenever you force an opponent into ledge-recovery mode.

With timing, you can punish most ledge-hanging options with back air. Short-hop in place, and back air is an effective ledge-pressuring tool. Also use this tool when meeting enemies far off a ledge to knock them out in air-to-air combat.

Up Air Attack: Palutena raises her staff into the air, emitting a brilliant aura that ensnares foes with multiple hits before launching them vertically into the sky. This is one of your main killing moves while in the advantage state. While it has considerable end lag, preventing you from using it and an additional aerial attack from a jump, you can use double-jumped up airs to alleviate some of this lag.

Down Air Attack: While airborne, Palutena delivers a downward light-imbued kick that spikes foes into the ground. Down air is relatively fast, but is active briefly, with only the first frame having a meteor smash effect. Against grounded foes, down air causes an add knockback effect, as it launches the enemy behind you. This sets up potential follow-ups, but it can be punished if shielded.

Special Moves

Neutral Special: Autoreticle: Palutena fires energy blasts directly at a nearby foe. The angle of the energy blasts is determined by the enemy's current position immediately upon performing the move (as soon as you press neutral special). In other words, if you hit neutral special when a foe begins to fast-fall, your energy blasts fire into the air while the enemy completely avoids them.

While it's an important part of your toolkit, this projectile-barrage attack should be used sparingly in your neutral game. If you're predictable with it, you can either be punished or forced to sacrifice space. Use it harass opponents who have limited mobility or have used their double jump pre-emptively. Otherwise, it can be used to force an approach.

Special Moves	
Move	Damage
Neutral special	3.5x3
Side special	1.5x5, 5.5
Up special	—
Down special	Varies

Side Special: Explosive Flame: Palutena sets off an expanding flame that explodes a set distance in front of her. Unlike conventional projectiles, Palutena's Explosive Flame always detonates at its location, even behind foes standing in front of you. Explosive Flame is your main midrange harassment and zone-control tool. Against foes with limited mobility options, it can be incredibly difficult to deal with due to its large area of effect, forcing enemies to reposition themselves or take shield damage.

Up Special: Warp: Palutena teleports in any direction, becoming invulnerable during her brief disappearance window. Warp is a remarkable recovery escape tool. However, its landing lag from the air can make it punishable, especially if your opponent can predict your teleport direction. If you Warp toward the ground from the air at an angle, it causes a sliding effect, followed by considerable landing lag. You can mitigate this with a ledge-canceling technique. Whenever you land by a ledge and slide off, you're allowed to immediately act (canceling the sliding landing lag).

Down Special: Counter/Reflect Barrier: Palutena doubles as a counterattack parry and projectile reflector. On a successful attack parry, she counterattacks with a radiant light blast, dealing damage based on the damage of the enemy's parried attack. Thanks to the added reflector property of Palutena's old Reflect Barrier, Counter can be used in multiple situations. While you generally don't use down special to parry attacks (since it's a high-risk maneuver for a moderate reward in damage), being able to reflect projectiles at the same time is a huge boon.

Final Smash: Black Hole Laser

Palutena creates a black hole to draw in her opponents. She follows up with a wide laser beam to damage and launch anyone caught in the attack. The black hole can capture several fighters, and the beam deals more damage to those caught in the black hole.

Peach / Daisy

Peach/Daisy Vitals	
Movement Options	
Jumps	1
Crouch Walk	No
Tether	No
Wall Jump	No
Wall Cling	No
Movement Ranks	
Ground Speed	D (53-56)
Air Speed	C (45-47)
Falling Speed	F (74-75)
Weight	D (53-54)

OVERVIEW

The princesses of the Mushroom Kingdom and Sarasaland don't need rescuing in this brawl. These nimble pixies can take care of themselves. Peach and Daisy are functionally the same, but differ in the colorful symbols they make appear during several moves (Peach emits hearts, while it's all daisies around Daisy).

Whichever ruler you select, she comes equipped with strong air pokes, unique specials like the Toad counter and the Vegetable pull, and an unsurpassed floating ability. Once during each airborne state, Peach and Daisy can totally halt vertical momentum and float in place, able to glide left and right. While floating, normal actions are possible. To float automatically at the apex of a jump, hold down the Jump button or hold up on the control stick. (This works whether jumping to normal altitude, or short-hopping from the ground with a Jump button tap or with Attack+Jump together.) To choose a different float height, either hold up or the Jump button after having used up her jump and double jump, or tap down on the stick while starting to hold Jump (this stops you from blowing a double jump early, saving it for after floating ends). This even works while standing on solid ground, resulting in a one-inch-high float, great for aggressive and unique ground movement.

Grounded Attacks

Neutral Attacks: A quick two-hit combo available to both Peach and Daisy. The first hit is as fast as any attack in the game, great for beating challengers to the punch in point-blank scrambles, or for retaliating after dropping shield. Having a near-instant basic attack synergizes well with Daisy and Peach's fast movement speed and grabs. The only caveat is that this one-two sequence does low damage.

Neutral Attacks	
Move	Damage
Neutral attack 1	2
Neutral attack 2	3

Dash Attack: On a run, the princesses can attack by jutting both arms straight forward, then spreading them wide. The initial double-arm jut and the arm spreading are two different attacks, which combo into each other naturally. Dash attack allows quick attacks to the side, and follow-ups after launching moves and throws that knock the enemy away low, around ground level.

Dash Attack	
Move	Damage
Dash attack	4, 6

Defensive Attacks	
Move	Damage
Ledge attack	9
Wake-up attack	7

Side Tilt: This slick high kick has good reach and launches victims into a tumble, creating a great opening for a juggle follow-up. The kick does the most damage at the foot, and less farther up the kicking leg. It's not notably fast, though not as slow as most smash attacks either.

Tilts	
Move	Damage
Side tilt	8
Up tilt	10
Down tilt	7

Up Tilt: This all-purpose up tilt punch is quite useful. It strikes way above the princess crowns with a gorgeous symbol (for Peach a heart, for Daisy a...daisy), striking safely overhead. Rare for an up tilt attack, it also strikes on both sides around the princess (though for a bit less damage). It's good quick anti-air versus short hops and falling enemies, and a tool for starting and perpetuating juggles.

Down Tilt: Either princess crouches with a sweeping kick. This low-profile attack has decent reach, and always trips the victim up into a comboable tumble. At low percentages you can side/up tilt or side/up smash immediately, then chase your target with jumping strikes. Against more battered challengers, you'll have to jump after them right away after sweeping.

Side Smash: Either princess swings with a variety of blunt instruments. The royals come equipped with a surprising selection. Input standard side smash (tapping straight left or right) for a golf-club swing. Of the attacks, this is not only the easiest to consistently produce, but also has the best hitbox by far. For a frying-pan swing, start side smash, then immediately hold up on either stick (control and C-stick both work for selecting alternate weapons, a handy tool to remember to improve consistency). This attack has the smallest hitbox (pretty much conforming to the pan), but swats the victim up into the best tumbling position for you to jump after them with juggle attempts. Finally, for a tennis-racket slice, start side smash, then hold down on either stick. Nailing someone with the tennis racket sends them sailing far and low. It's the worst for chasing and juggling a foe, but the best when they're backed to a ledge.

Smashes

Move	Damage
Side smash	15-21/18-25.2/13.5-18.9.
Up smash	17
Down smash	3x6, 4

Up Smash: This is a harder-hitting version of up tilt, dealing heaviest damage with a centered hit above the princess, inside the luminous heart/daisy. Strike someone above with the center of the symbol for the best launch potential. They'll be in position for you to either follow them up to try for further hits, or to watch them tumble down, looking to juggle with more anti-airs.

Down Smash: Peach and Daisy drop to the ground for a tripping spin kick. Down smash hits to both sides six times, offering good coverage. The finishing kick then flips the victim away at a low angle, like the tennis-racket variant of side smash. Depending on how the victim is blended up by the repeated kicks, they can be launched to the front or back of the princess.

Peach and Daisy put the trusty concierge Toad to use with their grab attacks, just like with their neutral special countermove. After the princess snags the defender with her grab animation, Toad joins in for the follow-up attacks or throws.

Peach and Daisy have quick grab speed, not the very best but not far from it, which jives well with their superfast neutral attacks and dominating short-hop air pokes.

Grabs

Move	Damage
Grab attack	1.3x1-5
Front throw	2, 8
Back throw	2, 9
Up throw	2, 6
Down throw	1, 7

Aerial Attacks

Neutral Air Attack: Peach and Daisy spin quickly with both arms outstretched, the action resembling a horizontal propeller tipped slightly forward. Anyone hit by the whirling arms is swatted away too quickly for subsequent twirls to catch them. Though it might look like a multi-hit attack, it's more like an attack that's periodically active. The first twirl of arms deals full damage, and the rest are basically halved. This is the quickest attack for the princesses in midair, with good coverage in front and a bit above and behind.

Aerials

Move	Damage
Neutral air attack	13
Forward air attack	15
Back air attack	12
Up air attack	4, 6
Down air attack	2x3, 5

Forward Air Attack: Peach and Daisy swing forward with a big hooking crown slap, potentially while moving a long distance forward in midair. The princess deals max damage with her hand holding the crown, with a bit less damage dealt farther up the swinging arm. The attack hits first at an upward angle before arching forward. There's momentary downward coverage at the end of the attack, but it's not an attack intended for aiming at stuff just below. It's great for attacking other airborne fighters air-to-air, for short-hopping at standing defenders, and to use as a pseudo ground attack while floating very low.

Back Air Attack: Daisy and Peach lunge backward in midair, their signature symbols highlighting the impact point of the body bump. Like a lower-powered version of Peach/Daisy Bomber, without the far lateral trajectory. The hitbox on this move is like a cannonball over the back of the princess, hitting a big area but only to her back.

Up Air Attack: Peach and Daisy do an upward double-wave, leaving rainbow trails with their back-to-front swipes. If the first swipe hits, the second will combo, with the second hit the stronger of the two. This excellent air attack covers all upward angles, and is great for jousting air-to-air with brawlers above, or for continuing juggles.

Down Air Attack: This four-hit stomping air move is one of Peach and Daisy's signature attacks. The initial three hits deal a bit of damage, followed by a fourth hit that pops recipients up into a vulnerable position. Whether they're popped up behind the princess or in front of her depends on where the final attack connects. Aim to hit cleanly with just her kicking leg to launch them forward, ready to be carried farther upward with up air attack or Peach/Daisy Parasol. If the final hit strikes farther back, like with the princess's hip, the target will be bounced up behind her. Try to aim for the clean bounce to maximize the reward for successful down airs.

Special Moves

Neutral Special: Toad: Peach and Daisy briefly hide behind their trusty old friend Toad, who steps in to serve as a shield. While Toad is flashing, any incoming attack causes him to retaliate with his countermove, a cloud of poisonous spores that can repeatedly hit anyone in the way.

Special Moves	
Move	Damage
Neutral special	3.5x6
Side special	12
Up special	3, 1x4, 4
Down special	8.6-33.8

Side Special: Peach/Daisy Bomber: Her majesty rockets sideways suddenly, trailing multicolored hearts or daisies. Aside from Vegetable tossing, side special is Peach and Daisy's fastest long-reaching attack. Anything she smacks into gets knocked away by the speedy hip bump, while the princess bounces off into an airborne state. She retains whichever jumping options saved during the airborne period. Nail someone with Peach/Daisy Bomber on the ground, and it's just like jumping—you have a double jump and float to work with. When jousting with side special against airborne targets, it depends on whether you already used up the double jump or float before the bounce.

Up Special: Peach/Daisy Parasol: The princess springs upward with a powerful parasol punch, launching anyone in the way quickly upward with heavy knockback. After she ascends behind short-jump height, the extended parasol can catch anyone in the way for a few weaker hits, before the parasol's opening caps it off. After the parasol is opened, the princess glides back down to the ground, falling speed greatly reduced. To fall faster, tap down to collapse the parasol; tapping up again reopens it, slowing fall speed again. Altering speed while steering left and right can help the princess be less predictable falling back down. As a small added bonus, the deployed parasol is actually an attack, inflicting 2 damage on anyone hit by it.

Down Special: Vegetable: Standing on solid ground, Peach and Daisy pluck a huge turnip from the ground, *Super Mario Bros. 2*-style. Armed with a fresh Vegetable, the princess has offensive and defensive item options even in tournament-style modes with items disabled. Now inputting Attack or Grab tosses the turnip. Tap the control stick in the desired direction at the same time to increase the toss's speed, distance traveled, and damage.

There are all kinds of turnips. The most powerful have double wrinkly squinting eyes on both sides, and deal tremendous damage with tapped smash throws. Double-pinprick-eyed specimens are also strong. When plucking Vegetables, there's a low chance the result will be a Mr. Saturn or Bob-Omb item! If you happen to score a Bob-omb, that's the highest-damage option, obviously.

Final Smash: Peach/Daisy Blossom

The princess dances in place while a rain of peaches or daisies saturates nearby territory, and can be acquired to recover health. Anyone too close to the princess takes damage while being put to sleep, as though Jigglypuff's beautiful singing voice had wafted into their ears! Aside from falling asleep, anyone afflicted also takes heavy damage. The closer to Peach or Daisy they are when this Final Smash is activated, the harder they're hit. And that's not taking into account whatever rude awakening royalty decides to dole out!

Pichu

OVERVIEW

A lot of what will become Pikachu's sparking toolkit is seen in nascent form with Pichu. Pichu is learning to harness electricity still and hasn't yet mastered it. This means that some of Pichu's attacks are *stronger* than Pikachus, but also that some of Pichu's moves backfire a bit, hurting the baby Pokémon with every use.

Pichu hurts itself during side tilt, side/down smash, front throw, front/back/down air, and all special moves. This means it's best to form a core game plan around the moves that don't hurt Pichu: up/down tilt, up smash, neutral/up air, and throws that aren't front throw. Luckily, these attacks are fantastic, and poking with down tilt goes well with using a forward crawl to move in low under some shots and attacks.

Pichu Vitals	
Movement Options	
Jumps	1
Crouch Walk	Yes
Tether	No
Wall Jump	Yes
Wall Cling	No
Movement Ranks	
Ground Speed	B+ (11)
Air Speed	C (45-47)
Falling Speed	A (5)
Weight	F- (76)

Grounded Attacks

Neutral Attacks	
Move	Damage
Neutral attack 1	1.2

Dash Attack	
Move	Damage
Dash attack	8

Defensive Attacks	
Move	Damage
Ledge attack	9
Wake-up attack	7

Neutral Attacks: For Pichu's neutral attack, the pint-sized Pokémon emulates Pikachu, jabbing at close range with its head. This neutral attack is among the game's fastest, just short of Little Mac in the top spot. There's only one neutral attack for Pichu, which it repeats in a blur as long as you hold down the button. You can score up to a five-hit combo just holding someone at point-blank range with repeated neutral attack headbutts, dealing 6% damage and leaving them at the edge of grab range.

Dash Attack: Pichu emerges from a dash or run with a sideways rushing headbutt. It does a little more damage if you hit with the beginning of the headbutt, but any dash attack hit knocks challengers into a position where Pichu can hit them again right away.

Side Tilt: Pichu plants its hands to strike with a quick, shocking double kick directly in front. The range is short, but the speed is excellent. The double kick doesn't combo with itself, side tilt can only hit each enemy once, but it does give the attack a lengthy active period.

Tilts	
Move	Damage
Side tilt	8
Up tilt	5
Down tilt	6

Up Tilt: Pichu's little tail flips over the top, hitting backward first, then up and over. The main use is for anti-airing enemies and perpetuating combos. The attack gives some coverage in front at the end, but is too slow to hit to use it this way effectively on purpose.

If up tilt DOES hit someone up close in front at a low percentage, Pichu can capitalize with some great combos, like up tilt, down tilt, up smash, then a juggle attempt with air moves or the Thunder special.

Down Tilt: With a low forward tail whip, Pichu pops up anyone nearby for an immediate combo. The speed is respectable for a down tilt. This move is given extra power thanks to Pichu's crawling ability. You can crawl forward under many short-hopping attacks and projectiles that bigger brawlers would have to deal with, then sweep with down tilts once in range.

Side Smash: The Pokémon juts its head forward and unleashes a close-range sparking flurry (inflicting a little damage against itself in the process!). If this hits anyone, it pulls them into a brief electric blender before they're kicked away with strong knockback, even if they haven't taken any damage yet.

Up Smash: Pichu whips its whole body forward in an upward-aimed headbutt. The hitbox is mainly around Pichu's big head and ears, but its body has a hitbox too, which is only likely to be useful if you're standing on top of a soft platform aiming at someone above just as another fighter tries jumping into Pichu from underneath.

Down Smash: Pichu spins low to the ground, sparking furiously and hitting both sides. Hitting someone pulls them in and shocks them several times before punting them in the direction Pichu faced when starting the move. Since down smash hits both sides simultaneously with decent speed, the only consideration when aiming this attack is which direction you want foes to end up.

Smashes

Move	Damage
Side smash	2x5, 8-2.8x5, 11.2
Up smash	14-19.6
Down smash	1.5x4, 8-2.1x4, 11.2

Pichu grabs quickly, just short of the fastest grabs in the game. Its range is small, so you need to dash right up next to throw candidates, or grab them after a few neutral attack hits up close.

For front throw, Pichu shocks the victim on its back for a second before flicking them forward, potentially hitting anyone else right in front too.

Pichu takes a tiny amount of damage from this throw, but not the others. During back throw, Pichu rolls backward before the toss.

Grabs

Move	Damage
Grab attack	1.3
Front throw	1.5x4, 6
Back throw	9
Up throw	5, 5
Down throw	4, 4

For up throw, Pichu headbutts the victim straight up in the air, in position to try juggling them after. At higher-damage percentages, nothing is guaranteed, and you just have to try to catch them as they float down. Down throw offers more guaranteed combo follow-ups, with Pichu bouncing foes off the ground at low altitude directly in front.

Aerial Attacks

Neutral Air Attack: Pichu pinwheels into three rapid forward flips, hitting all the way around as it spins. Neutral air is one of the fastest-hitting air attacks in the game and lasts for a *long* time, almost half a second! This makes it great for jousting with enemies air-to-air or sticking it out early above foes before fast-falling into them with later active frames. Despite the spins, this isn't a multi-hit attack, and only hits any given enemy once. With its speed, active period, decent damage, and that fact that it doesn't hurt Pichu to use it, neutral air should probably be your most-used maneuver.

Aerials

Move	Damage
Neutral air attack	7
Forward air attack	3.5x4
Back air attack	2x5, 2.5
Up air attack	4
Down air attack	13

Forward Air Attack: Flying through the air, Pichu jabs forward with its head four times quickly, while taking a little damage itself in the effort. The initial hit is slow for a Pichu move, so if you need something on short notice, lean toward neutral/up/back airs. If an enemy eats forward air, they'll be drawn into the hits and launched forward at the end. If using forward air to aggressively chase enemies on the ground, short-hop forward with forward air attack and make sure to fast-fall halfway through, dragging the final hits down toward the ground to land faster.

Back Air Attack: Pichu spins toward its back while sparking with electricity, dishing out more hits for a longer period than its other multi-hit moves. Back air hits very quickly, not quite as fast as neutral air but barely behind. Back air stays out long enough to sync perfectly with a backward short hop. Using it this way hits against close ground-level foes with about the same speed a typical tilt attack, but with higher potential damage payoff and less-predictable follow-ups.

Up Air Attack: Pichu flips forward while airborne, hitting from up-back to up-forward with its tail. The initial hitbox is active just as quickly as neutral air attack's, though aimed up and away. Jump and chase after high-altitude enemies from underneath with this attack, or poke at people standing on soft platforms above. Although up air is aimed upward, Pichu is so small and the attack is so fast that it's also an effective jump-in against challengers on solid ground.

Down Air Attack: Pichu flips upside down in midair, aiming straight down with an electrified headbutt. Pichu causes an extra secondary hit if this is done low to the ground, just before landing (this also adds an extra 0.5% to the damage Pichu inflicts on itself). If down air attack plunges into a target, then hits the ground, the resulting two-hit combo knocks them away. If you dive-bomb with down air and slightly miss a standing foe, this impact hit might knock them away even if the main headbutt misses.

Special Moves

Neutral Special: Thunder Jolt: Pichu channels electric energy to send a lively bouncing bolt across the stage. Pichu's Thunder Jolt is more damaging than Pikachu's, while also dealing a little damage to Pichu on every use. It bounces 10 times before vanishing. With the range based on how many times a Thunder Jolt bounces, you can eke more reach out of projectiles by jumping before releasing them, so it takes longer before the first bounce (using it on the ground, the first bounce is right at Pichu's feet).

Special Moves	
Move	Damage
Neutral special	7
Side special	4/7.9-33
Up special	0
Down special	4/14

Thunder Jolts stick to the first surface they hit, wrapping around corners and even bouncing along sheer surfaces, or upside-down across the undersides of stages. Multiple Thunder Jolts can be active at a time.

Side Special: Skull Bash: After gathering energy, Pichu blasts itself horizontally across the stage, hurting itself a little with the exertion. Pichu's distance traveled while spiraling is greater than Pikachu's, covering the ground of about five dashes. Hold the side special input to charge up Pichu's energy before release, increasing the damage and distance traveled by an absurd amount. A fully charged Pichu Skull Bash delivers a tremendous 33 damage hit while basically traveling across the full width of any flat stage. Beware that stage edges don't automatically stop the lateral travel of an overzealous Skull Bash; without care, you can make Pichu fly right off the side!

Up Special: Agility: Pichu's movement-oriented special move is a two-stage air dash, basically. Input up special by itself, and Pichu zips straight up once. Hold any direction before the zip to make Pichu choose a straight-line path in that direction instead. Before Pichu arrives at the end of the first stage's travel, hold a different direction for a second zip. After the two rapid air movements, Pichu lags until landing. Each use of Agility's first stage deals 0.6% damage to Pichu, while each addition of the second stage adds 1.4%. Nothing adds up Pichu's damage on itself faster than repeated uses of Agility, so be very careful with this.

Down Special: Thunder: Pichu summons a lightning bolt from high above, which streaks straight down toward the Pokémon. The lightning bolt has a long thin hitbox, shocking anyone along the way while continuing toward the ground. If it strikes Pichu, the Pokémon absorbs and discharges the energy in an explosion around itself, dealing high damage to anyone close. Pichu is intangible while catching a lightning bolt, so the attack doesn't lose out if the bolt makes it all the way to its master. Getting hit by a lightning bolt creates a powerful attack, but it's also the quickest way for Pichu to stack up self-inflicted pain, adding 3% damage to Pichu's escalating total.

Eating a bolt in midair maintains Pichu's altitude, and the lag isn't long. Thundering oneself offstage on purpose can be an effective stalling tactic, changing the timing of when you make your play to recover back to solid ground. Just beware that Pichu's maneuverability after a midair Thunder hit isn't as flexible as Pikachu's since Pichu's Skull Bash has more aerial lag.

Final Smash: Volt Tackle

With a Smash Ball's energy safely stored, Pichu is ready to cut loose with its strongest move. At the start, Pichu rockets straight across in the direction it's facing, stopping when it smacks onto a valid target along the way. From here, Pichu zips to and fro across the screen in all directions, repeatedly striking all parts of the visible screen. The baby Pokémon's focus is on the first opponent it hit upon start-up, but everyone else can take hits with all the movement.

Pikachu

OVERVIEW

The original Pokémon superstar (if not actually a starter Pokémon; you're looking for Pokémon Trainer for that) makes a speedy, evasive brawler. Pikachu's attacks are usually fast and hit multiple times over a long active period. Thunder Jolt adds a harassing projectile option that's easy to implement, and regular Thunder is a defensive vertical projectile. Skull Bash and Quick Attack provide locomotion options. Quick Attack by itself gives Pikachu access to some of the most varied air movement possible.

Pikachu Vitals	
Movement Options	
Jumps	1
Crouch Walk	Yes
Tether	No
Wall Jump	Yes
Wall Cling	No
Movement Ranks	
Ground Speed	B- (18)
Air Speed	D (60)
Falling Speed	C (44-47)
Weight	F+ (67-69)

Movement specials and good mobility give Pikachu a fighting chance when launched far away, and being a lightweight means Pikachu has a decent chance of shuffling out of an opponent's juggle attempts. But being lightweight also means that Pikachu is easier to hurl a long distance in the first place, or even KO outright off solid hits.

Grounded Attacks

Neutral Attacks

Move	Damage
Neutral attack 1	1.4

Dash Attack

Move	Damage
Dash attack	11

Defensive Attacks

Move	Damage
Ledge attack	9
Wake-up attack (faceup)	7
Wake-up attack (facedown)	7

Neutral Attacks: Pikachu leans and jabs its head forward rapidly. Hold down the neutral attack input, and Pikachu repeats the headbutt so quickly the little electric blurs. Pikachu doesn't have a neutral attack combo with different stages; the same neutral attack repeats itself. The headbutt does the most damage right next to Pikachu, but the range is surprisingly good, extending a little past Pikachu's crown. Enemies caught in a continuous stream of neutral attack headbutts can be hit several times for a combo, but they'll eventually be pushed away.

Dash Attack: Pikachu throws itself forward from a run with a heavy headbutt, much more powerful than its neutral attack head bash. Hitting early in the dash attack deals the most damage, but hitting late in the dash attack pops recipients into the best position for a follow-up juggle.

Side Tilt: Pikachu plants its front paws to kick forward with both back limbs, with decent hitboxes around the legs and a big one around the feet. This side tilt can be aimed a bit up or down, with the upward-angled version doing slightly more damage, and the downward-angled one doing slightly less. The damage on this move is very good, but the knockback is low, so don't expect this to gain you breathing room.

Tilts

Move	Damage
Side tilt	10
Up tilt	5
Down tilt	6

Up Tilt: The mighty Pokémon attacks with its tail stretching up over its body from behind, hitting first to the back before covering upward and forward angles. If you think of this as an attack to swing at people in front of Pikachu, it's not very fast. But if you think of it as an anti-air and juggle tool that happens to hit anyone in front at the end, it's great. Even on a low-percentage hit, it knocks victims off their feet in position for an immediate juggle hit.

Down Tilt: Pikachu shifts to the side to sweep its tail to the front for a quick hit. This hits a tiny bit slower than side tilt while doing less damage, but it has slightly more knockback at low percentages and the potential to briefly trip foes off their feet, so it's a better poke when unsure of your advantage. It also syncs up well with Pikachu's ability to crawl forward, so you can move toward enemies and dodge under many projectile attacks before swiping at them with down tilt.

Side Smash: Pikachu cuts loose, sending a sparking blast forward from its rosy cheeks. After a typical smash attack windup period, the spark starts right in front of Pikachu's head, then travels forward quickly, greatly outranging any tilt attack options. The spark is active for a huge amount of time for a ground poke, staying active almost as long as the uncharged windup takes. The lengthy active period alone makes this a great ground move.

Up Smash: Pikachu backflips in place, sending its zigzag-shaped tail around as a launching attack. The tail hits in front first, then sweeps overhead to hit above, then behind. A hit at any point along the way pops the victim up above Pikachu.

When aiming at tumbling enemies or jumpers, uncharged up smash strikes upward angles only marginally slower than up tilt, while dealing much more damage.

Down Smash: Lying flat, Pikachu spins in place twice, sparks flying all around. During the spins, Pikachu creates large hitboxes to either side, and a small one centered on its body. Anyone caught by one of the hits is pulled into the rest, getting hit several times before a stronger final hit launches them low in the direction Pikachu is facing.

Smashes	
Move	Damage
Side smash	18-25.2
Up smash	14-19.6
Down smash	2x5, 3-2.8x5, 4.2

For a clear-out-capable attack, down smash hits with shocking speed; it's only slightly slower than down tilt, while covering both sides. Since it's basically identical whether aiming to the front or back, you can choose how to attack with down smash based on the direction you'd like to punt targets afterward.

Pikachu's grab isn't one of the fastest, but it's not quite heavyweight grab territory either. The variable neutral attack combo length of Pikachu gives it ample chances to mess with opponents' minds so they don't know exactly when a grab attempt is coming. You can jab at them with varying numbers of close-range neutral headbutts before pausing, then going for a grab, or before dodge-rolling behind them to grab from behind.

Grabs	
Move	Damage
Grab attack	1
Front throw	2x5
Back throw	9
Up throw	3, 5
Down throw	5

Aerial Attacks

Neutral Air Attack: For this simple and effective air poke, Pikachu emits stored electricity in several bursts. Pikachu's body itself is the hitbox here, so the attack's range is small; you basically have to plow right into targets with Pikachu's torso. But the attack starts up almost instantly and lasts for a long time, making it an excellent all-purpose move.

Forward Air Attack: Pikachu lies prone facing forward in midair, emitting sparks from either side of its head. This air attack has a forward-stretching hitbox that also covers slightly above and below Pikachu's head. This is much slower to hit than neutral air, but stays active for a long time once it's out. It's great for aiming directed attacks at foes in front, as long as there's time to get it out.

Aerials	
Move	Damage
Neutral air attack	1.8x3, 3.5
Forward air attack	1.4x5, 4.8
Back air attack	1x5, 3.6
Up air attack	6
Down air attack	13

Back Air Attack: Pikachu spins sideways repeatedly in midair, almost like a jumping version of down smash. Back air hits extremely quickly, just slightly slower than neutral air attack, and much faster than forward air attack. The catch is that the range is extremely short. Like with neutral air, the hitting area is basically just Pikachu's body, but flatter. But like most of the Pokémon's air attacks, back air stays out a long time, making it easier to connect with.

Up Air Attack: Swinging its tail from up-back to up-forward during a forward flip, Pikachu swats at anyone above. The hit is very fast, with the initial up-back-directed hitbox emerging with the same speed as back air. Up air is great for the usual purpose of attacking upward and juggling, but since it's so fast and is Pikachu's only quick single-hit jumping attack, it has some use as a late falling jump-in attack too, used against standing targets just before Pikachu lands.

Down Air Attack: Pikachu's strongest air attack is also its slowest, almost like a downward-aimed smash attack. Use this offstage when trying to spike recovering foes downward, and midstage when falling on grounded foes. Down air attack has unique landing lag if used just before hitting the ground, with Pikachu's touchdown force capable of delivering a secondary hit. Drop on someone with a perfectly aimed down air, and you net the falling attack's damage plus the landing hit.

Special Moves

Neutral Special: Thunder Jolt: For Pikachu's staple projectile attack, a small bouncing thunderbolt is fired in the desired direction. You can change the direction before it's released by inputting the opposite direction immediately after inputting neutral special, which is important for redirecting your offense in midair. Once released, a Thunder Jolt projectile travels down-forward toward a hard surface. Once it hits a hard surface, the little lightning bolt travels along any continuous surface, bouncing seven times before disappearing. Thunder Jolts can travel up sheer walls and even curl around corners to keep traveling along their paths. Since Thunder Jolt's eventual range is based on bounces, you get farther-reaching bolts by jumping high in the air before releasing them. The first bounce doesn't register until it reaches the ground. Thunder Jolts can be fired repeatedly, up to three on-screen if you throw the first one while airborne. They have myriad uses, whether to chip from afar along the ground, or to cover yourself while falling back to the stage.

Special Moves	
Move	Damage
Neutral special	5
Side special	6.2/10-21.4
Up special	2, 3
Down special	8/15

Side Special: Skull Bash: Pikachu launches itself suddenly to one side, flying laterally with a spinning electric headbutt. The horizontal travel is impressive for a relatively quick special move of this type, sending Pikachu rocketing across about four dashes' worth of space. Also impressive, Skull Bash's damage doesn't diminish with distance traveled.

Skull Bash can be charged before release, greatly increasing damage at the cost of start-up time. For a little bit of free pre-charge, perform Skull Bash with a smash-style input, snapping the control stick all the way to the side. This starts the base damage at 10 instead of 6.2, and there's no reason not to use this method, since it doesn't add any extra windup.

Up Special: Quick Attack: Upon inputting up special, Pikachu briefly preps for a moment while waiting for you to input a different direction. If you don't, Pikachu zips straight upward. If you hold a direction, Pikachu zips precisely in a straight line in that direction. During this zipping movement, hold a different direction to make Pikachu zip a second time along the new heading. Each zip deals a little damage, with the second zip being slightly stronger, but this move's purpose isn't really attacking. It greatly reinforces Pikachu's status as a lightning-fast, erratically moving combatant who's hard to pin down.

Down Special: Thunder: While Pikachu beckons the sky, a powerful lightning bolt streaks straight down toward the location Pikachu summoned it from. The bolt has a long vertical hitbox and can hit anyone above the Pokémon while still streaming downward. If the bolt hits Pikachu, it explodes in an even more powerful hit, striking anyone nearby. (If the bolt strikes Pikachu in midair, it zaps the Pokémon upward a bit for some gained altitude.)

If you use Thunder while on the ground or jumping straight up, the lightning bolt is guaranteed to hit Pikachu and trigger the secondary effect. However, if you use Thunder while drifting sideways in midair, the lightning bolt misses Pikachu and sputters out upon striking the ground. You can use this to great effect on purpose when edge-guarding. Jump off the stage, use Thunder so the lightning bolt plunges past the stage edge, then go about recovering (by double-jumping and Skull Bashing or Quick Attacking back to safety). Time this properly, and the bolt might intercept someone just as they're trying to lunge toward a ledge from below!When used in midair, Bowser skips the launcher part and performs the high-damage dive-bomb-into-impact-shudder. Both hits can combo if this hits squarely on someone low to the surface underneath.

Final Smash: Volt Tackle

Chase down a Smash Ball or fill the FS Gauge to ready Volt Tackle. Pikachu travels laterally in a flash upon activation, starting a full-screen crisscrossing attack upon contact with the first opponent. Pikachu scurries back and forth rapidly in blue flashes, focusing on the main target but fully capable of hitting everyone else in the way.

Pit / Dark Pit

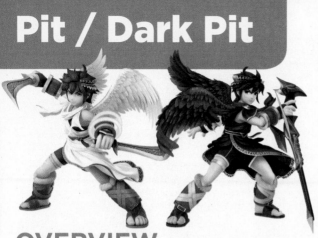

Pit / Dark Pit Vitals

Movement Options	
Jumps	3
Crouch Walk	No
Tether	No
Wall Jump	No
Wall Cling	No

Movement Ranks	
Ground Speed	C (27-28)
Air Speed	D (64-65)
Falling Speed	C- (52-53)
Weight	C+ (32-35)

OVERVIEW

Pit and Dark Pit are balanced fighters with some unique weapons at their disposal. Pit is a medium-sized fighter with above-average mobility. While he can technically quadruple-jump thanks to his wings, these additional hops boost him only slightly. Overall, Pit's a relatively simple fighter to learn and play. If you want to practice with a strong zoning fighter, Pit is highly recommended. He has access to decent attacks that don't extend vulnerable portions of his body and an easy-to-use move set.

His main strength is his Palutena Bow. Mastering his projectile use can take practice, but once you're accustomed to implementing intelligent zoning and arrow-curving strategies into your conventional offense, you'll be able to decimate foes, especially with well-executed edge-guarding techniques.

PIT VS. DARK PIT

While Dark Pit shares most of Pit's tools, there are some key differences in regards to special moves. Dark Pit's neutral special (the Silver Bow), greatly differs from the Palutena Bow, and has dramatic implications on how these two fighters are played. Dark Pit is much more effective at zoning the horizontal space, while dealing more damage with his bow. But he sacrifices the midflight arrow control, which can be crucial in several scenarios (especially edge-guarding).

Dark Pit's side special is a bit different as well, although practical uses are almost identical. Electroshock Arm deals slightly more damage and launches enemies away, whereas Upperdash Arm launches enemies at a more vertical angle.

Grounded Attacks

Neutral Attacks

Move	Damage
Neutral attack 1	2
Neutral attack 2	2
Neutral attack 3 (rapid)	0.5xN, 2
Neutral attack 3 (launcher)	4

Dash Attack

Move	Damage
Dash attack	11

Defensive Attacks

Move	Damage
Ledge attack	9
Wake-up attack (faceup)	—
Wake-up attack (facedown)	—

Neutral Attacks: Pit uses his bow blades to perform a swift right-handed slash, quickly transitioning into a mirrored left-handed slash, and finishing with either a rapid stab-attack combo or a heavy launching attack. This is your safest ground-based spacing and poking attack for most situations. Like most neutral attack jabs, it's the ideal retaliation option right after blocking an attack when you aren't in grab range. The rapid-attack variant (neutral attack input three times in rapid succession), can force the opponent into a tech get-up situation, while the normal three-hit jab sequence launches them into the air for potential combo-juggle setups.

Dash Attack: Pit's dash attack is a strong horizontal slash, superb for punishing your opponent's landing lag and forcing them to play more defensively. Pit's dash attack helps create openings since it's relatively safe (compared to most other dash attacks), allowing you to use it aggressively. Space the attack and try to hit with its tip as often as possible.

Side Tilt: Pit lunges forward with a low profile and extends his bow blades directly in front of him, knocking away foes. Side tilt is a good deterrent to the enemy's ground-based aggression and deals extra damage if hitting with the tips of the extended blades. It can be used as both a poke and a whiff-punish attack (particularly against ledge climbs).

Tilts

Move	Damage
Side tilt	10
Up tilt	4, 5
Down tilt	6

Up Tilt: Pit delivers a double hop kick attack, popping up his target into the air for a potential follow-up. His up tilt is a high-priority anti-air you can use to harass enemies on platforms above you. You generally want to use this attack over up smash in anti-air scenarios, since its total duration is shorter, leaving you safer on whiff or if your opponent baits it out.

Down Tilt: From a kneeling crouch, Pit sweeps at the opponent's legs with one of his bow blades, sending his victim into the air. Similar to side tilt, down tilt is a relatively safe neutral poke attack with solid range and start-up time. On hit, it sets up follow-up attacks such as dash-in grab and dashing attack.

Side Smash: Pit performs two powerful slashes in front of him using the Palutena Bow. The first hit stuns the enemy long enough for the second slash to blast them away. This two-hit smash attack boasts long reach and beefy hitboxes. Like most smash attacks, it's best used deliberately, so take care not to whiff it. Thanks to its reach, it's great for attacking opponents who tech your knockdowns.

Smashes

Move	Damage
Side smash	20.9-29.3
Up smash	16.5-23
Down smash	11.8-16.5/14.1-19.8

Up Smash: Pit delivers a three-hit anti-air attack sequence directed above his head, launching foes into the sky. Up smash is an excellent punishment attack against air dodges and ledge rolls. If you can find an opening beneath a foe, up smash deals considerable damage and has high knockout potential.

Down Smash: Pit sweeps the floor with the Palutena Bow at the ground in front of him, followed by a rear sweep, clearing out foes from the area. For a smash attack, down smash is incredibly fast with relatively low end lag. It starts up absurdly quickly and can be difficult to punish. As a clear-out attack, it hits behind you, making it rather flexible for defending against ground-based rushes. It's also one of your stronger options for snuffing recovering enemy attempts to grab the ledge.

Grabs

Move	Damage
Grab attack	1.5x1-5
Front throw	9.4
Back throw	12.9.
Up throw	8.2
Down throw	5.8

Pit's grab attempt hits quickly, not among the fastest grabs but not far behind. It has average reach. As Pit, down throw is your most important variant, as it leads to the most damage while your opponent is at low and medium percentages. Otherwise, Pit's grab and throw game is relatively straightforward. Use front and back throws to finish off enemies, tossing them into the blast zone if they're near a ledge. Use up throw to set up "sharking" (juggle-trapping) opportunities, and down throw for guaranteed combo damage at certain percentages.

Aerial Attacks

Neutral Air Attack: Pit twirls the Palutena Bow in midair, striking foes several times before knocking them back. Neutral air's persistent hitboxes make it great for punishing on-the-spot dodges and ledge-recovery options. If you can make a read on where your opponent is going to recover to, you can stick out a relatively safe neutral air to punish. You can make it safer by fast-falling, ensuring the last hit of the spinning attack connects with grounded foes.

Aerials

Move	Damage
Neutral air attack	9.4
Forward air attack	17.6
Back air attack	14.1
Up air attack	10.2
Down air attack	14.1

Forward Air Attack: While airborne, Pit delivers a multi-hit attack, spinning his bladed bow directly in front of him. Forward air is your primary aerial poking and pressuring tool. While it doesn't easily hit smaller fighters, you can fast-fall the attack during short hops to ensure it hits at the lowest altitude possible. Deep forward air attacks allow you to follow up with ground pressure, such as neutral attack or grab.

Back Air Attack: Pit thrusts the sharp points of his Palutena Bow halves behind him, striking aerial foes and knocking them up. Back air is much stronger than forward air, but takes more precision. Like side tilt, the tips of the blades deal max damage, with less coming from a hit with the arm. Hitting in closer with the arm sets up certain combo opportunities.

Like many back air attacks, Pit's is great for dealing shield damage. Back air is your primary edge-guarding attack, especially far out from the ledge.

Up Air Attack: Pit uses the Palutena Bow like helicopter blades, positioned laterally above him, cutting into airborne enemies several times before popping them upward. This anti-air move is your conventional double jump baiting and juggling attack, mainly used against airborne foes attempting to descend to safety.

Down Air Attack: Pit uses one half of the Palutena Bow to attack enemies below him with a wide-angled slash, potentially inflicting a meteor smash. Down air attack is a decent defensive move thanks to its wide-angle hitbox. If you're under pressure, you can use it from an out-of-shield jump, then pull away from your aggressor while you're airborne. It has a spiking effect right at the beginning, so it can be used to meteor smash enemies off the stage.

Special Moves

Special Moves: Pit

Move	Damage
Neutral special	3.2 (8.6 at max charge)
Side special	11
Up special	—
Down special	—

Special Moves: Dark Pit

Move	Damage
Neutral special	5.5 (14 at max charge)
Side special	12
Up special	—
Down special	—

Neutral Special (Pit): Palutena Bow: Pit fires a chargeable magic arrow that he can control, able to bend its trajectory midflight—making Palutena Bow one of the best projectile-based edge-guarding tools in the game. The bow can be directed vertically or horizontally. To fire the bow above him, hold up on the control stick. The arrow can be curved midflight. When fired horizontally, control it with up and down inputs. When fired vertically, control it with left and right inputs. Pit's arrows are incredible for harassing, chipping, and zoning out enemies.

Neutral Special (Dark Pit): Silver Bow: Dark Pit fires an arrow imbued with darkness. Dark Pit's arrows are more powerful than Pit's, but are influenced much less by midflight inputs (although they can still be directed, albeit slightly).

Side Special (Pit): Upperdash Arm: Pit dashes forward and delivers an uppercut that launches foes high into the sky. Pit's Upperdash Arm launches foes much higher with a sharper vertical angle than Dark Pit's Electroshock Arm, but deals slightly less damage. During the dash, this special move deflects projectiles. If executed in midair, it packs less punch as a launcher, but leaves you less vulnerable. Upperdash Arm and Electroshock Arm can be used to get back onstage, while at the same time retaliating against edge-guarding opponents.

Side Special (Dark Pit): Electroshock Arm: Dark Pit charges forward with a weapon that launches foes diagonally upward. While Pit's Upperdash Arm is more likely to knock out enemies vertically into the sky, Dark Pit's Electroshock Arm is noticeably more effective for knocking out enemies near ledges. Like Pit's Upperdash Arm, Dark Pit's Electroshock Arm deflects projectiles while he dashes forward.

Up Special (Pit and Dark Pit): Power of Flight: After a brief midair pause, Pit soars through the air. This air dash special can be redirected with the control input. After the up special input, hold left, up-left, up, up-right, or right to send Pit flying in that direction. This recovery option leaves you vulnerable as you descend from the air, so be careful not only in your positioning, but with your opponent's possible punishment options, as you're left helpless during your descent.

Down Special (Pit and Dark Pit): Guardian Orbitars: Pit shields his front and rear, reflecting incoming projectiles back at their origin. Guardian Orbitars can only take so much damage before they break. Once broken, the special move becomes disabled for 10 seconds. However, that's not necessarily your greatest vulnerability. You can still be grabbed while holding your shields out. Furthermore, astute and sharp opponents can bait out your Guardian Orbitars and charge up a smash attack, simply waiting until you release and punishing your lag with a massive attack. Guardian Orbitars should be used sparingly, and only if you can make a strong read against your opponent's aggression and projectile habits.

Final Smash: Lightning Chariot / Dark Pit Staff

Pit: Lightning Chariot: Pit boards the Lightning Chariot and targets opponents with a reticle before charging forward and launching any opponents he hits.

Dark Pit: Dark Pit Staff: Dark Pit uses his staff to launch opponents with a high-speed horizontal blast that goes straight through obstacles. It can hit multiple foes in a row, but only the first feels its full force.

Pokémon Trainer

OVERVIEW

Anyone who wonders what it would be like to wade into battle with trusty Pokémon need look no further. When selecting Pokémon Trainer, you can select a female or male Trainer, choose from different color schemes, plus select which Pokémon battles first. Pokémon Trainer her/himself doesn't take to the field; he or she stands in the background while you control the current active Pokémon.

Brawling as Pokémon Trainer is like using a single complex fighter with multiple versions. Squirtle, Ivysaur, and Charizard all do different things well, and you may want to swap between their abilities depending on the matchup or situation. Each is heavier than the last, which is relevant for avoiding KOs and following a match's natural pace.

COMMON MOVES

Down Special: Pokémon Change

With any of the Pokémon, down special prompts the Trainer to use a Poké Ball to cycle from one fighter to the next. The down special cycling order is: Squirtle > Ivysaur > Charizard > Squirtle.

The simplest way to think of Squirtle, Ivysaur, and Charizard in the context of the team is as flyweight, middleweight, and heavyweight. Elements matter too: Squirtle, while weak to grass, is resistant to fire damage, a great trait to have considering how many flaming attacks and items there are. Ivysaur is weak against fire damage, which many enemies can exploit. On the other hand, Ivysaur is brimming with grass attacks, great against Squirtle in Pokémon Trainer mirror matches. Meanwhile, Charizard is one of those fire-damage sources that Squirtle shrugs off and Ivysaur fears, while being vulnerable to water attacks itself (like those from Squirtle).

Final Smash: Triple Finish

All three Pokémon combine their powers for a series of overlapping attacks. This super-effective Final Smash spews a solid Solar Beam straight across from wherever it's activated, as well about half the way out, for some extra coverage. In close, the Whirlpool created by the unison of Pokémon powers can suck nearby opponents in.

It's super effective!

Squirtle Vitals

Movement Options	
Jumps	1
Crouch Walk	Yes
Tether	No
Wall Jump	Yes
Wall Cling	Yes
Movement Ranks	
Ground Speed	C- (31-34)
Air Speed	C (52)
Falling Speed	D (58-61)
Weight	F (73-74)

Ivysaur Vitals

Movement Options	
Jumps	1
Crouch Walk	Yes
Tether	Yes
Wall Jump	No
Wall Cling	No
Movement Ranks	
Ground Speed	D (53-56)
Air Speed	C- (55)
Falling Speed	D (55-56)
Weight	C+ (32-35)

Charizard Vitals

Movement Options	
Jumps	2
Crouch Walk	No
Tether	No
Wall Jump	No
Wall Cling	No
Movement Ranks	
Ground Speed	B+ (9)
Air Speed	B- (33-35)
Falling Speed	C (48)
Weight	A- (6-7)

SQUIRTLE ARSENAL

Grounded Attacks

Neutral Attacks:
Squirtle swings with the fastest attack available to a Pokémon Trainer Pokémon. Point-blank, Squirtle's neutral attack combo is a legitimate offensive and defensive threat. Use it to slide out of dashes and check foes, to react instantly after dropping shield, and to hit them in the back just after landing from short-hopping air attacks. The first two hits are a one-two jab sequence, while the third hit is a spin-kick finisher. The combo can be executed tapping Attack repeatedly, or just holding it.

Dash Attack: Speedy Squirtle flies out of a run or dash with a sideways screw kick that resembles its forward air attack. Challengers nailed by this pop a little bit up in the air near Squirtle, in position for more hits.

Neutral Attacks

Move	Damage
Neutral attack 1	2
Neutral attack 2	1.5
Neutral attack 3	4

Dash Attack

Move	Damage
Dash attack	8

Defensive Attacks

Move	Damage
Ledge attack	9
Wake-up attack	7

Side Tilt:
Squirtle ducks away momentarily to swing its tail forward. The tail's angle can be slightly altered, aimed up-forward or down-forward. This quick attack might deal low damage, but Squirtle's tail is intangible. Poke with the tip of side tilt tail swings for a safe check against shields, or a low juggle hit.

Tilts

Move	Damage
Side tilt	5
Up tilt	5
Down tilt	8

Up Tilt: For up tilts, these Pokémon all have a similar upward-leaping attack, though with much different results. Squirtle hops in place with a headbutt pointed straight up.

This isn't really effective against standing opponents nearby. Save it for hopping into enemies falling from the air.

Down Tilt: This long-reaching tail swipe deals more damage than Squirtle's other tilts, though it's slower to hit. It also has more severe knockback, kicking defenders farther away.

Side Smash: One of Squirtle's water-based attacks. After the charging period (if desired), the trusty turtle ejects a short-range water spout straight forward. It might look like this attack sweeps upward somewhat, but it doesn't. The range for the linear hit is good, at least.

Smashes

Move	Damage
Side smash	15-21
Up smash	3, 13-4.2, 18.2
Down smash	13-18.2

Up Smash: While up tilt doesn't offer lateral coverage, up smash more than makes up for it. Squirtle leaps upward with forceful spigots bursting to either side. Anyone caught by either spout pops up into the air, potentially jugglable.

When comparing clear-out options, up smash has better follow-up potential, while down smash pushes everyone farther away.

Down Smash: Squirtle spins first to the front, then points behind with a gushing waterspout, sweeping both sides with liquid. Anyone in the way is knocked or pushed away, like a down tilt hitting both sides.

Move	Damage
Grab attack	1
Front throw	2, 6
Back throw	8
Up throw	2, 5
Down throw	2, 5

Squirtle has a quick, short-range grab animation to match its lightning-fast neutral attack punch. These attacks sync up with air attacks to give it a quick, punchy point-blank offense. Squirtle's diminutive grab attacks give you a chance to squeeze in one or two more than usual before the follow-up throw. Front and back throw give the usual options tossing a foe to one side or another, without exceptional range. Up throw places them in better position for juggles at jump height, while down throw bounces them off the ground right before Squirtle, good for short-hopping or ground-level juggles.

Aerial Attacks

Neutral Air Attack: Squirtle extends its little limbs in a midair tumble and essentially becomes a circular projectile. It deals the most damage right on activation, but the attack's active period lingers long enough to make this a great all-purpose air attack. It can be good jumping into enemies air-to-air and falling onto standing foes, whether fast-falling or drifting normally, and whether landing in front of them or behind.

Forward Air Attack: Squirtle lies prone in midair and kicks forward with its whole lower body, generating a small corkscrew of water. The most damage is dealt with the initial thrust, though Squirtle's legs stay out for a split second after at lower strength. Front and back air start out basically identical, but you'll want to lean on one or the other in different positions. Forward air attack is punchier and easier to use, but back air has more potential, with more risk too.

Back Air Attack: Squirtle spins with its tail extended to its full length backward, hitting multiple times with a very good backward-aimed hitbox (for such a small brawler). Scoring all of the drilling hits before the final airborne finisher requires Squirtle's jump arc to line up correctly with the enemy's trajectory and position.

Back air attack's tailspin and forward air attack's watery kick basically do the same thing, with different results. Forward air deals less damage, but all in one hit, with much better landing lag if done on the way down. Back air has better hitboxes and more damage and juggle potential, but runs the risk of missing hits if the aim isn't lined up. Also, low-altitude back air ends with unique landing lag: Squirtle lands on its belly with a thud, shell up. Its impact with the ground is a low-damage hit, capable of working seamlessly as the final hit if aimed correctly.

Move	Damage
Neutral air attack	10
Forward air attack	7
Back air attack	1x3, 6, 2
Up air attack	7
Down air attack	1.5x5, 4

Up Air Attack: Squirtle whips upward with its tail, starting aimed up-forward and rotating to up-back. Matches are full of chances to chase after higher-altitude adversaries with up air attack. The most basic examples are right after grabbing and hurling someone with up throw, or launching them with up smash.

Down Air Attack: Like back air attack's spinning tail attack but aimed straight down. Squirtle drills down while falling, hitting multiple times. After five starting hits, a sixth hit knocks victims away. This down air can't meteor smash, and can be a little finicky to aim and get all the hits. Still, it's decent short-hopping at grounded foes or stepping off a stage edge to snipe straight down with the tail at a recovering foe before jumping back to safety.

Special Moves

Special Moves	
Move	Damage
Neutral special	0
Side special	13
Up special	1.4x7, 3
Down special	0

Neutral Special: Water Gun: Squirtle's Water Gun is a zero-damage move, like Mario's F.L.U.D.D., used for redirecting items, shots, and enemies. You have to charge up first before Squirtle can squirt its water jet. The charge can be canceled early by dodge-rolling (but not by sidestepping, jumping, or double-jumping), if you need to dodge something incoming. The best (or certainly most fun) use of Water Gun is when edge-guarding, if the opportunity presents itself to push someone back with the water stream just as they're making their final play for the ledge.

Side Special: Withdraw: Squirtle pulls into its sturdy shell and spins in one direction, bouncing off after hitting anything. Squirtle is invincible while spinning, though if anyone leaps on top with good timing, Squirtle will be flipped like a Koopa in *Super Mario Bros.*!

Up Special: Waterfall: Squirtle surfs a sudden huge spout of water upward like a big ball. This is useful as a defensive reversal, a juggle extender, and a recovery lunge. Holding forward or backward can influence the surging waterball's travel. Afterward, Squirtle is helpless until landing.

IVYSAUR ARSENAL

Grounded Attacks

Neutral Attacks:
Ivysaur's neutral attack combo is a three-stage sequence, starting with a couple of vine slaps. On short notice, down tilt and dashing attacks are faster to hit than neutral attacks. When poking up close, consider using

short-hopping back air attack or neutral air attack in places where you might tend toward neutral attacks. Since Ivysaur has to go through pre-jump takeoff before neutral air or back air comes out, the overall sequence is a bit slower than a plain old neutral attack, but being off the ground makes those moves less exploitable if they're blocked or dodged. The neutral attack's third stage is a furious multi-hit vine blender. You can perpetuate this attack indefinitely by holding the button, though any foe being hit by the vine is eventually pushed out of the hits.

Dash Attack: Along with down tilt, Ivysaur's dash attack is its fastest-hitting physical strike. The galloping Bulbasaur evolution throws its weight into a forward headbutt, knocking victims into a low-altitude tumble that allows follow-up hits.

Side Tilt: The leaves surrounding Ivysaur's bulb spin rapidly, delivering several slaps to the air in front of the Pokémon. It might look like this attack has vertical and back coverage, but it only hits in front. The active period is long, at least, with a hitbox along the floor. This makes it decent for edge-guarding, when trying to intercept someone's fingers just as they grab the ledge, but before they're intangible.

Neutral Attacks	
Move	Damage
Neutral attack 1	2
Neutral attack 2	2
Neutral attack 3	0.5x7, 2

Dash Attack	
Move	Damage
Dash attack	12

Defensive Attacks	
Move	Damage
Ledge attack	9
Wake-up attack (faceup)	7
Wake-up attack (facedown)	7

Tilts	
Move	Damage
Side tilt	1.5x6, 2
Up tilt	7
Down tilt	5.5

Up Tilt: Ivysaur's tendrils serve as an anchor and trampoline, launching Ivysaur's body straight up into a hopping hit. This has shocking reach upward, but very little side coverage. This attack is clearly intended for juggle combos and anti-air, and for those roles it performs exceptionally, reaching way higher than most up tilts and up smashes.

Down Tilt: Ivysaur hunches down and slaps far in front with a low tendril swipe. Even at low-damage percentages, this knocks victims backward. The damage is low, but the range is good, and the speed is even better: down tilt is functionally Ivysaur's fastest move. When in doubt, or worried about the lag on Ivysaur's other moves, lean heavily on down tilt.

Side Smash: After tensing up charging, Ivysaur launches forward, pushing itself with planted tendrils. Ivysaur itself is kind of like a big short-range projectile, almost like up tilt if it could be aimed sideways. The range and hitting power are solid, and Ivysaur can be aimed slightly up or down to account for tiny crouchers and short hoppers. There's considerable lag afterward as Ivysaur rolls backward to its starting point.

Smashes

Move	Damage
Side smash	16-22.4
Up smash	17-23.8.
Down smash	12-16.8

Up Smash: This attack is very slow to start, even uncharged, but makes up for it with a huge hitbox right above Ivysaur. The bulb generates a spore explosion, which has considerable launching power against anyone caught inside the radius. If you can compensate for the speed (it takes nearly half a second for up smash to hit, uncharged), this move is great for shooting at aerial foes.

Down Smash: Ivysaur stretches its tendrils out wide to both sides at ground level, knocking away anyone nearby. For a smash attack that clears out on both sides at the same time, down smash is surprisingly fast. This isn't one of those clear-out smashes that hits front right away, then behind much later. The reach for both vines is also terrific. If you're finding yourself surrounded midstage, down smash is probably the solution.

Ivysaur's vines give it much longer grab range than most fighters. You have to make the most of that extra reach, too, because Ivysaur's grab animation is one of the slowest around. Practice with the range, so you're attempting grabs from far enough away that smaller fighters can't just counter-poke or grab Ivysaur first. Even better, practice dashing, then grabbing immediately; not only does the dash add even more to the range, but starting a grab during a dash gives forward momentum to the grab animation, so there's a double bonus to grab range from

Grabs

Move	Damage
Grab attack	1.3
Front throw	5, 5
Back throw	12
Up throw	4, 5
Down throw	7

dashing first. To practice the range, get flush against a fighter in Training Mode, dash away from them twice, then dash toward them once and cancel the dash by grabbing. Once they're in Ivysaur's clutches, the standard options are in play.

Aerial Attacks

Aerials

Move	Damage
Neutral air attack	1x7, 2
Forward air attack	12
Back air attack	3, 6
Up air attack	15
Down air attack	10

Neutral Air Attack: Airborne Ivysaur splays its big-bladed leaves and pinwheels to hit in all directions. This is a great attack for general use, with Ivysaur like a flying pizza cutter. For the full combo, you have to strike right away, but the move is still good for bullying with late hits, like after fast-falling. Since Ivysaur's ground attacks tend to be slow and laggy, it helps to think of short-hopping neutral air as basically a ground poke.

Forward Air Attack: Ivysaur lashes out with a vine from diagonally up-forward to down-forward. For an aerial attack this is slow, hitting in about the time smash attacks usually take, but the range and power are great. Recipients get knocked off their feet.

Back Air Attack: Ivysaur whips backward twice. The hitbox for the two backward hits covers a slightly smaller wedge than forward air attack's. The first vine whip combos into the second to knock victims away. Back air has slightly less coverage and damage than forward air, but it hits much faster, as fast as neutral air attack. And back air has equally good reach, if shallower coverage up and down.

Up Air Attack: When the bulb on Ivysaur's back explodes, enemies nearby can be launched far away by the sudden burst of air and spores. The bulb explosions during up air attack (and down air attack, and up smash) hit a huge area around the bulb, making this a dominating move when going after enemies higher in the air, or standing on platforms above. It's not fast for an air attack, but up air from a short hop is still twice as fast as uncharged up smash, while fulfilling the same role.

Down Air Attack: An upside-down version of up air attack and up smash, featuring Ivysaur flipped upside down to direct the bulb's spore explosion downward. Down air does less damage than other bulb moves but hits faster, with just as generous a hitbox. With the big bulb explosion blanketing a circle under Ivysaur, this can even be used to ward off foes on lower platforms without dropping down a floor. It also has the obvious use, aiming downward at enemies on the ground or, even better, offstage.

Special Moves

Special Moves	
Move	Damage
Neutral special	3, 1.5x4, 3
Side special	8
Up special	11
Down special	0

Neutral Special: Bullet Seed: Ivysaur starts shooting seeds straight upward rapidly. The force Ivysaur gathers to start shooting is an attack in itself, popping close-range foes up right into the seed fusillade. On a normal input, the whole sequence launching victims at the end. Holding the input launches more seeds. Depending on the target's damage percentage, you can hold them in place for three or four times more seeds than standard, still scoring the launcher hit on release.

Side Special: Razor Leaf: Ivysaur tosses a crescent-shaped plant projectile, which twirls at variable speed through anything in the way. It can plow through multiple targets, if they're all lined up. When throwing this special, use a tilt-style input for a slower version that doesn't travel as far before disappearing. This mostly affects the leaf's deceleration toward the end. For a fast, farther-reaching Razor Leaf, use a snap-style input, like with a smash attack.

Up Special: Vine Whip: Ivysaur's Vine Whip special is variable depending on where you use it. Midstage, Ivysaur only lofts up a little bit during the first midair use of a given jumping period. It's better to think of this as a powerful up-forward-aimed vine attack, like a midair smash, rather than a traditional up special. Used this way, it has huge vertical reach, great for striking at high-fliers and helpless tumbling enemies. It also doesn't leave Ivysaur helpless after, so you can still double-jump (if it's in reserve) or perform other actions while in midair, even another up special Vine Whip.

Offstage, Vine Whip is Ivysaur's lifeline. Within reach of a valid ledge, using up special lashes Ivysaur to the ledge with the outstretched tendril. Vine Whip's aim is automatic, winching a ledge from above or below. Ivysaur then drifts down to the vine's extended length, waiting for another input before pulling into the ledge or dropping off (since the Vine Whip tether to the edge counts as touching a surface, dropping off into space allows for a double jump).

CHARIZARD ARSENAL
Grounded Attacks

Neutral Attacks:
Charizard swings away with a bruising three-hit combo. The first neutral attack is the fastest move in this Pokémon's arsenal. The full neutral attack combo is great for retaliating right after successfully blocking someone's attack. One or two can be used when dancing around enemies looking for hits and trying to dodge attacks; if they get claw-swiped too many times moving aggressively or carelessly, opponents may respond by being more defensive, which opens them up to Charizard's grabs.

Dash Attack: Charizard lunges forward with a serious dropkick. It does the most damage right on activation, but any hit sends enemies sailing away.

Neutral Attacks

Move	Damage
Neutral attack 1	2.5
Neutral attack 2	2.5
Neutral attack 3	5

Dash Attack

Move	Damage
Dash attack	11

Defensive Attacks

Move	Damage
Ledge attack	9
Wake-up attack (faceup)	7

Side Tilt: Charizard lashes forward with a long flaming tail tip. The attack can be angled a little bit up or down. The damage and knockback power are highest right at the tip, and less closer in. With the reach and strength, this poke is like a miniature smash attack.

Up Tilt: The Pokémon springs up on its tail with both wings extended. There are flat hitboxes along both wings, and a larger one around Charizard's body.

Charizard's riff on the hopping up tilts of Squirtle and Ivysaur also dominates against anyone airborne, but lacks lateral coverage.

Down Tilt: The fastest tilt attack the Pokémon has is a low, far-reaching head bash. For a reliable lateral poke that isn't simply a neutral attack, this beats out most moves except the first hit of uncharged up smash. It hits at the same angle as, but has a lot less commitment than, dashing attacks and side smashes.

Tilts

Move	Damage
Side tilt	11
Up tilt	8
Down tilt	10

Side Smash: This devastating attack gives Charizard brief intangibility just before the hitting period begins, which helps compensate for the slow speed. Anyone in the way of the fierce sideswiping headbutt takes heavy damage and huge knockback, especially with a charged side smash. Even if they block the attack, they're likely in danger of having their shield broken.

Up Smash: The Pokémon lurches back slightly to get momentum for a forward wing smash. Charizard's quick shuffle at the start is a close-range attack, its second-fastest after a neutral attack! This starting hit launches victims directly in the way of the follow-up wing slap. Otherwise, the wing slap can function as an attack on its own, when used against fliers and tumbling combo candidates.

Smashes

Move	Damage
Side smash	17-23.7
Up smash	5, 11-7, 15.4
Down smash	16.1-22.4

Down Smash: Charizard stomps with teeth-shattering force, shaking the area to both sides. The hit area to both sides of Charizard is enormous, like an enhanced version of Ivysaur's (already quite big) down smash, with the same speed. All Pokémon Trainer's down smashes hit both sides at the same time, boosting these creatures' odds in party battles.

Charizard's grab is right in line with normal heavyweights, not exceptionally slow or fast. Neutral attack and close-range up smash are attacks faster than Charizard's grab, needed (alongside low-altitude air moves) to bully foes to get them to sit still long enough to get grabbed in the first place. Charizard's front and back throws have great power and knockback. Up throw feels like a special-move throw, flying high to slam enemies off the ground, in perfect position for immediate midair hits. As the Pokémon falls with its prey, anyone underneath takes damage from the impact. Charizard is airborne right after bouncing them off the turf. At low percentages, you can combo with forward air attack right away. At higher percentages, you have to double-jump right away, then slash with forward air to nail them. You can even try double-jumping, then firing with Flare Blitz! Down throw also affords combo chances. Charizard holds foes down and spews flames on them for a second, then bounces them up in front a short distance.

Grabs

Move	Damage
Grab attack	1.6
Front throw	10
Back throw	10
Up throw	8, 3
Down throw	1x6

Aerial Attacks

Neutral Air Attack: Charizard spins forward, hitting around most of its body with the curved tail. The tail's tip is the strongest point and starts its travel aimed up-back, before curling over the top to down-forward. With the tail wrapped around Charizard, neutral air's coverage is great; it's just the speed that's below par. If short-hopping toward foes with neutral air, think of it like aiming a somewhat slow uncharged smash attack.

Forward Air Attack: This frontal claw swipe is Charizard's fastest air attack. It's strong enough to knock foes off their feet even at low percentages. Forward air is a great general-use air attack if you're facing the right way, and the only one that's remotely speedy.

Back Air Attack: Charizard lashes backward with a tail strike, reaching far and hitting hard. The reach is fantastic, if you have time for the windup.

Up Air Attack: Charizard swipes upward with its horned head front-to-back. This fills the usual role of most up tilts, swinging across an arc upward to juggle helpless enemies or knock down jumping ones. Charizard's head is intangible here, helping up air win out against whatever anyone above tries out.

Down Air Attack: While airborne, the Pokémon stomps with one leg. When falling toward a target or jockeying for higher position with an opponent offstage, this is your option for aiming straight down and maybe spiking them. It's slow to hit and the hitbox is relatively small compared to other air moves, so it can be difficult to use.

Aerials

Move	Damage
Neutral air attack	12
Forward air attack	12
Back air attack	14
Up air attack	13
Down air attack	14

Special Moves

Neutral Special: Flamethrower: Charizard begins emitting a ferocious spew of flames. The torrent is very powerful at first, but quickly dwindles as Charizard's bellows deplete. When the fire is temporarily gutted, you have to lay off of using Flamethrower for a while. With a down-forward trajectory covering a wide close-range swath, what with all the fire, this is very good edge-guarding against someone coming in from below at a 45-degree angle, or to unleash on groups preoccupied fighting each other. There are also circumstances where it can be used to juggle foes, like after down throw's low bounce.

Side Special: Flare Blitz: Charizard hunches for a moment, building tension, then rockets forward an astonishing distance, flames and smoke trailing in its wake. This attack is so forceful that Charizard takes damage with every use—5% for a whiff, and 10% for a hit (whether foe or wall). If anything gets in the way, Charizard slams into it with an extremely powerful blow, bouncing off rather than continuing on the usual lengthy path. If used standing on solid ground, Flare Blitz doesn't send Charizard plowing off a stage edge; the attack stops at the cliff. But if used in midair, all bets are off: it's up to the player to aim prudently with Flare Blitz while jumping.

When Flare Blitz ends low to a surface, Charizard has considerable landing lag lying down. Being so potentially predictable and punishable comes with the territory for something so fast and strong. If performed high enough in the air, so the attack doesn't end right above a potential landing pad, the air recovery isn't too bad. Recovery is possible after a missed high-altitude Flare Blitz, or even a Flare Blitz back in the direction you came from.

Special Moves	
Move	**Damage**
Neutral special	2x3, 1x3
Side special	6, 18
Up special	5, 2x4, 4
Down special	0

Up Special: Fly: Charizard rockets almost straight upward with a scary launcher. The initial hit at ground level is generous at close range, popping up anyone vulnerable to get carried upward with further hits. As Charizard rises, several more hits are delivered. Charizard can be steered a bit left or right while rising with Fly, though not too much. The vertical gain is good, at least. Afterward, Charizard is helpless while falling, able only to drift in the desired direction. Overall lateral travel for recovery purposes for such a move is kind of weak, despite the hangtime. Flare Blitz early may be a better option than Fly late, depending on the recovery situation. Keep in mind that Charizard is one of few brawlers capable of triple-jumping, which aids offstage survival.

Ridley

OVERVIEW

Ridley is unique in that he's considered a heavyweight fighter but, at the same time, is a highly mobile flight-based fighter with several air-traversal options. As a winged space pirate, Ridley can flutter his wings to remain airborne (essentially a "triple jump" that allows him to change his facing direction). His up special is a multidirectional dash special called Wing Blitz, which could be considered four additional aerial options. Then his Space Pirate Rush grab attack doubles as a kind of horizontal air dash if used non-offensively. All of these options combined make Ridley a difficult foe to edge-guard.

Ridley Vitals	
Movement Options	
Jumps	2
Crouch Walk	No
Tether	No
Wall Jump	No
Wall Cling	No
Movement Ranks	
Ground Speed	B+ (10)
Air Speed	C (40-43)
Falling Speed	B (16)
Weight	B+ (11-15)

Ridley's general game plan revolves around his Plasma Breath pressure and incredible air attacks. He can force out mistakes from his foes with his chargeable projectiles, luring enemies into range of his neutral air attack, down air, and Space Pirate Rush unshieldable grabs.

Grounded Attacks

Neutral Attacks: Ridley quickly slashes the enemy with a simple left, right, left claw-swipe combo. On whiff, if the Attack button is held, Ridley executes the rest of the auto-combo, with the second and third neutral attacks improving in range. Since Ridley's strengths primarily revolve around his aerial moves, you don't use neutral attack too often. It should be mainly used as an out-of-shield buffer-retaliation punish after guarding enemy attacks.

Rapid Neutral Attack Special: Ridley's tail becomes a rapid-fire piercing machine. This unique attack is performed by tapping neutral attack three times quickly in succession. Once Ridley begins the lightning-tail animation, hold the Attack button to fire his tail indefinitely. Releasing the button results in a final tail-launch attack that knocks away enemies. This isn't a particularly strong or useful attack as a poke, since you're immobilized and grounded. Be careful of accidentally unleashing this attack if you're going for a normal three-hit neutral auto-combo.

Neutral Attacks	
Move	Damage
Neutral attack 1	2
Neutral attack 2	1.5
Neutral attack 3	5
Rapid neutral attack special	0.7 x N, 2

Dash Attack	
Move	Damage
Dash Attack	12

Defensive Attacks	
Move	Damage
Ledge attack	10
Wake-up attack	7

Dash Attack: While flying forward, Ridley lunges and takes a bite out of his foe, launching them away. Ridley's dash speed and the start-up of his dash attack are below average, so his dash attack can be difficult to implement into your game, especially since your game plan largely revolves around projectiles and air-based strategies. The launch effect of dash attack doesn't effectively lead into further combo potential.

Side Tilt: Ridley thrusts his tail into the enemy. If he successfully stabs the foe with the pointy end of his tail, they take much more damage and knockback. Side tilt angled up and side tilt angled down can be used to minutely alter the attack, although it's important to note that non-angled side tilt has a slight horizontal range advantage. Critical tail end hits are much more likely to KO enemies, making it an excellent attack for high-damage-percentage foes.

Tilts	
Move	Damage
Side tilt	13
Up tilt	9
Down tilt	9

Up Tilt: Ridley performs a vertical wing swipe, reaching far above him with an attack area that covers his rear and front. Up tilt has a deceptive effective range and quick start-up. Visually, the attack begins behind Ridley, but the hit effect impacts almost instantaneously all around him. Although its main strength is in its anti-air property, you can use up tilt in almost any ground-to-ground and ground-to-air situation, thanks to its speed and generous hitbox. Up tilt is one of the few ground attacks that should be used regularly in your arsenal.

Down Tilt: Ridley delivers a low-profile tail swing in front of him, sweeping enemies off their feet while crouching and minimizing his size vulnerability. While this attack looks like a sweep attack, its hit effect area covers a sizable horizontal block in front and can be treated like a relatively fast general-purpose side attack. It deals much less damage than side tilt.

Side Smash: Ridley exhales a powerful burst of flame from his maw, blasting away foes before him. Like most smash attacks, this side smash has a lengthy start-up time, but rewards successful hits with incredible knockback and damage. Since it's a breath-type projectile, it can absorb a single opposing projectile. It's also moderately safe (aside from the slow start-up), as Ridley doesn't extend a vulnerable limb during the attack.

Smashes

Move	Damage
Side smash	20
Up smash	17
Down smash	16

Up Smash: Ridley performs a front-somersault kick, covering a crescent-shaped angle above him. Up smash isn't nearly as useful as up tilt in most situations, but it deals much more damage and boasts a large area of effect for its hitbox, along with an intangible limb (only Ridley's extended attacking leg is intangible).

If you can catch opponents off-guard (if they're standing on a platform or ledge above you), up smash can be an effective surprise attack.

Down Smash: Ridley pounds the ground and sends out a small shockwave, knocking away nearby foes. This is a clear-out attack, particularly useful in free-for-all skirmishes where you're surrounded by multiple enemies. In one-on-one scenarios, it can be a liability because of its slow start-up and considerable lag, but it offers a slight range advantage over side smash, so in certain scenarios, it can be used to KO high-damage foes. Ridley's down smash is also deceptively difficult to beat out directly since he's in such a low-profile state as he slams the ground, although after the ground pound, he's extremely vulnerable.

As a heavyweight brawler, Ridley's grounded normal grab starts up relatively slowly, but with considerable reach. Ridley's grab attack is a quick tail stab. His up throw puts the foe in a comboable air state where you can potentially follow up with extra juggle damage. His forward and back throws are almost identical, except back throw deals a bit more damage. His down throw is where the meat is, allowing for guaranteed combo follow-ups depending on the enemy's damage value. A majority of your ground game should be grab-focused. When you're not harassing foes with fireballs and neutral air attacks, you should be going for dashing grab attempts.

Grabs

Move	Damage
Grab attack	1.6
Front throw	9
Back throw	11
Up throw	12
Down throw	7

Aerial Attacks

Neutral Air Attack: Ridley performs a full somersault backflip in the air, knocking away enemies within proximity. Neutral air attack is one of your best attacks; it boasts excellent angle coverage, low enough lag to perform twice in one jump, and a decent start-up speed. It's highly effective as a fast fall attack. At the peak of a jump, input neutral air, then immediately input down to fast-fall. Your neutral air persists enough to behave as a sort of somersault dive-bomb attack (with a huge rotating hit effect), nailing anyone below you. A strong base game plan for Ridley should revolve around the threat of your neutral air.

Aerials

Move	Damage
Neutral air attack	12
Forward air attack	5, 5, 7
Back air attack	15
Up air attack	12
Down air attack	14

Forward Air Attack: Ridley quickly executes a triple tail-stab combo in front of him, blasting the victim to long range. Forward air is a relatively fast attack, but limited in its attack area coverage, only stabbing the small area in front. Its damage slightly varies depending on how initial tail strikes connect, but ultimately, the difference is negligible. This attack's main strength is as a quick deterrent attack. It's relatively easy to punish when shielded.

Back Air Attack: Ridley performs an aerial backswing kick, dealing heavy damage and blasting away foes behind him. This high-damage air-to-air attack is largely conventional, with middle-of-the-road properties. It has a linear, horizontal hit effect, with few active frames. While you most likely won't go out of your way to use back air attack, it deals the most damage out of all your air attacks, and it does its job sufficiently as a solid air-to-air.

Up Air Attack: Ridley thrusts his wings into the air, popping up foes above him. Up air is a standard air-thrust attack that covers all the conventional roles. It sets up combos when connected deep (against low-altitude or grounded enemies) and functions as a solid air-to-air anti-air, popping up foes and setting them up for extra combo damage and 50/50 juggle setups.

Down Air Attack: Ridley quickly descends from any altitude with a double-talon foot stomp, obliterating enemies below him. Down air is a dive-kick-type attack, with a persistent hit effect from any altitude, lasting until Ridley hits the ground. It offers combo opportunities, but only when hit at specific angles. At other angles, down air sends opponents flying away. While Ridley's dive kick can be a strong surprise attack, it's punishable when shielded. It has a high amount of landing lag as Ridley sticks his landing, so don't be predictable with it, especially in one-on-one fights.

Special Moves

Neutral Special: Plasma Breath: Ridley spits out up to five bouncing fireballs. The longer he readies the attack, the more fireballs he spits. While this is an exceptionally powerful projectile attack, it has a glaring weakness: while Ridley is charging up, his mouth area becomes a weak point (the longer he charges, the larger his weak point becomes). If he's struck in the mouth while charging Plasma Breath, his mouth explodes and he takes massive damage.

Special Moves	
Move	Damage
Neutral special	5.7 (4.4 midrange falloff)
Side special	4, 2 x N, 7
Up special	18 (up), 16 (side), 15 (down)
Down special	40

Side Special: Space Pirate Rush: Ridley smashes the opponent into the ground and then drags them along the floor until they escape or Ridley decides to toss them into the air. Space Pirate Rush is a unique special move with distinct mechanics. The floor-drag duration and damage of Space Pirate Rush directly correlate with how much more damage the opponent has taken in comparison to Ridley.

This difference also determines how difficult it is for the opponent to shake out of the grab. For instance, Ridley at 0% dragging a 200% foe almost always KOs, while at the same time being extremely difficult to mash out of. At the other end of the spectrum, if Ridley is at 200% and he grabs a foe at 10% with his Space Pirate Rush, it will almost certainly be ineffective, as they easily escape his clutches.

Up Special: Wing Blitz: Ridley musters energy and then boosts into the air with force. Wing Blitz is a versatile air-traversal tool that allows you to select one of four directions to charge in. It can be used for everything: to attack enemies from below with a launching skyward wing attack (hold up input upon start-up), as a dive kick (hold down input upon start-up), as an aggressive horizontal down-angled charge attack (hold forward input upon start-up), or as an up-angled rear attack (hold back input upon start-up).

Down Special: Skewer: After a brief charge-up, Ridley stabs his sharp tail forward. If the pointy end of his tail finds its mark, he deals a critical amount of damage and debilitates his victim. Skewer causes crumple stun for a potential jab follow-up on critical tail-end hit, but is relatively difficult to hit against agile enemies. Non-critical hits deal only 5 damage (if you hit with the inner part of Ridley's tail), so you should almost always aim to hit with the pointy end if you're going for this high-damage, high-risk attack. This attack should be reserved for punishing laggy moves, not routinely used as a poking tool.

Final Smash: Plasma Scream

Ridley flies forward horizontally, tackles anyone in his way, and hurls them onto Samus's Gunship. He then fires a devastating ray that can hit up to two opponents. Enemies with at least 100% damage are instantly KO'd.

R.O.B.

OVERVIEW

R.O.B. is a highly mobile heavyweight brawler who specializes in a defensive stage-controlling playstyle. Thanks to his powerful Robo Beam and Gyro projectiles, R.O.B. can force his enemies to make mistakes from almost anywhere on the battlefield. As foes are forced to avoid and deal with his long-range attacks, R.O.B. can capitalize on their openings with a strong walling tactic, boxing out fighters with high-priority moves.

R.O.B. Vitals	
Movement Options	
Jumps	1
Crouch Walk	No
Tether	No
Wall Jump	No
Wall Cling	No
Movement Ranks	
Ground Speed	C- (37)
Air Speed	B (26-28)
Falling Speed	C (36-39)
Weight	B (16-17)

R.O.B.'s melee-range attacks are usually punishable when shielded (even some of his aerial attacks), but he makes up for this deficiency in offense with his long-range pressure game. While other fighters apply pressure through close-quarters pokes and grabs, R.O.B. penetrates shields and defenses with well-timed and well-placed Gyros while prodding at foes with his Robo Beam.

Grounded Attacks

Neutral Attacks: R.O.B. swings his robot arms in front of him for a simple two-hit punch attack, knocking back foes in range. Since R.O.B. is a more defensive, projectile-centric fighter, you don't use his neutral attacks that often. They're decent for fending off foes at point-blank range but don't deal much damage, and they force you to commit to staying grounded briefly. As R.O.B., if you're going to be grounded, you want to be either charging a Gyro or firing your laser.

Neutral Attacks	
Move	**Damage**
Neutral attack 1	3
Neutral attack 2	3

Dash Attack: While dashing, R.O.B. slams his arms down into the ground, launching enemies up and away while allowing him to follow up with an attack. R.O.B.'s dashing attack is relatively fast, but punishable when shielded. He can't pass through foes either, so you're likely to eat a throw combo if you go for a dashing attack against a quick-witted opponent on the ground.

Dash Attack	
Move	**Damage**
Dash attack	7

Defensive Attacks	
Move	**Damage**
Ledge attack	9
Wake-up attack	7

Side Tilt: R.O.B. drives one of his arms forward with an extended horizontal attack that launches enemies away. It can be angled upward or downward. Side tilt is a decent ground-based poke for deflecting aggression against foes just beyond your neutral attack range. Since R.O.B. benefits most from staying airborne and using ground time to throw out projectiles, you should use this attack sparingly.

Tilts	
Move	**Damage**
Side tilt	10
Up tilt	3, 5
Down tilt	5

Up Tilt: R.O.B. thrusts both arms over his head, launching enemies above him high into the air for a potential follow-up. This is your primary combo-extender off low-altitude knock-up attacks. It has narrow hit coverage, primarily extending directly above R.O.B.'s head, but has a minor horizontal hitbox that can nick enemies.

Down Tilt: While leaning low to the ground, R.O.B. quickly stabs at the enemy's feet, staggering them. Down tilt has fast start-up and low lag. At low-to-mid-percentage range, repeated down tilts create enough advantage to combo into itself. While you shouldn't dash around the stage fishing with down tilts (since you should be using your space to fire projectiles), you can use it to check enemy dashes or as a feint attack, potentially baiting your opponent into certain ledge recoveries.

Side Smash: R.O.B. charges up and fires an energy beam from his eyes, blasting foes with high knockback power. The beam can be angled slightly upward or downward, at the enemy's feet. R.O.B.'s side smash deals massive damage and boasts an impressive range, but is easily punishable. Its range is best used against ledge-recovering enemies. If you can read a ledge roll or ledge climb with a well-timed side smash, you can potentially finish off enemies at mid to high percentages.

Up Smash: R.O.B. performs a handstand, then fires his thrusters directly above him. Foes caught in the burst are launched sky-high. R.O.B.'s handstand has a tiny hit effect at point-blank range. This hit pops up the enemy into the vertical thruster attack. But like most smash attacks, R.O.B. is severely vulnerable to high-damage punishes if it's shielded. Up smash is mainly used to finish off foes into the upper blast zone. The thruster hitbox makes it a solid anti-air if you can time it.

Smashes

Move	Damage
Side smash	15
Up smash	3, 14
Down smash	3, 3.5, 5

Down Smash: R.O.B. spins around at high speeds with his arms extended, striking nearby foes several times before launching them away. This is R.O.B.'s fastest-starting smash attack. It has the bonus of hitting both sides, so you can use it as a defensive option right after blocking, retaliating against opponents who cross you up. It also boasts a solid range and damage, so while it's not safe to throw out haphazardly, it can be worth the risk in many cases.

R.O.B.'s grab is swift, but with limited range. Many of his throws have unique properties that set up for more potential damage. R.O.B.'s front throw is unique compared to other front throws in that he can act almost immediately after tossing the enemy. You can potentially combo into a dashing short hop forward air if your opponent doesn't shuffle away. Back throw is similar, allowing you to follow up with a dash attack against low-damage foes.

Grabs

Move	Damage
Grab attack	1.3
Front throw	8
Back throw	10
Up throw	12
Down throw	5

R.O.B.'s pile-driver up throw slams the enemy into the ground, bouncing them up for a potential follow-up forward air. Down throw is a burying throw, planting the opponent into the ground before they're launched into the sky. The opponent can shake out with control inputs, releasing them earlier, so sharp foes may be able to avoid your follow-up attacks altogether.

Aerial Attacks

Neutral Air Attack: Airborne, R.O.B. fires his thrusters while delivering a somersault attack that incinerates enemies around him with the exhaust from his burners. Thanks to its low landing lag, R.O.B. can safely use neutral air to "box out" enemies (i.e., use his extended hitboxes to deter aggression). Retreating neutral air (short hop into neutral air, then immediately begin holding the opposite direction to back away) is an incredibly safe and powerful defensive maneuver you can use to punish aggressive foes dashing in on the ground. When used offensively, you can make neutral air even safer by crossing over the enemy and using its rear-thruster hitbox to put foes in shield-stun (while they're facing the opposite direction).

Aerials

Move	Damage
Neutral air attack	9.5
Forward air attack	7
Back air attack	12
Up air attack	1.5x4, 4
Down air attack	12

The main downside to defending and attacking with neutral air attack is its significant start-up time. You need a little space to initiate it (aiming with the first active frame is a bit like aiming a hopping side smash).

Forward Air Attack: R.O.B. swiftly swings his arms forward in midair, smacking foes away with low knockback power. Forward air is a remarkably fast air-to-air and air-to-ground poke attack. It has incredibly low air lag and moderately low landing lag. If timed to hit deep (low altitude) during your hop, it's safe to most out-of-shield options (although shield grabs will still get you). Forward air should be used when you're in a tight spot against an aggressive opponent, when neutral air attack would be too slow to start.

Back Air Attack: In midair, R.O.B. aims his Robo Burners behind him and fires them. His thrusters propel him forward while devastating foes hit by the blast. Back air is a high-damage attack that alters R.O.B.'s aerial trajectory, boosting him forward (usually away from the target you're attacking). Back air can be a difficult attack to use properly, especially if you aren't used to its boost effect. Since you're launched away from the hit effect, you don't use this attack to extend combos. Its high knockback power makes it one of your most effective edge-guarding tools, though.

Up Air Attack: R.O.B. spins both arms vertically in an alternating rhythm, rapidly striking foes above him before sending them off with a double-armed launch. Up air is your juggle-trap tool and air-combo finisher. It starts up quickly and hits several times, but has a relatively strict hit effect, covering only the area directly above R.O.B.

Down Air Attack: R.O.B. jumps above an enemy and activates his base thrusters, boosting his altitude slightly while meteor smashing foes beneath him. Down air has considerable air lag, but since it boosts you up into the air (behaving like a second double jump), you never have landing lag after landing from a down air. It almost always causes a meteor smash if it hits.

Special Moves

Neutral Special: Robo Beam: R.O.B. depletes all of his charge and fires a laser beam across the stage. If his charge is maxed out, he fires a Super Robo Beam that obliterates anything in its path. There are three distinct power levels to R.O.B.'s Robo Beam, determined by a behind-the-scenes counter that maxes out at 860 frames. When this counter is below 300, his Robo Beam is a short-range blast. Between 300 and 860 (max), the beam is upgraded and consists of a short-range blast along with a horizontal beam that deals a bit of damage. For the final form of the attack, at 860, the horizontal beam deals high damage with much more knockback and has a slightly larger hitbox.

Side Special: Arm Rotor: R.O.B. leaps forward with a grinding Arm Rotor attack, striking enemies several times, then completing the sequence with a robot uppercut punch that launches foes up and away. The aerial version of Arm Rotor slightly propels you upward while allowing you to act when you're actionable. Arm Rotor has extreme end lag, so it's incredibly risky to throw out excessively, especially if you're grounded.

Special Moves

Move	Damage
Neutral special	Lv1: 7. Lv2: 7+4.5. Lv3: 7+15
Side special	1.5x(5 to 10), 3
Up special	—
Down special	4 + (4.5 to 6.7)

Up Special: Robo Burner: R.O.B. steadily activates blue thrusters that boost him into the air, allowing him to either fly high into the air or hover in place, as long as he has burner fuel to use. You can cancel and restart Robo Burner midflight. Tapping up+Special activates the burner and lifts you a set distance. Holding up+Special continuously drains fuel while further boosting your altitude. You can tap and hold Special (or the up direction) repeatedly to micromanage your altitude and fuel usage, so you can use your fuel judiciously in case you need it to recover out of the air. Burner fuel replenishes while you're grounded but not while you're hanging off a ledge. Simply hopping into the air temporarily stops your fuel from replenishing. Fortunately, R.O.B. has a handy gauge indicator located down the side of his torso. When it's blue, you're at over two-thirds of max burner fuel gauge.

Down Special: Gyro: R.O.B. pulls out a top and begins revving up its RPM before releasing it in front of him, flying at his foe and knocking them away. The longer the top is revved up, the higher its velocity, which in turn increases its damage. Gyro deals high damage on hit and can knock enemies down. When it's shielded, the Gyro disappears immediately. When a Gyro is tossed without making contact with an enemy, it remains spinning on the ground with a persistent hit effect. You can only have one Gyro on-screen at any given time.

Final Smash: Guided Robo Beam

Automatically lock on to multiple opponents, then fire homing lasers at them. Finish the attack by shooting a giant beam that hits multiple targets. The angle of the beam can be adjusted up or down.

Robin

Robin Vitals

Movement Options	
Jumps	1
Crouch Walk	No
Tether	No
Wall Jump	No
Wall Cling	No
Movement Ranks	
Ground Speed	F- (75)
Air Speed	C (40-43)
Falling Speed	C- (49-51)
Weight	C+ (36-39)

OVERVIEW

Robin has access to a plethora of incredible attacks and spells, generally much more powerful than other fighters' abilities. However, their uses are limited. At the beginning of a match, Robin is equipped with the Bronze Sword and full Tome Gauges, with the Levin Sword becoming accessible as time passes (after 10 seconds). For most air attacks and for all of his smash attacks, the Levin Sword provides extra range, damage, and other noticeable advantages over the Bronze Sword.

Robin's overall game plan is to zone out enemies with intelligent use of his ranged spells in order to level and store his Thunder spell. Once he gains space, he can begin charging up his neutral special, granting him access to Arcthunder and Thoron. When applied properly, Arcthunder provides effective offensive setups thanks to its hit effects and area coverage.

The Levin Sword can be used eight times before it's discarded, at which point you have to wait 10 seconds for the gauge to refill. During this waiting period, performing smash attacks and directional midair attacks slightly increases the gauge. Additionally, KO'ing an opponent grants an instant 50% gauge while you don't have the Levin Sword.

Each of Robin's spells has a Tome associated with it. Neutral special costs Thunder Gauge, up special costs Wind Gauge, side special costs Fire Gauge, and down special costs Dark Gauge.

Grounded Attacks

Neutral Attacks

Move	Damage
Neutral attack 1	2
Neutral attack 2	1.5
Neutral attack 3 (rapid/wind)	0.7xN, 2
Neutral attack 3 (fire)	5

Dash Attack

Move	Damage
Dash attack	10

Defensive Attacks

Move	Damage
Ledge attack	9
Wake-up attack (faceup)	7
Wake-up attack (facedown)	7

Neutral Attacks: With the Bronze Sword, Robin delivers a swift slash upward followed by a backhanded slash, finishing the two-hit sequence with one of two magic-based attacks: a flurry of potentially infinite Elwind blades or a burst of Arcfire. The wind blades knock the enemy up into the air, while the fiery explosion knocks them far away. To perform the wind blades finisher attack, press the second and third Attack inputs quickly in succession. For the fire-based finisher, slow your inputs down.

Neutral attack is an uppercut-like hitbox, excellent for deterring approaching enemies as well as those coming down from the air in front of you. Like most neutral attacks, it's one of your primary out-of-shield options for retaliating after blocking an opponent's laggy attack.

Dash Attack: While dashing, Robin extends his Bronze Sword, using his momentum to empower the attack. Robin's dash attack is conventional in its speed and knockback effect. It has an average start-up time and, on hit, knocks foes up and away while not providing enough hitstun to guarantee a follow-up attack.

Side Tilt: Robin leans forward and delivers a direct slash in front of him. While it appears to have an upper arc, it's not effective for striking foes in the air or above his head. Use this attack sparingly since Robin's down tilt and dash grabs are generally more useful.

Up Tilt: With a bit of leg power, Robin performs a slight jump into the air while swiping his Bronze Sword at the area above him. Up tilt is a decent, conventional anti-air with a hitbox that extends well past his hittable limbs. Against grounded foes, it can combo into another up tilt at low percentages. At around 30%, you can combo up tilt after down throw.

Down Tilt: Robin leans down low and quickly strikes at his foe's feet with his Bronze Sword, causing them to lose their footing for a split-second. Down tilt is incredibly fast and, along with your neutral attack, is used largely to defend yourself from aggressive opponents.

Tilts

Move	Damage
Side tilt	7.5
Up tilt	6
Down tilt	6

Side Smash: Robin performs a heavy forward thrust with the Levin Sword, blasting foes a long distance. The Bronze Sword variant has lower range. Both the Levin Sword and Bronze Sword versions of this attack have high start-up

Smashes: Levin Sword

Move	Damage
Side smash	16
Up smash	15
Down smash	15

Smashes: Bronze Sword

Move	Damage
Side smash	9.6
Up smash	9
Down smash	8

times, making them tough to use effectively in your neutral game. It has a lot of shield knockback, but leaves you at a major frame disadvantage, giving the enemy a chance to dash in and hit or grab you. Side smash is best used if you can make a hard read on your opponent's ledge-recovery or air dodge.

Up Smash: Robin throws his spinning Levin Sword above him, launching foes above into the air. The Levin Sword variation has a much larger vertical effect and starts with a brief horizontal hit effect near Robin's body (whereas the Bronze Sword version does not). It's best used to poke at enemies standing on platforms above you.

Down Smash: Robin slams the Sword into the ground in front of him, launching enemies into the sky. The Levin Sword version of this attack has an added launching hitbox effect near the ground. Down smash is Robin's most useful and effective smash attack. It deals a massive amount of shield damage with its secondary hit and can be used to punish mistakes like mistimed rolls and ledge recoveries.

Grabs

Move	Damage
Grab attack	1.5
Front throw	8
Back throw	11
Up throw	9
Down throw	6

Robin's almost-slow grab has a decent amount of range due to the whirling magic effect in front of him. However, there's a significant amount of lag on whiff, making it punishable by attentive opponents. Robin's grab is essential to his game, both offensively and defensively. Thanks to its impressive reach, you're more likely to punish aggressive foes with it.

Aerial Attacks

Neutral Air Attack: While airborne, Robin executes two consecutive slashes: a downward slash in front of him, followed by a rear slash behind. Neutral air fills several roles, including defensive aerial zoning, KO'ing foes off ledges, and damaging shields safely.

Forward Air Attack: Robin delivers an extended aerial uppercut slash with the Levin Sword in front of him, sending struck foes flying away. With the Bronze Sword, he performs a similar attack, but with considerably less range. Forward air is a staple, an incredible spacing attack that can be used aggressively, defensively, and in combos. Deep (low-altitude) forward air attacks are one of your primary attack sequences. If you can condition your opponent to shield them, you can follow up with potential mix-ups.

Back Air Attack: Robin turns around and thrusts the Levin Sword behind him, blasting back foes. With the Bronze Sword, the range of back air is reduced. While forward air is overall a more useful attack in most situations, back air can potentially KO at lower percentages. Back air is best used for edge-guarding purposes, or to extend a deep aerial attack against an enemy behind you.

Up Air Attack: Robin delivers a high-reaching upward swipe above him, launching foes high into the air with his Levin Sword. With the Bronze Sword, the range and damage are greatly diminished. Up air is your main anti-air for air-to-air combat and for juggling purposes. It's also used as a finisher for down throw and up tilt combos. It can start combos when performed as a deep jump-in attack, naturally linking into up tilt and up smash.

Aerials: Levin Sword

Move	Damage
Neutral air attack	11.5 back on hit.
Forward air attack	12.5
Back air attack	15
Up air attack	13
Down air attack	11

Aerials: Bronze Sword

Move	Damage
Neutral air attack	6.9
Forward air attack	7.5
Back air attack	9
Up air attack	7.8
Down air attack	7.2

Down Air Attack: From above his foe, Robin thrusts the Levin Sword below him with meteoric force, sending his victim plummeting. This attack doesn't have a meteor effect with the Bronze Sword. Down air is a niche attack that can be difficult to apply in most practical scenarios. It's incredibly slow compared to other down thrust-type attacks, and its low-persistence hit effect can leave you vulnerable.

Special Moves

Neutral Special: Thunder (Thunder Tome): Robin channels his Thunder-type magic, potentially charging it to four separate power tiers. Each level of charge is denoted by the color of your summoning energy (blue for Thunder, yellow for Elthunder, and purple for Arcthunder).

While charging, you can roll, jump, or shield in order to cancel the charge. Your charge progress is "stored" once you reach a new power level, but if you fail to charge to the next power level, you have to try again, starting from the first frame of your current power level.

Thunder is a high-velocity projectile that travels medium range, costs 1 spell stock, and requires no charge. It deals low damage but can be difficult to react to. Use Thunder to pester enemies, and to force them to react to your annoying jolts.

Elthunder takes around two-thirds of a second to charge and costs 3 spell stocks. Elthunder is similar to Thunder but deals much more damage and offers double the range. Its travel speed is slightly lower, but it packs much more killing power, able to KO foes off ledges in Battlefield stages at high percentages (~140%).

Arcthunder requires roughly 1.3 seconds of charge and costs 5 spell stocks. Robin releases a mass of electricity that begins slowly but quickly accelerates and hurtles forward. Upon impact, it transforms into a multi-strike storm, devastating foes caught in its X-shaped effect. Much of your game plan revolves around charging up to this attack. It deals high damage, sets up combos, and when shielded, provides offensive opportunities as the enemy is stuck briefly shielding its jolts.

Special Moves	
Move	Damage
Neutral special	Thunder: 5.5, Elthunder: 11, Arcthunder: 6, 2.4x4, 8, Thoron: 2.6x7
Side special	2, 1.3x6, 4
Up special (ground)	7, 7
Down special	2x9

Thoron requires about two seconds of charge and costs 8 spell stocks. Robin unleashes a persistent beam attack that extends across the entire stage, dealing almost 18% damage to anyone caught in the blast and knocking out those around 130%.

Side Special: Arcfire (Fire Tome): Robin casts a fireball spell, triggering a pillar of flames when it connects with an enemy or the floor. Arcfire is a remarkable edge-guarding tool. If timed and placed accurately against a ledge-hanging opponent, it covers several of their recovery options and sets them on fire if they just hang on to the ledge.

Up Special: Elwind (Wind Tome): While airborne, Robin summons a magical wind that propels him upward, dealing damage and boosting him into the air twice. Elwind is your primary recovery tool and should be used carefully, since Robin's mobility is lacking otherwise. Elwind doubles as a finisher attack in edge-guarding scenarios, thanks to its meteor smash effect the moment it's released. When Elwind hits the ground, it creates a gust of wind that pushes foes back.

Down Special: Nosferatu (Dark Tome): Robin conjures up a dark curse that siphons the life force out of his enemies. Nosferatu is a powerful "command grab" (unshieldable special grab) that recovers health (reduces your damage percentage), but it can only be used three times in a row, with its Tome requiring about 30 seconds to recharge.

Nosferatu has considerable range for a command grab and can be set up off of ranged spells like Arcthunder and Arcfire. Since you can use it in the air, you can grab opponents standing on platforms above you.

Final Smash: Pair Up

Chrom dashes forward, and if he lands a hit, Robin joins him for a flawless combination of attacks that launches the opponent. After the attack, the Levin Sword and each Tome become fully charged. Make sure to hit an opponent with that initial dash.

Rosalina & Luma

OVERVIEW

Rosalina and Luma are a unique pair of fighters with their own mechanics. Rosalina's partner is a star treated as a separate fighter with its own separate attacks, its own health pool, and its own hurtbox (i.e., its body interacts with other players and can be attacked). The duo's fighting style centers around reactionary defense, control, and midrange zoning, using Luma as a barrier between Rosalina and her foes. A strong Rosalina-and-Luma player can be extraordinarily frustrating to fight against since approaching them is much different from approaching conventional fighters.

In most matchups, your goal with Rosalina and Luma is to use Luma's attacks to poke at enemies, ensuring that Luma is always between Rosalina and your opponent. Rosalina and Luma are floaty fighters with below-average ground mobility, so you want to play a reserved, defense-heavy style, focusing on reacting to your opponent's aggression rather than rushing in yourself. To apply pressure, deploy Luma in a forward position by using Luma Shot.

Rosalina & Luma Vitals	
Movement Options	
Jumps	1
Crouch Walk	Yes
Tether	No
Wall Jump	No
Wall Cling	No
Movement Ranks	
Ground Speed	C- (29)
Air Speed	C (40-43)
Falling Speed	F (73)
Weight	D (62-63)

ROSALINA & LUMA: DUO-SPECIFIC MECHANICS

Rosalina can crouch-walk, and while Rosalina is crouching, Luma lowers itself in front of her.

Luma can be KO'd and takes 10 seconds to respawn in one-on-one battles. It can take roughly 50% damage before it's knocked out.

When Luma is at low health, it visually appears down and exhausted to let you know it can't withstand any more damage. While Luma is exhausted, its travel speed is decreased. Luma can be easily knocked offstage by enemies, so be careful around ledges.

While Luma is deployed, its physical attacks deal an additional 50% damage on top of its base damage.

Grounded Attacks

Neutral Attack: Rosalina strikes with her wand twice, then finishes with either a magical rapid-attack sequence or a third flick of the wand that knocks foes upward. Luma punches twice, then either performs a spinning attack into headbutt combo or an uppercut that launches foes up into the air. If Rosalina is knocked down as Luma is performing its rapid jab attack, you can keep Luma going by holding the Attack button down while moving around with Rosalina. If you pay close attention to Luma's attacks while Rosalina is being struck, you can make it attack with almost anything. While holding down Luma's rapid attack, Rosalina can't attack or perform a standing grab.

Neutral Attacks

Move	Damage
Neutral attack 1	2 / 1
Neutral attack 2	2 / 1
Neutral attack 3 (rapid)	0.3xN, 2.5 / 0.1xN, 1
Neutral attack 3 (launch)	3 / 2

Dash Attack

Move	Damage
Dash attack	3, 4 / 3

Defensive Attacks

Move	Damage
Ledge attack	9
Wake-up attack	7

Dash Attack: Rosalina and Luma both dive headfirst into the enemy, launching them away. Rosalina's dash attack starts up remarkably fast for a fighter of her height and speed. It's also incredibly elusive. As Rosalina dives, her hurtbox becomes slim, dodging most air attacks and even some grounded ones that don't quite extend to the ground.

Side Tilt: Rosalina delivers a magic-laced spinning-kick attack in front of her while Luma performs a straight roundhouse kick that launches foes away. Side tilt can be used to stuff enemy aggression from past your neutral attack range. It's much slower to start than neutral attack, but it's a decent strike to throw out if you need the extra range to punish an enemy or to stuff their approach. It can leave your duo vulnerable if it's shielded.

Tilts

Move	Damage
Side tilt	7.5 / 4.5
Up tilt	10 / 8
Down tilt	5.5 / 3.5

Up Tilt: Rosalina's halo fires directly above her while Luma performs a Shoryuken-like uppercut that launches foes vertically into the air. Up tilt is a fantastic anti-air. Rosalina's head is intangible for a brief period as her halo is released. If an enemy challenges your up tilt, you're almost always going to beat them. Luma's rising uppercut has high launching power, making it a powerful finisher, especially if Luma is deployed.

Down Tilt: Rosalina performs a quick dropkick attack while Luma performs a headbutt. Rosalina's down tilt starts as fast as her jab does, but it's punishable when shielded. At mid percentages (around 40-60%), it can force a tech get-up situation as it knocks foes down, but at lower percentages, it simply knocks enemies back slightly.

Side Smash: Rosalina thrusts her palms out with a cosmic blast in front of her while Luma angrily delivers a mighty thrust punch, launching foes back. Side smash is extremely unsafe when shielded, so it's best used as a ranged Luma-deployed attack, particularly effective as an anti-ledge-recovery option. If you can read your opponent's recovery, such as a ledge jump, you can obliterate them with an angled side smash attack.

Smashes

Move	Damage
Side smash	12 / 7
Up smash	12 / 6
Down smash	7 / 4

Up Smash: Rosalina and Luma simultaneously perform a backflip somersault attack, knocking foes up into the air. Up smash is a powerful anti-air launcher. Rosalina extends her attack in front of and behind her, so it can be used immediately after blocking against enemies attacking you from behind. Like most smash attacks, it can be used as a surprise finisher to knock out aggressive foes dashing into you.

Down Smash: Rosalina elegantly performs a cosmically infused leg attack, knocking away enemies in front and behind, while Luma delivers a spinning roundhouse kick targeting its rear, then its front. Rosalina's down smash on its own is extremely unsafe when shielded, while Luma's attack makes it much safer (still punishable, just not as easily). If Luma connects with its down smash, it inflicts much more shield-stun. Down smash is best used with Luma deployed in a forward position so that you cover much more area with both of your clear-out attacks. Otherwise, down smash should be left out of your neutral-game arsenal due to its lagginess and vulnerability.

Rosalina's grab offers average range and speed, but is one of her most important attacks because of her defensive playstyle. Front throw is used to toss foes offstage or to set up her potent dashing attack/grab mix-up.

Since Rosalina's dashing attack and dashing grab are visually similar, it can be difficult for your opponent to discern between the two. Down throw bounces the enemy up and farther away than up throw. It deals a bit more damage, but doesn't provide much in the way of juggle opportunity.

Grabs

Move	Damage
Grab attack	1.3
Front throw	9
Back throw	11
Up throw	7
Down throw	9

Aerial Attacks

Neutral Air Attack: While soaring through the air, Rosalina twirls her magic-infused wand around her while Luma performs its clear-out spin kick. Luma's attack launches foes while Rosalina's wand attack pops them up. Neutral air is a staple neutral-game attack: it has relatively low air and landing lag while boasting an impressive arc with its hit effect, covering every angle around Rosalina. Against grounded foes, Rosalina's neutral attack causes a pop-up effect, allowing for a guaranteed combo follow-up with short hop forward air.

Aerials

Move	Damage
Neutral air attack	10 / 3
Forward air attack	1x5, 6 / 3
Back air attack	11 / 4
Up air attack	10 / 4
Down air attack	7 / 5

Forward Air Attack: In midair, Rosalina performs a somersault kick, extending cosmic energy that strikes foes multiple times before launching them away. Luma performs a headbutt attack. Like neutral air attack, forward air boasts an impressive hitbox that extends way beyond Rosalina's feet. It's a superb air-to-air and air-to-ground attack (although its landing lag make it unsafe against shield grabs).

Back Air Attack: Rosalina thrusts her legs behind her with a cosmic kick attack while Luma mirrors her. Back air's effectiveness is situational. It deals more damage than her other air attacks, but has a narrow hit effect and its active window is short. It also has a comparatively high air lag, so you can't quickly throw out multiple back air attacks in succession.

Up Air Attack: Rosalina fires her halo directly above her a short distance while Luma performs its rising uppercut attack. Rosalina's halo trajectory is strictly locked to a set distance away from her positioning, meaning she can direct where the halo goes as she travels through the air. This unique trajectory property, along with the halo being a separate projectile, makes up air an amazing juggle-trapping tool.

Down Air Attack: While airborne, Rosalina throws out a halo projectile beneath her while Luma drives its foot down with an aerial stomp attack that launches foes up and away with incredible force. Like up air, Rosalina's down air halo travels a certain distance, but its positioning correlates with Rosalina's position. While recovering from a high altitude, you can use down air as a descending attack to challenge foes beneath you. The halo persists for a relatively long time, and since it's a separate hitbox, it can beat out most melee-based anti-airs if spaced properly.

Special Moves

Neutral Special: Luma Shot: Rosalina flings Luma forward, boosting Luma's attack power and locking it to a set distance away from Rosalina. When Luma is deployed away from Rosalina, it deals an additional 50% damage and always faces the direction of a nearby opponent, so if Luma is behind an enemy, it turns around to attack them. Luma Shot is your primary offensive maneuver and should be used to force action from a defensive foe. Not only does a deployed Luma deal more damage, but it also sets up unique combo situations, allowing you to ping-pong foes back and forth between Luma and Rosalina. Becoming familiar with Luma's attacks is essential to optimizing your Luma Shot. In many situations, the best way to approach an enemy is to focus on controlling Luma instead of Rosalina, by focusing on its attack range and how they can be used to safely deal damage and force out enemy mistakes.

Special Moves

Move	Damage○
Neutral special	5 to 16
Side special	3x3
Up special	—
Down special	Varies

Side Special: Star Bits: Luma fires three Star Bits in the direction used while inputting Special (left/right). Star Bits allows you to apply ranged pressure from Luma. Although it's a laggy attack that leaves you at actionable disadvantage when shielded, it deals solid damage and forces action from defensive foes. You can use Star Bits as an edge-guarding tool to harass offstage opponents. It's even more effective if Luma is positioned farther away off the stage.

Up Special: Launch Star: Rosalina flies away up into the air while Luma follows with its midair jumps. Launch Star is as straightforward and simple as it gets in terms of an aerial-recovery move. You can control both her launch and midair trajectory, but she descends from the air in a helpless falling state. You can still control Luma's attacks during Rosalina's descent, potentially punishing foes who attempt to punish you. If Luma Shot is deployed, Luma stays near the ground instead of following Rosalina into the air.

Down Special: Gravitational Pull: Rosalina uses her cosmic powers to pull nearby projectiles, altering their trajectories and forcing them into an orbit around her. Gravitational Pull essentially nullifies all incoming projectile attacks while using them as an orbiting shield that can damage foes. Rosalina essentially invalidates an opponent's entire projectile game, rendering them useless!

Final Smash: Grand Star

A Grand Star shoots out stars while also pulling in opponents who are hit. In the end, the Grand Star explodes. Rosalina and Luma can freely move around during the Final Smash, giving them a chance to land extra attacks.

Roy / Chrom

Roy / Chrom Vitals	
Movement Options	
Jumps	1
Crouch Walk	No
Tether	No
Wall Jump	No
Wall Cling	No
Movement Ranks	
Ground Speed	B (13-14)
Air Speed	A (4-5)
Falling Speed	B+ (10-15)
Weight	C+ (36-39)

OVERVIEW

Roy's sweet and sour spots are the inverse of Marth's. Where Marth's sweet spots are the tip and outer edges of his swings and strikes, Roy's sweet spots are usually closer and inside the inner portions of his attacks. This has a significant implication in your playstyle, as instead of fighting at the outer edges of your hitboxes and attack effects, you're incentivized to fight more aggressively and up close, essentially at point-blank range. Using Roy's attacks as if he's "punching" with his sword is a great way to connect with his sweet spot. Many of Roy's air attacks have relatively generous sweet spots close to his body. Roy and Chrom are identical in almost every way, except in damage distribution. Roy's strikes have sweet and sour spots, rewarding you for accurate "critical hits," while Chrom's damage is distributed evenly across his hitboxes. Theoretically, Roy deals higher damage, scaling with how skillful you are at landing sweet-spot hits.

Grounded Attacks

Neutral Attacks: Roy issues a fast upward slash with his sword extended, clearing out foes standing in front of him. The active window starts quickly, making it relatively fast considering its generous hitbox. Like most jab attacks, this is your fastest strike. Though it doesn't have a follow-up attack, nor can it be chain-canceled into additional attacks, it boasts an impressive hitbox and arc that cover almost the entire block of space in front of you.

Neutral Attacks: Roy	
Move	Damage
Neutral attack	7.5

Neutral Attacks: Chrom	
Move	Damage
Neutral attack	6.5

Dash Attack: Roy	
Move	Damage
Dash attack	13

Dash Attack: Chrom	
Move	Damage
Dash attack	12

Defensive Attacks	
Move	Damage
Ledge attack	10
Wake-up attack (faceup)	7
Wake-up attack (facedown)	7

Dash Attack: Roy runs at the enemy and then slashes at their shins with a powerful launching attack, sending the enemy up and away. Given Roy's quick dashing speed, you can punish most whiffed attacks with this from midrange. While it's on the slower end in terms of start-up speed, it deals a high amount of damage. The inner hitbox packs much more launching power, while the tip of the attack has a much lower knockback power.

Tilts: Roy

Move	Damage
Side tilt	12.5
Up tilt	12
Down tilt	11

Tilts: Chrom

Move	° Damage
Side tilt	10.9
Up tilt	10.4
Down tilt	9

Side Tilt: Roy steps forward and performs a speedy downward slash, slicing enemies near his head and knocking away enemies in front. This lightning-fast side tilt attack has effective early hitboxes near his midsection and slightly above his head, making it an excellent anti-air and point-blank hybrid attack. Note that Roy lunges forward a bit, making it more likely to hit in its sweet spot, dealing more damage.

Up Tilt: Roy quickly swings his sword in a broad arc above him, starting with a frontal upper slash and ending the slash behind him. This incredible attack is amazing all around. It's quick to start, covers an extraordinary area including the rear, and has an extended vertical hitbox. This anti-air is your staple in combos and juggle 50/50 setups. It's also usable as a ground-to-ground attack in some cases since its initial hitbox starts up quickly in front, with potential for hitting foes coming up from behind.

Down Tilt: Roy crouches low to the ground and quickly thrusts his sword at the opponent's legs, potentially knocking them off their feet. This is a low-profile attack with excellent speed. It's fast with limited lag, making it difficult to punish. Against higher-damage foes, it can knock them into a tech get-up situation. It's also an excellent attack against ledge-hanging foes.

Smashes: Roy

Move	Damage
Side smash	20
Up smash	1, 2x3, 10
Down smash	15, 17.1

Smashes: Chrom

Move	Damage
Side smash	18
Up smash	1, 2x3, 10
Down smash	12.4, 14.2

Side Smash: Roy delivers a forceful overhead swing, smashing down his sword on foes in front of him and blasting them away. While it's fairly fast for a smash attack, dealing optimal sweet-spot damage can be difficult since it requires being within point-blank range. However, as long as you aren't hitting with the sour spot, it's generally worth going for side smash if you need to rack up damage or knock an enemy out into a blast zone.

Up Smash: Roy charges up his blade and thrusts it straight into the sky, causing a series of blasts nearby that devastates foes caught in it. This multi-hit smash is incredibly laggy, with a relatively slow start-up, but deals a massive amount of damage if all of its hits connect. It should be mainly used as a finisher attack, or as a heavy punish to a huge whiffed attack. Roy's arm is intangible during the attack, allowing you to beat out most incoming air attacks.

Down Smash: Roy uses his sword to sweep his front and his rear, clearing out foes from both sides. Roy's sweep attack leaves him highly vulnerable and should be used sparingly. Its start-up time is decent but still extremely unsafe, especially against wary opponents.

Roy's grab is somewhere between heavyweight and midweight speed, not quite slow, and has a relatively limited range. Roy's grab attack is a knee bash to the midsection. His up throw is a simple vertical toss that sets up follow-up combo potential. Front throw is a shoulder check that knocks his victim away into a possible tech and combo situation, while back throw is a quick leg trip. Down throw is a ground spike that pops the enemy up, providing enough tumbling hitstun for a combo follow-up in most situations (particularly against heavy and fast-falling fighters).

Grabs

Move	Damage
Grab attack	1.3
Front throw	5
Back throw	5
Up throw	6
Down throw	5

Aerial Attacks

Aerials: Roy

Move	Damage
Neutral air attack	6, 8.5
Forward air attack	11
Back air attack	12
Up air attack	9
Down air attack	15

Aerials: Chrom

Move	Damage
Neutral air attack	4.8
Forward air attack	9
Back air attack	10.9
Up air attack	7.6
Down air attack	14.2

Neutral Air Attack: Roy jumps into the air and dispenses two successive horizontal swipes. The first swing is directed at enemies in front, while the second swing hits in front and can potentially strikes enemies coming from behind. This versatile aerial spacing tool can be used to set up juggle combos with its first hit at low altitudes, as a short hop ground deterrent, or as a fast fall strike. The safest way to approach with neutral air attack is by spacing it, giving you an opportunity for a max-range jab. A shielded neutral air up close can usually be punished by quick-witted opponents.

Forward Air attack: While airborne, Roy cuts downward in a wide arc in front of him, ending the slash near his feet. Forward air is one of Roy's best attacks, especially when combined with short hop. You can use it to aggressively damage enemy shields, conditioning your foes and then using the threat of your forward air to go for a fast fall grab attempt.

Back Air Attack: Roy turns around and delivers a quick uppercut in the air. Back air covers an area similar to forward air, but with the added effect of altering his facing direction. Back air is one of your most important tools, as it gives you freedom to turn around on command while airborne. Additionally, back air attack isn't particularly laggy, so you can easily implement it into your edge-guarding strategy.

Up Air Attack: Roy swipes up into the air above him, taking down airborne opponents from the sky. Up air is your primary air-control tool. It can also be used to start juggle combos when hit deep, similar to neutral air attack, as long as you can avoid connecting with the first part of the attack.

Down Air Attack: Roy unleashes a brief but mighty down swing directly below, spiking down foes hit by his blade. He stabs directly down, dealing high damage but sacrificing utility. Down air is one of few lackluster air attacks in your arsenal and should be reserved for meteor smashing enemies over a pit. Otherwise, it can be difficult to hit accurately due to its limited active window and relatively small hitbox.

Special Moves

Special Moves: Roy

Move	Damage
Neutral special	8 (50 max charge, up close)
Side special	3, 3, 4, 6, up special (second, third, fourth attack): 3, 4, 7, down special (third, fourth attack): 4, 2x4, 5
Up special	5.5, 1.1x3, 8
Down special	1.35x incoming damage

Special Moves: Chrom

Move	Damage
Neutral special	8 (50 max charge, up close)
Side special	2.8, 2.8, 3.8, 5.2, up special (second, third, fourth attack): 2.8, 3.8, 6.5, down special (third, fourth attack): 3.8, 2x4, 4.3
Up special	6, 1.5, 1.5, 6, 6
Down special	1.35x incoming damage

Neutral Special: Flare Blade: Roy's sword erupts as he brings it down. It's so powerful that at max charge it deals damage to Roy himself! At first glance, it may seem clunky and risky, but it's quite safe on shield block thanks to low lag and high shield hitstun. It's particularly useful as a descending aerial move and edge-guarding attack. If you can charge Flare Blade briefly (around half a second), you can make it extra safe on shield, while dealing more damage.

Side Special: Double-Edge Dance: Roy executes a customizable combo in which he can switch slash types, either launching his foes, knocking them farther away, or stabbing them repeatedly for extra damage. Roy's Double-Edge Dance is almost identical to Marth's Dancing Blade. The forward (or neutral) swing finisher is for knocking enemies off platforms. The up-swing finisher is for deliberately launching an enemy above you. The down-swing finisher is for dealing the most damage and shield damage.

Up Special (Roy): Blazer: Roy wraps his sword in flame and leaps high into the sky with a jumping slash. Blazer is intangible briefly and invincible for additional hits, allowing you to blow through opposing attacks for a brief window during its start-up. If you're being pressured while blocking, you can drop shield and use Blazer to blow through enemy attacks. If you're beneath a platform, Blazer becomes a bit safer, as you'll blow through enemy attacks while landing on the middle platform above.

Up Special (Chrom): Soaring Slash: Chrom knocks his foe sky-high and pursues them into the air, following up his combo sequence with a dive-bomb sword attack, launching the opponent away. Chrom's Soaring Slash vastly differs from Roy's Blazer. Since your trajectory can only be slightly influenced, it's more difficult to use as a recovery mechanism. However, it deals high damage.

Down Special: Counter: Roy briefly goes into a countering stance. As he absorbs an enemy attack, he returns the favor with an even stronger counterattack. Counter can be used midair, including as an anti-edge-guarding attack (although extremely risky!). Counter's damage depends on the damage of the opponent's attack.

Final Smash: Critical Hit / Awakening Aether

Roy: Critical Hit: Roy swings his blade around to catch enemies, then brings the sword down to finish them off in a blast of fire. The initial swing not only hits opponents in front of Roy, but also those behind.

Chrom: Awakening Aether: Chrom quickly charges forward, slashes upward, then swings his blade diagonally to launch opponents upward. If the first hit misses, the move doesn't activate. If it connects, the move can hit multiple opponents.

Ryu

OVERVIEW

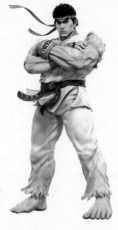

Ryu is a quite unconventional *Super Smash Bros. Ultimate* brawler. As a fighter comprehensively drawn from a completely different fighting game, his move set is vast, with an extraordinary range of strengths and uses, along with exclusive mechanics like special moves performed with specific control stick inputs. While he's one of the most difficult fighters to master, he can be highly rewarding to train with since his wide-ranging arsenal makes him incredibly versatile. Like Ken, Ryu is a fighter with a high skill ceiling—you can almost always improve upon his game, so the more your execution and timing improve, the more effective you can be. His dash speed, jump speed, and aerial Focus Attack and Tatsumaki Senpukyaku allow him to close distance and get within range to threaten with powerful *Street Fighter* combos, or to break shields with Collarbone Breaker (side tilt hold).

Ryu Vitals	
Movement Options	
Jumps	1
Crouch Walk	No
Tether	No
Wall Jump	No
Wall Cling	No
Movement Ranks	
Ground Speed	D (52)
Air Speed	B (29-30)
Falling Speed	C (36-39)
Weight	B (22-23)

As a *Street Fighter* character, Ryu can rack up damage by hit-confirming his attacks into combos. Because he has access to variable strength attacks and special moves, Ryu is effective in almost every situation and range. Slow-traveling light Hadoken can be used from long range to cover your advance; Tatsumaki Senpukyaku allows for a burst of horizontal movement, good for both offense and defense; and his signature Shoryuken makes for a powerful combo-finisher and anti-air. Shakunetsu Hadoken is one of the best projectiles around, thanks to its damage, speed, size, and multi-hit effect. It threatens enemy shields from long range.

UNIQUE STREET FIGHTER MECHANICS

When facing a single opponent in a one-on-one match, the Street Fighters behave even more like in their home games. They automatically face their foes, and moving the control stick away from the enemy to move backward doesn't make them turn around. Instead, they walk backward, just like in *Street Fighter*. This makes it much easier to execute manual-input special moves such as Tatsumaki Senpukyaku.

Grounded Attacks

Neutral Attacks

Move	Command	Damage
Standing light punch	Neutral attack tap	1.5
Target combo	Neutral attack tap x 3 (4 if up close)	1.5, 1.5, 1.5, 5
Standing hard kick	Neutral attack hold	10

Neutral Attacks: Ryu quickly jabs the opponent with his non-dominant fist. This swift punch attack, recognizable from the *Street Fighter* series as a Shoto standing light punch, is a relatively standard neutral attack with the ability to transition into an auto-combo (target combo) on repeated attack inputs. Although it's his fastest-starting attack, its use in *Super Smash Bros. Ultimate* differs from its use in the *Street Fighter* games. Jabs in SF are used as safe and quick hit-confirmable strikes. In *Super Smash Bros. Ultimate*, jabs are normally used as punisher attacks after successfully shielding attacks, rather than as a deliberate form of offense.

Dash Attack

Move	Damage
Dash attack	12

Defensive Attacks

Move	Damage
Ledge attack	10
Wake-up attack	7

Ryu (and Ken) players must take into consideration a limitation in buffering their reprisal attacks. Due to their long-press hold attack commands, buffering a light attack reprisal is much more difficult for the *Street Fighter* fighters since holding down Attack ultimately results in a slower medium attack.

Neutral Attack Combo (Target Combo): Ryu's *Street Fighter* target combo is a three-hit combo, beginning with a jab and continuing into a right-handed body blow, finally finishing with a heavy left hook that knocks the enemy off their feet. Up close, this "auto-combo" requires four Attack inputs. Ryu begins the combo with two jabs before proceeding into a body blow. From beyond point-blank range, Ryu only sticks out one jab before going into the body blow and hook finisher. The body-blow attack is cancelable with any special move. Note that special cancels don't have to be performed with command inputs (you can use neutral special instead of ↓↘→ + Attack, but for less damage).

Neutral Attack Hold: Ryu delivers a wheel kick roundhouse to the opponent's face. This is Ryu's standing hard kick (also known as standing roundhouse) from the *Street Fighter II* series. It's a no-nonsense heavy attack that can be used as an angled anti-air or a ground-checking horizontal attack against aggressors. Its lackluster start-up speed can make it difficult to use accurately in fast-paced matches against agile opponents.

Dash Attack: While dashing, Ryu almost instantaneously transitions into a flying kick, driving his foot through the enemy and launching them up and away into the air. The initial hit effect as Ryu extends the attack deals higher damage with a high knock-away effect, while the lingering hit effect deals less damage but launches the enemy directly above, allowing for a potential follow-up combo. If you can space this attack, it makes for a remarkably strong whiff-punish attack from midrange.

Tilts

Move	Command	Damage
Close light punch	Up tilt tap	2
Close hard punch	Point-blank neutral attack hold OR up tilt hold from any range	12
Standing medium kick	Side tilt tap	6.8
Close medium punch	Point-blank side tilt tap	6
Collarbone Breaker	Side tilt hold	3, 6
Crouching light kick	Down tilt tap	1.6
Crouching medium kick	Down tilt hold	7

Up Tilt Tap: Ryu swiftly delivers an elbow strike, sending foes airborne. Also known in the *Street Fighter* series as a close standing jab, this quick close-range attack sets up enemies for combos in most situations, as it causes a slight pop-up effect on hit. At low-damage values, foes are knocked up in place and can be juggled with repeated up tilt taps. Alternatively, you can hit-confirm close standing jab with up special (or a manual input →↓↘ + Attack) Shoryuken. While neutral attack jabs are quicker, up tilt tap attacks are generally better overall for both harassing and hit-confirming, because of the superior knock-up effect.

Up Tilt Hold / Close Neutral Hold: Ryu's close standing hard punch attack from the *Street Fighter* series is a powerful left-handed uppercut that launches his foe into the air, allowing for potential follow-ups. Up tilt hold attack features upper-body intangibility that begins almost immediately upon start-up and lasts until its first few active frames that almost guarantee you'll beat out descending aerial attacks. Upon contact (hit or shielded), you can cancel this hard punch with a special move. On hit, cancel into Shoryuken for a two-hit combo.

Side Tilt Tap: Ryu delivers a quick, high-priority leg thrust to the enemy's midsection. This swift mid kick sports intangibility around the extending leg attack. While it's effective for its niche use of beating out incoming enemy hits, you generally don't use it too often—the risk-reward ratio may not be worth it, since it requires committing to an uncancelable and uncomboable ground attack.

Close Side Tilt Tap: At point-blank range, Ryu thrusts his right elbow into the opponent. When next to an opponent, inputting a side tilt tap attack results in a special-cancelable thrusting-elbow strike. While you can pull off two-hit special combos starting with this strong elbow strike, it isn't particularly practical in a fast-paced match against sharp, attentive opponents.

Side Tilt Hold: Ryu's side tilt hold attack is his signature "overhead" Collarbone Breaker. While *Street Fighter*-style low and high blocking doesn't exist in this game, Collarbone Breaker functions similarly. In *SF*, it's used to deal damage against low-guarding opponents. In Super Smash Bros. Ultimate, Collarbone Breaker deals massive damage against shielding enemies, potentially causing an instant shield-break stun!

Down Tilt Tap: Ryu prods the enemy's foot with his own in this quick foot attack. This attack's strength lies in its chaining properties rather than its utility in breaking an opponent's low/high defense. Although low and high shielding aren't generally relevant in *Super Smash Bros. Ultimate*, Ryu's "crouching short" is situationally more effective than his neutral tap jab in cases where you want to hit-confirm into a special attack.

Down Tilt Hold: Ryu attacks the opponent's feet with a ranged leg thrust. *Street Fighter* players may recognize this as "low forward" or "crouching medium kick." Its hit properties are much different in *Super Smash Bros. Ultimate* vs. *Street Fighter*. On hit, it pops enemies up into the air, providing simple two-hit special-cancel combos, such as the renowned crouching medium kick into ↓↘→ + Attack Hadoken cancel sequence. Generally this isn't an effective move to throw out as a staple attack.

Side Smash: Ryu lunges forward with a high-impact side kick thrust, devastating the enemy and blasting them away. Joudan Sokutou Geri originates from the *Street Fighter III* series as a new special move unique to Ryu. In *Super Smash Bros. Ultimate*, it's represented as his side smash attack, making it much different from its original combo-oriented usage. Like most smash attacks, Joudan Sokutou Geri is a high-risk, high-reward attack. Whiffing this attack against attentive opponents can easily cost you, as it leaves you vulnerable to whiff-punishing attacks.

Up Smash: Ryu crouches low and launches a mighty uppercut, devastating enemies above. Ryu's up smash is his familiar anti-air, renowned for being an "alternative Shoryuken." While it functions as a serviceable ground-to-air anti-air, there's not much reason to use up smash over up tilt hold attack (close standing fierce).

Down Smash: Ryu delivers a heavy crouching sweep attack in the area in front of him. Ryu's crouching hard kick extends slightly beyond his crouching medium kick, but is much less safe on whiff and block. It isn't special-cancelable (none of Ryu's smash attacks are), nor does it have a rear hitbox as many down smashes do. Since its effective hitbox isn't particularly useful in an aerial-based game like *Super Smash Bros. Ultimate*, refrain from using Ryu's sweep unless you can find a glaring opening.

Smashes		
Move	Command	Damage
Joudan Sokutou Geri	Side smash	17.5
Crouching hard punch	Up smash	17
Crouching hard kick	Down smash	16

Ryu grabs a nearby foe and puts them into a mixed martial arts guard position where he can follow up with one of four throw options. Ryu's leg-thrust back throw deals the most direct damage out of his grab. You can earn more total damage with down throw. Down throw followed by holding up tilt (close hard punch) canceled into Shoryuken deals a massive amount of damage against 0% opponents.

Up throw deals low damage, but allows for potential air-juggling opportunities, forcing the enemy into air-dodging or eating one of your aerial attacks or anti-airs. Since buffering light attacks can be challenging for Ryu and Ken because of their additional medium hold attacks, it can be difficult to punish certain moves after shielding.

Grabs	
Move	Damage
Grab attack	1.3
Front throw	9
Back throw	12
Up throw	8
Down throw	6

Aerial Attacks

Neutral Air Attack: Ryu extends a short-range knee while descending on his foe from the air. Neutral air is recognizable as Ryu's jumping light kick (or "jumping short") from the *Street Fighter II* series. This jumping attack is known for its persistent hitbox, remaining extended for an extraordinarily lengthy duration (in some *SF* games, it remains extended for the entirety of Ryu's jump!).

Aerials		
Move	Command	Damage
Jumping medium kick	Neutral air attack	8
Jumping hard kick	Forward air attack	14
Neutral jumping hard kick	Back air attack	16
Jumping medium punch	Up air attack	5, 6
Jumping hard punch	Down air	12

In *Super Smash Bros. Ultimate*, Ryu's neutral air attack is one of his best attacks and should be a staple in your arsenal. It features a quick start-up and decent damage (if you can connect with it during its start-up), and it's special-cancelable! Combining neutral air with aggressive jumping Focus Attack, you can dominate air-to-air and air-to-ground duels.

Forward Air Attack: Ryu delivers his forward jumping hard kick. It boasts farther range than his neutral air, but doesn't start up as quickly, nor does it stay out as long. It's best used in combos or if you need the extra damage and range.

Back Air Attack: Ryu jumps into the air and performs a rear roundhouse kick, recognized in many of the *Street Fighter* series as a "neutral jumping roundhouse." This is Ryu's highest-damage aerial attack, but it's a bit more mechanically demanding to use effectively since it's a back air attack with few active frames.

Up Air Attack: While airborne, Ryu thrusts his fist into the air for a two-hit aerial uppercut, catching enemies above him. This jumping attack is identifiable as his "jumping strong" or "jumping medium punch" in the *Street Fighter* series. In *Super Smash Bros. Ultimate*, it functions in the same way—an air-to-air anti-air that's readily hit-confirmable thanks to its double-hitting property. Since much of your offense in *Super Smash Bros. Ultimate* revolves around juggling airborne descending foes, Ryu's up air is an extremely effective move in your arsenal. On hit, you can simply cancel into up special (or command →↓↘ + Attack) for respectable damage.

Down Air Attack: From the air, Ryu descends on the opponent with a weighty fist spike. This fierce attack is known as a "jumping fierce" from the *SF* series. It's primarily used to meteor smash enemies down pits and over ledges, but can also be used in combos, as it causes a great pop-up effect when connected against grounded foes.

Special Moves

The strengths of the following attacks depend on how long the Attack button is held upon execution. Hadoken, Tatsumaki Senpukyaku, and Shoryuken each have three levels: weak, medium, and strong. Performing these attacks with the special *Street Fighter* directional inputs rewards you with higher damage and other beneficial properties. Note that the input strength of Shakunetsu Hadoken only affects its travel speed.

Short hold: Activates quickly and leaves you less vulnerable.
Long hold: Powerful and has a long reach.

Variable Strength Street Fighter Specials		
Move	Command (When Facing Right)	Damage Totals (Light/Medium/Heavy)
Hadoken	Neutral special OR ↓↘→ + Attack (hold button to increase power level)	6 (7.5) / 6.5 (8.1) / 7 (8.7)
Shakunetsu Hadoken	←↙↓↘→ + Attack	1.1 x 4, 5
Tatsumaki Senpukyaku	Side special OR ↓↙← + Attack (hold button to increase power level)	9 (10.4) / 10 (11.6) / 11 (12.7)
Shoryuken	Up special OR →↓↘ + Attack (hold button to increase power level) OR �‌↘↓ + Attack	13 (15.6) / 14 (16.8) / 15 (18)

Neutral Special: Hadoken: Ryu conjures and throws a blue fireball from his palms across the battlefield. Executing Hadoken with the *Street Fighter*-style command motion (↓↘→ + Attack) rewards you with a bigger fireball (and a bigger area of effect), along with higher damage. You should almost always attempt to use the command version since the motion doesn't interfere with your movement. The longer the Attack button is pressed when performing Hadoken, the faster and stronger the projectile becomes. The light version is generally the most desirable to throw out, since a slower on-screen projectile is more annoying to deal with for the opponent.

Side Special: Tatsumaki Senpukyaku: Ryu flies forward horizontally through the air with a flurry of spinning kicks. Tatsumaki Senpukyaku, or "hurricane kick," is a multi-hit, multifunctional gap-closer attack. Tatsumaki Senpukyaku is an excellent mobility option for quickly traveling horizontally, particularly to escape foes or find your way back onto a ledge. The longer the Attack button is held, the farther you travel and the more damage the kick deals. While the command-input version deals more damage, it can be unwieldy to execute.

Up Special: Shoryuken: Ryu flies into the air with a rising uppercut, famously known as Shoryuken (or "Rising Dragon Fist"). Shoryuken can be performed with either up special or →↓↘ + Attack. Although both versions have some degree of intangibility, the command version rewards you with a much longer invulnerability window, allowing you to blow through opposing attacks more easily. It may be challenging to execute on demand. Like many up special attacks, Shoryuken leaves you highly vulnerable and unable to attack until your feet touch ground. Although you still have a certain level of air-trajectory control, you can't air-dodge, double-jump, or attack once you commit to performing a Shoryuken.

Other Special Street Fighter Moves		
Move	Command (When Facing Right)	Damage
Focus Attack	Down special (chargeable)	12 / 17 (max charge)

Down Special: Focus Attack: Ryu transitions into a meditative squatting stance, mustering his strength while preparing to absorb and counter incoming attacks. Ryu's Focus Attack originates from the *Street Fighter IV* series. It's a chargeable down special attack with several unique and powerful properties. While charging, Ryu can absorb one hit, essentially ignoring and blowing through enemy attacks.

There are three distinct Focus Attack power levels. The first level (releasing the attack anytime before Ryu flashes white) deals high damage and knocks away foes hit by the body blow. Charging just past the flash point (about one second of charging) powers up the attack to cause a crumple-stun on enemies you hit, leaving them vulnerable to follow-up attacks. The third and final power level not only inflicts crumple-stun, but also breaks through enemy shields. Charging to maximum requires about two full seconds. While charging, Focus Attack can be dash-canceled by tapping forward, forward or back, back quickly on the control stick.

Final Smash: Shin Shoryuken / Shinku Hadoken

Ryu unleashes a Shinku Hadoken that penetrates through and across the stage, allowing it to strike multiple foes and deal serious damage. If Ryu is close to an enemy, he uses a Shin Shoryuken uppercut attack instead.

Samus / Dark Samus

OVERVIEW

Samus's gameplay mirrors much of her *Super Metroid* gameplay, revolving primarily around her ground-based special attacks. Compared to most *Super Smash Bros. Ultimate* fighters, she's relatively difficult to play and can be unintuitive to novices. Her main strengths lie in her versatile and safe-zoning strategy. Charge Shot and Missile force out enemy movement (usually forcing opponents to go aggressive and attack you). Past long range, Samus has several defense-oriented attacks and tools that can deter aggressors. She has an exceptional ground game as well. Her ground attacks all have superb hitboxes, and her tilt attacks apply enough hitstun to keep you safe from most reprisals.

Samus / Dark Samus Vitals	
Movement Options	
Jumps	1
Crouch Walk	No
Tether	Yes
Wall Jump	Yes
Wall Cling	No
Movement Ranks	
Ground Speed	D (42-43)
Air Speed	B- (33-35)
Falling Speed	D (62-63)
Weight	B+ (8-10)

One of your objectives as Samus is to create space and time so that you can charge up your Charge Shot freely. Having a maxed-out Charge Shot ready drastically changes your options and threat level. Samus has one of the slowest rolls and is easily punishable, so it's recommended that you use her air dodge for evading attacks. As Samus is a primarily zoning-based fighter, try to avoid getting into these sticky situations altogether.

Grounded Attacks

Neutral Attacks

Move	Damage
Neutral attack 1	3
Neutral attack 2	8

Dash Attack

Move	Damage
Dash attack	10

Defensive Attacks

Move	Damage
Ledge attack	9
Wake-up attack	7

Neutral Attacks: Samus delivers a quick straight punch, followed by an overhead smash attack. Samus's neutral attack is arguably one of the weakest links in her arsenal. Against low-damage foes, it's easily punishable and usually doesn't combo, so even if you hit with it, you might still be at a disadvantage. If you're using it defensively (which is basically the only way you should use it), it's recommended that you only jab once, then retreat and start up your zoning game.

Dash Attack: While dashing, Samus halts her forward momentum briefly, then shoulder-tackles a nearby foe, launching them up and away into the sky. Samus's dash attack is a high-impact whiff punisher with moderate start-up time. It can be risky to use haphazardly, as it leaves you vulnerable when it's shielded or whiffed, but it has strong KO potential. Samus's slower-than-average dash speed hinders its power a bit, making it relatively easy for your opponent to react to.

Side Tilt: Samus performs a weighty horizontal roundhouse kick, knocking away enemies in front of her and dealing extra damage to foes hit by her boot. Side tilt is a strong attack with a decent horizontal hitbox and can be used sparingly to keep enemies in check. If you hit with it, you can always begin charging up your Charge Shot, potentially forcing extra shield damage.

Tilts

Move	Damage
Side tilt	10
Up tilt	13
Down tilt	12

Up Tilt: Samus performs a crescent axe kick, swinging her boot up above her head and smashing it down on foes in front of her. Up tilt is primarily used as anti-air, but can also be used to start combos when it connects against grounded fighters. When shielded, it's punishable by almost all jabs and most tilt attacks. However, when spaced out, it can be incredibly hard to punish, as the shield pushback can put you out of range of reprisals.

Down Tilt: Samus slams her Arm Cannon down in front of her, causing a large explosion that launches her victims sky-high. Down tilt is one of Samus's fastest-starting moves and is exceptional for setting up juggles, as it pops enemies into the sweet spot where you can threaten follow-up up air hits. Down tilt is also a superb knockout move against high-damage opponents thanks to its quick speed.

Smashes

Move	Damage
Side smash	14
Up smash	3x4, 6
Down smash	10 (12)

Side Smash: Samus thrusts her Arm Cannon in one of three angles in front of her, causing a large eruption that blows away foes caught in its blast radius. This is a slow but powerful KO smash attack that can be modified by tilting the control stick up and down while charging. Side smash is strong for punishing laggy moves and for deterring ledge-hanging foes from using certain ledge-recovery options. Compared to other side smash attacks, it's quite fast, though whiffing it can be devastating.

Up Smash: Samus delivers a series of Arm Cannon blasts in a front-to-back sequence above her that juggles her foe before knocking them up into the air. This ground-based anti-air leaves you vulnerable to reprisal, but can be difficult to deal with for enemies descending on you.

It deals great damage, but can be relatively risky to throw out predictably. The last explosive round deals more damage than the rest of the attack.

Down Smash: Samus clears out foes from both the front and rear with this two-part leg sweep. It's a relatively risky attack to throw out due to its laggy vulnerability. However, its start-up speed is decent compared to most smash attacks, so you may be able to connect with it against unsuspecting foes. The rear, second hitbox deals slightly more damage than the initial hitbox.

Samus has a rare tether grab. Unlike most fighters, she doesn't have to be within point-blank range to ensnare her enemies. Samus sends out her Plasma Whip a short distance that reaches just beyond her side smash range, and immediately puts the first foe hit by its unshieldable hitbox into Samus's grab lock. The drawback to having a ranged grab is that it's incredibly slow compared to conventional grabs. Samus's grab takes a quarter of a second to activate from a standing and walking position, and slightly longer from dashing.

Grabs

Move	Damage
Grab attack	1.3
Front throw	10
Back throw	10
Up throw	12
Down throw	8

Her grab attack is a simple chop with her free hand. Her up throw is a cannon launcher into the air, allowing for potential combo anti-air follow-ups. For her back and forward throws, she chucks her victim with her Plasma Whip, from which you're rewarded with time to charge up your Charge Shot. These two are your edge-guarding and knockout throws. Samus's down throw is a ground slam that pops up enemies in front of her for a possible forward air combo follow-up. Up and down throws are the most commonly used, thanks to their high-damage potential.

Aerial Attacks

Neutral Air Attack: While airborne, Samus delivers a spin kick that covers the front and rear horizontally. This is your basic air-to-air attack that deals moderate damage. It's quick enough to perform early on in a jump, with little lag, allowing you to follow up with one of her other aerial attacks, depending on the situation. Neutral air attack is one of your main defensive tools against ground-based aggressors.

Aerials

Move	Damage
Neutral air attack	10, 9
Forward air attack	3, 1.6x3, 5
Back air attack	14
Up air attack	3, 1.3x3, 4
Down air attack	14

Forward Air Attack: Samus descends with a sequence of blasts from her Arm Cannon. The explosions begin above her head and end down by her feet, great for deterring and hitting foes in a wide arc in front. However, the total lag time is considerable, so you generally can't fire off forward air early in a hop, followed by another meaningful attack. Forward air is one of your best edge-guarding attacks. It's extremely difficult to air-dodge because of its persistent hit effects, lasting longer than the intangibility durations of most air dodges. It's also an excellent ledge-recovery tool.

Back Air Attack: With a hefty amount of force, Samus swings her leg back, booting away foes. Back air isn't the fastest air attack, but it's quick enough to safely use as an edge-guarding tool. With your back facing a ledge, you can threaten with back air against recovering opponents, thanks to its decent horizontal reach.

Up Air Attack: Samus performs an upward spiraling drill attack with her legs extended vertically for a multi-hit anti-air. On hit, it launches foes higher into the air, allowing for a potential follow-up air attack. This is one of your staple air attacks, and likely Samus's best air attack overall. It makes Samus a fierce air controller, as she can maintain a strong advantage while combo-juggling opponents above her.

Down Air Attack: Samus swings her Arm Cannon in a wide arc, obliterating enemies beneath her. There's a specific meteor smash window in the middle of the attack animation. If you can land the meteor smash on an enemy attempting to recovery over to a ledge, you're likely to score a KO. Otherwise, spiking enemies on a solid floor gives you air-control advantage for potential combos and mix-ups.

Special Moves

Neutral Special: Charge Shot: Samus charges up her Arm Cannon and unleashes a massive energy-based projectile on command. To start charging, tap the Special button. To release the projectile, tap the Special button again. However, if you charge long enough, Samus stores the attack (signified by her fighter model flashing white). When the shot is stored, you can unleash the high-damage projectile anytime (even while airborne). This gives you a flexible zoning tool, effective in almost any situation. Max Charge Shot deals a large amount of shield damage (around 70% of total shield HP).

Special Moves	
Move	Damage
Neutral special	5 (28 max charge)
Side special	Super Missile: 12, Homing Missile: 8
Up special	3, 1x7, 2
Down special	4, 5

Side Special: Missile: Samus launches a Homing Missile that pursues a nearby target. There are two variations of this attack: a lower-damage Homing Missile with tracking capabilities, performed by tilting the control stick and pressing Special; and a high-damage, high-velocity Super Missile that flies across the screen, executed by flicking the stick forward and simultaneously inputting the special attack. Homing Missile is useful for controlling airspace and forcing the enemy into moving from certain positions. Super Missile is for dealing high damage and clearing out horizontal space to cover a potential aggressive approach.

Up Special: Screw Attack: Samus spins into the air, and any enemies caught by the move are swept into a multi-hit combo. Screw Attack doubles as a mobility tool for grabbing on to ledges and a strong anti-air thanks to its intangibility window and prominent attack area. Screw Attack is an excellent combo finisher as well as a knockout attack for juggling recovering foes. However, it leaves you vulnerable if you whiff it, so sticking with up air attack and forward air is recommended.

Down Special: Bomb: Samus transitions into her Morph Ball form and lays a Bomb that detonates after a full second. If Samus is within the Bomb's blast radius, it boosts her and sends her in the opposite direction of the blast. Bomb is an excellent air-to-ground projectile, allowing you to pester enemies and deplete their shields while they're beneath you, without having to commit to a potentially risky down air attack.

MORPH BALL CANCEL TECHNIQUE

Samus's Morph Ball mode allows for subtle frame-saving buffer techniques. While you're in Morph Ball mode, and as long as you're holding Crouch (down on the control stick), your next attack can be buffered, allowing you to attack earlier than normal. For instance, drop a Morph Ball Bomb, and while holding down on the control stick, also hold Attack. This lets you perform an immediate down tilt, canceled out of your Morph Ball attack. While this seems like minor time-saving, every frame counts in this game!

Final Smash: Zero Laser

Samus: Zero Laser: Samus unleashes a massive, long-range beam. You can angle the beam up or down while firing. Enemies caught in its path are sucked into the center and take a high amount of damage.

Dark Samus: Zero Laser: Dark Samus unleashes a massive, long-range beam. You can angle the beam up or down while firing. Fighters are drawn to the center, and the attack repeatedly hits any foes caught in its blast.

Sheik

OVERVIEW

Sheik is the quintessential assassin. She's equipped with lightning-fast attacks, outstanding ground speed, and incredible aerial mobility. Her neutral game (the phase in which no combatant has a distinct stage advantage) is one of the best, thanks to her amazingly safe combo-starting ground-based pokes and aerial attacks. Sheik can overwhelm her enemies' attacks, almost with impunity.

Sheik Vitals	
Movement Options	
Jumps	1
Crouch Walk	Yes
Tether	No
Wall Jump	Yes
Wall Cling	Yes
Movement Ranks	
Ground Speed	A+ (4)
Air Speed	B (19-24)
Falling Speed	B (20-21)
Weight	F (70)

Sheik has a high skill ceiling, with combo potential being essentially limitless; the more experience you have with her and the better you are at adapting to enemy shuffling and damage percentages, the stronger your combo game becomes. Not only is Sheik incredibly quick, but her versatile toolkit allows her to be played in a number of ways. She can fight in a bait-and-punish weaving-in-and-out style of play with forward air attack, side tilt, and down tilt; or she can pressure foes from afar with her Needle Storm and Burst Grenade, forcing them into making positioning errors.

Grounded Attacks

Neutral Attacks	
Move	Damage
Neutral attack 1	2
Neutral attack 2	1.6
Neutral attack 3	0.3xN, 2

Dash Attack	
Move	Damage
Dash attack	7

Defensive Attacks	
Move	Damage
Ledge attack	9
Wake-up attack	7

Neutral Attack: Sheik's incredibly fast jab is one of the best offensive neutral attacks in the game. When shielded, she's free to act at the same time as the opponent. Since her neutral attack comes out so quickly, she can beat out any kind of defensive response (unless it's a well-timed shield-grab reprisal). Sheik's jab is so quick that it can be looped into repeated jab strings (i.e., you can combo neutral attack 1, 2 into neutral attack 1, 2). The main weakness in her neutral attack is its low range, although this is mitigated by Sheik's remarkable speed, as she can generally get into jab range whenever she pleases.

Dash Attack: Sheik uses her high-velocity dash momentum to carry out a horizontal slashing attack with her fingertips that knocks enemies into the air. While it boasts an impressive start speed for a dashing attack, Sheik's dash attack launches foes up and far away from you, leaving little possibility for further combo damage. Because it has a lot of end lag (compared to Sheik's side and down tilt attacks), it's generally best saved for rare situations, like if you need the extra dash distance for punishing a retreating enemy.

Side Tilt: Sheik performs a swift slashing kick aimed forward at an upward angle that pops up enemies struck by it. Side tilt is one of your bread-and-butter attacks. It's remarkably fast and combos into essentially any kind of follow-up, including another side tilt. At lower percentages, your goal is to set up your foes into a side tilt knock-up, allowing you to combo into short hop forward air, which leads into a plethora of other possible juggle opportunities.

Tilts	
Move	Damage
Side tilt	3
Up tilt	3, 4
Down tilt	4.5

Up Tilt: Sheik extends her heel above her, perpendicular to the ground, then after a very brief pause, drives it downward into the ground, knocking up foes struck by the axe kick. Like many of her attacks, up tilt can be used to set up and extend combos. The first heel hit naturally combos into the axe kick portion, which pops the opponent up into a potential follow-up (such as forward short hop forward air). You can use up tilt as an anti-air against foes coming down from directly above you, then dish out additional damage with follow-up attacks.

Down Tilt: From a low-profile prowling position, Sheik sweeps the enemy off their feet and into the air for a potential follow-up. The tip of down tilt knocks up foes vertically, while the inner portions of Sheik's leg pop them up at a slight away angle. Either launcher can be used to start combos, but the tip launcher makes it much easier to follow up with side tilt since the enemy is knocked up closer to you.

Smashes

Move	Damage
Side smash	5, 8
Up smash	15
Down smash	4, 6

Side Smash: Sheik delivers a heavy side kick to the opponent's midsection, then transitions into a spinning flying kick, blasting the enemy away. Like most of Sheik's attacks, her side smash starts up quickly compared to most other brawlers' smash attacks. But it leaves you exposed to reprisals, including out-of-shield tilt attacks and, of course, shield grabs. Side smash can be used to punish high-lag whiffs and air dodges. Its high launching power makes it strong for finishing off foes near side blast zones.

Up Smash: Sheik raises her arms directly above her, then slashes them down to her sides, knocking back foes in front and behind. This is Sheik's most damaging attack. While it's unsafe if whiffed and when shielded, you can use it to punish air dodges and rolls thanks to its double-sided hit effect. It's also a strong anti-air attack. As Sheik raises her arms, they're intangible, so if a descending foe comes down on you with an attack, you'll most likely beat them out if you challenge their attack with a well-timed up smash. Against middleweights at around 120%, this is essentially a guaranteed knockout.

Down Smash: Sheik spins on her back and performs a windmill kick attack, launching away foes around her. Down smash is a double-sided attack with limited use in one-on-one battles. It's extremely unsafe when shielded and is easily punishable on whiff. It should be left out of your neutral game arsenal altogether since, even if it hits, it doesn't set up any meaningful damage follow-ups.

Sheik's grab suffers from having one of the shortest ranges in the game, but her incredible dash speed makes up for these shortcomings. All of Sheik's throws launch the enemy vertically into the air (even her forward and back throws), making them effective for juggle-trapping foes and less effective for instant side-blast-zone knockouts. Front throw allows for combo opportunities against certain fighters. Down throw into jump forward air into double jump forward air is a potential guaranteed combo against certain weight classes (such as Mario at 30%).

Grabs

Move	Damage
Grab attack	1
Front throw	7
Back throw	7
Up throw	6
Down throw	6

Aerial Attacks

Neutral Air Attack: Like Mario's and Link's neutral airs, Sheik's extends a persistent hit effect that, in conjunction with fast fall, makes for an exceptional air-to-ground and air-to-air attack. While forward air is your primary offensive air attack, its hitbox doesn't stay out as long.

Forward Air Attack: While airborne, Sheik performs a swift slash with her hand that arcs directly in front of her and at a slight downward angle, knocking up foes for a potential follow-up. Forward air attack is a staple tool in your

Aerials

Move	Damage
Neutral air attack	6
Forward air attack	4.5
Back air attack	9.5
Up air attack	1x3, 4
Down air attack	10, 2

arsenal. It's a versatile attack that's safe to throw out in most situations, thanks to its low air and landing lag. You can use it as an air-to-air poke, an air-to-ground offensive maneuver, and to extend and finish combos. Sheik's offense-based aerial game centers around using her fast jump and fall speed in conjunction with her forward air attack, so learning how to manipulate your jumps while timing your forward air attacks is crucial.

Back Air Attack: In midair, Sheik thrusts her right leg back behind her at an upward angle, knocking away enemies. Back air is primarily used as an edge-guarding tool in conjunction with Bouncing Fish. It can also be used offensively to start standing hitstun combos at lower percentages, or to stop aggressive enemies chasing you as you back away.

Up Air Attack: Sheik delivers an up-angled corkscrew attack, similar to Samus's up air. On hit, it launches foes upward into the sky. While it isn't particularly effective as a poke, up air is a solid attack used to finish off foes near the upper blast zone. Its narrow, vertical attack range can make it challenging to hit with unless you send your opponent into the air with a vertical launch. The first three hits of up air cause a "drag" effect, allowing you to pull foes through the air into certain positions.

Down Air Attack: Sheik halts her aerial momentum briefly, then dives down with a forceful kick attack, driving her weight into the ground. Upon landing, she causes a small eruption that launches foes. Down air attack causes a meteor smash effect during the early portion of the attack, right as Sheik begins her descent. It's essentially a kamikaze attack if performed offstage, since you have no way of reversing your trajectory or recovering after it hits. As one of Sheik's riskiest attacks, down air is difficult to use effectively without being punished for it. Like most stall-then-fall attacks, it leaves you vulnerable when shielded, and its landing lag is significant.

Special Moves

Neutral Special: Needle Storm: Sheik loads up throwing needles between her fingers, then throws them directly forward, piercing her foes. While airborne, Sheik throws them at a down-forward angle. Needle Storm projectiles deal more damage during the first half of their flight. Sheik can load up to a maximum of five needles to throw out in a direct line. Each needle takes a third of a second to load, so to quickly throw out a fully charged Needle Storm, you need to charge for just under two seconds, then immediately hit Special again. Needle Storm charge is cancelable, allowing you to keep your stored needle load.

Special Moves	
Move	Damage
Neutral special	1.5xN (6 max)
Side special	1, N (vacuum), 12.6 (explosion)
Up special	12, 5
Down special	11

Side Special: Burst Grenade: Sheik throws a grenade, attached to a chain, at the enemy. After a full second, Sheik pulls on the pin, using the attached tripwire in order to detonate it. Upon detonation, the grenade inflicts a damaging gravitational effect, pulling in nearby foes before incinerating them with an explosion. Burst Grenade throw range and detonation time can be extended by holding the Special button. Release Special to have Sheik pull the pin. If Sheik is interrupted as she's pulling out a Burst Grenade (and before its pin is pulled), it becomes an interactable item that can be picked up and thrown by anyone. The item-grenade doesn't explode, but deals enough damage and hitstun to be used as a projectile. And Sheik can pull another Burst Grenade while there's an item-grenade on-screen.

Up Special: Vanish: Sheik deploys a bomb at her position and then disappears, reappearing behind another damaging explosion. You can combo the first and second explosive hits of Vanish by tilting the control stick toward the enemy's launch path. You generally shouldn't use Vanish as an offensive tool, though, since Sheik has much more effective, and safer, attacks at her disposal. Nevertheless, Vanish is one of the best recovery options in the game. Sheik is one of the only fighters who can bypass the momentary vulnerable period right when a fighter grasps a ledge, before they become intangible while hanging.

Down Special: Bouncing Fish: Sheik performs a backflip through the air toward the enemy and strikes them with a double-heel kick, bouncing off her foe into another unique flip kick. You can alter the trajectory of Bouncing Fish by holding left or right. If Sheik is hit out of her Bouncing Fish while airborne, she can't use the attack again until touching ground or reaching a ledge.

Final Smash: Sheikah Dance

Sheik charges forward and strikes an opponent in her path. Upon being hit, the opponent is surrounded by darkness, and Sheik unleashes multiple quick attacks. The final attack can strike other opponents as well.

Shulk

OVERVIEW

As the wielder of the legendary Monado sword, Shulk's main features revolve around activating Monado Arts, which modifies his attributes in various ways. Each Monado Art comes with increased power, but also increased vulnerabilities in certain aspects. For instance, Buster Art increases Shulk's damage output, but at the cost of raising the damage he receives. Managing Shulk's Monado Arts is vital to optimizing Shulk's potential. Adapting to the situation at hand and activating the appropriate Art can mean a world of difference.

Shulk Vitals	
Movement Options	
Jumps	1
Crouch Walk	No
Tether	No
Wall Jump	No
Wall Cling	No
Movement Ranks	
Ground Speed	D+ (40-41)
Air Speed	B- (31)
Falling Speed	C (40-43)
Weight	B- (30-31)

Shulk's neutral and forward air attack are some of the best aerial attacks in *Super Smash Bros. Ultimate*. Whereas most air attacks in *Super Smash Bros. Ultimate* cause varying amounts of landing lag depending on when you land during the attack's animation, Shulk's are unique in that no matter when you land during his attack animations, his landing lag is constant (although the amount of lag differs between attacks). You can get around this fixed lag by performing your aerial attack early on during your jump so that you go into air lag instead.

Grounded Attacks

Neutral Attacks

Move	Damage
Neutral attack 1	2
Neutral attack 2	1.5
Neutral attack 3	5

Dash Attack

Move	Damage
Dash attack	12.5

Defensive Attacks

Move	Damage
Ledge attack	9
Wake-up attack	7

Neutral Attack: Shulk delivers a quick jab and follows up with a high roundhouse kick, then finishes the sequence with an uppercut slash of the Monado. On whiff, holding neutral attack allows for repeated jabs. Alternatively, repeated pressing neutral attack on whiff results in the punch, kick, slash "auto-combo." This jab combo is best reserved as a quick input-buffered punish tool (after shielding incoming attacks, for instance), and to relieve offensive pressure by the opponent. For the most part, you want to stay off the ground and in the air.

Dash Attack: While dashing, Shulk mightily swings the Monado in front of him, sending foes flying up and away into the sky. Shulk's dash attack boasts impressive range and extends an intangible hitbox, out-prioritizing incoming attacks. However, it's highly punishable when shielded or if you miss with it. You can make it safer by spacing it, forcing the enemy to shield the tip of the Monado. However, hits at this range are "sour."

Side Tilt: Shulk swipes the area in front of him with the Monado. The range on this horizontal blade attack makes it effective and safe to throw out in most ground-to-ground scenarios or as an edge-guarding tool. There's a slight start-up period before it hits, so it may be difficult to implement in combos, but it's one of your most important attacks due to its relatively decent recovery and lag. Like most of Shulk's Monado attacks, his side tilt benefits from Speed Art while maintaining respectable damage.

Tilts

Move	Damage
Side tilt	13.5
Up tilt	10
Down tilt	9.5

Up Tilt: Shulk swings the Monado in a wide arc above him. Up tilt is an excellent kill move against foes at high damage and should be one of your staple ground attacks. It's a quintessential anti-air with a pronounced vertical attack effect. It can hit foes directly in front of you, but doesn't quite reach to the rear, making it a situational attack in the ground game. The main advantage is its vertical reach, giving you incredible anti-air juggle and combo control against descending enemies.

Down Tilt: Shulk sweeps the ground in front of him with the Monado. Down tilt is primarily used against shorter fighters like Pikachu and Kirby, but decently effective against other fighters because of its range advantage over side tilt.

Side Smash: Shulk activates the Monado's energy-extension blade and delivers a mighty thrust in front of him. Thanks to its incredible range, Shulk's side smash is a decent poke tool. However, as with most smash attacks, it comes with the price of considerable lag, making it relatively dangerous to use often. You're generally better off using neutral air and forward air as pokes since they're safer and allow you to remain mobile.

Smashes

Move	Damage
Side smash	5.5, 13
Up smash	4.5, 13.5
Down smash	14

Up Smash: Shulk thrusts the Monado blade straight into the air, piercing foes above him. Up smash is the vertical variant of side smash and should be used sparingly. While these smash attacks deal incredible damage, they leave you highly vulnerable. High-speed fighters are sure to punish your whiffed smash attacks, so try to stick to using your tilt and air attacks.

Down Smash: With the Monado's projected energy blade, Shulk performs a 360-degree floor-sweeping spin attack. This sword sweep is a clear-out attack, potentially hitting multiple surrounding enemies. Naturally, it's enormously unsafe on shield and whiff, but has its niche use, particularly in free-for-all battles within a constrained skirmish.

Shulk's grab attack consists of bashing his victim with the butt of the Monado. Each of Shulk's grab follow-up options has situational uses, with his up and down throws being the most effective for setting up combos and dealing extra damage. While Speed Art is active, you can usually hit a guaranteed combo off of down throw with neutral air if you're fast enough. At high enemy-damage values, your back and forward throws have much higher knockout potential while Smash Art is active. Though situational, Smash can make a big difference since being able to grab and knock out with a throw is a powerful ability.

Grabs

Move	Damage
Grab attack	1.3
Front throw	8
Back throw	9
Up throw	7
Down throw	5.5

Aerial Attacks

Neutral Air Attack: Shulk swings the Monado all around him in an exaggerated arc, clearing out nearby foes. Neutral air is one of your best attacks as you jockey for position and poke at foes. It covers all angles, with the initial active frames starting below you and its ending active frames behind you. Generally, using neutral air over forward air is better for covering your rear and upper body, while forward air is better in most other situations. Neutral air has the least amount of fixed landing lag out of Shulk's aerial attacks.

Aerials

Move	Damage
Neutral air attack	8.5
Forward air attack	8
Back air attack	12.5
Up air attack	5.5, 10.5
Down air attack	6, 11.5

Forward Air Attack: Shulk delivers an overhead swing, swiping the Monado in a giant arc in front of him and ending slightly behind. Forward air will likely be your most-used attack. It excels in most situations and has uses in combos and setups. It's relatively safe, especially considering its decent speed and incredible hitbox angle. Short hop into forward air should be a staple attack and defense sequence.

Back Air Attack: While airborne, Shulk thrusts the Monado far behind him, devastating enemies caught in its path. This is your best horizontal poke in the neutral game. It's a safe option against the majority of the cast, and only leaves you vulnerable against the fastest fighters. It boasts incredible horizontal range, and it's safe on shield with proper spacing.

Up Air Attack: While hopping, Shulk activates the Monado blade and thrusts it far into the air above him. Up air is one of your strongest knockout attacks because of its huge vertical attack effect, naturally used as a follow-up to pop-up attacks like your down/up throw, Air Slash, and up tilt. With Jump Art active, you can combo repeated up air attacks at higher-damage counts.

Down Air Attack: Shulk does his best Link impersonation, performing a down-thrust attack with the Monado that dunks enemies below him. While this attack is visually similar to Link's Down Thrust, it's much more difficult to use and hit accurately. Its start-up is considerably slow, its active window is relatively short, and the hitbox of the Monado isn't too impressive. Shulk's other air attacks are much more effective in most circumstances. Furthermore, it causes the longest landing lag out of all of Shulk's air attacks, leaving you vulnerable if you use it haphazardly.

Special Moves

Neutral Special: Monado Arts: Shulk cycles through and toggles on a Monado Art, increasing and decreasing certain attributes depending on which Art is chosen. There are two methods of selecting Monado Arts: Tapping neutral special quickly cycles through them in order (Jump > Speed > Shield > Buster > Smash), automatically activating an Art when you stop cycling (takes around one second). Alternatively, you can bring up the Monado Arts wheel by holding neutral special and then using the control stick to select an Art. Selecting certain Monado Arts using the wheel can be much quicker than cycling.

Quickly activate Monado Arts on demand by holding Special and immediately inputting and releasing the associated direction.

◄ **Jump:** Jump height increased by 60%, damage taken increased by 29%.

↗ **Speed:** Movement speed increased by 80%, damage dealt decreased by 30%, jump height decreased by 20%.

◣ **Shield:** Damage taken reduced by 50%, weight increased by 20%, damage dealt decreased by 50%, movement speed decreased by 40%.

➡ **Buster:** Damage dealt increased by 40%, damage taken increased by 50%, launch power decreased by 60%.

↑ **Smash:** Launch power increased by 60%, damage dealt reduced by 70%, launch resistance decreased by 30%.

You can manually disable and cancel the active Monado Art by tapping neutral special three times quickly in succession.

Special Moves

Move	Damage
Neutral special	Varies
Side special	10 (16.8)
Up special	6, 5.5
Down special	10

Side Special: Back Slash: Shulk leaps forward and chops his foes down with a jumping sword attack. Deals bonus damage if striking enemies from behind. Back Slash is a high-risk, moderate-reward special that deals bonus damage if you can connect the Monado with an opponent's rear side. This jumping attack persists until landing, so if you execute it from a high altitude, you remain vulnerable in a locked attack animation until you hit the floor.

Up Special: Air Slash: Shulk drives the Monado skyward, launching enemies into the air with a rising slash, then striking them out of the sky with a horizontal air swing. Air Slash is a high-velocity uppercut slash with a bonus hit that can be performed on hit (for a combo-finisher) and on whiff.

Down Special: Vision: Shulk evades an incoming attack with a backstep, then lunges forward with an upward swing of the Monado. This parry-type move is straightforward. If you can predict and call out an enemy attack, you can punish them with a high-damage retaliation attack. Enemies attacking into the parry freeze in place for a short duration while Shulk winds up and hits them with his swing.

Final Smash: Chain Attack

Shulk quickly fires off a bright circle of light in front of him, then calls upon his friends to unleash a coordinated cinematic attack, dealing an amount of damage that depends on the active Monado Art.

Simon / Richter Belmont

OVERVIEW

The family line that serves as Dracula's timeless scourge swoops into action in *Super Smash Bros. Ultimate*! Simon Belmont is the most legendary of the vampire hunters, the forebear against whom all future whip-swingers are judged. Richter, one of those descendants who blazed his own distinct trail in the annals of nosferatu-nullifying, is Simon's Echo Fighter, sharing the same moves and strengths. They even have their classic *Castlevania* series jump hangtime, floating at the apex of their jump arcs. Beware when using directional air dodges to avoid incoming attacks while airborne, though, since the Belmonts have far more lag after angled air dodges than most fighters.

The vampire hunters have incredible reach with their whip-swinging attacks, and tremendous knockback power if aiming to hit with the morning star at the end of the chain. But with the whip's lengthy windup, Simon and Richter's attacks tend to be slower to hit than most other fighters'. Success with the Belmont bros. comes down to making effective use of their unique special moves and enormous whip-swinging range to keep adversaries at bay, warding them away from point-blank range with tossed Holy Water, Axes, and Crosses, while making liberal use of max-range whip strikes.

Simon / Richter Belmont Vitals	
Movement Options	
Jumps	1
Crouch Walk	Yes
Tether	Yes
Wall Jump	No
Wall Cling	No
Movement Ranks	
Ground Speed	D- (62-63)
Air Speed	D (62-63)
Falling Speed	B+ (7-9)
Weight	B+ (11-15)

Grounded Attacks

Neutral Attacks

Move	Damage
Neutral attack 1	2
Neutral attack 2	2
Neutral attack 3	0.5x7, 2.5
Neutral attack hold	1.5

Dash Attack

Move	Damage
Dash attack	1.7x5, 3.5

Defensive Attacks

Move	Damage
Ledge attack	9
Wake-up attack	7

Neutral Attacks: The Belmonts attack at close range with a short section of their whip, holding back most of its length wrapped around the other arm. The Belmont neutral attack is slower than average, about as fast as most fighters' tilts. Simon and Richter whip the head of the weapon back and forth for the first two hits. After the first two swings connect, a third attack input leads to the rapid-fire capper, a spinning whip attack that ends by launching the victim a short distance away.

For the Belmont classic freehand whip technique, press and hold down neutral attack. Once the whip is dangling freely, move the control stick around to redirect it. You can keep this up as long as you like, if no one interrupts. If engaged against a close-range adversary, spinning the chain rapidly can juggle them in place several times before they're knocked away. Although the hits don't do much damage or knockback individually, the constant, flexible hitbox of the extended whip can interfere with enemy efforts to grasp or rise from ledges. Whipping the held chain around can also deflect incoming items and projectiles before they hit.

Dash Attack: While sprinting, the Belmonts can twirl the vampire-killer whip in a tight circle alongside, hitting foes in all directions during the forward movement. The whip rotates briefly around the hunter, creating hitboxes at the diagonals; the final whip rotation covers the whole hunter's body in a tight circle. The progression of hit areas is similar to neutral air attack, except Simon/Richter is moving along the ground.

Side Tilt: The vampire hunter whips straight forward with a basic far-reaching whip strike. The damage is higher at the tip, and a lot lower if used against close-range targets, where only Simon or Richter's arm connects. Although this attack has decent range, the slow speed and laggy vulnerable position on the ground mean it's better to aim short-hopping front/back air attacks at grounded or low-altitude enemies, angling the hopping whip swings diagonally as needed. Hopping adds extra start-up over doing side tilt on the ground, but has slightly more range and is a lot more flexible in terms of follow-up options and general evasiveness and mobility.

Tilts

Move	Damage
Side tilt	12
Up tilt	10
Down tilt 1	5
Down tilt 2	7

Up Tilt: The whip is whirled just above Belmont's head, covering airspace above. The hitbox on this whip attack is shaped like a T, so it'll miss standing foes next to Belmont, but is great as anti-air or when juggling tumbling targets. On contact it pops enemies straight up, allowing you to go for a combo.

Down Tilt: It's not just about whip-swinging. The brothers have a fast, forward-moving slide kick with an optional second part. During the initial slide kick along the floor, pressing the Attack button again makes Belmont launch from his low-profile slide kick into a leaping vault kick, serving as both a quick-movement tool and a long-reaching knockdown kick. For just the vault kick, tap the Attack button twice immediately to cut the slide short and go straight into the upward-arcing vault kick portion.

Side Smash: The whip-slingers' side smash is a much more powerful and far-reaching version of side tilt, whipping straight forward. Like all whip strikes, damage and knockback are best at the tip. Side smash is slow to start up, so use it from as far as possible to avoid leaving Belmont totally vulnerable up close. Like with side tilt, the damage is lessened on close foes, but the damage penalty isn't anywhere near as bad.

Smashes

Move	Damage
Side smash	18-25.2
Up smash	16-22.4
Down smash	16-22.4

Up Smash: Dracula's perennial antagonist swings the whip straight up for a far-reaching vertical strike. While up tilt provides generous coverage against any airborne threats incoming at low altitude, up smash requires more precision. Its hitbox is a thin line extending up from the hunter.

Take care when sniping at fliers above Belmont; it's risky to use a slow up smash attack and miss, which might result in the intended target landing next to Belmont while he's lagging from the attack.

Down Smash: The Belmonts' most useful smash attack starts with a toe-targeting whip slash in front, then spins around to repeat the hit to the back. Not only does this cover both sides with a powerful clear-out hit, but it's not painfully slow for a smash attack, coming in slightly below average. This is their most reliable option when caught at close range against multiple assailants.

Belmont grab attempts are a bit slower than for most brawlers, taking twice as long as, say, Mario when laying hands on a point-blank opponent. Since their close-range neutral attacks are also below average in speed, this puts the Belmonts in the same class as heavyweights like Bowser and Donkey Kong when grappling and poking in close quarters.

Grabs

Move	Damage
Grab attack	1.3x1-5
Front throw	7
Back throw	7
Up throw	6, 4
Down throw	8

You won't get much mileage out of basing a rushdown game with the Belmonts on getting in close and trying for grabs and neutral attack combos. But their far-reaching tilts and smashes can open the way for an effective dash-grab game plan. Front and back throw are great for tossing an enemy toward an edge, especially when they have high damage built up. Down throw bounces them forward off the ground, serving as a different kind of front throw that you can follow with an immediate down tilt into vault kick for an extra hit. From up throw, juggle follow-ups are possible.

Aerial Attacks

Neutral Air Attack: Like neutral attack on the ground, this is the shortest-ranged option in the Belmont aerial arsenal. Either fighter spins his whip around in a tight wheel, creating a blender of hits. The active hitboxes as the whip's head whirls around are found on the diagonal corners around Belmont; the move's threat area is an X around the fighter, not a cross. The lengthy active period gives neutral air attack uses that other Belmont whip attacks lack.

Forward and Back Air Attack: Belmont uses a long-range whip swing, like side tilt on the ground. Also like side tilt, this is below average in speed for an attack of its kind, but more than makes up for it with huge range and knockback potential. Belmont front and back air pokes can be aimed at an angle by performing the moves with diagonal inputs. Max-range, short-hopping forward/back air swings, performed with downward diagonals, are better ground-poking tools than side tilts.

Up Air Attack: Belmont lashes straight up with an aerial whip swing. This is a lot like up smash on the ground, but far less vulnerable, if only because you can steer in midair or perform other actions afterward, instead of being stuck on the ground during recovery lag. On top of that, performing a short-hopping up air (up on the control stick plus Attack+Jump at once) hits straight up a bit faster than an uncharged up smash, and with more reach.

Down Air Attack: Like down tilt, this adds footwork to all the whip attacks. Belmont halts aerial movement for a second, gathering tension, before rocketing down-forward with a dive kick. On contact, whether hit or shielded, Belmont bounces off like he's hit a trampoline. From the bounce, Belmont is back to an airborne state, and can perform any air actions as normal.

Aerials

Move	Damage
Neutral air attack	1x6, 4
Forward air attack	12
Back air attack	12
Up air attack	12
Down air attack	7

Special Moves

Neutral Special: Axe: Belmont hurls a heavy Axe on a wide, alterable arch. Tap the Special input for a normal Axe toss, or hold left or right just after starting the move to stretch the arc slightly in that direction, shortening or extending overall reach. Axes travel an unusual path, and pass through solid obstacles! This means that Axes make effective weapons against opponents on platforms above or below, even if the floors in between aren't passable by fighters. Unlike the Belmonts' other special projectiles, there's nothing stopping you from throwing more than one Axe at a time.

Special Moves

Move	Damage
Neutral special	15
Side special	6-8
Up special	2, 1.5x4, 6
Down special	2.4-2.8, 1.4x8

Side Special: Cross: Belmont flicks the Cross with variable speed and power: tap the stick to one side plus the Attack input together for a max-speed, max-power Cross, like executing a smash attack; perform it more like a tilt attack (with a partial side press, or holding a side direction ahead of time) for a slower, weaker Cross. The Cross goes spinning along a straight path, eventually slowing before reversing and traveling in the direction it was thrown from. The Cross continues until it leaves the screen or comes back in contact with Belmont. Another Cross cannot be thrown until the original disappears (whether it's caught or flies off-screen).

Up Special: Uppercut: Simon and Richter rocket upward with a high-reaching special punch. Upon activation, the attack hits quickly, with a little period of intangibility around the first striking frame. After this launching hit, Belmont travels upward for a moment, launched foe lofted upward too, before transitioning into the finishing multi-hit portion. It's Simon and Richter's most powerful close-range move.

Down Special: Holy Water: The Belmonts underhand-toss a vial filled with flammable water. The bottle itself is a projectile capable of hurting targets along the way. Once it hits a surface (or enough enemies in midair), it shatters, spewing explosive liquid over a small radius. A brief pillar of flame erupts, repeatedly striking and damaging anyone caught within. Simon's vials cause a gout of red flames, while Richter's flames are an icy-looking blue. Only one Holy Water vial can be active at a time. Holy Water flames briefly dominate an area, and if someone is caught within, you can rush forward and add hits to the combo.

Final Smash: Grand Cross

Simon and Richter briefly share some of the horror of the Transylvanian nightmares they've experienced with the other brawlers onstage. Dracula's coffin appears midscreen and opens wide, sucking in anyone nearby within a big radius. Multiple enemies can be imprisoned at once, taking heavy damage while trapped inside.

Snake

OVERVIEW

The legendary master of espionage action is one of the strongest zoning and camping presences in the game. Snake has a multitude of delayed explosive threats he can layer on-screen, creating waves of explosions and uncertainty in foes about when and where the next blast will come from.

But Snake is far from just a demolition man. He's expert in CQC—close-quarters combat—with lots of quick and powerful moves on the ground. His dash attack and down tilt both bring him prone to the ground, potentially avoiding incoming attacks. Plus, he hunches during each forward dash, meaning that moving across the stage with repeated dashes (tapping forward over and over) is more avoidant than simply running across the stage (tapping and holding forward).

Snake Vitals	
Movement Options	
Jumps	1
Crouch Walk	Yes
Tether	No
Wall Jump	No
Wall Cling	No
Movement Ranks	
Ground Speed	D (53-56)
Air Speed	C- (56-57)
Falling Speed	B (22)
Weight	B (16-17)

Grounded Attacks

Neutral Attacks	
Move	Damage
Neutral attack 1	2.5
Neutral attack 2	2.5
Neutral attack 3	6

Dash Attack	
Move	Damage
Dash attack	11

Defensive Attacks	
Move	Damage
Ledge attack	10
Wake-up attack (faceup)	7

Neutral Attacks: The master of CQC strikes with two quick jabs, before knocking defenders away with a big kick. The initial jab is quick, but not among the game's fastest. This combo provides an easy way to retaliate to small openings, after shielding moderately laggy attacks, or just as foes emerge from dodge rolls.

Dash Attacks: From a combat run, Snake dives forward with a shockingly fast dash attack. Hitting early in the attack launches foes forward, while hitting them as the attack ends flips them right over Snake's shoulder. Snake lands in a full crouch, the same way he ends down tilt, which can mess up opponents' attempts to counterattack if they shield it.

Tilts	
Move	Damage
Side tilt 1	3
Side tilt 2	12
Up tilt	14.5
Down tilt	12

Side Tilt: Snake thrusts with a fast knee. Another Attack input with the knee out leads into his follow-up, a heavy double hammer-fist. The knee is one of the fastest tilt attacks in the game, giving Snake another good out-of-shield punish option besides striking with neutral attacks. (Side tilt's knee is slower than a neutral attack jab, but barely.) Doing the whole thing, knee into fists, leaves Snake wide open if his foe shields it and retaliates immediately. You can delay the hammer-fist for a surprising amount of time.

Up Tilt: Snake uses his body mastery to arc an expert launching kick straight up. The first hit appears quickly in front as he raises his leg, popping up anyone at close range who isn't shielding. His leg then fully rises, pointed straight up to shoot down anyone in low airspace. This is a fast, effective hit either up close on the ground or against airborne targets, good for anti-air and combos. The damage is extremely good too. However, up tilt offers no backward coverage.

Down Tilt: Snake strikes rapidly with a low-profile sweep kick. This hits with the same speed as up tilt but with much more reach. Anyone it hits is swept off their feet, into a juggle position. Against foes who shield down tilt and strike back, Snake's at a punishable disadvantage. His prone position means that many fighters trying for immediate quick attacks will miss over his body, though.

Side Smash: Snake busts out an RPG and launches a shell right at the ground in front of him, directing heavy damage in a big radius (that he somehow manages to avoid). This is one of the slowest smash attacks around, taking over half a second uncharged. But the damage, KO potential, and shield-shattering are undeniable. Most of the lag here is front-loaded; Snake is at a disadvantage if the rocket is shielded (if the enemy's shield isn't broken), but not much, and the enemy is probably pushed out of range by the explosion anyway. If you have time to squeeze this off, it's worth it.

Up Smash: This unique smash attack is more like a secret special move. Snake starts out by laying a mortar launcher at his feet, with this setup producing a momentary launching hitbox. This physical mortar launcher hit isn't as fast as up tilt, but hits about the same area in front. Then, over half a second after the move is initiated, the mortar flies up from the tube. If a foe is popped up by the launcher itself, the projectile detonates right away for a two-hit combo. If not, the dumb-fired explosive travels on a sharp arc up and then down directly in front of Snake. (Like side smash and Remote Missiles, this is one of his own explosives that won't hurt him.) Enemies who chase after Snake after he uses up smash risk being interrupted by the explosive falling back down.

Down Smash: Snake aims a shin kick out in front, then sweeps it around to cover behind him. This is Snake's main clear-out option when trapped in a big melee on the ground. It hits decently fast and pushes victims back on both sides. If someone in front of Snake shields the front kick, he's wide open to punishment. If someone behind him blocks the back kick, the situation is a little better. He's still at a disadvantage, but not as bad, and opponents might be pushed far enough away to negate guaranteed reprisal.

Smashes

Move	Damage
Side smash	22-30.8
Up smash	4, 14
Down smash	12 front, 14 back-16.8 front, 19.6 back

Grabs

Move	Damage
Grab attack	1.3
Front throw	9
Back throw	9
Up throw	7, 4
Down throw	9

Snake is deliberate with his grappling game, grabbing with the speed of an average heavyweight. So his speed isn't amazing, but the range is decent, farther than it looks from his hand positions. His throw attacks are unconventional, with both his front and back throws bouncing victims off the floor for momentum, and the up throw bouncing them into an airborne juggle position the way most down throws do. Down throw is unique, with Snake dishing out a quick, non-lethal version of his sleeper hold, laying his foe out flat.

Aerial Attacks

Neutral Air Attack: It's like close-quarters combat in midair! Snake unleashes a quartet of jump kicks that take up his time for three-quarters of a second. Do neutral air right on takeoff, and the kicks cover the full duration of a jump or hop, making this easy to use as a wall of kicks on the ground, but beware there's some landing lag. The first kick is a bit slow for a neutral air, but once he starts kicking, there are periodic hitboxes in front of him for a half-second. The final kick packs most of the punch.

Forward Air Attack: This hard-hitting air move takes a long time to hit, over a third of a second, before Snake brings down a midair axe kick. His leg starts out hitting up, before crashing down to a forward finale. Even most smash attacks are noticeably faster to become a threat than Snake's forward air. This is where Snake's layered explosive game comes in handy. Putting different kinds of timed threats in your way first, like up smash mortars, Hand Grenades, and C4 blocks, paves the way for striking with forward air.

Back Air Attack: Snake sticks out a quick, strong kick behind him. For a kick of its kind, it stays out for a long time, almost a third of a second, so it's lenient for aiming backward. It's much quicker to hit than most of Snake's other air moves. However, it's not great for reverse rushing tactics or poking backturned near the ground, because it has a lot of landing lag, with Snake landing on his side. It's best aimed air-to-air at double jump altitude, or when going for juggles on launched foes.

Up Air Attack: Snake flips to kick straight up with both legs, launching victims upward if successful. This is naturally great for aiming at foes straight above, but don't expect lateral coverage. The landing lag is prohibitive, with Snake landing on his head before flipping over. But it has some use as a last-second jump-in at standing targets, or short hoppers under you in midair.

Down Air Attack: This is Snake's fastest air attack by far, with him sticking a foot downward just as fast as he punches with neutral attack when standing. After the first jabbing kick straight down, he follows with three more, like a faster, downward-aimed version of neutral air. Like neutral air, the final kick is strongest. The last kick strikes down with such force that it halts Snake's descent for a moment, so it has some use for changing Snake's jump trajectory.

Aerials	
Move	Damage
Neutral air attack	3x3, 12
Forward air attack	15
Back air attack	16
Up air attack	14
Down air attack	4, 3x2, 10

Special Moves

Neutral Special: Hand Grenade: Tap neutral special, and Snake pops the pin on a grenade and gives it a toss. Hold down a neutral special input, and Snake pops the pin and holds it (the grenade, not the pin). Grenades have a two-second timer—they detonate whether they're in Snake's hand or not. When they detonate, they deal around 9% damage to anyone nearby—including Snake! Snake can walk and jump while holding a ticking grenade, though he can't change direction. Whenever you toss a grenade, holding forward or backward on the control stick affects the arc. Up to two grenades can be active at a time. Snake can catch or pick up his own grenades, but so can enemies.

Side Special: Remote Missile: Snake busts out his trusty guided Nikita launcher, remotely piloting an agile missile all over the stage. This is one of the most finely controllable moves in the game, even more than Ness's PK Thunder. You can basically steer Remote Missile anywhere. The missile flies faster in a straight line than when being nudged in one direction or another. Snake is a sitting duck while piloting Remote Missile. To drop control prematurely if someone is rushing him, fly the missile into a nearby surface, or tap the Shield button to ditch control and return to Snake.

Special Moves	
Move	Damage
Neutral special	~2, ~9
Side special	14
Up special	6
Down special	17

Up Special: Cypher: Snake hitches a ride upward on a Cypher drone. This is his main recovery move, since it gains tremendous altitude. Cypher can be steered left or right, and releases Snake when it can't carry him any higher. It doesn't leave him helpless when it's over; after release, Snake can use any normal air actions except double-jumping or using up special again. You can drop off Cypher early on the way up by tapping down, or by performing an air action to cancel it. Cypher is best thought of as a pure recovery tactic, like Villager's and Isabelle's Balloon Trip.

Down Special: C4: Classic Snake, setting up remotely detonated blocks of plastic explosive. He can set these on surfaces, platforms, or even people! Once C4 is in place, another down special input sets it off, dealing heavy damage. One caveat is that the detonation is high-commitment, occupying Snake for about a third of a second as he presses the detonator. You can't just snap off detonations in a flash, or while occupied by other actions.

In the air, a block of C4 can be dropped as a bomb that, as far as opponents know, might go off anytime. On solid ground, it's a mine. Set up on enemies, it's a bizarre kind of mobile mine. If it isn't manually detonated, a deployed C4 block explodes after 25 seconds.

Final Smash: Covering Fire

This Final Smash is like a screenwide version of Remote Missile, with Snake targeting anyone and everyone. Drag the reticle over as many challengers as possible to achieve lock-ons. A swarm of homing missiles shows up shortly, zeroing in on all locked targets. Like Remote Missile, this requires finding a safe place for a moment of Snake's targeting time. But given a safe haven, he's a threat anywhere.

Sonic

OVERVIEW

Sonic is a unique fighter, not only because he's the speediest brawler in the game, but because his fighting style vastly differs from most of the cast. He's most effectively played with a bait-and-punish fighting style, dashing around at high speeds and capitalizing on the enemy's whiffed attacks.

Naturally, he has the fastest dash speed in the game, so he's effective at punishing whiffed attacks from range. He also skids to a stop faster than almost anyone. He goes from zero to sixty and sixty to zero like nobody's business, allowing him to run and immediately stop, possibly transitioning into a tilt or smash attack. He even has a wall jump that can aid him during his ledge-recovery phase.

Sonic Vitals

Movement Options	
Jumps	1
Crouch Walk	No
Tether	No
Wall Jump	Yes
Wall Cling	No
Movement Ranks	
Ground Speed	S+ (1)
Air Speed	B+ (12-16)
Falling Speed	B- (28-33)
Weight	D (59-60)

Grounded Attacks

Neutral Attacks

Move	Damage
Neutral attack 1	2
Neutral attack 2	1.5
Neutral attack 3	4

Dash Attack

Move	Damage
Dash attack	6

Defensive Attacks

Move	Damage
Ledge attack	9
Wake-up attack (faceup)	7
Wake-up attack (facedown)	6

Neutral Attacks: Sonic performs a quick one-two punch sequence, followed by a thrusting side kick that launches enemies away. Sonic's jab combo is generally best used interchangeably with side tilt and down tilt to defend against aggressive foes.

Dash Attack: While running at supersonic speed, Sonic drives his momentum into the enemy with a high-powered flying kick. Like most dash attacks, Sonic's leaves him exposed if it's shielded, making it punishable. This vulnerability can be mitigated if you pass through the enemy, although it requires executing the dash attack within point-blank range, which in itself makes it risky.

Tilts

Move	Damage
Side tilt	4, 7
Up tilt	2, 6
Down tilt	6

Side Tilt: Sonic stands on his hands and extends a horizontal double-heel kick in front of him that hits twice, with the second hit launching foes away. Side tilt is a solid defensive option for punishing attacks outside your neutral attack range. During the attack, Sonic shrinks his hurtbox size, mitigating his vulnerability while extending a pronounced hitbox of his own. It's relatively unsafe when shielded, so it's best used from a distance or as a turnaround attack against a pursuer.

Up Tilt: Sonic performs a two-hit spinning roundhouse combo, similar to Captain Falcon's up smash, that launches the opponent up into the air for a potential follow-up juggle. Up tilt should only be used to pressure enemies standing on a platform above you or as an anti-air against descending enemies. It's highly punishable when shielded and leaves you exposed for a long time if you whiff it.

Down Tilt: Sonic delivers a crouching leg sweep that knocks enemies up into the air. Down tilt is a great poking tool that's relatively safe when shielded, especially if it's spaced at maximum range. It can also be used to punish a recovering opponent's ledge-grabbing vulnerability window if timed accurately.

Side Smash: Sonic leans back, winds up his arm, then unleashes a haymaker, driving his enlarged fist through the enemy. While it's not completely safe when shielded, side smash becomes safer when it's at least slightly charged up. You can use it as a turnaround attack to punish opponents chasing you.

Up Smash: After a brief standing pose, Sonic leaps up into

Smashes

Move	Damage
Side smash	14
Up smash	5, 1x6, 3
Down smash	12

a levitating ball attack. As he leaps, he knocks foes into the air, where he transitions into a five-hit spinning ball combo. The final hit launches foes upward. While up smash starts with some intangibility, it's punishable when shielded.

Down Smash: Sonic pounces up, then performs the splits, launching his legs out to his sides, clearing out the area of enemies. Like most clear-out smash attacks, Sonic's down smash is extremely unsafe to throw out carelessly. It's best used either to hit a ledge roll or as a counterattack after blocking if your attacker is behind you.

Grabs

Move	Damage
Grab attack	1.3
Front throw	7
Back throw	7
Up throw	6
Down throw	8

Sonic's grab reaches as far as his neutral attack. It starts up a tad slower than the fastest grabs, but since he's the fastest fighter in the game in terms of ground speed, he has little trouble getting into his grab range. His front and back throws are conventional throw attacks designed to KO foes near the side blast zones and to set up an offstage edge-guarding game. Up throw leads into the most potential damage and a juggle-trapping game as Sonic impales his victim with his spines, launching them directly above him.

Down throw is a unique one: he plants the ensnared foe into the ground, then grinds on them while he's in his ball form. Releasing them forces a tech get-up knockdown situation (the opponent can't act while airborne, but can tech). Sonic doesn't recover from his down throw animation early enough to capitalize on the opponent's tech get-up vulnerability window.

Aerial Attacks

Aerials

Move	Damage
Neutral air attack	12
Forward air attack	0.8x5, 3
Back air attack	14
Up air attack	3, 8
Down air attack	8

Neutral Air Attack: While airborne, Sonic transitions into ball form for a persistent long-lasting spin attack. It deals much more damage the earlier in hits in the attack. This versatile attack boasts relatively low landing lag and an excellent long-lasting hit effect as Sonic soars through the air, spinning and knocking up anyone he touches.

Forward Air Attack: Sonic dives through the air like a spiraling missile, driving his head through the enemy. Forward air hits up to six times, with the final hit knocking foes away. Forward air is primarily used in combos after certain launching attacks, such as off of down tilt, down air, or neutral air. It's punishable when shielded and has significant landing lag, so it should be left out of your air-to-ground neutral game.

Back Air Attack: In midair, Sonic thrusts his leg behind him with a forceful rear kick, launching enemies away. While it has a slow start speed, Sonic's back air deals the most damage out of his aerial attacks, making it a superb edge-guarding finisher attack. It has significant air and landing lag, so you can't throw out two in a single jump.

Up Air Attack: While airborne, Sonic executes a double-sided kick attack by driving his legs to his sides, then claps his legs together for a vertical launching attack that pops enemies upward. Up air is your best normal attack. It starts up quickly, hits both sides, and can be used in a vast array of situations.

Down Air Attack: Sonic briefly halts all of his air momentum before barreling down from the sky with a downthrusting dive kick. The kick deals more damage and can dunk enemies early on during Sonic's descent. The latter portion of the attack knocks foes up and away. Down air can be used to spike enemies off the stage near a ledge, but can be a bit risky. Generally, down air should rarely be used unless you can make a hard read on your opponent's air recovery.

Special Moves

Neutral Special: Homing Attack: Sonic transitions into ball form, leaps into the air and musters speed and power, then unleashes a homing spin attack at the closest enemy fighter. Press Special once to activate and charge Homing Attack, then press Special again to release it. Charging increases damage and knockback. Homing Attack has a lock-on and homing effect, but it can risky to throw out haphazardly. You should use it only if you've confused your opponent enough with Spin Dash and Spin Charge.

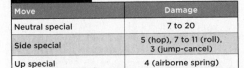

Special Moves

Move	Damage
Neutral special	7 to 20
Side special	5 (hop), 7 to 11 (roll), 3 (jump-cancel)
Up special	4 (airborne spring)
Down special	1, 2, 6 (special hop), 3 (attack hop)

Side Special: Spin Dash: Sonic revs up in ball form and quickly hops forward with a spin attack, landing with a high-velocity spin that he uses to smash into the enemy. The longer Special is held down, the faster Sonic's velocity and damage as he spins forward (his max charge speed is indicated by a bright yellow glow). During charge, you can jump to evade certain attacks, such as incoming projectiles.

Once Spin Dash is charged enough to where Sonic is engulfed in a yellow glow, he no longer performs the initial hop. Instead, he rolls forward speedily, smashing into grounded foes unless you manually input an attack to cancel into Spin Dash Roll Attack (a special up-forward angled attack/jump). While Sonic spins on the ground during Spin Dash, you can turn around up to two times. This can be used to punish shielding enemies.

Spin Dash has a brief intangibility window during the upward arc of the initial hop. This makes it exceptional against aggressive foes or those who challenge you from the air with an attack. Since there are so many options and attack sequences you can deploy from Spin Dash, it's one of the more difficult special moves in the game to master. But that also makes it one of the best.

Up Special: Spring Jump: Sonic deploys a reusable red spring beneath him that propels him high into the air. If Sonic deploys the spring while he's airborne, it drops beneath him, dealing damage to enemies it lands on. With grounded Spring Jump, you can continuously bounce—landing on a deployed spring restores your double jump. Bear in mind that, like Mega Man's Rush dog, anyone can use the spring. Sonic is intangible near the beginning of Spring Jump, making it a relatively safe recovery tool.

Down Special: Spin Charge: Sonic performs his iconic Spin Charge. After gathering enough power, he bursts forward, plowing through foes. Spin Charge behaves differently from most charge attacks in *Super Smash Bros. Ultimate*. Sonic's iconic Spin Charge is executed similarly to how it's done in the *Sonic the Hedgehog* games. You have to keep the down direction pressed while mashing the Special button to charge it—the faster your inputs, the faster you charge it up (when Sonic glows yellow, he's at max). It's important to note that you can "lose" charge if you slow down your inputs (Sonic's yellow glow can change back to blue). To optimize your charge time, mash as fast as you can, then release the down direction.

During and after charge release, you control Spin Charge in a variety of ways. You can cancel the charge by pressing the Attack or Jump button, causing Sonic to hop straight up with a low-damage aerial attack/jump (it behaves like a normal hop, cancelable into any of his air moves). If you release the down direction during charge, Sonic rolls forward until he hits an enemy. Change roll direction by using left or right on the control stick. Cancel the rolling attack with a jumping roll by pressing Attack, Jump, or Special. From this jumping rolling attack, you can perform any air move as if you hopped normally (including double jump and aerial specials).

Final Smash: Super Sonic

Sonic uses the Chaos Emeralds to turn into Super Sonic, then dashes left and right, crossing through the stage at supersonic speed. You can adjust the angle at which Sonic moves through the air slightly up or down.

Toon Link

OVERVIEW

Toon Link is relatively speedy and mobile for a fighter who specializes in projectile zone control, allowing him to pester foes while evading their attacks. Like Young Link and adult Link, his strengths lie in setting up traps with his myriad projectile options, alongside controlling the ground with his Boomerang and high-speed dashing. Toon Link's game plan revolves around safely unleashing Bombs, arrows, and Boomerangs from a distance. Smart projectile use is crucial. His on-the-spot dodges and side rolls are some of the fastest in the game, allowing him to punish aggressive foes in situations that others may not.

Many of Toon Link's melee attacks suffer from higher lag and slower start speeds when compared to adult Link's, and his throw combos are slightly weaker than with many other fighters. His close-range tools are best used to deter enemy aggression with their intangible hitboxes. Additionally, he's "floaty" compared to the other Links, making him slightly more vulnerable to juggle mix-ups coming from below.

Toon Link Vitals	
Movement Options	
Jumps	1
Crouch Walk	No
Tether	Yes
Wall Jump	Yes
Wall Cling	No
Movement Ranks	
Ground Speed	C (24)
Air Speed	C (40-43)
Falling Speed	D (55-56)
Weight	C- (48-49)

ADULT LINK VS. TOON LINK: KEY DIFFERENCES

Toon Link's Bomb behaves similarly to Young Link's and self-detonates, while adult Link's Bomb requires a remote detonation.

Toon Link has a ranged grab, which can ledge-tether, while adult Link's grab is a conventional close-range one.

Toon Link is much lighter than adult Link, so he's less susceptible to certain juggle combos, while being more susceptible to knockouts.

Toon Link cannot pick up his dropped arrows.

Toon Link is a much smaller target than adult Link.

Grounded Attacks

Neutral Attacks: Toon Link delivers a swift three-hit sword-slash combo, beginning with a simple one-two swipe sequence and ending with a forceful thrust that knocks victims back. Neutral attack is one of your primary close-range defensive options. It's used as an out-of-shield attack and to stuff enemy aggression. The third jab is relatively unsafe if shielded, while the first attack is safe, particularly when used at its max hit range.

Neutral Attacks

Move		Damage
Neutral attack 1		2
Neutral attack 2		2
Neutral attack 3		4

Dash Attack

Move	Damage
Dash attack	8

Defensive Attacks

Move	Damage
Ledge attack	9
Wake-up attack (faceup)	7
Wake-up attack (facedown)	7

Dash Attack: Toon Link pursues his foe with a running overhead slash that sends them diagonally up into the air. On hit, Toon Link's dash attack doesn't lead into a guaranteed combo, but does set you up for a potential dash-in juggle or more Bomb and Boomerang pressure. Dash attack is mainly used to pursue and punish descending enemies.

Tilts

Move	Damage
Side tilt	9
Up tilt	5
Down tilt	7

Side Tilt: Toon Link smashes his sword down into the floor. Its wide-angle arc covers the area above his head and his entire front side, knocking back enemies in the vicinity. Side tilt is mainly used to deter and stuff your opponent's approach. If an opponent is chasing you, stop with a turnaround side tilt to punish them with relative safety.

Up Tilt: Toon Link performs an upward sword-swipe attack above him. The attack arc begins in front and ends behind him. Foes struck by it are popped into the air for potential follow-ups. Up tilt is a relatively safe and quick attack. On hit, you can generally score multiple follow-up up tilts, potentially into an up air juggle. You can use it to punish enemy attacks on the ground or as an anti-air, and to complement your projectile traps.

Down Tilt: From a kneeling position, Toon Link sweeps at the floor in front of him with his sword, potentially tripping his foes. Like most down tilt sweep attacks, Toon Link's down tilt is safe on shield if spaced correctly and is good for dealing shield damage while minimizing your risk. If you poke with a max-range down tilt and your opponent commits to an out-of-shield option, you can bait out their attack and punish with your own side or down tilt.

Smashes

Move	Damage
Side smash	14
Up smash	13
Down smash	12 front, 13 back

Side Smash: Toon Link leans back and puts his all into a mighty uppercut slash, devastating foes in front of him and launching them away. Side smash is a slow uppercut attack with an impressive hitbox, but is unsafe if shielded. It should only be used to punish ultra-laggy attacks, or if you can predict your opponent's movement or attack.

Up Smash: Letting out a battle cry, Toon Link performs a powerful slash into the air that blasts enemies it hits high into the sky. Up smash can hit enemies behind you, but it's largely unsafe to use without heavy advantage. In most cases where you'd use up smash, up tilt is more effective and less risky.

Down Smash: Toon Link crouches down and clears out the area around him with a sweeping slash. Down smash's rear hitbox makes it decent for punishing ledge rolls and other enemy moves that leave them behind you. It has a reasonably quick start-up, but is easily punishable on shield and on whiff.

Grabs

Move	Damage
Grab attack	1
Front throw	7
Back throw	7
Up throw	7
Down throw	7

While grounded, Toon Link fires his ranged Hookshot, ensnaring his opponent. In midair, Toon Link's Hookshot knocks back and damages foes. While airborne and near a ledge, Toon Link's Hookshot acts as a grappling hook, allowing him to grab on to the ledge. Up throw can lead into trap and juggle mix-up situations where you can bait and punish air dodges and double jumps with up air attack. Front and back throws are used to knock out high-percentage enemies near ledges, or to set up your Bomb throw and Boomerang pressure.

Aerial Attacks

Neutral Air Attack: In midair, Toon Link delivers an aerial clear-out attack, swiftly swiping in front, followed by a rear slash. Neutral air has very low landing lag and a quick start-up speed. However, it can be unsafe if used at certain altitudes, as it leaves you more vulnerable as you perform the attack high in the air. It's best used defensively to cover both of your sides, or as an out-of-shield hop attack.

Forward Air Attack: While airborne, Toon Link performs a heavy upward sword swing that knocks away foes in front of him. Although not particularly quick on start-up, forward air attack is your safest air-to-air option since it has little air lag. You can use it to poke at enemy shields as long as you space and time it well (for example, as a short hop into pull-back attack). Its low lag allows you to short-hop forward air attack and immediately double-jump before you land. However, it has more landing lag than neutral air, so input neutral air before landing to avoid this.

Back Air Attack: Toon Link spins around in midair and slashes at the area behind him, knocking enemies higher. Back air has considerably less landing lag than his other aerial attacks, making it an excellent low-altitude air-to-ground poke against grounded foes. It's also a superb air-to-air attack with knockout potential and should be used for offstage combos against recovering enemies.

Up Air Attack: Toon Link performs his unique up thrust attack that launches foes into the air. Since Toon Link has a high jump and double jump, up air is superb for punishing enemy double jumps—it beats out most attacks and stays out long enough to beat air dodges. If you can bait your foe into a double jump during their descent, you can chase them up into the air and catch them with your upward thrust.

Aerials

Move	Damage
Neutral air attack	10
Forward air attack	8.5
Back air attack	8
Up air attack	11
Down air attack	16

Down Air Attack: While airborne, Toon Link boosts even higher before plummeting with a sword plunge that meteor smashes enemies below him. Upon landing, Toon Link's down air attack has a slight "windbox" (a non-damaging hitbox with a pushback effect). However, it's still a largely unsafe attack to whiff and to have shielded, so reserve its use for specific situations, such as for spiking enemies to their deaths as they're coming in from offstage.

Special Moves

Neutral Special: Hero's Bow: Toon Link draws and fires his bow, with the arrow traveling farther and dealing increased damage the longer the bow is drawn. Uncharged Hero's Bow is useful for poking at enemies from midrange, potentially racking up incremental damage or forcing them to shield, from which you can take advantage with a follow-up melee engagement. With good aim, you can use your arrows to harass offstage foes who are trying to recover.

Special Moves

Move	Damage
Neutral special	4-12 at max charge
Side special	8 normal, 9.6 smash-style
Up special	Ground 1x9, 3/Airborne: 4, 2x3, 4
Down special	4.2+(1.5-2.5)

Side Special: Boomerang: Toon Link chucks a Boomerang that knocks back foes and can potentially hit enemies during its return flight. You can increase the damage and range on your Boomerang throw by performing it with a smash-style flick+Special input. While this has its advantages, it also has a subtle disadvantage in that it takes longer for you to receive and throw another Boomerang. It can also be thrown upward or downward by holding the control stick in the direction you want it to go before Link releases it.

The Boomerang is one of Toon Link's most important attacks, and its use should be prioritized when you're given the space to throw it out. Boomerangs cover large portions of space and remain active for a long time, affording you powerful zone control.

Up Special: Spin Attack: While grounded, Toon Link performs a multi-hit spinning-attack combo sequence that pops his victim into the air for a potential follow-up. While airborne, Toon Link propels himself higher into the air while delivering a spinning-sword combo. Spin Attack can be used defensively, covering both sides. Its relatively fast start-up speed makes it a decent out-of-shield option, but is unsafe if shielded.

Down Special: Bomb: Toon Link pulls out a throwable Bomb that detonates after its five-second fuse timer ends, or if he successfully hits an enemy with it. Bombs also detonate after taking damage, or if they're ignited by fire-based attacks. They can nullify powerful projectiles as they're detonated on collision.

Bombs bounce off enemy shields, so if you advance with a dashing Bomb throw, you can potentially retrieve it with an aerial Grab input and immediately throw the Bomb again.

As Bombs are core to Toon Link's gameplay, learning how to use them in almost every situation is crucial. They can be applied in almost every combat scenario, such as dropping them onto ledge-hanging enemies, throwing them at offstage recovering foes, and even as anti-air against airborne opponents. Simply holding on to a Bomb can have an impact, as it can cause your foes to behave differently since they have to respect and fear your Bomb-throw potential.

Final Smash: Triforce Slash

Toon Link charges forward and traps his foes in the Triforce for his Final Smash. Then Toon Link strikes at foes repeatedly and launches them with force. Time the initial attack well—missing that first slash leaves Toon Link hanging.

Villager

OVERVIEW

Villager is a quirky and adorable fighter who packs much more punch than you might expect. He or she (it's up to you, there are many different looks for Villager, like with Inklings or Pokémon Trainer) might look unassuming, but Villager hides a unique array of long-range tools that are difficult to deal with. Pocket combines with Timber and Lloid Rockets to give Villager zoning and stalling dominance. Most far-reaching attacks opponents muster can be stored and reused by Villager, and Timber trees provide easy temporary cover. Villager can also wall-jump, adding to maneuverability options offstage, and the festive Balloon Trip move gives Villager incredible recovery potential...as long as no one snipes those extremely fragile balloons.

Villager Vitals

Movement Options	
Jumps	1
Crouch Walk	No
Tether	No
Wall Jump	Yes
Wall Cling	No
Movement Ranks	
Ground Speed	F (71)
Air Speed	C- (56-57)
Falling Speed	D (64-65)
Weight	C (44-47)

Grounded Attacks

Neutral Attacks

Move	Damage
Neutral attack 1	1
Neutral attack 2	1
Neutral attack 3	1, 2

Dash Attack

Move	Damage
Dash attack	10

Defensive Attacks

Move	Damage
Ledge attack	9
Wake-up attack	7

Neutral Attacks: Villager's neutral attack is a quick jab, not as fast as the fastest neutral attacks (like Zero Suit Samus's, as the very cream of the crop, or Mario's and Luigi's, still lightning-fast but not the very best), but it's not drifting into sluggish territory either. If you hold down the Attack button, Villager performs a flurry of punches one after another; upon button release he performs one final, extra-stout punch, dealing twice the damage of the others. If you use single taps to execute jabs, three taps make Villager perform three quick jabs into a fourth finishing hit. But if you simply hold the button down, he wails with left-right punches endlessly until release.

Dash Attack: While running, Villager takes a prat fall and drops a fragile potted plant in the process. The plant tumbles forward as a short-range projectile, which launches enemies on contact.

Side Tilt: You never know when it'll be a rainy day, so Villager is always packing an umbrella. For side tilt, he or she swings it in front, hitting with good range and making a kind of shield in front of Villager with the hitbox. Apart from poking at the edge of side tilt's reach, this swinging move can also be used to bat some projectiles back at their pitchers, like swatting King Dedede's Gordo Throws back at him.

Tilts

Move	Damage
Side tilt	9
Up tilt	5, 6
Down tilt	12

Up Tilt: Villager playfully waves a stick around in the air above. Villager starts the swipes aimed diagonally up-back, bringing the stick to up-forward twice. The two hits automatically combo, lofting victims into a low-altitude tumble.

The forward reach against grounded foes isn't exceptional, but it consistently picks them up if Villager is standing up close.

Down Tilt: Ever the amateur botanist, Villager takes a moment during down tilt to pluck an unsightly weed from the dirt. This does the most damage up close, where the weed emerges, but has a hitbox that reaches surprisingly far forward. This is just a hair slower to hit than side tilt, but has marginally more forward reach along the ground.

Side Smash: Villager is prepared for any occasion, whether it's a rain day, weedy terrain, trees to chop down, or a few frames of bowling fun. Villager reveals a bowling ball stashed somewhere, dropping it straight down in front. Midstage, side smash doesn't have a lot of use. It's extremely slow for a smash attack, and lacks exceptional range or hitboxes. At stage edges, the situation changes. Standing at a ledge, waiting for an opponent to try to recover, Villager drops the ball like normal, but with no ground to stop it, it picks up speed (and damage potential) as it plummets.

Up Smash: Villager sets up a little fireworks show, then braces, covering up ears to protect from the sound. There's a small hitbox at ground level when the fireworks stand detonates, shooting a few fun rockets up to short hop altitude. Four small fireworks are followed by a larger finishing blast, signaling the end of the festivities. If someone is struck by the initial fireworks launch, they're caught in the sparkling explosions too for a small combo, leaving them floating in the air and potentially comboable.

Smashes

Move	Damage
Side smash	17-20.4
Up smash	3, 1x4, 4-4.2, 1.4x4, 5.6
Down smash	6-8.4

Down Smash: When Villager gets to digging, he or she spades the dirt first in front, then behind, like with many clear-out-capable down smash moves. The shovel swing in front is fairly quick, not as fast as staple tilt pokes, but not as slow as most smash moves. The follow-up shovel swing aimed toward Villager's back comes out fairly slowly, though, so there won't be a reason to use it on purpose. If the backward shovel hits, it's likely to be incidental. Anyone on the ground who gets smacked by the shovel will find themselves temporarily stuck in the mud, partially buried by Villager's digging madness! Tack on more hits for free while the victim struggles to dig themselves out.

Villager has terrific reach grabbing with a butterfly net, but the grabbing speed is extremely slow, about the same as many uncharged smash attacks. Once the target's ensnared, front and back throws are good for pushing them toward or over an edge. Up throw puts them in the air above, in position for you to go for a midair combo. Down throw bounces them low, in place for you to try for a dash attack.

Grabs

Move	Damage
Grab attack	1.3x1-5
Front throw	9
Back throw	11
Up throw	10
Down throw	6

Aerial Attacks

Neutral Air Attack: Villager spins upside down in midair with his limbs splayed, each of them a tiny hitbox pointing in every direction. Damage is highest right when the move starts, but it stays out a decent amount of time, so it has lots of usefulness when airborne (especially since Villager's front and back air attacks are unconventional). It's great for jumping in at ground foes whether landing in front of or behind them, and whether fast-falling or dropping normally.

Forward Air Attack: For front and back air attacks, Villager wields a trusty, quick, low-power slingshot. These projectiles are tiny and fast, taking almost no commitment to fire all over the place. Up close, shots deal respectable damage, like other featherweight air attacks.

The damage deteriorates quickly with distance, but the damage isn't really what these are for. Slingshot slugs may seem piddly, but the space control is undeniable. They're good midstage for owning short hop airspace, and great past stage edges for harassing foes trying to recover. All that damage adds up; at higher percentages, they begin to deliver meaningful knockback on hit.

Aerials

Move	Damage
Neutral air attack	9
Forward air attack	7
Back air attack	9
Up air attack	13/10/8
Down air attack	13/10/8

Back Air Attack: Backward-facing slingshot rounds are functionally the same as forward air attacks. Back air just takes a tiny bit longer to fire. The slug hits slightly harder. If you're stalling, holding off foes with Lloid Rockets backed up by max-range slingshot rounds, you can maximize potential damage by keeping your back to the enemy while firing the slingshot in between Lloid deployments.

Up Air Attack: Villager swings upward quickly with a small harvest of turnips. This attack's damage is dependent upon how many turnips he's got. It'll be one, two, or three, and the result is random. More is much better: a three-turnip up air adds a lot to the attack's launch potential.

Down Air Attack: Villager attacks straight down with turnips. Again, more turnips is better (isn't this always true?). A three-turnip down air is a meteor smash, great for bounce combos midstage, and scoring KO's after tossing someone low offstage and chasing them. With Villager's great recovery ability, it's not that risky to fall off stages and engage with returning fighters. It's only a bit of a bummer if you score a direct down air hit on someone below but it ends up being a single-turnip smack.

Special Moves

Neutral Special: Pocket: Villager reaches out and collects whatever projectile or item is incoming. An icon by Villager's portrait indicates when an item or projectile is Pocketed. Input neutral special again to retrieve the item. In some cases, this puts the item in Villager's hand, ready to be wielded or tossed as normal. For projectiles—things that can't be held, exactly—Villager fires them off in normal form.

Special Moves	
Move	Damage
Neutral special	Varies
Side special	15.4/7
Up special	0
Down special	Varies

Side Special: Lloid Rocket: Tap the side special input to deploy Lloid Rocket and watch it jet across the screen, or hold Special down to stay aboard and take a fast track across the stage. If opting to ride Lloid Rocket along, you can hop off at any time with Attack, Jump, or Special inputs, though you'll drift helplessly until landing after hopping off. You won't typically want to ride Lloid, unless using the rocket's generous horizontal travel for offstage recovery. Usually you'll want to use Lloid Rockets as ranged attacks. Deploying Lloid Rockets and then following up on them is one of Villager's core strengths.

Lloid Rocket is also notable because it totally halts momentum when used in midair, even if you opt not to ride the rocket. Anytime you get hurled offstage, getting a Lloid Rocket out on the way back should be on your mind.

Up Special: Balloon Trip: Villager lofts upward, raised by colorful red balloons. Hold Special to flap arms rapidly for max altitude, or tap Special as desired to fine-tune height. This special move is almost unmatched for maneuverability, but has no attack portion. It's also variable. At first, you have two balloons for max airtime. But using and reusing this move lowers your stock of balloons.

Give Balloon Trip time to cool off, and balloons will fully replenish. Otherwise, used over and over, you'll be stuck with a single half-capacity balloon. Opponents can also pop balloons, which sends Villager plunging if none are left.

Down Special: Timber: This multistage special has myriad uses for an industrious Villager. With no saplings or trees on-screen, down special makes Villager attempt to plant a seed. You've got to be on solid ground for this; trying it in midair results in a confused Villager. With the seed rooted, down special becomes a short-range watering move. Water a planted seed enough (it doesn't take long), and it sprouts into a tree. An unwatered sapling persists for about 15 seconds before disappearing naturally.

With a sapling watered and grown, you have a happy little tree. Having a tree onstage does several things. For one, the tree becomes makeshift cover, blocking projectiles and thrown items. It's also a mild physical impediment, particularly powerful when planted on a stage edge against recovering opponents. Villager can move back and forth through a tree without any hiccups, but other fighters trying to walk or run past a tree are briefly slowed. A tree is also, potentially, a powerful weapon: chop a tree down with a couple hatchet swings and it falls away from Villager, slamming against anyone on the other side for 25% base damage. Chopping down a tree may also chip off a wood block for another 8% damage, which can then be Pocketed by Villager and used as an item.

Final Smash: Dream Home

Tom Nook come out of the woodwork to build Villager's Dream Home during this industrious Final Smash. Activate the attack close to your prime target to get the building underway, and anyone else caught in the construction takes damage too.

Wario

OVERVIEW

Wario's a heavyweight, but he's distinguished among bruisers by his motorcycle and by some of the best air speed of anyone. He can steer laterally while airborne quickly, and his neutral air and forward air attacks are both fast-hitting and long-lasting. Adding to that, Wario can pull out his Wario Bike special off the ground, plus the chance to jump again by ditching the bike—basically a triple jump. All that air speed is good for Wario's goal, which is getting in close for Chomp! Chomp is Wario's centerpiece, a healing throw with a long grabbing period that's perfect for springing on opponents just as they emerge from dodge rolls and ledge-climbing options. On top of letting Wario gnash on foes for self-healing and them-hurting, Chomp works on items. You can clear the board of pickups, both to deprive your opposition of them, and to refill Wario's health. Just watch out for explosives!

Speaking of explosives, something's rumbling in Wario's belly as the match progresses. The ever-present threat of the noxious Wario Waft grows the longer you hold it in. Keep the gas bottled up for two minutes or longer, and Wario Waft becomes one of the strongest moves in the game! Fully, uh, charged Wario Waft (combined with deft aerial Wario Bike ditching) helps make up for Corkscrew's predictable and rigid recovery path.

Wario Vitals	
Movement Options	
Jumps	1
Crouch Walk	Yes
Tether	No
Wall Jump	No
Wall Cling	No
Movement Ranks	
Ground Speed	D (44-45)
Air Speed	A (8)
Falling Speed	C (35)
Weight	B+ (11-15)

Grounded Attacks

Neutral Attacks

Move	Damage
Neutral attack 1	4
Neutral attack 2	5

Dash Attack

Move	Damage
Dash attack	11

Defensive Attacks

Move	Damage
Ledge attack	10
Wake-up attack	7

Neutral Attacks: Wario swings with a sluggish jab into a much bigger follow-up punch. With Wario's girth and the initial jab's stubby range and slow speed, this isn't the best sparring weapon. On the ground, down tilt and Corkscrew (up special) are both faster, and short-hopping neutral attacks and forward air attacks are about as fast and play more into Wario's strengths.

Dash Attack: On the run, Wario throws his weight into a burly body check. Hitting as the dashing tackle begins does the most damage and tosses victims the farthest. Hitting with later active frames does less damage, but flips them into the air over Wario. Watch out for this kind of contact for the pressure and combo opportunities it creates.

Tilts

Move	Damage
Side tilt	13
Up tilt	6
Down tilt	4

Side Tilt: For Wario's slowest tilt move, he swats with a giant slap, with better reach than neutrals and other tilts. This can be aimed slightly up or down. Damage and knockback are worse closer in, so aim with the palm.

The downward-aimed side tilt in particular is important for swinging at foes right when they try to grab a ledge for safety. The hitbox is perfect for knocking them off a would-be safe perch just as they arrive, before their ledge-hanging intangibility kicks in.

Up Tilt: Wario slaps upward with both hands, launching victims on hit. This is quick for Wario, the same speed as a neutral attack jab. It's great for slapping at airborne opponents, but it doesn't offer the side coverage of many up tilts. It might hit point-blank enemies on either side, depending on their posture and everyone's momentum and so on, but it also might not. For reliable double-sided protection, use down smash.

Down Tilt: Crouching down, Wario jabs at toes with a big flat hand. This is Wario's fastest move, he shifts down a little while doing it, and the reach is decent. It's a good "what now?" option for poking on the ground at nearby foes, before returning to Wario's primary diet of short hops and Chomp attempts. It can trip low-percentage enemies for a moment, and combo into itself if used repeatedly at middle to high percentages.

Side Smash: Wario leans back briefly before stepping forward and swinging a comically oversized first, striking backhanded. They'll feel it when this hits, with great damage and knockback. The huge fist is mostly just a hitbox, intangible to any clashing enemy moves. The problem is that it's relatively slow to hit, and leaves Wario wide open if you miss, or if targets spot-dodge or dodge-roll through it.

Smashes

Move	Damage
Side smash	20-28
Up smash	17-23.8
Down smash	13-18.2

Up Smash: His head swelling to proportions that match his ego, Wario swings rapidly above with a headbutt. His huge head is intangible just before and during the first active frames, giving this great priority against descending moves. It's about as fast as side tilt, not one of Wario's very fastest, but not getting painfully slow either. It launches victims straight up in a vulnerable position if they don't shield or dodge. It also covers three angles, though you don't have margin for error on aim because it's active so briefly.

Down Smash: Wario falls down and spins like a top on his back, wobbling quickly between front-leaning and back-leaning hits. As he spins three times, his damage (and the size of the hitbox around his body) starts out big and diminishes bit by bit each spin. This requires a lot less timing precision for something that hits both sides than up smash, and hits faster too. Contact with foes on either side blasts them away far and low, buying Wario breathing room.

Wario's grab is standard-issue for a heavyweight, and matches the speed of his neutral attack. This isn't too bad, considering how agile he is in the air. Not to mention that his neutral special, Chomp, complements his hopping rushdown and grab games, adding literal teeth. It's the same speed as a regular grab with a tiny bit more reach, it has an active throw hitbox for over twice as long, and it can be used in midair. On the other hand, it's much riskier to whiff Chomp than a normal grab.

Grabs

Move	Damage
Grab attack	1.6
Front throw	4, 8
Back throw	7
Up throw	4x2
Down throw	4, 7

When going for normal grabs, front throw can hit other enemies in close, if they're in the way. Back throw spins the enemy for momentum before the throw, which clears out any number of fighters on both sides! Up throw knocks them upward with a double-fisted punch, leading to combo opportunities right away above. Back throw bounces them behind Wario, not in position for a juggle hit but ripe for you to pursue with a dash attack or hopping move as they try to tech.

Aerial Attacks

Neutral Air Attack: Neutral air is essentially two attacks. It begins as a fast two-sided clear-out, with Wario's arms outstretched. This is good for going up against other airborne foes, or for jumping in on enemies on the ground. Once Wario stops spinning and hitting with his arms, he falls with a belly flop. The belly-flop portion lasts a third of a second. If it hits, it launches victims up into the air.

Aerials

Move	Damage
Neutral air attack	6
Forward air attack	7
Back air attack	12
Up air attack	13
Down air attack	1.3x6, 4

Forward Air Attack: Wario juts a big foot out right in front for an agile dropkick. This hits fast, with decent damage and a generous active period. Though not quite like neutral air attack, it's enough for sticking out above foes before dragging it down on them with fast fall. This is one of Wario's most important pokes, whether short-hopping or pursuing helpless or recovering targets. Knockback is low, which means you can go right into quick ground moves after using forward air attack last-moment on a standing target. Like neutral air, this has very little landing lag, making it great for moving from air to ground-based offense.

Back Air Attack: This backward-leaning surprise headbutt hits with the crown of Wario's huge head. The damage and knockback are high, and it covers a small arc from up-back to down-back. The lag on landing is bad, since Wario thuds on his side. It's okay for smacking grounded enemies if your back's to them in midair for whatever reason, but try to land at max range from them and don't expect follow-ups. Back air is mainly for aiming at jumpers behind midair Wario.

Up Air Attack: Wario attacks upward with an oversized clap, just where the hands meet. It might look like it, but it doesn't cover along Wario's palms until they meet. Like up smash on the ground, up air doesn't have a long active period, so aim it well to keep foes bouncing off Wario's hands. Up air has lots of air lag after use, so you'll likely drift all the way back to the ground afterward, unable to double-jump for combos and second tries. The hitbox on the clap, being high above Wario, also doesn't make this suited to jump-in use on standing enemies.

Down Air Attack: Spinning upside down like a drill, Wario lands a multi-hitting downward combo in one attack. This packs a lot of hits into a short period, active for as long as forward air attack. This means it's relatively easy to get most or all of the hits, compared to similar blender multi-hits. Wario can be steered a bit while he spins. The final hit is harder than the rest and sends victims soaring up into the air.

Special Moves

Neutral Special: Chomp: Wario opens his maw wide, looking to feed his gluttonous appetite. If enemies are trapped by Wario's bite, maximize the chewing by mashing on the Attack or Special buttons (the max possible number of bites is eight, dealing 25.8% damage to the chewee while refilling 4.8% of Wario's damage!). Chomp, like normal grabs, cannot be shielded. After a few bites, foes escape naturally, taking heavy damage while Wario regains some health. Chomp can also be used to eat items and motorcycle parts, removing them from the field while granting some health to Wario. Chomping down food items instead of picking them up normally also enhances their heal amounts! Chomp starts being active with the same speed as his regular grab attempts, heavyweight-grade, but it stays active for over *twice* as long.

Side Special: Wario Bike: Wario mounts his gnarly chopper and bears down on anyone in front of him. Wario doesn't mount the bike quickly; getting going on the bike is like using a sluggish smash attack. Once it's going, you have tons of options with one of the game's most variable specials. Whenever the bike eventually is destroyed onstage or ditched off of it, it takes five seconds before Wario can reuse this special, summoning another rumbling hog.

On the ground, holding forward accelerates to max ramming speed. Leave the control stick neutral, and Wario lumbers forward on his bike at idling speed, hitting for much less damage. The bike's actual hitting area is around the engine and headlight (not the front tire). If starting Wario Bike in midair, he whips out the chopper and mounts it, then glides to the ground. Hold back to tilt the front wheel up, or forward to angle the front wheel down toward the ground. A bike gliding toward the ground also has a hitbox toward the front around the engine.

Special Moves

Move	Damage
Neutral special	2.6x3+, 5
Side special	Varies
Up special	5, 1x4, 4
Down special	Varies

Wario Bike Damage

Bike State	Base Damage
Driving (faster for more damage)	0.6-11.2
Gliding (air hit)	3.9-7.5
Turning skid (tap backward)	7, longer pivot skid at higher speed
Rising wheelie (tap up)	8.3, launches
Popped wheelie	5
Wheelie drop (hold down to drop faster)	13
Driverless bike slowing (ditched bike)	3.5
Lateral bike toss	-10, -13 with smash-style input
Vertical bike toss	-14, -18 with smash-style input

Tapping backward sends Wario into a skidding turn, creating a brief hitbox behind the bike as it skids backward before Wario speeds off in the other direction. The faster the bike is going before a skidding turn, the longer the turn skids backward, and the longer the skidding hitbox behind the bike persists. While driving forward, tap up to pop a Wario wheelie. The front tire issues a launching hit on the way up. Wario pumps his fist twice with the front wheel fully popped, then brings the front tire crashing back down for another launching hit. Then he keeps speeding forward as normal.

The bike can be ditched anytime with any Attack/Special/Jump button input. Wario leaps off the bike as it begins to slow. This is a normal jump, allowing air moves, a double jump, and air dodges. While the bike slows to a stop, it can still hit enemies for slightly reduced damage. The faster you're going when you bail, the longer the bike persists as a projectile on the ground. Once it runs out of momentum, it falls over.

Up Special: Corkscrew: Wario blasts himself upward with a launching hit directly in front at the beginning, then multiple blender hits on the way up. After the attack ends, Wario drifts down, helpless until landing. Tap left or right *immediately* after inputting up special to make Wario take a diagonal trajectory instead of flying straight up, great when using Corkscrew for offstage recovery back to a safe ledge. Corkscrew's travel distance isn't amazing, and it's predictable for enemies, so put double jumps and airborne Wario Bike to good use as well to make recovery plays less obvious.

Down Special: Wario Waft: All that Chomping and gloating adds up to some fiendish indigestion and gas. Over time, as Wario fights, he builds up nauseating pressure in his gut. Wario Waft charges, um, automatically, just by Wario's dietary habits and gut bacteria doing their thing. You don't have to do anything but avoid using down special. The longer you go between Wario Waft releases, the more pressure piles up. The more you charge Wario Waft, the higher the damage when it's finally used. Longer charge times also result in faster fart releases. Wario Waft doesn't stop charging for anything, not until the match ends; even losing a Wario stock doesn't reset his gut's progress. This guarantees that you'll get a chance to use more powerful Wario Wafts no matter what, given enough time.

Wario Waft Damage	
Charge Time	Damage
0-14s	0
15s	12
30s	13
45s	14
1m	21
1m15s	24
1m30s	26
1m45s	28
2m	27 early, 20 late

Between zero and 15 seconds of charge, Wario Waft is fairly slow to release, about like an average side smash, and deals no damage. It temporarily stuns anyone close enough to Wario to get a whiff. Between 15 and 59 seconds of charge, Wario Waft's activation is faster, just a hair slower than his neutral attack jab. Between 60 and 119 seconds of charge, Wario Waft's activation speed is very fast. Only Wario's down tilt hits marginally quicker. Power and knockback between one to two minutes of charge are very high, making Wario Waft a potent instant KO move on opponents with high damage (80%+) built up. With over two minutes of held gas, Wario flashes and begins glowing to indicate a full charge. Fully pressurized Wario

Waft becomes a different attack entirely. The release speed slows a bit—not as fast as farting with a charge between one and two minutes, but not as slow as a charge between 15 seconds and one minute, either. The initial tooting hitbox is much bigger around Wario, launching him upward rapidly—fully-charged Wario Waft catapults him upward higher than double-jumping! He doesn't lag after he stops rising, so you can perform other actions.

In general, you should save Wario Wafts for at least one minute at a time, gaining access to a potential KO move for anyone who slips up near Wario. Try to get a sense for the timing and pace of matches, so you know when a killfart is ready for deployment. If you happen to sit on Wario Waft until Wario glows, adjust your plans to account for the one-time-use super-move you've stocked.

Final Smash: Wario-Man

Prepare yourself for the most aromatic Final Smash in *Super Smash Bros. Ultimate*. Wario starts by rushing horizontally, so line up desired targets even with him for cutting loose. If he hits anyone on his initial dash, he transitions into a superhero montage of heroic Warios smacking the victim from every direction, before the lead Wario finishes them off with the mother of all farts.

Wii Fit Trainer

Wii Fit Trainer Vitals

Movement Options	
Jumps	1
Crouch Walk	Yes
Tether	No
Wall Jump	Yes
Wall Cling	No
Movement Ranks	
Ground Speed	C (26)
Air Speed	C (49-51)
Falling Speed	D (67-69)
Weight	C+ (32-35)

OVERVIEW

As you might expect from world-renowned workout instructors, Wii Fit Trainers (both female and male variants) are quick and powerful fighters with lots of athletic tricks hidden up their sleeves. For one, these lithe fighters have a version of crouch-walking by holding down-back or down-forward on the control stick. Lying prone, Wii Fit Trainer hops forward or backward with little push-ups! Wii Fit Trainers can also capably wall-jump, increasing recovery ability.

Unusual among combatants, most of Wii Fit Trainer's poking attacks cover both sides, including the standard neutral attack jab. Neutral attack, side and up tilt, all smash attacks, and the Super Hoop up special all hit both to the front and back.

Grounded Attacks

Neutral Attacks

Move	Damage
Neutral attack 1	2
Neutral attack 2	2
Neutral attack 3	3

Dash Attack

Move	Damage
Dash attack	10

Defensive Attacks

Move	Damage
Ledge attack	9
Wake-up attack (faceup)	7
Wake-up attack (facedown)	7

Neutral Attacks: Wii Fit Trainer's routine begins with a simple arm stretch, leg extended backward for balance. Both the extended arm and foot have hitboxes (along the area under her arm, accounting for crouchers), so Wii Fit Trainer covers front and back with a quick neutral attack! Hold down a neutral attack input, and Wii Fit Trainer whiffs this attack until you let go. On hit (or whiff if tapping instead of holding neutral attack), Trainer goes from extending an arm to a raised deep-knee stretch, which falls into a forward lunge. Wii Fit Trainer moves forward a little during this three-hit combo. The hitting area for the second and third stretches surrounds the forward knee. Enemies struck by the third hit—the knee lunge—will find themselves planted in the dirt briefly, until they shake out of it.

Dash Attack: From a dash, Wii Fit Trainer slides to a stop while executing a side and spine-bending stretch. The torso is tilted sideways with both arms extending forward, making a big launching hitbox in front. The launching angle is slightly different depending on whether you hit early or late with the dash attack's hitbox.

Side Tilt: Wii Fit Trainer's side tilt attack is a buffer version of the first neutral attack poke. Wii Fit Trainer extends one arm forward and slightly down, while raising one leg high in back. This strikes enemies on either side. In front, the arm jab works as a quick poke. More surprisingly, the raised leg in back works as a weak launcher! This doesn't have much range, but can provide incidental coverage to Wii Fit Trainer's back in party battle modes, not to mention allowing you to use a "wrong direction" side tilt as an anti-air against someone falling in behind. If you *do* pop someone up right behind Trainer with the back coverage of side tilt, you can usually combo them.

Up Tilt: For this twist and stretch, Wii Fit Trainer reaches high with one arm while reaching toward the ground with the other. The result is a poke that points straight up, the arm intangible to help Wii Fit Trainer beat out incoming air attacks. Hits with the upstretched arm pop victims straight up, but Trainer's toned backside during this stretch also has a small hitbox, which can pop foes up at a slight diagonal angle behind Trainer.

Down Tilt: Lying on the ground, Wii Fit Trainer starts the beginning of a tabletop stretch, arching knees upward in front while his or her shoulders are still on the ground. Down tilt slides Trainer forward during execution, though he or she flips back to the original position during the lag after the hitting portion ends.

Side Smash: Wii Fit Trainer steps forward and extends both arms out to either side. The hitboxes on both arms extend a generous bit past and around his or her hands, giving this great priority even if the arms aren't technically intangible. The only catches are that attacks coming from straight above or below will hit Wii Fit Trainer in the vulnerable head/legs, dodging the arms entirely.

Up Smash: Trainer crouches a bit, placing palms together, before jabbing them straight upward. Fully extended, the arms stretch well above the head, covering low airspace, as well as providing a supplemental hitbox around Wii Fit Trainer's torso. Up smash is one of Wii Fit Trainer's most useful attacks, since it's fully intangible as the strike starts, it covers either side up close while also shooting down jumps and short hops, and adds a high-damage juggle-combo tool.

Down Smash: From all fours, Wii Fit Trainer extends one arm straight forward and the opposite leg straight back. This works the core and hits anyone in front or behind. The low profile and generous hitboxes on leg and arm enable this to knock away anyone encroaching on Wii Fit Trainer on the ground, but beware that this attack has slightly below-average speed for a smash attack intended as a panic tool used to get multiple people off you.

Tilts	
Move	**Damage**
Side tilt	11
Up tilt	10
Down tilt	13.5

Smashes	
Move	**Damage**
Side smash	15.5-21.7
Up smash	18.0-25
Down smash	12.0-16.8

Grabs	
Move	**Damage**
Grab attack	1.3x1-5
Front throw	3, 7
Back throw	3, 6
Up throw	8
Down throw	7

Wii Fit Trainer's speed, two-sided poke attacks, and quick grab work together to give him or her a powerful throw game. The forward throw spikes the victim forward like they're a volleyball, while the back throw plants both feet squarely on them before kicking them away. The up throw variant is a typical juggle starter, enabling Wii Fit Trainer to immediately attack upward for a combo. Finally, the back throw bounces the victim slightly behind Wii Fit Trainer, also enabling combos.

Aerial Attacks

Neutral Air Attack: Wii Fit Trainer begins sprawled, arms and legs out with hitboxes around hands and feet. Hitting with these early portions launches the victim up over Trainer. Hit in front, and they're popped up and over to Wii Fit Trainer's back; hit in back, and they're popped over to the front. After these initial hitting frames, limbs out, Wii Fit Trainer scissors arms and legs upward. The move's damage is at its peak when arms and legs meet, and the hitbox is like a big circle centered on Wii Fit Trainer's knee.

Forward Air Attack: Forward air attack is like grounded neutral attack, hitting up-forward with a stretched arm and down-back with a leg jutting for balance. When aiming with the front side of the attack, you want to come up at higher-altitude targets, launching them diagonally up and away. If targets are behind and below Wii Fit Trainer in the air, the hitbox on the back leg can spike them quickly downward! This rear-hitting kick can also work as a kind of "cross-up," falling right past someone on the ground.

Back Air Attack: Wii Fit Trainer enacts a little cat-pose stretch while floating through the air, sticking both legs out behind. This is Wii Fit Trainer's fastest-hitting air attack, striking slightly faster than up air attack or even neutral air attack. Only on the initial leg extension does this do full damage, so aim to hit with the beginning of the attack.

Up Air Attack: In midair, Wii Fit Trainer makes an arm steeple and rotates the upper body in an arc going from front up to back. This is great for opening up the obliques and traps, as well as covering all upward angles while in midair. There's no intangibility on Wii Fit Trainer's limbs here, but the hitbox extends well above his or her hands, so the priority is still terrific.

Down Air Attack: This aerial downward-leg extension is slow for an air attack, hitting in about the same time as most uncharged smash attacks, but has great use on direct hits against someone immediately below. At medium-damage percentages and higher, centered down air hits bounce victims off stages for juggle combos, or simply kick them straight down into pits before they can react.

Aerials

Move	Damage
Neutral air attack	9
Forward air attack	12
Back air attack	13.5
Up air attack	10
Down air attack	13

Special Moves

Neutral Special: Sun Salutation: Upon first input, he or she begins charging. Wii Fit Trainer can interrupt the charging pose if desired, like if aggressors are incoming. In midair, you can cancel Sun Salutation's charging by double-jumping or air dodge; on the ground, it can be canceled by rolling to either side, an on-the-spot dodge, or jumping. Otherwise, when the follow-up shot is fully charged, Wii Fit Trainer stops charging automatically. You can build up a full charge in bits and piece, picking up a little more charge whenever it's safe to do so. Sun Salutation's power can vary from fairly weak for an instant shot (starting charge, then immediately firing for a small shot), to very strong for a fully charged projectile.

Side Special: Header: Wii Fit Trainer tosses a soccer ball a short distance straight up, leaping afterward to spike it with a sick Header. This is a projectile setup, a projectile shot, and a physical attack rolled into one move. Tap the initial input, and Wii Fit Trainer automatically heads the ball down-forward at about a negative 30-degree angle. It travels in a gently diminishing slope until it bounces off a surface or fighter.

Special Moves

Move	Damage
Neutral special	5-21
Side special	15 head, ~6-9 ball
Up special	5x3
Down special	0

Tap the initial input, then press it again right away to make Trainer headbutt early, on the way up instead of at the top. This launches the ball more outward than down-forward, so its descent is more of a gentle curve than a direct line. Once gravity catches up with the ball, it falls at more of a negative 45-degree angle. Either way, a spiked ball bounces for several seconds before disappearing; striking it again while it's traveling redirects it, so one projectile can essentially be reused! This can keep up until the ball naturally disappears. Beware that a soccer ball in play might get used against Wii Fit Trainer; enemies can hit the ball to bat it right back at Trainer, or to knock it out of his or her control before the Header connects!

Up Special: Super Hoop: Wii Fit Trainer crouches low, before jumping upward, gracefully swiveling to spin three Hula-Hoops at once. The crouching windup is the only preamble, as the attack is active as soon as Trainer is surging up from the squat. Each Hula-Hoop can hit each opponent one time, making this a potential three-hit combo by itself. Unusually, the Super Hoop up special can be directed left or right during the ascent. At the end of Super Hoop's upward travel, Wii Fit Trainer drifts down, unable to act again until landing (besides steering the drift). The primary purpose of this move is recovery from offstage. Rapidly tap the Special button during travel to float even higher, up to 50% more than without mashing the input.

Down Special: Deep Breathing: Trainer's down special begins a deep inhalation, indicated by a shrinking circle closing in on Wii Fit Trainer. Once the shrinking white circle overlaps the solid red circle over Wii Fit Trainer, press the Special or Attack button to complete the breath. Properly done, this slightly reduces Wii Fit Trainer's accumulated damage, and temporarily increases his or her damage and knockback dealt! The buff to damage potential lasts for just under 10 seconds.

Since the buff lasts 10 seconds, which isn't really very long, it's important to judge when it's a good time to apply Deep Breathing for maximum effectiveness. One obvious place is right after hitting or throwing someone a long way off the stage; before they drift back within sight of a ledge, you should have time to take a short deep breath, making sure any moves you take to keep them from returning have a little extra pep.

Final Smash: Wii Fit

With the energy from a crushed Smash Ball (or filled FS Gauge) coursing through your favorite personal Trainer's veins, he or she is ready to lead the most brutal workout in *Super Smash Bros. Ultimate*. Upon activation, Wii Fit Trainer strikes a pose and sends forth an army of aerobic athlete silhouettes, finishing with a gigantic final shadow emulating the look of Wii Fit Trainer's backturned side tilt. Of all the Final Smashes in the game, this is one of the farthest-reaching, laterally, so just line up as many adversaries as possible on one side, then invite them all to join the sweat session.

Wolf

Wolf Vitals

Movement Options	
Jumps	1
Crouch Walk	No
Tether	No
Wall Jump	Yes
Wall Cling	No
Movement Ranks	
Ground Speed	D- (59)
Air Speed	A (6-7)
Falling Speed	B+ (10-15)
Weight	C (44-47)

OVERVIEW

Wolf is the heaviest out of all the *Star Fox* fighters, and while he shares a similar special-moves kit with Fox and Falco, he plays much differently, with his fighting style centered more around baiting and punishing with heavy damage. His claw-based attacks deal more damage, have a range advantage over Fox's normal attacks, and are only slightly slower (but still decently quick, particularly his neutral attack and grab).

Wolf's main drawback is his ground speed, with both his walk and dash speeds being subpar. His aerial attacks aren't as versatile as Fox's, but each of them serves its intended purpose well, with neutral air attack and forward air standing out as staple attacks. He can also wall-jump, giving him an additional tool in his offstage recovery phase.

Your general game plan with Wolf is to pressure enemies with the threat of your powerful attacks, luring out mistakes and punishing them for misplacing and mistiming their attacks. Although Wolf's Blaster projectile is noticeably laggy, its range, damage, and travel speed are good enough to damage enemy shields, forcing foes into repositioning.

Grounded Attacks

Neutral Attacks

Move	Damage
Neutral attack 1	2
Neutral attack 2	2
Neutral attack 3	4

Dash Attack

Move	Damage
Dash attack	11

Defensive Attacks

Move	Damage
Ledge attack	9
Wake-up attack	7

Neutral Attacks: Wolf slashes a nearby foe with a three-hit claw combo, starting with a swift one-two strike and finishing with a heavy reverse right-handed slash that sends enemies away into the air. Wolf's jab is faster than average with decent reach. The first neutral attack is safe when shielded, while the second and third hits aren't. It's a solid finisher against high-percentage foes near the screen's edge, especially as a whiff punisher or post-blocking counterattack.

Dash Attack: While running, Wolf drives his boot into the enemy's midsection, popping them directly above him. Connecting with the initial active window of this attack pops the enemy up (and deals more damage) for a potential combo follow-up, while hitting with the latter portion simply knocks them back. Dash attack is one of your main whiff-punishing attacks from midrange and can be used to chase down retreating airborne enemies.

Side Tilt: Wolf leans forward and, with both claws, performs a vicious heavy slash in front of him. Wolf's side tilt can be angled upward or downward with the control stick. Upward side tilt is especially useful as an anti-air and for following up pop-up attacks. Side tilt deals considerable damage when both hits connect just short of max distance.

Its overall speed is excellent, making it a solid attack for checking enemy aggression, thanks to its range and relatively quick start-up.

Up Tilt: Wolf delivers a high front kick with an arc that covers his entire front side and the area directly above his head.

While it doesn't have a generous horizontal hitbox like Fox's up tilt, Wolf's up tilt can hit small crouching foes in front of him. On hit, it launches the enemy into the air. Wolf's up tilt isn't as versatile as Fox's wide-angle up tilt, since it doesn't cover his rear at all, so you have to reverse up tilt (up-back tilt and attack) to hit foes behind you. It's also punishable when shielded.

Tilts

Move	Damage
Side tilt	5, 6
Up tilt	10
Down tilt	6

Down Tilt: Wolf crouches down and delivers a swift leg poke aimed at his foe's feet. Down tilt is fast, but is limited in its range and end lag. Since it lacks range, it's generally punishable by most jab attacks when shielded. If it hits, it doesn't lead into a combo unless your opponent misses their tech get-up.

Side Smash: Wolf forcefully drives his left palm forward, blasting away foes. Side smash is a much less practical version of side tilt. It has less range, a smaller hitbox, and a slower start-up speed. However, these drawbacks are balanced by its shield-stun and end lag, making it quite safe as long as it connects with a foe, hit or shielded. It's decent for safely dealing shield damage against defense-oriented foes, but it may be difficult to find spots to use it.

Up Smash: Wolf performs a sweeping windmill kick attack, popping up foes directly above him, then launches them into the sky with a springboard kick. The first part of up smash is a low sweep that can covers both sides, while the second half is an anti-air launcher. Although it leaves you vulnerable on whiff, it's a solid option that can punish laggy attacks and ledge rolls thanks to the clear-out effect of the initial active hit. It's particularly effective for KO'ing foes at relatively high percentages.

Smashes

Move	Damage
Side smash	15
Up smash	6, 12
Down smash	16

Down Smash: Wolf crouches down and delivers a powerful sweep attack in front of and behind him with his right claw, blasting away anyone nearby. While it's punishable by most jabs when shielded, Wolf's down smash has a lot of shield pushback so that only far-reaching counterattack jabs hit. The rear sweep is even safer on shield. Use down smash to punish air dodges and ledge rolls or to clear out foes around you in free-for-all brawls. It can leave you exposed to reprisal if you whiff it fishing for hits on foes.

Wolf swiftly reaches out and ensnares the enemy by the collar. Wolf can grapple-attack almost immediately after successfully grabbing an enemy, so you're likely to sneak in a few before going for a throw. Up throw deals the least amount of direct damage, but potentially leads into the most damage overall. Back throw has the most off-screen KO potential, while front throw leaves the enemy relatively close by. Down throw is lackluster in both direct damage and potential damage since it doesn't bounce the opponent into the air (they're simply knocked back away from you).

Grabs

Move	Damage
Grab attack	1.3
Front throw	9
Back throw	11
Up throw	7
Down throw	8.5

Wolf's grab range is comparable to his neutral attack, giving him a solid mix-up between the two while he's within jab range. Grab is also an excellent punish option just after blocking, thanks to its above-average range and speed.

Aerial Attacks

Neutral Air Attack: While airborne, Wolf delivers a long-lasting kick attack. It deals significantly more damage early on. It's not as fast as Fox's neutral air, but it serves a similar purpose. Its persistent hitbox makes it a great air-to-ground fast-falling attack and offers good combo potential. Neutral air is a good "walling" tool thanks to its enemy-deterring persistent hitbox, effective from both jumps and short hops. However, it has considerable landing lag, making it relatively easy to punish when shielded if you land too close to the enemy, so don't be too predictable with it.

Forward Air Attack: In midair, Wolf performs a far-reaching claw slash aimed downward. The attack starts above his head and knocks foes up into the air, potentially setting up a juggle opportunity. Forward air is fast, has a high-priority hitbox extending forward, and covers a wide angle. Due to its versatility, forward air is one of your staple attacks. It's a strong air-to-air that can beat out incoming attacks because of its extended reach. Off of a deep forward air, you can almost always score a combo follow-up. The main drawback of Wolf's forward air is its landing lag, so connect with it as low to the ground as possible.

Aerials	
Move	Damage
Neutral air attack	12
Forward air attack	9
Back air attack	15
Up air attack	12
Down air attack	15

Back Air Attack: Wolf performs a powerful rear heel kick, knocking back foes behind him. Out of all his aerial attacks, back air has the least amount of landing lag (unless you land during its start-up period). It's not a particularly strong combo-starter since its knockback effect is largely horizontal, but it's an excellent air-to-air edge-guarding attack with a high amount of knockback. While it's not versatile, it fills its role well as a finishing move against offstage fighters.

Up Air Attack: Wolf swings his claw in a wide arc above his head, launching airborne enemies higher into the sky. Up air attack starts up quickly, has significant landing lag, and is active briefly. Its hitbox only covers the area above you, so it doesn't hit most grounded fighters, making it strictly an air-to-air anti-air and combo tool. While it has its downsides, it makes up for those with speed, launching power, and a high-priority hitbox.

Down Air Attack: Wolf descends upon his foe with a vicious double-clawed meteor smashing attack. Down air attack is incredibly slow, but incredibly powerful. It almost always causes a spiking meteor smash effect on hit (at around 50%), making it a superb finisher against offstage recovering enemies. However, its slow start-up speed can make landing it difficult. It has the most landing lag out of all his aerial attacks, so you need to be precise and deliberate.

Special Moves

Neutral Special: Blaster: Wolf draws his Blaster while simultaneously stabbing its attached blade in front of him before firing off a Blaster shot. Blaster is a unique special in that it functions as both a melee and projectile attack. When he draws his gun, he extends a horizontal hitbox, fires the gun, then swings the melee hitbox upward, ending above his head. The melee arc can potentially be used as an anti-air against short-hopping aggressors. Blaster is a decent midrange zoning tool to force action from your opponent, although it can leave you vulnerable due to its significant lag.

Side Special: Wolf Flash: Wolf rockets forward and into the air at an angle with a two-part slashing attack. The first slashing attack while he flies through the air launches foes for a potential combo follow-up, while the second aerial slash attack has a meteor smash effect. You can alter the angle of this attack by holding up or down on the control stick as Wolf readies the attack. Like Fox's side special, Wolf Flash is largely used as a recovery tool, with the potential to hit edge-guarding opponents.

Special Moves	
Move	Damage
Move	Damage
Neutral special	8, 6
Side special	Dash: 3, Claw: 20 (15)
Up special	3.5, 1.5x3, 5
Down special	Activation: 4, Reflected projectile: 1.5x

Up Special: Fire Wolf: Wolf becomes engulfed in blue energy that damages nearby foes. He then transitions into a multi-hit flying kick in any direction, dragging enemies with him before launching them away. Fire Wolf is a recovery option that can be launched in any direction with the control stick as Wolf is charging up the attack. It's a high-risk maneuver and is generally best saved as a recovery tool to get back onto the stage. It has considerable launching power.

Down Special: Reflector: Wolf activates a projectile-reflecting barrier. Reflected projectiles deal an additional 50% of their base damage. Wolf's Reflector has a significantly longer start-up than Fox's, but deals more damage overall, in both its activation hit and projectile-multiplier effect. As Wolf is a heavyweight fighter with subpar ground speed, Reflector is a handy tool that gives him a way to deal with zoners. Since he can't outmaneuver foes as well as Fox can, Wolf can potentially make more use out of Reflector.

Final Smash: Team Star Wolf

Wolf displays a targeting reticle in front of himself, which can lock on to opponents. If you catch an opponent in the attack, Wolf's team shows up and aids you by firing on the target.

Yoshi

Yoshi Vitals

Movement Options	
Jumps	1
Crouch Walk	Yes
Tether	No
Wall Jump	No
Wall Cling	No
Movement Ranks	
Ground Speed	B- (17)
Air Speed	A (1)
Falling Speed	D (70)
Weight	B (18-21)

OVERVIEW

Yoshi is a dinosaur, so he's naturally one of the heavier fighters in the game. He has a remarkably high maximum air velocity, allowing him to cover large distances with a full short hop as he soars through the air. He can crawl low to the ground, allowing him to evade certain mid and high projectiles as he traverses the stage. Yoshi's main weaknesses are his recovery game, since he relies heavily on having his double jump, and his lack of a quick shield grab.

His aerial mobility and recovery options are unconventional in that he doesn't have a special move designed for boosting altitude. His up special is an egg toss, and while it isn't an explicit aerial-recovery move, it boosts him up slightly as he throws his egg. But he has an outstanding double jump; not only does it quickly double his jump altitude, but it grants him super armor. As soon as he double-jumps, attacks don't inflict hitstun on him, allowing him to push through them with his aerial attack. You can think of aerial Egg Throw as a conventional low-altitude midair jump, and his normal double jump as his recovery special.

Yoshi's egg shield is unique. Unlike other brawlers, Yoshi's shield size is static, regardless of how much shield health he has remaining. While he's in his egg, he doesn't have to adjust his shield to deflect attacks coming from below or above. But his shield can still be broken if he leaves it up long enough or if it takes too much damage. You can tell how much shield health he has remaining by the shading of his egg: as his shields are depleted, his eggshell becomes much darker.

Grounded Attacks

Neutral Attacks

Move	Damage
Neutral attack 1	3
Neutral attack 2	4

Dash Attack

Move	Damage
Dash attack	11

Defensive Attacks

Move	Damage
Ledge attack	9
Wake-up attack	7

Neutral Attacks: Yoshi performs a two-hit kick combo, starting with a quick front kick and followed by an inward spin kick that knocks foes away.

Dash Attack: Yoshi transfers all of his running momentum into a flying kick attack. It persists for a brief period and launches foes at an up-forward angle. Yoshi's dash attack deals more damage if it hits early on as Yoshi extends his kick. If you hit with the tail end of the attack, it deals less damage but you're actionable soon after, so you can potentially dash in for a hopping neutral air follow-up combo.

Tilts

Move	Damage
Side tilt	8
Up tilt	7
Down tilt	5

Side Tilt: Yoshi swings his tail in front of him in an upward scooping motion, knocking up enemies into the air. It can be angled upward or downward. Yoshi's side tilt launches foes straight up into the air (instead of away, like most side tilts). If you hit with it at point-blank range, you can combo into up tilt. At max distance (where it's safest), you can follow up with a mix-up attempt by threatening with either another side tilt, an up tilt, or a grab/Egg Lay as the opponent lands.

Up Tilt: Yoshi raises his tail into the air and swings it behind him, launching up enemies directly above. You can usually follow with another up tilt at low percentages. Up tilt is an incredibly effective ground-based anti-air attack. It covers a wide arc and has low lag, allowing you to combo with it at most damage percentages.

Down Tilt: From his low crawling posture, Yoshi sweeps the opponent off their feet with a swift tail strike. This low-profiling attack is a solid aggression-deterring tool against short hops and dash-in attempts. It's safe when shielded, leaving you and the opponent neutral, able to attack or shield at the same time—you're only punishable by shield grabs (if you're within grab range) and perfect shields. You don't get much of a follow-up on hit at low percentages, but at higher damage, down tilt causes a techable knockdown. At very high percentages, it causes a spinning untechable knockdown.

Smashes

Move	Damage
Side smash	15.5
Up smash	14
Down smash	12

Side Smash: Yoshi rams his head forward with extreme force, launching foes far away. Yoshi can angle his head to ram upward and low to the ground. His head is intangible, so it beats out most attacks challenging it. The down-angled variant of side smash slinks him low to the ground, allowing him to avoid mid and high attacks while extending a pronounced hitbox of his own.

Up Smash: Yoshi performs a somersault flash kick. He kicks out in front of him and over his head, arcing behind him. Foes hit by it are sent sky-high. Up smash covers Yoshi's entire frontal area and a bit of his rear (near his head). It's easily punishable due to its high end lag, but it's a powerful KO attack against aggressive foes at high-damage percentages, especially if you're near the upper blast zone.

Down Smash: Yoshi delivers two heavy sweep attacks with his tail: one in front, then one to his rear. Down smash is a situational attack, best used in free-for-all and team battles to clear out surrounding enemies. In one-on-one battles, it leaves you way too vulnerable when shielded. Its horizontal reach leaves a lot to be desired as well.

Grabs

Move	Damage
Grab attack	1.3
Front throw	9
Back throw	9
Up throw	5
Down throw	4

Yoshi grabs enemies with his tongue. It's a slow to start, ranged-type grab extending just past his max side tilt range. If his tongue grabs an enemy, Yoshi swallows them (where they're in a clinched grapple state).

Yoshi's front and back throws are unremarkable, used for throwing foes offstage and into blast zones. Your opponent can usually act before you can follow-up with a guaranteed hit. Yoshi's up throw flings the enemy directly above him, but usually doesn't provide enough hitstun to follow up with a guaranteed attack. His down throw deals the most damage while putting his opponent into a disadvantaged juggle state.

Aerial Attacks

Aerials	
Move	Damage
Neutral air attack	10
Forward air attack	15
Back air attack	3.5x2, 5.5
Up air attack	12
Down air attack	2.3x6, 1.9x6, 2.8

Neutral Air Attack: While airborne, Yoshi extends a lightning-fast straight kick. It doesn't inflict much knockback, but its active window persists for a long period of time. Neutral air is an incredibly versatile attack, and one of Yoshi's staple moves. It's quick to start, has low landing lag, and its persistent effect allows you to use it to descend on foes offensively.

Forward Air Attack: Yoshi flings his head forward with a mighty headbutt while he's soaring through the air. It deals high damage, but has a surprisingly low amount of kick, only causing a slight knockback effect against healthy foes. Forward air is slow to start and has considerable landing lag, but low air lag. It can be used as an edge-guarding attack for spiking enemies offstage (although you need to hit it with precise accuracy). Hitting with the tip of Yoshi's head at the tail end of the attack can meteor smash.

Back Air Attack: In midair, Yoshi whips his tail rapidly behind him for a three-hit combo. The first two hits can drag foes around in the air, while the last hit launches the enemy up and away. Back air is relatively safe when shielded. It's usually only punishable by shield grabs. Back air isn't as strong an edge-guarding attack as forward air due to its high air lag. If you jump off a ledge and miss the enemy, you have to wait a while before you're actionable.

Up Air Attack: While airborne, Yoshi whips his tail straight up into the air, popping up enemies above him. Up air starts up quickly and has a low amount of end lag, making it remarkable for juggle-traps, extending air combos, and prodding at enemies standing on platforms. It also has a generously wide hitbox that hits most grounded fighters. You don't even need to hit with Yoshi's tail—as long as Yoshi's body is touching the enemy fighter, up air hits.

Down Air Attack: Yoshi flails his legs beneath him, essentially running in midair while striking foes with a 13-hit combo. Down air has a high amount of landing lag, but dishes out a ton of damage if all Yoshi's kicks connect. Although it's easily punishable on shield or whiff, it ranks as one the most damaging aerial attack in the game. If you can force an enemy on a platform above you to shield an entire jumping down air, it inflicts around 70% shield damage! Down air deals more damage in the center of the attack (that is, directly beneath Yoshi).

Special Moves

Special Moves	
Move	Damage
Neutral special	7
Side special	~10 to 13
Up special	6
Down special	Grounded: 4, 15, Airborne: 12
Down special	Activation: 4, Reflected projectile: 1.5x

Neutral Special: Egg Lay: Yoshi flings his tongue out in front of him and swallows a nearby enemy, then poops them out encased in an eggshell. The more damaged the enemy, the longer they're stuck in the egg. The opponent can break out of the egg earlier by shaking the control stick back and forth.

Egg Lay usage is straightforward: use it against super-defensive opponents who tend to throw up their shields whenever you're within range. Egg Lay's range is comparable to Yoshi's normal grab, with its start speed slightly slower. Egged foes are left vulnerable to Yoshi's attacks, so you can follow up with almost anything, such as a side smash attack. Egged foes pop out of the egg briefly intangible and able to attack you, so watch for retaliation.

Side Special: Egg Roll: Yoshi does his best Sonic impression and encases himself into an egg, then tumbles across the stage, plowing through foes and knocking them airborne. Like Sonic's Spin Dash, he can turn around midroll to attack enemies multiple times. Yoshi can jump once during Egg Roll. Use Egg Roll to pass through enemies in order to escape. If Egg Roll is performed while airborne, it doesn't begin dealing damage until Yoshi rolls along the ground.

Up Special: Egg Throw: Yoshi pulls out an egg and lobs it like a basketball. You can throw it at various angles with input from the control stick before Yoshi releases the egg. You can throw the egg straight up into the air by inputting the direction Yoshi's facing away from just before throwing. Use this to fake out your opponents, and if they dash in to attack you, you can potentially hit them with the falling egg as it drops at your position. While Yoshi doesn't have a conventional up special recovery move, you can use Egg Throw while airborne to flutter upward a bit, keeping you in the air longer to give you that extra boost to make it over ledges and platforms.

Down Special: Yoshi Bomb: Yoshi pounces high into the sky, then performs a dive-bomb attack straight into the ground, dealing heavy damage and launching foes up and away. If performed while in the air, Yoshi immediately dive-bombs. If you use this while offstage, you get knocked out since there's no turning back (even if you hit an enemy along the way!). Grounded Yoshi Bomb extends a small hitbox in front of Yoshi at the beginning of the attack. Foes hit by it are launched a fixed distance, setting up for Yoshi's dive-bomb to combo. You can fall through platforms by holding the down direction on the control stick during Yoshi's dive-bomb.

Final Smash: Stampede

Yoshi knocks down opponents with a tackle. Then Yoshis of various colors appear and send the opponent flying! The first tackle can affect up to three opponents, but be sure not to KO yourself if you miss everyone.

Young Link

OVERVIEW

Like Link, Young Link is a remarkably balanced brawler with a wide array of options at his disposal. While his overall toolkit makes him effective in most situations and ranges, his main strength comes from his ability to set up projectile-based traps and zoning areas, forcing enemies to either take shield damage or attack him.

Young Link's Deku Shield can block most projectiles, including larger ones like Corrin's charged Dragon Fang Shot. As long as he's in an established standing, walking, or crouching position and facing the incoming projectile, the Deku Shield totally nullifies it, preventing damage.

Young Link Vitals	
Movement Options	
Jumps	1
Crouch Walk	No
Tether	Yes
Wall Jump	Yes
Wall Cling	No
Movement Ranks	
Ground Speed	C- (35)
Air Speed	D+ (59)
Falling Speed	B+ (10-15)
Weight	D (55-57)

ADULT LINK VS. YOUNG LINK: KEY DIFFERENCES

Unlike Link, Young Link retains his multifunctional Hookshot that can be used to grab grounded foes, knock them out of the air, or grab on to ledges as a recovery tool. Adult Link has a conventional close-range grab.

Young Link's Bomb is self-detonating since it's pulled out with its fuse lit, while adult Link's version of down special is a remote-controlled bomb. It also deals more damage than the other Links' bombs (if all four hits connect).

Young Link is a lighter fighter than Link, so he's knocked back farther and up higher when launched.

Young Link deals slightly less damage per attack and has a weaker launching game, but his attacks are slightly faster and generally produce less lag.

Adult Link has a more complicated projectile system, with his Remote Bomb requiring a separate input to detonate. His Arrows can be picked up as items, while Young Link's arrows cannot.

Grounded Attacks

Neutral Attacks: Young Link performs a multi-strike sword attack sequence, beginning with two speedy sword slashes and ending with either a single heavy sword thrust or a flurry of stabs into a launching uppercut swipe. Neutral attacks are generally best used to stop aggressive foes in their tracks, either as an out-of-shield option to punish aggression, or an approach-checking tool that can knock enemies away on hit. The rapid-attack ender deals potentially more damage and sends enemies flying into the air, while the normal-jab ender is a thrust that knocks foes directly away.

Neutral Attacks

Move	Damage
Neutral attack 1	2
Neutral attack 2	1.5
Neutral attack 3 (rapid)	0.3xN, 2.5
Neutral attack 3 (thrust)	3.5

Dash Attack

Move	Damage
Dash attack	11

Defensive Attacks

Move	Damage
Ledge attack	9
Wake-up attack (faceup)	7
Wake-up attack (facedown)	7

Dash Attack: While rushing forward, Young Link lunges at the enemy with an overhead slash that knocks foes diagonally away and upward. Most dash attacks are unsafe on shield, and Young Link's is no different. It has a noticeable end lag, so it's best used to chase down descending foes coming down from a double jump or recovery move. On hit, it only knocks foes away, with limited potential in follow-up combos (although it can KO opponents near a ledge).

Tilts

Move	Damage
Side tilt	12
Up tilt	8
Down tilt	10

Side Tilt: Young Link slams his sword down toward the ground with a weighty forward swing, beginning from up above his head, knocking away foes. Side tilt is a moderately quick attack with a superb arc and hitbox. The initial active window of this attack begins above Link's head, so this attack can be used as an anti-air against short hop attempts. It can also be used to cover and stuff forward movement from approaching enemies, and is an excellent whiff punisher with solid KO potential at higher percentages, especially near the stage's edge.

Up Tilt: Young Link delivers a sword-swipe attack above him, covering a wide arc, starting at his front and ending behind him. Up tilt is a solid and versatile anti-air. It has generous horizontal hitboxes in front and to Link's rear as it makes a wide arc. Combos are much easier to score if you hit with the tail end of the attack (the rear hitbox).

Down Tilt: Young Link crouches low to the ground and slices at the enemy's legs, sending them up into the sky. This is his best and most useful ground attack. It's comparatively quick, launches foes, and is safe against jab punishes when shielded. When spaced to hit at max distance, you can follow up with more pressure, such as with a Hookshot grab.

Smashes

Move	Damage
Side smash 1	6
Side smash 2	12
Up smash	3, 3, 8
Down smash	13

Side Smash: Wielding his sword with both hands, Young Link delivers a powerful overhead blow to the enemy in front of him and follows up with a launching attack that blasts the foe up and away. Young Link's side smash is a two-part combo, with the second launching attack being optional. If you press Attack during the first swing, you follow with an upward slash that knocks enemies into the air. Side smash is fairly fast for a smash attack and can be used as a whiff punish, ledge-recovery punish, or to check your opponent's aggression.

Up Smash: Young Link performs three crescent-arced slashes directed above his head. The first two strikes pop the enemy up, with the final high-powered strike sending them into the air.

Up smash is a high-risk finishing attack, best used if you can make a hard read on your opponent. It's considerably laggy and difficult to use safely in the neutral game, so it's recommended that you stick with up tilt in most situations.

Down Smash: Young Link clears out the area around him with a forceful back-to-back sweeping slash, first striking the ground in front of him, followed by a sweep behind. Down smash is Young Link's fastest smash attack, and thanks to its clear-out effect, it's an ideal move to use for punishing rolls that end up behind you. It's easily punishable if whiffed in the neutral game, but good as an edge-guarding tool against ledge-hanging enemies trying to recover back onto the stage.

Young Link fires his grappling hook that ensnares a foe and hooks on to ledges. All of Young Link's throws deal the same amount of initial damage, while up and down throws allow for more damage potential since you can combo off them. Forward and back throws should be reserved for specific edge-knockout opportunities.

Grabs

Move	Damage
Grab attack	1
Front throw	6
Back throw	6
Up throw	6
Down throw	6

When air grapple is used midair, and as long as you're near a grabbable ledge, Young Link automatically throws his Hookshot to it, extending your edge-grab range. This is an incredibly valuable asset to your recovery game. Like most ranged ledge grapples, you're limited to three Hookshot grapples while you're offstage. On the fourth attempt, you bounce off and likely plummet to your death.

Aerial Attacks

Aerials	
Move	Damage
Neutral air attack	10
Forward air attack	6, 8
Back air attack	5, 7
Up air attack	15
Down air attack	18

Neutral Air Attack: In midair, Young Link delivers an incredibly fast kick attack, leaving his leg extended for a brief time. Neutral air attack is one of your best attacks. It's extremely versatile thanks to its start speed and persistence. Although it doesn't deal much damage or have great knockout potential, it's an excellent offstage edge-guarding tool because of its long active window, making it difficult for recovering foes to get past.

Forward Air Attack: Young Link leaps into the air and performs a spinning two-hit sword combo, slashing at foes in front of him, knocking them out of the sky. Forward air is a solid offensive tool to apply pressure with. Depending on your timing, you can force the first or the second hit to connect at a low altitude. The first hit slightly pops foes up, allowing for a potential combo.

Back Air Attack: While airborne, Young Link performs a two-kick combo: starting with a straight back kick with his left leg, followed by a spin kick with his right. Back air excels as an edge-guarding attack. Like forward air, the first hit pops up grounded enemies, allowing for a potential combo follow-up. Back air has very little lag, midair or on landing, so it's great as a poke as well, allowing you to attack multiple times in a jump.

Up Air Attack: Young Link performs his signature upward-thrust attack from *The Adventure of Link*: a stab directly above his head that he leaves extended for a lengthy duration and launches the first enemy it hits. Up thrust has a narrow up-angled hitbox, but its long active window makes it difficult for descending enemies to challenge. It leaves you vulnerable if you miss with it, since it stays out for so long and has considerable end and landing lag. Use it deliberately and carefully.

Down Air Attack: Young Link performs his signature downthrust: he descends from the air using his sword like a pogo stick, extended downward and bouncing off foes it connects with while spiking them into the ground. Like up air, your down air stays out for a long active period and can be punished if you're imprecise with it, since it has a distinct and lengthy landing lag (the landing effect doesn't have a hitbox, although it may look like it). Down air can cause a meteor smash and is particularly effective for spiking foes off the stage as they try to recover below you.

Special Moves

Special Moves	
Move	Damage
Neutral special	4 (12 at max charge)
Side special	Normal: 11, Flicked: 13.2
Up special	Grounded: 1x10, 3, Airborne: 3, 2x3, 3
Down special	2x4
Down special	Activation: 4, Reflected projectile: 1.5x

Neutral Special: Fire Arrow: Young Link fires an arrow engulfed in fire that causes more damage the longer he has his bow drawn. Like Link's Arrow attack, Young Link makes great use of his fiery arrows when pestering offstage recovering opponents, punishing them with obstacles they have to get past as they try to jump back onto the ledge. The fire on Young Link's Fire Arrows isn't just for show. As a fire-based attack, they can interact with explosives, detonating adult Link's Remote Bombs, for instance.

Side Special: Boomerang: Young Link throws a Boomerang that bounces off the first enemy it contacts before returning to Young Link, damaging additional foes it connects with on the way back. There are two variants of this attack: flicked and non-flicked. Flicked Boomerang, performed by flicking a side direction while inputting Special, deals more damage and travels farther than the non-flicked version. Non-flicked Boomerang is performed by holding a side direction and hitting Special.

Up Special: Spin Attack: Young Link performs a multi-hit spinning attack that ensnares struck foes briefly before launching them into the air. The grounded version is simply a high-damage attack that allows for follow-ups such as up air attack. The aerial version is mainly a recovery tool dealing an altitude boost in order to grab on to ledges, improving your air mobility. It's also a strong knockout attack against high-percentage enemies. As a poke, it can be unsafe to throw out since you're left in a helpless falling state.

Down Special: Bomb: Young Link pulls out a throwable Bomb that detonates after its four-second fuse timer ends, or when it contacts an enemy. Bombs are detonated in a variety of ways. Once pulled, the Bomb's fuse lasts four seconds before automatically exploding. Otherwise, Bombs can be detonated by impacting an opposing fighter, hitting the stage at a certain speed, or connecting with other fire-based attacks, such as Ryu's Shakunetsu Hadoken or Ken's fiery Shoryuken. While the self-detonating explosion can hurt you, detonations from hitting an opponent with the Bomb don't.

Final Smash: Triforce Slash

Young Link dashes forward to seal an opponent in the Triforce. He then strikes them repeatedly before launching them. The initial strike must hit in order for Young Link to begin his sealing combo.

Zelda

OVERVIEW

The princess of Hyrule legend comes to the *Super Smash Bros. Ultimate* brawl equipped as a zoning counterpuncher. She's got many attacks that have good range, powerful sweet spots at the tip, and variable aim. Din's Fire is intangible until detonated, curving slightly around impediments. Phantom Slash gives a grounded option for delayed, invincible attacks from a source besides Zelda herself, creating a temporary teammate. Farore's Wind grants unpredictable, flexible, invulnerable long-range movement. Meanwhile, Nayru's Love is used to send any of the foe's ranged salvos right back at them.

Her moves favor a hit-and-run, keepaway-oriented style. Zelda's biggest weaknesses, then, are the higher-than-normal precision her attacks require, and her relatively slow, floaty speed compared to many agile aggressors. But with a measured and careful ranged game, Zelda can shine by keeping them at bay, letting them get into trouble running into her attacks constantly while coming after her.

Zelda Vitals	
Movement Options	
Jumps	1
Crouch Walk	No
Tether	No
Wall Jump	No
Wall Cling	No
Movement Ranks	
Ground Speed	F (69)
Air Speed	C+ (36-37)
Falling Speed	D (58-61)
Weight	D (61)

Grounded Attacks

Neutral Attacks	
Move	Damage
Neutral attack 1	2.5x2
Neutral attack 2	0.2x8, 3

Dash Attack	
Move	Damage
Dash attack	12

Defensive Attacks	
Move	Damage
Ledge attack	9
Wake-up attack	7

Neutral Attacks: On an initial input, Zelda jabs straight ahead, magical energy twinkling around her arm. Relative to the rest of the cast, this punch isn't fast or slow. The hitbox is mostly along the underside of her outstretched arm, but there's another one around her forward knee. This prevents the jab from whiffing up close against someone tiny. Either hold the Attack button or tap it during neutral attack 1 to follow up with the next stage, a rapid-fire series of weak hits, followed by a straight jab that knocks victims low and away.

Dash Attack: Zelda leans forward with a palm strike using both hands, projecting mystic energy ahead of them. The initial hit is pretty fast for a dash attack, with max damage and knockback potential concentrated in the air ahead of her palms, at the tip of the magic flash. Hitting closer in deals less damage with less knockback. After the initial arm jut, the hitbox persists for a few frames as a weaker hit that still knocks victims away. If enemies shield this, Zelda is extremely punishable.

Side Tilt: The princess attacks with an arm slash in front. This is relatively slow to hit for a side tilt, almost like a side smash with above-average speed. It can be aimed up or down by angling the control stick a bit during execution. This is noteworthy among side tilt attacks for knocking targets away even at low percentages. The sweet spot right at the slash's tip deals the most damage and knockback, but like with her dash attack, this requires precision aim.

Tilts	
Move	Damage
Side tilt	12
Up tilt	7.2
Down tilt	5.5

Up Tilt: Zelda sweeps in a rainbow arc front-to-back, covering three angles. She hits in front first, much faster than her side tilt or grab attacks. She then sweeps through upward directions, ending with her arm hitting straight backward—the attack takes just shy of a third of a second. Although it's not quick to hit behind, enemies that shield up tilt behind Zelda aren't guaranteed punishment against her; she can shield or jump away immediately after up tilt before a grounded foe's out-of-shield gambit connects. On hit, enemies are popped up into a juggle-vulnerable position above.

Down Tilt: The princess juts out a low kick that reaches forward, though not quite as far as her neutral attack. She crouches down during the move, which can help her avoid incoming attacks. This is active fast for a tilt attack. At low percentages, down tilt doesn't lead to anything. At medium percentages and higher, it trips victims into a tumbling knockdown!

Smashes

Move	Damage
Side smash	1x4, 13-1.4x4, 18.2
Up smash	2x4, 0.8x2, 5-2.8x4, 1.1x2, 7
Down smash	12 front, 10 back-16.8 front, 14 back

Side Smash: The princess extends forward both arms and creates a multi-hit swirl of energy in front of her hands. After several weaker hits, a powerful final blow ejects victims out of her grasp. This is different from moves like dash attack and side tilt in that anywhere along her arms deals the same damage.

Up Smash: Zelda conjures a shower of sparks directly above her head, holding enemies who get caught within for several hits. There's a hitbox around Zelda's torso, but it's primarily aimed upward, with an umbrella of hitboxes above her head where the sparks twinkle. Up smash is quicker to hit anti-air angles than up tilt. It's a reliable option for warding off jumping enemies and for batting tumbling targets back up.

Down Smash: Zelda sweeps to both sides with a quick kick, first hitting directly in front with the same speed as down tilt before spinning to kick behind. The front kick deals a little more damage than the backward-aimed follow-up. At medium-damage percentages or higher, both kicks knock foes away fast. Zelda is easily punishable if they shield, though, whether in front or behind.

Zelda's grab is abnormally slow for someone of her size and weight, taking longer to grab than most heavyweights. It's not quite tether-grab-grade slow, but it's close. The reach is good, extending a bit past her grasping hands. If you grab after running and pivoting, her grab is a bit slower, but has even more range. A good defensive option against onrushing aggressors is to run away, pivot, then grab.

Grabs

Move	Damage
Grab attack	1.3
Front throw	10
Back throw	12
Up throw	11
Down throw	1.5x4, 2

Once a target is in Zelda's clutches, use front throw and back throw to hurl them toward the closest stage edge. Up throw and down throw lead to combo chances. Up throw flings them straight up above, while down throw bounces them off the ground, so any juggle will be behind Zelda.

Aerial Attacks

Neutral Air Attack: The princess twirls quickly in midair, arms hitting to both sides. Neutral air, forward air, and back air all hit initially at the same speed, but while front/back air have incredibly strong first-active-frame sweet spots, later hits are much weaker and the hitboxes don't persist for long. Neutral air, on the other hand, hits front and back at once and lasts a long time, about a fourth of a second.

Aerials

Move	Damage
Neutral air attack	2.5x4, 5
Forward air attack	20
Back air attack	20
Up air attack	17
Down air attack	16

Forward Air Attack: The princess sticks her leg out in a precise frontal jump kick. There's an incredible sweet spot at the very tip of the kick right upon activation, dealing a whopping 20% damage with heavy knockback! The accuracy needed for this damage is extremely precise, though. If you hit deeper with the kick on the initial frame, or strike with later frames of the attack, it deals much less damage: between 4% and 8%. Forward air has a lot of lag after use, so it doesn't lend itself well to low-altitude attacks.

Back Air Attack: Back air is just like forward air, only aimed behind Zelda. It hits with the same speed, so there's no timing penalty for aiming the kick backward. This move also has a hugely damaging sweet spot at the tip, right when the kick begins. Deeper or later hits with this kick deal only 4% damage. Just like forward air, this has a lot of end lag in midair, and landing lag if used near the ground.

Up Air Attack: After a lengthy jumping windup period, Zelda aims upward with a magical flaming blast. This is kind of like using a jumping smash attack in terms of speed. The hitbox is well above Zelda in midair, beyond where she points her upstretched arm. Anyone hit by this takes severe damage while being popped upward, vulnerable to more attacks.

Down Air Attack: Zelda aims downward with a powerful stomp, hitting in about the time it takes for up air to hit upward. Down air is much more lenient for aim, though, since her kick persists as a hitbox for a sixth of a second, instead of the eyeblink explosion of up air. Down air, like many other Zelda moves, has a precise sweet spot that deals way more damage and knockback right when it first hits. If you hit precisely with the very beginning of down air, it acts as a meteor smash, kicking foes straight down into the abyss or bouncing them off the stage into juggle position.

Special Moves

Neutral Special: Nayru's Love: Zelda spins in place, surrounded by a temporary crystal shield. The spinning crystals serve as an attack, hitting to both sides with speed analogous to a somewhat fast smash attack, shredding anyone for several hits, ground or air. But this move's main purpose is projectile reflection. Starting early in the move and lasting for half a second, any projectile that collides with the crystal becomes Zelda's, redirected at her challengers!

There's a brief period of intangibility for the princess near the beginning, helping give this priority against projectiles about to hit her early in start-up.

Special Moves

Move	Damage
Neutral special	2x3, 5
Side special	3.5-14
Up special	6, 12 (10 on ground)
Down special	4.7-14.1

Phantom Slash

Assembly Stage	Attack	Damage
No gauntlets	Short-range kick	4.7
Gauntlets, no sword	Short-range punch	6.6
Sword, no chest piece	Short-range sword slash	8.5
Sword with chest piece	Midrange sword chop	11.3
Chest piece and shield	Midrange sword chop	12.2
Helmet	Long-range upward-sweeping sword	14.1

Side Special: Din's Fire: Zelda casts a magical fireball, which drifts forward as long as you hold the input (up to a point). While holding the input, Din's Fire grows in strength, and can be curved up or down with the control stick. It's not as controllable as Ness's PK Thunder, but Din's Fire can be swerved around minor obstacles to hit someone on the other side. Din's Fire creates a local hitbox wherever it explodes. Using this attack requires precision, because it doesn't detonate just because you steer it into something. You have to release the button with appropriate timing.

Up Special: Farore's Wind: Zelda twirls and vanishes, warping quickly to a new location in any direction. There's a brief hitbox both when she disappears and when she reappears. Immediately after input, hold the control stick in the desired direction to zip that way. Zelda is intangible while warping, so she can't be interrupted, and travels clean through any kind of attack. Farore's Wind is her main recovery tool. If you direct Zelda's warp downward into the ground, she doesn't just reappear on the ground when it blocks her warp trajectory; she slides laterally for as long as the warp has left to go. Be careful using Farore's Wind to warp downward to the ground near stage edges, as she can slide right off while invisible, reappearing off the stage!

Down Special: Phantom Slash: Zelda summons a phantom set of mystic armor, which constructs itself piece by piece right behind her. With no further input after down special, Zelda is occupied for a little over one second during conjuration, then she can act again. The completed phantom suit strikes two seconds after the move is initiated. This gives Zelda almost one second to work with in between finishing her conjuring and when the suit strikes. However, it can be triggered earlier. Pressing the Special button again while the suit of armor is coming together sends it in for an immediate attack. The type of attack depends on how much of the suit is constructed when Zelda sends it forth.

Final Smash: Triforce of Wisdom

With the energy from a Smash Ball, Zelda is capable of unleashing the power of the legendary Triforce. The Triforce appears before her like a huge icon, repeatedly damaging anyone nearby inside a big radius. Opponents who have extremely high damage (over 100%) are KO'd by the Triforce outright!

Zero Suit Samus

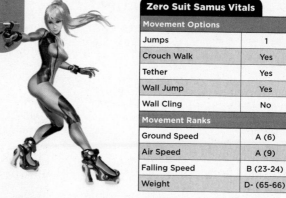

OVERVIEW

Zero Suit Samus is one of the fastest fighters in the game, rivaled by a select few (such as Captain Falcon). Not only does much of her move set boast incredibly fast-starting active hitboxes, but her vulnerability windows (move lag) are relatively short, making her abnormally difficult to punish, which means she can take higher risks than most fighters. Her greatest strengths revolve around juggling and forcing out mistakes while aggressively pursuing airborne enemies. She excels at baiting out bad air dodges and punishing them, especially since many of her specials and attacks synergize and sequence well together.

She can also grab on to ledges with her Plasma Whip by using either her side special or her unique air grab. This can be done only three times (regardless of which of the two ranged grapples you use). The fourth attempt causes her whip to bounce off the edge, leaving Zero Suit Samus to plummet to her death in most cases. Reset this counter by touching the stage.

Zero Suit Samus Vitals	
Movement Options	
Jumps	1
Crouch Walk	Yes
Tether	Yes
Wall Jump	Yes
Wall Cling	No
Movement Ranks	
Ground Speed	A (6)
Air Speed	A (9)
Falling Speed	B (23-24)
Weight	D- (65-66)

Grounded Attacks

Neutral Attacks	
Move	Damage
Neutral attack 1	1.5
Neutral attack 2	1.5
Neutral attack 3	3

Dash Attack	
Move	Damage
Dash attack	8

Defensive Attacks	
Move	Damage
Ledge attack	9
Wake-up attack	7

Neutral Attacks: Zero Suit Samus delivers a lightning-fast chop, followed by a right swing, and ending with a straight elbow strike, knocking her victim away. Zero Suit Samus has the fastest jab in the game (it hits instantly, on the very first frame!). You can hold the Attack button on whiff to repeatedly chop, useful as an edge-guarding tactic to deter certain ledge-recovery options. Jabs aren't generally used offensively, and Zero Suit Samus's neutral attack is no different. It's unsafe off of the second hit, and even more unsafe if the third hit is shielded. However, as the fastest jab in the game, you can almost always punish shielded attacks and deter and challenge enemy aggression.

Dash Attack: With the momentum of her speedy dash, Zero Suit Samus drives her knee into the enemy, launching them into the air. Although Zero Suit Samus's dash speed and dash attack are incredibly quick, Samus's dash attack leaves her extremely vulnerable when shielded. If your opponent responds to your approaching dash by putting up a shield, you can be punished quite easily.

Side Tilt: Zero Suit Samus delivers a staggering roundhouse kick to her opponent's midsection. While side tilt covers a solid horizontal range, it should be used carefully, as Zero Suit Samus has much more effective and safer tools that fill the same role. Its primary use is for checking enemy aggression.

Tilts	
Move	Damage
Side tilt	7
Up tilt	5, 7
Down tilt	8

Up Tilt: Zero Suit Samus quickly performs a handstand spin kick, striking nearby enemies from both her front and rear. This attack is exceptionally quick for an up tilt attack (faster than other fighters' neutral attacks). As such, it's an amazing out-of-shield buffer attack option for shielded attacks with a potential combo. However, up tilt is considerably unsafe on block, so while it's quick and decently sets up your offense on hit, you can be punished if you're too predictable with your retaliation attempts.

Down Tilt: Zero Suit Samus sinks down low to the ground and sweeps her foe off their feet. Down tilt pops enemies up into the air on hit, allowing for tech setups and potential combo opportunities. It has surprising reach, with a hitbox extending slightly past her neutral attack 2. If spaced correctly, it's difficult to punish when shielded.

Smashes

Move	Damage
Side smash	5, 11
Up smash	4, 0.8x5, 3
Down smash	8

Side Smash: Zero Suit Samus executes a graceful double-roundhouse attack to the enemy's midsection, sending them flying away. This attack can be angled up or down in order to slightly alter its effective hitbox. While Zero Suit Samus's side smash leaves you vulnerable to reprisal, it has its uses as a combo finisher after certain hit-confirm attacks (mainly, after you successfully Paralyze an enemy with your Paralyzer shot or down smash). Otherwise, it's highly recommended that you leave this attack out of your normal neutral-game arsenal, saving it only as a high-damage punish attack or if you make a hard read on an aggressive foe.

Up Smash: Zero Suit Samus attacks the space above her with a powerful whip attack. Up smash is a strong anti-air for challenging descending enemies, zoning them out. Since the whip doesn't extend a vulnerable limb, you're likely to beat out foes trying to get the drop on you as long as you're accurate with your up smash timing.

Down Smash: Zero Suit Samus fires her blaster at the ground in front of her, causing a sizable area-of-effect burst that stuns and knocks up foes caught in its blast radius. Down smash is an excellent setup for juggling and setting up combos. You can follow up down smash into forward smash as a kill combo, although it may be rare that you land it from the neutral game. However, down smash is a superb edge-guarding tool to threaten recovering foes or to punish them just as they grab the ledge.

Zero Suit Samus's grab is a ranged tether that's unshieldable, but much slower to start than other fighters' conventional point-blank grabs. Like most throw options from grab, her front and back throws set up knockdown and tech situations, and her up throw is a launching flip kick that gives you a bit of juggle-trapping and mix-up potential. Down throw provides the most in terms of damage since you can usually score a guaranteed up air follow-up against low-percentage foes (such as against Mario at 20%).

Grabs

Move	Damage
Grab attack	1.3
Front throw	5
Back throw	5
Up throw	6
Down throw	5

Like regular Samus, Zero Suit Samus has an air grab attack. Although it doesn't transition into a grab-and-throw state, it's an incredibly useful move. It's a non-committal attack (doesn't extend a vulnerable hurtbox), similar to a projectile. It's particularly effective when used from jump into fast fall or simply off of a short hop. Its landing lag isn't too bad either, so you're unlikely to be punished for pestering enemies with these sequences.

Aerial Attacks

Aerials

Move	Damage
Neutral air attack	8
Forward air attack	5, 7
Back air attack	12
Up air attack	6.5
Down air attack	5

Neutral Air Attack: Zero Suit Samus cracks her electrified whip through the air, striking enemies in front and behind. This neutral air is one of her best spacing tools because of its effective range. It connects against small fighters during jump descent as long as your timing is accurate, with even the rear hitbox occasionally able to hit small-to-medium-sized fighters. It's also (usually) safe on landing. Neutral air is one of your staple combo-starters and poke attacks. Your effective distance revolves around your neutral air whip, and you want to keep the spacing in mind when attacking. Note that the lag on neutral air is considerably high compared to your other air attacks.

Forward Air Attack: Zero Suit Samus delivers two quick horizontal kicks in succession, knocking foes away. This double-hit air attack excels at air-to-air horizontal skirmishes, particularly for edge-guarding and air-combo juggling chase-downs. Use this as a complementary attack with up air, especially after launch setups like down throw.

Back Air Attack: Zero Suit Samus quickly delivers an aerial rear-roundhouse kick. Back air attack is your main edge-guarding tool for keeping recovering opponents far from the ledge. It has low air lag time, so you can stick out back air and another air move. It's also a decent and safe knockout tool, so you can opt to prioritize going for this attack while you chase down high-percentage enemies.

Up Air Attack: Zero Suit Samus delivers a somersault kick, taking down airborne enemies directly above. This is your air-control attack and your main juggling tool. Use this once you gain aerial positional advantage to keep your opponents guessing as you harass them aggressively with these somersault attacks and your other air attacks.

Down Air Attack: Zero Suit Samus commits to a powerful downward thrust, launching herself from any altitude down a specific trajectory until she makes contact with a platform. As a dive-bomb-type attack, you have no control over your trajectory once you commit. If you perform it off a ledge over a pit, you're going to die, so be wary of your surroundings!

Special Moves

Neutral Special: Paralyzer: Zero Suit Samus fires an energy blast that stuns enemies. At max charge, the blast's range, power, and stun are enhanced. Paralyzer is an incredibly powerful projectile attack that sets up combo opportunities. As its name implies, the attack Paralyzes and stuns foes in place for a certain duration (depending on how long you hold the charge upon execution). There are several possible follow-ups you can use when your Paralyzer shot connects, such as dash-in grab and dash-in Boost Kick combo.

Side Special: Plasma Whip: Zero Suit Samus snaps at her foe with her electrified energy whip. It can also be used to grab on to ledges. Although this attack deals a considerable amount of damage, it's one of Zero Suit Samus's slowest attacks and should be used scarcely. If you stick out Plasma Whip right before you land during a jump, you're punished with extra landing lag. However, if you perform Plasma Whip early enough and your move animation completes while you're still airborne, you're met with much less landing lag.

Special Moves	
Move	Damage
Neutral special	4 (6 max)
Side special	1.2x4, 8
Up special	5, 1.3x5, 4
Down special	Head Stomp: 8, Flip Cancel Kick: 14

Up Special: Boost Kick: Zero Suit Samus launches herself into the air with a multi-hit strike, ending with a stylish spin kick that launches her victim. Along with your side smash, Boost Kick is one of your primary knockout moves for taking a stock from high-percentage foes. To set it up, either stun the enemy with a Paralyzer and then dash in and immediately Boost Kick, or pop them up with down smash into dash-in Boost Kick.

Down Special: Flip Jump: In an evasive maneuver, Zero Suit Samus flips through the air. If she successfully lands on a foe, she digs her heels in and buries them in the ground, leaving them vulnerable (if this hits an airborne enemy, they're meteor smashed). Alternatively, she can transition from the flip into a high-damage heavy kick. You can influence the distance covered with Flip Jump by tilting the stick forward or back. Although Zero Suit Samus always flips in the direction you're facing, you can drastically alter trajectory by immediately hitting back after inputting down+Special.

Final Smash: Zero Laser

Zero Suit Samus rides her gunship and aims its laser cannon via a targeting reticle. When fired, the laser hits consecutively and deals massive damage. It finishes with one last energy blast that launches opponents.

SUPER SMASH BROS. ULTIMATE

Written by Joe Epstein and Long Tran

Additonal contributions by Campbell Tran

DK/Prima Games,
a division of Penguin Random House LLC
6081 East 82nd Street, Suite #400
Indianapolis, IN 46250

© 2018 Nintendo.

Based on a game rated by the ESRB: E 10+

BASED ON A GAME RATED BY THE **ESRB** — EVERYONE 10+ — E10+

ISBN: 978-0-7440-1903-2

Printing Code: The rightmost double-digit number is the year of the book's printing; the rightmost single-digit number is the number of the book's printing. For example, 18-1 shows that the first printing of the book occurred in 2018.

21 20 19 18 4 3 2 1

001-310108-Dec/2018

Printed in the USA.

Credits

Senior Product Manager
Jennifer Sims

Book Designer
Tim Amrhein

Production Designers
Keith Lowe
Julie Clark
Wil Cruz

Production
Elisabet Stenberg

Copy Editor
Serena Stokes

Prima Games Staff

Publisher
Mark Hughes

Licensing
Paul Giacomotto

Digital Publisher
Julie Asbury

Marketing Manager
Jeff Barton

Acknowledgments

Prima Games would like to thank Emiko Ohmori, Melena Anderson, Taylor Stockton, Robert Jahn, Sebastian Galloway, Gordon Brown, Chris Kuehnberger, Gatlin Brown, Trace Gordon, Frank Caraan, Douglas Lynn, Jamari Suazo-West, Sean Kennedy, Garrett Higgins, Jeffrey C. Miller, Anna Semenets, Ivan Samoilov, Michelle Stilwell, Michael Keough, and the rest of the amazing Nintendo team for all their help and support on this project!